THE LIBRARY OF LIVING PHILOSOPHERS

# THE PHILOSOPHY OF
# BERTRAND RUSSELL

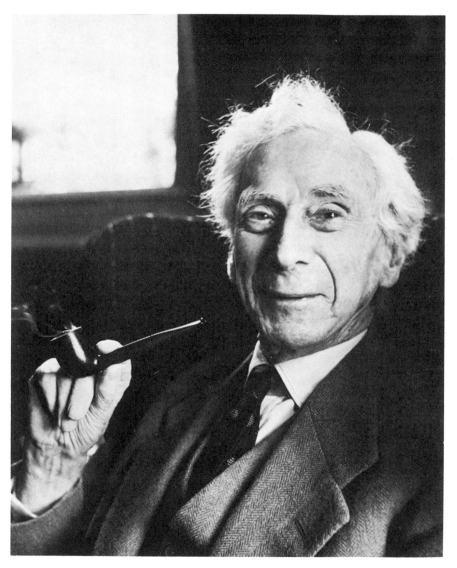

BERTRAND RUSSELL

# THE

# PHILOSOPHY

## OF

# BERTRAND

# RUSSELL

EDITED BY

PAUL ARTHUR SCHILPP

NORTHWESTERN UNIVERSITY &
SOUTHERN ILLINOIS UNIVERSITY

LA SALLE, ILLINOIS • OPEN COURT • ESTABLISHED 1887

# THE PHILOSOPHY OF BERTRAND RUSSELL

Printed and bound in the United States of America.

First printing 1989

Cloth ISBN: 0-87548-138-8
Paper ISBN: 0-8126-9074-5

FIFTH EDITION

# GENERAL INTRODUCTION*
## TO
# "THE LIBRARY OF LIVING PHILOSOPHERS"

ACCORDING to the late F. C. S. Schiller, the greatest obstacle to fruitful discussion in philosophy is "the curious etiquette which apparently taboos the asking of questions about a philosopher's meaning while he is alive." The "interminable controversies which fill the histories of philosophy," he goes on to say, "could have been ended at once by asking the living philosophers a few searching questions."

The confident optimism of this last remark undoubtedly goes too far. Living thinkers have often been asked "a few searching questions," but their answers have not stopped "interminable controversies" about their real meaning. It is none the less true that there would be far greater clarity of understanding than is now often the case, if more such searching questions had been directed to great thinkers while they were still alive.

This, at any rate, is the basic thought behind the present undertaking. The volumes of *The Library of Living Philosophers* can in no sense take the place of the major writings of great and original thinkers. Students who would know the philosophies of such men as John Dewey, George Santayana, Alfred North Whitehead, Benedetto Croce, G. E. Moore, Bertrand Russell, Ernst Cassirer, Etienne Gilson, Martin Heidegger, *et al.,* will still need to read the writings of these men. There is no substitute for first-hand contact with the original thought of the philosopher himself. Least of all does this *Library* pretend to be such a substitute. The *Library* in fact will spare neither effort nor expense in offering to the student the best possible guide to the published writings of a given thinker. We shall attempt to

---

* This *General Introduction*, setting forth the underlying conception of this *Library*, is purposely reprinted in each volume (with only very minor changes).

meet this aim by providing at the end of each volume in our series a complete bibliography of the published work of the philosopher in question. Nor should one overlook the fact that the essays in each volume cannot but finally lead to this same goal. The interpretative and critical discussions of the various phases of a great thinker's work and, most of all, the reply of the thinker himself, are bound to lead the reader to the works of the philosopher himself.

At the same time, there is no blinking the fact that different experts find different ideas in the writings of the same philosopher. This is as true of the appreciative interpreter and grateful disciple as it is of the critical opponent. Nor can it be denied that such differences of reading and of interpretation on the part of other experts often leave the neophyte aghast before the whole maze of widely varying and even opposing interpretations. Who is right and whose interpretation shall he accept? When the doctors disagree among themselves, what is the poor student to do? If, finally, in desperation, he decides that all of the interpreters are probably wrong and that the only thing for him to do is to go back to the original writings of the philosopher himself and then make his own decision—uninfluenced (as if this were possible!) by the interpretation of any one else—the result is not that he has actually come to the meaning of the original philosopher himself, but rather that he has set up one more interpretation, which may differ to a greater or lesser degree from the interpretations already existing. It is clear that in this direction lies chaos, just the kind of chaos which Schiller has so graphically and inimitably described.[1]

It is strange that until now no way of escaping this difficulty has been seriously considered. It has not occurred to students of philosophy that one effective way of meeting the problem at least partially is to put these varying interpretations and critiques before the philosopher while he is still alive and to ask him to act at one and the same time as both defendant and judge. If the world's great living philosophers can be induced to coöperate in

[1] In his essay on "Must Philosophers Disagree?" in the volume by the same title (Macmillan, London, 1934), from which the above quotations were taken.

an enterprise whereby their own work can, at least to some extent, be saved from becoming merely "desiccated lecture-fodder," which on the one hand "provides innocuous sustenance for ruminant professors," and, on the other hand, gives an opportunity to such ruminants and their understudies to "speculate safely, endlessly, and fruitlessly, about what a philosopher must have meant" (Schiller), they will have taken a long step toward making their intentions clearly comprehensible.

With this in mind *The Library of Living Philosophers* expects to publish at more or less regular intervals a volume on each of the greater among the world's living philosophers. In each case it will be the purpose of the editor of *The Library* to bring together in the volume the interpretations and criticisms of a wide range of that particular thinker's scholarly contemporaries, each of whom will be given a free hand to discuss the specific phase of the thinker's work which has been assigned to him. All contributed essays will finally be submitted to the philosopher with whose work and thought they are concerned, for his careful perusal and reply. And, although it would be expecting too much to imagine that the philosopher's reply will be able to stop all differences of interpretation and of critique, this should at least serve the purpose of stopping certain of the grosser and more general kinds of misinterpretations. If no further gain than this were to come from the present and projected volumes of this *Library*, it would seem to be fully justified.

In carrying out this principal purpose of the *Library*, the editor announces that (in so far as humanly possible) each volume will conform to the following pattern:

*First,* a series of expository and critical articles written by the leading exponents and opponents of the philosopher's thought;

*Second,* the reply to the critics and commentators by the philosopher himself;

*Third,* an intellectual autobiography of the thinker whenever this can be secured; in any case an authoritative and authorized biography; and

*Fourth,* a bibliography of the writings of the philosopher to provide a ready instrument to give access to his writings and thought.

Future volumes in this series will appear in as rapid succession as is feasible in view of the scholarly nature of this *Library.*

It is a real pleasure, finally, to make grateful acknowledgment for the financial assistance which this project has already received. Without such help the work on this *Library* could never have been undertaken. The first five volumes have been (and are being) made possible in large part by funds granted by the Carnegie Corporation of New York. Additional financial assistance, for the first and fifth volumes, came from the Alumni Foundation Fund of the College of Liberal Arts of Northwestern University, for the third volume from Mr. Lessing Rosenthal of Chicago, and for the third, fourth and fifth volumes also by small grants of the Social Science Research Council of Northwestern University. To these donors the editor desires to express his sincere gratitude and deep appreciation. Neither the Carnegie Corporation nor the other donors are, however, in any sense the authors, owners, publishers, or proprietors of this *Library* and they are therefore not to be understood as approving by virtue of their grants any of the statements made in this or in any preceding or succeeding volume.

PAUL ARTHUR SCHILPP
*Editor*

101-102 FAYERWEATHER HALL
NORTHWESTERN UNIVERSITY
EVANSTON, ILLINOIS

# TABLE OF CONTENTS

# PREFACE

EVERY serious student of twentieth century philosophy will
welcome the appearance of Volume V in our *Library of
Living Philosophers*. For the name of Bertrand Russell has
been in the forefront of philosophical discussion for more than
forty years. His contributions to mathematical philosophy and
symbolic logic have marked him as one of the world's very few
really great and seminal thinkers. And the breadth of his in-
terests and variety of his writings have made him at the same
time one of the most widely read and critically discussed of our
contemporaries.

Yet the present volume is no mere work of supererogation.
For, although many of Mr. Russell's philosophical ideas have
been the subject of innumerable essays, dissertations, and mono-
graphs, they have never before been treated systematically and
subject by subject. Still less have most previous criticisms of his
ideas been able to elicit from Mr. Russell the careful and studied
replies which the reader will find here in his "Reply to Criti-
cisms" (cf. pp. 679-741).

There will be many philosophers, of course, who will not be
satisfied with Mr. Russell's "Reply." Some of these will object
to the relative brevity of the "Reply." Others, however, will be
dissatisfied on more "philosophical"—or is it "temperamental"?
—grounds. There is no likely way of meeting the demands of
this latter group—unless, indeed, one join their respective camp.
As concerns the former, the editor merely desires to say that
(only day before yesterday) he discovered what he believes to
be the major reason why Mr. Russell did not reply at greater
length. In conversation with the editor, Mr. Russell intimated
that his greatest surprise, in the reading of the twenty-one con-
tributed essays, had come from the discovery that "over half of
their authors had *not* understood" him [i.e., Russell]. This
fact amazed Mr. Russell all the more because he always thought

that he had been making every effort to write clearly and to express his ideas in the briefest possible and most direct way. In other words, Mr. Russell undoubtedly felt that—not having succeeded in making his ideas clear in the first place by his numerous and varied writings—it was hopeless to expect any better understanding for a renewed attempt in his "Reply," and therefore useless to waste words on anything more than seemed absolutely called for.

*Does this prove that the major aim of our* Library *is itself doomed to failure?* We shall leave the answer to this question to our readers and reviewers.

However, especially in view of Mr. Russell's thus expressed sentiments, the editor is all the more grateful to him for his never failing kindness, courtesy, and helpfulness throughout the years of work on this volume. Needless to say, without such continued coöperation from Mr. Russell the present volume could not have materialized.

Similar gratitude is, of course, due to the twenty-one contributors, each of whom wrote his essay for this volume at no small cost to himself in time and energy. The editor also desires to express his appreciation and gratitude to Messrs. Lester E. Denonn, of New York City, and Robert S. Hartman, of Lake Forest, Illinois. Mr. Denonn undertook the heroic task of compiling the bibliography of Mr. Russell's published works; and Mr. Hartman was so kind as to do most of the work on the thankless—but for the research-scholar so exceedingly important—job of preparing the index to this volume.

One new feature of the present volume is the appearance of one of the contributed essays in two languages. Professor Albert Einstein wrote his contribution in German. In view of the significance of his "Remarks" (as he modestly calls his paper), it has seemed best to publish his contribution both in the original German and in English translation.

When Professor Harold Chapman Brown was invited to contribute an essay to this volume, little did the editor dream that the paper on "A Logician in the Field of Psychology" would be Professor Brown's last contribution to philosophy. Early last fall Mr. Brown was already too ill to read and make the neces-

sary corrections on the galley-proofs. On November 9, 1943, he passed away in his home at Stanford University, where he had taught for a quarter of a century, and where the editor years ago had the privilege of sitting at Professor Brown's feet in some of the latter's graduate seminars. We are particularly happy, therefore, to have his last philosophical work preserved here.

Rapidly failing health and untimely death also cheated the readers of this volume out of an essay which was to have appeared here. Professor L. Susan Stebbing had promised several years ago to contribute an essay on "Russell's Conception of Philosophy" to our Russell volume. During the early summer of 1943 we received first a cablegram from London, saying that serious illness would prevent her from fulfilling her promise. On September 11, she too passed on, bringing to a sudden end a career which doubtless had been that of the most noted contemporary philosopher of her sex. Fortunately we were able to print her essay on "Moore's Influence" in Volume IV of this *Library*.

From the beginning of this series we knew that at some time we should find ourselves confronted by the fact that one of our great *living* philosophers should be passing off the scene before we had the chance to finish the volume on his philosophy. We greatly regret to have to record the fact that this fear has already been justified by the event. In February of this year (1944) Léon Brunschvicg died at the age of seventy-five. As early as 1939 he had promised his coöperation in the production of a volume which was to have dealt with his philosophy. Consequently a volume on the philosophy of Léon Brunschvicg has been announced in each of our first four volumes. This unexpected death of M. Brunschvicg obviously makes the carrying out of this promise impossible. France and the world have lost another great philosopher.

<div style="text-align: right">P. A. S.</div>

DEPARTMENT OF PHILOSOPHY
NORTHWESTERN UNIVERSITY
EVANSTON, ILLINOIS

*March 18, 1944*

# ACKNOWLEDGMENTS

Grateful Acknowledgment is hereby made to the publishers of all of Mr. Russell's books as well as to the editors and publishers of philosophical, literary, scientific, and mathematical journals and magazines for their kind permission to quote from the works of Bertrand Russell. We are particularly grateful for their courtesy in not insisting upon a detailed enumeration of the books and articles quoted. Exact title, name of publisher, and place and date of publication of each of Mr. Russell's works are given in the bibliography, which will be found on pages 743 to 804 of this volume.

Grateful acknowledgment is further made to the publishers of other works quoted in the following pages, who have also been kind enough not to require the specific enumeration of the works quoted.

# PREFATORY NOTE ADDED IN 1971

The editor wishes to express his appreciation to the new publishers of the Library—The Open Court Publishing Company—for undertaking to keep all of the volumes of the Library permanently in print; to the Advisory Board of the Library, for their help in planning future volumes (the present membership of the Board is listed below) ; and to the National Endowment for the Humanities, Washington, D. C., for generous grants for the years 1967-1969.

<div align="right">Paul A. Schilpp</div>

*Department of Philosophy*
*Southern Illinois University*
*Carbondale, Illinois*

## ADVISORY BOARD

# PREFATORY NOTE TO THE 1971 EDITION

This edition contains on pages xviii-xx a few pages of additions to his "Reply," which Lord Russell wrote before his passing. We are happy to be able to insert this new material from Russell's pen to this new edition.

<div align="right">Paul A. Schilpp</div>

*Department of Philosophy*
*Southern Illinois University*
*Carbondale, Illinois*

# ADDENDUM TO MY "REPLY TO CRITICISMS"

I AM glad to know that the volume concerned with me in Schilpp's *Library of Living Philosophers* is to be reprinted and I am grateful for the invitation to add a note to my "Reply to Critics." My addition will have to be brief as most of my time since the original publication has been devoted to an attempt to keep the human race from exterminating itself. Some books of pure philosophy—wholly, or in large part, pure philosophy—it is true, I have published in the intervening period, notably, a *History of Western Philosophy* (1945), *Human Knowledge* (1948), *Human Society in Ethics and Politics* (1954), and *My Philosophical Development* (1959). It is matters contained in these books that will chiefly occupy me in what follows.

The chief purpose of *Human Knowledge* was to examine non-demonstrative inferences. I had said my say about demonstrative inferences and had become persuaded that there were none which could justify the broad outlines of science. Induction, which had formerly been called upon to fulfil this role, proved totally ineffective when applied without other aids. I came to the conclusion that what are needed for the validity of scientific inference are four principles generally tacitly assumed in reasoning about the validity of science. I did not maintain that these principles are *a priori* truths valid, like the principles of logic, in any possible universe. Nor did I maintain that they can be known by mere reflection. I regarded them as the residue from an analysis of actual scientific reasonings and I took, throughout, the view that science and common sense are, in their main outlines, true. This theory, so far as I know, pleased few, but I have, so far, seen no reason to abandon it.

Another subject which was discussed in *Human Knowledge* was the contradictions which have appeared in formal logic and the cognate discoveries of Gödel. This is a vexatious and diffi-

cult subject, and one of which the ultimate solution, I fear, will not be found quickly. I found a sort of solution of the contradictions which I embodied in *Principia Mathematica*, but the solution was not one with which a logician could feel comfortable. Others have found other solutions, but no one, so far, has found one which is wholly satisfying.

Not long after the appearance of *Principia Mathematica*, Gödel propounded a new difficulty. He proved that, in any systematic logical language, there are propositions which can be stated, but cannot be either proved or disproved. This has been taken by many (not, I think, by Gödel) as a fatal objection to mathematical logic in the form which I and others had given to it. I have never been able to adopt this view. It is maintained by those who hold this view that no systematic logical theory can be true of everything. Oddly enough, they never apply this opinion to elementary every-day arithmetic. Until they do so, I consider that they may be ignored. I had always supposed that there are propositions in mathematical logic which can be stated, but neither proved nor disproved. Two of these had a fairly prominent place in *Principia Mathematica*—namely, the axiom of choice and the axiom of infinity. To many mathematical logicians, however, the destructive influence of Gödel's work appears much greater than it does to me and has been thought to require a great restriction in the scope of mathematical logic. It is held by many that, before developing the consequences of some set of axioms, one should be able to prove that no contradictions are to be found among them. For my part, I had always thought this impossible, since the number of consequences of any given set of axioms is infinite. My critics, however, consider that I was punished for my imprudence by actually coming upon such a contradiction. I adhere to the view that one should make the best set of axioms that one can think of and believe in it unless and until actual contradictions appear. But the whole discussion is still in its infancy. Other puzzles have troubled mathematicians, though less than they should. The axiom of parallels troubled people from the time of Euclid to the time of Lobachewsky, a period of some two thousand, three hundred years. Incommensurables

troubled people from Pythogoras to Weierstrass. Perhaps Gödel's problem will have an equally long life.

I come now to a more general problem—namely, the question of the degree of objectivity of such things as universals or false propositions. Several of my critics in this volume, and probably a majority of philosophers elsewhere, have found fault with me for excessive objectivity. I agree with these critics in wishing to share their view, but I find it impossible to do so. Take the proposition "it is not raining," enunciated on a sunny day. Can you maintain that it is only in the mind that it is not raining? You can, of course, adduce a number of positive propositions all of which imply the proposition "it is not raining," but none of them is equivalent to this proposition and none of them is known to be incompatible with it. I endeavoured, at one time, to make a language in which everything could be said, but in which the word "not" and its equivalents did not occur. This attempt foundered on general propositions. "All men are mortal," for example, does not obviously contain any negation, but, if you ask yourself how it could be proved, it could only be by counting all the men you knew of and then saying "Well, there are no more," or, at any rate, by some procedure leading to the conclusion "there are no immortal men." This procedure could only be avoided in the case of logical entities such as numbers. You could say, for example, that there are no square numbers between fifty and sixty. You could then invent a word "round" and say all numbers between fifty and sixty are "round." But in empirical material we cannot know that we have enumerated all the individuals of some kind. Such procedures are impossible. I gave a number of examples of knowledge transcending experience in Chapter IV, Part VI, of *Human Knowledge*, and I see no reason to abandon any of them. Generally, I do not think that the truth or falsity of a proposition depends upon its verifiability, or the verifiability of its contradictory. I think that, if there were no life on earth, it would still be the same distance from the Pole to the Equator as it is now, although there would be no schoolboys who had to learn this fact.

Many of the questions that we have been discussing are

trivial, at least as compared to the continued existence of the human race. Since this became in jeopardy, I have lost interest in the kind of discussion that has come to constitute British philosophy. I am sorry to leave so many questions unanswered and so many answers uncertain, but uncertainty is, at any rate, better than mistaken certainty. I have frequently experienced a passage from the latter to the former. This degree of success, at least, I can claim.

*Bertrand Russell*

MY MENTAL DEVELOPMENT

# MY MENTAL DEVELOPMENT

MY mother having died when I was two years old, and my father when I was three, I was brought up in the house of my grandfather, Lord John Russell, afterwards Earl Russell. Of my parents, Lord and Lady Amberley, I was told almost nothing—so little that I vaguely sensed a dark mystery. It was not until I was twenty-one that I came to know the main outlines of my parents' lives and opinions. I then found, with a sense of bewilderment, that I had gone through almost exactly the same mental and emotional development as my father had.

It was expected of my father that he should take to a political career, which was traditional in the Russell family. He was willing, and was for a short time in Parliament (1867-68); but he had not the temperament or the opinions that would have made political success possible. At the age of twenty-one he decided that he was not a Christian, and refused to go to Church on Christmas Day. He became a disciple, and afterwards a friend, of John Stuart Mill, who, as I discovered some years ago, was (so far as is possible in a non-religious sense) my godfather. My parents accepted Mill's opinions, not only such as were comparatively popular, but also those that still shocked public sentiment, such as women's suffrage and birth control. During the general election of 1868, at which my father was a candidate, it was discovered that, at a private meeting of a small society, he had said that birth control was a matter for the medical profession to consider. This let loose a campaign of vilification and slander. A Catholic Bishop declared that he advocated infanticide; he was called in print a "filthy foul-mouthed rake;" on election day, cartoons were exhibited accus-

3

ing him of immorality, altering his name to "Vice-count Amberley," and accusing him of advocating "The French and American system."[1] By these means he was defeated. The student of comparative sociology may be interested in the similarities between rural England in 1868 and urban New York in 1940. The available documents are collected in *The Amberley Papers*, by my wife and myself. As the reader of this book will see, my father was shy, studious, and ultra-conscientious—perhaps a prig, but the very opposite of a rake.

My father did not give up hope of returning to politics, but never obtained another constituency, and devoted himself to writing a big book, *Analysis of Religious Belief*, which was published after his death. He could not, in any case, have succeeded in politics, because of his very exceptional intellectual integrity; he was always willing to admit the weak points on his own side and the strong points on that of his opponents. Moreover his health was always bad, and he suffered from a consequent lack of physical vigour.

My mother shared my father's opinions, and shocked the 'sixties by addressing meetings in favour of equality for women. She refused to use the phrase "women's rights," because, as a good utilitarian, she rejected the doctrine of natural rights.

My father wished my brother and me to be brought up as free thinkers, and appointed two free thinkers as our guardians. The Court of Chancery, however, at the request of my grandparents, set aside the will, and I enjoyed the benefits of a Christian upbringing.

In 1876, when after my father's death, I was brought to the house of my grandparents, my grandfather was eighty-three and had become very feeble. I remember him sometimes being wheeled about out-of-doors in a bath-chair, sometimes in his room reading Hansard (the official report of debates in Parliament). He was invariably kind to me, and seemed never to object to childish noise. But he was too old to influence me directly. He died in 1878, and my knowledge of him came

---

[1] My parents, when in America, had studied such experiments as the Oneida community. They were therefore accused of attempting to corrupt the purity of English family life by introducing un-English transatlantic vices.

through his widow, my grandmother, who revered his memory. She was a more powerful influence upon my general outlook than any one else, although, from adolescence onward, I disagreed with very many of her opinions.

My grandmother was a Scotch Presbyterian, of the border family of the Elliots. Her maternal grandfather suffered obloquy for declaring, on the basis of the thickness of the lava on the slopes of Etna, that the world must have been created before B.C. 4004. One of her great-grandfathers was Robertson, the historian of Charles V.

She was a Puritan, with the moral rigidity of the Covenanters, despising comfort, indifferent to food, hating wine, and regarding tobacco as sinful. Although she had lived her whole life in the great world until my grandfather's retirement in 1866, she was completely unworldly. She had that indifference to money which is only possible to those who have always had enough of it. She wished her children and grandchildren to live useful and virtuous lives, but had no desire that they should achieve what others would regard as success, or that they should marry "well." She had the Protestant belief in private judgment and the supremacy of the individual conscience. On my twelfth birthday she gave me a Bible (which I still possess), and wrote her favourite texts on the fly-leaf. One of them was "Thou shalt not follow a multitude to do evil;" another, "Be strong, and of a good courage; be not afraid, neither be Thou dismayed; for the Lord Thy God is with thee whithersoever thou goest." These texts have profoundly influenced my life, and still seemed to retain some meaning after I had ceased to believe in God.

At the age of seventy, my grandmother became a Unitarian; at the same time, she supported Home Rule for Ireland, and made friends with Irish Members of Parliament, who were being publicly accused of complicity in murder. This shocked people more than now seems imaginable. She was passionately opposed to imperialism, and taught me to think ill of the Afghan and Zulu wars, which occurred when I was about seven. Concerning the occupation of Egypt, however, she said little, as it was due to Mr. Gladstone, whom she admired. I remember an

argument I had with my German governess, who said that the
English, having once gone into Egypt, would never come out,
whatever they might promise, whereas I maintained, with much
patriotic passion, that the English never broke promises. That
was sixty years ago, and they are there still.

My grandfather, seen through the eyes of his widow, made
it seem imperative and natural to do something important for
the good of mankind. I was told of his introducing the Reform
Bill in 1832. Shortly before he died, a delegation of eminent
nonconformists assembled to cheer him, and I was told that
fifty years earlier he had been one of the leaders in removing
their political disabilities. In his sitting-room there was a statue
of Italy, presented to my grandfather by the Italian Govern-
ment, with an inscription: "A Lord John Russell, L'Italia
Riconoscente;" I naturally wished to know what this meant,
and learnt, in consequence, the whole saga of Garibaldi and
Italian unity. Such things stimulated my ambition to live to
some purpose.

My grandfather's library, which became my schoolroom,
stimulated me in a different way. There were books of history,
some of them very old; I remember in particular a sixteenth-
century Guicciardini. There were three huge folio volumes
called *L'Art de vérifier les dates*. They were too heavy for me
to move, and I speculated as to their contents; I imagined
something like the tables for finding Easter in the Prayer-
Book. At last I became old enough to lift one of the volumes
out of the shelf, and I found, to my disgust, that the only "art"
involved was that of looking up the date in the book. Then there
were *The Annals of Ireland* by the Four Masters, in which I
read about the men who went to Ireland before the Flood and
were drowned in it; I wondered how the Four Masters knew
about them, and read no further. There were also more ordi-
nary books, such as Machiavelli and Gibbon and Swift, and a
book in four volumes that I never opened: *The Works of An-
drew Marvell Esq. M. P.* It was not till I grew up that I
discovered Marvell was a poet rather than a politician. I was
not supposed to read any of these books; otherwise I should
probably not have read any of them. The net result of them

was to stimulate my interest in history. No doubt my interest was increased by the fact that my family had been prominent in English history since the early sixteenth century. I was taught English history as the record of a struggle against the King for constitutional liberty. William Lord Russell, who was executed under Charles II, was held up for special admiration, and the inference was encouraged that rebellion is often praiseworthy.

A great event in my life, at the age of eleven, was the beginning of Euclid, which was still the accepted textbook of geometry. When I had got over my disappointment in finding that he began with axioms, which had to be accepted without proof, I found great delight in him. Throughout the rest of my boyhood, mathematics absorbed a very large part of my interest. This interest was complex: partly mere pleasure in discovering that I possessed a certain kind of skill, partly delight in the power of deductive reasoning, partly the restfulness of mathematical certainty; but more than any of these (while I was still a boy) the belief that nature operates according to mathematical laws, and that human actions, like planetary motions, could be calculated if we had sufficient skill. By the time I was fifteen, I had arrived at a theory very similar to that of the Cartesians. The movements of living bodies, I felt convinced, were wholly regulated by the laws of dynamics; therefore free will must be an illusion. But, since I accepted consciousness as an indubitable datum, I could not accept materialism, though I had a certain hankering after it on account of its intellectual simplicity and its rejection of "nonsense." I still believed in God, because the First-Cause argument seemed irrefutable.

Until I went to Cambridge at the age of eighteen, my life was a very solitary one. I was brought up at home, by German nurses, German and Swiss governesses, and finally by English tutors; I saw little of other children, and when I did they were not important to me. At fourteen or fifteen I became passionately interested in religion, and set to work to examine successively the arguments for free will, immortality, and God. For a few months I had an agnostic tutor with whom I could talk about these problems, but he was sent away, presumably because he was thought to be undermining my faith. Except

during these months, I kept my thoughts to myself, writing them out in a journal in Greek letters to prevent others from reading them. I was suffering the unhappiness natural to lonely adolescence, and I attributed my unhappiness to loss of religious belief. For three years I thought about religion, with a determination not to let my thoughts be influenced by my desires. I discarded first free will, then immortality; I believed in God until I was just eighteen, when I found in Mill's *Autobiography* the sentence: "My father taught me that the question 'Who made me'? cannot be answered, since it immediately suggests the further question 'Who made God'?" In that moment I decided that the First-Cause argument is fallacious.

During these years I read widely, but as my reading was not directed, much of it was futile. I read much bad poetry, especially Tennyson and Byron; at last, at the age of seventeen, I came upon Shelley, whom no one had told me about. He remained for many years the man I loved most among great men of the past. I read a great deal of Carlyle, and admired *Past and Present*, but not *Sartor Resartus*. "The Everlasting Yea" seemed to me sentimental nonsense. The man with whom I most nearly agreed was Mill. His *Political Economy*, *Liberty*, and *Subjection of Women* influenced me profoundly. I made elaborate notes on the whole of his *Logic*, but could not accept his theory that mathematical propositions are empirical generalizations, though I did not know what else they could be.

All this was before I went to Cambridge. Except during the three months when I had the agnostic tutor mentioned above, I found no one to speak to about my thoughts. At home I concealed my religious doubts. Once I said that I was a utilitarian, but was met with such a blast of ridicule that I never again spoke of my opinions at home.

Cambridge opened to me a new world of infinite delight. For the first time I found that, when I uttered my thoughts, they seemed to be accepted as worth considering. Whitehead, who had examined me for entrance scholarships, had mentioned me to various people a year or two senior to me, with the result that within a week I met a number who became my life-long

friends. Whitehead, who was already a Fellow and Lecturer, was amazingly kind, but was too much my senior to be a close personal friend until some years later. I found a group of contemporaries, who were able, rather earnest, hard-working, but interested in many things outside their academic work—poetry, philosophy, politics, ethics, indeed the whole world of mental adventure. We used to stay up discussing till very late on Saturday nights, meet for a late breakfast on Sunday, and then go for an all-day walk. Able young men had not yet adopted the pose of cynical superiority which came in some years later, and was first made fashionable in Cambridge by Lytton Strachey. The world seemed hopeful and solid; we all felt convinced that nineteenth-century progress would continue, and that we ourselves should be able to contribute something of value. For those who have been young since 1914 it must be difficult to imagine the happiness of those days.

Among my friends at Cambridge were McTaggart, the Hegelian philosopher; Lowes Dickinson, whose gentle charm made him loved by all who knew him; Charles Sanger, a brilliant mathematician at College, afterwards a barrister, known in legal circles as the editor of Jarman on Wills; two brothers, Crompton and Theodore Llewelyn Davies, sons of a Broad Church clergyman most widely known as one of "Davies and Vaughan," who translated Plato's *Republic*. These two brothers were the youngest and ablest of a family of seven, all remarkably able; they had also a quite unusual capacity for friendship, a deep desire to be of use to the world, and unrivalled wit. Theodore, the younger of the two, was still in the earlier stages of a brilliant career in the government service when he was drowned in a bathing accident. I have never known any two men so deeply loved by so many friends. Among those of whom I saw most were the three brothers Trevelyan, great-nephews of Macaulay. Of these the oldest became a Labour politician and resigned from the Labour Government because it was not sufficiently socialistic; the second became a poet and published, among other things, an admirable translation of Lucretius; the third, George, achieved fame as an historian. Somewhat junior

to me was G. E. Moore, who later had a great influence upon my philosophy.

The set in which I lived was very much influenced by McTaggart, whose wit recommended his Hegelian philosophy. He taught me to consider British empiricism "crude," and I was willing to believe that Hegel (and in a lesser degree Kant) had a profundity not to be found in Locke, Berkeley, and Hume, or in my former pope, Mill. My first three years at Cambridge, I was too busy with mathematics to read Kant or Hegel, but in my fourth year I concentrated on philosophy. My teachers were Henry Sidgwick, James Ward, and G. F. Stout. Sidgwick represented the British point of view, which I believed myself to have seen through; I therefore thought less of him at that time than I did later. Ward, for whom I had a very great personal affection, set forth a Kantian system, and introduced me to Lotze and Sigwart. Stout, at that time, thought very highly of Bradley; when *Appearance and Reality* was published, he said it had done as much as is humanly possible in ontology. He and McTaggart between them caused me to become a Hegelian; I remember the precise moment, one day in 1894, as I was walking along Trinity Lane, when I saw in a flash (or thought I saw) that the ontological argument is valid. I had gone out to buy a tin of tobacco; on my way back, I suddenly threw it up in the air, and exclaimed as I caught it: "Great Scott, the ontological argument is sound." I read Bradley at this time with avidity, and admired him more than any other recent philosopher.

After leaving Cambridge in 1894, I spent a good deal of time in foreign countries. For some months in 1894, I was honorary attaché at the British Embassy in Paris, where I had to copy out long dispatches attempting to persuade the French Government that a lobster is not a fish, to which the French Government would reply that it was a fish in 1713, at the time of the Treaty of Utrecht. I had no desire for a diplomatic career, and left the Embassy in December, 1894. I then married, and spent most of 1895 in Berlin, studying economics and German Social Democracy. The Ambassador's wife being a

lations, and to distrust the logical bases of monism. I disliked the subjectivity of the "Transcendental Aesthetic." But these motives would have operated more slowly than they did, but for the influence of G. E. Moore. He also had had a Hegelian period, but it was briefer than mine. He took the lead in rebellion, and I followed, with a sense of emancipation. Bradley argued that everything common sense believes in is mere appearance; we reverted to the opposite extreme, and thought that *everything* is real that common sense, uninfluenced by philosophy or theology, supposes real. With a sense of escaping from prison, we allowed ourselves to think that grass is green, that the sun and stars would exist if no one was aware of them, and also that there is a pluralistic timeless world of Platonic ideas. The world, which had been thin and logical, suddenly became rich and varied and solid. Mathematics could be *quite* true, and not merely a stage in dialectic. Something of this point of view appeared in my *Philosophy of Leibniz*. This book owed its origin to chance. McTaggart, who would, in the normal course, have lectured on Leibniz at Cambridge in 1898, wished to visit his family in New Zealand, and I was asked to take his place for this course. For me, the accident was a fortunate one.

The most important year in my intellectual life was the year 1900, and the most important event in this year was my visit to the International Congress of Philosophy in Paris. Ever since I had begun Euclid at the age of eleven, I had been troubled about the foundations of mathematics; when, later, I came to read philosophy, I found Kant and the empiricists equally unsatisfactory. I did not like the synthetic *a priori*, but yet arithmetic did not seem to consist of empirical generalizations. In Paris in 1900, I was impressed by the fact that, in all discussions, Peano and his pupils had a precision which was not possessed by others. I therefore asked him to give me his works, which he did. As soon as I had mastered his notation, I saw that it extended the region of mathematical precision backwards towards regions which had been given over to philosophical vagueness. Basing myself on him, I invented a notation for relations. Whitehead, fortunately, agreed as to the importance of the method, and in a very short time we worked out together

cousin of mine, my wife and I were invited to dinner at the Embassy; but she mentioned that we had gone to a Socialist meeting, and after this the Embassy closed its doors to us. My wife was a Philadelphia Quaker, and in 1896 we spent three months in America. The first place we visited was Walt Whitman's house in Camden, N.J.; she had known him well, and I greatly admired him. These travels were useful in curing me of a certain Cambridge provincialism; in particular, I came to know the work of Weierstrass, whom my Cambridge teachers had never mentioned. After these travels, we settled down in a workman's cottage in Sussex, to which we added a fairly large work-room. I had at that time enough money to live simply without earning, and I was therefore able to devote all my time to philosophy and mathematics, except the evenings, when we read history aloud.

In the years from 1894 to 1898, I believed in the possibility of proving by metaphysics various things about the universe that religious feeling made me think important. I decided that, if I had sufficient ability, I would devote my life to philosophy. My fellowship dissertation, on the foundations of geometry, was praised by Ward and Whitehead; if it had not been, I should have taken up economics, at which I had been working in Berlin. I remember a spring morning when I walked in the Tiergarten, and planned to write a series of books in the philosophy of the sciences, growing gradually more concrete as I passed from mathematics to biology; I thought I would also write a series of books on social and political questions, growing gradually more abstract. At last I would achieve a Hegelian synthesis in an encyclopaedic work dealing equally with theory and practice. The scheme was inspired by Hegel, and yet something of it survived the change in my philosophy. The moment had had a certain importance: I can still, in memory, feel the squelching of melting snow beneath my feet, and smell the damp earth that promised the end of winter.

During 1898, various things caused me to abandon both Kant and Hegel. I read Hegel's *Greater Logic*, and thought, as I still do, that all he says about mathematics is muddle-headed nonsense. I came to disbelieve Bradley's arguments against re-

such matters as the definitions of series, cardinals, and ordinals, and the reduction of arithmetic to logic. For nearly a year, we had a rapid series of quick successes. Much of the work had already been done by Frege, but at first we did not know this. The work that ultimately became my contribution to *Principia Mathematica* presented itself to me, at first, as a parenthesis in the refutation of Kant.

In June 1901, this period of honeymoon delight came to an end. Cantor had a proof that there is no greatest cardinal; in applying this proof to the universal class, I was led to the contradiction about classes that are not members of themselves. It soon became clear that this is only one of an infinite class of contradictions. I wrote to Frege, who replied with the utmost gravity that *"die Arithmetik ist ins Schwanken geraten."* At first, I hoped the matter was trivial and could be easily cleared up; but early hopes were succeeded by something very near to despair. Throughout 1903 and 1904, I pursued will-o'-the wisps and made no progress. At last, in the spring of 1905, a different problem, which proved soluble, gave the first glimmer of hope. The problem was that of descriptions, and its solution suggested a new technique.

Scholastic realism was a metaphysical theory, but every metaphysical theory has a technical counterpart. I had been a realist in the scholastic or Platonic sense; I had thought that cardinal integers, for instance, have a timeless being. When integers were reduced to classes of classes, this being was transferred to classes. Meinong, whose work interested me, applied the arguments of realism to descriptive phrases. Everyone agrees that "the golden mountain does not exist" is a true proposition. But it has, apparently, a subject, "the golden mountain," and if this subject did not designate some object, the proposition would seem to be meaningless. Meinong inferred that there is a golden mountain, which is golden and a mountain, but does not exist. He even thought that the existent golden mountain is existent, but does not exist. This did not satisfy me, and the desire to avoid Meinong's unduly populous realm of being led me to the theory of descriptions. What was of importance in this theory was the discovery that, in analysing a significant sen-

tence, one must not assume that each separate word or phrase has significance on its own account. "The golden mountain" can be part of a significant sentence, but is not significant in isolation. It soon appeared that class-symbols could be treated like descriptions, i.e., as non-significant parts of significant sentences. This made it possible to see, in a general way, how a solution of the contradictions might be possible. The particular solution offered in *Principia Mathematica* had various defects, but at any rate it showed that the logician is not presented with a complete *impasse*.

The theory of descriptions, and the attempt to solve the contradictions, had led me to pay attention to the problem of meaning and significance. The definition of "meaning" as applied to words and "significance" as applied to sentences is a complex problem, which I tried to deal with in *The Analysis of Mind* (1921) and *An Inquiry into Meaning and Truth* (1940). It is a problem that takes one into psychology and even physiology. The more I have thought about it, the less convinced I have become of the complete independence of logic. Seeing that logic is a much more advanced and exact science than psychology, it is clearly desirable, as far as possible, to delimit the problems that can be dealt with by logical methods. It is here that I have found Occam's razor useful.

Occam's razor, in its original form, was metaphysical: it was a principle of parsimony as regards "entities." I still thought of it in this way while *Principia Mathematica* was being written. In Plato, cardinal integers are timeless entities; they are equally so in Frege's *Grundgesetze der Arithmetik*. The definition of cardinals as classes of classes, and the discovery that class-symbols could be "incomplete symbols," persuaded me that cardinals as entities are unnecessary. But what had really been demonstrated was something quite independent of metaphysics, which is best stated in terms of "minimum vocabularies." I mean by a "minimum vocabulary" one in which no word can be defined in terms of the others. All definitions are theoretically superfluous, and therefore the whole of any science can be expressed by means of a minimum vocabulary for that science. Peano reduced the special vocabulary of arithmetic to **three**

terms; Frege and *Principia Mathematica* maintained that even these are unnecessary, and that a minimum vocabulary for mathematics is the same as for logic. This problem is a purely technical one, and is capable of a precise solution.

There is need, however, of great caution in drawing inferences from minimum vocabularies. In the first place, there are usually, if not always, a number of different minimum vocabularies for a given subject-matter; for example, in the theory of truth-functions we may take "not-$p$ or not-$q$" or "not-$p$ and not-$q$" as undefined, and there is no reason to prefer one choice to the other. Then again there is often a question as to whether what seems to be a definition is not really an empirical proposition. Suppose, for instance, I define "red" as "those visual sensations which are caused by wave-lengths of such and such a range of frequencies." If we take this as what the word "red" means, no proposition containing the word can have been known before the undulatory theory of light was known and wave-lengths could be measured; and yet the word "red" was used before these discoveries had been made. This makes it clear that in all every-day statements containing the word "red" this word does not have the meaning assigned to it in the above definition. Consider the question: "Can everything that we know about colours be known to a blind man?" With the above definition, the answer is yes; with a definition derived from every-day experience, the answer is no. This problem shows how the new logic, like the Aristotelian, can lead to a narrow scholasticism.

Nevertheless, there is one kind of inference which, I think, can be drawn from the study of minimum vocabularies. Take, as one of the most important examples, the traditional problem of universals. It seems fairly certain that no vocabulary can dispense wholly with words that are more or less of the sort called "universals." These words, it is true, need never occur as nouns; they may occur only as adjectives or verbs. Probably we could be content with one such word, the word "similar," and we should never need the word "similarity." But the fact that we need the word "similar" indicates some fact about the world, and not only about language. What fact it indicates about the world, I do not know.

Another illustration of the uses of minimum vocabularies is as regards historical events. To express history, we must have a means of speaking of something which has only happened once, like the death of Caesar. An undue absorption in logic, which is not concerned with history, may cause this need to be overlooked. Spatio-temporal relativity has made it more difficult to satisfy this need than it was in a Newtonian universe, where points and instants supplied particularity.

Thus, broadly speaking, minimum vocabularies are more instructive when they show a certain kind of term to be indispensable than when they show the opposite.

In some respects, my published work, outside mathematical logic, does not at all completely represent my beliefs or my general outlook. Theory of knowledge, with which I have been largely concerned, has a certain essential subjectivity; it asks "how do *I* know what I know?" and starts inevitably from personal experience. Its data are egocentric, and so are the earlier stages of its argumentation. I have not, so far, got beyond the earlier stages, and have therefore seemed more subjective in outlook than in fact I am. I am not a solipsist, nor an idealist; I believe (though without good grounds) in the world of physics as well as in the world of psychology. But it seems clear that whatever is not experienced must, if known, be known by inference. I find that the fear of solipsism has prevented philosophers from facing this problem, and that either the necessary principles of inference have been left vague, or else the distinction between what is known by experience and what is known by inference has been denied. If I ever have the leisure to undertake another serious investigation of a philosophical problem, I shall attempt to analyse the inferences from experience to the world of physics, assuming them capable of validity, and seeking to discover what principles of inference, if true, would make them valid. Whether these principles, when discovered, are accepted as true, is a matter of temperament; what should not be a matter of temperament should be the proof that acceptance of them is necessary if solipsism is to be rejected.

I come now to what I have attempted to do in connection with social questions. I grew up in an atmosphere of politics,

and was expected by my elders to take up a political career. Philosophy, however, interested me more than politics, and when it appeared that I had some aptitude for it, I decided to make it my main work. This pained my grandmother, who alluded to my investigation of the foundations of geometry as "the life you have been leading," and said in shocked tones: "O Bertie, I hear you are writing *another* book." My political interests, though secondary, nevertheless, remained very strong. In 1895, when in Berlin, I made a study of German Social Democracy, which I liked as being opposed to the Kaiser, and disliked as (at that time) embodying Marxist orthodoxy. For a time, under the influence of Sidney Webb, I became an imperialist, and even supported the Boer War. This point of view, however, I abandoned completely in 1901; from that time onwards, I felt an intense dislike of the use of force in human relations, though I always admitted that it is sometimes necessary. When Joseph Chamberlain, in 1903, turned against free trade, I wrote and spoke against him, my objections to his proposals being those of an internationalist. I took an active part in the agitation for Women's Suffrage. In 1910, *Principia Mathematica* being practically finished, I wished to stand for Parliament, and should have done so if the Selection Committee had not been shocked to discover that I was a free thinker.

The first world war gave a new direction to my interests. The war, and the problem of preventing future wars, absorbed me, and the books that I wrote on this and cognate subjects caused me to become known to a wider public. During the war I had hoped that the peace would embody a rational determination to avoid future great wars; this hope was destroyed by the Versailles Treaty. Many of my friends saw hope in Soviet Russia, but when I went there in 1920 I found nothing that I could like or admire. I was then invited to China, where I spent nearly a year. I loved the Chinese, but it was obvious that the resistance to hostile militarisms must destroy much of what was best in their civilization. They seemed to have no alternative except to be conquered or to adopt many of the vices of their enemies. But China did one thing for me that the East is apt to do for Europeans who study it with sensitive sympathy: it taught me

to think in long stretches of time, and not to be reduced to despair by the badness of the present. Throughout the increasing gloom of the past twenty years, this habit has helped to make the world less unendurable than it would otherwise have been.

In the years after my return from China, the birth of my two older children caused me to become interested in early education, to which, for some time, I devoted most of my energy. I have been supposed to be an advocate of complete liberty in schools, but this, like the view that I am an anarchist, is a mistake. I think a certain amount of force is indispensable, in education as in government; but I also think that methods can be found which will greatly diminish the necessary amount of force. This problem has both political and private aspects. As a rule, children or adults who are happy are likely to have fewer destructive passions, and therefore to need less restraint, than those who are unhappy. But I do not think that children can be made happy by being deprived of guidance, nor do I think that a sense of social obligation can be fostered if complete idleness is permitted. The question of discipline in childhood, like all other practical questions, is one of degree. Profound unhappiness and instinctive frustration is apt to produce a deep grudge against the world, issuing, sometimes by a very roundabout road, in cruelty and violence. The psychological and social problems involved first occupied my attention during the war of 1914-18; I was especially struck by the fact that, at first, most people seemed to enjoy the war. Clearly this was due to a variety of social ills, some of which were educational. But while individual parents can do much for their individual children, large-scale educational reform must depend upon the state, and therefore upon prior political and economic reforms. The world, however, was moving more and more in the direction of war and dictatorship, and I saw nothing useful that I could do in practical matters. I therefore increasingly reverted to philosophy, and to history in relation to ideas.

History has always interested me more than anything else except philosophy and mathematics. I have never been able to accept any general schema of historical development, such as

that of Hegel or that of Marx. Nevertheless, general trends can be studied, and the study is profitable in relation to the present. I found much help in understanding the nineteenth century from studying the effect of liberal ideas in the period from 1814 to 1914.[2] The two types of liberalism, the rational and the romantic, represented by Bentham and Rousseau respectively, have continued, ever since, their relations of alternate alliance and conflict.

The relation of philosophy to social conditions has usually been ignored by professional philosophers. Marxists are interested in philosophy as an *effect*, but do not recognize it as a *cause*. Yet plainly every important philosophy is both. Plato is in part an effect of the victory of Sparta in the Peloponnesian war, and is also in part among the causes of Christian theology. To treat him only in the former aspect is to make the growth of the medieval church inexplicable. I am at present writing a history of western philosophy from Thales to the present day, in which every important system is treated equally as an effect and as a cause of social conditions.

My intellectual journeys have been, in some respects, disappointing. When I was young I hoped to find religious satisfaction in philosophy; even after I had abandoned Hegel, the eternal Platonic world gave me something non-human to admire. I thought of mathematics with reverence, and suffered when Wittgenstein led me to regard it as nothing but tautologies. I have always ardently desired to find some justification for the emotions inspired by certain things that seemed to stand outside human life and to deserve feelings of awe. I am thinking in part of very obvious things, such as the starry heavens and a stormy sea on a rocky coast; in part of the vastness of the scientific universe, both in space and time, as compared to the life of mankind; in part of the edifice of impersonal truth, especially truth which, like that of mathematics, does not merely describe the world that happens to exist. Those who attempt to make a religion of humanism, which recognizes nothing greater than man, do not satisfy my emotions. And yet I am unable to believe that, in the world as known, there is anything that I can

[2] *Freedom and Organization, 1814-1914* (1934).

value outside human beings, and, to a much lesser extent, animals. Not the starry heavens, but their effects on human percipients, have excellence; to admire the universe for its size is slavish and absurd; impersonal non-human truth appears to be a delusion. And so my intellect goes with the humanists, though my emotions violently rebel. In this respect, the "consolations of philosophy" are not for me.

In more purely intellectual ways, on the contrary, I have found as much satisfaction in philosophy as any one could reasonably have expected. Many matters which, when I was young, baffled me by the vagueness of all that had been said about them, are now amenable to an exact technique, which makes possible the kind of progress that is customary in science. Where definite knowledge is unattainable, it is sometimes possible to prove that it is unattainable, and it is usually possible to formulate a variety of exact hypotheses, all compatible with the existing evidence. Those philosophers who have adopted the methods derived from logical analysis can argue with each other, not in the old aimless way, but coöperatively, so that both sides can concur as to the outcome. All this is new during my lifetime; the pioneer was Frege, but he remained solitary until his old age. This extension of the sphere of reason to new provinces is something that I value very highly. Philosophic rationality may be choked in the shocks of war and the welter of new persecuting superstitions, but one may hope that it will not be lost utterly or for more than a few centuries. In this respect, my philosophic life has been a happy one.

Bertrand Russell

BRYN MAWR, PENNSYLVANIA
JULY, 1943

I

*Hans Reichenbach*

BERTRAND RUSSELL'S LOGIC

# BERTRAND RUSSELL'S LOGIC

## I

IT is the plan of this book to open discussions between a philosopher and his critics, benevolent or otherwise, for the purpose of creating an opportunity to clarify opinions and correct misinterpretations. I must confess that this program, welcome as it appears in many other cases, makes it somewhat difficult for me to contribute to the present volume. Bertrand Russell distinguishes himself from many other philosophers by the clarity with which he has always presented his ideas. An attempt to further clarification, therefore, seems to be out of place, and should be reserved for other sorts of philosophy. There are philosophies, indeed, which were so vaguely stated that every school of philosophy was able to give them interpretations corresponding to its own views. Many a philosopher derives his significance from the obscurity of his exposition rather than from the weight of his ideas; and I should like to believe that such ideas would have lost their persuasive power had they been formulated more precisely and coherently. Bertrand Russell is certainly not a philosopher of this sort. He constitutes a fortunate example showing that a philosopher may owe his success to clarity and cogency, to painstaking analysis and the renunciation of the mysterious language of oracles. It seems therefore scarcely necessary to provide for a second edition of his philosophy enlightened for the use of posterity by the criticism of opponents. What makes the present writer even more unsuitable for such a purpose is the fact that he does not even feel himself an opponent, that he agrees very much with most of the fundamental views of Bertrand Russell, to

whom he is deeply grateful for the instruction and enlighten-
ment which he has always gathered from Russell's books.

In order that this essay may serve the general purpose of the
present volume I shall therefore try to follow another plan.
I shall attempt to summarize the contributions which Russell
has made to modern logic, hoping that Mr. Russell will cor-
rect my summary wherever it is incomplete or where the
emphasis is on the wrong point. I hope, in addition, that Mr.
Russell will answer some questions as to the genesis of his ideas
and thus give us some valuable information concerning the his-
tory of modern logic. Finally I am optimistic enough to assume
that at least on some points there will remain a diversity of
opinion which may supply the reader with the most coveted
fruit on the tree of philosophy: a philosophical dispute.

## II

Let us have a short view of the situation within the history
of logic at the time when Russell entered its field. Aristotelian
logic, which for two thousand years had dominated Western
thought, had finally been superseded by the symbolic logic
constructed by such men as Boole, de Morgan, Peirce, Peano,
Cantor, Frege, and Schröder. Boole's work, from which we
may date the modern period of logic, was already fifty years
old. But the new ideas had not yet acquired any significant
publicity; they were more or less the private property of a
group of mathematicians whose philosophical bias had led them
astray into the realm of a mathematical logic. The leading
philosophers, or let us better say the men who occupied the
chairs of philosophy, had not taken much notice of it and did
not believe that Aristotelian logic could ever be surpassed, or
that a mathematical notation could improve logic. Russell, then
at the age of twenty-eight, had read the writings of this group
and attended a congress of logic in Paris in the year 1900,
where he met Schröder, Peano, Couturat and others. A few
years later he wrote his *Principles of Mathematics*, followed
after some further years by the *Principia Mathematica*, written
in coöperation with Whitehead. Why is it that from the ap-
pearance of these books we date the second phase of modern

logic, the phase which united the various starting points and logistic calculi into one comprehensive system of symbolic logic?

There are several reasons which made Russell's work the beginning of this new phase. The first is given by a number of technical improvements over the symbolic systems of his predecessors. The second is that he combined the creation of a symbolic logic with the claim of including the whole of mathematics, an idea which, controversial as it has always been, has never ceased to excite the minds of mathematicians and logicians alike. The third is that Russell, uniting in his books a skilfully chosen notation with the brilliant style of a writer, drew the attention of philosophers of all camps to symbolic logic, which thus was made palatable for the first time.

## III

I shall try to summarize the technical improvements which Russell has contributed to symbolic logic.

There is to be mentioned first Russell's introduction of the concept of *propositional function*. The idea of conceiving grammatical predicates as classes is of course much older and goes back to Aristotle; Boole's algebra of logic makes wide use of it. But Russell's concept of propositional function extends the concept of a *class* to that of a *relation* and thus combines the advantage of the mathematical analogy with a closer correspondence to conversational language. This close relation to conversational language constitutes one of the strong points in Russell's logic. It manifests itself also in his theory of descriptional functions. Using the iota-symbol introduced by Peano, Russell showed the way to the understanding of the definite article "the" and similar particles of speech, and developed Peano's notation into a general syntax of a high degree of perfection. It is surprising to what extent the understanding of the logical nature of language is facilitated by the use of Russell's concepts. In many a logic course I have given I have had the occasion to watch this effect of Russell's logic. Through its clarification of the structure of language, symbolic logic awakens logical abilities till then dormant in the minds of the students.

Next I must mention Russell's decision to use material implication. This sort of implication with its puzzles, it is true, has been known for a long time; Peirce,[1] who himself saw the advantages of this implication, quotes Sextus Empiricus as the first to have pointed out the nature of this relation, and justifies its use by showing that its queer consequences cannot lead to wrong results. But Russell was the first to discover that the whole system of logic can be consistently developed by the use of this sort of propositional operation. He saw that this is a point where the correspondence to meanings of conversational language must be abandoned, if a satisfying logic is to be constructed; and his logic thus was the first which is consciously *extensional*. He was not afraid to use propositions like "snow is black implies sugar is green," since he saw that the meaning of the word "implies" used here can be clearly defined and leads, unreasonable as it appears at first sight, to a reasonable logical calculus. He deliberately postponed the construction of concepts better fitting conversational usage, in the hope that this might be possible within the frame of an extensional logic, by the introduction of more complicated relations. His formal implication represents a stepping stone on this path; Russell saw that it corresponds much more closely to what is usually meant by an implication, although he frankly stated the limitations holding even for this generalized implication. This line of development has later been continued in Carnap's discovery, according to which a reasonable implication can be defined by the use of the metalanguage; a further continuation of this line of thought, which leads from tautological implications to a more general kind of implication corresponding to natural laws, has been given by the present author.[2]

It is the advantage of extensional operations that they permit us to define the notion of tautology. Although the formal definition of tautology on the basis of truth-tables seems to have been an idea of Wittgenstein's, I have no doubt that Russell has always clearly seen this fact and used it for the definition of logical formulae. The necessity expressed by logical formulae de-

[1] Chas S. Peirce, *Collected Papers*, Cambridge, 1932, Vol. II, 199.
[2] A presentation of these results has, however, not yet been published.

rives from the fact that they are true whatever be the truth-values of their constituents. This tautological character of logical propositions, on the other hand, represents the ground of their emptiness; and Russell has always emphasized that a logical formula states nothing. He saw, at the same time, that this result does not make logic superfluous. On the contrary, the use of logic within all forms of scientific thought is based on the fact that logic is empty. Were it not so, we would not be allowed to add logical formulae to empirical assumptions. Logical transformations exhibit the inherent meanings of such assumptions without secretly increasing their content. Moreover, although a tautology is empty, the statement that a certain formula is a tautology is not empty; and the discovery of new and intricate tautologies will always remain a challenge to the logician or mathematician. The history of mathematics, revealing more and more unexpected tautological relations, represents a proof of this contention.

I should like to add here a remark concerning Russell's distinction between inference and implication. Although at the time he wrote the *Principia* the present distinction between levels of language (with which we have to deal later) was not yet known, Russell clearly saw that inference and implication are of a different logical nature. Whereas implication is an operation connecting propositions and leading to a new proposition, inference represents a procedure, performed on propositions. Russell emphasized that inferences cannot be stated in a formula, a result which may appear somewhat paradoxical, since he symbolized it in the traditional schema

$$\frac{p \supset q}{q}$$

We know today that the correct formulation is to say that the schema belongs to the metalanguage; that the formalization of inference can be given, not in statements of the object language, but only in the metalanguage. This formulation given at a later stage was anticipated by Russell's original distinction of formalizable and non-formalizable parts of logic.

I have mentioned here only a few prominent points among Russell's technical contributions to symbolic logic, since an extensive historical study is not included in the program of my paper. There remains to be given an analysis of Russell's views on the foundations of logic. But we cannot go into this problem without having first outlined his theory of the relation between logic and mathematics.

## IV

What Russell claims to have shown is the identity of logic and mathematics, or, more precisely, that mathematics is a part of logic. The proof of this thesis is given in two steps. On the first he gives a definition of the positive integers, or natural numbers, showing that they are expressible in terms of purely logical notions including the operators "all" and "there is." On the second he shows, in correspondence with theories developed by other mathematicians, that the whole of mathematics is reducible to the notion of natural number.

The enormous significance of this theory is evident. If it is true, the whole of mathematics is reducible to logical statements containing only the simplest logical concepts; although the translation of a complicated mathematical formula into such simple notions cannot actually be carried through because of the limitations of man's technical abilities, the statement that such a translation can be carried through *in principle* represents a logical insight of an amazing depth. The unification of mathematics and logic so constructed can be compared to the unification of physics and chemistry attained in Bohr's theory of the atom, a result which also can be stated only in principle, since the actual translation of a chemical reaction into quantum processes involving only protons, electrons, and so on, cannot be carried through. Here, as in the case of Russell's logical theory of mathematics, it is the fact that there is such an ultimate unity which has excited the admiration of scientists and philosophers alike.

I shall not here go into the discussion of the second step. The reducibility of mathematics to the theory of natural numbers is regarded as possible by the majority of mathematicians. The interesting version given to this theory by Russell, according

to which the irrational numbers are to be conceived as classes of rational numbers, is a continuation of a principle which in its full import was introduced by him within his analysis of the first step; and we shall discuss this *principle of abstraction* in that connection.

Let us, therefore, enter directly into an examination of the first step. Russell's definition of number is based on the discovery, anticipated in Cantor's theory of sets, that the notion of "equal number" is prior to that of number. Using Cantor's concept of similarity of classes, Russell defines two classes as having the same number if it is possible to establish a one-to-one coördination between the elements of these classes. Thus when we start from the class constituted by the men Brown, Jones and Robinson, the class constituted by Miller, Smith and Clark will have the same number because we can establish a one-to-one correspondence between the elements of these classes. Now the class of all classes which have the same number as the class constituted by Brown, Jones and Robinson is considered by Russell as constituting the number *3*. A number is therefore a class of classes.

It may appear strange that a number, which seems to be a very simple logical element, is to be interpreted by so complicated a notion as a class of classes, or a totality of totalities, of physical things; a concept which includes so many classes of unknown objects. But Russell shows that this definition provides us with all the properties required for a number. When we say that there are 3 chairs in this room, all we wish to say is that there is a relation of one-to-one correspondence between the class of these chairs and certain other classes, such as Brown, Jones and Robinson; a relation which can be expressed, for instance, in the fact that, if Brown, Jones and Robinson sit down on these chairs, there will be no chair left, and each of the men will have his chair. It is this property of the class of the chairs which we express by saying that this class has the number 3; and since having a property is translatable into being a member of a certain class, we can state this property also by saying that the class of the chairs is a member of the class of classes which by the above definition is called the number *3*.

This definition of number represents an illustrative application of the *principle of abstraction,* which has been made by Russell one of the cornerstones of logic. To define a property by abstraction has usually been interpreted as a rule singling out the common property of the objects concerned. Russell saw that the rule: "consider the property which such and such objects have in common," is in this form of a questionable meaning. He replaces it by the rule: "consider the class constituted by all objects having a certain given relation to each other;" i.e., he defines the common property in extension rather than in intension. Once more we see here the principle of extensionality at work. Russell shows that it is unnecessary to go beyond the extensional definition. All that can be said about the common property can be replaced by the statement that something is a member of this class. Thus in order to say what "green" means we shall point to a green object and define: a thing is green if it has the same color as this thing. The meaning of the word "green" therefore is definable by the statement: something is green if it is a member of the class of things which have the same color as this thing. We see that the principle of abstraction expressed in this sort of definition represents an application of Occam's razor; it would be an "unnecessary multiplication of entities," if we were to distinguish the meaning of the word "green" from the membership in the class defined. In the same sense Russell's definition of number constitutes a standard example of an application of Occam's razor.

Since a definition by abstraction refers to physical objects as determining the property under consideration, the definition of number above given is an ostensive definition. For example, in order to define the number 3 we point to some objects such as Brown, Jones and Robinson and say it is the number of *this* class which we call '3.' Russell has however given another definition of number which is not of the ostensive type, and we must now analyze the nature of this definition.

This *logical* definition of number applied to the number 1 is written in the form

$$(F \, \varepsilon \, 1) =_{\mathrm{Df}} (\exists x)(x \, \varepsilon \, F) \cdot (y)[(y \, \varepsilon \, F) \supset (y = x)]$$

This definition states that a class F has the number 1 if the class has a member so that if anything is the member of the class it is identical with this member. Similarly we can state that a class F has the number 3 by the following formula

$$F \varepsilon 3 = {}_{Df} (\exists x)(\exists y)(\exists z) \cdot (x \varepsilon F) \cdot (y \varepsilon F) \cdot (z \varepsilon F) \cdot (x \neq y) \cdot (y \neq z)$$

$$(x \neq z) \cdot (u)[(u \varepsilon F) \supset (u = x) \vee (u = y) \vee (u = z)]$$

This is equally a logical definition since it does not refer to three physical objects in an ostensive way. It is true that the definition itself contains three symbols, namely existential operators, which thus represent a class of three physical objects in extension. But the definition does not refer to these objects, since it does not speak about the signs occurring in it. It would be different if, for instance, we were to write the word "green" always in green ink and then to say: green is the color of this sign. Such a definition refers to a property of a symbol occurring in it and is therefore ostensive.

In order to see clearly what is achieved in Russell's logical definition of number let us consider his definition of the number 1. Here the meaning of the term "one" is reduced to the meaning of some other terms including the term "there is a thing having the property F." The meaning of this latter sentence must be known when we wish to understand the definition. It is a primitive term in Russell's sense. Now it is clear that this term practically contains the meaning of "one." For instance, we must know that the sentence "there is an apple in the basket" is true even when there is only one apple in the basket. We could define the existential operator in such a way that an existence statement is true only when there are at least two objects of the kind considered. That this is not the ordinary meaning of the phrase "there is," is something we have to know when we apply existential operators. Therefore the meaning of the term "at least one" is antecedent to Russell's definition of the number 1. This does not make this definition circular, since, as the definition shows, the meaning of the *number* 1 is given by a rather complicated combination of primitive terms, among which the primitive "at least one" is only one constituent.

Let us now consider the relation of Russell's definition to Peano's axiomatic definition of natural numbers.

Peano in his famous five axioms has stated the formal properties of natural numbers. These axioms contain the two undefined concepts "the first number," and "successor." Peano then defines by the use of his axioms what a natural number is.[3] His definition is a recursive definition; therefore we can paraphrase it by saying that something is a natural number if it is derivable from the two fundamental concepts in compliance with the rules stated in the axioms. It is well known that Peano's definition admits of a wider interpretation than that given by the natural numbers. The even numbers, e.g., satisfy Peano's axioms if the interpretation of the term successor is suitably chosen. The series defined by Peano has therefore been given the more general name of a *progression*. This result shows that, as in the case of all axiomatic definitions, or implicit definitions, we must distinguish between the *formal system* and its *interpretation*.

This may be illustrated by the example of geometry. An axiomatic construction of Euclidean geometry, such as that given by Hilbert, though fully listing all internal properties of the fundamental notions, must be supplemented by *coördinative definitions* of these notions when the formal system is to be applied to reality. Thus physical geometry is derived from Hilbert's system by the use of coördinative definitions, according to which straight lines are interpreted as light rays, points as small parts of matter, congruence as a relation expressed in the behavior of solid bodies, etc. This interpretation is not a consequence of the formal system; and there are many other admissible interpretations. But these other interpretations do not furnish what we call *physical* geometry.

Similarly it is only one of the interpretations of Peano's system which represents the series of natural numbers. It is here that Russell's definition comes in: this definition furnishes an interpretation of Peano's system. Russell's definition can be

---

[3] This, at least, is our present conception of Peano's axioms, based on the work of Frege and Russell. Peano himself considered the notion of natural number as a third undefined concept and seems to have regarded all his axioms as synthetic.

used to define the *first number* (it may be advisable to use here the number one, and not the number zero used by Peano, in order to make the definition clearer), and in addition to define the successor relation. All the rest is then done by Peano's axioms; these axioms will lead to the consequence that all numbers are classes of classes in Russell's sense. The system so obtained may be called the Peano system in Russell's interpretation. It is this system which we use in all applications.

The necessity of combining Peano's definition with his own has been recognized by Russell in his discussion of the principle of mathematical induction. This principle, also called the principle of recurrence, is used in the famous inference from n to n + 1, applied in many mathematical proofs. When it is shown that the number 1 has a certain property, for instance that of satisfying a certain equation; and when it is shown in addition that if a number n has this property the number n + 1 must have this property also, then we regard it as proved that all numbers have this property. How do we know the validity of this inference? We can actually perform this inference only for a certain number of steps, and we cannot run through an infinite number of such steps and therefore cannot extend the inference in this way to all numbers. Poincaré therefore regarded the principle of mathematical induction as a synthetic principle *a priori*. It was Frege and, independently, Russell who recognized that a very simple solution to this problem can be found: the principle must be considered as constituting a part of the definition of natural numbers. It thus distinguishes this series from other series which do not have this property, and represents a specific feature which less strictly is expressed by saying that every element of the series can be reached in a finite number of steps, although the number of all elements is infinite.

When this conception is to be utilized for Russell's definition of number we must notice that this is possible only because of a certain peculiarity of recursive definitions. The Peano system contains the three fundamental notions "first number," "successor," and "natural number." But only the first two of these are undefined; the third is defined in terms of the two others. Therefore, only these first two fundamental notions require

coördinative definitions; the interpretation of the third notion then is determined by the given two coördinative definitions in combination with the formal system. In other words, the totality of physical objects belonging to the system is defined in a recursive way in terms of the interpretations of the first two fundamental notions.

To make this clear let us consider a similar example limited to a finite series. Let us assume that there is a certain male fly with pink wings, and that there is a law according to which the male descendants of such a fly will also in general have pink wings. The first fly may be called the Adam fly. We now define the term "color family derived from the Adam fly" as follows: 1) the Adam fly belongs to this family; 2) if any fly belongs to the family then each one of its male offspring belongs to it which has the same color of wings as its male parent. These two definitions are sufficient to determine a totality of flies; it is this totality to which we give the above name. The family will presumably be finite, because at a certain stage there will be no male offspring with pink wings or no offspring at all. It is not necessary, however, to give any direct definition of this totality, i.e., a definition which allows us to determine whether a given individual fly belongs to this totality without examining its relations to the Adam fly. In the same sense the totality of natural numbers is defined if the first number and the successor relation are defined, as soon as the limitation of the totality through the inductive axiom has been added.

The interpretation of Peano's axioms given by Russell's definition of number is of a peculiar kind. It does not refer Peano's undefined notions to empirical terms, as is done by the physical interpretation of geometry. When we use Russell's logical definition of the number 1 we do not introduce any new notions into the Peano system. All the notions used in the above logical definition of the number 1 are equally used in Peano's formal system. Thus the statement that each element of the progression has one and only one successor, when formalized, is written in the same way as the definition of the number 1, by the use of an existential operator followed by a qualification in terms of an all-operator and an identity sign. Russell's interpretation of the

Peano system must therefore be called a logical interpretation, to be distinguished from an empirical interpretation.

For this reason it is possible to regard Russell's definition of number, not as an interpretation but as a supplementation of Peano's system. We can simply write Russell's definition of the number 1 as a sixth axiom, to be added to Peano's five axioms. Similarly the definition of the successor relation can be expressed in a purely logical way and then added as a seventh axiom. The Peano system thus is made complete and loses its character as a system of implicit definitions, since the terms "first number" and "successor" are no longer undefined. When used in the first five axioms they stand only as abbreviations for what is said in the sixth and seventh axiom. It then is even possible to prove Peano's axioms, with the exception of the axiom of infinity. The latter axiom seems to be a condition which we must write as an *implicans* before the whole of mathematics, thus conceiving mathematics ultimately as a system of implications.

I think, therefore, that Russell is right when he says a logical definition of natural number can be given. He is also right when he insists that the meaning of the number 1 used in mathematics is expressed by his definition, and that the mathematical number 1 is not completely defined when it is conceived as a term defined implicitly in Peano's five axioms. This is clear also from the fact that Peano's five axioms use the complete meaning of "one," in Russell's sense, within the statement that each element of the series has *one and only one* successor. We saw that the formalization of this expression requires all the means used in Russell's definition of "one." Using this result we can say that, in the formalist interpretation, the Russell numbers are implicity contained; they occur in such notations as "the first successor," "the second successor," "the twelfth successor," etc. What the formalist uses, when he applies Peano's axioms to arithmetic, are not the undefined elements, but these successor numbers. All that Russell says, then, is that the latter numbers should be used for the interpretation of the undefined elements of the system. To refuse this would simply represent a tactics of evasion.

I should like to add a remark concerning the application of arithmetical concepts to physics. The formalists are inclined to regard this application as being of the same type as the application of geometry, namely as based on coördinative definitions of the empirical kind. The first to express this conception was Helmholtz.[4] He explains that, e.g., the concept of addition can be realized by various physical operations; we then must check whether the operation used actually has the properties required for an addition. Thus, if we empty a bag of apples into a basket containing apples also, this operation has the character of an arithmetical addition. On the other hand, mixing hydrogen molecules and oxygen molecules at a rather high temperature does not have the character of an addition since these molecules will disintegrate into atoms and then combine to water molecules in such a way that the number of water molecules is not the sum of the numbers of hydrogen molecules and oxygen molecules. This conception seems to contradict the logical interpretation of arithmetic, according to which no empirical coördinative definition concerning the arithmetical fundamentals is necessary.

I think this contradiction can be eliminated as follows. We frequently do apply arithmetic in Helmholtz's sense by the use of coördinative definitions of the empirical type. But there is, besides, the purely logical application in Russell's sense. The latter is given only when the arithmetical operations are not connected with any physical change of the objects concerned. Thus adding five apples to seven apples in Russell's sense means that as long as a class of five apples and a separate class of seven apples exist, these two classes can be simultaneously conceived as one class of twelve apples. Russell's conception does not say whether this additive relation holds when the joined class is the result of a physical process to which the original classes are submitted, e.g., by putting the apples into the same bag. A statement that in the latter case we also can speak of arithmetical addition is of the Helmholtz-kind. In this case we leave the sign

[4] H. V. Helmholtz, "Zählen und Messen erkenntnistheoretisch betrachtet," 1887. Reprinted in Schlick-Hertz, *Helmholtz' Schriften zur Erkenntnistheorie*, Berlin, 1921, 70.

of arithmetical addition logically uninterpreted, and interpret it, instead, by means of a coördinative definition of the empirical type. The logical definition of number operations can be conceived as the limiting case of empirical definitions holding when no physical changes are involved. It does not depend on physical assumptions, because its application is empty, like all statements of deductive logic, and leads merely to logical transformations of statements. It is true that the practical value of arithmetic derives from its frequent use in combination with coördinative definitions of the empirical kind. But it is also true that such definitions would be useless if we had no purely logical definition of number: we state, in such cases, that the addition, which has been defined empirically, leads to the same result as an addition which is logically defined. If numbers were not used in the meaning given by the logical definition, arithmetic could not be applied to physical operations. It is the historical significance of Russell's logic to have pointed out this fact.

## V

I must turn now to a discussion of Russell's *theory of types*. After having discovered the antinomy of the class of classes which do not include themselves, Russell saw that too liberal a use of functions of functions, or classes of classes, leads into contradictions. He therefore introduced a rule narrowing down such use. This is the rule of types.

It is the basic idea of this theory that the division of linguistic expressions into true and false is not sufficient; that a third category must be introduced which includes *meaningless* expressions. It seems to me that this is one of the deepest and soundest discoveries of modern logic. It represents the insight that a set of syntactical rules—Carnap now calls them *formation rules*— must be explicitly stated in order to make language a workable system, and that it is a leading directive for the establishment of such rules that the resulting language be free from contradictions. We need not ask whether or not a certain expression is "really" meaningful; it is a sufficient condition for absence of meaning when a certain sort of expression leads to contradictions. It is from this viewpoint that I have always regarded the theory

of types. This theory is an instrument to make language consistent. This is its justification; and there can be no better one.

In the further development of the theory of types Russell introduced a second form; to the *simple* theory of types he later added the *ramified* theory of types. The simple theory of types states that a function is of a higher type than its argument; it follows that classes which contain themselves cannot be defined. This simple rule has found the consent of most logicians and appears at present so natural to the younger generation of logicians that it has acquired an almost self-evident character. Such is the fate of all great discoveries; artificial and sophisticated as they may appear at the time when they are first pronounced, after a while nobody can imagine why they had not been recognized from the very beginning. "Truth is allotted only a short period of triumph between the two infinitely long intervals in which it is condemned as paradox or belittled as trivial," says Schopenhauer.

The ramified theory of types, on the contrary, has met with much aversion on the side of the logicians. According to this theory every type must be subdivided into functions of different orders so that each order can contain only lower orders as their argument. Russell saw that this restriction excludes too great a part of mathematics. To save this group of mathematical theorems he introduced the axiom of reducibility, according to which to every function of a higher order there exists a corresponding function of the first order which is extensionally equivalent to it. Russell himself seems not to have been too much pleased with this axiom, although he sometimes defended it as being of the same sort as Zermelo's axiom of choice.

Meanwhile a more convenient solution of the difficulties was given by the line of thought which was attached to Ramsey's classification of the paradoxes into logical and semantical ones and which has been continued by Carnap and Tarski. Logical paradoxes are those in which only functions are involved; in semantical paradoxes, on the other hand, we are concerned with the use of *names* of functions alongside of the functions themselves. A paradox of this sort is the statement of the Cretan

who says that all Cretans lie. For the purpose of logical analysis, this historically famous paradox is better simplified to the form "this statement is false," where the word "this" refers to the sentence in which it occurs. It was only this sort of paradox which made the introduction of the ramified theory of types necessary; for the paradoxes of the logical sort the simple theory of types is sufficient. Now it has been shown that the semantical paradoxes can be ruled out if in addition to the theory of *types* a theory of *levels of language* is introduced. According to this theory the object language must be distinguished from the metalanguage, a distinction carried on to the introduction of a meta-metalanguage, and so on. Disregarding some exceptions, it is in general considered as meaningless if a linguistic expression refers to the language in which it is contained. This extension of the theory of types to a theory of levels of language was anticipated by Russell himself who, in his Introduction to Wittgenstein's *Tractatus*, referring to the problem of generality, wrote:[5]

These difficulties suggest to my mind some such possibility as this: that every language has, as Mr. Wittgenstein says, a structure concerning which, *in the language*, nothing can be said, but there may be another language dealing with the structure of the first language, and having itself a new structure, and that to this hierarchy of languages there may be no limit.

It seems to me, therefore, that the theories of Carnap and Tarski about the distinction of levels of language represent merely a continuation of ideas originating from Russell himself, a continuation which perhaps also includes ideas derived from Frege and Hilbert. Russell has recently published a statement[6] expressing on the whole his consent to Carnap's exposition of this linguistic solution of the semantical paradoxes. Thus it seems that this is at least a point on which a general consensus of opinion is attainable.

[5] Ludwig Wittgenstein: *Tractatus Logico-Philosophicus*, London, 1922, 23.
[6] In his new Introduction to the second edition of his *Principles of Mathematics* New York, 1938.

## VI

I should like now to discuss a question as to the foundation of logic; a question which has often occurred to me when I was studying Russell's logic.

Russell has emphasized that logic is not purely formal, that it contains some primitive terms whose meaning must be understood before we can enter into formal operations. He has listed these primitive terms, among them propositional operations and the existential operator, or, instead of the latter, the all-operator. Equally, some of the axioms of logic must be understood as necessarily true; then other formulae can be formally derived from them. Later analysis has shown that it is possible to eliminate all material thinking from the object language and to define logical necessity as a formal property of formulae, namely the property of being true for all truth-values of their constituent propositions. But the results of this formalization should not be overestimated, since in performing it we cannot dispense with material thinking in the metalanguage. Russell is therefore justified in that primitive notions and propositions will remain necessary at least on one level of language. Although they can also be eliminated from the metalanguage, they will reappear in the meta-metalanguage and so on. For instance, in the construction of truth-tables, which belong to the metalanguage, we take it for granted that for two elementary propositions only the four combinations "true-true," "true-false," "false-true," and "false-false" are possible. This means an application in the metalanguage of the same sort of tautologies as are formally proved within the object language.

It appears indeed inevitable that the directive of self-evidence has to be followed. In saying so I do not intend to introduce a sort of apriorism into logic. When we use a logical statement as self-evident we do not combine with this use the claim that the statement will always appear evident. If tomorrow we discover that we were mistaken we shall be ready to correct our statement, and shall follow new evidence, once more without the claim of eternal validity. It seems to me that in this sense the concept of *posit*, which I have introduced within the analysis of inductive inference, applies also to deductive logic. It is true,

if we make an inductive posit we can very well imagine that it be false; whereas when we state a logical tautology we cannot imagine that the formula be false. But we can imagine that tomorrow we shall *say* that it is false. The procedure of positing is here in the metalanguage. The formula "p ∨ ∼ p" is a tautology; but *that* it is a tautology is not a tautology, but an empirical statement concerning a group of signs given to the sense of sight.[1] The statement about the tautological character has therefore only the reliability of empirical statements, and can only be *posited*.

I should believe that this conception corresponds to Russell's views, and I should like to know whether he considers it as a satisfactory solution of the problem of self-evidence.

The revision of opinion which we reserve with every statement of a self-evident character can be of two sorts. First, we must always envisage the possibility of an error in the sense of a slip of the controls of our thinking. Of this sort are errors made in the addition of numbers, or in the committing of logical fallacies. A second sort of error is of a deeper nature. It consists in not seeing that our statement is true only within certain limitations, that it depends on certain assumptions which we do not explicitly state, but which if once stated can be abandoned. We shall thus arrive at generalizations within which our former statement appears as a special case. It is self-evident for this special case, but outside this usage it is simply false.

An example of this sort seems to me to be given in the *tertium non datur*. This principle has long been considered as one of the pillars of logic; and it is used so not only in traditional logic, but equally in Russell's logic. But modern developments have shown that the principle can be abandoned. That either "p" or "non-p" is true, holds only for a two-valued logic; but if we use, instead, a three-valued logic, the principle is false. An unqualified validity must be replaced by a qualified

[1] It is true that we can construct in the metalanguage a tautological statement by *describing* the formula "p ∨ ∼ p" and then saying that such a formula is a tautology. But then it remains an empirical question whether a certain formula written on paper has these properties. We ultimately must always refer to statements which are thus empirically given.

validity; the *tertium non datur* is valid only with respect to certain assumptions about the nature of propositions.

Propositions can be classified in various ways. It is customary to divide them into the two categories of true and false propositions; if this is done the *tertium non datur* is self-evident. But that propositions *must* be divided into these two categories can by no means be asserted. The necessity of the *tertium non datur* is therefore of a relative nature; the formula is necessary with respect to a dichotomy of propositions. This division of propositions, on the other hand, has the character of a *convention*. It therefore can never be proved false; but it can equally be replaced by another convention, e.g., a trichotomy of propositions. Which sort of classification is to be used will depend on the purposes for which the classification is made. When the dichotomy leads to a system of knowledge satisfying the exigencies of human behavior it will be considered as reasonable; this is the ground on which we use a two-valued logic in conversational language and equally in the language of classical science. But it may happen that for certain purposes a dichotomy will appear unreasonable and that a classification of propositions into three categories will seem preferable. We then shall not hesitate to use a three-valued logic and thus abandon the *tertium non datur*.

The reasons determining the usefulness of a classification of propositions will depend on the purposes for which the classification is used and on the means by which it is carried through. To speak of "Truth in itself" and "Falsehood in itself," existing as Platonic ideas, constitutes a method which has no relation to actual procedures of knowledge. We cannot use this sort of truth-value. The notion of truth used in actual knowledge is so defined that it is related to what actually can be done. We have methods to find out the truth, and if no such methods existed it would be no use to speak of true propositions. This does not mean that we are always able to apply these methods; there may be technical limitations to them. But we require that in principle such methods should be given; otherwise the notion of truth would be a castle in the air.

These considerations show that when we speak of truth in ordinary language we actually mean verifiability, i.e., the pos-

sibility of verification. Russell has objected that, by a restriction of language to verifiable statements, many statements which we usually regard as meaningful, would be cancelled from the domain of meaning. I do not think that a theory replacing truth by verifiability must lead to these consequences. If the notion of verifiability is defined in a sufficiently wide sense, it will include all sorts of statements which Russell would like to consider as true or false, such as his example "it snowed on Manhattan Island on the first of January in the year 1 A.D."[8] This aim can be reached if the term "possibility," applied within the expression "verifiability," is suitably defined. It certainly would narrow down meanings too much if we should require that a sentence be true only when it is actually verified. In the latter case it is *known* to be true; but "true" is defined in the wider meaning that a sentence is true if it can be shown to satisfy certain conditions, called verification. Similarly, a sentence will be called false if it can be shown that the sentence does not satisfy these conditions.

Are we then allowed to say: for every sentence it is possible to show that it is either true or false? I do not think that a logician can have the courage to assert such a far-reaching statement, if he does not have a proof for it.

Arguments of this sort have first been used by Brouwer in his famous criticism of mathematical methods. His three-valued logic is somewhat complicated because of its application to mathematics. Mathematics is a completely deductive science; its truth is determined by logical methods alone and does not refer to observation. The only way to determine whether a mathematical formula is true, is by deriving it from the axioms of mathematics, whose truth may be regarded as shown by self-evidence. When a mathematical formula of a syntactically correct form is given, is it possible, in principle, either to derive this formula or its negation from the axioms? Brouwer has raised this question; he regards it as unanswerable and there-

[8] Russell's *An Inquiry Into Meaning and Truth*, New York (1940), 347. As to a wider form of the verifiability theory of meaning, cf. the author's *Experience and Prediction*, Chicago (1938), Chapter I. The conception that verifiability is a pragmatic concept is perhaps a consequence of too narrow a definition of verifiability, resulting in particular from reference to technical, instead of physical, possibility in this definition. It may be possible to construct verifiability as a semantic notion.

fore insists on a division of mathematical statements into the three categories of true, false, and indeterminate. If we could give an affirmative answer to that question, Brouwer's trichotomy would be dispensable. But we all know that thus far such a proof has not been given. Gödel's theorem has shown that if we submit mathematical demonstrability to certain limitations there certainly are "undecidable" formulae. But Gödel also shows that the truth or falsehood of these formulae can be found out by methods using the metalanguage. Thus the controversy is still open.

Russell answers considerations of this sort by distinguishing truth from verifiability;[9] he thinks that independently of whether we are able to find the truth we should assert the principle that a sentence is, or is not, true. I do not see what this principle can mean other than a convention. If we are not given any methods to find out a truth, all we can do is to say that we wish to retain the formula "$p \vee \sim p$" for all sorts of statements. But if this convention is established for a purely deductive science such as mathematics, there will arise the question of consistency. If it were possible to show that the postulate of the *tertium non datur* will never lead to contradictions, its establishment would represent a permissible convention. But Hilbert and his collaborators, in spite of ingenious advances in this direction, have so far not been able to give the proof.

For empirical sciences the situation is different. Here the methods of verification are widely dependent on conventions, at least when physical objects which are not directly observable are concerned. It is therefore possible to combine the postulate of the *tertium non datur* with the principle of verifiability, if suitable conventions as to the method of verification are introduced. But if this is done, another problem may arise which represents, for empirical languages, the correlate of the problem of consistency existing for a deductive science: this is the problem whether the use of a two-valued language is compatible with certain other fundamental principles usually maintained for empirical sciences.

A case of this sort has turned up in recent developments in

[9] *Ibid.*, Chapter XVI.

physics, namely in quantum mechanics. We are facing here the question whether we shall introduce rules determining the values of unobserved entities, and thus introduce a two-valued logic in the sphere of the quanta. Now the results of quantum mechanics can be so interpreted that when we insist upon constructing the language of physics in a two-valued manner it will be impossible to satisfy the postulate of causality, even when an extension of causal connections to probability connections is admitted. The violations of the principle of causality are of another kind; they consist in the appearance of an action at a distance. On the other hand, it can be shown that causal anomalies disappear when the statements of quantum mechanics are incorporated into a three-valued logic. Between true and false statements we then shall have indeterminate statements; and the methods by which the truth-values of statements are derived from empirical observations are so constructed that they will classify any quantum mechanical statement in one of the three categories.[10]

This situation resembles very much the development of the problem of physical geometry. After it had been shown that in addition to Euclidean geometry several other geometrical systems can be constructed, the question as to which geometry holds for the physical world could be answered only on the basis of a convention. It could be shown, furthermore, that some of these conventions, if used for the description of the physical world, will lead to causal anomalies. Thus Einstein's theory of general relativity leads to the result that a use of Euclidean geometry for the description of the physical universe leads to causal anomalies. This is the reason that Euclidean geometry has been abandoned and replaced by a Riemannian geometry.[11] Similarly, we must distinguish between various logical systems and make the question of application dependent on the sort of physical system so obtained.

I do not see why this conception of the *tertium non datur*

---

[10] This interpretation of quantum mechanics is given in a book by the author on the *Philosophic Foundations of Quantum Mechanics*, in press at the University of California Press.

[11] Cf. the author's *Philosophie der Raum-Zeitlehre*, Berlin (1928), §12.

should lead to difficulties. I do not quite understand Russell's[12] insistence upon the law of excluded middle; in particular I am not clear whether he considers the law as *a priori* or has other reasons for insisting upon this law. I should be glad to get Professor Russell's opinion on this point.

One argument may be stated in favor of the superiority of the *tertium non datur*. The multi-valued logics introduced by Brouwer, Post, Lucasiewicz and Tarski, including the three-valued logic of quantum mechanics, are so constructed that the metalanguage coördinated to them is two-valued. Thus we can say in the metalanguage of a three-valued logic of this type, "a proposition is either true or it is not true," in the ordinary meaning of the word *not*. That the category "not true" divides into the two categories "indeterminate" and "false," makes for the metalanguage no more difficulties than, for our ordinary two-valued logic, a division say of a country's armed forces into the three categories of army, navy and air force. It is this use of a two-valued metalanguage which makes the multi-valued logical system very simple and easy to handle. I do not think, however, that it is necessary always to use a two-valued metalanguage. Elsewhere I have given an example[13] of a multi-valued logic applied within an infinite series of metalanguages. It is true that the metalanguage in which this theorem is stated, and which is not contained in the denumerable infinity of the metalanguages to which the theorem refers, is two-valued. But it should be possible to define a method by which each two-valued language on every level can be translated into a multi-valued language; this method would then be applicable also to the language in which it is stated.

Our preference for a two-valued logic seems to be based on psychological reasons only. This logic is of a very simple nature, and we shall therefore prefer it to other conventions concerning a classification of propositions. On the other hand, a closer consideration shows that the two-valued logic which we use in all these cases is never strictly two-valued, but rather must be considered as resulting from probability logic by the

[12] *An Inquiry Into Meaning and Truth,* Chapters XX and XXI.
[13] *Wahrscheinlichkeitslehre,* Leiden (1935), 371.

method of division, which I have described elsewhere.[14] Such a logic satisfies the usual rules only with exceptions. Thus if "p" is true and "q" is true, it may occasionally happen that "p and q" is false. These discrepancies can be eliminated when the two-valued logic is replaced by a probability logic; the logic of the metalanguage used will then be once more of the approximately two-valued type, but with a higher degree of approximation, i.e., with fewer exceptions. This process can be continued. The replacement of a two-valued logic by a multi-valued logic and the use of a two-valued logic on a higher level, therefore, seems to represent only a method of proceeding to a higher degree of approximation. But a strictly two-valued language is perhaps never used.

## VII

Russell's logic is a *deductive* logic. It never was intended to be anything else; and its value derives from the fact that it represents an analysis of the analytic, or demonstrative, components of thought. But Russell has frequently recognized that there are other components which have a synthetic character and which include *inductive* methods.

I think we should be grateful that a man, who has devoted so much of his work to deductive logic and who has given a new foundation to this science, which in its modern form will for ever be connected with his name, has never pretended that deductive operations can cover the whole of cognitive thought. Russell has repeatedly emphasized the need for inductive methods and recognized the peculiar difficulties of such methods. He thus makes it clear that he does not belong to the category of logicians who claim that the cognitive process can be completely interpreted in terms of deductive operations, and who deny the existence of an inductive logic. It is indeed hardly understandable how such utterances can be made, in view of the fact that knowledge includes predictions, and that no deductive bridge can lead from past experiences to future observations. A logic which does not include an analysis of inductive inference will always remain incomplete.

Now it is a perfectly sound method to restrict one's field of

[14] *Experience and Prediction*, Chicago (1938), §36.

work to one sort of thought operations and to leave the analysis of another sort to others. And yet I should like to ask Professor Russell to tell us a little more about his personal opinions in this other field. His books occasionally contain very interesting remarks on induction. Thus we find in one of his writings a well-aimed caricature of a familiar misinterpretation of the inductive inference. The latter is regarded by some logicians as being of the form: p implies q, now we know q, therefore p. Russell[15] illustrates this inference by the example: "If pigs have wings, some winged animals are good to eat; now some winged animals are good to eat, therefore pigs have wings." I should like to add that I do not regard this sort of inference as being improved if the conclusion is stated in the form: "p is probable." I do not think it is probable that pigs have wings. Actually, the calculus of probabilities knows no such inference; and it appears hardly understandable why some logicians try to impose upon scientific method the use of an inference which every mathematician would refuse to recognize. I do not see, either, that the logic of the inference is improved when it is named an inference by confirmation.

I think an analysis of the problem of induction must be attached to the form of inductive inference which has always stood in the foreground of traditional inductive theories: the inference of induction by enumeration. It can be shown that all inductive methods, including the so-called inference by confirmation, are ultimately reducible to this sort of inference; more precisely: it can be proved that what such methods contain in addition to inductive inferences by enumeration, belongs to deductive logic. This is shown by the axiomatic construction of the calculus of probabilities.[16] I should like to believe that Russell agrees with this statement.

As to the analysis of induction by enumeration, the traditional discussion has been greatly influenced by the criticism of David Hume. I think Hume's proof that the conclusion of inductive

[15] In his contribution to: *The Philosophy of John Dewey*, Evanston and Chicago (1939), 149.
[16] Cf. the author's *Wahrscheinlichkeitslehre*, and his *Experience and Prediction*, chap. V.

inferences can never be proved to be true, is unquestionable. But I do not think that Hume's interpretation of induction as a habit is able to point a way out of the difficulties. Russell occasionally follows Hume by remarking that, in regarding inductive inference as a method of cognition, we turn *causes* of our belief into *grounds* of such belief.[17] If this were the only answer which could be given to the problem of induction, we should frankly state that modern logic is unable to account for scientific method.

Now it seems to me that Hume's treatment of the problem of induction, apart from its healthy refutation of all sorts of rationalism, has seriously biased later philosophies of induction. Even the empiricist camp has not overcome Hume's tacit presupposition that what is claimed as knowledge must be proven as true. But as soon as this assumption is discarded, the difficulties for a justification of induction are eliminated. I do not wish to say that we can at least demonstrate the inductive conclusion to be probable. The analysis of the theory of probability shows that not even this proof can be given. But a way out of Hume's skepticism can be shown when knowledge is conceived, not as a system of propositions having a determinable truth value or probability value, but as a system of posits used as tools for predicting the future. The question of whether the inductive inference represents a good tool can then be answered in the affirmative by means of considerations which do not use inductive inferences and therefore are not circular.

## VIII

It is only within the frame of a system of knowledge which *as a whole* is posited that we can coördinate probability values to individual propositions. Here, in fact, probability replaces truth in so far as no empirical sentence is known to be true, but can be determined only as more or less probable.

Russell has argued that such a usage of probabilities does not eliminate the notion of truth. He contends that even in a probability theory of knowledge every sentence should be regarded as true or false, and that what a degree of probability refers to is

---

[17] *An Inquiry Into Meaning and Truth*, 305.

the degree to which a proposition is true.[18] I do not think that this conception is necessary. The sentences "p" and "p is true" are equipolent, and therefore it is of course permissible to attach the degree of probability either to the one or to the other. But it appears an unnecessary complication to use the second version; it is simpler to say directly that "p" is probable. Such a semantical interpretation of probabilities can be consistently carried through.[19]

The question may be asked whether the concept of truth is completely redundant. Russell is inclined to say that it is not, and that if it is eliminated from one place it will reappear in another place of the system of knowledge. I think this leads back to what was discussed in section VI. There is no doubt that, if a probability logic is used for the object language, the notion of truth is dispensable for this language. What can be asked is only whether the concept will reappear in the metalanguage. Now it seems that what I said about the approximately two-valued character of this language holds equally whether the object language is conceived as a three-valued system or as following the rules of a probability logic. Actually, what is called truth in conversational language has never had more than a high degree of probability. The truth of statements made under oath, for instance, is certainly not more than a probability of high degree. It seems that truth is a concept which we use only in idealized logical systems, but which in all applications is replaced by a substitute sharing only to a certain extent the properties of truth.

This result, it seems to me, applies also to the problem of basic statements. I think it is an outstanding feature in Russell's philosophy that he attaches so much importance to the empirical nature of basic statements. He has emphasized the necessity of an observational basis of science in discussions with some authors who apparently attempted to discard the notion of observation entirely from the exposition of scientific method. Russell here has carried on the empiricist tradition in opposition to logical

---

[18] *Ibid.*, 400.

[19] Cf. the author's "Über die semantische und die Objekt-Auffassung von Wahrscheinlichkeitsausdrücken," *Erkenntnis, Journal of Unified Science*, VIII, (1939), 50.

systems which, in spite of their claims to cover the method of empirical science, resemble only too much a modern form of rationalism. But, in spite of this agreement in general, I have to raise some objections to Russell's theory of basic statements as given in one of his recent publications.[20]

It seems to me that Russell's attempt to reduce the content of immediate observations to sense-data springs from the desire to find a basis of knowledge which is absolutely certain. I do not quite understand whether he wishes to say that sense-data statements are absolutely certain, or whether they possess only the highest degree of certainty attainable. But it seems clear that he wishes to construct a system of basic statements of such a kind that no basic statement can ever be shaken by later observations.[21] Now everybody will agree with Russell, I think, when he says that basic statements must be logically independent, i.e., that they must be so formulated that none of them can ever logically contradict another. But I cannot see how such an independence can be maintained when inductive methods are admitted.

Russell has argued[22] that basic statements cannot be empty, because if such statements were empty their sum also would be empty, and no synthetic knowledge could be derived from them. This, I think, is a sound argument. But I should like to use it in reverse also: if by the use of inductive methods basic statements will lead to a prediction of future observations, then such observations conversely will also make the original statements more or less certain. Inductive methods always work both ways. The rule of Bayes represents an inference by which probabilities holding in one direction are transformed into inverse probabilities. If, therefore, the system of knowledge is construed as being derived from basic observations in terms of inductive methods, this will include the admission that the totality of observations can be used as a test for the validity of an individual observation.

If this is once recognized, it appears no longer necessary to

[20] *An Inquiry Into Meaning and Truth,* Chapters X and XXII.
[21] *Ibid.,* 398.
[22] *Ibid.,* 395, 397.

look for basic statements different from statements of simple physical observations, i.e., to regard sense-data as the immediate object of observation. A set of less reliable statements will do, if such statements are of the observational type, i.e., if they are reports about concrete physical objects. If such basic statements have a sufficiently high initial weight, or in other words, if they are at least subjectively true in an approximate meaning of truth, they can be used for the construction of knowledge; and the probability of this knowledge can, on the whole, be even greater than the probability of any individual basic statement. That such possibilities are given by the use of probability methods may be illustrated by the fact that the average error of the mean of a set of observations is smaller than the error of the individual observations of this set. It is the advantage of the probability theory of knowledge that it frees us from the necessity of looking for a basis of data having absolute certainty.

## IX

I have tried to outline the major results of Russell's logic; and I have ventured to criticize Russell's views on certain points. But I think that my criticism concerns what, for Russell's logic, are only minor points. This logic is not of a type which needs to be afraid of critique.

My exposition would be incomplete without the addition of some words concerning the influence of Russell's logical work on the present generation of philosophers. Comparing the general level of philosophical writings at the time when Russell wrote the *Principia* with that of today, we find a remarkable change. Studies in mathematical logic, which forty years ago appeared only occasionally and were read only by a small group of experts, today occupy a great part of the space filled by philosophical publications. A school of younger logicians has grown whose work, to a great extent, has been stimulated by the study of Russell's books and who have tried to continue Russell's methods even beyond the goal for which they were created. The knowledge of Russell's symbolism is today a necessary condition to pass any academic examination in logic; the discussion of Russell's theory of mathematics and of his theory of

types plays a prominent part in philosophical seminars, and Russell's methods have become the tools by which a younger generation tills the philosophical soil. The logic and epistemology of today is unthinkable without Russell's contributions; his work has been assimilated even by those who in part contradict his views and look for other solutions.

It would be too optimistic an interpretation of this situation if we were to believe that the use of mathematical logic and its methods will always indicate profundity. Some decades ago we hoped, and I think I can include Russell in this "we," that if mathematical logic should some day become a part of general philosophical education, the times of vague discussions and obscure philosophical systems would be over. We cannot help admitting that our belief was based on a fallacious inference. We see today that the knowledge of symbolic logic is no guarantee for precision of thought or seriousness of analysis.

This has been shown, in particular, by some criticisms of Russell's more recent writings. I do not say this with the intention of condemning a critique of Russell's views. But I do think that such criticism should bear the mark of the same seriousness which distinguishes Russell's thought. Who criticizes Russell should first try to understand the major issues which always stand behind Russell's conceptions. It does not make a good show when a critic, who learned his logic from Russell, indicates with friendly condescension between his lines that he regards Russell's recent writings as not quite up-to-date. The reader might be induced to discover that the use of a metalinguistic vocabulary is not a sufficient criterion for a more advanced state of logical analysis. What use is it to make minor distinctions, if these discriminations are irrelevant for the problems considered? There is such a thing as a fallacy of misplaced exactness; this may be mentioned to those who are inclined to strain out the gnat but to swallow the camel. A truly philosophical attitude will be shown in the ability to balance purpose and means, in the subordination of technical research to the general issue for which it is being undertaken.

It is this balancing of purpose and means which we can learn from Russell himself. The enormous technical work of the

*Principia* was done by him in the pursuit of a major philosophical aim, the unification of logic and mathematics. Russell's work bears witness that logical analysis can become an instrument for the solution of major philosophical problems. Let us not forget that a display of logical symbolism is not in itself the aim of philosophy. There are philosophical problems still unsolved; let us try to use logical technique in order to solve them. Let us look at Bertrand Russell as a man who, by the precision of his methods and by the largeness of his mind, has opened an approach to a philosophy adequate to our time.

HANS REICHENBACH

DEPARTMENT OF PHILOSOPHY
UNIVERSITY OF CALIFORNIA AT LOS ANGELES

**2**

*Morris Weitz*

ANALYSIS AND THE UNITY OF RUSSELL'S
PHILOSOPHY

# ANALYSIS AND THE UNITY OF RUSSELL'S PHILOSOPHY

IN this essay I shall attempt to prove three related propositions regarding Russell's philosophy: (1) The fundamental element in his philosophy is the method of analysis. (2) This method of analysis has been exemplified by him in four rather distinct ways, in ontology, abstract cosmology, mathematical logic, and in the examination of the symbolism of science and ordinary life. The first exemplification, because it has to do with the "stuff" of reality, I shall label "ontological analysis;" Russell himself calls the second exemplification "formal analysis," the third "logistic," and the fourth, among other expressions, "constructionism." A more adequate term, however, because of the unfortunate associations which have surrounded "constructionism,"[1] is the phrase, "the resolution of incomplete symbols," and I shall use it in referring to the application of analysis to scientific and common-sensical symbolism. (3) By analysis Russell—although he has never systematically said so —means mainly a form of definition, either real definition of a non-Aristotelian sort, or contextual definition, i.e., definition of symbols in use. The first two doctrines are proved together and occupy the first four sections, while the third doctrine is demonstrated in the final section.

Two important consequences result from the demonstration of these three doctrines. The first is that C. D. Broad's remark,[2]

---

[1] For example, many students of Russell seem to think that constructionism is concerned with the making of entities, the way a carpenter builds a house. Such a view is incorrect, but is wholly understandable because of the unfortunate term, "constructionism."

[2] "As we all know, Mr. Russell produces a different system of philosophy every

which he may have uttered in jest, but which many philosophers accept as a serious charge, to the effect that Russell is a flighty philosopher because he has published a new system of philosophy every few years, is absolutely untrue. Most of the changes in Russell's philosophy are minor ones and occur in his application of analysis to ontology. It is shown that these changes are due to a more rigorous application of his analytical method. Once the primacy of analysis is understood, it will become evident that there *is* a basic unity in his work, and that this unity revolves around his method.

The second consequence has to do with Russell's theory of analysis. Many contemporary philosophers[3] seem to regard it as axiomatic that philosophy never analyzes facts, i.e., that which is non-linguistic, but always symbols. Ayer, e.g., maintains that the *entirety* of philosophical analysis is contextual definition.[4] It will be seen, I think, that this is too narrow a view and does not exhaust philosophical analysis, especially as Russell has practiced it. Many of Russell's analyses, I shall show, are concerned with complexes which are primarily non-linguistic, and therefore have nothing to do with contextual definition.

SECTION I. ANALYSIS AS ONTOLOGY

Russell began his philosophical career as an Absolute Idealist, so far as ontological analysis is concerned. That is, he maintained that the fundamental stuff of reality was the Absolute Mind.[5] However, in 1898, G. E. Moore convinced him of the

---

few years . . . ," in "Critical and Speculative Philosophy," *Contemporary British Philosophy*, First Series, 79.

[3] Especially the logical positivists, Carnap and his followers.

[4] A. J. Ayer, *Language, Truth and Logic*, Ch. IV.

[5] "Logical Atomism" (hereafter L. A.), *Contemporary British Philosophy*, First Series, 360. A full alphabetical list of the abbreviations of Russell's works to be referred to in this essay is as follows: (1) *A. of Matter* = *The Analysis of Matter*; (2) *A. of Mind* = *The Analysis of Mind*; (3) *E. W.* = *Our Knowledge of the External World*; (4) *Inquiry* = *An Inquiry Into Meaning and Truth*; (5) *I.M.P.* = *Introduction to Mathematical Philosophy*; (6) K.A.D. = "Knowledge by Acquaintance and Knowledge by Description" (reprinted in *Mysticism and Logic*); (7) L. A. = "Logical Atomism;" (8) M. T. of C. = "Meinong's Theory of Complexes and Assumptions" (*Mind*, n.s., 1904); (9) M. T. of T. = "The Monistic Theory of Truth" (reprinted in *Philosophical Essays*, 1910); (10) N. of A. = "On the Nature of Acquaintance" (*Monist*, 1914); (11) *Phil.* =

inadequacy of this position.[6] The arguments used by Moore, and accepted by Russell, against Absolute Idealism, did not appear in print until 1903, in Russell's *P. of M.* and in Moore's "Refutation of Idealism,"[7] and 1906, in Russell's M. T. of T. Before 1903, however, Russell read Leibniz and

came to the conclusion . . . that many of his most characteristic opinions were due to the purely logical doctrine that every proposition has a subject and a predicate. This doctrine is one which Leibniz shares with Spinoza, Hegel and Mr. Bradley; it seemed to me that, if it is rejected, the whole foundation for the metaphysics of all these philosophers is shattered.[8]

In 1900 Russell published *P. of L.*, in which he proved that the most popular part of Leibniz' philosophy, the monadology, was a deduction from certain premises, mainly logical, which Leibniz tacitly accepted as self-evident.[9]

Russell's motivation in his rejection of Absolute Idealism was his desire to establish the irreducibility of relations and a Platonic theory of propositions, which would render them independent of mental activity. He needed these doctrines in order to satisfy his desire to establish the foundations of mathematics.[10] Without these, mathematical philosophy is rendered self-contradictory, hence impossible.[11] Thus, in 1898, when Russell was working on the foundations of mathematics, he was quite willing

---

*Philosophy*; (12) P.L.A. = "Philosophy of Logical Atomism" (*Monist*, 1918/19); (13) *P. of L.* = *The Philosophy of Leibniz*; (14) *P.M.* = *Principia Mathematica*; (15) *P. of M.* = *The Principles of Mathematics*; (16) *P. of P.* = *The Problems of Philosophy*; (17) P: W. T. A. = "On Propositions: What They Are and How They Mean" (*Proceedings Aristotelian Society*, Suppl. Vol. 1919); (18) R. S. D. P. = "The Relation of Sense-Data to Physics" (*Mysticism and Logic*); (19) R. U. P. = "On the Relations of Universals and Particulars" (*Proceedings Aristotelian Society*, 1912); (20) S. M. P. = "On Scientific Method in Philosophy" (*Scientific Method in Philosophy*); (21) U.C.M. = "The Ultimate Constituents of Matter" (*Mysticism and Logic*).

[6] L. A., 360.

[7] This article first appeared in *Mind* (1903), 433-454.

[8] L. A., 360.

[9] *P. of L.*, 4.

[10] "I came to philosophy," Russell writes, "through mathematics or rather through the wish to find some reason to believe in the truth of mathematics." L. A., 359.

[11] *P. of M.*, xvii.

to accept a philosophy like Moore's dualism, which would give him an adequate basis for the non-self-contradictory character of extant mathematics.

By 1900 Russell was a dualist, contending that mind and matter, and universals and particulars, are ultimate. But before we can adequately discuss his arguments for dualism, we must say something more about his rejection of idealism.

His fundamental objection to idealism of the monistic and monadic sort, represented by Hegel and Leibniz respectively, is logical, whereas his refutation of Berkeley rests mainly upon empirical grounds. Absolute Idealism, Russell maintains, assumes as its basic axiom the doctrine of internal relations, the view that "every relation is grounded in the natures of the related terms."[12] It regards the axiom as equivalent to the assumptions that every relation is really an adjective of the terms taken as a whole and that every proposition has one subject and one predicate; from which it follows, Russell argues, that, for this view, there is only one final and complete truth which consists of one proposition with one subject (the Whole) and one predicate.[13]

Russell has three objections to the axiom: (1) It cannot be carried out, especially in the case of asymmetrical relations. If we try to reduce a relation like "greater than" to adjectives of the related terms, considered as a whole, we cannot then distinguish the relation from its converse; consequently, we cannot give any sense or direction to the relation.[14] (2) It fails to give any significant meaning to the phrase "nature of a term." To mean anything the nature must not be other than its term because there would then have to be an irreducible relation binding them. A term, hence, *is* its nature. But

. . . in that case, every true proposition attributing a predicate to a subject is purely analytic, since the subject is its own nature. . . . If the "nature of a term" is to consist of predicates, and at the same time to be the same as the term itself, it seems impossible to understand what we mean when we ask whether S has the predicate P.[15]

[12] M. T. of T., in *Philosophical Essays*, 160.
[13] *Ibid.*, 163-164.
[14] P. of M., 225.
[15] M. T. of T., 167.

(3) It is absurd on its own grounds. Its fundamental proposition, "There is only one subject and its predicate," is false because it implies a distinction between the predicate and the subject. This calls for the assertion of absolute identity in reality, which is incompatible with the idealist thesis of identity in difference.

The difficulty is that "identity in difference" is impossible, if we adhere to strict monism. For identity in difference involves many partial truths which combine . . . into the one whole of truth. But the partial truths, in a strict monism, are not merely not quite true: They do not subsist at all. If there were such propositions . . . that would give plurality. In short, the whole conception of "identity in difference" is incompatible with the axiom of internal relations; yet without this conception monism can give no account of the world . . . I conclude that the axiom is false, and that those parts of idealism which depend upon it are therefore groundless.[16]

Russell's criticism of monadism differs very little in its broad features from his refutation of monism. His rejection of Leibniz' monadology is directed mainly against Leibniz' treatment of relations. Leibniz, while he recognized relations, attempted to reduce them to predicates of individual substances. Russell objects to this treatment on two grounds: (1) It cannot convey the sense of an asymmetrical relation either;[17] and (2) it is incompatible with Leibniz' belief in a plurality of spirits, which is the essence of his idealism. To maintain any form of pluralism, Russell contends, the ultimacy of relations must be insisted upon. Without such a doctrine, we get either monism or solipsism, where all other individuals are reduced to adjectives of oneself.[18]

Russell's refutation of Berkeley is derived from Moore's distinction between consciousness and the object of consciousness.[19] Fundamentally, Russell contends, Berkeley's argument is based upon the fallacy of equivocation; he uses "idea" in two different senses: (1) as the object of sensation and (2) as the

[16] *Ibid.*, 168-169.
[17] *P. of M.*, 221-224.
[18] *P. of L.*, 15.
[19] Moore, *op. cit.*, 450; Russell, *P. of P.*, 17.

sensation itself. Berkeley's theory that the *esse* of the object must be mental

. . . seems to depend for its plausibility upon confusing the thing apprehended with the act of apprehension. Either of these might be called an "idea;" probably either would have been called an idea by Berkeley. The act is undoubtedly in the mind; hence, when we are thinking of the act, we readily assent to the view that ideas must be in the mind. Then, forgetting that this was only true when ideas were taken as acts of apprehension, we transfer the proposition that "ideas are in the mind" to ideas in the other sense, i.e., to the things apprehended by our acts of apprehension. Thus, by an unconscious equivocation, we arrive at the conclusion that whatever we can apprehend must be in our minds. This seems to be the true analysis of Berkeley's argument, and the ultimate fallacy upon which it rests.[20]

Russell's refutation of Berkeley brings us to his dualism of the mental and the physical, and the universal and the particular. Let us begin with his dualism of the mental and the physical and consider it from 1898 until 1921, in which year he published his own version of neutral monism in *A. of Mind*, thereby giving up the earlier dualism.

The earliest statement of Russell's dualism is, I think, in his articles, M. T. of C., which were published in 1904. There are, Russell states, certain theses which Moore has led him to accept. Among these is the view ". . . that every presentation and every belief must have an object other than itself and, except in certain cases where mental existents happen to be concerned, [the object is] extramental."[21] The arguments for this thesis are not fully developed until 1912, in *P. of P.*, i.e., in his refutation of idealism and his positive statement of mind-matter dualism.

Mind and matter are the ultimate entities of the world of existence (as against subsistence) in *P. of P.*, so far as ontological analysis is concerned. The argument for matter is based upon sense-data and certain principles of inference. The argument for mind is based upon immediate experience.

What is matter, according to *P. of P.*? It is, for one thing,

[20] *P. of P.*, 65-66; see also R. S. D. P., in *Mysticism and Logic*, 152; U. C. M., in *Mysticism and Logic*, 130; and *E. W.* (First Edition), Ch. III.

[21] M. T. of C., *Mind* (1904), 204.

the assemblage of all physical objects, but it may also be considered, in a narrow sense, as the same thing as a single physical object.[22] As a physical object, it is the cause of our sense-data, i.e., it is that which we regard as the cause of the immediate objects of sense-experience, when we take our sense-experience to be veridical.[23] What reasons are there for supposing matter to be real? Because the hypothesis that it is real is the simplest one which can account for the facts; i.e., the hypothesis that matter exists apart from and independently of our sense-experience can explain (1) certain gaps in our sense-experience and (2) certain causal properties, which no other hypothesis, e.g., solipsism, can do.[24]

Now, granted the hypothesis that matter is real, what is its nature? Here Russell is agnostic. Both idealism and materialism are too dogmatic in their interpretation of matter, since we can know nothing about its intrinsic nature. But it does not follow that we are left with the *Ding-an-sich*, because we can know certain logical properties of matter. These are derived from the assumption that matter exists and the correspondences between matter and sense-data.[25] For example, "If one object looks blue and another red, we may reasonably presume that there is some corresponding difference between the physical objects. . . . But we cannot hope to be acquainted directly with the quality in the physical object which makes it look blue or red."[26]

Russell says little about mind in *P. of P.* But from what he does say, we may derive a picture of what he takes mind to be. In the first place, it is the self, i.e., that which is aware of things in sensation and of universals in conception; and it is also that which believes and thinks and desires: in short, it is *consciousness*.[27] The central problem about mind is whether we know it by acquaintance or by description; i.e., do we know it immediately as an object of experience, the way we know a sense-datum, like a red patch, or by means of a true proposition of

[22] *P. of P.*, 18.
[23] *Ibid.*, 35.
[24] *Ibid.*, 35-36.
[25] *Ibid.*, 54; see also *A. of Matter*, 226-228.
[26] *Ibid.*, 53.
[27] *Ibid.*, 79-81.

the form "The one and only one thing which is acquainted with certain sense-data and universals, etc.?" Russell acknowledges the difficulty of the problem but holds, with hesitation, that we do know the self by acquaintance because we may at times be acquainted with an actual case of acquaintance, in which case the self is a constituent of the total datum "self-acquainted-with-sense-datum."[28]

It must not be supposed that, because we are acquainted with our selves, we are acquainted with *mental substance*. We may be acquainted with our individual consciousness as it functions in apprehending objects other than itself or in apprehending itself but it does not follow that *that* which apprehends or is apprehended is a more or less permanent person which underlies all of our momentary experiences. To prove the existence of mental substance demands further argument and cannot be derived from the single fact that we are aware of our momentary selves.[29]

The distinction between mind and matter is maintained by Russell until 1914. In R. S. D. P. he replaces matter by "sensibilia," thereby reducing the physical in reality to that which resembles sense-data. Before discussing this change, however, we must say something about Russell's contribution to ontological analysis in N. of A.

The major concern of these articles on the nature of acquaintance is to analyze experience. Russell finds, as an empirical truth, that the simplest and most pervading aspect of experience is acquaintance. It ". . . is a dual relation between a subject and an object which need not have any community of nature. The subject is 'mental', the object is not known to be mental except in introspection."[30]

As a matter of fact, "acquaintance," in N. of A., replaces "mind" as the ultimate mental activity. That is, Russell rejects mind as the ultimate mental *entity*, substituting for it acquaintance as the ultimate mental *fact*. The way this comes about is through Russell's rejection of his *P. of P.* view that we are

---

[28] *Ibid.*, 79.
[29] *Ibid.*, 29.
[30] N. of A., *Monist* (1914), I, 1.

acquainted with our selves. Under the impact of Hume's analysis of experience and the critique of dualism by neutral monism, Russell is forced to deny that we ever have more than self-consciousness. It follows that we are not acquainted with the self as an isolated entity and, therefore, we do not know its intrinsic nature; from which it further results that we are acquainted only with mental facts. The mental is thus defined as a fact involving acquaintance and relations based upon it:[31] the distinctive characteristic of the mental ". . . is not to be found in the particulars involved, but only in the nature of the relations between them."[32] To sum up: the basic difference between *P. of P.* and *N. of A.* is that the mental in the latter essays is defined in terms of facts and not in terms of particulars.

The next important essay in ontological analysis is R. S. D. P. Its chief contribution is the replacement of matter by sensibilia as the ultimate physical entities. What are sensibilia? They are ". . . those objects which have the same metaphysical and physical status as sense-data, without necessarily being data to any mind."[33] They become sense-data by entering into the relation of acquaintance. That they exist apart from acquaintance Russell accepts as a metaphysical hypothesis which, like many of his hypotheses, is justified by the principle of continuity:

We have not the means of ascertaining how things appear from places not surrounded by brain and nerves and sense-organs, because we cannot leave the body; but continuity makes it not unreasonable to suppose that they present *some* appearance at such places. Any such appearance would be included among *sensibilia.*[34]

The function of sensibilia in this essay is to replace the "matter" and "physical object" of *P. of P.* Both of these can now be constructed out of sensibilia. Constructionism will be discussed in Section IV, but something must be said about it here. To put it briefly, it seems to me that Russell means by a logical construction the *substitution of a symbol* whose denota-

---

[31] *Ibid.,* III, 442.
[32] *Ibid.,* IV, 583.
[33] R. S. D. P., in *Mysticism and Logic,* 148.
[34] *Ibid.,* 150.

tion is given in sense-experience or is continuous with and similar to something given in sense-experience for a symbol whose denotation is neither given in sense-experience nor is similar to and continuous with something given in sense-experience but is postulated as an unempirical, inferred entity. The justification of this interpretation will be presented in Section IV, and must be taken for granted here.

For constructionism, then, a symbol of a physical object no longer denotes an entity which was postulated as the cause of our sense-data and whose intrinsic nature is a mystery to us. Rather it denotes a whole class of appearances, which includes sense-data and ". . . also those 'sensibilia', if any, which, on grounds of continuity and resemblance, are to be regarded as belonging to the same system of appearances, although there happen to be no observers to whom they are data."[35] Matter is not defined as the whole class of appearances but as the limiting appearances of the thing: "The *matter* of a given thing is the limit of its appearances as their distance from the thing diminishes."[36]

Although Russell says little about the mental in R. S. D. P., he is still a dualist, making references to mental facts as those which involve awareness.[37] Sensation is the simplest kind of mental fact. It is to be distinguished from sensibilia and sense-data. "By a sensation I mean the fact consisting in the subject's awareness of the sense-datum."[38] The subject—and here Russell rejects his thesis of N. of A.—is mental because it is a constituent in a mental complex (e.g., sensation) and the only constituent which is not physical. In N. of A. Russell argued that the subject cannot be known to be either mental or physical because we are not acquainted with it; in R. S. D. P. the subject is inferred as mental because it appears in a mental fact, sensation, which contains no other mental constituent and, therefore, it must be mental in order for sensation itself to be mental. The significance of this argument is that once again we may assert

[35] *Ibid.*, 154.
[36] *Ibid.*, 165.
[37] *Ibid.*, 150.
[38] *Ibid.*, 152.

that there are mental *particulars*, which are defined as those constituents of mental facts that are aware of something.

The last of the 1914 writings pertaining to ontological analysis are Lectures III and IV of *E. W.* These lectures are more concerned with the problem of constructing the notions of physics out of the data of sense-experience than they are with ontology. Nevertheless, they do contain one important alteration: Russell reduces all sensibilia which are not sense-data to "ideal" elements and defines them in terms of "actual" elements, i.e., sense-data.[39]

The final essay on ontology in this period which we must consider is U. C. M. (1915). It contains nothing radically new but represents pretty much the view Russell proclaimed until he presented his version of neutral monism in 1921. The dualism between sense-data and sensation is adhered to. The world of existents Russell regards as consisting of ". . . a multitude of entities [which are] arranged in a certain pattern. The entities which are arranged I shall call 'particulars'. The arrangement or pattern results from relations among particulars."[40] These particulars are like the notes in a symphony which is being played:

The ultimate constituents of a symphony (apart from relations) are the notes, each of which lasts only for a very short time. We may collect together all the notes played by one instrument: these may be regarded as the analogues of the successive particulars which common sense would regard as successive states of one "thing." But the "thing" ought to be regarded as no more "real" or "substantial" than, for example, the rôle of the trombone.[41]

Mind is also a logical construction, constituted by ". . . an assemblage of particulars, namely, what would be called 'states of mind', which would belong together in virtue of some specific common quality,"[42] i.e., consciousness.

This brings us to the close of our description of Russell's dualism of the mental and the physical in the period from

[39] *E. W.*, 111-112.
[40] U. C. M., in *Mysticism and Logic*, 129.
[41] *Ibid.*, 130.
[42] *Ibid.*, 131-132.

1898-1921. His second period, that of neutral monism, extends from 1921 to the present. However, before we can discuss neutral monism, we must complete the dualistic picture of reality which Russell maintained during the first period and say something about his theory of universals and particulars. Russell's dualism is a double one, consisting in the beliefs that the mental and the physical are ultimate and that the universal and the particular are irreducible.

In 1898 Russell became a Platonist as regards universals. His motivation was mathematical, just as it was in his acceptance of mind-matter dualism. His desire was to make mathematics independent of the human mind.[43] This desideratum, which is an integral part of logistic, was in direct revolt against the Kantian intuitionism, which made the truth of mathematical propositions dependent upon mental activity. Once intuitionism was rejected, Russell, in order to guarantee the truth of mathematics, contended that mathematics consisted of analytic *a priori* truths, i.e., truths which are independent of all experience.

This thesis, that mathematics is analytically *a priori*, carried with it certain implications. The two most important were (1) that mathematical ideas, e.g., implication, number, etc., are Platonic essences; and (2) that *any* term, mathematical or otherwise, is a universal which, as a timeless entity, inhabits the realm of being.[44]

*P. of M.*, Russell's earliest work in which universals are discussed, is orthodox Platonism, except for one very curious doctrine, namely, that universal *relations* have no instances.[45]

---

[43] *P. of M.*, xviii; L. A., 359-361.

[44] *P. of M.*, 42-43.

[45] Russell's argument for this doctrine, somewhat simplified, is as follows: Consider two statements, "A differs from B" and "C differs from D." Assume that the "differs from" in these two statements *are* instances of the universal relation "difference." In order for them to be instances of the relation, they must have something in common with the universal relation. And to have something in common with the universal relation, they must have a common relation to the universal relation. But they cannot have a common relation to the universal relation because that would contradict the first hypothesis, that the relation is one of *difference.* Therefore, the "differs from" in "A differs from B" and "C differs from D" cannot be instances of the universal relation "difference." From which it

However, in his next discussion of universals, in K. A. D. (1910-11), he rejects this view, without offering any reason for doing so, for he is so convinced that universal relations do have instances that he devotes most of his argument to the proof that we are acquainted with universal relations themselves. He writes, e.g., "Thus we must suppose that we are acquainted with the meaning of 'before', and not merely with *instances* of it."[46]

In R. U. P. (1911-12), which is Russell's most brilliant essay on the problem of universals, he contends that dualism (of universal and particular) rests upon the belief that the relation of predication is ultimate, i.e., that there are particulars and that these have qualities or relations which are instances of universals.[47] Nominalism and universalism, which deny universals and particulars respectively, are rejected, the first because it must admit the universal relation "similarity," in its denial of universal qualities and relations other than similarity;[48] the second because it cannot account for our actual experience of numerical diversity of similar universals in perceptual space.[49]

From the point of view of ontological analysis, all the entities in reality, Russell maintains, are divisible into two classes:

(1) Particulars, which enter into complexes only as the subjects of predicates or as the terms of relations, and if they belong to the world of which we have experience, exist in time, and cannot occupy more than one place at one time in the space to which they belong; (2) universals, which can occur as predicates or relations in complexes, do not exist in time, and have no relation to one place which they may not simultaneously have to another.[50]

In *P. of P.*, which is the last of the writings on universals

---

follows that the universal itself appears wherever it is used. And, since the same difficulty confronts every universal relation, no relation, Russell concludes, can have instances. *P. of M.*, 50-52.

[46] K. A. D., in *Mysticism and Logic*, 213 (my italics).

[47] R. U. P., *Proceedings of the Aristotelian Society* (1911-12), 8.

[48] *Ibid.*, 8-9; also *P. of P.*, 150.

[49] R. U. P., 16-17.

[50] *Ibid.*, 23-24.

in this period, Russell uses language to prove the reality of universals and particulars: any sentence contains at least one element, the verb, which symbolizes a universal; and may, if it denotes something with which we are acquainted, contain one element, the proper name, which symbolizes a particular. Besides verbs, prepositions and adjectives also denote universals.[51]

The status of the universal is Russell's final point. The particular, of course, is either mental or physical. "Thus thoughts and feelings, minds and physical objects *exist*. But universals do not exist in this sense; we shall say that they *subsist* or *have being*, where 'being' is opposed to 'existence' as being timeless."[52]

This concludes our discussion of Russell's dualism: of the mental and the physical; and the universal and the particular. It was his position, as regards ontological analysis, from 1898 until 1921, the year of the publication of *A. of Mind*. From 1921 until the present day, so far as I know, Russell has been a modified neutral monist, as far as mental-physical dualism is concerned, and, in regard to universals and particulars, he has either become dubious about or rejected his dualism. Which it is, we shall try to determine later.

Neutral monism is a metaphysical theory which was formulated, independently of each other, by William James and Ernst Mach, and was developed by R. B. Perry, E. Holt and other American new-realists. Russell interprets it as

. . . the theory that the things commonly regarded as mental and the things commonly regarded as physical do not differ in respect of any intrinsic property possessed by the one set and not by the other, but differ only in respect of arrangement and context. The theory may be illustrated by comparison with a postal directory, in which the same names come twice over, once in alphabetical and once in geographical order; we may compare the alphabetical order to the mental, and the geographical order to the physical.[53]

---

[51] *P. of P.*, 81, 146.
[52] *Ibid.*, 156.
[53] N. of A., II, 161.

When Russell first considered neutral monism seriously in 1914 he rejected it for two important reasons: It could not explain the difference between sensation and sense-data;[54] nor could it make intelligible the fact that each person's experience is partial and not inclusive of all reality.[55]

Notwithstanding his critique of neutral monism, Russell, even in 1914, was much attracted by the view, especially by its use of Occam's razor. "That the things given in experience should be of two fundamentally different kinds, mental and physical, is far less satisfactory to our intellectual desires than that the dualism should be merely apparent and superficial."[56] Also his own attempt to reduce "matter" to a logical construction in *E. W.*, Russell recognized, came close to neutral monism. The great stumbling block in his acceptance of neutral monism was what he regarded as an irreducible distinction: that between the object of experience and the subject of experience. When Russell realized that the subject itself was a construction, and that, consequently, the distinction between sense-data and sensation was illusory, he became a neutral monist.

It is in *A. of Mind* that the distinction between sense-data and sensation is given up. Russell writes: "If we are to avoid a perfectly gratuitous assumption, we must dispense with the subject as one of the actual ingredients in the world."[57] And why is the subject a gratuitous assumption? Because it is not given in experience: "Empirically, I cannot discover anything corresponding to the supposed act [i.e., subject]; and theoretically I cannot see that it is indispensable."[58] When the distinction between the subject and what he is aware of is given up, ". . . the possibility of distinguishing the sensation from the sense-datum vanishes. . . . Accordingly the sensation that we have when we see a patch of colour simply *is* that patch of colour, an actual constituent of the physical world, and part of what physics is concerned with."[59]

[54] *Ibid.*, 185.
[55] *Ibid.*, III, 447.
[56] *Ibid.*, II, 169.
[57] *A. of Mind*, 142.
[58] *Ibid.*, 17-18.
[59] *Ibid.*, 142.

Russell's answer to the second objection to neutral monism is presented, although quite indirectly, in his discussion of the classification of particulars and will be considered when we come to that topic later in this section.

I come now to the basic doctrines of Russell's neutral monism. Orthodox neutral monism, i.e., the theory as expressed by Mach, James and the new-realism, maintains two doctrines: (1) the stuff of the world is neither physical nor mental but neutral; and (2) the dualism in the world is not of entities but of causal laws. It is evident that Russell is a neutral monist as far as (2) is concerned.

The dualism of mind and matter . . . cannot be allowed as metaphysically valid. Nevertheless, we seem to find a certain dualism, perhaps not ultimate, within the world as we observe it. The dualism is not primarily as to the stuff of the world, but as to causal laws.[60]

However, it is not clear that he accepts the first doctrine. Consider, e.g., the following quotation:

My own belief . . . is that James is right in rejecting consciousness as an entity, and that the American realists are partly right, not wholly, in considering that both mind and matter are composed of a neutral-stuff which, in isolation, is neither mental nor material [i.e., physical]. I should admit this view as regards sensations: what is heard or seen belongs equally to psychology and to physics. But I should say that images belong only to the mental world, while those occurrences (if any) which do not form part of any "experience" belong only to the physical world. There are, it seems to me, *prima facie*, different kinds of causal laws, one belonging to physics, and the other to psychology. The law of gravitation, for example, is a physical law, while the law of association is a psychological law. Sensations are subject to both kinds of laws, and are therefore truly "neutral." . . . But entities subject only to physical laws, or only to psychological laws, are not neutral, and may be called respectively purely material [i.e., physical], and purely mental.[61]

Our problem, now, is this: how can we reconcile this quotation with the first doctrine of neutral monism? Perhaps it can

[60] *Ibid.*, 137.
[61] *Ibid.*, 25-26. Cf. P: W. T. A., *Aristotelian Society Supplementary Volume* (1919), 18.

be done, with the aid of the theory of types, in the following way: The doctrine that the stuff of the world is neither mental nor physical but neutral is ambiguous and may mean one or both of two things: (a) Mentality and physicality are not first-order properties of ultimate entities, like the properties of redness or roundness, but are second-order properties which accrue to these entities when they have certain kinds of causal relations to each other. Thus, two entities are mental when they have a relation to each other which psychology studies; or two entities are physical when they have a relation to each other which physics studies. This part of the first doctrine, I think, Russell accepts. (b) *Any* entity can be either mental or physical, i.e., any entity can possess the second-order property of mentality or physicality. Here Russell objects because, as our quotation states, some entities, the *unperceived entities of physics*, even though they are neutral—i.e., have no first-order property of mentality or physicality—cannot be brought into psychological causal laws; while other entities, *images*, which are also neutral in the above sense, cannot be considered in physical causal laws. It is only the remaining entities, *sensations*, also neutral, which can be treated causally by both physics and psychology.

If this interpretation is correct, it follows that Russell is a neutral monist, but of a modified sort, accepting the doctrine that the dualism in the world is causal and the doctrine that mentality and physicality are properties of entities-in-relation and not of entities-in-isolation, but rejecting the orthodox neutral monistic doctrine that *any* neutral event can be treated by both psychology and physics.

As an ontological theory, then, Russell's neutral monism revolves around two related doctrines: (1) The world is composed of neutral events, which are sensations in some contexts, images in other contexts, and unperceived events in still other contexts; and (2) the dualism in the world is not between entities, as it is for Descartes and orthodox dualism, but between causal laws.[62] Let us discuss these in turn.

(1) Russell says, in regard to the doctrine of eventism:

[62] *A. of Mind*, 137, 143-144.

"Everything in the world is composed of 'events'; that, at least, is the thesis I wish to maintain."[63] What, then, is an event? For ·one thing, it is something which occupies a small finite region of space-time.[64] It is also something penetrable and destructible, unlike the matter of traditional physics.[65] We know this empirically; i.e., we experience the overlapping of events and, according to physics, events in the form of "electrons" and "protons" actually annihilate each other. Our usual experience with events is in terms of sensations and images. E.g., "seeing a flash of lightning is an event; so is hearing a tire burst, or smelling a rotten egg. . . ."[66]

The ultimate kinds of events-in-relation are sensations, images and unperceived events. Everything which we recognize as "mind" and "matter" can be built up out of these. "Mind" is constructed out of sensations and images.[67] "Matter" is constructed out of sensations and unperceived events.[68] Indeed, Russell suggests that in a completed science the concepts "mind" and "matter" would disappear, and would be replaced by causal laws concerning events.[69]

Sensations are definable in at least three ways: (1) as the intersection of mind and matter;[70] (2) as the non-mnemic element in a perception, i.e., as that element in a perception which does not depend upon past experience, i.e., habit, memory, etc.;[71] and (3) as events whose causal laws include events which are stimuli *external* to the brain.[72]

Images are defined with the aid of the third definition of sensations, namely, as events whose causal laws include events which are sensations.[73]

Images belong exclusively to psychology because, if they

[63] *Phil.*, 276.
[64] *A. of Matter*, 286.
[65] *Ibid.*, 386.
[66] *Phil.*, 276.
[67] *A. of Mind*, 69, 109, 121, 143.
[68] *Ibid.*, 121.
[69] *Phil.*, 281.
[70] *A. of Mind*, 144.
[71] *Ibid.*, 139.
[72] *Ibid.*, 109.
[73] *Ibid.*

also belonged to physics, they would contradict the laws of physics. Russell uses this argument to refute behaviorism when it denies the existence of images. Behaviorism denies the distinction between images and sensations, regarding images as faint sensations. If this is true, especially for visual and auditory images, physics is contradicted because these images do not have the connections with physical events which visual and auditory sensations actually have.

Suppose, for example, that I am sitting in my room, in which there is an empty arm-chair. I shut my eyes, and call up a visual image of a friend sitting in the arm-chair. If I thrust my image into the world of physics, it contradicts all the usual physical laws. My friend reached the chair without coming in at the door in the usual way; subsequent inquiry will show that he was somewhere else at the moment. If regarded as a sensation, my image has all the marks of the supernatural.[74]

Besides sensations and images there are unperceived events. The argument for them is given in *A. of Matter*. The basic assumption is the causal theory of perception which says, in effect, that any percept[75] is a member of a group of percepts, given and inferred; and that the whole group can be correlated with another group of events which do not enter into perception.[76]

Perhaps the theory may be clarified by being formalized: Let "Px" = x is a percept; "A" = a group of percepts, given and inferred; "B" = a group of unperceived events; and "1-1" = the correlator. Then the causal theory of perception says:

$$(x)(\exists A,B):.\ Px:\supset :x\epsilon A\cdot A1-1B.$$

For example, suppose I am having a blue percept; then the causal theory states (1) that this percept is a member of a class of percepts which includes roundness, hardness, shininess, etc., and which I call a "table;" and (2) that the class itself is related to events which can be correlated with hardness, blueness, roundness, etc. These events psychology calls the

[74] *Ibid.,* 153.
[75] A percept is a sensation plus its physiological, as against its psychological, accompaniments. See *A. of Matter,* 189.
[76] *A. of Matter,* Ch. XX.

"stimuli" of our perceptions and physics the "causes" of our perceptions.

According to Russell, both sciences are correct in their belief that there are events which no one perceives or can perceive and which can be correlated with events which we do perceive or are perceptible. The alternatives to this belief are phenomenalism and solipsism, both of which Russell rejects, the second because it is too desperate an alternative[77] and the first because it cannot account for such obvious facts as dictaphones repeating conversations or the hearing of a noise sooner by people who are close to its source than by people farther from its source.[78]

(2) Causal dualism is the theory that the dualism in the world is not of entities but of laws. These two kinds of causal laws are irreducible. Russell calls them the physical and the psychological causal laws.[79] As we have seen, according to Russell, the world is made up of evanescent particulars. Collected in one way they form psychological laws; collected in another way they form physical laws.

For the understanding of the difference between psychology and physics it is vital to understand these two ways of classifying particulars, namely: (1) according to the place where they occur; (2) according to the system of correlated particulars in different places to which they belong, such system being defined as a physical object.[80]

Psychology, thus, is interested merely in the places where different particulars occur, i.e., in *certain* particulars themselves, whereas physics is concerned with the *whole* system of appearances. This method of collecting particulars enables us to suggest what Russell would probably reply to his N. of A. objection to neutral monism. He said that neutral monism cannot account for the partiality or egocentricity of each person's experience. The way in which psychology collects appearances, I think, makes it inevitable that our experiences shall be partial because particulars appear from certain points of view. Partiality, therefore, is explicable by Russell's neutral monism as the

[77] *Ibid.*, 198.
[78] *Ibid.*, 214.
[79] *A. of Mind,* Ch. V.
[80] *Ibid.*, 102.

inevitable fact that one person's experience is the resultant of the universe seen from one, not from all, points of view.

This brings us to the question why causal dualism is ultimate. As Russell interprets it, it is, I think, identical with the problem of materialism. One can define materialism in one of two ways: (1) the ultimate stuff of the world is physical, i.e., non-mental; or (2) the ultimate laws in the world are physical, and *all* genuine laws are fundamentally physical. Russell rejects materialism in the first sense as being too dogmatic.[81] And the truth or falsity of materialism in the second sense reduces itself, it seems to me, to the following five problems in Russell's later works.

(1) Can "vital" movements be reduced to "mechanical" ones? Russell says, in answer to this problem of reduction, that our information is too meagre to declare oneself either way on the question.[82]

(2) Are images reducible to sensations? As we have seen, Russell rejects materialism in this sense, arguing that images cannot be brought into the statement of physical laws without falling into contradiction. However, Russell adds: "I am by no means confident that the distinction between image and sensation is ultimately valid, and I should be glad to be convinced that images can be reduced to sensations of a peculiar kind."[83]

(3) Are mnemic phenomena ultimate? That is, does the past operate upon our present experience directly or by means of its modification of the brain? The issue is between the ultimacy of mnemic phenomena and the ultimacy of the "engram," i.e., the modified brain structure. As an empiricist, Russell maintains that we do not have sufficient evidence to reduce mnemic phenomena to physiology, since the engram is an inferred entity, whereas the influence of the past upon a response is given directly in experience.[84]

(4) Is "physicalism" true? Physicalism is the view, advocated by Carnap and his followers, which holds that ". . . every

[81] *A. of Matter*, 382.
[82] *A. of Mind*, 47.
[83] *Ibid.*, 156.
[84] *Ibid.*, 85.

sentence of any branch of scientific language . . . can . . . be translated into the physical language without changing its content."[85] Although Russell does not criticize physicalism directly, nevertheless, we can discover what he thinks of it from his discussion of the sort of thesis it proclaims. Physics, he says, can tell us a good deal about the world, but *nothing* about the most intimate part of it, sensations or perceptions.

To take a simple instance: physics might, ideally, be able to predict that at such a time my eye would receive a stimulus of a certain sort; it might be able to trace the physical properties of the resulting events in the eye and the brain, one of which is, in fact, a visual percept; but it could not itself give us the knowledge that one of them is a visual percept. It is obvious that a man who can see knows things which a blind man cannot know; but a blind man can know the whole of physics. Thus the knowledge which other men have and he has not is not part of physics.[86]

(5) Is determinism true? Russell says no, basing his denial upon the quantum theory, which destroys any form of "mind-brain determinism." That is, Russell argues: assume that the mind and brain *are* causally connected. But,

perhaps the electron jumps when it likes; perhaps the minute phenomena in the brain which make all the difference to mental phenomena belong to the region where physical laws no longer determine definitely what must happen. This, of course, is merely a speculative possibility; but it interposes a veto upon materialistic dogmatism.[87]

I conclude, then, that Russell is a causal dualist, even though he would like very much to reduce all causal laws to physics and thereby accept a causal materialism.

I come now to the final topic of this section, Russell's theory of universals and particulars in the years 1921-40. As a dualist Russell accepted three related doctrines: (1) there are universal qualities; (2) there are universal relations; and (3) there are particulars. In this second period of ontological analysis Russell,

---

[85] R. Carnap, *Philosophy and Logical Syntax*, 89.

[86] *A. of Matter*, 389.

[87] *Ibid.*, 393.

at one time or another, has either become dubious about, modified, or rejected these doctrines.

(1) In *A. of Mind* Russell expressed doubt about the reality of universal qualities, offering an interpretation of them which is nominalistic. Whiteness, e.g., may be taken ". . . as denoting a certain set of similar particulars or collections of particulars."[88] However, in *Inquiry*, Russell returns to the view that there are universal qualities, basing his argument, as he did in R. U. P. and *P. of P.*, upon the premiss that there are universal relations.[89]

(2) Russell also retains his earlier thesis about universal relations, but he modifies his doctrine somewhat in that he no longer regards them as self-evident. There are, Russell contends in *A. of Mind*, good reasons for believing that universal relations, although not self-evident, are part of the *inferred* structure of the world.[90] These reasons, however, do not appear until *Inquiry*, where Russell employs the causal theory of meaning, i.e., the theory that the words we use are caused by *non-verbal* contexts, to prove the reality of universal relations.[91]

(3) The doctrine that there are particulars was ably defended by Russell in R. U. P., in his criticism of universalism, which is the theory that denies the existence of particulars. It maintains that universals and not their instances exist in all places where they appear. If two places have the same shade of colour, e.g., the shade in both places is identical. It denies the relation of predication: to say "this is white" is really to say "whiteness exists here."[92] Dualism contends, on the other hand, that there are particulars and that predication holds between a universal and a particular. Thus, to say "this is white" is to say "whiteness is a predicate of a particular which I call 'this'." Russell's rejection of universalism was based upon (1) our sense-experience of diversity, i.e., our perception of two similar patches of, e.g., white; and (2) the logical principle that

[88] *A. of Mind*, 196.
[89] *Inquiry*, 436-437.
[90] *A. of Mind*, 228.
[91] *Inquiry*, 429-437.
[92] R. U. P., 8.

existents in different places at the same time cannot be numerically identical.

Russell's rejection of universalism was maintained by him, so far as I know, from 1911-40. In *Inquiry*, however, Russell, in discussing a problem quite remote from that of universals, namely, substance, sketches a theory which, if he really accepts it, makes him a universalist. Stated simply the theory is this: Proper names, like "this" and "that," are regarded by many philosophers as symbols of *particulars*. Thus, when one utters the statement "this is red," one means, on this view, that a given sense-particular, which one calls "this," has the predicate or quality of redness. But, Russell argues, if one construes the proposition in such a way (which, of course, Russell does in his dualistic doctrine of R. U. P.), ". . . one finds that 'this' becomes a substance, an unknowable something in which properties inhere, but which, nevertheless, is not identical with the sum of its properties. Such a view is open to all the familiar objections to the notion of substance."[93] In order to avoid this difficulty with the word "this" as a symbol of an unknowable substance, Russell rejects the doctrine that "this" (and "that") stand for particulars. He suggests that, whenever we have a subject-predicate proposition, like "this is red," we must interpret it as "redness is here." Thus, in the case of a physical object, like an apple, we must not say, "this is an apple," but "redness, roundness, sweetness, etc., are here."[94] A thing, then, is nothing but a bundle of coexisting qualities. All of this follows, unless we wish to get stuck with the substratum of Locke. Now, that this theory is tantamount to universalism is shown by the fact that it denies implicitly the relation of predication, which is basic to dualism and rejected by universalism. The interpretation of "this is red" as "redness is here," i.e., the rejection of subject-predicate propositions, is exactly the way in which universalism interprets propositions of this sort.

Our problem here, of course, is to show how Russell would answer his own objection to universalism, as he expressed it in R. U. P. It seems to me, from a careful reading of Chapter VI

[93] *Inquiry*, 120.
[94] *Ibid.*, Ch. VI.

of *Inquiry*, where this problem is considered (quite indirectly, though), that Russell might say to the dualist: it is true that we do experience spatial diversity, i.e., two similar patches of white; and it is just as true that two patches of white cannot be numerically identical. But—and this would be the vital point—the white in the two patches of white is identical. What makes the white two are not the instances of white but the spatial coordinates.[95] That is, two patches of white are two, not because they are instances of white, but because the universal has two separate sets of co-ordinates. The names of the whiteness are, in our example, "Whiteness plus co-ordinates A, B" and "Whiteness plus co-ordinates C, D." Thus, the twoness of two patches of white depends upon the specificity of the co-ordinates, not upon the instances of white.[96]

If this account of Russell's new theory of universals is correct,—and I do not see how else to interpret his discussion in *Inquiry*,—then it is a fact that Russell has rejected (knowingly or not) his earlier dualism of universals and particulars, substituting in its place the doctrine of universalism which denies the existence of particulars.

### SECTION II. ANALYSIS AS FORMAL ANALYSIS

Formal analysis, as Russell has conceived it, is the application of analysis to abstract cosmological problems. As a kind or use of analysis it was developed by him from the very beginnings of his philosophical career, but it reached its climax after the publication of *P. M.*, in a series of articles, P. L. A. (1918-19).

[95] *Ibid.*, 122.

[96] The chief difficulty with this theory, I think, has to do with these co-ordinates: (1) Russell treats them as if they were *qualities* apart from the qualities that they describe. But co-ordinates are no more experienceable separate qualities than the unknowable substratum which forced Russell to give up his dualism in the first place. (2) Granted that co-ordinates are distinct from the qualities which they describe, are they not then *particulars*, not in the sense of being instances of universals perhaps, but in the sense of being the denotation of proper names? Has Russell done more than substitute for "this" and "that" the names of co-ordinates, which denote one quality at one place at one time? If Russell admits that spatial co-ordinates are particulars and their symbols are proper names, the whole point of his universalism is lost, because the relation of predication is readmitted: all qualities become predicates of their co-ordinates.

The easiest way in which to understand formal analysis is to begin with Russell's conception of logic, because it is in terms of. logic that he defines formal analysis. Logic, according to Russell, has two continuous but distinguishable parts, a philosophical and a mathematical part. The philosophical part is concerned, first, with the forms which are abstracted from an examination of the linguistic and non-linguistic aspects of reality, and, secondly, with the foundations of mathematics. The mathematical part of logic comprises the theorems which are deduced from the foundations.[97]

That part of philosophical logic which deals with the forms of reality is formal analysis, whereas the other part, the foundations of mathematics, is logistic. Logistic will be considered in the next section; but it is important to see at the outset the common root of formal analysis and logistic, i.e., to see that both are defined in terms of logic.

Form, which is the basic problem of formal analysis, may be defined in two ways, by an analysis of language or by an analysis of experience. Russell, in the isomorphic tradition of Plato, Aristotle and Wittgenstein, begins with the first way and uses his findings as a clue, but not as *the* clue, in the analysis of non-linguistic form. The best way to define form, according to Russell, is in terms of actual propositions.

> In every proposition . . . there is, besides the particular subject-matter concerned, a certain *form*, a way in which the constituents of the proposition . . . are put together. If I say "Socrates is mortal," "Jones is angry," "The sun is hot," there is something in common in these three cases, something indicated by the word "is." What is in common is the *form* of the proposition, not an actual constituent.[98]

From any of these propositions one can derive the others, by

---

[97] "Logic, we may say, consists of two parts. The first part investigates what propositions are and what forms they may have; this part enumerates the different kinds of atomic propositions, of molecular propositions, of general propositions, and so on. The second part consists of certain supremely general propositions, which assert the truth of all propositions of certain forms. This second part merges into pure mathematics, whose propositions all turn out, on analysis, to be such general formal truths." E. W., 61. See also S. M. P., in *Mysticism and Logic*, 112; *I. M. P.*, 1; P. L. A., IV, 48; and E. W., 46.

[98] E. W., 45-46; see also I. M. P., 199 and P. L. A., V, 202.

substitution; that which remains unchanged when one replaces constituents and gets different propositions is the form of these propositions. Propositional form, thus, is that which one gets when one substitutes variables for the constituents of propositions.

The same analysis of factual form can be given:

Two facts are said to have the same "form" when they differ only as regards their constituents. In this case, we may suppose the one to result from the other by *substitution* of different constituents. For example, "Napoleon hates Wellington," results from "Socrates loves Plato" by substituting Napoleon for Socrates, Wellington for Plato, and *hates* for *loves*. It is obvious that some, but not all, facts can be thus derived from "Socrates loves Plato." Thus some facts have the same form as this and some have not. We can represent the form of a fact by the use of variables: thus "xRy" may be used to represent the form of the fact that Socrates loves Plato.[99]

We come now to the different kinds of forms, i.e., to the enumeration of the various fundamental ways in which the ultimate ontological entities can be organized. There are two basic kinds of forms: (1) proper names and logical particulars; and (2) propositions and facts. Let us begin with the form manifested by proper names and particulars.

A proper name ". . . is a simple symbol whose meaning is something that can only occur as subject."[100] It ". . . directly [designates] an individual which is its meaning, and [it has] this meaning in its own right, independently of the meanings of all other words."[101] It is the only kind of word which is theoretically capable of standing for a particular and can only be applied to a particular with which the speaker is acquainted; for one cannot name anything one is not acquainted with.[102]

True examples of proper names are very difficult to find. Most people regard words like "Socrates," "Roosevelt," etc., as proper names. But, according to Russell, they are mistaken, because these words do not stand for particulars, but for compli-

[99] P: W. T. A., 2.
[100] I. M. P., 173.
[101] Ibid., 174.
[102] P. L. A., II, 523-524.

cated systems of particulars, and are really abbreviations for definite descriptions.[103]

The only words one does use as names in the logical sense are words like "this" or "that." One can use "this" as a name to stand for a particular with which one is acquainted at the moment. . . . It is only when you use "this" quite strictly, to stand for an actual object of sense, that it is really a proper name.[104]

Logical particulars are what proper names mean. They are, along with facts, the sort of objects one would have to take into account in any inventory of the world. They have this peculiarity,

. . . that each of them stands entirely alone and is completely self-subsistent. It has that sort of self-subsistence that used to belong to substance, except that it usually only persists through a very short time, so far as our experience goes. That is to say, each particular that there is in the world does not in any way logically depend upon any other particular.[105]

Besides proper names and logical particulars, formal analysis is concerned with another basic dichotomy: propositions and facts. A proposition, for Russell, is an indicative sentence, one which either asserts or denies something. It is that which we believe truly or falsely; i.e., it is the logical vehicle of truth or falsehood. A proposition, Russell points out, differs from a name because its relations are different; there are two relations that a proposition may have to a fact, being true and being false; whereas there is only one relation that a name can have to that which it names: it can just name it, and if it does not, it is a mere noise.[106] It follows that facts cannot be named by propositions but only asserted or denied (or questioned, etc.) by them.

It is as necessary to distinguish between facts and particulars as it is to distinguish between propositions and names. A fact is not a particular, but the sort of thing represented by whole sentences.[107] It is a complex of particular(s) and qualities and

---

[103] *Ibid.*; see also *A. of Mind*, 193.

[104] P. L. A., II, 524-525. But cf. *P. of M.*, 42-43 and *Inquiry*, Ch. VI.

[105] P. L. A., II, 525; see also *A. of Matter*, 199-200.

[106] P. L. A., I, 507-508.

[107] *Ibid.*, 520.

relations.[108] Furthermore, a fact is

... the kind of thing that makes a proposition true or false. If I say "It is raining," what I say is true in a certain condition of weather and is false in other conditions of weather. The condition of weather that makes my proposition true (or false . . .) is what I should call a "fact."[109]

Finally, facts are objective, i.e., independent of our thinking about them. Russell regards this as an undeniable datum of formal analysis. It follows that the world ". . . is not completely described by a lot of 'particulars', but that you must also take account of these things that I call facts . . . and that these . . . are part of the real world."[110]

Thus far in our discussion of formal analysis we have defined form and distinguished between the basic forms: proper names and particulars, and propositions and facts. The latter category contains various species which we must discuss next. There are five such species which Russell has persisted in accepting as valid: atomic propositions and facts; molecular propositions and facts; existence propositions and facts; general propositions and facts; and completely general (or logical) propositions and facts. Since these may be either positive or negative, there are also negative facts to be considered.

(1) An atomic proposition is one which ". . . asserts that a certain thing has a certain quality, or that certain things have a certain relation."[111] Examples are: "this is white;" "this is below that;" "this is between that and the other thing." Every atomic proposition has an adjective or verb and a subject, which is the proper name of the proposition.[112]

Corresponding to atomic propositions are atomic facts. They ". . . are what determine whether atomic propositions are to be asserted or denied."[113] They are the simplest kinds of facts, consisting in the possession of a quality or relation by some

---

[108] P: W. T. A., 1-2.
[109] P. L. A., I, 500-501.
[110] Ibid., 502; see also E. W., 55.
[111] E. W., 56; see also P. M., I, xv.
[112] P. L. A., II, 523.
[113] E. W., 56.

particular(s).[114] In every atomic fact there is one component which is either the quality or the relation and one or more terms (particulars). Thus, there is a perfect isomorphism between atomic propositions and atomic facts: subjects (proper names) correspond to terms (particulars); adjectives correspond to qualities; and verbs correspond to relations.

(2) A molecular proposition is one that contains ". . . other propositions which you may call their atoms."[115] It is a proposition in which truth-function words like "or," "if," "and," etc., occur. An example is: "If you stay, so will your sister."

The problem regarding molecular forms is whether there are molecular facts. Russell, at first, denies their existence:

I do not suppose there is in the world a single disjunctive fact corresponding to [the proposition] "p or q." It does not look plausible that in the actual objective world there are facts going about which you could describe as "p or q."[116]

According to Russell, then, "pvq" refers to two facts, the fact corresponding to "p" and the fact corresponding to "q."

When Russell discusses general facts, however, he reverses his decision and affirms the existence of molecular facts, because he accepts the existence of general facts, which is the genus of the molecular species.[117]

(3) An existence proposition is the traditional "I" or "O" proposition. For Russell it is a proposition which asserts the truth of at least one value of a propositional function; e.g., "Some men are brutal."

That there are existence facts, as distinct from atomic facts, Russell regards as obvious: "Of course, it is not so difficult to admit what I might call existence-facts—, such facts as 'There are men. . . .' Those, I think, you will readily admit as separate and distinct facts over and above the atomic facts."[118]

(4) A general proposition is the traditional "A" or "E" proposition, interpreted in the Boolean sense. It is a proposition

---

[114] P. L. A., II, 520.
[115] Ibid., III, 37.
[116] Ibid., 39.
[117] Ibid., V, 201.
[118] Ibid., 200-201.

which asserts (or denies) the truth of all values of a proposi-
tional function.

A general fact is one which corresponds to a general propo-
sition. One cannot deny the existence of general facts or reduce
them to other facts:

> It would be a very great mistake to suppose that you could describe the
> world completely by means of particular facts alone. Suppose that you
> had succeeded in chronicling every single particular fact throughout the
> universe, and that there did not exist a single particular fact of any sort
> anywhere that you had not chronicled, you still would not have got a
> complete description of the universe, unless you also added: "these that
> I have chronicled are all the particular facts there are,"[119]

which, of course, is a general fact.

(5) A completely general proposition is one which occurs in
logic, either as an axiom or a theorem. It contains only variables
and truth-functions.[120]

Completely general propositions are analytic and *a priori*
because of a ". . . certain peculiar quality which marks them out
from other propositions."[121] What this quality is, Russell is not
sure:

> Although it is a necessary characteristic of logical propositions that they
> should consist solely of variables, i.e., that they should assert the uni-
> versal-truth, or the sometimes-truth, of a propositional function consisting
> solely of variables . . . it is not a sufficient one.[122]

Russell's treatment of completely general facts is vague and,

---

[119] *Ibid.*, I, 502-503.

[120] *Ibid.*, V., 200. However, not all propositions which contain only variables
and truth-functions are logical. A proposition, to be logical, must be expressed in
the language of logic and deduced from the premisses of logic (or be a primitive
premiss of logic). There are some propositions which are expressed logically, but
not proved logically, e.g., 'There is at least one thing in the world'; see *ibid.*,
204-205.

[121] *Ibid.*, 206.

[122] *Ibid.* In *A. of Matter* (176), however, Russell accepts the analysis of
Wittgenstein, that the peculiar characteristic of logical propositions is their
tautological character. But in the new "Introduction" to *P. of M.* (1937), Russell
gives up this analysis as being too linguistic and conventional, offering nothing in
its place. Thus, so far as I know, he has no complete analysis of logical proposi-
tions; that they consist solely of variables and truth-functions, and that they are
*a priori*, is clear, but that they are only that or conventional, Russell cannot believe.

unfortunately, I cannot find any adequate discussion of them in his essays on formal analysis.

(6) This brings us to positive and negative propositions and facts. These are not distinct species but two different ways of looking at the others. That is, an atomic proposition or fact, e.g., may be either positive or negative.

That there are positive and negative propositions most of us would admit. Also, the view that there are positive facts would cause little dispute. But negative facts seem to us to be in the same category as "blue centaurs," etc. Indeed, the belief in negative facts seems to violate that robust feeling of reality which is one of Russell's cardinal principles. Nevertheless, with all this against him, he insists that there are negative facts:

I think you will find that it is better to take negative facts as ultimate. Otherwise you will find it so difficult to say what it is that corresponds to a proposition. When, e.g., you have a false positive proposition, say "Socrates is alive," it is false because of a fact in the real world. A thing cannot be false except because of a fact, so that you will find it extremely difficult to say what exactly happens . . . unless you are going to admit negative facts.[123]

To sum up: Formal analysis is the examination of the world considered *abstractly*, i.e., apart from whether it is physical or mental or neutral, etc. Its concern is with the various modes of organization which are disclosed by the linguistic and non-linguistic aspects of reality. Together with ontological analysis, formal analysis comprises part of what has been traditionally called "metaphysics:" ontological analysis is concerned with the ultimate categories: the mental, the physical, the universal, etc.; formal analysis is abstract cosmology and deals with the abstract patterns in which the ontological categories are organized.

## Section III. Analysis as Logistic

Logistic, or analysis as applied to mathematical logic, is probably the best known of the species of analysis in Russell. Also, no one, I suppose, would criticize Russell here as lacking in

[123] P. L. A., III, 46; see also P: W. T. A., 5.

fundamental unity, since he has been expounding the same basic philosophy of mathematics from 1900 to the present. Because logistic is so well known and its unity in Russell's work is granted by all (and our space is limited), it will not be necessary to treat it at any length.[124] What I shall try to do in this section, therefore, is to offer the briefest sort of general picture of logistic, in order to make the exposition of Russell's philosophy in terms of analysis as complete as possible.

The best answer to the problem of the nature of logistic lies, I think, in the answer to a broader question: What is the correct philosophy of mathematics? Since the latter half of the nineteenth century when, for the first time, mathematics became a well-defined science, through the brilliant work of Weierstrass and Peano, there have been in the main three philosophies of mathematics: intuitionism, formalism, and logistic.

Intuitionism, in its modern form, stems from Kant and Poincaré, and is represented at present by Brouwer and Weyl. In the work of the latter two, according to Russell, it is characterized by two doctrines: finitism and the denial of the principle of excluded middle.[125] It claims, Russell asserts, that a mathematical proposition is neither true nor false unless there exists a method which enables us to determine which it is. When no such method is forthcoming in the consideration of a certain proposition, that proposition is regarded as literally meaningless. The first consequence of this doctrine is the denial of the principle that any proposition is either true or false; from which it further results that many hitherto accepted theorems regarding infinity are thrown out of mathematics as meaningless because they cannot be known to be either true or false.

Russell rejects intuitionism; his criticism amounts to saying that it is *too empirical*. If its thesis, that mathematics is a set of intuitive constructions governed by the principle of verification, be maintained and pushed to its logical consequences, it results in absurdity:

[124] A fuller treatment of logistic, as well as more complete discussions of many of the topics of this essay, may be found in my doctoral dissertation, *The Method of Analysis in the Philosophy of Bertrand Russell* (University of Michigan, 1943).

[125] *P. of M.* (new "Introduction," 1937), v-vi.

Men, for example, though they form a finite class, are practically and empirically, just as impossible to enumerate as if their number were infinite. If the finitist's principle is admitted, we must not make *any* general statement—such as "All men are mortal"—about a collection defined by its properties, not by actual mention of all its members. This would make a clean sweep of all science and of all mathematics, not only of the parts which the intuitionists consider questionable.[126]

Formalism, which had its royal birth in the non-Euclidean geometries of the nineteenth century and in the work of Peano, is best represented by Hilbert. Essentially, Hilbert distinguishes between two disciplines: mathematics-proper and meta-mathematics. The former is a collection of symbols about which there are certain undefined ideas and axioms, which tell us what we are allowed to do to the symbols in order to derive the propositions which we desire. Meta-mathematics consists of statements about mathematics-proper that reveal which formulae can and which cannot be derived from the axioms according to the rules.

Now, just as intuitionism is too empirical, so formalism, Russell argues, is *too rational*. Neither in the form of Peano nor Hilbert can it account for our practical uses of mathematics.

The formalists have forgotten that numbers are needed, not only for doing sums, but for counting. Such propositions as "There were 12 Apostles" or "London has 6,000,000 inhabitants" cannot be interpreted in their system. For the symbol "o" may be taken to mean any finite integer, without thereby making any of Hilbert's axioms false; and thus every number-symbol becomes infinitely ambiguous. The formalists are like a watchmaker who is so absorbed in making his watches look pretty that he has forgotten their purpose of telling the time, and has therefore omitted to insert any works.[127]

The third prevalent philosophy of mathematics is logistic, which was developed by Frege and Russell. Independently of each other, they carried on the arithmetization of mathematics to the "logicizing" of arithmetic; i.e., they reduced the theory of natural numbers to certain logical ideas and propositions.

[126] *Ibid.*, vii; see also "The Limits of Empiricism," *Proceedings of the Aristotelian Society* (1935-36), 141-145.
[127] *P. of M.*, vi.

Logistic, to Russell, is fundamentally the view that mathematics and logic are continuous and identical. "They differ as boy and man: logic is the youth of mathematics and mathematics is the manhood of logic."[128] It is easy to see, I think, although many modern logicians have forgotten it, that logistic represents a compromise between the complete empiricism of intuitionism and the complete rationalism of formalism. The nature of this compromise can be seen best in Russell's rejection of formalism. The *analysis* of mathematical ideas and propositions, Russell contends, must not only do justice to the bare formulae of mathematics, but also to our experiences with mathematics, e.g., in counting.

We want our numbers not merely to verify mathematical formulae, but to apply in the right way to common objects. We want to have ten fingers and two eyes and one nose. A system in which "1" meant 100, "2" meant 101, and so on, might be all right for pure mathematics, but would not suit daily life. . . . We have already some knowledge (though not sufficiently articulate or analytic) of what we mean by "1" and "2," and so on, and our use of numbers in arithmetic must conform to this knowledge.[129]

These, then, are the prerequisites of an adequate philosophy of mathematics: it must make articulate our unanalyzed knowledge of mathematical ideas and propositions and it must so define these ideas and deduce these propositions, in terms of logical ideas and propositions, that the definitions and deductions both verify mathematics as a body of abstract formulae and conform to our experience of counting. It is the contention of Russell that only logistic has satisfied these requirements. In his logical writings—*P. of M.* (1903), *P. M.* (1910-13), which was written with Whitehead, and *I. M. P.* (1919)—the determination of the basic ideas and propositions of mathematics and the reduction of them to logic has been worked out. This determination of the basic ideas and propositions of mathematics and the reduction of them to logic constitute *analysis as logistic* in the philosophy of Russell.

[128] *I. M. P.*, 194.
[129] *Ibid.*, 9.

### Section IV. Analysis as the Resolution of Incomplete Symbols

What is to be called the resolution of incomplete symbols in this section is what Russell has at various stages of his writings called (1) the analysis of denoting phrases,[130] (2) the analysis of incomplete symbols,[131] (3) constructionism,[132] (4) the principle which dispenses with abstractions,[133] and (5) the logical-analytic method.[134] In principle, all of these, I think, mean the same thing: they are all names of a technique whereby certain symbols, because they are defective, are replaced by other symbols or groups of symbols. The advantage of our term is that it emphasizes this fact: that one kind or species of analysis in Russell has to do with getting rid of, i.e., *resolving*, certain symbols in favor of certain other symbols.

Analysis as the resolution of incomplete symbols is probably the most successful attempt at semantical analysis since Plato's explication of negative judgment in the *Sophist*. The problems which it solves are tremendous in their scope; for they include not only traditional linguistic questions but also many problems which have not been considered by most philosophers to be mainly linguistic in their nature.

The setting of this fourth species of analysis in Russell's philosophy is to be found in *P. of M.* Now, in many ways, this work represents the climax of the revolt, begun in the nineteenth century by certain mathematicians, against the classical logic, e.g., in its proofs that the subject-predicate proposition is not the ultimate or the only kind of proposition. In spite of the revolutionary character of this book, however, it nevertheless proclaims one of the fundamental doctrines of the classical logical tradition: that language has its non-linguistic correlate in reality. As Russell writes:

Whatever may be an object of thought, or may occur in any true or false proposition, or can be counted as *one*, I call a *term*. This, then, is

---

[130] "On Denoting," *Mind* (1905), 479.
[131] *P. M.*, "Introduction," Ch. III.
[132] R. S. D. P., 157; *E. W.*, viii; and L. A., 364.
[133] *E. W.*, 44; and L. A., 364.
[134] *E. W.*, vii.

the widest word in the philosophical dictionary. I shall use as synonymous with it the words unit, individual, entity. The first two emphasize the fact that every term is *one*, while the third is derived from the fact that every term has being, i.e., *is* in some sense. A man, a moment, a number, a class, a relation, a chimaera, or anything else that can be mentioned is sure to be a term; and to deny that such and such a thing is a term must always be false.[135]

This doctrine,—which he shared with Meinong,—Russell recognized immediately after the publication of *P. of M.*, in "On Denoting," as having one very serious difficulty, it fell into contradiction. As he expressed it later: Consider, e.g., the proposition "the round square does not exist." This is a true and significant proposition to everyone, even Meinong. But ". . . we cannot regard it as denying the existence of a certain object called 'the round square.' For if there were such an object, it would exist: we cannot first assume that there is a certain object, and then proceed to deny that there is such an object."[136]

Meinong's and *P. of M.*'s defect, Russell now points out, arises primarily from "the violation of a robust sense of reality."[137] All analysis, Russell insists, must preserve a robust sense of what is real and must not invent all *sorts of realities* to suit all occasions and to match all difficulties. Applied to propositions like "the round square does not exist," this sense of reality means that the ascription of reality to unreal and self-contradictory objects must be avoided at all costs. Analysis should no more admit as real round squares, centaurs and golden mountains than mathematics, zoology and geology do.[138]

When Russell abandoned his position of *P. of M.* and gave up Meinong's mode of analysis, he realized that his problem was to present an analysis of propositions containing symbols of unreal and self-contradictory objects which would preserve our robust sense of reality and yet allow us to discourse about these "pseudo-objects" intelligibly. This he solved in his famous

[135] *P. of M.*, 43.
[136] *P. M.*, I, 66.
[137] *I. M. P.*, 169.
[138] *Ibid.*

theory of descriptions. In essence, the theory amounts to making a fundamental distinction between two basic kinds of symbols: proper names and descriptions. A proper name, taken in an extended sense, is a simple symbol like "Scott." It designates an individual directly; that individual is its meaning, and it has this meaning in isolation, i.e., independently of all other words. A description is a complex symbol, like "the author of *Waverley*." It does not designate an individual directly, since it would then be a proper name. Because it does not refer to an actual object directly the way a proper name does, Russell calls it an "incomplete symbol," i.e., a symbol which has no meaning in isolation, but which obtains a meaning in a context with other symbols.[139] This analysis of propositions containing definite descriptions enables us to talk intelligibly about unreal and self-contradictory pseudo-objects, because all propositions about them can now be interpreted as propositions involving propositional functions and variables and not real objects which somehow are also unreal.

The theory of descriptions became very significant after it was developed in 1905, because it became a model to Russell for the treatment of other philosophical symbols. Classes, numbers, relations (in extension), points, instants, particles of matter, even ordinary objects, like tables and people, were dealt with in the same way as descriptions: each of these was reduced from an actual entity to an incomplete symbol which could be interpreted in terms of propositional functions and variables or sensible objects.

There are, it seems to me, three rather distinct kinds of incomplete symbols in Russell's work: (1) descriptions, (2) specifically mathematical symbols, and (3) the symbols of the natural sciences (including those of ordinary discourse which can be assimilated by the natural sciences, e.g., "tables," "chairs," "persons," etc.). It will be impossible to deal with all of these here; consequently I shall discuss rather fully one example from each of the three categories: (1) definite descriptions; (2) classes; and (3) points. Let us begin with definite descriptions.

[139] *Ibid.*, 173-174; *P. M.*, I, 66; and *P. L. A.*, IV, 57.

Russell's earliest treatment of definite (and indefinite) descriptions as incomplete symbols was in the article, "On Denoting" (1905). In that article he considers descriptions as species of denoting phrases. A phrase, Russell points out, denotes

. . . solely in virtue of its *form*. We may distinguish three cases: (1) A phrase may be denoting, and yet not denote anything; e.g., "the present King of France." (2) A phrase may denote one definite object; e.g., "the present King of England" denotes a certain man. (3) A phrase may denote ambiguously; e.g., "a man" denotes not many men, but an ambiguous man.[140]

Denoting phrases are analyzed by Russell in the following way: he takes as fundamental the variable. He then declares that "x has C" means a propositional function in which "x" is a constituent and, as a variable, is undetermined. With this logical machinery, he can now interpret phrases containing "everything," "something," and "nothing," which are the most primitive denoting phrases. Thus, "everything has C," e.g., is to mean " 'x has C' is always true."

"Everything," "nothing," and "something" are incomplete symbols because they have no meaning in isolation. Rather, as the above example shows, a meaning is assigned to the propositions in which they occur. This is the basic thesis of Russell's theory of denoting phrases, that they ". . . never have any meaning in themselves, but that every proposition in whose verbal expression they occur has a meaning."[141]

In this same article Russell also offers analyses of other denoting phrases: those involving words like "a," "all," "no," and "the." E.g., suppose I say "I met a man." This, according to Russell's theory, becomes: "The propositional function 'I met x and x is human' is not always false." This analysis leaves the phrase "a man," by itself, without meaning, but attributes a meaning to every proposition in whose verbal expression "a man" occurs.

One can hardly exaggerate the significance of "On Denoting." Not only did it explain how we may speak truly and meaningfully about "the round square," "the present King of

[140] "On Denoting," 479.
[141] *Ibid.*, 480.

France," "the golden mountain," etc., without assuming that
these enter into discourse as the denotata, in the form of actual
entities, of our verbal symbols; but it also showed, by implica-
tion, how we may utter phrases like "a man," "the present King
of England," etc., without assuming that there are objects
which correspond to these phrases either. Other theories, like
Meinong's, which regard denoting phrases as designating gen-
uine objects, fall into contradiction,—e.g., in simultaneously af-
firming and denying the existence of the round square,—and
can escape this difficulty only by inventing various kinds of
realities: imaginative, logical, empirical, etc., which give rise to
further difficulties centering around the denial of our robust
sense of reality.

We may now consider, somewhat systematically, Russell's
theory of definite descriptions. There are two parts to the
theory: (1) to determine why they are incomplete symbols;
and (2) to resolve them into symbolic contexts which give them
their meanings. As our example of a definite description let us
take "the author of *Waverley*."

"The author of *Waverley*" is an incomplete symbol, to begin
with, because it is not a proper name, for three reasons: (a) it is
not a simple symbol which designates a particular or an indi-
vidual treated as a particular, but is a complex symbol. (b) Its
meaning is determinate; as a phrase, its meaning is fixed as soon
as we know the meanings of the separate words, whereas the
meaning of a proper name is not determined by words but by
our knowing to whom the name is applied.[142] (c) If it were a
proper name, it would render "Scott was the author of *Waver-
ley*" either tautological or false. That is, if "the author of
*Waverley*" were a proper name, then one could substitute for
it any proper name. If that name were "Scott," the proposition
becomes "Scott was Scott," which is trivial; and if that name
were other than "Scott," the proposition would be false. How-
ever, the proposition is neither trivial nor false, but revealing
and true, disclosing a fact of literary history.[143]

[142] P. L. A., VI, 210-211.
[143] P. M., I, 67; and I. M. P., 174.

A second, closely related, reason why descriptive phrases are incomplete symbols is because *what* they are supposed to refer to are not really "constituents of propositions."[144] That is, there is no actual entity which we may call its denotation. When a description occurs in a proposition there is no constituent of that proposition corresponding to that description as a whole. This is a consequence of the fact that we may utter significant and true propositions which deny the existence of the so-and-so as, e.g., "the golden mountain does not exist." This proposition could not be significant and true, which it is, if the golden mountain had to be an actual constituent of the proposition, since, if there were no golden mountain, it certainly could not be a constituent of *any* proposition.

This completes our exposition of Russell's argument that definite descriptions are incomplete symbols. Our next problem is to resolve them into meaningful symbolic contexts. Now, the most important thing about the resolution or analysis of definite descriptions is that it does not consist in the analysis of the descriptions themselves, but of the *propositions* in which they occur; and the propositions themselves must be so analyzed that what were the grammatical subjects shall have disappeared.[145]

According to Russell, the best way to begin the analysis of propositions containing definite descriptions is to see what circumstances would render them false.[146] Our example, "Scott was the author of *Waverley*," is certainly false if (1) *Waverley* had never been written; (2) several people had written *Waverley*; or (3) the person who wrote *Waverley* was not Scott. In order to resolve the proposition, we need only negate these three conditions of falsity; then (1) becomes " 'x wrote *Waverley*' is not always false; i.e., at least one person wrote *Waverley*;" (2) becomes "if x and y wrote *Waverley*, then x and y are identical; i.e., at most one person wrote *Waverley*;" (3) becomes " 'if x wrote *Waverley*, then x was Scott', is always

[144] P. L. A., VI, 207.
[145] P. M., I, 66.
[146] I. M. P., 177.

true." Taken all together, these three propositions state that " 'x wrote *Waverley*' is always equivalent to 'x was Scott'."[147]

We come now to our second example, the resolution of symbols which are supposed to represent classes. The theory of classes as incomplete symbols and the resolution of them into defined symbolic contexts was developed in 1910, in *P. M.*, where it is stated:

> The symbols for classes, like those of descriptions, are, in our system, incomplete symbols; their *uses* are defined, but they themselves are not assumed to mean anything at all. That is to say, the uses of such symbols are so defined that, when the *definiens* is substituted for the *definiendum*, there no longer remains any symbol which could be supposed to represent a class. Thus classes, so far as we introduce them, are merely symbolic or linguistic conveniences, not genuine objects as their members are if they are individuals.[148]

This theory of classes, it is apparent, is the historical resultant of Russell's treatment of descriptions, in 1905. Like most logicians, Russell desires to abstain from making any unnecessary assumptions, without, of course, thereby rendering precarious the subject-matter which is being considered. Consequently, when he succeeded in dealing with described "objects" in such a manner that we no longer needed to assume their existence, it was only natural for him, as a logician, to try to do the same thing with classes. However, there is this difference between his treatments of descriptions and classes: with described "objects," he is quite certain that they do not exist, and that any theory which thinks otherwise falls into contradiction. But with classes, he is not so dogmatic. He neither asserts nor denies their reality as actual entities. He writes: "We are merely agnostic as regards them: like Laplace, we can say *'je n'ai pas besoin de cette hypothèse'.*"[149]

The resolution of symbols for classes, like the resolution of descriptive symbols, does not consist in the definition of classes themselves but in the definition of the *propositions* in which words apparently representing classes appear. These proposi-

---

[147] *P. M.*, I, 68.
[148] *Ibid.*, 71-72.
[149] *I. M. P.*, 184.

tions are defined in such a manner that these class-symbols disappear. How is this resolution of a class-symbol into a symbolic complex, in which no class-symbol appears, accomplished? It is done by resolving every proposition supposedly about a class into a proposition about the values that satisfy some propositional function. For example:

Take such a statement as, "The class of people interested in mathematical logic is not very numerous." Obviously this reduces itself to, "Not very many people are interested in mathematical logic." For the sake of definiteness, let us substitute some particular number, say 3, for "very many." Then our statement is, "Not three people are interested in mathematical logic." This may be expressed in the form: "If x is interested in mathematical logic, and also y is interested, and also z is interested, then x is identical with y, or x is identical with z, or y is identical with z." Here there is no longer any reference at all to a class. [150]

In this example, then, the proposition containing the symbol for the *class* of people interested in mathematical logic is resolved into a complex statement about the *individuals* who satisfy the function "x is interested in mathematical logic." In a similar fashion, Russell insists, all propositions about classes can be resolved into propositions about the values of propositional functions.[151]

Upon the completion of *P. M.* both Russell and Whitehead reassembled the techniques which they had employed in mathematics and applied them to the *natural* sciences. The enormous success they had achieved in their treatment of descriptions, classes, numbers, relations (in extension), etc., as incomplete symbols inspired in them the hope that they might be able to deal similarly with the symbols of the other scientific disciplines. Both of them recognized in the techniques of *P. M.* a powerful instrument for the solution of many of the traditional problems

---

[150] *E. W.*, 224-225.

[151] *P. M.*, I, 23; *I. M. P.*, 184-193; P. L. A., VII, 359-363; and L. A., 364. In *P. M.*, Russell (and Whitehead) develop a uniform method for the resolution of propositions containing class-symbols; its distinctive feature is its reduction of propositions about classes to propositions about extensional predicative functions which are formally equivalent to certain first-order functions (*P. M.*, I, 72-78; also *I. M. P.*, Ch. 17).

of scientific philosophy: time, space, mind and matter.[152]

Whitehead was the first to turn the full force of *P. M.* upon the natural sciences. By 1914 he had persuaded Russell that the world of physics is to be regarded no longer as an inference, as in *P. of P.,* but as a construction out of empirical data.[153] From 1914 until 1928 Russell's philosophical contribution consisted, to a great extent, in the formulation and exemplification of "the method of constructionism," as applied to the fundamental natural sciences, physics and psychology.

The basic problem which led Russell to treat the symbols of the natural sciences as incomplete was the status of the entities which the symbols of science apparently designate. Physics, e.g., talks about points in space, instants of time and particles of matter. Furthermore, it asserts that it is an empirical science, i.e., based upon observation; hence its points, instants, and electrons ought to be observable. But, of course, they are not: what we observe—empiricists agree—are immediate data of sense, with certain spatio-temporal relations. If physics desires to become an empirical science, Russell advised, it must be reconciled to these sense-data. One way, the most radical, but not the only way in which this can be done is to define the objects of physics as functions of the immediate data of sense, a procedure in direct contrast to the usual one in physics:

In physics as commonly set forth, sense-data appear as functions of physical objects: when such-and-such waves impinge upon the eye, we see such-and-such colours, and so on. But the waves are in fact inferred from the colours, not vice versa. Physics cannot be regarded as validly based upon empirical data until the waves have been expressed as functions of the colours, and other sense-data.[154]

So to interpret the entities of physics means, of course, that they are no longer the denotata of proper names, as they had been in *P. of M.,* nor the denotata of descriptions, as they were in *P. of P.* They became pseudo-entities or, more correctly, *unnecessary* entities, i.e., things without which we can get along

[152] L. A., 361.
[153] E. W., viii and R. S. D. P., 157.
[154] R. S. D. P., 146.

excellently in scientific discourse, and even in the language of daily life.

The symbols for these unnecessary entities, because they are not proper names and, consequently, have no meaning in themselves, become incomplete symbols, to be dealt with along lines similar to the treatment of other incomplete symbols. That is, the propositions in which these unnecessary entities are supposedly designated are interpreted in such a manner that the symbols for these unnecessary entities are resolved into other symbolic contexts whose denotata are empirical.[155]

The earliest formulation by Russell of the method of constructionism as applied to the natural sciences was in 1914, in *E. W.* and in *R. S. D. P.* especially. In *P. L. A.* (1918-19), *L. A.* (1924), and *A. of Matter* (1927), he supplemented his earlier statement. However, in none of these writings does he present a comprehensive picture of constructionism. This being the case, it becomes our task here to attempt a brief synthesis of what Russell means by constructionism.

The easiest way to understand constructionism, I think, is in its historical setting, as a philosophy of science. Since the seventeenth century there have been many philosophies of science, among them the following: (1) the view that the function of philosophy is to accept completely the results of science and to generalize these results so that they embrace all aspects of reality, including human experience. The philosophy of evolutionism as championed by Spencer is perhaps the classic example of this kind of view. (2) Then there is the theory of

---

[155] As Russell says: "I do not mean that statements apparently about points or instants . . . or any of the other entities which Occam's razor abolishes, are false, but only that their linguistic form is misleading, and that, when they are rightly analyzed, the pseudo-entities in question are found to be not mentioned in them. 'Time consists of instants', for example, may or may not be a true statement, but in either case it mentions neither time nor instants. It may, roughly, be interpreted as follows: Given any event x, let us define as its 'contemporaries' those which end after it begins, but begin before it ends; and among these let us define as 'initial contemporaries' of x those which are not wholly later than any other contemporaries of x. Then the statement 'time consists of instants' is true if, given any event x, every event which is wholly later than some contemporary of x is wholly later than some initial contemporary of x" (*P. of M.*, new "Introduction," xi).

Hume, that the function of philosophy, in relation to science, is to challenge the assumptions of science, specifically: induction, causality and substance. (3) Philosophers like Berkeley, I think, regard the function of philosophy, so far as science is concerned, to be one of sharp reconstruction. Specifically, philosophy, they assert, must attempt an interpretation of the concepts and entities of science so that these harmonize with the more gross facts of human experience. (4) Finally, there is the view of philosophers like Kant, who maintain that the function of a scientific philosophy is the justification of science, either as a method or as a body of knowledge.

Now, when we come to Russell's conception of the rôle of philosophy in relation to science, we find that he has much in common with Berkeley, Hume, and especially Kant, whom he has disparaged so vehemently! Like Hume he thinks that philosophy should challenge the assumptions of science and he agrees with Berkeley that philosophy should reconcile science and experience. But, above all, I think, he considers the grand rôle of philosophy to be the justification of science. Unlike Hume he does not seek to challenge science in order to transform our knowledge into scepticism; nor does he wish, like Berkeley, to reconstruct science in terms of experience in order to establish some sort of pan-psychism. *His challenge to and his reconstruction of science is motivated by his desire to justify science.* From his debut into philosophy, when he wished ". . . to find some reason to believe in the truth of mathematics . . . ,"[156] until the present day, Russell's primary interest, it seems to me, has been the attempt to justify science.

Taken broadly and loosely, science consists of two related parts, a methodology and a body of propositions. Its methodology contains a set of operative techniques, e.g., measurement; and a set of principles or assumptions, e.g., induction and causality. Induction, of course, is the most important principle of science, and any complete justification of science must offer some validation of the principle of induction. Unfortunately, at this very point Russell has no solution, which, in itself, is a very

[156] L. A., 359.

serious gap in his attempt to justify science.[157]

Russell's great contribution has been his justification of science, considered as a body of knowledge, and not as a set of techniques or principles. It is this which distinguishes him from Kant, since the latter's energy was primarily directed toward the justification of the methodology of science, especially induction.

Before we consider the meaning of the justification of the natural sciences, let us make our general remarks more specific. The method of constructionism, Russell proclaims, has for its historical antecedent the maxim of William of Occam: "Entities are not to be multiplied beyond necessity." Russell regards this maxim as the fundamental one of a scientific philosophy.[158] He states it in a somewhat different form: "Wherever possible, substitute constructions out of known entities for inferences to unknown entities."[159] In practice, the maxim comes in in the following way:

Take some science, say physics. You have there a given body of doctrine, a set of propositions expressed in symbols . . . and you think that you have reason to believe that on the whole those propositions, rightly interpreted, are fairly true, but you do not know what is the actual meaning of the symbols that you are using. The meaning they have *in use* would have to be explained in some pragmatic way: they have a certain kind of practical or emotional significance to you which is a datum, but the logical significance is not a datum, but a thing to be sought, and you go through . . . these propositions with a view to finding out what is . . . the smallest apparatus, not necessarily wholly empirical . . . out of which you can build up these propositions.[160]

Constructionism, then, as this quotation discloses, is dependent for its use upon the existence of a body of propositions which it interprets in such a way as to preserve the truth-value of the propositions while minimizing the amount of inference to

[157] Russell's early view, that the principle of induction is *a priori*, he abandoned in 1914 (*E. W.*, 37). From 1914-27 he devoted little attention to induction, and in *A. of Matter* (1927) he states quite baldly his inability to provide a solution of the problem (398-399).

[158] R. S. D. P., 155.

[159] L. A., 363.

[160] P. L. A., VIII, 366-367.

unempirical entities. That is, constructionism, in interpreting a science, leaves alone its details; it is only the fundamental ideas which are changed. Russell calls this process the preservation of the structure of science.[161]

When a scientific philosophy functions as the justification of science, considered as an extant body of propositions, it is identical with constructionism. This is, I think, the most comprehensive definition of constructionism. As we have seen, there are to be found in any of the natural sciences certain symbols for entities which we never experience. The function of constructionism, in regard to these entities, is neither to affirm nor to deny their existence, but to replace the symbols for these entities by other symbols. That is, to substitute symbols whose denotata are either given directly in sense-experience or are similar to and continuous with what is given in sense-experience for symbols whose denotata are not given in sense-experience but are postulated as inferred entities completely unlike those given in sense-experience. This substitution of empirical for unempirical symbols means, of course, that scientific symbols are defined in sensory terms, which validates the claim of (natural) science that it is empirical. It is in this sense, I think, that constructionism is the justification of science.

This process, whereby empirical symbols replace unempirical symbols, has, it seems to me, two distinct parts: (1) to determine what are the ultimate wholly or partially empirical entities,[162] and (2) to define, by means of logic, the symbols of science in terms of the wholly or partially empirical entities.[163]

The determination of the ultimate wholly empirical entities was accomplished by Russell in *P. of P.*, before he became a constructionist. In that work, as we have seen, he employs two

---

[161] L. A., 367.

[162] By an ultimate *wholly empirical* entity, I mean one which is given directly in sense-experience, e.g., a sense-datum; by an ultimate *partially empirical* entity, one which is inferred as similar to and continuous with what is given directly in sense-experience, e.g., a sensible. Both of these are to be contrasted with a *wholly unempirical* entity, i.e., one which is inferred or postulated as completely unlike that which is given directly in sense-experience, e.g., an electron.

[163] To divide constructionism in such a manner is, I think, in keeping with Russell and Occam: "In dealing with any subject-matter, find out what entities are undeniably involved, and state everything in terms of these entities," *E. W.*, 113.

principles in order to establish the ultimate entities of reality:
the Cartesian method of doubt and the method of hypothesis.
The first gives him the ultimate empirical and conceptual
entities, the second the ultimate inferred entities. Examples of
the first are sense-data and universals; of the second, other
minds and physical objects. The ultimate wholly empirical
entities, according to the method of doubt, are sense-data: these
are the most undeniable entities of sense-experience.[164]

In R. S. D. P., Russell accepts completely this doctrine that
the ultimate wholly empirical entities are sense-data. Besides
these, Russell regards "unsensed sensibilia" as entities which
physical constructions may denote: these are inferred as similar
to and continuous with sense-data, except that no one is aware of
them.

Many students of Russell think that constructionism does
not employ as ultimate denotata of scientific symbols any *in-
ferred* entities. But this is not true, as the admission of unsensed
sensibilia as legitimate constituents of constructions in R. S. D. P.
proves. What is true is that Russell rejects inferred entities
which are wholly unempirical, like Kant's *Ding-an-sich*. It is
only in *E. W.* that Russell construes constructionism as the
method which dispenses with *all* inferred entities as valid con-
stituents of constructions. But in Russell's other constructionist
works, at least as regards physical constructions, both wholly and
partially empirical entities are employed.

In *E. W.* Russell contends that the only acceptable entities
of constructions are the wholly empirical ones, sense-data. How-
ever, before we discuss his reasons for rejecting unsensed sensi-
bilia as valid constituents of constructions, let us return our
attention to the method which discloses the ultimate wholly
empirical character of sense-data, the Cartesian method of
doubt, since this method is an integral part of the search for
the ultimate empirical entities. The method of doubt was first
practiced by Russell in *P. of P.*, not upon the propositions of
science, but upon ordinary common-sensical propositions. The
work itself opens with the question: "Is there any knowledge
in the world which is so certain that no reasonable man could

[164] *P. of P.*, 30, 81, 171, 178-179.

doubt it?"[165] This quest for certainty is, I think, the distinctive inquiry of constructionism because it is the results of this quest which comprise the empirical and logical premisses of constructionism. As Russell expresses it in a later article:

> The things we have got to take as premisses in any kind of work of analysis are the things which appear to *us* undeniable—to us here and now, as we are—and I think on the whole that the sort of method adopted by Descartes is right: that you should set to work to doubt things and retain only what you cannot doubt because of its clearness and distinctness. . . ."[166]

This, then, is the initial task of constructionism: to take a body of propositions and to practice doubt upon them in order to establish some sort of "hierarchy of dubitables," i.e., some sort of system in which the least dubious propositions constitute the premisses of the entire system of propositions.[167]

In *P. of P.* a specific hierarchy is presented: the propositions of which we are most certain, when we begin systematically to doubt, are those about sense-data and logic. Lower are propositions about immediate memory, awareness, distant memory and ethical value. Lowest in the hierarchy are propositions about inferred objects, like tables, chairs and other minds.[168]

In *E. W.* a similar hierarchy is offered: Russell characterizes as "hard data," i.e., those propositions which appear as luminously certain, our knowledge of sense-data, logic, recent memory, introspection, relations of time and space and, finally, universals; these data are contrasted with "soft data," i.e., those propositions about whose truth we are no longer certain when we practice doubt upon them, which include our knowledge of physical objects and other minds.[169]

---

[165] *Ibid.*, 9.

[166] P. L. A., I, 500.

[167] This erection of a hierarchy of dubitables is what Russell takes to be the supreme task of epistemology too. See *P. of P.*, 39-41; N. of A., IV; and *Inquiry*, 15-19. Thus, in our interpretation of Russell, epistemology plays a subsidiary rather than a preëminent rôle in his *total* philosophy.

[168] *P. of P.*, 176-178; 182-183; 217.

[169] *E. W.*, 72-77. It is a rather interesting footnote on Russell's unity, I think, that the Cartesian method of doubt and the hierarchy of dubitables, worked out in *P. of P.*, a pre-constructionist book, have been retained by him throughout his

The importance for constructionism of the method of doubt, then, is twofold: (1) it establishes the wholly and partially empirical entities; and (2) it provides a logical instrument for constructionism which is as self-evident as the empirical entities. The significance of (1) and (2), taken together, is that they furnish the ultimate, self-evident, empirical and logical elements of constructionism.

Let us now return to the basic empirical entities of constructionism in *E. W.* Like R. S. D. P., the main concern of this work is with the symbols of physics, not with those of psychology. It is Russell's most extreme exhibition of constructionism, because of his doctrine that the only valid constituents of constructions are the wholly empirical ones, sense-data. The inferred and partially empirical entities, "unsensed sensibilia," are rejected and defined as functions of "sensed sensibilia," i.e., sense-data. In fact, all the symbols of physics, in an attempt to render them completely empirical, are interpreted in terms of sense-data:

I think it may be laid down quite generally that, *in so far* as physics . . . is verifiable, it must be capable of interpretation in terms of actual sense-data alone. The reason for this is simple. Verification consists always in the occurrence of an expected sense-datum. . . . Now if an expected sense-datum constitutes a verification, what was asserted must have been about sense-data; or, at any rate, if part of what was asserted was not about sense-data, then only the other part has been verified.[170]

As far as physics is concerned, then, *E. W.* satisfies the requirements of the constructionist ideal: all inferences to unknown entities are replaced by constructions out of known entities, i.e., sense-data.

However, in U. C. M. Russell returns to the view of R. S. D. P., that the ultimate denotata of the symbols of physics are either wholly or partially empirical.[171] He retains this view

---

writings, from *E. W.* to *Inquiry.* The only changes that have occurred are in the specific data of the hierarchy. *E.g.,* in *A. of Matter* (180-181) the facts of awareness are omitted, the reason being, of course, that Russell abandoned the belief in consciousness as an entity. See also *A. of Mind,* 262-266 and 297-299; and *Inquiry,* Chs. X-XI.

[170] *E. W.,* 86; see also 117-118.
[171] U. C. M., 130, 137, 143.

in *A. of Mind*[172] and *A. of Matter*,[173] which is the last of his major writings devoted to physics. In the latter work, the basic wholly empirical entities are perceptual events and the basic partially empirical entities are unperceived events. These are inferred as (1) continuous with perceptual events, by means of the causal theory of perception and (2) similar to perceptual events, with the aid of the general theory of neutral monism. Every concept of physics—"points," "space," "time," "electrons," etc.—Russell proclaims, can be interpreted as a function of these perceptual and unperceived events.[174]

In *A. of Mind* Russell discusses fully the basic empirical entities of the constructions of *psychology:* these are the wholly empirical entities, sensations and images. Every concept of psychology, Russell claims, can be built up in terms of these.[175]

This brings us to the second part of constructionism, the defining of the symbols of physics and psychology in terms of the wholly and partially empirical entities which we have discovered. If we examine the writings of Russell in which he has practiced constructionism in the natural sciences, we shall find that there are about twenty constructions.[176] Space limitations permit me to discuss only one of these and I shall choose Russell's construction of "points" in *E. W.*, because it seems to me best to represent the sort of thing Russell does when he defines scientific symbols in terms of empirical entities.

The definition of the "points" of mathematical physics in sensory terms is not especially difficult. The problem is to find ". . . some complex assemblage of immediately given objects, which will have the geometrical properties required of points."[177] The empirical objects which have these requisite properties are sense-data. Consider a sense-datum. What are its

[172] *A. of Mind*, 97-107, 121, 143, 306-307.
[173] *A. of Matter*, 139-140, 214-217, 270-271, 399.
[174] *Ibid.*, 275-278.
[175] *A. of Mind*, 69, 109, 121, 143.
[176] These are, in physics, "space," "time," "thing," or "matter," "points," "instants," "qualitative series," "space-time," "interval," and "quanta;" see R. S. D. P., *E. W.*, Chs. III, IV, and *A. of Matter*; and, in psychology, "instinct," "habit," "desire," "feeling," "perception," "memory," "conception," "thought," "belief," "emotions," "will," and "consciousness;" see *A. of Mind* and *Phil.*
[177] *E. W.*, 121.

obvious properties? We know that it is always of some *finite* extent; that is, any visual datum, e.g., has a surface which is never ostensibly infinitesimal. Furthermore, a sense-datum, which is *prima facie* one undivided whole, may, upon strict attention, be broken up into its constituent parts. Whenever this phenomenon occurs, we have one part contained within a different part and entirely enclosed by it. This relation of "enclosure," which is given in sense-experience, is the first property of sense-data which will enable us to define "points" in terms of them.

The second requisite property has to do with certain hypotheses which are attributed to the relation of enclosure. What we desire, in order to define "points" in terms of sense-data and enclosure, is that a set of visual data, considered as volumes or surfaces, should get smaller and smaller so that ". . . of any two of the set there is always one that encloses the other."[178] This desideratum is satisfied with the aid of six hypotheses, which are as follows:

The hypotheses required for the relation of enclosure are that (1) it must be transitive; (2) of any two *different* spatial objects, it is impossible for each to enclose the other, but a single object always encloses itself; (3) any set of spatial objects such that there is at least one spatial object enclosed by them all has a lower limit or minimum, i.e., an object enclosed by all of them and enclosing all objects which are enclosed by all of them; (4) to prevent trivial exceptions, we must add that there are to be instances of enclosure, i.e., there are really to be objects of which one encloses the other. When an enclosure-relation has these properties we will call it a "point-producer."[179]

The fifth hypothesis is necessary to guarantee that space is infinite: (5) "Any object which encloses itself also encloses an object other than itself."[180] Finally, the sixth hypothesis is concerned with an enclosure-series—i.e., a set of objects in which, of any two of them, one is contained in the other—converging to a point: (6) "Let our enclosure-series be such that, given any other enclosure-series of which there are members enclosed in any arbitrarily chosen member of our first series, then there are

[178] *Ibid.*, 122.
[179] *Ibid.*
[180] *Ibid.*, 123.

members of our first series enclosed in any arbitrarily chosen member of our second series."[181] When this sixth hypothesis is realized, the first enclosure-series is called a "punctual enclosure-series."

We may now define a "point," as it is conceived by mathematical physics. It is a logical construction which has as its constituents ". . . all the objects which enclose members of a given punctual enclosure-series."[182] This definition, Russell concludes, is sufficient to express all that physics requires in regard to its use of "points;" and it validates the claim of physics that it is an empirical science.

### SECTION V. WHAT DOES RUSSELL MEAN BY ANALYSIS?

It is a curious fact that Russell, one of the greatest modern exponents of the method of analysis, has never discussed in any detail what he means by it. Like a prodigious mathematician, who is too preoccupied doing mathematics to seek into its foundations, Russell has devoted most of his philosophical writings to the exemplification, rather than to the explication, of analysis. As we have seen, he has practiced the analytical method especially in four disciplines: (1) ontology, (2) abstract cosmology, (3) mathematical logic, and (4) semantics, or the examination of ordinary and scientific discourse. In our previous sections we have dealt with these uses of analysis in Russell, attempting, as much as possible, to discuss them in an historical manner, so that the reader might be able to appreciate more fully the significance of each use of analysis and the total unity of his philosophy. In none of these sections, however, did we venture an interpretation of what Russell means by analysis. I shall now attempt to remedy this deficiency.

The view regarding Russell's theory of analysis which I wish to present in this final section is this: that Russell means by analysis a form of definition, either real definition of a non-Aristotelian sort, or contextual definition, i.e., definition of symbols in use. I shall not attempt to show that Russell does not mean something *more* by analysis nor shall I try to prove

[181] *Ibid.*
[182] *Ibid.*

*conclusively* that he means by analysis either of these kinds of definition. I wish merely to present an hypothesis concerning his theory of analysis which, it seems to me at least, can explain all of his uses of analysis.

Let us begin with Russell's theory of analysis as real definition. Now, real definition, as conceived by the Aristotelian tradition, has suffered much abuse, perhaps deservedly, because its conception of real definition—that it is concerned with ascertaining the essences of species—is certainly not a credible one, especially since Darwin's refutation of the notion of fixed species. However, there is another sense of definition which, because it obviously cannot be interpreted as nominal, can be characterized as real definition: namely, the sense in which the *properties of a given complex are enumerated;* where I mean by "properties" (1) the elements of a complex, (2) their characteristics, and (3) the relations among them; and by a "complex," a group of facts, which exists independently of the way in which we use language.

Does Russell accept this conception of analysis? I think that he does. It is, however, no easy matter to prove this; the reason being that whenever Russell discusses the nature of definition he seems to reject real definition by explicitly affirming a nominalistic view. Nevertheless, if we examine closely his writings on definition, even these affirmations of nominalism, we shall see that always Russell is *also* defending real definitions. Consider, e.g., his classic statement of nominalism in *P. M.:*

A definition is a declaration that a certain newly-introduced symbol or combination of symbols is to mean the same as a certain other combination of symbols of which the meaning is already known. . . .

It is to be observed that a definition is, strictly speaking, no part of the subject in which it occurs. For a definition is concerned wholly with the symbols, not with what they symbolise. Moreover it is not true or false, being the expression of a volition, not of a proposition. Theoretically, it is unnecessary ever to give a definition. . . . [Definitions] are, strictly speaking, mere typographical conveniences. Practically, of course, if we introduce no definitions, our formulae would very soon become so lengthy as to be unmanageable; but theoretically, all definitions are superfluous.

In spite of the fact that definitions are theoretically superfluous, it is

nevertheless true that they often convey more important information than is contained in the propositions in which they are used . . . [One reason for this is that] when what is defined is (as often occurs) something already familiar, such as cardinal or ordinal numbers, the definition contains an analysis of a common idea, and may therefore express a notable advance. Cantor's definition of the continuum illustrates this: his definition amounts to the statement that what he is defining is the object which has the properties commonly associated with the word "continuum," though what precisely constitutes these properties had not before been known. In such cases, a definition is a "making definite:" it gives definiteness to an idea which had previously been more or less vague.[183]

This quotation expresses exactly Russell's ambivalent theory. In the first half he affirms the nominalistic theory: a definition is a stipulation as to how one intends to use a word or symbol; it is neither true nor false; it is convenient; and it has to do merely with symbols, not with what is symbolized. All of these are among the well-worn characteristics of a nominalistic theory.

The second part of the quotation, however, tells a different story. In effect, it asserts that there are *some* definitions, e.g., of cardinal numbers or the continuum, which, even though they may be formally expressed on the printed page as statements about our intentions to use symbols in certain ways, contain implicitly analyses of given complexes. These analyses consist in the enumeration of the properties of the complex and purport to be true (or false). As Russell says: Cantor's definition of the continuum ". . . amounts to the statement that *what he is defining is the object which has the properties commonly associated with the word 'continuum'* " (my italics).

If our reading of this quotation is correct, then Russell's theory of analysis amounts to this: that in the analysis of many given complexes, what we do is (1) to enumerate the properties of our given complex and (2), if we so desire, to express these properties in a formal definition which, when it appears on the printed page, resembles a nominal definition, but which actually functions as a convenient, abbreviated expression of a real definition.[184]

[183] *P. M.*, I, 11-12.
[184] Russell's statement in *P. of M.* (63) bears out this view, that many apparent nominal definitions are actually abbreviations of real definitions or analyses: "It is

Let us now examine certain examples of analyses, taken from Russell's writings, which further validate our hypothesis concerning his theory of real definition. Consider, to begin with, his definition of pure mathematics in *P. of M.*:

> Pure mathematics is the class of all propositions of the form "p implies q," where p and q are propositions containing one or more variables, the same in the two propositions, and neither p nor q contains any constants except logical constants.[185]

Let us ask ourselves: Is this merely a nominal definition; i.e., does this definition merely express the way that Russell intends to use the words "pure mathematics?" Consider his answer to this question:

> The definition professes to be, not an arbitrary decision to use a common word in an uncommon signification, but rather a precise analysis of the ideas which, more or less unconsciously, are implied in the ordinary employment of the term.[186]

Next, let us look at the *P. M.* definition of number as a class of classes similar to a given class. Is this merely a statement as to the way in which Russell intends to use the word "number?" Or does it also embody an analysis of number, i.e., an enumeration of the constituent properties of the complex which we call "number?" Part of the answer to this question, I think, is to be sought in Russell's critique of Peano's system of arithmetic and the formalist theory of mathematics in general. What, then, is Russell's objection to Peano's conception of number? Briefly, it is this: Peano makes "number," along with "zero" and "successor," an undefined concept of arithmetic. This conception, Russell points out, allows us to interpret number in an infinite

---

a curious paradox, puzzling to the symbolic mind, that definitions, theoretically, are nothing but statements of symbolic abbreviations, irrelevant to the reasoning and inserted only for practical convenience, while yet, in the development of a subject, they always require a very large amount of thought, and often embody some of the greatest achievements of analysis." See also *E. W.* (222) for the same view.

The doctrine that analysis is the enumeration of the constituent properties of a given complex, and that such an enumeration constitutes a real definition of that complex, may be found also in *P. of M.* (141 and 466), *E. W.* (222) and *Inquiry* (160 and Ch. XXIV).

[185] *P. of M.*, 1.
[186] *Ibid.*

variety of ways, without invalidating the five postulates of Peano's system. The fact that number is amenable to such a variety of interpretations, Russell argues, reveals the inadequacy of Peano's conception. Any adequate conception of number, Russell proclaims, must correspond to our unanalyzed notion of it, especially as it is used in the experience of counting:

We want to have ten fingers and two eyes and one nose. A system in which "1" meant 100 and "2" meant 101, and so on, might be all right for pure mathematics, but would not suit daily life. We want "0" and "number" and "successor" to have meanings which will give us the right allowance of fingers and eyes and noses. We have already some knowledge . . . of what we mean by "1" and "2" and so on, and our use of numbers in arithmetic must conform to this knowledge.[187]

Our conception of number, then, whether we leave it undefined or define it, must correspond to our knowledge and experience of it. If we choose to define it, our definition cannot be merely a stipulation regarding the way we intend to use the symbol "number," but it must also contain implicitly an enumeration of the constituent properties which, in ordinary daily life, we call "number." The *P. M.* definition professes to be just that. However, when we examine the definition for the first time, it seems to be too paradoxical to be a real definition of number; and some logicians have argued that, because it is so paradoxical, it is a *false* definition. This criticism is meaningful, although not necessarily true, only if what we have asserted about the characteristics of real definitions is accepted; it is not a meaningful criticism if Russell's definition is taken to be nominal, since nominal definitions are, among other things, never true or false.

Russell's definition, however, provides for this sort of criticism. It admits the apparent paradox of the definition, but insists that the paradox arises from the fact that the definition is *empirical;* i.e., that it is an enumeration of the empirical properties of the complex we call "number."[188] The objection to Russell's definition usually springs from the belief in the doctrine that number is either a Platonic universal or an inferred

[187] *I. M. P.,* 9.
[188] *Ibid.,* 18, and *E. W.,* 222-223.

entity which is postulated as existing in the flux rather than in the realm of essence. Russell regards this objection as harmless because it is founded not upon the actual, given, experienced properties of number, but upon the inferred, unempirical properties which it is supposed to have. Consequently, Russell's definition not only claims to be an enumeration of the properties of number, but also a *true* definition, in the sense that it has exhausted all of its empirical properties. To sum up, then: Russell's definition of number as a class of classes similar to a given class is an abbreviated, formal expression of an analysis or real definition of the complex which we call "number."

The example which illustrates best Russell's use of analysis as real definition is his analysis of memory, in *A. of Mind* (Ch. IX). If we examine closely that discussion, we note certain statements, like the following:

[1] "In the present lecture I shall attempt the *analysis* of memory-knowledge . . . ;" [2] "I am only anxious to point out that, whatever the *true analysis* of knowledge may be, knowledge of past occurrences is not proved by behaviour which is due to past experience;" [3] "Perhaps a more *complete analysis* could explain the memory-belief also on lines of association . . . ;" [4] "This analysis of memory is probably extremely *faulty*, but I do not know how to improve it."[189]

Now, what is the meaning of such statements regarding memory-knowledge, which use words like "analysis," "faulty analysis," "true analysis" and "complete analysis?" This is an extremely important question, because the total meaning of Russell's analysis of mental and physical phenomena revolves about its answer, since Russell's treatment of "memory" may be regarded as a model of his treatment of "points," "matter," "habit," "perception," etc. Indeed, it was the consideration of this question which first led me to the hypothesis that Russell means by analysis, at least in some cases, real definition. It is only in terms of analysis as real definition that I can give any meaning to faulty, true, and complete analyses. Any other interpretation, e.g., that Russell's analysis consists merely in the stipulation as to how he shall use the word "memory" or as to how he shall interpret sentences containing the word "memory,"

[189] *A. of Mind*, 157, 167, 178, 187 respectively (my italics).

does not do even partial justice to the above phrases. If analyses are only stipulations about the use of symbols or symbolic contexts, then how can they be faulty or true or complete? No, the only way to interpret these phrases is in terms of real definition. Thus, what Russell means when he talks about the analysis of memory, etc., is primarily the enumeration of the properties of a given complex which we call "memory," but which does not depend for its existence upon the fact that it is called "memory."[190]

Enough has been said, I think, to show that Russell does accept the conception of analysis as real definition.[191] Our next problem is to determine whether or not Russell means something more by analysis. There is, I think, another meaning of analysis in Russell's philosophy which also has to do with definition, specifically, nominal definition. There are two sorts of nominal definitions, the ordinary or dictionary kind and the contextual kind, i.e., the definition of symbols in use. Both of these have in common, first, the fact that they involve the sub-

---

[190] These properties are: (1) certain *elements*, namely, sensations and images; (2) their *characteristics*, namely, the feelings of pastness, context, familiarity and respect; and (3) the *relations* among them, namely, the relation between (a) the feelings and the memory-image, (b) the belief and the content, and (c) the memory-image and the feeling of respect. See *A. of Mind.*, Ch. IX.

[191] Although I do not have the space to prove it, it seems to me that this conception is basic to at least three of the four species of analysis in Russell: ontology, abstract cosmology, and mathematical logic. That is, as an ontologist, Russell practices analysis as real definition. Both as a dualist and neutral monist, Russell's analysis consists in an enumeration of the ultimate entities of reality, with their characteristics and relations. As an abstract cosmologist, Russell is also meaning by analysis real definition: he is endeavoring to enumerate the basic forms of reality, as revealed by language and fact. Analysis as logistic is real definition, too, for it consists in the definition of the basic notions of mathematics in logical terms; specifically, it is the enumeration of the fundamental properties of "number," etc.

Furthermore, I think, Russell practices analysis as real definition in his search for the ultimate wholly and partially empirical entities, which is the first part of constructionism. The analysis of "points," e.g., consists primarily, as we have seen, in the enumeration of the empirical properties of the complexes which we call "points," but which do not depend for their existence upon the fact that they are so called. These properties are sense-data, their characteristics (e.g., they are of finite extent) and their relations (e.g., enclosure).

For a more complete discussion of the relation between real definition and the uses of analysis in Russell, see my dissertation, *op. cit.*, (*cf.* footnote 124 above) 256-276.

stitution of one symbol for another, or one set of symbols for another set; i.e., they are strictly concerned with language. Secondly, they are not propositions in the sense of truth-claims but are, rather, stipulations regarding our verbal desires. Thirdly, they are much shorter in length than the phrases that they are defined as meaning.

Nominal definitions, according to their exponents, are supposed to possess a fourth characteristic, arbitrariness. But, as we shall see, it is only the ordinary nominal definitions which have this characteristic. However, even here, I think, we must be careful. Arbitrariness is an ambiguous word and, so far as nominal definitions are concerned, at least two meanings must be distinguished: arbitrariness as capriciousness and arbitrariness as the possibility of making a choice in the presence of alternatives. Now, although all ordinary nominal definitions are arbitrary in the sense that they are choices among alternative expressions, there are few such definitions which are arbitrary in the capricious sense, since every significant ordinary nominal definition is an attempt to *answer* certain needs.

There are many examples of ordinary nominal definitions in Russell. His definitions of words like "truth-value," "atomic proposition," "emergent," "perspective," "phenomenalism," etc., are all convenient abbreviations of longer phrases and, although they are choices among alternative expressions, they are not capricious, for they are formulated to meet certain expository or stylistic requirements. As important as these definitions are in Russell's writings, they are not analyses, nor are they intended to be. When they function, as they may, as formal, resultant abbreviations of real definitions, they do serve as statements which embody analyses and, as such, they are true or false. But otherwise they are merely symbolic conveniences having the usual characteristics of nominal definitions.

Now, in the second sense in which Russell, as it seems to me, means analysis, it is not ordinary nominal definition, but contextual definition. The best example of analysis as contextual definition in Russell, and probably in the whole of philosophical literature, is his analysis of definite descriptions, which we considered in the previous section.

This analysis of definite descriptions amounts to a *definition* of the sentences in which definite descriptions occur. Consider e.g., the analysis of "the author of *Waverley*." It proceeds by defining certain sentences in which "the author of *Waverley*" appears; e.g., "Scott was the author of *Waverley*." The analysis of this sentence, then, consists in giving a definition of it, which is: " 'x wrote *Waverley*' is not always false, i.e., at least one person wrote *Waverley*; and if x and y wrote *Waverley*, then x and y are identical, i.e., at most one person wrote *Waverley*; and 'if x wrote *Waverley*, then x is Scott' is always true."

This analysis is a contextual nominal definition because (1) it is concerned with a purely linguistic complex and involves the substitution of one set of symbols for another set; (2) it consists of a declaration regarding our verbal intentions. It is saying that the symbolic complex "Scott was the author of *Waverley*" is to be defined as the symbolic complex " 'x wrote *Waverley*' is not always false, etc.;" hence the definition is neither true nor false; (3) it is typographically convenient; (4) it is a definition in use, i.e., of symbols in certain used contexts, namely, sentences; and (5) it is *not* arbitrary, for two reasons: (a) Russell contends that the definition of sentences containing definite descriptions is an *accurate* analysis of the logical structure of certain sentences; i.e., it reveals the constituent parts of the expression "Scott was the author of *Waverley*," namely, (1) at least one person wrote *Waverley*, (2) at most one person wrote *Waverley* and (3) that person was Scott. The value or purpose of this analysis, and of contextual nominal definition in general, where the logical complexity of an expression is resolved into its constituents, is that it offers a revelation of the logical structure of language. It is this characteristic, that both are concerned with the analysis of complexes, one with non-linguistic, the other with linguistic complexes, which brings real and contextual definition close together and contrasts them with ordinary definition. (b) The second reason why the analysis of sentences containing definite descriptions is not arbitrary is because it is designed to meet certain difficulties, which *no other* extant analysis or definition can meet, namely, it enables us to talk meaningfully and truly about non-existent and self-contradictory pseudo-objects, without inventing all sorts of realities to do so. Thus, e.g., the

proposition "The present King of France is bald" is defined as, or analyzed into, the proposition "There is someone who is at present both king of France and bald and there is not at present two kings of France." The present King of France, whom Meinong assumed was an actual entity, having some sort of existence, because we could talk about him, is no longer mentioned in the defined symbolic complex but is replaced by a statement about a value of a variable which satisfies a propositional function. The definition also enables us to talk meaningfully and truly about things which we ordinarily regard as actual entities, like "the author of *Waverley*" or "the present King of England," etc., without assuming that they exist either. The reason why the treatment of descriptive phrases, whether they are like "the golden mountain," "the round square," or even "the author of *Waverley*," is uniform is because in each case we may wish to make statements in which these phrases appear without assuming that their non-linguistic correlates exist. If the author of *Waverley*, the round square or the golden mountain had to be actual entities in order for us to talk about them, then we could never deny their existence, as we often do, when, e.g., we say "the round square is unreal," without falling into contradiction by first assuming and then denying that these pseudo-objects exist.

This conception of analysis as contextual definition is, I think, what Russell mainly means by analysis when he practices it as the resolution of incomplete symbols. Descriptive symbols, specifically mathematical symbols and the symbols of the natural sciences, because they are incomplete, i.e., have no meanings in themselves, have to be assigned meanings in sentential contexts. It is this attribution of meaning which constitutes the analysis— in the form of a contextual definition—of the sentences in which these symbols appear.[192]

Real and contextual definitions may sometimes proceed to-

---

[192] Thus, the analysis of sentences in which symbols for classes occur consists in the contextual definition of the sentences. The sentence "there is not a class of three people interested in mathematical logic" becomes, by analysis or contextual definition: "If x is interested in mathematical logic, and also y is interested and also z, then x is identical with y, or x is identical with z, or y is identical with z." This analysis is a contextual definition because it possesses all the characteristics of such a definition.

gether. Consider, e.g., Russell's analysis of "time" or "instants." We may, in analyzing these concepts, first enumerate the empirical properties of the non-linguistic complex that we call "time" or "instants," which properties are *events*, with their characteristics and relations. This enumeration constitutes a real definition of this non-linguistic complex. Secondly, *upon the basis of this enumeration or real definition,* we may realize that these concepts are no longer simple symbols, i.e., proper names of simple particulars, but are rather incomplete symbols. In this case we may present an analysis of the sentences in which the symbols occur, where they will be resolved into whole new complexes of symbols having to do with events and not with time or instants. That is to say, the sentence "time consists of instants," upon the basis of an enumeration of the empirical properties of *what* we call "time" and "instants," is analyzed into the sentence: "Given any event x, every event which is wholly later than some contemporary of x is wholly later than some initial contemporary of x." This analysis of the sentence containing the words "time" and "instants," in which the words disappear, being replaced by phrases about events, constitutes a contextual definition of this linguistic complex. Thus, in this manner, we may offer a real definition of a non-linguistic complex and at the same time present a contextual definition of the sentences containing the symbols of that complex.

To sum up: It is our contention that Russell means by analysis two kinds of definition, real and contextual. The chief characteristics of these are: (1) real definition is concerned primarily with complexes which are non-linguistic, i.e., independent of the way in which we use language, whereas contextual definition is concerned wholly with linguistic complexes. Another way to express this difference is: that the contextual definition is concerned with symbols, real definition with *what* is symbolized. (2) Real definition is the enumeration of the properties of a given complex; contextual definition is the substitution of one set of symbols for another set. (3) Real definitions are true or false, i.e., they are truth-claims about the properties of given complexes; contextual definitions are neither true nor false, but are volitional stipulations regarding our verbal intentions.

This means that real definitions are expressed in empirical, synthetic propositions, whereas contextual definitions are *a priori* and analytic. (4) Neither real nor contextual definitions are ever arbitrary, since both are designed to cope with certain problems, and, as analyses, deny the adequacy of an alternative definition. (5) Real definitions may be expressed in statements which resemble ordinary nominal definitions, but when they are, the statements are actually formal abbreviations of analyses as real definitions; contextual definitions are always expressed in statements which resemble ordinary definitions, but these statements embody accurate analyses of linguistic complexes. (6) The value or purpose of real and contextual definitions is that they reduce the vaguenesses of certain complexes by calling attention to their various components.

MORRIS WEITZ

UNIVERSITY OF MICHIGAN

3

*Kurt Gödel*

# RUSSELL'S MATHEMATICAL LOGIC

## RUSSELL'S MATHEMATICAL LOGIC

MATHEMATICAL LOGIC, which is nothing else but a precise and complete formulation of formal logic, has two quite different aspects. On the one hand, it is a section of Mathematics treating of classes, relations, combinations of symbols, etc., instead of numbers, functions, geometric figures, etc. On the other hand, it is a science prior to all others, which contains the ideas and principles underlying all sciences. It was in this second sense that Mathematical Logic was first conceived by Leibniz in his *Characteristica universalis*, of which it would have formed a central part. But it was almost two centuries after his death before his idea of a logical calculus really sufficient for the kind of reasoning occurring in the exact sciences was put into effect (in some form at least, if not the one Leibniz had in mind) by Frege and Peano.[1] Frege was chiefly interested in the analysis of thought and used his calculus in the first place for deriving arithmetic from pure logic. Peano, on the other hand, was more interested in its applications within mathematics and created an elegant and flexible symbolism, which permits expressing even the most complicated mathematical theorems in a perfectly precise and often very concise manner by single formulas.

It was in this line of thought of Frege and Peano that Russell's work set in. Frege, in consequence of his painstaking analysis of the proofs, had not gotten beyond the most elementary properties of the series of integers, while Peano had accomplished a big collection of mathematical theorems expressed

[1] Frege has doubtless the priority, since his first publication about the subject, which already contains all the essentials, appeared ten years before Peano's.

in the new symbolism, but without proofs. It was only in *Principia Mathematica* that full use was made of the new method for actually deriving large parts of mathematics from a very few logical concepts and axioms. In addition, the young science was enriched by a new instrument, the abstract theory of relations. The calculus of relations had been developed before by Peirce and Schröder, but only with certain restrictions and in too close analogy with the algebra of numbers. In *Principia* not only Cantor's set theory but also ordinary arithmetic and the theory of measurement are treated from this abstract relational standpoint.

It is to be regretted that this first comprehensive and thorough going presentation of a mathematical logic and the derivation of Mathematics from it is so greatly lacking in formal precision in the foundations (contained in *1-*21 of *Principia*), that it presents in this respect a considerable step backwards as compared with Frege. What is missing, above all, is a precise statement of the syntax of the formalism. Syntactical considerations are omitted even in cases where they are necessary for the cogency of the proofs, in particular in connection with the "incomplete symbols." These are introduced not by explicit definitions, but by rules describing how sentences containing them are to be translated into sentences not containing them. In order to be sure, however, that (or for what expressions) this translation is possible and uniquely determined and that (or to what extent) the rules of inference apply also to the new kind of expressions, it is necessary to have a survey of all possible expressions, and this can be furnished only by syntactical considerations. The matter is especially doubtful for the rule of substitution and of replacing defined symbols by their *definiens*. If this latter rule is applied to expressions containing other defined symbols it requires that the order of elimination of these be indifferent. This however is by no means always the case ($\varphi!\hat{u} = \hat{u}[\varphi!u]$, e.g., is a counter-example). In *Principia* such eliminations are always carried out by substitutions in the theorems corresponding to the definitions, so that it is chiefly the rule of substitution which would have to be proved.

I do not want, however, to go into any more details about

either the formalism or the mathematical content of *Principia*,[2] but want to devote the subsequent portion of this essay to Russell's work concerning the analysis of the concepts and axioms underlying Mathematical Logic. In this field Russell has produced a great number of interesting ideas some of which are presented most clearly (or are contained only) in his earlier writings. I shall therefore frequently refer also to these earlier writings, although their content may partly disagree with Russell's present standpoint.

What strikes one as surprising in this field is Russell's pronouncedly realistic attitude, which manifests itself in many passages of his writings. "Logic is concerned with the real world just as truly as zoology, though with its more abstract and general features," he says, e.g., in his *Introduction to Mathematical Philosophy* (edition of 1920, p. 169). It is true, however, that this attitude has been gradually decreasing in the course of time[3] and also that it always was stronger in theory than in practice. When he started on a concrete problem, the objects to be analyzed (e.g., the classes or propositions) soon for the most part turned into "logical fictions." Though perhaps this need not necessarily mean [according to the sense in which Russell uses this term] that these things do not exist, but only that we have no direct perception of them.

The analogy between mathematics and a natural science is enlarged upon by Russell also in another respect (in one of his earlier writings). He compares the axioms of logic and mathematics with the laws of nature and logical evidence with sense perception, so that the axioms need not necessarily be evident in themselves, but rather their justification lies (exactly as in physics) in the fact that they make it possible for these "sense perceptions" to be deduced; which of course would not exclude that they also have a kind of intrinsic plausibility similar to that in physics. I think that (provided "evidence" is understood in a sufficiently strict sense) this view has been largely justified by subsequent developments, and it is to be expected that it will be still more so in the future. It has turned out that (under the

[2] Cf. in this respect W. V. Quine's article in the Whitehead volume of this series.
[3] The above quoted passage was left out in the later editions of the *Introduction*.

assumption that modern mathematics is consistent) the solution of certain arithmetical problems requires the use of assumptions essentially transcending arithmetic, i.e., the domain of the kind of elementary indisputable evidence that may be most fittingly compared with sense perception. Furthermore it seems likely that for deciding certain questions of abstract set theory and even for certain related questions of the theory of real numbers new axioms based on some hitherto unknown idea will be necessary. Perhaps also the apparently unsurmountable difficulties which some other mathematical problems have been presenting for many years are due to the fact that the necessary axioms have not yet been found. Of course, under these circumstances mathematics may lose a good deal of its "absolute certainty;" but, under the influence of the modern criticism of the foundations, this has already happened to a large extent. There is some resemblance between this conception of Russell and Hilbert's "supplementing the data of mathematical intuition" by such axioms as, e.g., the law of excluded middle which are not given by intuition according to Hilbert's view; the borderline however between data and assumptions would seem to lie in different places according to whether we follow Hilbert or Russell.

An interesting example of Russell's analysis of the fundamental logical concepts is his treatment of the definite article "the." The problem is: what do the so-called descriptive phrases (i.e., phrases as, e.g., "the author of *Waverley*" or "the king of England") denote or signify[4] and what is the meaning of sentences in which they occur? The apparently obvious answer that, e.g., "the author of *Waverley*" signifies Walter Scott, leads to unexpected difficulties. For, if we admit the further apparently obvious axiom, that the signification of a composite expression, containing constituents which have themselves a signification, depends only on the signification of these constituents (not on the manner in which this signification is expressed), then it follows that the sentence "Scott is the author of *Waverley*" signifies the same thing as "Scott is Scott;" and this again leads

---

[4] I use the term "signify" in the sequel because it corresponds to the German word "*bedeuten*" which Frege, who first treated the question under consideration, used in this connection.

almost inevitably to the conclusion that all true sentences have
the same signification (as well as all false ones).[5] Frege actually
drew this conclusion; and he meant it in an almost metaphysical
sense, reminding one somewhat of the Eleatic doctrine of the
"One." "The True"—according to Frege's view—is analyzed
by us in different ways in different propositions; "the True"
being the name he uses for the common signification of all true
propositions.[6]

Now according to Russell, what corresponds to sentences in
the outer world is facts. However, he avoids the term "signify"
or "denote" and uses "indicate" instead (in his earlier papers
he uses "express" or "being a symbol for"), because he holds
that the relation between a sentence and a fact is quite different
from that of a name to the thing named. Furthermore, he uses
"denote" (instead of "signify") for the relation between things
and names, so that "denote" and "indicate" together would
correspond to Frege's "*bedeuten.*" So, according to Russell's
terminology and view, true sentences "indicate" facts and,
correspondingly, false ones indicate nothing.[7] Hence Frege's
theory would in a sense apply to false sentences, since they all
indicate the same thing, namely nothing. But different true
sentences may indicate many different things. Therefore this
view concerning sentences makes it necessary either to drop the
above mentioned principle about the signification (i.e., in Rus-

---

[5] The only further assumptions one would need in order to obtain a rigorous
proof would be: 1) that "φ (a)" and the proposition "a is the object which has the
property φ and is identical with a" mean the same thing and 2) that every proposi-
tion "speaks about something," i.e., can be brought to the form φ (a). Furthermore
one would have to use the fact that for any two objects a. b. there exists a true
proposition of the form φ (a, b) as, e.g., a ≠ b or a = a. b = b.

[6] Cf. "Sinn und Bedeutung," *Zeitschrift für Philosophie und philosophische
Kritik*, Vol. 100 (1892), p. 35.

[7] From the indication (*Bedeutung*) of a sentence is to be distinguished what
Frege called its meaning (*Sinn*) which is the conceptual correlate of the objectively
existing fact (or "the True"). This one should expect to be in Russell's theory
a possible fact (or rather the possibility of a fact), which would exist also in the
case of a false proposition. But Russell, as he says, could never believe that such
"curious shadowy" things really exist. Thirdly, there is also the psychological cor-
relate of the fact which is called "signification" and understood to be the cor-
responding belief in Russell's latest book. "Sentence" in contradistinction to "prop-
osition" is used to denote the mere combination of symbols.

sell's terminology the corresponding one about the denotation
and indication) of composite expressions or to deny that a de-
scriptive phrase denotes the object described. Russell did the
latter[8] by taking the viewpoint that a descriptive phrase denotes
nothing at all but has meaning only in context; for example, the
sentence "the author of *Waverley* is Scotch," is defined to mean:
"There exists exactly one entity who wrote *Waverley* and who-
ever wrote *Waverley* is Scotch." This means that a sentence in-
volving the phrase "the author of *Waverley*" does not (strictly
speaking) assert anything about Scott (since it contains no con-
stituent denoting Scott), but is only a roundabout way of asserting
something about the concepts occurring in the descriptive phrase.
Russell adduces chiefly two arguments in favor of this view,
namely (1) that a descriptive phrase may be meaningfully em-
ployed even if the object described does not exist (e.g., in the
sentence: "The present king of France does not exist"). (2) That
one may very well understand a sentence containing a descriptive
phrase without being acquainted with the object described;
whereas it seems impossible to understand a sentence without
being acquainted with the objects about which something is being
asserted. The fact that Russell does not consider this whole
question of the interpretation of descriptions as a matter of mere
linguistic conventions, but rather as a question of right and
wrong, is another example of his realistic attitude, unless per-
haps he was aiming at a merely psychological investigation of
the actual processes of thought. As to the question in the logical
sense, I cannot help feeling that the problem raised by Frege's
puzzling conclusion has only been evaded by Russell's theory
of descriptions and that there is something behind it which is
not yet completely understood.

There seems to be one purely formal respect in which one
may give preference to Russell's theory of descriptions. By de-
fining the meaning of sentences involving descriptions in the
above manner, he avoids in his logical system any axioms
about the particle "the," i.e., the analyticity of the theorems
about "the" is made explicit; they can be shown to follow from

---

[8] He made no explicit statement about the former; but it seems it would hold
for the logical system of *Principia*, though perhaps more or less vacuously.

the explicit definition of the meaning of sentences involving "the." Frege, on the contrary, has to assume an axiom about "the," which of course is also analytic, but only in the implicit sense that it follows from the meaning of the undefined terms. Closer examination, however, shows that this advantage of Russell's theory over Frege's subsists only as long as one interprets definitions as mere typographical abbreviations, not as introducing names for objects described by the definitions, a feature which is common to Frege and Russell.

I pass now to the most important of Russell's investigations in the field of the analysis of the concepts of formal logic, namely those concerning the logical paradoxes and their solution. By analyzing the paradoxes to which Cantor's set theory had led, he freed them from all mathematical technicalities, thus bringing to light the amazing fact that our logical intuitions (i.e., intuitions concerning such notions as: truth, concept, being, class, etc.) are self-contradictory. He then investigated where and how these common sense assumptions of logic are to be corrected and came to the conclusion that the erroneous axiom consists in assuming that for every propositional function there exists the class of objects satisfying it, or that every propositional function exists "as a separate entity;"[9] by which is meant something separable from the argument (the idea being that propositional functions are abstracted from propositions which are primarily given) and also something distinct from the combination of symbols expressing the propositional function; it is then what one may call the notion or concept defined by it.[10] The existence of this concept already suffices for the paradoxes in their "intensional" form, where the concept of

[9] In Russell's first paper about the subject: "On Some Difficulties in the Theory of Transfinite Numbers and Order Types," *Proc. London Math. Soc.*, Second Series, Vol. 4, 1906, p. 29. If one wants to bring such paradoxes as "the liar" under this viewpoint, universal (and existential) propositions must be considered to involve the class of objects to which they refer.

[10] "Propositional function" (without the clause "as a separate entity") may be understood to mean a proposition in which one or several constituents are designated as arguments. One might think that the pair consisting of the proposition and the argument could then for all purposes play the rôle of the "propositional function as a separate entity," but it is to be noted that this pair (as one entity) is again a set or a concept and therefore need not exist.

"not applying to itself" takes the place of Russell's paradoxical class.

Rejecting the existence of a class or concept in general, it remains to determine under what further hypotheses (concerning the propositional function) these entities do exist. Russell pointed out (*loc. cit.*) two possible directions in which one may look for such a criterion, which he called the zig-zag theory and the theory of limitation of size, respectively, and which might perhaps more significantly be called the intensional and the extensional theory. The second one would make the existence of a class or concept depend on the extension of the propositional function (requiring that it be not too big), the first one on its content or meaning (requiring a certain kind of "simplicity," the precise formulation of which would be the problem).

The most characteristic feature of the second (as opposed to the first) would consist in the non-existence of the universal class or (in the intensional interpretation) of the notion of "something" in an unrestricted sense. Axiomatic set theory as later developed by Zermelo and others can be considered as an elaboration of this idea as far as classes are concerned.[11] In particular the phrase "not too big" can be specified (as was shown by J. v. Neumann[12]) to mean: not equivalent with the universe of all things, or, to be more exact, a propositional function can be assumed to determine a class when and only when there exists no relation (in intension, i.e., a propositional function with two variables) which associates in a one-to-one manner with each object, an object satisfying the propositional function and vice versa. This criterion, however, does not appear as the basis of the theory but as a consequence of the axioms and inversely can replace two of the axioms (the axiom of replacement and that of choice).

For the second of Russell's suggestions too, i.e., for the zig-zag theory, there has recently been set up a logical system which shares some essential features with this scheme, namely

[11] The intensional paradoxes can be dealt with e.g. by the theory of simple types or the ramified hierarchy, which do not involve any undesirable restrictions if applied to concepts only and not to sets.

[12] Cf. "Über eine Widerspruchfreiheitsfrage in der axiomatischen Mengenlehre," *Journal für reine und angewandte Mathematik*, Vol. 160, 1929, p. 227.

Quine's system.[13] It is, moreover, not unlikely that there are other interesting possibilities along these lines.

Russell's own subsequent work concerning the solution of the paradoxes did not go in either of the two afore-mentioned directions pointed out by himself, but was largely based on a more radical idea, the "no-class theory," according to which classes or concepts *never* exist as real objects, and sentences containing these terms are meaningful only to such an extent as they can be interpreted as a *façon de parler*, a manner of speaking about other things (cf. p. 141). Since in *Principia* and elsewhere, however, he formulated certain principles discovered in the course of the development of this theory as general logical principles without mentioning any longer their dependence on the no-class theory, I am going to treat of these principles first.

I mean in particular the vicious circle principle, which forbids a certain kind of "circularity" which is made responsible for the paradoxes. The fallacy in these, so it is contended, consists in the circumstance that one defines (or tacitly assumes) totalities, whose existence would entail the existence of certain new elements of the same totality, namely elements definable only in terms of the whole totality. This led to the formulation of a principle which says that "no totality can contain members definable only in terms of this totality, or members involving or presupposing this totality" [vicious circle principle]. In order to make this principle applicable to the intensional paradoxes, still another principle had to be assumed, namely that "every propositional function presupposes the totality of its values" and therefore evidently also the totality of its possible arguments.[14] [Otherwise the concept of "not applying to itself" would presuppose no totality (since it involves no quantifications),[15] and the vicious circle principle would not prevent its application to itself.] A corresponding vicious circle principle

---

[13] Cf. "New Foundations for Mathematical Logic," *Amer. Math. Monthly*, Vol. 44, p. 70.

[14] Cf. *Principia Mathematica*, Vol. I, p. 39.

[15] Quantifiers are the two symbols ( ∃ x) and (x) meaning respectively, "there exists an object x" and "for all objects x." The totality of objects x to which they refer is called their range.

for propositional functions which says that nothing defined in terms of a propositional function can be a possible argument of this function is then a consequence.[16] The logical system to which one is led on the basis of these principles is the theory of orders in the form adopted, e.g., in the first edition of *Principia*, according to which a propositional function which either contains quantifications referring to propositional functions of order n or can be meaningfully asserted of propositional functions of order n is at least of order n $+$ 1, and the range of significance of a propositional function as well as the range of a quantifier must always be confined to a definite order.

In the second edition of *Principia*, however, it is stated in the Introduction (pp. XI and XII) that "in a limited sense" also functions of a higher order than the predicate itself (therefore also functions defined in terms of the predicate as, e.g., in p 'κ ε κ) can appear as arguments of a predicate of functions; and in appendix B such things occur constantly. This means that the vicious circle principle for propositional functions is virtually dropped. This change is connected with the new axiom that functions can occur in propositions only "through their values," i.e., extensionally, which has the consequence that any propositional function can take as an argument any function of appropriate type, whose extension is defined (no matter what order of quantifiers is used in the definition of this extension). There is no doubt that these things are quite unobjectionable even from the constructive standpoint (see p. 136), provided that quantifiers are always restricted to definite orders. The paradoxes are avoided by the theory of simple types,[17] which in

---

[16] Cf. *Principia Mathematica*, Vol. I, p. 47, section IV.

[17] By the theory of simple types I mean the doctrine which says that the objects of thought (or, in another interpretation, the symbolic expressions) are divided into types, namely: individuals, properties of individuals, relations between individuals, properties of such relations, etc. (with a similar hierarchy for extensions), and that sentences of the form: "a has the property φ," "b bears the relation R to c," etc. are meaningless, if a, b, c, R, φ are not of types fitting together. Mixed types (such as classes containing individuals and classes as elements) and therefore also transfinite types (such as the class of all classes of finite types) are excluded. That the theory of simple types suffices for avoiding also the epistemological paradoxes is shown by a closer analysis of these. (Cf. F. P. Ramsey's paper, quoted in foot-

*Principia* is combined with the theory of orders (giving as a result the "ramified hierarchy") but is entirely independent of it and has nothing to do with the vicious circle principle (cf. p. 147).

Now as to the vicious circle principle proper, as formulated on p. 133, it is first to be remarked that, corresponding to the phrases "definable only in terms of," "involving," and "presupposing," we have really three different principles, the second and third being much more plausible than the first. It is the first form which is of particular interest, because only this one makes impredicative definitions[18] impossible and thereby destroys the derivation of mathematics from logic, effected by Dedekind and Frege, and a good deal of modern mathematics itself. It is demonstrable that the formalism of classical mathematics does not satisfy the vicious circle principle in its first form, since the axioms imply the existence of real numbers definable in this formalism only by reference to all real numbers. Since classical mathematics can be built up on the basis of *Principia* (including the axiom of reducibility), it follows that even *Principia* (in the first edition) does not satisfy the vicious circle principle in the first form, if "definable" means "definable within the system" and no methods of defining outside the system (or outside other systems of classical mathematics) are known except such as involve still more comprehensive totalities than those occurring in the systems.

I would consider this rather as a proof that the vicious circle principle is false than that classical mathematics is false, and this is indeed plausible also on its own account. For, first of all one may, on good grounds, deny that reference to a totality necessarily implies reference to all single elements of it or, in other words, that "all" means the same as an infinite logical

<hr />

note 21, and A. Tarski, *Der Wahrheitsbegriff in den formalisierten Sprachen*, *Stud. phil.*, Vol. I, Lemberg, 1935, p. 399.)

[18] These are definitions of an object $\alpha$ by reference to a totality to which $\alpha$ itself (and perhaps also things definable only in terms of $\alpha$) belong. As, e.g., if one defines a class $\alpha$ as the intersection of all classes satisfying a certain condition $\varphi$ and then concludes that $\alpha$ is a subset also of such classes u as are defined in terms of $\alpha$ (provided they satisfy $\varphi$).

conjunction. One may, e.g., follow Langford's and Carnap's[19] suggestion to interpret "all" as meaning analyticity or necessity or demonstrability. There are difficulties in this view; but there is no doubt that in this way the circularity of impredicative definitions disappears.

Secondly, however, even if "all" means an infinite conjunction, it seems that the vicious circle principle in its first form applies only if the entities involved are constructed by ourselves. In this case there must clearly exist a definition (namely the description of the construction) which does not refer to a totality to which the object defined belongs, because the construction of a thing can certainly not be based on a totality of things to which the thing to be constructed itself belongs. If, however, it is a question of objects that exist independently of our constructions, there is nothing in the least absurd in the existence of totalities containing members, which can be described (i.e., uniquely characterized)[20] only by reference to this totality.[21] Such a state of affairs would not even contradict the second form of the vicious circle principle, since one cannot say that an object described by reference to a totality "involves" this totality, although the description itself does; nor would it contradict the third form, if "presuppose" means "pressuppose for the existence" not "for the knowability."

So it seems that the vicious circle principle in its first form applies only if one takes the constructivistic (or nominalistic) standpoint[22] toward the objects of logic and mathematics, in particular toward propositions, classes and notions, e.g., if one understands by a notion a symbol together with a rule for translating sentences containing the symbol into such sentences as do

[19] See Rudolf Carnap in *Erkenntnis*, Vol. 2, p. 103, and *Logical Syntax of Language*, p. 162, and C. H. Langford, *Bulletin American Mathematical Society*, Vol. 33 (1927), p. 599.

[20] An object a is said to be described by a propositional function $\varphi$ (x) if $\varphi$ (x) is true for x = a and for no other object.

[21] Cf. F. P. Ramsey, "The Foundations of Mathematics," in *Proc. London Math Soc.*, Series 2, Vol. 25 (1926), p. 338. (Reprinted in *The Foundations of Mathematics*, New York and London, 1931, p. 1.)

[22] I shall use in the sequel "constructivism" as a general term comprising both these standpoints and also such tendencies as are embodied in Russell's "no class" theory.

not contain it, so that a separate object denoted by the symbol appears as a mere fiction.[23]

Classes and concepts may, however, also be conceived as real objects, namely classes as "pluralities of things" or as structures consisting of a plurality of things and concepts as the properties and relations of things existing independently of our definitions and constructions.

It seems to me that the assumption of such objects is quite as legitimate as the assumption of physical bodies and there is quite as much reason to believe in their existence. They are in the same sense necessary to obtain a satisfactory system of mathematics as physical bodies are necessary for a satisfactory theory of our sense perceptions and in both cases it is impossible to interpret the propositions one wants to assert about these entities as propositions about the "data," i.e., in the latter case the actually occurring sense perceptions. Russell himself concludes in the last chapter of his book on *Meaning and Truth*, though "with hesitation," that there exist "universals," but apparently he wants to confine this statement to concepts of sense perceptions, which does not help the logician. I shall use the term "concept" in the sequel exclusively in this objective sense. One formal difference between the two conceptions of notions would be that any two different definitions of the form $\alpha (x) = \varphi (x)$ can be assumed to define two different notions $\alpha$ in the constructivistic sense. (In particular this would be the case for the nominalistic interpretation of the term "notion" suggested above, since two such definitions give different rules of translation for propositions containing $\alpha$.) For concepts, on the contrary, this is by no means the case, since the same thing may be described in different ways. It might even be that the axiom of extensionality[24] or at least something near to it holds for

[23] One might think that this conception of notions is impossible, because the sentences into which one translates must also contain notions so that one would get into an infinite regress. This, however, does not preclude the possibility of maintaining the above viewpoint for all the more abstract notions, such as those of the second and higher types, or in fact for all notions except the primitive terms which might be only a very few.

[24] I.e., that no two different properties belong to exactly the same things, which, in a sense, is a counterpart to Leibniz's *Principium identitatis indiscernibilium*, which says no two different things have exactly the same properties.

concepts. The difference may be illustrated by the following definition of the number two: "Two is the notion under which fall all pairs and nothing else." There is certainly more than one notion in the constructivistic sense satisfying this condition, but there might be one common "form" or "nature" of all pairs.

Since the vicious circle principle, in its first form does apply to constructed entities, impredicative definitions and the totality of all notions or classes or propositions are inadmissible in constructivistic logic. What an impredicative definition would require is to construct a notion by a combination of a set of notions to which the notion to be formed itself belongs. Hence if one tries to effect a retranslation of a sentence containing a symbol for such an impredicatively defined notion it turns out that what one obtains will again contain a symbol for the notion in question.[25] At least this is so if "all" means an infinite conjunction; but Carnap's and Langford's idea (mentioned on p. 136) would not help in this connection, because "demonstrability," if introduced in a manner compatible with the constructivistic standpoint towards notions, would have to be split into a hierarchy of orders, which would prevent one from obtaining the desired results.[26] As Chwistek has shown,[27] it is even possible under certain assumptions admissible within constructivistic logic to derive an actual contradiction from the unrestricted admission of impredicative definitions. To be more specific, he has shown that the system of simple types becomes contradictory if one adds the "axiom of intensionality" which says (roughly speaking) that to different definitions belong different notions. This axiom, however, as has just been pointed out, can be assumed to hold for notions in the constructivistic sense.

Speaking of concepts, the aspect of the question is changed completely. Since concepts are supposed to exist objectively, there seems to be objection neither to speaking of all of them

---

[25] Cf. Carnap, loc. cit., footnote 19 above.

[26] Nevertheless the scheme is interesting because it again shows the constructibility of notions which can be meaningfully asserted of notions of arbitrarily high order.

[27] See Erkenntnis, Vol. 3, p. 367.

(cf. p. 143) nor to describing some of them by reference to all (or at least all of a given type). But, one may ask, isn't this view refutable also for concepts because it leads to the "absurdity" that there will exist properties φ such that φ (a) consists in a certain state of affairs involving all properties (including φ itself and properties defined in terms of φ), which would mean that the vicious circle principle does not hold even in its second form for concepts or propositions? There is no doubt that the totality of all properties (or of all those of a given type) does lead to situations of this kind, but I don't think they contain any absurdity.[28] It is true that such properties φ [or such propositions φ (a)] will have to contain themselves as constituents of their content [or of their meaning], and in fact in many ways, because of the properties defined in terms of φ; but this only makes it impossible to construct their meaning (i.e., explain it as an assertion about sense perceptions or any other non-conceptual entities), which is no objection for one who takes the realistic standpoint. Nor is it self-contradictory that a proper part should be identical (not merely equal) to the whole, as is seen in the case of structures in the abstract sense. The structure of the series of integers, e.g., contains itself as a proper part and it is easily seen that there exist also structures containing infinitely many different parts, each containing the whole structure as a part. In addition there exist, even within the domain of constructivistic logic, certain approximations to this self-reflexivity of impredicative properties, namely propositions which contain as parts of their meaning not themselves but their own formal demonstrability.[29] Now formal demonstrability of a proposition (in case the axioms and rules of inference are correct) implies this proposition and in many cases is equiva-

---

[28] The formal system corresponding to this view would have, instead of the axiom of reducibility, the rule of substitution 'for functions described, e.g., in Hilbert-Bernays, *Grundlagen der Mathematik*, vol. I (1934), p. 90, applied to variables of any type, together with certain axioms of intensionality required by the concept of property which, however, would be weaker than Chwistek's. It should be noted that this view does not necessarily imply the existence of concepts which cannot be expressed in the system, if combined with a solution of the paradoxes along the lines indicated on p. 149.

[29] Cf. my paper in *Monatshefte für Mathematik und Physik*, Vol. 38 (1931), p. 173, or R. Carnap, *Logical Syntax of Language*, § 35.

lent to it. Furthermore, there doubtlessly exist sentences re-
ferring to a totality of sentences to which they themselves belong
as, e.g., the sentence: "Every sentence (of a given language)
contains at least one relation word."

Of course this view concerning the impredicative properties
makes it necessary to look for another solution of the paradoxes,
according to which the fallacy (i.e., the underlying erroneous
axiom) does not consist in the assumption of certain self-reflexiv-
ities of the primitive terms but in other assumptions about these.
Such a solution may be found for the present in the simple
theory of types and in the future perhaps in the development of
the ideas sketched on pp. 132 and 150. Of course, all this refers
only to concepts. As to notions in the constructivistic sense there
is no doubt that the paradoxes are due to a vicious circle. It is
not surprising that the paradoxes should have different solu-
tions for different interpretations of the terms occurring.

As to classes in the sense of pluralities or totalities it would
seem that they are likewise not created but merely described by
their definitions and that therefore the vicious circle principle
in the first form does not apply. I even think there exist inter-
pretations of the term "class" (namely as a certain kind of
structures), where it does not apply in the second form either.[30]
But for the development of all contemporary mathematics one
may even assume that it does apply in the second form, which
for classes as mere pluralities is, indeed, a very plausible as-
sumption. One is then led to something like Zermelo's axiom
system for set theory, i.e., the sets are split up into "levels" in
such a manner that only sets of lower levels can be elements of
sets of higher levels (i.e., $x \varepsilon y$ is always false if x belongs to a
higher level than y). There is no reason for classes in this sense
to exclude mixtures of levels in one set and transfinite levels. The
place of the axiom of reducibility is now taken by the axiom

---

[30] Ideas tending in this direction are contained in the following papers by D.
Mirimanoff: "Les antinomies de Russell et de Buraliforte et le problème fonda-
mental de la théorie des ensembles," *L'Enseignment mathematique*, Vol. 19 (1917),
pp. 37-52, and "Remarques sur la théorie des ensembles et les antinomies Cantorien-
nes," *L'Enseignment mathematique*, vol. 19 (1917), pp. 209-217 and vol. 21
(1920), pp. 29-52. Cf. in particular Vol. 19, p. 212.

of classes [Zermelo's *Aussonderungsaxiom*] which says that for each level there exists for an arbitrary propositional function $\varphi(x)$ the set of those x of this level for which $\varphi(x)$ is true, and this seems to be implied by the concept of classes as pluralities.

Russell adduces two reasons against the extensional view of classes, namely the existence of (1.) the null class, which cannot very well be a collection, and (2.) the unit classes, which would have to be identical with their single elements. But it seems to me that these arguments could, if anything, at most prove that the null class and the unit classes (as distinct from their only element) are fictions (introduced to simplify the calculus like the points at infinity in geometry), not that all classes are fictions.

But in Russell the paradoxes had produced a pronounced tendency to build up logic as far as possible without the assumption of the objective existence of such entities as classes and concepts. This led to the formulation of the aforementioned "no class theory," according to which classes and concepts were to be introduced as a *façon de parler*. But propositions, too, (in particular those involving quantifications)[31] were later on largely included in this scheme, which is but a logical consequence of this standpoint, since e.g., universal propositions as objectively existing entities evidently belong to the same category of idealistic objects as classes and concepts and lead to the same kind of paradoxes, if admitted without restrictions. As regards classes this program was actually carried out; i.e., the rules for translating sentences containing class names or the term "class" into such as do not contain them were stated explicitly; and the basis of the theory, i.e, the domain of sentences into which one has to translate is clear, so that classes can be dispensed with (within the system *Principia*), but only if one assumes the existence of a concept whenever one wants to construct a class. When it comes to concepts and the interpretation of sentences containing this or some synonymous term, the state of affairs is by no means as clear. First of all, some of them

[31] Cf. "Les paradoxes de la logique," *Rev. de Metaph. et de Morale*, Vol. 14 (1906), p. 627.

(the primitive predicates and relations such as "red" or "colder") must apparently be considered as real objects;[32] the rest of them (in particular according to the second edition of *Principia*, all notions of a type higher than the first and therewith all logically interesting ones) appear as something constructed (i.e., as something not belonging to the "inventory" of the world); but neither the basic domain of propositions in terms of which finally everything is to be interpreted, nor the method of interpretation is as clear as in the case of classes (see below).

This whole scheme of the no-class theory is of great interest as one of the few examples, carried out in detail, of the tendency to eliminate assumptions about the existence of objects outside the "data" and to replace them by constructions on the basis of these data.[33] The result has been in this case essentially negative; i.e., the classes and concepts introduced in this way do not have all the properties required for their use in mathematics, unless one either introduces special axioms about the data (e.g., the axiom of reducibility), which in essence already mean the existence in the data of the kind of objects to be constructed, or makes the fiction that one can form propositions of infinite (and even non-denumerable) length,[34] i.e., operates with truth-functions of infinitely many arguments, regardless of whether or not one can construct them. But what else is such an infinite truth-function but a special kind of an infinite extension (or structure) and even a more complicated one than a class, endowed in addition with a hypothetical meaning, which can be understood only by an infinite mind? All this is only a verification of the view defended above that logic and mathematics (just as physics) are built up on axioms with a real content which cannot be "explained away."

What one can obtain on the basis of the constructivistic attitude is the theory of orders (cf. p. 134); only now (and this

---

[32] In Appendix C of *Principia* a way is sketched by which these also could be constructed by means of certain similarity relations between atomic propositions, so that these latter would be the only ones remaining as real objects.

[33] The "data" are to be understood in a relative sense here, i.e., in our case as logic without the assumption of the existence of classes and concepts.

[34] Cf. Ramsey, *loc. cit.*, footnote 21 above.

is the strong point of the theory) the restrictions involved do not appear as *ad hoc* hypotheses for avoiding the paradoxes, but as unavoidable consequences of the thesis that classes, concepts, and quantified propositions do not exist as real objects. It is not as if the universe of things were divided into orders and then one were prohibited to speak of all orders; but, on the contrary, it is possible to speak of all existing things; only, classes and concepts are not among them; and if they are introduced as a *façon de parler*, it turns out that this very extension of the symbolism gives rise to the possibility of introducing them in a more comprehensive way, and so on indefinitely. In order to carry out this scheme one must, however, presuppose arithmetic (or something equivalent) which only proves that not even this restricted logic can be built up on nothing.

In the first edition of *Principia*, where it was a question of actually building up logic and mathematics, the constructivistic attitude was, for the most part, abandoned, since the axiom of reducibility for types higher than the first together with the axiom of infinity makes it absolutely necessary that there exist primitive predicates of arbitrarily high types. What is left of the constructive attitude is only: (1.) The introduction of classes as a *façon de parler;* (2.) the definition of $\sim$, v, ., etc., as applied to propositions containing quantifiers (which incidentally proved its fecundity in a consistency proof for arithmetic); (3.) the step by step construction of functions of orders higher than 1, which, however, is superfluous owing to the axiom of reducibility; (4.) the interpretation of definitions as mere typographical abbreviations, which makes every symbol introduced by definition an incomplete symbol (not one naming an object described by the definition). But the last item is largely an illusion, because, owing to the axiom of reducibility, there always exist real objects in the form of primitive predicates, or combinations of such, corresponding to each defined symbol. Finally also Russell's theory of descriptions is something belonging to the constructivistic order of ideas.

In the second edition of *Principia* (or to be more exact, in the introduction to it) the constructivistic attitude is resumed again. The axiom of reducibility is dropped and it is stated explicitly

that all primitive predicates belong to the lowest type and that the only purpose of variables (and evidently also of constants) of higher orders and types is to make it possible to assert more complicated truth-functions of atomic propositions,[35] which is only another way of saying that the higher types and orders are solely a *façon de parler*. This statement at the same time informs us of what kind of propositions the basis of the theory is to consist, namely of truth-functions of atomic propositions.

This, however, is without difficulty only if the number of individuals and primitive predicates is finite. For the opposite case (which is chiefly of interest for the purpose of deriving mathematics) Ramsey (*loc. cit.*) took the course of considering our inability to form propositions of infinite length as a "mere accident," to be neglected by the logician. This of course solves (or rather cuts through) the difficulties; but it is to be noted that, if one disregards the difference between finite and infinite in this respect, there exists a simpler and at the same time more far reaching interpretation of set theory (and therewith of mathematics). Namely, in case of a finite number of individuals, Russell's *aperçu* that propositions about classes can be interpreted as propositions about their elements becomes literally true, since, e.g., "$x \varepsilon m$" is equivalent to "$x = a_1, \vee x = a_2 \vee \ldots \vee x = a_k$" where the $a_i$ are the elements of $m$; and "there exists a class such that . . ." is equivalent to "there exist individuals $x_1, x_2, \ldots x_n$ such that . . .,"[36] provided n is the number of individuals in the world and provided we neglect for the moment the null class which would have to be taken care of by an additional clause. Of course, by an iteration of this procedure one can obtain classes of classes, etc., so that the logical system obtained would resemble the theory of simple types except for the circumstance that mixture of types would be possible. Axiomatic set theory appears, then, as an extrapolation of this scheme for the case of infinitely many individuals or an infinite iteration of the process of forming sets.

[35] I.e., propositions of the form $S(a)$, $R(a,b)$, etc., where S, R are primitive predicates and a, b individuals.

[36] The $x_i$ may, of course, as always, be partly or wholly identical with each other.

Ramsey's viewpoint is, of course, everything but constructivistic, unless one means constructions of an infinite mind. Russell, in the second edition of *Principia*, took a less metaphysical course by confining himself to such truth-functions as can actually be constructed. In this way one is again led to the theory of orders, which, however, appears now in a new light, namely as a method of constructing more and more complicated truth-functions of atomic propositions. But this procedure seems to presuppose arithmetic in some form or other (see next paragraph).

As to the question of how far mathematics can be built up on this basis (without any assumptions about the data—i.e., about the primitive predicates and individuals—except, as far as necessary, the axiom of infinity), it is clear that the theory of real numbers in its present form cannot be obtained.[37] As to the theory of integers, it is contended in the second edition of *Principia* that it can be obtained. The difficulty to be overcome is that in the definition of the integers as "those cardinals which belong to every class containing 0 and containing x + 1 if containing x," the phrase "every class" must refer to a given order. So one obtains integers of different orders, and complete induction can be applied to integers of order n only for properties of order n; whereas it frequently happens that the notion of integer itself occurs in the property to which induction is applied. This notion, however, is of order n + 1 for the integers of order n. Now, in Appendix B of the second edition of *Principia*, a proof is offered that the integers of any order higher than 5 are the same as those of order 5, which of course would settle all difficulties. The proof as it stands, however, is certainly not conclusive. In the proof of the main lemma *89.16, which says that every subset α (of arbitrary high order)[38] of an inductive class β of order 3 is itself an inductive class of order 3, induction is applied to a property of β involving α [namely α—β≠Λ, which, however,

---

[37] As to the question how far it is possible to build up the theory of real numbers, presupposing the integers, cf. Hermann Weyl, *Das Kontinuum*, reprinted, 1932.

[38] That the variable α is intended to be of undetermined order is seen from the later applications of *89.17 and from the note to *89.17. The main application is in line (2) of the proof of *89.24, where the lemma under consideration is needed for α's of arbitrarily high orders.

should read $\alpha - \beta \sim \varepsilon$ Induct₂ because (3) is evidently false]. This property, however, is of an order $> 3$ if $\alpha$ is of an order $> 3$. So the question whether (or to what extent) the theory of integers can be obtained on the basis of the ramified hierarchy must be considered as unsolved at the present time. It is to be noted, however, that, even in case this question should have a positive answer, this would be of no value for the problem whether arithmetic follows from logic, if propositional functions of order n are defined (as in the second edition of *Principia*) to be certain finite (though arbitrarily complex) combinations (of quantifiers, propositional connectives, etc.), because then the notion of finiteness has to be presupposed, which fact is concealed only by taking such complicated notions as "propositional function of order n" in an unanalyzed form as primitive terms of the formalism and giving their definition only in ordinary language. The reply may perhaps be offered that in *Principia* the notion of a propositional function of order n is neither taken as primitive nor defined in terms of the notion of a finite combination, but rather quantifiers referring to propositional functions of order n (which is all one needs) are defined as certain infinite conjunctions and disjunctions. But then one must ask: Why doesn't one define the integers by the infinite disjunction: $x = 0 \lor x = 0 + 1 \lor x = 0 + 1 + 1 \lor \ldots . ad$ *infinitum*, saving in this way all the trouble connected with the notion of inductiveness? This whole objection would not apply if one understands by a propositional function of order n one "obtainable from such truth-functions of atomic propositions as presuppose for their definition no totalities except those of the propositional functions of order $< n$ and of individuals;" this notion, however, is somewhat lacking in precision.

The theory of orders proves more fruitful if considered from a purely mathematical standpoint, independently of the philosophical question whether impredicative definitions are admissible. Viewed in this manner, i.e., as a theory built up within the framework of ordinary mathematics, where impredicative definitions are admitted, there is no objection to extending it to arbitrarily high transfinite orders. Even if one rejects impredicative definitions, there would, I think, be no objection to

extend it to such transfinite ordinals as can be constructed within the framework of finite orders. The theory in itself seems to demand such an extension since it leads automatically to the consideration of functions in whose definition one refers to all functions of finite orders, and these would be functions of order $\omega$. Admitting transfinite orders, an axiom of reducibility can be proved. This, however, offers no help to the original purpose of the theory, because the ordinal $\alpha$—such that every propositional function is extensionally equivalent to a function of order $\alpha$— is so great, that it presupposes impredicative totalities. Nevertheless, so much can be accomplished in this way, that all impredicativities are reduced to one special kind, namely the existence of certain large ordinal numbers (or, well ordered sets) and the validity of recursive reasoning for them. In particular, the existence of a well ordered set, of order type $\omega_1$ already suffices for the theory of real numbers. In addition this transfinite theorem of reducibility permits the proof of the consistency of the Axiom of Choice, of Cantor's Continuum-Hypothesis and even of the generalized Continuum-Hypothesis (which says that there exists no cardinal number between the power of any arbitrary set and the power of the set of its subsets) with the axioms of set theory as well as of *Principia*.

I now come in somewhat more detail to the theory of simple types which appears in *Principia* as combined with the theory of orders; the former is, however, (as remarked above) quite independent of the latter, since mixed types evidently do not contradict the vicious circle principle in any way. Accordingly, Russell also based the theory of simple types on entirely different reasons. The reason adduced (in addition to its "consonance with common sense") is very similar to Frege's, who, in his system, already had assumed the theory of simple types for functions, but failed to avoid the paradoxes, because he operated with classes (or rather functions in extension) without any restriction. This reason is that (owing to the variable it contains) a propositional function is something ambiguous (or, as Frege says, something unsaturated, wanting supplementation) and therefore can occur in a meaningful proposition only in such a way that this ambiguity is eliminated (e.g., by substituting a

constant for the variable or applying quantification to it). The
consequences are that a function cannot replace an individual in
a proposition, because the latter has no ambiguity to be re-
moved, and that functions with different kinds of arguments
(i.e., different ambiguities) cannot replace each other; which
is the essence of the theory of simple types. Taking a more
nominalistic viewpoint (such as suggested in the second edition
of *Principia* and in *Meaning and Truth*) one would have to
replace "proposition" by "sentence" in the foregoing considera-
tions (with corresponding additional changes). But in both cases,
this argument clearly belongs to the order of ideas of the "no
class" theory, since it considers the notions (or propositional
functions) as something constructed out of propositions or sen-
tences by leaving one or several constituents of them undeter-
mined. Propositional functions in this sense are so to speak
"fragments" of propositions, which have no meaning in them-
selves, but only in so far as one can use them for forming propo-
sitions by combining several of them, which is possible only if
they "fit together," i.e., if they are of appropriate types. But,
it should be noted that the theory of simple types (in contradis-
tinction to the vicious circle principle) cannot in a strict sense
follow from the constructive standpoint, because one might con-
struct notions and classes in another way, e.g., as indicated on
p. 144, where mixtures of types are possible. If on the other
hand one considers concepts as real objects, the theory of simple
types is not very plausible, since what one would expect to be a
concept (such as, e.g., "transitivity" or the number two) would
seem to be something behind all its various "realizations" on
the different levels and therefore does not exist according to
the theory of types. Nevertheless, there seems to be some truth
behind this idea of realizations of the same concept on various
levels, and one might, therefore, expect the theory of simple
types to prove useful or necessary at least as a stepping-stone
for a more satisfactory system, a way in which it has already
been used by Quine.[39] Also Russell's "typical ambiguity" is a
step in this direction. Since, however, it only adds certain simpli-

---

[39] *Loc. cit.*, cf. footnote 13 above.

fying symbolic conventions to the theory of types, it does not *de facto* go beyond this theory.

It should be noted that the theory of types brings in a new idea for the solution of the paradoxes, especially suited to their intensional form. It consists in blaming the paradoxes not on the axiom that every propositional function defines a concept or class, but on the assumption that every concept gives a meaningful proposition, if asserted for any arbitrary object or objects as arguments. The obvious objection that every concept can be extended to all arguments, by defining another one which gives a false proposition whenever the original one was meaningless, can easily be dealt with by pointing out that the concept "meaningfully applicable" need not itself be always meaningfully applicable.

The theory of simple types (in its realistic interpretation) can be considered as a carrying through of this scheme, based, however, on the following additional assumption concerning meaningfulness: "Whenever an object x can replace another object y in one meaningful proposition, it can do so in every meaningful proposition."[40] This of course has the consequence that the objects are divided into mutually exclusive ranges of significance, each range consisting of those objects which can replace each other; and that therefore each concept is significant only for arguments belonging to one of these ranges, i.e., for an infinitely small portion of all objects. What makes the above principle particularly suspect, however, is that its very assumption makes its formulation as a meaningful proposition impossible,[41] because x and y must then be confined to definite ranges of significance which are either the same or different, and in both cases the statement does not express the principle or even part of it. Another consequence is that the fact that an object x is (or is not) of a given type also cannot be expressed by a meaningful proposition.

[40] Russell formulates a somewhat different principle with the same effect, in *Principia*, Vol. I, p. 95.

[41] This objection does not apply to the symbolic interpretation of the theory of types, spoken of on p. 148, because there one does not have objects but only symbols of different types.

It is not impossible that the idea of limited ranges of signifi-
cance could be carried out without the above restrictive prin-
ciple. It might even turn out that it is possible to assume every
concept to be significant everywhere except for certain "singular
points" or "limiting points," so that the paradoxes would appear
as something analogous to dividing by zero. Such a system
would be most satisfactory in the following respect: our logical
intuitions would then remain correct up to certain minor correc-
tions, i.e., they could then be considered to give an essentially
correct, only somewhat "blurred," picture of the real state of
affairs. Unfortunately the attempts made in this direction have
failed so far;[42] on the other hand, the impossibility of this
scheme has not been proved either, in spite of the strong in-
consistency theorems of Kleene and Rosser.[43]

In conclusion I want to say a few words about the question
whether (and in which sense) the axioms of *Principia* can be
considered to be analytic. As to this problem it is to be remarked
that analyticity may be understood in two senses. First, it may
have the purely formal sense that the terms occurring can be
defined (either explicitly or by rules for eliminating them from
sentences containing them) in such a way that the axioms and
theorems become special cases of the law of identity and dis-
provable propositions become negations of this law. In this
sense even the theory of integers is demonstrably non-analytic,
provided that one requires of the rules of elimination that they
allow one actually to carry out the elimination in a finite number
of steps in each case.[44] Leaving out this condition by admitting,
e.g., sentences of infinite (and non-denumerable) length as inter-
mediate steps of the process of reduction, all axioms of *Principia*

---

[42] A formal system along these lines is Church's (cf. "A Set of Postulates for
the Foundation of Logic," *Annals of Mathematics*, Vol. 33 (1932), p. 346 and
Vol. 34 (1933), p. 839), where, however, the underlying idea is expressed by the
somewhat misleading statement that the law of excluded middle is abandoned.
However, this system has been proved to be inconsistent. See footnote 43.

[43] Cf. S. C. Kleene and J. B. Rosser, "The Inconsistency of Certain Formal
Logics," *Annals of Math.*, Vol. 36 (1935), p. 630.

[44] Because this would imply the existence of a decision-procedure for all arith-
metical propositions. Cf. A. M. Turing, *Proc. Lond. Math. Soc.*, Vol. 42 (1936),
p. 230.

(including the axioms of choice, infinity and reducibility) could be proved to be analytic for certain interpretations (by considerations similar to those referred to on p. 144).[45] But this observation is of doubtful value, because the whole of mathematics as applied to sentences of infinite length has to be presupposed in order to prove this analyticity, e.g., the axiom of choice can be proved to be analytic only if it is assumed to be true.

In a second sense a proposition is called analytic if it holds, "owing to the meaning of the concepts occurring in it," where this meaning may perhaps be undefinable (i.e., irreducible to anything more fundamental).[46] It would seem that all axioms of *Principia*, in the first edition, (except the axiom of infinity) are in this sense analytic for certain interpretations of the primitive terms, namely if the term "predicative function" is replaced either by "class" (in the extensional sense) or (leaving out the axiom of choice) by "concept," since nothing can express better the meaning of the term "class" than the axiom of classes (cf. p. 140) and the axiom of choice, and since, on the other hand, the meaning of the term "concept" seems to imply that every propositional function defines a concept.[47] The difficulty is only that we don't perceive the concepts of "concept" and of "class" with sufficient distinctness, as is shown by the paradoxes. In view of this situation, Russell took the course of considering

[45] Cf. also F. P. Ramsey, *loc. cit.*, (footnote 21), where, however, the axiom of infinity cannot be obtained, because it is interpreted to refer to the individuals in the world.

[46] The two significations of the term *analytic* might perhaps be distinguished as tautological and analytic.

[47] This view does not contradict the opinion defended above that mathematics is based on axioms with a real content, because the very existence of the concept of e.g., "class" constitutes already such an axiom; since, if one defined e.g., "class" and "ε" to be "the concepts satisfying the axioms," one would be unable to prove their existence. "Concept" could perhaps be defined in terms of "proposition" (cf. p. 148 (although I don't think that this would be a natural procedure); but then certain axioms about propositions, justifiable only with reference to the undefined meaning of this term, will have to be assumed. It is to be noted that this view about analyticity makes it again possible that every mathematical proposition could perhaps be reduced to a special case of a = a, namely if the reduction is effected not in virtue of the definitions of the terms occurring, but in virtue of their meaning, which can never be completely expressed in a set of formal rules.

both classes and concepts (except the logically uninteresting primitive predicates) as non-existent and of replacing them by constructions of our own. It cannot be denied that this procedure has led to interesting ideas and to results valuable also for one taking the opposite viewpoint. On the whole, however, the outcome has been that only fragments of Mathematical Logic remain, unless the things condemned are reintroduced in the form of infinite propositions or by such axioms as the axiom of reducibility which (in case of infinitely many individuals) is demonstrably false unless one assumes either the existence of classes or of infinitely many *"qualitates occultae."* This seems to be an indication that one should take a more conservative course, such as would consist in trying to make the meaning of the terms "class" and "concept" clearer, and to set up a consistent theory of classes and concepts as objectively existing entities. This is the course which the actual development of Mathematical Logic has been taking and which Russell himself has been forced to enter upon in the more constructive parts of his work. Major among the attempts in this direction (some of which have been quoted in this essay) are the simple theory of types (which is the system of the first edition of *Principia* in an appropriate interpretation) and axiomatic set theory, both of which have been successful at least to this extent, that they permit the derivation of modern mathematics and at the same time avoid all known paradoxes. Many symptoms show only too clearly, however, that the primitive concepts need further elucidation.

It seems reasonable to suspect that it is this incomplete understanding of the foundations which is responsible for the fact that Mathematical Logic has up to now remained so far behind the high expectations of Peano and others who (in accordance with Leibniz's claims) had hoped that it would facilitate theoretical mathematics to the same extent as the decimal system of numbers has facilitated numerical computations. For how can one expect to solve mathematical problems systematically by mere analysis of the concepts occurring, if our analysis so far does not even suffice to set up the axioms? But there is no need to give up hope. Leibniz did not in his writings about the *Characteristica universalis* speak of a utopian project; if we are to

believe his words he had developed this calculus of reasoning to a large extent, but was waiting with its publication till the seed could fall on fertile ground.[48] He went even so far[49] as to estimate the time which would be necessary for his calculus to be developed by a few select scientists to such an extent "that humanity would have a new kind of an instrument increasing the powers of reason far more than any optical instrument has ever aided the power of vision." The time he names is five years, and he claims that his method is not any more difficult to learn than the mathematics or philosophy of his time. Furthermore, he said repeatedly that, even in the rudimentary state to which he had developed the theory himself, it was responsible for all his mathematical discoveries; which, one should expect, even Poincaré would acknowledge as a sufficient proof of its fecundity.

KURT GÖDEL[50]

THE SCHOOL OF MATHEMATICS
THE INSTITUTE FOR ADVANCED STUDY
PRINCETON, NEW JERSEY

[48] *Die philosophischen Schriften von G. W. Leibniz,* herausgegeben von C. J. Gerhardt, Vol. 7 (1890), p. 12. Cf. also G. Vacca, "La logica di Leibniz" (section VII), *Riv. di Mat.,* Vol. 8 (1902-06), p. 72, and the preface in the first volume of the first series of *Leibniz's Sämtliche Briefe und Schriften,* herausgegeben von der Preussischen Akademie der Wissenschaften (1923-    ).

[49] Leibniz, *Philosophische Schriften* (ed. Gerhardt), Vol. 7, p. 187.

[50] I wish to express my thanks to Professor Alonzo Church of Princeton University, who helped me to find the correct English expressions in a number of places.

**4**

*James Feibleman*

A REPLY TO BERTRAND RUSSELL'S
INTRODUCTION TO THE SECOND EDITION OF
*THE PRINCIPLES OF MATHEMATICS*

# A REPLY TO BERTRAND RUSSELL'S
# INTRODUCTION TO THE SECOND EDITION OF
## *THE PRINCIPLES OF MATHEMATICS*

THE decision to reprint *The Principles of Mathematics* after thirty-four years was a most fortunate one. The work has had a tremendous influence and should be available to all interested students of the subject. Here is a landmark in the history of thought which many persons have heard about but never seen, and now the new edition will place it before the public again. The importance of *The Principles* rests to some extent upon two of its points: it is the first comprehensive treatise on symbolic logic to be written in English; and it gives to that system of logic a realistic interpretation. It is with the second point chiefly that these remarks shall be concerned. Symbolic logic as a discipline is here to stay, whatever its philosophical interpretation; but the interpretation itself is still a doubtful question. Of course, the metaphysical interpretation of symbolic logic is not strictly a problem of logic, but lies on the borderline between logic and metaphysics. In all probability, it belongs to metaphysics, more particularly to the metaphysics of logic. But it is a most important topic for all that, and moreover constitutes a field in which much yet remains to be done.

Are the foundations of symbolic logic realistic or nominalistic? A reading of *The Principles* should be sufficient to convince any sceptical person of the explanatory usefulness of the realistic philosophy. The assumption that relations are real and non-mental, if not true, has at least a pragmatic value; and since the criterion of truth cannot be anything except self-consistency and range of applicability, realism must to a large extent be true. That must have been also Russell's opinion when he wrote *The*

*Principles.* Since then he has altered his position sharply; for now in the new Introduction he challenges the validity of the philosophy underlying the work. He says

Broadly speaking, I still think this book is in the right where it disagrees with what had been previously held, but where it agrees with older theories it is apt to be wrong. The changes in philosophy which seem to me to be called for are partly due to the technical advances of mathematical logic. . . . Broadly, the result is an outlook which is less Platonic, or less realist in the mediaeval sense of the word. How far it is possible to go in the direction of nominalism remains, to my mind, an unsolved question. . . .[1]

The present paper takes issue with Russell on his new thesis, and is thus in the position of making out a case for an old book in order to defend it against the new rejection by its own author. In other words, the old Russell is to be defended against the new Russell.

Perhaps the simplest method of accomplishing this purpose would be to set forth all the arguments which have ever been advanced by anyone in favor of the truth of realism, and to refute all the arguments which have ever been used against it. But to attempt to defend realism in such a fashion would mean to become embroiled in a controversy which is most likely endless. There is another alternative. Russell puts forward certain specific and clear-cut objections to the validity of his former position. The simplest way would seem to be to show that these objections are groundless arguments, to demonstrate that his present reasons for acceding to the invalidity of his old work are themselves invalid. This will be the method adopted; and we shall take the arguments one by one in the order in which they are introduced.

The first attack upon realism consists in questioning the existence of logical constants. Russell asks, "Are there logical constants?" By logical constants are meant such expressions as "or," "and," "if-then," "1," "2," and so on. Russell says that "when we analyse the propositions in the written expression

[1] Bertrand Russell, *The Principles of Mathematics*, 2nd ed. (1938), p. xiv. All references, unless otherwise stated, will be to this work.

of which such symbols occur, we find that they have no constituents corresponding to the expressions in question."[2] One way in which the refutation of an opponent's arguments can be made to seem the most effective is first to overstate his position for him. This way, his position appears to be self-evidently untenable and is ripe for ridicule. Where possible, Russell has done this for himself by describing realism in a manner in which it is certain he himself never accepted it, even when as a realist he wrote down *The Principles*. Selecting as typical of the logical constants the term "or," he says, "not even the most ardent Platonist would suppose that the perfect 'or' is laid up in heaven, and that the 'or's' here on earth are imperfect copies of the celestial archtype."[3] Do there exist any longer realists who would be willing to accept such a description of their belief? To confine the realistic position to such an extreme version would be equivalent to asserting of all nominalists that they are admitted solipsists, which is very far from being the case. Even Russell has asserted that the question of how far it is possible to go in the direction of nominalism is as yet an unsolved one. Much the same defense might be given for realism.

We can accept a modified realism without asserting the existence of a realm of essence, or heaven, in which perfect actual things are stored in order to cast the shadows which we mistake for them. Certainly there is no perfect "or" laid up in heaven, but this does not establish nominalism or deny a modified realism. From the position of modified realism, the logical constant "or" is *logical* because it can neither be successfully contradicted nor shown to involve self-contradiction, and is *a constant* because it involves a constant relationship. The relation "or" is that of alternativity, which is a logical possibility, an unchanging relationship which actual things *may* have (but do not have to have) and which has being (since it *can* exist) regardless of whether it exists at any special place and date or not. Thus the reply to Russell on this point must be as follows. The logical constant "or" is a symbol which occurs in some

[2] P. ix.
[3] P. ix.

propositions. When it occurs in true propositions and sometimes when it occurs in partly true propositions, "or" has an objective constituent, the constituent corresponding to the expression in question being the relation of alternativity.

Russell next argues that the theory of descriptions, as it is called in symbolic logic, dispenses with the actual particulars which do service as the constituents of some logical terms. For instance, he says that in "Scott is the author of *Waverley*" there is no constituent corresponding to "the author of *Waverley*." The argument consists in an analysis of the proposition; and the analysis reduces the proposition to the following. "The propositional function '*x wrote Waverley* is equivalent to *x is Scott*' is true for all values of x."[4] Russell is correct in his assertion that this does away with the realm of Being of Meinong, in which the golden mountain and the round square have a place. The theory of descriptions does "avoid this and other difficulties," but does it refute realism? The evidence here would seem to be quite to the contrary. The task performed by the theory of descriptions is the elimination of all *specified* actual particulars as the constituents of terms in propositions, and the substitution of propositional functions. Now propositional functions are relations, possibilities which can be specified by actual particulars. These relations or possibilities certainly exist. The relation between the *x* who wrote *Waverley* and the *x* who is Scott—one of equivalence—is "true for all values of *x*," which is to say can be assigned constituents by assigning specific values for *x*, but holds whether or not specific values be assigned for *x*.

The theory of descriptions not only refutes the realm of essence but also happily points out the enormously wide gulf which yawns between realm-of-essence realism and modified realism, a gulf as wide as that between realism and nominalism. We do not have any actual golden mountains and round squares; hence the assertion of Meinong that they must exist in a realm of being is equivalent to the assertion not of realism but of crypto-materialism, which is a form of nominalism. Nothing exists really except actual physical particulars, or so asserts

[4] P. x.

nominalism. But golden mountains and round squares *are* actual physical particulars: they are *remote* actual physical particulars, or so asserts crypto-materialism. The refutation of such contentions, accomplished logically by the theory of descriptions, argues for, rather than against, a modified realism, since it asserts that real existence means possibility of actualization, expressed in propositional functions.

Much the same argument as that employed above can be used to refute Russell's reasons for the abolition of classes. The cardinal numbers, Russell would persuade us, can be made to disappear in a cloud of propositional functions, and he accordingly performs the trick.[5] The numbers 1 and 2 are resolved into invariant relations holding between other invariant relations. The question is, have the numbers "entirely disappeared?" As numbers they have, because numbers are not and never were anything more than relations. Russell in his analysis has revealed their true nature; but he has not caused the relations which they essentially represent to disappear, nor has he given one argument in refutation of realism thereby. Any argument to show that specified things are not independent things but rather things dependent upon invariant relations which they exemplify can hardly be said to be an argument *against* realism. What are invariant relations, what are propositional functions, if not possibilities susceptible of actualization but never necessarily demanding it in order to show their being?

The fact is that Russell has not "dissolved" any numbers nor made them "disappear." He has merely shown them to be invariant relations between variables. This is very far from having disposed of their realistic character. Russell often talks about logic and mathematics as though he had never heard of any realism except the extreme realism which supposes that the Platonic Ideas are laid up forever in a heavenly realm of essence. Even Plato did not always believe this but sometimes argued for a status of possibility for unactualized as well as for actualized universals. Invariant relations, then, are what *can happen* to variables, and numbers are real possibilities as are all invariant relations which are non-contradictory.

[5] P. x.

Russell continues his argument against logical constants by carrying it over to cover "points of space, instants of time, and particles of matter, substituting for them logical constructions composed of events."[6] The substitution was made following Professor Whitehead's suggestion. Russell is appearing to present many arguments, whereas he is only presenting one. This one is the repeated assertion that, since logical constants prove to be relations, they are not fixed in the sense we once thought they were. They are not fixed because they have no constant reference; hence realism is untenable. The argument is no more valid in the case of physical relations than it was in the strictly logical field. Space, time, and matter have been resolved into relations varying from frame of reference to frame of reference, but invariant given the frame. The important point to bear in mind is that they are relations instead of actual things, relations which can be exemplified by the actual things to which they refer but not requiring actual things or any specific reference in order to be. This is an argument in favor of realism, and decidedly not one against it.

Russell is taking for granted throughout his argument concerning the disappearance of logical constants a confusion between two distinct meanings of "reference." There is (1) the reference of a symbol to its logical possibility, and there is (2) the reference of a logical possibility to its actual exemplification. Russell refers to them both by the same expression, "having a constituent," which is a source of unutterable confusion. In order to show what we mean let us give an example. (1) The letters a-u-t-o-m-o-b-i-l-e form a symbol, namely "automobile," which may refer to the possibility of constructing a horseless carriage propelled by an internal combustion engine, assuming that there already were or were not any, as in the sentence, "Let us build an automobile." (2) The letters a-u-t-o-m-o-b-i-l-e form a symbol, namely "automobile," which may refer to an actual physical object, assuming that there was at least one, as in the sentence, "This automobile runs well." The unfounded assumption that the refutation of the validity of meaning (2) also does away with the validity of meaning (1) accounts

[6] P. xi.

for most of the error responsible for Russell's change of view-point.

But perhaps there is more hidden beneath the surface of Russell's argument than we have been able thus far to grasp. A further quotation proves this to be the case. Russell goes on to say that "none of the raw material of the world has smooth logical properties, but whatever appears to have such properties is constructed artificially in order to have them."[7] This is only another way of saying that whenever there appears to be a one-to-one correspondence between logic and actuality it must have been faked. The argument runs that, since logic is ideal and actuality is not, logic cannot refer to anything actual. There is an assumption here which will not bear examination. Why cannot the part refer to the whole, the limited to the unlimited, the example to its exemplar, the actual to the ideal? Let us suppose that the fastest airplane would be one which could fly an infinite number of miles in zero seconds, yet we have to admit that, although no airplane flies that fast and probably none ever will, the airplane which flies four hundred miles per hour is nearer to the ideal than one which flies only one hundred and fifty miles per hour. The equivalence to four of two and two is tautological because that is what we mean by two and that is what we mean by four; yet this knowledge helps us to manipulate everything from apples to madonnas.

None of the raw material of the world needs to have smooth logical properties in order to refer to logic, so long as it is admissible for a cat to look at a king. Russell's charge that logic is an artificial construction, since nothing actual is ideal, also assumes the confusion which we have pointed out above in the example of the automobile, the confusion between two distinct levels of reference. Because Whitehead has persuaded Russell to substitute "logical constructions composed of events" for particles of space, time, and matter, Russell feels compelled to the further conclusion that logic is linguistic. This is the nominalistic view; the realist would say that language is logical. But then realism depends upon a careful segregation of the two levels of reference. Smooth logical properties are characteristic both of

[7] P. xi.

the tautologies of logic in language and thought, and of the possibilities to which they refer. Actuality exemplifies partially this logical possibility. For the raw material of the world to have smooth logical properties, there would have to be an identity between actuality and possibility, and this would be a signal that everything had happened that could happen. Until then, it is as much a requirement of actuality as it is of logic that the ideal contain more than the actual world.

It would appear that we have wandered a long way from our original point, but such is not the case. Having changed over from "points of space, instants of time, and particles of matter" to "logical constructions composed of events," Russell holds Whitehead responsible for his change from the realistic to the nominalistic interpretation of symbolic logic. But a careful inspection of Whitehead's own subsequent writings shows that what Whitehead was endeavoring to do was to change Russell over from a "substance" to a "relations" philosophy. In *Process and Reality* Whitehead himself still finds "eternal objects" (i.e., universals) consistent with the adoption of events. Whitehead's "events" upon analysis reveal themselves to consist of invariant relations, even the Platonic *receptacle* of simple spatio-temporal location having gone by the board.

The statement, "Time consists of instants," is shown by Russell to be false by means of an interpretation of time in terms of comparatively contemporary events. But the argument about the time statement is much the same as that we have given above concerning the cardinal numbers (p. 161). To demonstrate that an entity is analyzable into a process in terms of propositional functions does not invalidate its logically constant nature as an entity. A logical constant should only be expected to be *logically* constant, *not* actually constant as well. Time is actually composed of instants, as anyone who has actually tried to live by the clock can testify. Yet these instants resolve themselves, like all other actual things, into logical events, entities consisting of relations.

Russell's adversion from the view that realism is a valid metaphysical basis for symbolic logic rests chiefly upon the interpretation of the status of logical constants. Logical constants

seem to Russell to disappear between actual things (the refer-
ence of language) on the one hand, and the formal properties
of language itself on the other.[8] Thus by arbitrary definition of
terms he has managed to argue himself out of realism. For
language itself is merely a shorthand method of formulating
and communicating the apprehension of ideas, and not anything
in itself. It is safe to assert that everything in language refers
beyond itself. Russell himself maintains that "it seems rash to
hold that any word is meaningless."[9] Russell's error is the same
one that we have pointed out above (p. 162), and consists in
assuming that there is only one level of reference, a situation
which automatically precludes realism. The seeds of this con-
fusion were already contained in *The Principles,* where Russell
assigned the distinction between intension and extension to
psychology.[10]

Language has two kinds of reference: tautological proposi-
tions refer to possible things, whereas propositions about mat-
ters of fact refer to actual things. There is a third classification,
and one that contains the greatest number of propositions:
hypotheses, of which we do not know the exact reference, if any.
Hypothetical propositions may be false, and therefore not
propositions in the true sense at all, or they may belong to
tautologies or matters of fact. Thus the distinction between
hypotheses and the other two kinds of propositions is a matter
of ignorance (psychological), but the difference between tau-
tologies and matters of fact, or between intension and extension,
is a genuine objective difference. Now, Russell's error lies in the
supposition that tautological propositions are exhausted by the
language in which they are expressed and do not refer to any-
thing objective. Thus he disproves realism by first assuming its
denial. Logical constants, like all other logical terms, are part
of what language expresses, expressed as part of the language.
So long as tautological propositions are valid and have a refer-

---

[8] P. xi. The first sentence of the last paragraph reads, "Logical constants, if we
are able to say anything definite about them, must be treated as part of the language,
not as part of what the language speaks about."

[9] P. 71.

[10] P. 69.

ence, logical constants are emphatically *not* confined to the choice between referring to actual things and being merely verbal (i.e., having no reference at all).

"No proposition of logic," Russell goes on to say, "can mention any particular object." And he proceeds to show that the well known syllogism involving the mortality of Socrates is a special case of a wider and more abstract formulation. The point taken here seems to be quite correct: logic is ideal, and if actual things could be mentioned in ideal propositions, it would infer that actual things were ideal. There are, however, two dangerous fallacies lying in wait upon the outskirts of this argument. One is the conclusion that if logic is ideal and actuality is not, logic can have no reference to actuality at all. This would make of logic a kind of harmless but useless exercise or game, having no application to the real world. The point is that the Socrates syllogism is an *application* of logic. Logic, like mathematics, is ideal and does not refer to any specific actual thing, but it may be applied to any and all actual things. $2 + 2 = 4$ as a proposition in mathematics does not refer to shoes or ships or sealing wax, cabbages or kings, but it may refer to any one of them. The fact is that the abstract syllogism does apply to Socrates, but the form of the argument expressed in the syllogism does not have to be a valid syllogism. The mortality of Socrates is contingent upon the agreement of the mortality of all men with established fact. When taken as so applying, the syllogism is an actual proposition and not a tautological one.

What Russell seems to be arguing against in this passage is the absoluteness of ideal possibles occurring as such in actuality. The dilemma is this. If actual things are made ideal, then logic does not seem to be a discipline akin to mathematics and independent of actuality. But if actual things have nothing logical about them, then ideal disciplines such as logic and mathematics belong to a remote realm of essence and bestow their reality only upon a world superior to our actual world. Thus, in protecting realism from the errors of extreme realism, Russell falls into the opposite extreme of nominalism. Logic in the form of "if-then" propositions is not stating anything about logical constants (by which Russell sometimes seems to mean ideal

actuals). Neither Socrates nor mortality is asserted in the Socrates syllogism, but (granted the postulates) merely an invariant relation between them.

The question of contradictions is the final argument which Russell launches against his old position.[11] These are chiefly three: the mathematical, the logical, and the linguistic, and Russell offers an example of each.[12] It will be necessary, therefore, to confine our remarks to a few words about each of these specific contradictions as they are set forth in the Introduction.

Burali-Forti's contradiction rests on the assumption that N is the greatest of ordinals. But the number of all ordinals from O to N is $N + 1$, which is greater than N. Does the solution of this contradiction lie in the simple fact that O is not an ordinal number at all? Zero may be a cardinal but not an ordinal number. A symbol defined by "nothing" is perhaps required for the ordinal, corresponding to the cardinal, zero. For zero is not nothing; it represents the absence of *some*thing, namely, the cardinal number before one. Zero enumerates but does not order.

The second contradiction may be stated in Russell's words:

We know from elementary arithmetic that the number of combinations of $n$ things any number at a time is $2^n$, i.e., that a class of $n$ terms has $2^n$ sub-classes. We can prove that this proposition remains true when $n$ is infinite. And Cantor proved that $2^n$ is always greater than $n$. Hence there can be no greater cardinal. Yet one would have supposed that the class containing everything would have the greatest possible number of terms. Since, however, the number of classes of things exceeds the number of things, clearly classes of things are not things.[13]

The key to this contradiction lies in the theory of sub-classes. Russell's proof that "classes of things are not things" rests on the argument that the last and most inclusive class is not a thing. But if there are sub-classes there may be sub-classes of sub-classes and so on, so that classes form a hierarchical series of inclusiveness, and everything may be a class to the things below and a thing only to the classes above. This would make every

[11] P. xii.
[12] P. xiiif.
[13] P. xiii.

class a thing to the classes above (except the last class which would have no classes above it to make it a thing), and would make every thing a class to the things below (except the first thing, i.e., the actual unique thing, which would have no things below it to make it a class). Then there would be first (i.e., actual unique) things that were not a class, and there would be a last class that was not a thing. But all other classes of things would be things.

The third contradiction is linguistic, and, as Russell himself suggests, following Ramsey, linguistic contradictions can be solved by broad linguistic considerations, and lead to the so-called theory of types. The theory of types is a more detailed formula for which de Morgan's "universe of discourse" had already warned us we should have need. But even the theory of types must be applied judiciously. For instance, Russell wants to apply it to show that classes of things are not things. What should be asserted is that classes are not things in their relation to things but are things in their relation to more inclusive classes. He is correct, however, in asserting that the relations of a thing are not the relations of the class of which that thing is a member.

The fundamental realism of Russell hardly needs to be insisted upon at the last. Russell, as his own remarks betray, is a realist. However, it may be illuminating to show by chapter and verse what a profound realist he was, and perhaps still is. Let us run through *The Principles* for examples of realism. We shall not take the main categories of the work as evidence (although many of them are), but rather be on the lookout for more subtle remarks, on the grounds that the presence of realism in the assumptions will betray itself more clearly in observations and turns of thought, which could only have been implied by an unacknowledged though none the less real and effective fundamentally realistic viewpoint, than it would in more candid expressions.

The symbolic representativeness of words is the first indication we come across in our search. Russell said, "*Words* all have meaning, in the simple sense that they are symbols which stand for something other than themselves."[14] Surely, Russell does

[14] P. 47.

not mean here that words always refer to *actual* objects. The inference clearly is that the reference of *some* words, at least, is to possible objects. Another instance is the wholly realistic "distinction between a class containing only one member, and the one member which it contains."[15] The necessity for the viability of such a distinction is highly indicative of a fundamental position. In the same direction is the warning to beware of the extremely narrow limits of the doctrine that analysis is falsification. The whole may be more than its parts, he pointed out, but they are real parts. And, although analysis cannot give us the whole truth, it can give us truth.[16] "Where the mind can distinguish elements, there must *be* different elements to distinguish; though, alas! there are often different elements which the mind does not distinguish."[17] But just as analytic elements are real so are the synthetic wholes, or complexities. "All complexity is . . . real in the sense that it has no dependence upon the mind, but only upon the nature of the object."[18] Since the "complexities" referred to are not only meant to be those of actual objects, possible organizations alone can be intended.

". . . the whole denial of the ultimate reality of relations" is "rejected by the logic advocated by the present work."[19] These are plain words; and the feeling is unavoidable that Russell meant them. Order is reducible neither to psychology nor to Omnipotence itself.[20] Relations, and not terms, are necessary to order.[21] In a brilliant anticipation of modern macroscopic physics, Russell even went so far as to indicate the relational analysis of matter. Since "the only relevant function of a material point is to establish a correlation between all moments of time and some points of space,"[22] it follows that "we may replace a material point by a many-one relation."[23] The coupling of such a denial of actuality with the rejection of psychology already

[15] P. 130.
[16] P. 141.
[17] P. 466.
[18] *Ibid.*
[19] P. 166.
[20] P. 242.
[21] *Ibid.*
[22] P. 468.
[23] *Ibid.*

mentioned leaves nothing but the reality of a realm of possibility to be intended. This interpretation is confirmed by the assertion that "though a term may cease to exist, it cannot cease to be; it is still an entity, which can be counted as *one*, and concerning which some propositions are true and others false."[24]

As if in support of such a realistic thesis, Russell goes even farther than this in *The Principles*, in a definition of being. He says,

Being is that which belongs to every conceivable term, to every possible object of thought—in short to everything that can possibly occur in any proposition, true or false, and to all such propositions themselves. Being belongs to whatever can be counted. . . . Numbers, the Homeric gods, relations, chimeras and four-dimensional spaces all have being, for if they were not entities of a kind, we could make no propositions about them. Thus being is a general attribute of everything, and to mention anything is to show that it is.[25]

The entities of mathematics have being and truth, since "mathematics is throughout indifferent to the question whether its entities exist,"[26] and "what can be mathematically demonstrated is true."[27] Furthermore, propositions that are true are immutably true:

there seems to be no true proposition of which there is any sense in saying that it might have been false. One might as well say that redness might have been a taste and not a colour. What is true, is true; what is false, is false; and concerning fundamentals, there is nothing more to be said.[28]

But a true proposition is one which makes an assertion about that to which it refers. There is no difference between a true proposition and an asserted proposition.[29] Thus mathematically demonstrated propositions are likewise assertions. But pure mathematics, such as geometry, is likewise "indifferent to the question whether there exist (in the strict sense) such entities

[24] P. 471.
[25] P. 449.
[26] P. 458.
[27] P. 338.
[28] P. 454.
[29] P. 504.

as its premisses define."[30] What else could such non-existential propositions, as those of geometry, assert, except a realm of possibility, of potential being? Since mathematics is "merely a complication" of logic, the primitive ideas of mathematics being those of logic,[31] logic must share the non-existential reference which has been asserted by mathematics.

As a realist (and there can be little doubt that Russell was a realist when he wrote *The Principles*) he was opposed to the earlier positivists, particularly to Mach and Lotze. In the course of his opposition, it is clearly revealed that some of the doctrines of these modern nominalists, the logical positivists, are alien to his position in *The Principles*, since positivism in certain respects remains what it was.

For instance, against Mach's argument of the actual world being only what we find it,

any argument that the rotation of the earth could be inferred *if* there were no heavenly bodies is futile. This argument contains the very essence of empiricism, in a sense in which empiricism is radically opposed to the philosophy advocated in the present work.[32]

The philosophy advocated is "in all its chief features" derived from G. E. Moore,[33] and the G. E. Moore of 1902 was certainly a realist. Russell did in fact see quite clearly what the issue was. "The logical basis of the argument [i.e., the one stated above concerning the rotation of the earth] is that all propositions are essentially concerned with actual existents, not with entities which may or may not exist."[34] And on this argument, Russell had already stated his own position definitively, as we have seen.

The fate of Lotze in Russell's work is no better than that of Mach. Mach had confined reality to actuality; Lotze, so far as Russell was concerned, repeated the same error in other terms, for, after Leibniz, he had defined being as activity.[35] Russell refutes this definition by showing that if activity alone were real, only valid propositions would have being, since these and

[30] P. 372.
[31] P. 429.
[32] P. 492.
[33] P. xviii.
[34] P. 493.
[35] P. 450.

these alone would refer to active objects. But since false propositions which have no reference still have being, "being belongs to valid and invalid propositions alike."[36] Again, the Kantianism of supposing that propositions which are true are so because the mind cannot help but believe them, is an error due to the failure to make the "fundamental distinction between an idea and its object."[37] "Whatever can be thought of has being, and its being is a precondition, not a result, of its being thought of."[38] Thus Russell has, in his refutation of Lotze, rejected nominalism on two scores. He has rejected that objective form of nominalism which consists in holding that actuality alone is real, and he has rejected that subjective form which consists in holding that what the mind knows is real in virtue of being known.

Even now, although he has gone a little way with the logical positivists, he finds himself unable to go the whole way.[39] He is unable, for example, to accept the wholly linguistic interpretation of logic as that doctrine is advanced by Carnap. In rejecting Carnap's two logical languages as being too arbitrary, Russell says that "all propositions which are true in virtue of their form ought to be included in any adequate logic."[40] Indeed, the premisses of the realism which we have just succeeded in tracing in a number of passages from *The Principles* are in direct contradiction with the whole set of basic tenets set forth by the modern school of logical positivists. For instance, against the notion that complexity as well as analytical elements are real,[41] Carnap maintains that the question of reality concerns the parts of a system that cannot concern the system itself.[42] Carnap admits for the logical positivists a following of empiricism,[43] that same brand of empiricism which Russell has ex-

[36] *Ibid.*

[37] *Ibid.*

[38] P. 451.

[39] P. xii, second paragraph.

[40] P. xii.

[41] P. 169, above.

[42] Rudolf Carnap, *Philosophy and Logical Syntax* (London, 1935, Kegan Paul), p. 20.

[43] Rudolf Carnap, *The Unity of Science* (London, 1934, Kegan Paul), pp. 27-28.

plicitly rejected.[44] As for Bridgman, he seems guilty of an extreme case of the same error which afflicted Lotze, and thus would have to fall under the same ban of the Russell who wrote *The Principles*. Lotze made being into activity;[45] Bridgman narrows activity down to a matter of only a certain kind of activity, namely operations.[46] Lotze's second point: the Kantian view that those propositions are true which the mind cannot help but believe,[47] seems also to be held by Bridgman, who maintains that "our thinking mechanism essentially colours any picture that we can form of nature."[48] And finally, the Russell who derived his philosophy "in all its chief features" from the metaphysical realism of the early G. E. Moore[49] could hardly agree with the view of Wittgenstein that "philosophical matters are not false but senseless,"[50] or with Carnap that metaphysics is expressive but not assertive,[51] and that metaphysics is equivalent only to mud.[52] It is questionable whether any man who had understood realism so deeply and embraced it so wholeheartedly could ever change his position, no matter how much he wanted to. Despite Russell's rejection of realism and avowal of nominalism, he is not a nominalist but a realist, and it is the apparently insuperable logical difficulties standing in the path of a realistic interpretation of symbolic logic which shake his faith. In other words, he has not changed his early philosophy; he has merely become uncertain about the prospects of defending it.

This situation presents quite another kind of problem. We do not have any longer to pursue specifically logical answers to paradoxes; we have merely to convince Russell that there are some difficulties with *any* metaphysical interpretation of

[44] P. 171, above.
[45] P. 171, above.
[46] P. W. Bridgman, *The Logic of Modern Physics* (New York, 1928, Macmillan), p. 5.
[47] P. 172, above.
[48] P. W. Bridgman, *The Logic of Modern Physics*, p. xi.
[49] P. 171, above.
[50] Ludwig Wittgenstein, *Tractatus Logico-Philosophicus* (London, 1933, Kegan Paul), 4.003.
[51] Rudolf Carnap, *Philosophy and Logical Syntax*, p. 29.
[52] *Op. cit.*, p. 96.

symbolic logic. Whether these difficulties can be ironed out by an appeal to symbolic logic itself, as Russell suggests,[53] is debatable. It is not easy to see how an empirical fact can conclusively choose its own metaphysical interpretation. Relativity theory in physics seems to demonstrate for the materialists that all is material; it seems to the realists to show that all is resolvable into relations; and it seems to be an argument that the subjectivists can advance in favor of their own mentalism; and so on. Metaphysics is assuredly a world situation, and, although not arbitrary, it is at least broader than any limited empirical situation and thus not determinable in terms of the limited situation. If a metaphysical interpretation had no necessary implications to situations other than the one whose metaphysical nature was being investigated, it is likely that each situation would suggest its own. But metaphysics represents a system of universal implications in which non-contradiction is one of the essential features. Hence, where one empirical fact "seems to suggest" one broad interpretation and another another, we must conclude that at least one of the empirical facts is giving misleading suggestions.

Russell finds himself, before he has done, driven back to an immutable if as yet unknown truth. He is unwilling to accept the veiled subjectivism of the logical positivists' linguistic interpretation of logical truth. Axioms are not arbitrary, as Carnap would have them; they "either do, or do not, have the characteristics of formal truth. . . ."[54] To discover whether they do or do not have these characteristics may be a difficult task indefinitely prolonged; but when we have admitted that the question is not arbitrary we have already admitted that there is such a thing as absolute truth, the knowledge of which we seek to approximate in our limited formulations.

JAMES FEIBLEMAN

NEW ORLEANS, LOUISIANA

[53] P. xiv.
[54] P. xii.

*5*

*G. E. Moore*

RUSSELL'S "THEORY OF DESCRIPTIONS"

# RUSSELL'S "THEORY OF DESCRIPTIONS"

F. P. RAMSEY, in one of his posthumously published writings, used the phrase "that paradigm of philosophy, Russell's theory of descriptions."[1] What statement or statements of Russell's was Ramsey calling "Russell's theory of descriptions?" And what reasons are there for regarding this statement, or these statements, as a "paradigm of philosophy?"

I think there is no doubt that when Ramsey spoke of "Russell's theory of descriptions" he was using the word "descriptions" in one or other of two different technical senses, in each of which Russell has, in different places, used the word. One of these two technical senses is that in which it is used in *Principia Mathematica,* where the word occurs as a title in three separate places;[2] and this sense is one which the authors, where they first introduce the word,[3] try to explain by saying: "By a 'description' we mean a phrase of the form 'the so and so' or of some equivalent form." The other is a sense in which Russell has used the word in two later writings, his *Introduction to Mathematical Philosophy* and his lectures on "The Philosophy of Logical Atomism."[4] And what this other sense is is partly explained by the following sentences from the former, "A 'description'," says Russell,[5] "may be of two sorts, definite and indefinite (or ambiguous). An indefinite description is a phrase

---

[1] *The Foundations of Mathematics and other Logical Essays* (London: Kegan Paul, 1931), 263, n.

[2] *Principia Mathematica,* I², 30; 66; 173. (My references throughout are to the paging of the second edition, which is unfortunately slightly different from that of the first: I indicate this by writing I².)

[3] *Ibid.,* 30.

[4] *The Monist,* XXIX, 2 (April, 1919), 206 ff.

[5] *Introduction to Mathematical Philosophy,* 167.

of the form 'a so-and-so', and a definite description is a phrase of the form 'the so-and-so' (in the singular)." It is clear, I think, that "description" is here being used in a much wider sense than that in which it was used in *Principia*. In *Principia* it was so used that no phrase would be a "description" unless it were what Russell is now calling a "definite description;" in fact, in *Principia* "description" was used as a perfect synonym for the new expression "definite description," in the sense which Russell is now giving to that expression. But here, quite plainly, it is being used in such a sense that immense numbers of phrases which are *not* "definite descriptions" are nevertheless "descriptions." We may say that here "descriptions" is being used as a name for a genus of which "descriptions," in the *Principia* sense, are only one species, the other species being what Russell is now calling "indefinite" or "ambiguous" descriptions.

In which of these two senses, the wider or the narrower one, was Ramsey using the word when he spoke of "Russell's theory of descriptions?" If he were using it in the narrower one, the one in which it is used in *Principia*, he would be saying that some of the statements which Russell has made about phrases of the sort which, later on, he called "definite descriptions," are by themselves sufficient to constitute a "paradigm of philosophy." But, if he were using it in the wider one (the sense in which "indefinite descriptions" are just as truly "descriptions" as "definite" ones), he would not be committing himself to this assertion. On the contrary, it might be his view that, in order to get a "paradigm of philosophy," we have to take into account not only statements which Russell has made about "definite descriptions," but also statements which he has made about "indefinite" ones. Now I think it is pretty certain that, of these two alternatives, the former is the true one. I think Ramsey was using "descriptions" in the narrower of the two technical senses, *not* in the wider one; and that he did consider that statements which Russell has made about "definite descriptions" are by themselves sufficient to constitute a "paradigm of philosophy," without taking into account any of the statements which he has made about "indefinite" ones. And that he was using "descriptions" in the narrower sense—the sense of *Principia*—I think

we have *some* evidence (though not conclusive evidence) in another passage, in which he also speaks of "Russell's theory of descriptions." In this other passage,[6] he says, "A theory of descriptions which contented itself with observing that 'The King of France is wise' could be regarded as asserting a possibly complex multiple relation between kingship, France and wisdom, would be miserably inferior to Mr. Russell's theory, which explains exactly what that relation is." This looks as if he regarded Russell's theory as a theory about phrases which resemble the phrase "*The* King of France" in a respect in which the phrase "*A* King of France" does not resemble it. But whether or not (as I am pretty certain he did) Ramsey meant by "Russell's theory of descriptions" Russell's theory of *definite* descriptions, I am going to confine myself exclusively to statements which Russell makes about *definite* descriptions. Which of these could Ramsey have regarded as constituting his "theory of descriptions?" And why should he have thought them a "paradigm of philosophy?"

Now if we read the three different passages in *Principia* which are headed with the title "Descriptions;"[7] if we then read pp. 172-180 of the chapter entitled "Descriptions" in the *Introduction to Mathematical Philosophy;* and if, finally, we read pp. 209-222 in *The Monist* for April 1919, we shall find that in all those passages, taken together, quite a large number of different statements are made. Which among all those different statements are statements about "definite descriptions?" And which among those which are can be regarded as forming part of "Russell's theory of descriptions?" I propose to begin with one which is a statement about a "definite description;" which nevertheless cannot, I think, be regarded as itself forming part of Russell's theory of descriptions; but which is such that, by reference to it, two of the most fundamental propositions which do, I think, form a part of that theory, can be explained.

The statement I mean is one which is made by Russell on p.

---

[6] *Foundations of Mathematics,* 142.
[7] *P.M.,* I[2], 30-1; 66-7; 173-186.

177 of the *Introduction to Mathematical Philosophy*. He there writes out in a list the three following propositions:

(1) at least one person wrote *Waverley*

(2) at most one person wrote *Waverley*

(3) whoever wrote *Waverley* was Scotch

and then proceeds to make about these three propositions the following statement:

All these three are implied by "the author of *Waverley* was Scotch." Conversely, the three together (but no two of them) imply that the author of *Waverley* was Scotch. Hence the three together may be taken as defining what is meant by the proposition, "the author of *Waverley* was Scotch."

Now it is quite clear that, in making this statement, Russell has made a considerable number of different assertions. But it seems to me that the language which he has used in making them is, in some respects, such as not to make it quite clear just what he is asserting. I will mention in order the chief respects in which this seems to me to be the case.

It will be seen that he has expressed the proposition numbered (3) by the words "whoever wrote *Waverley* was Scotch." Now it seems to me that the most natural way, and even, so far as I can see, the *only* natural way of understanding these words, is as expressing a proposition which cannot be true unless somebody did write *Waverley:* i.e., is such that the proposition "whoever wrote *Waverley* was Scotch, but nobody did write *Waverley*" is self-contradictory. But, if Russell had been using the words in such a sense as this, then clearly his statement that though (1), (2) and (3) together imply that the author of *Waverley* was Scotch, yet *no two of them* do imply this, would be false: for (3) would imply (1), and hence (3) and (2) by themselves would imply everything that is implied by (1), (2), and (3) together. It is certain, I think, not only from this fact but from other things, that he was using these words in a sense such that the proposition expressed by them does not imply (1). And I think that the proposition which he was using them to express is one which can be expressed more clearly by the words, "There never was a person who wrote *Waverley* but

was not Scotch." In the case of this proposition, which I will call (4), it is, I think, quite clear that it does not imply (1), but is quite consistent with the falsehood of (1); for it is quite clear that if (1) were false, (4) would necessarily be true: if nobody ever did write *Waverley*, it would follow that there never was a person who did write *Waverley* but was not Scotch. I shall assume that (4) is the proposition which Russell was intending to express (improperly, as I think) by the words "whoever wrote *Waverley* was Scotch." And I shall assume that he was intending to assert of (1), (2), and (4) all the things which he actually asserts of (1), (2), and (3).

The next point as to which there might, I think, be some doubt, is as to how he is using the word "implies." I shall assume that he is so using it that one proposition $p$ can only be said, with truth, to "imply" another $q$, if it can also be said with truth that $q$ follows from $p$, and that the assertion that $p$ was true but $q$ false would be not merely false but *self-contradictory*. It follows that the meaning with which "implies" is being used here is not what the authors of *Principia* describe[8] as "the special meaning which we have given to implication," and which they say[9] they will sometimes express by the compound expression "material implication." For this "special meaning" is such that, provided it is false that $p$ is true and $q$ false, then it follows that it can be said with truth that $p$ implies $q$. It is clear, I think, that Russell was not here using "implies" with this special meaning; for, if he had been, his assertion that no two of the propositions (1), (2), and (3) imply that the author of *Waverley* was Scotch, would have been obviously false. For, in fact, it is true that the author of *Waverley* was Scotch, and consequently, if "implies" be used in the special sense adopted in *Principia*, it follows that not merely any *two*, but any *one* of the three propositions, (1), (2), and (3) implies that the author of *Waverley* was Scotch; it follows, in fact, that any other proposition whatever, true or false, implies it—for instance, the proposition that the moon is made of green cheese. I feel no doubt that Russell was here using "implies," not in

[8] *Ibid.*, 99.
[9] *Ibid.*, 7.

this "special" sense, but in one of the senses which the word can properly bear in English; nor yet that he was using it in that one among its common senses, in which $p$ cannot be truly said to imply $q$, unless the proposition that $q$ is false is inconsistent or incompatible with the proposition that $p$ is true; unless it is *impossible* that $p$ should be true and $q$ false; unless, if $p$ is true, $q$ *must* be true too—is *necessarily* true too. In other words, "implies" is being used in such a sense, that a *necessary* condition for its being true that $p$ implies $q$ is that it shall be *self-contradictory* to assert that $p$ is true but $q$ is false. But I do not think it is being used in such a sense that the fact that it would be self-contradictory to assert that $p$ is true but $q$ false is a *sufficient* condition for its being true that $p$ implies $q$. I doubt if there is any common sense of "implies" such that this is a *sufficient* condition. For, of course, the assertion that $p$ is true but $q$ false will necessarily be self-contradictory, if the assertion that $p$ is true is by itself self-contradictory, or the assertion that $q$ is false is by itself self-contradictory. But I do not think that in ordinary language "implies" is ever so used that in all cases where this is so, it would be true to say that $p$ implies $q$.

Owing to the ambiguity of the word "implies," I think it is often desirable where, as here, we are concerned with what it expresses when used with that particular one among its common meanings which I have tried to describe (though, of course, I have not attempted to define it), to use another word instead, as a synonym for "implies" when used in this particular way. And I shall do that now. I shall use the word "entails." I shall express the proposition which (I take it) Russell is here expressing by saying that the proposition "the author of *Waverley* was Scotch" both implies and is implied by the proposition which is the conjunction of (1), (2) and (4) by saying that each of these two propositions *entails* the other, or that they are "logically equivalent."

The third point which seems to call for some explanation is Russell's use of the phrase "may be taken as defining what is meant by." I take it that he is here using the expression "may be taken as defining," in what, I think, is its most natural sense, namely as meaning "may, *without error*, be taken as defining:"

in other words, he is asserting that any person who should "take it" that (1), (2) and (4) do define what is meant by the proposition "the author of *Waverley* was Scotch," would not be in error—would not be making a *mistake*—in "taking it" that this was the case. But, if he is asserting this, then his whole assertion is logically equivalent to the assertion that (1), (2) and (4) *do* define what is meant by the proposition in question: if a person would not be in error in "taking it" that $p$ is the case, it follows that $p$ is the case; and if $p$ is the case, it follows that a person would not be in error in taking it that $p$ is the case. Russell is therefore implying that the conjunction of (1), (2) and (4) *does* "define what is meant by" the proposition in question. But what can be meant by saying that one proposition "defines what is meant by another?" To define, in the commonest sense in which that word is used, is to "give a definition of" in a sense in which a *person* may give a definition (true or false) but in which a *proposition* cannot possibly do any such thing. If we talk of a proposition "defining what is meant by" something else, we must be using "define" in some sense which can be defined in terms of that other sense of "define" in which persons sometimes define but propositions never do. And I think it is plain enough what the sense is in which a proposition may be said "to define." To say that the conjunction of (1), (2) and (4) defines what is meant by the sentence S means neither more nor less than that anyone who were to assert "The sentence S means neither more nor less than the conjunction of (1), (2) and (4)" would be giving a *correct* definition of what is meant by the sentence S. But if we say that anyone who were to assert that the sentence S means neither more nor less than the conjunction of (1), (2) and (4) would be giving a *correct* definition of what is meant by S, we are saying two distinct things about any such person: we are saying (a) that *what* he asserts is true, i.e., that the sentence S *does* mean neither more nor less than the conjunction of (1), (2) and (4), and we are saying also (b) that what he asserts is of such a nature that he can properly be said to be *giving a definition* of S (or of the meaning of S) by asserting it. These two things are certainly distinct, because by no means every true assertion of the form

"The sentence S means neither more nor less than *p*," is such that it can properly be called a *definition* of *p*. The assertion "The sentence '*au moins une personne a écrit* WAVERLEY' means neither more nor less than that at least one person wrote *Waverley*" is (I believe) true; but a person who asserts it is certainly not *giving a definition* of the French sentence named. And the assertion, "The sentence, 'The sun is larger than the moon' means neither more nor less than that the moon is smaller than the sun" is certainly true, and yet anybody who asserted it would certainly not be *giving a definition* of the English sentence named. To give one last example: The assertion, "The sentence 'George VI is a male sibling' means neither more nor less than that George VI is a brother" is true but is certainly not a definition of the sentence "George VI is a male sibling;" whereas, on the other hand, the assertion "The sentence 'George VI is a brother' means neither more nor less than that George VI is a male sibling," which again is true, is also such that anybody who were to assert it could be correctly said to be *giving a definition* of one correct use of the sentence "George VI is a brother." On the question what conditions a statement of the form "*s* means neither more nor less than *p*" must satisfy if it is properly to be called a *definition* of the meaning of *s*, it will be necessary to say something later. For the present I only wish to make clear that I shall assume that, when Russell says "The conjunction of (1), (2) and (4) may be taken as defining what is meant by the proposition "the author of *Waverley* was Scotch," he is committing himself to the two assertions, (a) that the proposition "the author of *Waverley* was Scotch" means neither more nor less than the conjunction of (1), (2) and (4), and (b) that anybody who asserts (a) can be correctly said to be "giving a definition," and (since (a) is true) a *correct* definition of the meaning of the proposition named.

But now we come to one final point. What Russell actually says is that (1), (2) and (4) may be taken as defining what is meant by the *proposition* "the author of *Waverley* was Scotch;" he does not say that they may be taken as defining what is meant by the *sentence* "the author of *Waverley* was Scotch." If, therefore, I am right in what I said in the last paragraph, he is com-

mitting himself to the assertion that the *proposition* "the author of *Waverley* was Scotch" means neither more nor less than the conjunction of (1), (2), and (4); but is he also committing himself to the assertion that the *sentence* "the author of Waverley was Scotch" means neither more nor less than the conjunction of (1), (2) and (4)? It is quite certain, I think, that an expression which consists of the words "the proposition" followed by a given sentence in inverted commas, *can* be properly used in such a way that it has *not* the same meaning as the expression which consists of the words "the sentence" followed by the same sentence in inverted commas; and I am inclined to think that it can *not* be properly used in such a way that it *has* the same meaning. The *proposition* "The sun is larger than the moon" is the *same* proposition as the *proposition "Le soleil est plus grand que la lune,"* and one would be misusing the word "proposition," if one used it in such a sense that they were *not* the same; but the *sentence,* "The sun is larger than the moon" is *not* the same sentence as the *sentence "Le soleil est plus grand que la lune,"* and one would be misusing the word "sentence" if one used it in such a sense that they were the same. If we write the words, "the sentence" before a sentence in inverted commas, we shall be misusing language unless we are using the sentence in inverted commas *merely* as a name for itself and in no other way; but if we write the words "the proposition" before the very same sentence in inverted commas, we shall certainly not be misusing language if we are *not* using the sentence in inverted commas merely as a name for itself, and I think we *shall* be misusing language if we *are* using it merely as a name for itself. If we had to translate into French the sentence "The proposition 'the person who wrote *Waverley* was Scotch' implies that at least one person wrote *Waverley*," we should certainly not be giving an incorrect translation, if for the English sentence "the person who wrote *Waverley* was Scotch" we substituted the French sentence *"la personne qui a écrit* WAVERLEY *était une personne écossaise,"* and wrote *"La proposition 'la personne qui a écrit* WAVERLEY *était une personne écossaise' implique qu'au moins une personne a écrit* WAVERLEY," and I *think* we should be giving a definitely incorrect transla-

tion, unless we *did* substitute the French sentence for the English one; but if we had to translate, "The sentence 'the person who wrote *Waverley* was Scotch' means neither more nor less than the conjunction of (1), (2) and (4)" our translation would be definitely incorrect if we did substitute a French sentence for the English sentence "the person who wrote *Waverley* was Scotch." It appears, then, that if Russell had written "The proposition 'the author of *Waverley* was Scotch' means neither more nor less than the conjunction of (1), (2) and (4)," he would not have been using language incorrectly, if the assertion which he was making by the use of these words had been precisely the same as he might have made quite correctly by substituting for the English sentence "the author of *Waverley* was Scotch" a French sentence which was a correct translation of it. But suppose he had used such a French sentence, instead of the English one: would he, in that case, have been committing himself to any statement at all about the meaning of the English one? It seems to me to be quite certain that from the proposition or assertion or statement "The *proposition* '*l'auteur de* WAVERLEY *était une personne écossaise*' means neither more nor less than the conjunction of (1), (2) and (4)" *by itself* nothing whatever follows about the English *sentence* "the author of *Waverley* was Scotch;" although perhaps from the conjunction of this statement with the statement "The sentence 'the author of *Waverley* was Scotch' is a correct translation of the sentence '*l'auteur de* WAVERLEY *était une personne écossaise*'," it will follow that the *sentence* "the author of *Waverley* was Scotch" means neither more nor less than the conjunction of (1), (2) and (4). And I think, therefore, that a person who were to assert "The proposition 'the author of *Waverley* was Scotch' means neither more nor less than the conjunction of (1), (2) and (4)" would perhaps, if he were using the expression "the proposition 'the author of *Waverley* was Scotch'" correctly, *not* be committing himself to the assertion that the *sentence* "the author of *Waverley* was Scotch" means neither more nor less than the conjunction of (1), (2) and (4). But I feel no doubt that when Russell said "the conjunction of (1), (2) and (4) may be taken as defining what is

meant by the *proposition* 'the author of *Waverley* was Scotch'," he was (whether correctly or incorrectly) using the expression "the proposition 'the author of *Waverley* was Scotch' " in such a way that he was committing himself to the assertion that the *sentence* "the author of *Waverley* was Scotch" means neither more nor less than the conjunction of (1), (2) and (4); and I shall assume that this was so.

But now, assuming that in all these four respects I am right in my interpretation of Russell's words, it follows that among the various assertions which he was making in the statement quoted, two are as follows:

(a) The proposition that the author of *Waverley* was Scotch both entails and is entailed by the proposition that (1), (2) and (4) are all of them true; or, in other words, these two propositions are logically equivalent.

(b) The *sentence* "the author of *Waverley* was Scotch" means neither more nor less than the conjunction of (1), (2), and (4); and any one who says that it does, will, by so saying, be giving a definition of its meaning.

Are these two assertions, (a) and (b), true?

It is, I think, worth noticing that neither can be true, unless the expression "is the author of" can properly be used in such a sense that a person who is not male can be correctly said to have been "the author" of a given work; unless, for instance, Jane Austen can be properly said to have been "the author" of *Pride and Prejudice*. For it is quite certain that the conjunction of (1), (2) and (4) implies nothing whatever as to the sex of the person who wrote *Waverley*. Consequently, if nobody who is not male can properly be called an author, (b) cannot possibly be true, since there would then be no sense in which the sentence "the author of *Waverley* was Scotch" can properly be used, in which *all* that it means is the conjunction of (1), (2) and (4): that sentence would in any proper use mean *also* that some *male* person composed *Waverley*. And for the same reason the assertion of (a) that the conjunction of (1), (2), and (4) entails that the author of *Waverley* was Scotch would be false. For if the only proper use of "author" were such that nobody could have been the author of *Waverley* except a male,

then (1), (2) and (4) would be quite consistent with the proposition that *nobody* was the author of *Waverley*, and therefore also with the proposition that it is not the case that the author of *Waverley* was Scotch, which would necessarily be true if nobody was the author of *Waverley*. It is, therefore, only if Jane Austen can be properly said to have been the author of her novels, that (a) and (b) can be true. But I think it does not follow from this that (a) and (b) are false, since I think it is questionable whether "author" cannot be properly thus used, without any implication of male sex.

But I think that (a) and (b) are both of them unquestionably false for another reason. The reason is that there is no proper use of the word "author," which is such that the statement that a given person did not write a given literary composition is inconsistent with the statement that he was its author. Scott might perfectly well have been the author of *Waverley* without having *written* it. And my reason for saying this is not the obvious fact that he certainly might have been the author, even if he had dictated every word of it to an amanuensis and not written a word himself. I think this would have been a bad reason, because, so far as I can see, we have so extended the meaning of the word "write" that a person who has only dictated an original composition of his own may quite properly be said to have "written" it; perhaps he may be so said even if he only dictated it to a dictaphone. But it is surely unquestionable that a poet who, before the invention of writing, composed a poem or a story which was never written down, can *not* be properly said to have "written" it and yet may undoubtedly have been its *author*. There is no legitimate sense of the word "author" in which he will not have been its author, provided that he invented or composed it without the collaboration of any other person, and provided also that no other person or set of persons invented or composed the same poem or story independently. I think this shows clearly that there is no legitimate sense of the word "author" such that the proposition that a given person was the author of a given work is inconsistent with the proposition that the work in question was never written at all. It might have been true at the same time both that Scott was the author

of *Waverley* and also that *Waverley* was never written at all: there is no *contradiction* in supposing this to have been the case. He certainly would have been its author, if he had composed or invented the whole of it by himself, without collaboration, and if also no other person or set of collaborators had invented it independently; and it is certainly *logically possible* that this should have happened, without *Waverley's* having ever been written. I think, therefore, that it is a sheer mistake on Russell's part to say that "the author of *Waverley* was Scotch" implies "at least one person wrote *Waverley*." It does *not* imply this: the proposition "the author of *Waverley* was Scotch, but it is not the case that at least one person wrote *Waverley*" is not self-contradictory. (a), therefore, I think, is certainly false. And (b) is false too, for the same reason. There is no legitimate use of the sentence "the author of *Waverley* was Scotch" which is such that this sentence means neither more nor less than the conjunction of (1), (2) and (4). In its only legitimate use it means *less* than this conjunction. It does mean (if "author" can be properly used without implying male sex) neither more nor less than that at least one person invented *Waverley*, at most one person invented *Waverley*, and there never was a person who invented *Waverley* but was not Scotch. But to assert this conjunction is to assert *less* than to assert the conjunction (1), (2) and (4); since to assert that at least one person *wrote* *Waverley* is to assert that at least one person *invented* it, *and* something *more* as well.

Russell's statements (a) and (b) are, then, certainly false; but the fact that they are so makes nothing against his "theory of descriptions," since they form no part of that theory. And, though they are false, they will, I think, serve just as well as if they were true to explain the nature of two statements, which do, as far as I can see, form part of that theory and which, I think, are true.

I. The first of these two statements is a statement with regard to a class of propositions of which (a) is a member. And what it asserts with regard to this class is *only* that enormous numbers of propositions which are members of it are true. It

does not assert, with regard to any particular member of the class, that that particular member is true, nor does it assert that *all* of its members are true.

What is the class of propositions with regard to which it makes this assertion?

I think it can be defined by first defining a certain class of English *sentences*, which I will call "class C." Once we have defined this class of *sentences*, C, we can define the class of *propositions*, with regard to which I. makes the assertion that enormous numbers of them are true, by reference to this class of sentences.

What then is the class of sentences which I am proposing to call "Class C?"

It is a class of which the following sentence, which I will call "S," is a member, viz., "The proposition 'the author of *Waverley* was Scotch' both entails and is entailed by the proposition 'at least one person wrote *Waverley*, at most one person wrote *Waverley*, and there never was a person who wrote *Waverley* but was not Scotch'," and the rest of the members of class C are those sentences, and those only, which resemble S in certain respects which have now to be defined.

(This sentence, S, it will be seen, is merely another way of expressing that very same proposition of Russell's which I called (a), but which I then expressed by a different sentence.)

(1) In order to be a sentence which resembles S in the respects in question, a sentence must first of all resemble it in the following respects: it must begin with the words "the proposition;" these words must be immediately followed by an English sentence enclosed between inverted commas; this sentence must be immediately followed by the words "both entails and is entailed by the proposition;" these words again must be immediately followed by another English sentence enclosed between inverted commas—a sentence which is not identical with the earlier one enclosed between inverted commas; and this second sentence in inverted commas must complete the whole sentence. It is obviously very easy to tell whether a sentence does fulfil these conditions or not; and it is obvious that S does fulfil them.

(2) But, in order that a sentence, other than S, should belong to the class C, it is by no means sufficient that it should resemble S in the respects just mentioned under (1). It must also resemble S in other respects; and these other respects concern the two sentences in inverted commas which it must contain. These two sentences must resemble the two in inverted commas which S contains in the following respects: (α) the first of them must, like the first in S, begin with the word "the" followed by a noun in the *singular*, though it need not be *immediately* followed by such a noun—there may be an adjective in between: e.g., "the male inhabitant of London" or "the first President of the United States" will be just as good beginnings as "the author of *Waverley;*" (β) the second of them must, like the second in S, consist of three separate sentences, the last two of which are joined by the word "and;" and of these three sentences (again as in S) the first must begin with the words "at least one," the second with the words "at most one," and the third with the words "there never was" or with "there is not" or with "there will not be," while also there must be one identical phrase which occurs in all three of them, just as "wrote *Waverley*" occurs in all three of those which occur in the second in S. And finally (γ) the second of the two sentences in inverted commas must end with the same word or phrase as the first, just as, in S, they both end with the word "Scotch," though here, perhaps, it should be added that this will be only true if "stinks" is counted as the same word as "stink," and "limps" as "limp," etc., etc.

Here again, I think, there is no difficulty whatever in seeing whether a sentence, which does satisfy the conditions mentioned in (1), also satisfies these further conditions or not. S obviously does satisfy them; and they will also obviously be satisfied by each of the four sentences, satisfying the conditions of (1), in which the first and second sentences within inverted commas are the following pairs: "the chop in that cupboard stinks" and "at least one among all the things which exist at present is a chop in that cupboard, at most one among all the things which exist at present is a chop in that cupboard, and there is not any among all the things which exist at present which is a chop in that cupboard and which does not stink;" "the male inhabitant

of London limps" and "at least one person is a male inhabitant of London, at most one person is a male inhabitant of London, and there is not any person who is a male inhabitant of London and who does not limp;" "the first President of the United States was called 'Jefferson'" and "at least one person was President of the United States before any one else was, at most one person was President of the United States before any one else was, and there never was a person who was President of the United States before any one else was and who was not called 'Jefferson';" "the next book I shall read will be a French one" and "at least one book will be read by me before I read any other, at most one book will be read by me before I read any other, and there will not be any book which will be read by me before any other and which will not be a French one."

There is, therefore, no difficulty in understanding what class of *sentences* I am proposing to call "class C;" and a class of *propositions*, which I will call "class Γ," can be defined by reference to C as follows: A proposition will be a member of class Γ if and only if some sentence belonging to class C will, if the word "entails" is used in the way I have explained, and if the rest of the sentence is used in accordance with correct English usage, express that proposition.

Now of the propositions which belong to class Γ enormous numbers are false. Russell, as we have seen, happened to hit upon a false one, namely (a), which he declared to be true. But, though enormous numbers are false, I think it is also the case that enormous numbers are true; and I think there is no doubt that one proposition or statement which forms a part of Russell's "theory of descriptions" is this true statement that

> *Enormous numbers of propositions which are members of Class Γ are true.*

That this is true seems to me to be quite certain. Consider, for example, the C-sentence "The proposition 'the King of France is wise' both entails and is entailed by the proposition 'at least one person is a King of France, at most one person is a King of France, and there is nobody who is a King of France and is not wise' "—a sentence in which the first sentence en-

closed in inverted commas is the very sentence which Ramsey used in the statement about the theory of descriptions which I quoted above.[10] To anyone who understands English a very little reflection is, I think, sufficient to make it obvious that if, in this sentence, the word "entails" is being used in the way I explained, and if the rest of the sentence is being used in accordance with correct English usage, then the proposition which it expresses, which is, in that case, a $\Gamma$-proposition, is true. And, once this is seen, it is surely also obvious that it would be possible to go on indefinitely producing other examples of $\Gamma$-propositions which are true. That this is so, is, I think, obvious as soon as it is pointed out. But had anyone before Russell pointed it out? I do not know. But it seems to me that, in philosophy, it is often a great achievement to notice something which is perfectly obvious as soon as it is noticed, but which had not been noticed before. And I am inclined to think that it was a great achievement on Russell's part to notice the obvious fact that enormous numbers of $\Gamma$-propositions are true.

II. A second statement which seems to me to form part of the theory of descriptions is, like this last, a statement with regard to a certain class of propositions, to the effect that enormous numbers of propositions of that class are true. The class in question is a class of which the false proposition of Russell's which I have called (b) is a member, and I propose to call this class "class $\Delta$." The statement which the theory of descriptions makes about $\Delta$-propositions is only that enormous numbers of them are true: it does not state that all are, nor does it state with regard to any particular $\Delta$-proposition that that one is true.

This class of propositions, $\Delta$, can be defined by reference to a particular class of English *sentences* which I propose to call "D." A proposition will belong to $\Delta$, if and only if it can be properly expressed in English by a D-sentence; but, of course, the same proposition may also be capable of being properly expressed by sentences which are not D-sentences. Sentences

[10] See p. 179 above.

which are exact translations of a D-sentence in a foreign language will also properly express $\Delta$-propositions, and there may be English sentences which are not D-sentences, but which may be properly used to express the same proposition which a D-sentence expresses.

What class of sentences it is that I am proposing to call "D-sentences" can, I think, be most easily explained by reference to the class of C-sentences. A sentence will be a D-sentence, if and only if there is some C-sentence from which it differs and which it resembles in the following respects. Take any C-sentence you like: you will obtain the D-sentence which corresponds to it as follows. Substitute for the words "the proposition" with which the C-sentence begins the words "the sentence;" write down next, within inverted commas, the very same sentence which comes next in the C-sentence within inverted commas; then substitute for the words "both entails and is entailed by the proposition," which come next in the C-sentence, the words "means neither more nor less than that;" then write after those words, but *without putting it in inverted commas,* the very same sentence which is the second sentence in inverted commas in the C-sentence; and finally add at the end the words "and anyone who says that it does will be giving a definition of its meaning." Thus, if we take the C-sentence which I have called "S," the corresponding D-sentence will be "The sentence 'The author of *Waverley* was Scotch' means neither more nor less than that at least one person wrote *Waverley,* at most one person wrote *Waverley,* and there never was any person who wrote *Waverley* but was not Scotch; and anyone who says that it does will, by so saying, be giving a definition of its meaning." It will be seen that this particular D-sentence is merely another correct way of expressing the very same false proposition of Russell's which I called "(b)" above, but which I then expressed by a different sentence; and that therefore this proposition (b) *is* a member of the class of propositions which I am calling "$\Delta$," since it *can* be properly expressed by a D-sentence.

Now it is certain that enormous numbers of $\Delta$-propositions are false; but what this statement II of the theory of descriptions

asserts is only that enormous numbers are true. And this, I believe, is a true statement.

So far as I can see, the only way of seeing that it is true, is to see, in the case of some one particular Δ-proposition, that *it* is true, and then to see that an indefinite number of others could be found which are certainly also true, if this one is.

Now the following Δ-proposition seems to me to be true: namely "The sentence 'The King of France is wise' means neither more nor less than that at least one person is a King of France, at most one person is a King of France, and there is not anybody who is a King of France and is not wise; and anyone who says that it does, will, by so saying, be giving a definition of its meaning."

Is this proposition true?

We have to consider two points; namely (α) whether the the sentence "The King of France is wise," a sentence which I will now call "T," does mean neither more nor less than what this Δ-proposition says it does, and (β) whether anybody who says it does, will, by so doing, be "giving a definition" of the meaning of T. I will consider (β) first.

(β) I have already pointed out[11] that a person who makes an assertion of the form "the sentence *s* means neither more nor less than the proposition *p*" can by no means always be properly said to be giving a definition of the meaning of *s* by so doing. And the question whether he is giving a definition or not seems to me to depend on whether or not the *sentence* which he is using to express *p* is or is not related in one or other of certain ways to the *sentence s*. Now, in stating above the Δ-proposition about T, which I said I believed to be true, the sentence which I used to state the proposition about which that proposition asserted that T meant neither more nor less than it, was the sentence "at least one person is a King of France, at most one person is a King of France, and there is not anybody who is a King of France and is not wise,"—a sentence which I will now call "U." Now U has to T the following relation: it contains words or phrases which *mention separately* a greater number of distinct conceptions or "objects" than are mentioned separately in T. Thus we can say

[11] See p. 184 above.

that T and U both mention separately the conceptions of kingship and wisdom and the "object" France; but U mentions separately in addition the conception expressed by "at least one . . . ," that expressed by "at most one . . . ," that expressed by "there is . . . ," and the conception of negation; and even if we can say that T mentions separately some conception or conceptions, besides kingship and wisdom, it certainly does not mention separately as many more as U does. That the sentence which expresses the *definiens* in a definition does thus, as a rule, *mention separately* a greater number of conceptions than are mentioned by the sentence which is or expresses the *definition*, is, I think, the reason why the authors of *Principia* were able to say[12] that some of their definitions "contain an analysis of a common idea." But I do not think that the mere fact that, in making a statement of the form "*s* means neither more nor less than *p*," the sentence used to express *p* mentions separately a larger total number of conceptions or objects than *s* does, is by itself a sufficient reason for saying that the person who makes such a statement is giving a definition of *s*. Consider the two following statements. "The sentence 'the sun is larger than the moon' means neither more nor less than that anyone who were to believe that the sun is larger than the moon would not be in error in so believing." "The sentence 'the sun is larger than the moon' means neither more nor less than that it is false that it is false that the sun is larger than the moon." In both these cases the second sentence used certainly mentions separately a greater total number of conceptions and objects than the sentence in inverted commas; and yet I do not think that a person who were to assert either of those things, could be properly said to be giving a definition, either correct or incorrect, of the meaning of the sentence in inverted commas. But both these cases obviously differ from the case of T and U, in the respect that the second sentence used *contains as a part* the very same sentence with regard to the meaning of which an assertion is being made; whereas U does not contain T as a part of itself. And I think that this is a sufficient reason for saying that a person who were to make either of those two assertions would not, by making them, be giving a

[12] *P.M.*, I², 12.

definition at all. It may, perhaps, be suggested that he might be giving a definition, but that, if he were, it would be a circular one. But I think it is not incorrect to say that a circular definition is not a definition at all. One may, of course, commit a *circulus in definiendo*—that is to say, one may commit a circle in *trying* to define; but I think it is not incorrect to say that, if one does, then one has not succeeded in defining at all, either correctly or incorrectly. However that may be, it is, so far as I can see, a sufficient condition for saying that, in making an assertion of the form "*s* means neither more nor less than *p*," one has *given a definition* (correct or incorrect) of *s*, that the sentence used to express *p* should (1) mention separately a greater total number of conceptions and objects than *s* does and (2) should also not contain as a part of itself either *s* or any other sentence which has the same meaning as *s*. If this is so it follows that a person who uses U to say what T means, will, by so doing, be giving a *definition* (though, perhaps not a correct one) of the meaning of T. But though this, which I have stated, seems to me a *sufficient* condition for saying that a person who makes an assertion of the form "*s* means neither more nor less than *p*" is, by so doing, giving a definition, correct or incorrect, of the meaning of *s*, I do not think that it is a *necessary* condition. For it seems to me that a person who were to say "The sentence 'It is true that the sun is larger than the moon' means neither more nor less than that the sun is larger than the moon" might be correctly said to be giving a definition of the meaning of the sentence "It is true that . . . etc.;" and here condition (1) is certainly not fulfilled. But, so far as I can see, it is only where, as in this case, the sentence used to express the *definiens*, or some sentence which has the same meaning, forms a part of the sentence which is the *definitum*, that one can be properly said to be giving a definition in spite of the fact that (1) is not fulfilled.

I think, therefore, there is no doubt that any person who says "The sentence T means neither more nor less than that at least one person is a King of France, at most one person is a King of France, and there is not anybody who is a King of France but is not wise" can be properly said to be giving a definition of the meaning of the sentence T. But will he be giving a *correct* one?

He will be doing so only if this assertion which he makes is true; i.e., if the sentence T *does* mean neither more nor less than what he says it means. But does it?

This is the question which I called (α) above (p. 195).

(α) Let us call the assertion, with regard to which we are here asking whether it is true, "P." If we want to consider whether or not P is true, it is, I think, very important to distinguish P clearly from another proposition with which it is liable to be confused. In stating P, I have, as I pointed out in discussing (β), made use of the sentence U, that is to say, the compound sentence "at least one person is a King of France, at most one person is a King of France, and there is not anybody who is a King of France and is not wise." But I was not, in stating P, using U merely as a name for itself, whereas I was using T merely as a name for itself. That I was not so using U is clearly shown by the fact that it was preceded by the words "means neither more nor less than *that*." Wherever a sentence is preceded by a "that," used in this particular way, not as a demonstrative but as a conjunction, it is, I think, a sign that the sentence in question is not being used *merely* as a name for itself, but in the way in which sentences are most often used—a way which can, I think, be not incorrectly described by saying that they are used to express propositions. It is true that I could have expressed P, not incorrectly, in another way; namely, instead of writing U preceded by "that" and *not* putting inverted commas round it, I might have written, instead of "that," the words "the proposition," and followed these words by U *in inverted commas*. The fact that U, in inverted commas, was preceded by the words "the proposition" would again have been a sign that U was not being used *merely* as a name for itself. What I could not have done, if I wanted to express P correctly, is to write instead of the word "that" the words "the sentence," and to follow these words by U in inverted commas. For the fact that U, in inverted commas, was preceded by the words "the sentence" or "the words" would have been a sign that U was being used *merely* as a name for itself; and hence this would not have been a correct way of expressing P. Yet I am afraid it is not uncommon among philosophers to make, in similar cases,

a confusion, which, if they made it in this case, would consist in supposing that P is identical with the proposition "T means neither more nor less than U." In the sentence which I have just used to express this latter proposition, the words "means neither more nor less than" are, of course, used (quite correctly) as short for "means neither more nor less than *is meant by*." But in the sentence which I used to express P, the same words "means neither more nor less than" are not short for "means neither more nor less than *is meant by*," because the words which follow (i.e., the sentence U) are not being used merely as a name for themselves: "means" is being used in an equally correct and a more primitive way. It would be strange, would it not, if "means" were *always* used to mean "means what is meant by." Yet I am afraid it is not uncommon to suppose that when we give a definition by saying, e.g., "the expression 'is a triangle' *means* 'is a plane rectilineal figure, having three sides'," the statement we are making is identical with the statement "the expression 'is a triangle' *means what is meant by* the expression 'is a plane rectilineal figure, having three sides'." Mr. W. E. Johnson, in his *Logic*, seems to suppose this; but he also makes a true remark, which shows quite clearly that he was wrong in so supposing. His true remark is that, when we give a definition, a hearer or reader will not understand our definition unless he understands the expression which we use to express our *definiens*. I think this is obviously true; but if it is true, it follows that we are never giving a definition, if we merely say of one expression that it means what is meant by another. For, if this is all we are saying, a hearer or reader can understand us perfectly without needing to understand *either* of the expressions in question. I might, for instance, point to two sentences in a book, written in a language I do not understand at all, and say (pointing at the first) this sentence means what is meant by that (pointing at the second). And I might, by accident, or because somebody who knew the language had told me so, be right! The first sentence might really mean what is meant by the second, and the second might really be so related to the first that it could be *used* to give a definition of the first. Suppose this were so: then a person who saw the

sentences and understood the English words "means what is meant by" would be able to understand my assertion perfectly, without understanding either of the two sentences any better than I did! Since, therefore, it is *not* necessary, in order to understand such a statement, that either sentence be understood, it follows that such a statement is *never* a definition. Now P *is* a definition: that is to say, anyone who asserts P can be properly said to be giving a definition of the meaning of T. It follows that P is *not* the same proposition as "T means neither more nor less than is meant by U;" since this latter proposition could be understood perfectly by a person who did not understand either T or U. The important point is that, when I *use* U in stating P, I am not using U merely as a name for itself; whereas if I say "T means neither more nor less than U," I *may* be using U merely as a name for itself, and, if so, am not asserting P.

Let us call the proposition "T means neither more nor less than is meant by U" "Q." Even if it be admitted that, as I have argued, Q is *not* the same proposition as P, though liable to be confused with it, there is, I think, still a great temptation to suppose that P follows from Q, and Q from P, i.e., that P and Q mutually entail one another. But this, I think, is a mistake. From P, *by itself*, Q does not follow: it is only from P, *together with another premise*, that Q follows; and why there is a temptation to think that P, *by itself*, entails Q, is because this other premise is so obviously true that people assume it without noticing that they are doing so. And similarly from Q, *by itself*, P does not follow: it is only from Q, *together with another premise*, that P follows; but here again the other premise is so obviously true, that we are tempted to think that Q, by itself, entails P. What is the other premise which must be conjoined with P in order that we may be entitled to infer Q? I have already pointed out, in another instance, that, in order to express P, it is not necessary to use the sentence U *at all*; whereas, in order to express Q, it is absolutely necessary to use U *as a name for itself*, but in no other way. We can express P by using, instead of U, any sentence which is a correct translation of U in a foreign language; e.g., if my French is

correct (which perhaps it isn't), we can express P by "*Les mots*
'The King of France is wise' *veulent dire qu'une personne au
moins est un roi de France, qu'une personne au plus est un
roi de France, et qu'il n'y a aucune personne qui soit un roi de
France et qui ne soit pas sage, et ces mots ne veulent dire ni
plus ni moins que cela.*" And it seems obvious that some other
premise, in addition to this proposition P, is required in order to
entitle us to infer that the English sentence T means neither
more nor less than what is meant by the English sentence U.
*What* other premise is required? So far as I can see, the addi-
tional premise required is merely that the sentence U (which is,
we remember, the sentence "at least one person is a King of
France, at most one person is a King of France, and there is not
anybody who is a King of France and is not wise") means neither
more nor less than that at least one person is a King of France,
at most one person is a King of France, and there is not anybody
who is a King of France and is not wise. Let us call this premise
"R." From P and R *together* Q obviously does follow; since P
asserts of T that it means neither more nor less than the very
same proposition with regard to which R asserts that U means
neither more nor less than that very proposition: and, if T
and U both mean neither more nor less than this particular
proposition, it follows that T means neither more nor less than
is meant by U—a consequence which is the proposition Q. But
now R is a proposition which seems to be quite obviously true;
and there is a great temptation to think that it is a mere tau-
tology; and if it were, then any proposition which followed
from the conjunction of it with P, would follow from P alone;
and since Q does follow from the conjunction of P and R, and
R seems to be a tautology, people are naturally led to suppose
that Q follows from P alone. But I think it is a mistake to
suppose that R is a tautology: it *is* obviously true, but that is
not because it is a tautology, but because we who understand
English, know so well what the sentence U does mean. The
question at issue can be more conveniently discussed in the case
of a shorter sentence than U. If R is a tautology, then the
proposition which I will call "W," namely "The sentence 'At
least one person is a King of France' means that at least one

person is a King of France," is also a tautology; and if R is *not* a tautology, then W is also *not* a tautology. Is W a tautology? There is certainly a great temptation to think so; but the following reasons lead me to think that it is a mistake to think so. (1) W is the same proposition as *"Les mots* 'At least one person is a King of France' *veulent dire qu'une personne au moins est un roi de France."* But I think it is quite obvious that this proposition is not a tautology; and since it is the same proposition as W, it would follow that W is not either. It is true, of course, that the English sentence which I originally used to express W differs from this French sentence in a notable way. In the English sentence the expression "At least one person is a King of France," an expression which I will call "Z," occurs twice over, once, in inverted commas, *merely* as a name for itself,—once, without inverted commas, *not* merely as a name for itself but to express a proposition; whereas, in the French sentence, Z occurs once only, *merely* as a name for itself. And owing to this difference, if one wanted to assert W, it would always be quite useless to use the English sentence in order to do so, since nobody could possibly understand the English sentence unless he already knew what Z did mean. But from this fact that it will be useless to assert W by means of the English sentence, it does not follow that W is a tautology. I suggest that one reason why we are tempted to think that the proposition "The sentence 'At least one person is a King of France' means that at least one person is a King of France" is a tautology is for the irrelevant reason that we all see at once that we could not possibly convey any information to anybody by saying these words. (2) I think it is also obvious, on reflection, that the sentence Z *might*, quite easily, *not* have meant that at least one person is a King of France. To say that it does mean this is to say something about the correct English use of the words which occur in Z and of the syntax of Z. But it might easily not have been the case that those words and that syntax ever were used in that way: that they are so used is merely an empirical fact, which might not have been the case. There is, therefore, no *contradiction* in the supposition that Z does *not* mean that at least one person is a King of France: it *might*

have been the case that it did not. Of course, if Z had not meant
this, the words "Z does not mean that at least one person is a
King of France" would not have been a correct way of express-
ing the fact that Z had not this meaning. Anybody who, in that
case, had used these words to say this, would, of course, have
been saying something that was true, but would have been ex-
pressing this true proposition incorrectly; since he would have
been using Z, in the second place in which he used it, to mean
something which it does now in fact mean, but which, in the
case supposed, it would not have meant. But though no person,
in the case supposed, could have expressed correctly the propo-
sition which would in that case have been true by saying "Z
does not mean that at least one person is a King of France," *we*
can express correctly this proposition, which would then have
been true, by saying it would then have been true that Z did
not mean that at least one person was King of France. In short,
it seems that, in the case supposed, the very same proposition
would have been true, which, as things *are* (considering, that
is, how these words and their syntax are actually used), would
be correctly expressed by "Z does not mean that at least one
person is King of France," but which is, as things are, false. But
if this proposition would have been true, provided that a sup-
position which is certainly not self-contradictory had been the
case, it cannot be self-contradictory. It seems, then, that the
proposition "Z does *not* mean that at least one person is a
King of France" is *not* self-contradictory, and therefore that
the proposition "Z means that at least one person is a King of
France" is not a tautology. But it must be owned that though
the first of these two propositions, though false, seems not to
be self-contradictory, yet there is a special absurdity in ex-
pressing it by the words I have just used. The absurdity I mean
arises from the fact that when we use expressions to make an
assertion, we *imply* by the mere fact of using them, that we are
using them in accordance with established usage. Hence if we
were to assert "Z does *not* mean that at least one person is a
King of France" we should imply that Z *can* be properly used
to mean what, on the second occasion on which we are using it,
we are using it to mean. And this which we *imply* is, of course,

the contradictory of what we are asserting. We *imply* it, by using this language to make our assertion, though we do not assert it, nor is it implied (i.e., entailed) by what we do assert. To make our assertion by the use of this language is consequently absurd for the same reason for which it is absurd to say such a thing as "I believe he has gone out, but he has not" is absurd. This, though absurd, is not self-contradictory; for it may quite well be true. But it is absurd, because, by saying "he has not gone out" we *imply* that we do *not* believe that he has gone out, though we neither assert this, nor does it follow from anything we do assert. That we *imply* it means only, I think, something which results from the fact that people, in general, do not make a positive assertion, unless they do not believe that the opposite is true: people, in general, would not assert positively "he has not gone out," if they believed that he had gone out. And it results from this general truth, that a hearer who hears me say "he has not gone out," will, in general, assume that I don't believe that he has gone out, although I have neither asserted that I don't, nor does it follow, from what I have asserted, that I don't. Since people will, in general, assume this, I may be said to *imply* it by saying "he has not gone out," since the effect of my saying so will, in general, be to make people believe it, and since I know quite well that my saying it will have this effect. Similarly, if I use the words "at least one person is a King of France" not merely as a name for themselves, but to express a proposition, people will, in general, assume that I am using the words in their ordinary sense, and hence I may be said to *imply* that I am, though I am not asserting that I am, nor does it follow that I am from anything which I am asserting. Now suppose I *am* using them in their ordinary sense when I say "Z does not mean that at least one person is a King of France." What I am asserting is then the false proposition that Z, if used in its ordinary sense, does *not* mean the very thing which, using it in its ordinary sense, I am using it to mean. But, by the mere fact of using it, I imply, though I do not assert, that, if used in its ordinary sense, it does mean what I am using it to mean. I am, therefore, *implying* a proposition which is the contradictory of what I am

asserting, but which is not being asserted by me and is not entailed by what I assert. Owing to this peculiar absurdity which attaches to the asserting that Z does not mean that at least one person is a King of France, *by the use of those words*, we are tempted to think that that proposition is itself self-contradictory, when, in fact, it is not, but is only obviously false; and this, I think, is another reason why we are tempted to think that its negation, the proposition W, the proposition "The sentence 'At least one person is a King of France' means that at least one person is a King of France" is a mere tautology, when in fact it is not, but only obviously true.

But if W is not a tautology, then neither is R a tautology; and I am right in saying that Q does not follow from P by itself, but only from the conjunction of P and R. R is an extra premise required to be added to P in order to entitle us to infer Q. And the same extra premise, R, has also to be added to Q, in order to entitle us to infer P. P and Q, therefore, are not only different propositions; it is also true that neither entails the other. And it was important to bring this out, because the particular objection to P, which I want to consider, would be invalid, if P were identical with Q.

The objection is this:

P is the proposition that the sentence T, i. e., the sentence "The King of France is wise," means neither more nor less than that at least one person is a King of France, at most one person is a King of France and there is nobody who is a King of France and is not wise. But (1) it is quite certainly true that T means neither more nor less than that the King of France is wise. (2) If, therefore, P is true, we shall be expressing a true proposition both by the use of the sentence I have used to express P, and also by saying "T means neither more nor less than that the King of France is wise." But (3) if we are using "means neither more nor less than" correctly, then it cannot be said with truth both that T means neither more nor less than that at least one person is a king of France, at most one person is a king of France, and there is not anybody who is a king of France and is not wise, and also that T means neither more nor less than that the King of France is wise, unless it can also be

said with truth that the proposition "at least one person is a king of France, at most one person is a king of France, and there is nobody who is a king of France and is not wise" is *the same proposition* as "the King of France is wise." But (4) if this last can be said with truth, it will follow that it can also be said with truth that P is *the same proposition* as the proposition (which I will call "X") that T means neither more nor less than that the King of France is wise. But (5) P is certainly *not* the same proposition as X; and hence (6) it cannot be said with truth that "the King of France is wise" is *the same proposition* as "at least one person is a king of France, at most one person is a king of France, and there is nobody who is a king of France and is not wise," and hence (7) since (1) is true, P cannot be true.

And a similar argument can be used against the proposition Q, i.e., the proposition that T means neither more nor less than is meant by U. This argument would be as follows. (1) T means neither more nor less than that the King of France is wise, and (this is the proposition which I previously called "R") U means neither more nor less than that at least one person is a king of France, at most one person is a king of France, and there is nobody who is a king of France and is not wise. But (2), from the conjunction of (1) with Q, it follows that the proposition "The King of France is wise" *is the same proposition as* the proposition "at least one person is a king of France, at most one person is a king of France, and there is nobody who is a king of France and is not wise." But (3) if this is so, it follows that the proposition "The proposition 'The King of France is wise' both entails and is entailed by the proposition 'at least one person is a king of France, at most one person is a king of France, and there is nobody who is a king of France and is not wise'," *is the same proposition as* "The proposition 'The King of France is wise' both entails and is entailed by the proposition 'The King of France is wise'." But (4) the conclusion of (3) is certainly false. Therefore (5) the conclusion of (2) is also false; and (6), since (1) is true, Q must be false.

Now, as regards these two arguments, it seems to me unquestionable that, in the case of the first, (1), (2) and (3) are

all true, and, in the case of the second, both (1) and (2) are true; and also unquestionable that, in the case of the first, (5) is true, and, in the case of the second, (4). If, therefore, we are to avoid the conclusion that P and Q are both false, we must, in the case of the first argument, dispute (4), and, in the case of the second, dispute (3). And I think it is pretty certain that both the assertion which the first argument makes in (4), and the assertion which the second makes in (3) are false. But I don't think it's at all easy to see why they are false. Both are certainly very plausible.

To begin with, it must, I think, be admitted to those who may be inclined to say that "The King of France is wise" is *not* the same proposition as "at least one person is a king of France, at most one person etc.," that our use of "is the same proposition as" is such, that, even if it is correct to say that these two are the same proposition, it is *also* not incorrect to say that they are *not*. That this is so is implicit in the very language I have just used; for how could it be correct to say that *these two* are the same proposition, unless it were correct to say that "The King of France is wise" is *one* proposition and "at least one person is a king of France etc." is *another?* It is, indeed, not by any means always the case that where we can say with truth "the proposition '———' is the same proposition as the proposition '———'," a different *sentence* being enclosed within the first inverted commas from that which is enclosed within the second, that we can also substitute, with truth, the words "is *not* the same proposition as" for the words "*is* the same proposition." For instance, if one of the two sentences is an exact translation in a foreign language of the other, the proposition obtained by this substitution would, I think, be definitely false. "*Le roi de France est chauve*" *is* the same proposition as "The King of France is bald," and it would be definitely incorrect to say that it is a different proposition, or *not* the same. A person who were to use the first sentence, in its ordinary sense at a given time, to make an assertion, would definitely be making the *same* assertion or statement or proposition as a person who at the same time used the second sentence, in its ordinary sense, to make an assertion; and it would be definitely *wrong* to say that the one was making

a *different* proposition or statement from that which the other was making, in spite of the fact that they were using different sentences. But the same would not hold, if one of them said "The King of France is bald" and the other said "*Une personne au moins est un roi de France, une personne au plus est un roi de France, et il n'y a aucune personne qui soit un roi de France et qui ne soit pas chauve.*" Here even if we could (as I think we can) correctly say that they were making the same assertion or statement or proposition by the use of different sentences, on the ground that the information they were giving, if their statements were true, was exactly the same; yet it would also not be incorrect to say that the one was making a *different* proposition from that which the other was making. Any one who offered the French sentence as a translation of the English one, would be definitely giving an *incorrect* translation of it; and I think that wherever we can say that one sentence is *not* a correct translation of another, it is also not incorrect to say that it expresses a *different* proposition from that which the other expresses, though it may also be quite correct to say that it expresses the same proposition. Again, whenever, using two different sentences in the two different places enclosed by inverted commas, we can make, with truth, a proposition of the form "The proposition '———' both entails and is entailed by the proposition '———'," we can, I think, also make with truth the corresponding proposition of the form "The proposition '———' is a different proposition from the proposition '———'." If we were to say "The proposition 'The King of France is bald' both entails and is entailed by the proposition '*Le roi de France est chauve*'," we should be definitely misusing the expression "both entails and is entailed by;" it is definitely incorrect to say that "The King of France is bald" is a different proposition from "*Le roi de France est chauve*," and therefore also definitely incorrect to say that we have here an instance of *two* propositions, which are logically equivalent—of *two* propositions, each of which entails the other. But if we say "The proposition 'The King of France is bald' both entails and is entailed by '*Une personne au moins est un roi de France, une personne au plus est un roi de France, et il n'y a aucune personne qui soit un roi de France et qui ne*

*soit pas chauve* '," we are using "both entails and is entailed by"
perfectly correctly, because it is also correct to say that we have
here an instance of *two* different propositions, each of which
entails *the other*. This ambiguity which attaches to the expression
"is the same proposition as," and is such that, in hosts of cases,
where, writing one sentence in inverted commas after the words
"the proposition" the first time they occur and a different sen-
tence after the same words the second time they occur, we can
say, with truth "the proposition '———' is the same proposition as
the proposition '———'," we can *also* say, with truth, "the propo-
sition '———' is *not* the same proposition as the proposition
'———'," also, it seems to me, attaches to two other expressions
which are frequently used. In hosts of cases where it is not incor-
rect to say of one sentence that it "means the same as" another, it
is also not incorrect to say of the same two sentences that the one
does *not* "mean the same as" the other. And in hosts of cases
where it is not incorrect to say of a given sentence that it is "mere-
ly another way of saying" that so and so is the case, it is also not
incorrect to say of the very same sentence that it is *not merely*
another way of saying that so and so is the case, in spite of the
fact that in both cases the sentence used to express the "so and
so" in question is exactly the same. And, in all three cases, I
doubt if any precise rules can be laid down as to what distin-
guishes the cases where it is correct to say both of the two
apparently contradictory things from those in which it is not
correct to say both. Certainly, if we are to say of two different
sentences, which we *can* say express two different propositions,
that they also express the *same* proposition, a *necessary* condition
for our saying so with truth, is that we should also be able to say
with truth that each proposition *entails* the other; but I doubt
whether this is a *sufficient* condition for saying so. In cases where,
having two different *sentences* before us, we can rightly say
that we have *two* propositions before us, we certainly cannot
rightly say that those two propositions are the *same* proposition,
unless conditions which are necessary and sufficient for the truth of
the one are precisely the same as those which are necessary and
sufficient for the truth of the other; and in many cases where this
condition is fulfilled, we can, I think, rightly say that they are the

same proposition: but I doubt whether we can in all. On the other hand, where we have two sentences, like T and U, of which we can (as I think) rightly say that they express the same proposition or have the same meaning, a *sufficient* condition for its being also correct to say that they express different propositions or have *not* the same meaning, is, I think, that we should be able to say that, for those who understand the language or languages involved, the hearing or reading of the one sentence brings before the mind of the hearer or reader ideas which the other does not bring before his mind. It can, I think, hardly be denied that to those who understand English, the hearing or reading of U will, in general, bring before the mind ideas which the hearing or reading of T will not in general bring before the mind, for the very reason which makes it right to say that you can *give a definition* of T by means of U, i.e., that U mentions separately a greater total number of conceptions and objects than T does; and this, I think, is a sufficient justification for saying that *in a sense* U does *not* "mean the same" as T, and does *not* "express the same proposition." This, I think, is the element of truth contained in the argument, often used, that two given sentences do *not* "mean the same," because, when we understand the one, "what we are thinking" is not the same as what we are thinking when we understand the other. But what those who use this argument often overlook is that even where we can rightly say, for this reason, that two sentences do *not* "mean the same," it may also be perfectly right to say that, in another, and perhaps more important sense, they *do* mean the same. Though, however, the fact that one sentence will, in general, bring before the mind of those who understand it ideas which a different sentence, though in one sense it has the same meaning, will not bring before the mind, is, I think, *sufficient* to make it correct to say that the proposition expressed by the one is a different proposition from that expressed by the other, I doubt if this is *necessary* to make it correct to say so. Consider the two sentences "The sun is larger than the moon" and "The moon is smaller than the sun." It is certainly not incorrect to say that these two sentences are different ways of expressing the same proposition, and that they have the same meaning. Yet I doubt whether it is incorrect to

say that the proposition "the sun is larger than the moon" is one proposition, and the proposition "the moon is smaller than the sun" is *another* proposition. It is worth noticing that if we had to translate "*Le soleil est plus grand que la lune*" into English, it would be definitely incorrect to translate it by the second of these two sentences instead of by the first. And it is also, I think, not incorrect to say: "The proposition that the sun is larger than the moon both entails and is entailed by the proposition that the moon is smaller than the sun: these *two* propositions are logically equivalent." Whereas it would be definitely incorrect to say "The proposition '*Le soleil est plus grand que la lune*' both entails and is entailed by the proposition 'The sun is larger than the moon'," or to say that we have here *two* propositions which are logically equivalent. And yet I do not think we can say that the sentence "The sun is larger than the moon" brings before the mind any ideas which are not brought before it by the sentence "The moon is smaller than the sun," nor yet that the latter brings before the mind any ideas which are not brought before it by the former.

I think, therefore, it must be admitted to those who may be inclined to say that P and Q are false, that, so far as they are saying only that it is not incorrect to say that the proposition expressed by U is *not* the same as that expressed by T, and not incorrect to say that T and U do not have the same meaning, they are right. But the arguments which I gave, as arguments which might be used to show that P and Q are false, would seem to show more than this. For, when, in the first argument, (5) asserts that P and X are certainly not the same proposition, it seems that this is unquestionably true not merely in the sense that it is not incorrect to say that they are not the same, but in the sense that it is definitely *incorrect* to say that they *are* the same—that there is no sense whatever in which they can be correctly said to be the same. And similarly, in the second argument when (4) asserts that "the proposition 'The King of France is wise' both entails and is entailed by 'At least one person is a king of France, at most etc.' " is *not* the same proposition as " 'The King of France is wise' both entails and is entailed by 'The King of France is wise'," it seems that this is unquestionably

true not merely in the sense that it is not incorrect to say so, but in the sense that it would be definitely incorrect to say that they *are* the same. And in both cases it is not at all easy to see how it can be definitely incorrect to say that the propositions in question are the same, if it is not incorrect to say that "The King of France is wise" is the same proposition as "At least one person is a king of France, at most one etc." The question is: If it is definitely *incorrect* to say that P and X are the same, and that the propositions which (4), in the second argument, declares to be *not* the same, are the same, can it possibly be correct to say that "The King of France is wise" is the same proposition as "At least one person is a king of France, etc.?" I am convinced that it can, and is, but I must confess that I am unable to see *how* it can be, and *why* it is. I must, therefore, confess that I am unable to point out where the fallacy lies in these arguments to show that what P and Q say is definitely incorrect.

But that there is some fallacy in the arguments is, I think, evident from the fact that, if there were not, then, so far as I can see, *no* definition would ever be correct. Consider, for instance, the following definition of "is a widow:" "is a widow" means neither more nor less than "was at one time wife to a man who is now dead, and is not now wife to anyone." This is, I think, clearly a correct definition of at least one way in which the expression "is a widow" can be properly used in English. And it is clearly correct to say: The sentence "Queen Victoria was a widow in 1870" means neither more nor less than that, in 1870, Queen Victoria had been wife to a man who was then dead, and was not then wife to anyone. And yet this proposition which I have just written down can certainly *not* be correctly said to be the same proposition as: The sentence "Queen Victoria was a widow in 1870" means neither more nor less than that Queen Victoria was a widow in 1870. And it can certainly not be correctly said either that the proposition "The proposition that Queen Victoria was a widow in 1870 both entails and is entailed by the proposition that, in 1870, Queen Victoria had been wife to a man who was then dead, and was not then wife to anyone" is the same proposition as "The proposition that Queen Victoria was a widow in 1870 both entails and is entailed by the proposi-

tion that Queen Victoria was a widow in 1870." But the fact that neither of these two things can be correctly said is, I think, clearly not inconsistent with the proposition that the proposition "Queen Victoria was a widow in 1870" can be correctly said to be the same proposition as "In 1870, Queen Victoria had been wife to a man who was then dead, and was not then wife to anyone," though I cannot explain *why* they are not inconsistent with this proposition.

I think, then, that what I have described as Prop. II of Russell's theory of descriptions, namely, the statement that immense numbers of propositions, which resemble, in the respects I specified, the proposition "The sentence 'The King of France is wise' means neither more nor less than that at least one person is a king of France, at most one person is a king of France, and there is not anybody who is a king of France and is not wise; and anyone who were to assert that this is so would be giving a definition of the meaning of the sentence 'The King of France is wise' " are true, is certainly true.

And I think it must have been this statement made by the theory of descriptions, which led Ramsey to mention, as a merit of that theory, that it explains *exactly what* multiple relation between kingship, France and wisdom is asserted by "The King of France is wise." I think that if we are told that the sentence "The King of France is wise" means neither more nor less than that at least one person is a king of France, at most one person is a king of France, and there is nobody who is a king of France and is not wise, this statement, if true (as I have argued that it is), can be fairly said to explain exactly what multiple relation we should be asserting to hold between kingship, France and wisdom, if we were to assert that the King of France is wise. And I think it is a great merit in Russell's theory of descriptions that it should have pointed out (for the first time, so far as I know) that, in the case of enormous numbers of sentences, similar in certain respects to "The King of France is wise," an explanation, similar *mutatis mutandis* to this one, of what we are asserting if we use them to make an assertion, can be given.

But it should be emphasized, I think, that from this statement, which I am calling Prop. II of the theory of descriptions, it does

not *follow* that "The King of France is wise" means neither more nor less than that at least one person is a king of France, at most one person is a king of France, and there is nobody who is a king of France and is not wise. Prop. II only says that enormous numbers of $\Delta$-propositions are true; and from this it will not follow, in the case of any particular $\Delta$-proposition whatever, that *that* one is true. It would have been quite a different matter if Russell, or Whitehead and Russell, had somewhere, in what they say about "descriptions," presented us with a true *universal* proposition to the effect that *all* $\Delta$-propositions, which satisfy certain specified conditions, are true. The conditions specified might have been such that from this universal proposition it *followed* that the $\Delta$-proposition "The sentence 'The King of France is wise' means neither more nor less than that at least one person is a king of France, at most one, etc." is true, and similarly in the case of every other true $\Delta$-proposition. But I cannot see that we have anywhere been presented with a true universal proposition of this kind. In order to find such a universal proposition, it would be necessary, so far as I can see, to do two things. $\Delta$-propositions, as I have defined them, are propositions which make about some sentence beginning with the word "the" followed (with or without an intervening adjective) by a noun in the singular, a statement, similar in respects which I specified, to the statement made about the sentence "The King of France is wise" by the $\Delta$-proposition which I have just mentioned. And, so far as I can see, there are many sentences beginning with "the" followed by a noun in the singular, about which *no* true $\Delta$-proposition can be made. Take, for instance, these: "The heart pumps blood into the arteries," "The right hand is apt to be better developed than the left," "The triangle is a figure to which Euclid devoted a great deal of attention," "The lion is the king of beasts," or (to borrow an example from Professor Stebbing) "The whale is a mammal." It is obvious that no part of the meaning of any one of these sentences is (respectively) "at most one object is a heart," "at most one object is a right hand," "at most one object is a triangle," "at most one object is a lion," "at most one object is a whale." And even if (which I doubt) there could, in each case, be constructed in some complicated way a $\Delta$-

proposition which was true of that sentence, I think it is obvious that they are examples of uses of (to use Russell's phrase) "*the* in the singular," very different from those which he had in mind in what he says about "definite descriptions." He has, it seems to me, given a true, and most important, account of at least one use of "*the* in the singular," and perhaps this use is far the commonest; but there are other quite common uses to which his account does not apply. And, if I am right in thinking that there are many sentences beginning with "*the* in the singular," about which *no* Δ-proposition is true, then, in order to get a true *universal* proposition to the effect that all Δ-propositions *of a certain kind* are true, we should need to find some characteristic which distinguishes those sentences beginning with "*the* in the singular" about which some Δ-proposition is true, from those about which none is true—some characteristic, that is to say, *other* than the mere fact that some Δ-proposition is true of each of the sentences in question. If we could find such a characteristic, say Φ, we should be able to make the true universal proposition: Of *all* sentences beginning with "*the* in the singular" which have the characteristic Φ, some Δ-proposition is true; and Φ might be such that from this universal proposition it could be deduced that of the sentence "The King of France is wise" *some* Δ-proposition is true. But I doubt whether any such characteristic can be found; and even if one could, I do not think that Russell, or *Principia*, have anywhere mentioned such a characteristic. But, even if this could be done, something more would plainly be required, if we wanted to find a universal proposition from which it followed that the sentence "The King of France is wise" means neither more nor less than that at least one person *is a king of France*, at most one person *is a king of France*, and there is not anybody who is *a king of France*, and is not wise; and from which, similarly, every other true Δ-proposition also followed. We should need, in fact, a universal rule, which would tell us, in the case of each different phrase of the form "the so-and-so" such that *some* Δ-proposition was true of any sentence beginning with that phrase, *what* phrase must follow the words "at least one," "at most one," and "there is not," in order to get a sentence which expressed a true Δ-proposition. That it is easy to

make a mistake as to this is shown by the fact that Russell himself thought, falsely, as I have tried to show, that the statement "The sentence 'The author of *Waverley* was Scotch' means neither more nor less than that at least one person *wrote Waverley*, at most one person *wrote Waverley*, and there never was anybody who *wrote Waverley* and was not Scotch" was a true Δ-proposition. In order to get a sentence which does express a true Δ-proposition, in this case, we certainly need to substitute some other word for "wrote." It is, I think, clearly quite impossible to give any general rule whatever, which would ensure us against making mistakes of this kind. And hence I do not believe that it is possible to find any *universal* proposition to the effect that *all* Δ-propositions which are of a certain kind are true.

I think, therefore, that it is perhaps only by a stretch of language that the theory of descriptions can be said to explain exactly what relation we are asserting to hold between kingship, France and wisdom, if we assert that the King of France is wise. The theory of descriptions, I should say, consists only of *general* propositions. But general propositions may be of two kinds, which we may call *universal* propositions and *existential* propositions. I do not think that it contains, or could contain, any *universal* proposition from which it would follow, in the case of any Δ-proposition whatever which *is* true, that that proposition is true. And from the existential proposition that enormous numbers of Δ-propositions are true, it plainly will not follow, in the case of any particular one, that *that* one is true. But even if, as I think, the theory of descriptions only gives us a statement of the form "Enormous numbers of Δ-propositions are true" and does not give us any universal proposition of the form "All Δ-propositions, which have the characteristic Φ, are true," it is, I think, just as useful and important, as if it had given us such a universal proposition. The statement that enormous numbers are true is sufficient to suggest that, where we find a sentence beginning with "*the* in the singular," it will be wise to consider whether it is not one of which some Δ-proposition is true, and whether, therefore, the consequences which follow from its being one are not true of it. When once the question is suggested by the theory of descriptions, it is, I think, easy to see in particular

cases, both that a given sentence is one of which *some* Δ-proposition is true, and *what* Δ-proposition is true of it. It is, I think, only in this sense that the theory of descriptions can be said to tell us that "The King of France is wise" means neither more nor less than that at least one person is a king of France, at most one person is a king of France, and there is nobody who is a king of France and is not wise.

III. Is there any other statement, forming a part of the "theory of descriptions," which is both true and important? I think there is at least one. But the subject which I am now going to discuss seems to me to be one about which it is very difficult to see clearly what is true, and about which I may easily be wrong.

Prop. II has told us that, in enormous numbers of cases where we have a sentence beginning with "the" followed (with or without an intervening adjective) by a noun in the singular, some Δ-proposition is true of that sentence. Now suppose we have found such a sentence, of which some Δ-proposition is true, and have also found some Δ-proposition which is true of it. We then have a correct answer to the question: What is the meaning of that sentence? Thus, e.g., a correct answer to the question: What does the sentence "The King of France is wise" mean? is "It means that at least one person is a king of France, at most one etc." But having got a correct answer to the question: What is the meaning of this sentence as a whole? we may want to raise another question, namely: What is the meaning of that part of it which consists in the words "The King of France?" This is a question which has obviously interested Russell, and about which he has said a good deal. There is no doubt, that if some Δ-proposition is true of the sentence "The King of France is wise," then the words or phrase "The King of France" are what he would call a "definite description." And the corresponding words in any sentence of which a Δ-proposition is true would also be called by him a "definite description." E.g., in the sentence "The first President of the United States who was called 'Roosevelt' hunted big game," the words "The first President of the United States who was called 'Roosevelt' " would be a "definite description," pro-

vided that some Δ-proposition is true of that sentence, as I think is obviously the case. One thing which is, I think, not clear about his use of the phrase "definite description" (or, in *Principia*, "description") is whether or not a phrase, which, when used in the way in which it is used in a sentence of which a Δ-proposition is true, is a "definite description," is also to be called a "definite description," if (supposing that were possible) in another sentence it is used in a different way. Does to say that a phrase is "a definite description" mean only that it is *sometimes* used in a particular way, so that any phrase, which is *ever* so used, will be a "definite description," even when it is not so used? or can the very same phrase be a "definite description" when used in one way, and *not* a "definite description" when used in another? However that may be, Russell is certainly interested in the question what meaning such phrases have *when* used in sentences about which some Δ-proposition is true.

And his theory of descriptions is certainly supposed by him to give an answer to this question different, in important respects, from what he himself and other philosophers had formerly held to be a correct answer to it. This appears very plainly from the first of his writings in which he put forward the views which he subsequently expressed under the heading "Descriptions." In this early article in *Mind*, entitled "On Denoting,"[13] he uses the name "denoting phrases" as a synonym for "Descriptions" in the wider of the two senses in which, as I have pointed out, he subsequently used "Descriptions," i.e., to include both what he subsequently called "definite descriptions" and what he subsequently called "indefinite" or "ambiguous" descriptions; but he says (p. 481) that "phrases containing 'the' are by far the most interesting and difficult of denoting phrases" and he is chiefly concerned with these. He points out difficulties which he finds in the views about such phrases put forward by Meinong and Frege, and says[14] that the theory which he himself formerly advocated in the *Principles of Mathematics* was very nearly the same as Frege's, and quite different from that which he is now advocating.

[13] *Mind*, N. S., XIV, 479.
[14] *Ibid.*, 480, n. 1.

Now I think it is quite clear that this change of view arose from his having noticed that, e.g., "The King of France is wise" entails and is entailed by "at least one person is a king of France, at most one person is a king of France, and there is nobody who is a king of France and is not wise;" and having further thought that this fact must be relevant to the question what "the King of France" means, or (as it is put in *Principia*) that "in seeking to define the use" of such a symbol "it is important to observe the import of propositions in which it occurs."[15] Apparently when he wrote the *Principles* it had not occurred to him that the fact that such a proposition as "The King of France is wise" cannot be true unless at least one man and at most one man is a king of France, must be relevant to the question what "the King of France" means; nor, so far as I know, had it ever occurred to any other philosopher. That the noticing that it was relevant was, at least in part, the origin of the new view, first expressed in "On Denoting," and embodied in *Principia,* is, I think, quite clear. But what *is* the new view? and how does it differ from the old?

One novelty in the new view is one which the authors of *Principia* try to express by saying that such a phrase as "The King of France" "is not supposed to have any meaning in isolation, but is only defined in certain contexts"[16] and later by saying that "we must not attempt to define" such a phrase itself, but instead "must define the propositions," in "the expression" of which it occurs. They propose[17] to use the new technical term "is an incomplete symbol" as a short way of saying that this is true of a given phrase; and accordingly declare that "descriptions" are "incomplete symbols."

Now when they say that we "must not attempt to define" such a phrase as "The King of France," as used in the sentence "The King of France is wise," I suppose their reason for saying so must be that they think that, if we did attempt to define it, we should necessarily fail to get a *correct* definition of it. If it were possible to get a correct definition of it, there would seem to be

[15] *P.M.,* I², 67.
[16] *Ibid.,* 66.
[17] *Ibid.,* 67.

no reason why we shouldn't attempt to get one. I think, there-
fore, their meaning must be that it is *impossible* to give a correct
definition of this phrase *by itself;* and when they say that we
must define "propositions" in the "expression" of which it oc-
curs, I think what they mean might have been equally well ex-
pressed by saying that we must define *sentences* in which it
occurs.

But why does Russell hold that though we can define such a
sentence as "The King of France is wise" we can *not* define that
part of this sentence which consists in the words "The King of
France?" By introducing a new technical term for those phrases,
occurring as parts of sentences, which can't themselves be defined
although the sentences of which they are parts can be, he implies,
of course, that there are other phrases which are parts of sen-
tences, in the case of which we can not only define the whole
sentence, but *also* define the phrase which is a part of it. And
this certainly seems to be the case. To use an illustration which
I gave above: we can define the sentence "Mrs. Smith is a wid-
ow" by saying that it means "Mrs. Smith was formerly wife to
somebody who is now dead, and is not now wife to anybody."
And we can also say that *any* sentence of the form "*x* is a widow"
means that the person in question was formerly wife to somebody
who is now dead and is not now wife to anybody. But in this
case it seems also perfectly correct to take the phrase "is a widow"
by itself, and to say "is a widow" means "was formerly wife to
somebody who is now dead, and is not now wife to anybody."
In this case, as in hosts of others, it seems that we can both define
sentences in which a given phrase occurs, and *also* define the
phrase by itself. This, which seems to be possible in so many
cases, Russell seems to be declaring to be *impossible* in the case
of phrases like "The King of France." *Why* does he declare
it to be impossible? If we can define "is a widow" *as well as*
sentences in which it occurs, why should we be unable to define
"The King of France" *as well as* sentences in which it occurs?

I think there *is* a good reason for making this distinction be-
tween "The King of France" as used in the sentence "The King
of France is wise," and "is a widow" as used in "Mrs. Smith is

a widow;" but this, which I am going to give, is the only good reason I can see.

Let us consider a *different* definition of the sentence "The King of France is wise" from that which we have hitherto considered. Instead of considering the proposition "The sentence 'The King of France is wise' means neither more nor less than that at least one person is a king of France, at most one person is a king of France, and there is nobody who is a king of France and is not wise," let us consider the proposition "The sentence 'The King of France is wise' means neither more nor less than that there is somebody or other of whom the following three things are all true, viz. (1) that he is a king of France, (2) that nobody other than he is a king of France, and (3) that he is wise." This latter proposition is just as good a definition of the sentence in question as the former; and indeed, instead of saying that it is a *different* definition, but just as good a one, we can say, if we please, equally correctly, that it is *the same definition* differently expressed. For a very little reflection is sufficient to make it evident that the proposition "at least one person is a king of France, at most one person is a king of France, and there is nobody who is a king of France and is not wise" both entails and is entailed by "there is somebody or other of whom it is true that he is a king of France, that nobody else is a king of France, and that he is wise:" if the first is true, the second *must* be true too, and if the second is true, the first *must* be true too. And I think this is obviously a case, such as I spoke of before, in which it is equally correct to say either of the two apparently contradictory things: This is the same proposition as that; and: These *two* propositions are logically equivalent; and also equally correct to say of the two *sentences* each of the two apparently contradictory things: This sentence means the same as that, they are merely two different ways of saying the same thing; and: These two sentences have *not* quite the same meaning, they are *not* merely two different ways of saying the same thing. In support of the assertion that the two sentences have *not* the same meaning, and therefore do not express the same proposition, it may, for instance, be pointed out that the first proposition

is a conjunction of three *independent* propositions, whereas the second is not: how could the *same* proposition be both?

Let us, then, consider the proposition (which is a definition): "The sentence 'The King of France is wise' means neither more nor less than that there is somebody or other of whom it is true that he is a king of France, that nobody other than he is a king of France and that he is wise." If this be true (as it is) it follows that we can correctly say: The sentence "The King of France is wise" means the same as the sentence "There is somebody or other of whom it is true that he is a king of France, that nobody else is so, and that he is wise." But now it appears that we can also correctly say that in these two sentences the words "is wise" mean the same. But since the whole sentences mean the same, and one part of each means the same as a part of the other, it seems natural to conclude that the part of the one which is left over when "is wise" is subtracted from it *must* mean the same as the part of the other which is left over when "is wise" is subtracted from it: i.e., that "The King of France" means the same as "There is somebody or other of whom it is true that he is a king of France, that nobody else is, and that he . . . ." But do those two phrases mean the same? I think we must answer: No; they certainly don't. For some reason or other, we can't do in the case of these two sentences what we could do in the case of "Mrs. Smith is a widow" and "Mrs. Smith was formerly wife to somebody who is now dead and is not now wife to anyone." There we could subtract "Mrs. Smith" from both sentences, and say correctly that what was left of the one meant the same as what was left of the other. Here we can't say correctly that what is left of the one sentence when "is wise" is subtracted from it means the same as what is left of the other when "is wise" is subtracted from it; and this in spite of the fact that the two whole sentences certainly do mean the same!

Now, so far as I can see, if you take any sentence whatever which can be used to express the *definiens* in a correct definition of "The King of France is wise," provided that the definition in question is not a definition of the sentence *only* because it yields a definition of "is wise" or of "king" or of "France," it will always be found that the part of the sentence which is left

over when "is wise," or that part of it which has the same mean-
ing as "is wise," is subtracted from it, can *not* be said to have
the same meaning as the phrase "The King of France." And
this, I think, is a good reason for saying, as I have supposed
Whitehead and Russell intended to say, that you can't define
"The King of France" (in this usage), though you can define
sentences in which that phrase occurs. If this is what they mean
by saying that "The King of France," in this usage, is an "incom-
plete symbol," then I think it must be admitted that it *is* an
incomplete symbol.

In support of my contention that we cannot possibly say that
the phrase "The King of France," in this sentence means the
same as the phrase "There is somebody or other of whom it is true
(1) that he is a king of France (2) that nobody other than he is
so and (3) that he," I should like to call attention to the follow-
ing point. There is no doubt that the expression "The King of
France" can be properly called, as Russell once called it, a "de-
noting phrase," if we agree that a phrase can be properly called
a "denoting phrase," provided it is the *sort* of phrase which
*could* have a denotation as well as a meaning, even if it actually
has no denotation. If a person were to assert *now* that the King
of France is wise by the use of the sentence "The King of France
is wise," it would be correct to say that "the King of France,"
as used by him, though a "denoting phrase," "does not denote
anything" or has no denotation because at present there is not a
King of France; but, if an Englishman in 1700 had used that
sentence to say that the King of France was wise, it would have
been quite correct to say that "the King of France," as used by
him, did "denote" Louis XIV, or, if we had been in the presence
of Louis, it would have been correct to point at Louis and say
"The phrase 'The King of France' denotes that person." It ap-
pears from Russell's article "On Denoting" that one of the
things which had puzzled him before he arrived at the theory
explained in that article (that is to say, his "theory of descrip-
tions") was that it seemed to him that, in such a case as that of
an Englishman saying in 1700 "The King of France is wise,"
the Englishman's proposition would certainly have been "about"
the *denotation* of the phrase "the King of France," i.e., about

Louis, and *not* about the *meaning* of the phrase; and he was unable to see how the meaning was related to the denotation, when such a proposition was made. This puzzle his "theory of descriptions" seemed to him to solve. But the point I wish now to make is this: In the case of such an Englishman in 1700, it would certainly have been correct to say that his phrase "The King of France" *denoted* Louis XIV; but if he had said instead "There is somebody or other of whom it is true that he is a king of France, that nobody other than he is, and that he," would it have been correct to say that *this* phrase "denoted" Louis? I think nobody could possibly say so: and this seems to me a good reason for saying that his phrase "the King of France" would *not* have "meant the same" as this other phrase. And yet his whole sentence "the King of France is wise" would certainly have "meant the same" as the sentence "There is somebody or other of whom it is true that he is a king of France, that nobody else is, and that he is wise," if used at that time.

But, though in the case of sentences which resemble "The King of France is wise" in the respect that a true Δ-proposition can be made about them, there is, I think, good reason for saying that we can't define the phrase of the form "the so-and-so," with which they begin, though we can define the sentences in which the phrase occurs, it does not seem to me at all so clear that we cannot define such phrases when used in certain sentences in which they do not begin the sentence. Contrast, for instance, with "the King of France is wise," the sentence "There is a person who is the King of France," or the sentence "That person is the King of France," as it might have been used by an Englishman pointing at Louis XIV in 1700. Here, I think, we can certainly say that "is the King of France" does "mean the same" as "is a person of whom it is true both that he is a king of France and that no-one other than he is." If so, we must, I think, say that, in this usage, "the King of France" is *not* an incomplete symbol, though, where it begins a sentence about which a true Δ-proposition can be made, it *is* an incomplete symbol. It seems to me by no means paradoxical to say that the two usages are different; and even to say that, in this usage, "The King of France" never has denoted anyone, though in the other it has.

However that may be, there does seem to me to be good reason for saying that in the case of sentences about which some Δ-proposition is true, the phrase of the form "the so-and-so" with which such sentences begin, never can be defined, although the sentences in which it occurs can. And the statement that this is so should, I think, be reckoned as a third important part of "Russell's theory of descriptions."

Perhaps there are other statements, deserving to be called a part of that theory, which are also important, or perhaps even *as* important, as these three which I have distinguished. But it seems to me that these three, viz.

I. Enormous numbers of Γ-propositions are true.

II. Enormous numbers of Δ-propositions are true.

III. In the case of every sentence about which some Δ-proposition is true, the phrase, of the form "the so-and-so," with which it begins, cannot be defined *by itself,* although the sentences in which it occurs can be,——

statements, none of which, so far as I know, had ever been made before by any philosopher, are by themselves sufficient to justify Ramsey's high praise of the theory.

G. E. MOORE

SWARTHMORE, PA.

6

*Max Black*

RUSSELL'S PHILOSOPHY OF LANGUAGE

# 6

## RUSSELL'S PHILOSOPHY OF LANGUAGE

"The influence of language on philosophy has, I believe, been profound and almost unrecognized." (Russell)

### A. Introduction

*1. Russell's influence.* For the purpose of preliminary definition we might adapt a remark of William James and identify philosophy of language as "what a philosopher gets if he thinks long enough and hard enough about language." This characterization may serve as a reminder of the persistence and intensity of Russell's preoccupation with language, displayed in much of his philosophical writing during the past twenty-five years.[1] The flourishing condition of present-day "semiotic" is a sufficient testimony to the fertility of Russell's ideas; today, some twenty years after the epigraph of this essay was composed, it would be more accurate to say: "the influence of language on philosophy is profound and almost universally recognized."[2]

---

[1] The quotation at the head of this paper is taken from the article "Logical Atomism," in *Contemporary British Philosophy*, Vol. I (1924), which is, for all its brevity, the best statement of Russell's early program for philosophical inquiries into language. It is a matter for regret that the earlier lectures, published under the title of "The Philosophy of Logical Atomism" in *The Monist* (Vol. 28 (1918), 495-527; Vol. 29 (1919), 32-63, 190-222, 345-380), have never been reprinted. Language is a topic of central importance also in "On propositions: what they are and how they mean" (*Aristotelian Society Proceedings*, Supplementary Vol. 2 (1919), 1-43), in *The Analysis of Mind* (1921), (especially Ch. 10: "Words and Meaning") and *Philosophy* (1927, Ch. 4: "Language"). *An Inquiry into Meaning and Truth* (1940) is, of course, almost entirely devoted to the same topic.

[2] Contemporary concern with philosophy of language is most apparent in the members and sympathizers of the philosophical movement known as "Logical Positivism" or "Scientific Empiricism." In this instance the transmission of ideas can be traced with rare accuracy. It is known that the Vienna Circle was much influenced, in the post-war years, both by Russell's own work and that of his

If it is true that "Language has, so to speak, become the *Brenn-punkt* of present-day philosophical discussion,"[3] hardly another philosopher bears a greater share of the responsibility.

Philosophical study of language, conceived by Russell as the construction of "philosophical grammar,"[4] may have been regarded by him, at an early period, as a mere "preliminary" to metaphysics; it soon became much more than this. Philosophical linguistics may be expected to provide nothing less than a pathway to the nature of that reality which is the metaphysician's goal. To this very day the hope persists that ". . . with sufficient caution, *the properties of language may help us to understand the structure of the world.*"[5]

So ambitiously conceived, as a study potentially revealing ontological structure, philosophy of language cannot be restricted to the examination of uninterpreted formal systems, still less, as with earlier philosophers, to the rhetorical art of avoiding unintentional ambiguity. Its successful pursuit requires the use of data drawn from logic, psychology, and empirical linguistics and the formulation of reasoned decisions concerning the scope of metaphysics and the proper methods of philosophical research. Such questions as these arise constantly in Russell's discussions, even on occasions when he is most earnestly avowing the "neutrality" of his devotion to scientific method.

Since the full-bodied suggestiveness of Russell's work on language is a function of his refusal to adopt the self-imposed limitations of the mathematical logician, it would be ungrateful

---

pupil Wittgenstein. Although the *Tractatus* owes much to Russell, there can be no question but that the influence here was reciprocal, as Russell has frequently and generously acknowledged. The *Monist* articles are introduced with the words: "The following articles are . . . very largely concerned with explaining certain ideas which I learnt from my friend and former pupil, Ludwig Wittgenstein" (*The Monist*, Vol. 28, 495). A more detailed discussion of sources would call for some reference to the work of G. E. Moore (Russell's colleague at Cambridge). Cf. *The Philosophy of G. E. Moore*, 14 ff.

[3] W. M. Urban, *Language and Reality* (1939), 35.

[4] "I have dwelt hitherto upon what may be called *philosophical grammar*. . . . I think the importance of philosophical grammar is very much greater than it is generally thought to be . . . philosophical grammar with which we have been concerned in these lectures" (*The Monist*, Vol. 29, 364).

[5] *An Inquiry into Meaning and Truth*, 429 (italics supplied).

to regret the complex interweaving of themes which results. But any selection of topics, considered in abstraction from the context of Russell's general philosophical doctrines, is bound to be somewhat misleading. It must be hoped that the aspects of Russell's earlier procedures here chosen for brief critical examination so typically manifest his style of philosophic thought at this period that an understanding of their merits and defects will serve as a guide to the evaluation of the more extensive doctrines of which they are a part.

2. *The scope of this paper.* The main topics discussed in the remainder of this paper are:

(i) *The consequences of applying the theory of types to "ordinary language."* A new paradox will be presented whose resolution requires extensive reformulation of Russell's theory, and a critical judgement will be made of the value of the renovated theory.

(ii) *The search for "ultimate constituents" of the world.* The procedure here, so far as it is relevant to the criticism of language, will be shown to be, in part, susceptible of a neutral interpretation, and, for the rest, to be based upon an unproven epistemological principle, (reducibility to acquaintance), which will, after examination, be rejected.

(iii) *The notion of the "ideal language."* This branch of the investigation concerns the goal of the entire method. The construction of an "ideal language" will be condemned, for due reason presented, as the undesirable pursuit of an ideal incapable of realisation.

These headings cover most of Russell's *positive* contributions to philosophy of language.[6] There will be no space for discussion of the genesis of the whole enquiry in the destructive criticism of "ordinary language."[7] The bare reminder must suffice that the English language, as now used by philosophers, offends by provoking erroneous metaphysical beliefs. Syntax induces misleading opinions concerning the *structure* of the world (notably in the attribution of ontological significance to the subject-predicate form), while vocabulary, by promoting the hypostati-

---

[6] The only serious omission is reference to Russell's behavioristic analysis of meaning (cf. especially the last four works cited in footnote 1 above). I have already explained my reasons for objecting to this mode of analysis in an article (*The Journal of Philosophy*, Vol. 39, 281-290) whose arguments apply with little modification to Russell's position on this matter.

[7] *Contemporary British Philosophy*, Vol. I, 368.

zation of pseudo-entities, encourages false beliefs concerning
the *contents* of the world. In either case we are "giving meta-
physical importance to the accidents of our own speech."[8] It is
in trying to remedy these defects of ordinary language by search-
ing for what is *essential* in language that we arrive finally at the
"ideal language" and its valid metaphysical implications.

## B. The Consequences of Applying the Theory of Types to Ordinary Language

*1. The genesis and character of the theory of types.* Russell's
arguments against philosophers who insist upon reducing all
statements to the subject-predicate form amounts to showing
that their procedure leads to contradiction.[9] But the "new logic"
of relations, whose function it was to take account of complexi-
ties of form neglected by syllogistic logic, proved to be infected
by the new and more puzzling contradictions of the "mathe-
matical and logical paradoxes." The basis of Russell's cure for
this malady is the observation that each paradox involves a
characteristic reflexive application of terms (as exemplified typi-
cally in the notion of a class being a member of itself). The
cure provided in *Principia Mathematica*, as the "theory of
types," is, accordingly, a restriction upon the kind of symbols
which may be inserted into a given context.[10] Entities designated
by symbols all of which may be inserted into some one context
are said *to belong to the same type*. There results a segregation
of entities into a logical hierarchy of types, whose members are

---

[8] *The Analysis of Mind*, 192.

[9] Cf. *Our Knowledge of the External World etc.*, 58. It may be noted that
the argument, as there presented, is defective in requiring the alleged defender
of the universality of the subject-predicate form to propose an analysis which is
not of that form. The argument could however be patched up. It would then
establish that the attempt to express all relational propositions as logical products
of functions of *one* variable (i.e., to assert that $xRy \equiv Px.Qy$ for all x and y)
would lead to inconsistency with the theorems of the relational calculus. Russell
interprets this result as a proof of the inadequacy of exclusive adherence to the
subject-predicate form; but an opponent (such as Bradley, against whom the
argument was directed) might regard it as one further manifestation of the "un-
reality of relations."

[10] Cf. the article by Alonzo Church on "Paradoxes, logical" (in *The Dictionary
of Philosophy*, 224-225) for a convenient statement of the problem and a bibli-
ography.

individuals, functions of individuals, functions of functions of individuals, etc. (or an equivalent extensional hierarchy of classes and relations). Specification of the types of the entities involved is sufficient to reveal as invalid the arguments used in deriving *some* of the paradoxes.

This refutes only the paradoxes expressed in terms belonging wholly to mathematics or logic; but this is all that is required within logic itself, as subsequent logicians have emphasised. They follow Ramsey in rejecting the further subdivisions inside the types (the "branching theory of types") which were the basis of Russell's contribution to the solution of the remaining paradoxes. They agree with Ramsey that the latter are caused by "faulty ideas concerning thought and language,"[11] and, by claiming that "the fault must lie in the linguistic elements,"[12] they achieve a radical simplification of the original form of Russell's theory. This is no doubt satisfactory for those engaged in constructing a formal logic of maximum manipulative simplicity,[13] but it still leaves to be unravelled an imputed and endemic "ambiguity" of "ordinary language." Russell's discussion of this important residual problem deserves more critical attention than it has hitherto received.

2. *The definition of the logical types of entities designated by words of the ordinary language.* As contrasted with the definition of logical types in the artificial language of mathematical logic, the main point of difference which arises when the attempt is made to establish distinctions of type within "ordinary language" depends upon the fact that in the latter case modifica-

---

[11] F. P. Ramsey, *Foundations of Mathematics,* 21. In the group of logical paradoxes Ramsey puts those arguments, such as that involved in the contradiction of the greatest cardinal number, ". . . which, were no provision made against them, would occur in a logical or mathematical system itself. They involve only logical or mathematical terms . . ." The remainder ". . . are not purely logical, and cannot be stated in logical terms alone; for they all contain some reference to thought, language or symbolism, which are not formal but empirical terms." (*Ibid.*)

[12] F. P. Ramsey, *loc. cit.* (He proceeds to urge the need for further examination of the "linguistic elements.")

[13] " . . . the contradictions against which this part of type theory was directed are no business of logic anyway . . . the whole ramification, with the axiom of reducibility, calls simply for amputation." W. V. Quine (*The Philosophy of Alfred North Whitehead,* 151).

tion is introduced into a system of vocabulary and syntax *already in use*. There can be no question, therefore, of attaching unambiguous indications of type to symbols *introduced by definitions* (as in *Principia Mathematica*); the need is rather for a principle which will serve to reveal ambiguities of type within the system of grammatical rules already current.

The leading principle of the theory of types, so far as it applies to ordinary language, consists in the assertion that *grammatically* impeccable sentences often prove to be crypto-nonsense generated by a propensity for substituting in the same context words which agree in grammatical while differing in logical form. "In its technical form, this doctrine states merely that a word or symbol may form part of a significant proposition, and in this sense have meaning, without being always able to be substituted for another word or symbol in the same or some other proposition without producing nonsense."[14]

The benefit to be anticipated from an application of the theory of types to ordinary language will, therefore, consist in a set of criteria specifying *which* substitutions of words are legitimate. Since words which may so replace one another in all contexts are said to belong to the same type (by an extension of the usage of the similar expression in *Principia Mathematica*) the notion of logical types, as *here* used, will be of crucial importance.

The definition of a logical type [Russell says,] is as follows: A and B are of the same logical type if, and only if, given any fact of which A is a constituent, there is a corresponding fact which has B as a constituent, which either results by substituting B for A or is the negation of what so results. To take an illustration, Socrates and Aristotle are of the same type, because "Socrates was a philosopher" and "Aristotle was a philosopher" are both facts; Socrates and Caligula are of the same type, because "Socrates was a philosopher" and "Caligula was not a philosopher" are both facts. To love and to kill are of the same type, because "Plato loved Socrates" and "Plato did not kill Socrates" are both facts.[15]

In the form presented, this definition can be made to generate

---

[14] *Contemporary British Philosophy*, I, 371.
[15] *Op. cit.*, 369-370.

a new and instructive paradox, whose existence will demonstrate the need for further clarification of Russell's procedure.

3. *The paradox of dissolution of types.* Let it be supposed that K and L are of the same type, as defined above, and K and M are of *different* types. Then the following statements are true:

(1) "L is of the same type as K" is a fact,
(2) "M is not of the same type as K" is a fact.[16]

Now the second fact is the negation of what results from substituting M for L in the first fact. And the situation is formally analogous to that used for illustrative purposes by Russell, with L, M, and *being of the same type as K* corresponding respectively to Socrates, Caligula, and *being a philosopher*. Since L and M can replace each other in the manner specified in the definition, it follows that *L and M are of the same type*. But this clearly contradicts the initial assumption that M belongs to a type other than that to which both K and L belong. Expressed otherwise, the argument would seem to establish that, if there are at least three entities in the world, it is impossible that they should not all belong to the same type.[17]

Such a consequence would, of course, be quite intolerable. For, since it may be granted that there are at least three entities, it would be permissible to substitute any symbol for another in all contexts, and the application of the theory to ordinary language would achieve precisely nothing.

Two suggestions for the removal of this difficulty, each having a certain initial plausibility, will now be discussed.

4. *The consequences of relying upon ambiguity in the term "fact" to resolve the paradox.* It would be in the spirit of Russell's own exposition to retort that the word "fact" occurs, in the sentences (1) and (2) above, in a sense other than was intended in the definition of logical type. For, according to his account, "the following words . . . by their very nature sin against it [the doctrine of types]: attribute, relation, complex,

---

[16] The statements have been expressed in ways parallel to those used in Russell's examples.

[17] This contradiction does not seem to have been previously discovered.

*fact,* . . ."[18] No doubt it is required that a fact to the effect that K and L are of the same type shall be of an order of complexity other than that of an empirical fact in which K or L are constituents. But if this is maintained, Russell's definition of type becomes itself ambiguous and of indefinite application.[19]

So long as the word "fact" is taken in the colloquial sense in which to say " 'X' is a fact" is merely to say "it is true that X," the definition is plainly intelligible (though itself then sinning against the theory of types). In this sense *every* true sentence must be admitted to express a "fact," and the paradox is unassailable. But if the word "fact," as it occurs in the definition, is to be so restricted in meaning that only *some* true sentences shall be permitted to express facts in this unusual sense, it now becomes imperative to indicate how *such* facts are to be identified. In the absence of such supplementary information the definition will be useless.

Should such specification of the technical meaning of the crucial term "fact," however, be possible there would remain the further difficulty that the definition, now amended to be consistent with the theory of types, would have application only to a restricted class of sentences, viz., those expressing "facts" in the narrow technical sense. There would be no guarantee that the restricted theory of types resulting would not allow paradoxes to proliferate in the area over which it exercised no jurisdiction.

The theory is, then, indefinite and possibly self-contradictory; at best it can hope only to be incomplete. It would seem that Russell's own formulation leads to formidable if not insuperable difficulties.

5. *The paradox resolved by a re-interpretation of Russell's theory.* The root of the difficulties above displayed is to be found in Russell's interpretation of the relationship of *belonging to the same type* as holding between "entities." A

---

[18] *Contemporary British Philosophy,* I, foot of 371.

[19] An alternative proposal that might deserve examination would be to render the relation *being of the same type as* systematically ambiguous according to the type of the entities it relates. But this proposal would itself violate the theory of types.

direct escape is provided by substituting a parallel relation holding between *words*.

Let the locution, "K and L are of the same type," be abandoned in favor of the expression "the *words* 'K' and 'L' are *syntactically similar*" (and let it be agreed that in such cases 'K' and 'L' shall be said to belong to the same *syntactical type*). With this understanding, the sentences (1) and (2) above must be rewritten in some such form as

(3) "λ is of the same syntactical type as κ" is a fact,
(4) "μ is not of the same syntactical type as κ" is a fact,

where λ, μ, and κ are now *words*. And from this it will follow only that the *names* of all three words will be syntactically similar. Since the name of a word is not identical with the word itself, no contradiction will now result. Thus this suggestion, which is in line with Russell's own remark that "the theory of types is really a theory of symbols, not of things,"[20] would seem to provide a satisfactory resolution of the paradox.

But only at the cost of considerable increase in complexity. It may be left as an exercise to the reader to show that it will be necessary at the very least to provide an infinite hierarchy of senses of the expression "syntactically similar" corresponding to the different syntactical levels of the words it relates. There will need to be one relation of syntactical similarity between words, another between names of words, still another between names of names, and so forth. But this hierarchy has the advantage of being generated *by definition;* since the expression "syntactically similar" is specifically introduced into the language by definition, there can be no objection to the supplementary differentiation of several senses; the character of the hierarchy involved makes the identification of the level involved in any particular instance immediate and unmistakable.

6. *The need for a negative interpretation of Russell's theory.* If a linguistic translation of Russell's theory on the lines suggested above should prove feasible, there will still be required further modifications, if contradiction is to be avoided.

There are certain syntactically polygamous contexts able to

[20] *The Monist*, Vol. 29, 362.

receive words of the most diverse syntactical types without degenerating into nonsense. It is proper to say both "I am thinking about Russell" and "I am thinking about continuity;" thus nothing that has so far been said would prevent the disintegrating and absurd inference that "Russell" and "continuity" are syntactically similar. Unless further inhibitory measures are instituted, a wholesale merging and dissolution (this time of syntactical types) will once again be in prospect.

There seems no solution for this kind of difficulty, which arises in connection with all sentences expressing propositional attitudes (whether of knowing, supposing or believing), except to interpret the theory of types negatively as essentially an instrument for establishing *differences* of type. It will be necessary however to add a supplementary provision for the transmission of type distinctions to the associates of the ambiguous word in every context. The new procedure consists in asserting that two typographically distinct words are syntactically *dissimilar* if there is *at least one* context in which one cannot be substituted for the other without generating nonsense. To this is added the further condition that corresponding elements of contexts capable of receiving syntactically dissimilar words are themselves to be regarded (independently of typographical similarity) as syntactically dissimilar. (The first part of this test shows "Russell" and "continuity" to be syntactically dissimilar; the second then requires the two occurrences of "thinking" in "I am thinking about Russell" and "I am thinking about continuity" to be construed as instances of *two* words belonging to different syntactical types.)

Thus the application of the theory of types to ordinary language is a more complex undertaking than Russell's own account would suggest. A single attempt at substitution may establish that "A" is not of the same (syntactical) type as "B." Suppose two sentences are typographically identical except in containing "A" in place of "B;" then the corresponding symbols, in spite of typographical identity, must be considered as belonging to different types. Implicit recognition of this consequence may have been responsible for Russell's criticism of the use of such words as "attribute," "relation," etc., and for

his subsequent comment that after discriminating the type ambiguities, ". . . we usually arrive, not at one meaning, but at an infinite series of different meanings."[21]

7. *The value of Russell's application of the theory of types.* The consequences of Russell's procedure should by now be sufficiently clear. Any interpretation that will be faithful to his intentions requires the impossibility of substituting two words for one another in even a single context to be regarded as sufficient cause for their segregation into mutually exclusive types. The consistent elaboration of this leading idea involves the making of ever finer distinctions of "meaning" between words not customarily regarded as ambiguous. So stringent does the requirement prove that it becomes difficult, if not impossible, to state the theory itself without contradiction; such difficulty being only a single instance, though a striking one, of a general tendency to produce a paralysis of the general statements of which philosophical discussion so largely consists.

The case for submitting to such unwelcome consequences is something less than conclusive. It is well to recall that the theory was originally designed to purge discourse of those paradoxes which are not accounted for by the non-branching theory of types. But it may be supposed that the paradoxes in question might prove capable of a solution having less drastic consequences; indeed it is plausible to expect that prohibition of a characteristic reflexive type of *definition* might be enough to achieve this end.[22] Whether this suggestion should prove fruitful or not, it may be suspected that Russell's theory does less than justice to the success with which communication is actually achieved in *ordinary* language. The demonstration of distinctions of type, defined in terms of possibility of mutual substitution of words, is on occasion a valuable technique for exhibiting operative ambiguity whose removal is relevant to the solution of philosophical disputes. But the consequences of

---

[21] *Contemporary British Philosophy*, I, 372. It is to be noted that the quoted statement, by referring collectively to "meanings," itself sins against the theory of types.

[22] Thus the paradox of the least finite integer definable in a specified number of words depends upon the lack of definition (or the simultaneous use of contradictory definitions) of the term "definable."

an attempt to apply such techniques universally may be re-
garded as a *reductio ad absurdum* of a point of view which
seeks to apply to ordinary language segregatory criteria ap-
propriate to an artificially constructed calculus. And this in
turn can be traced back to the inclination to regard the relation
between language and the world exclusively in the light of
identity of structure.

## C. The Search for Ultimate Constituents of the World

*1. The genesis of the theory of descriptions.* For all their
drastic character, the segregatory techniques of the theory of
types prove insufficient to cure *all* the philosophical confusions
which can be attributed to excessive confidence in grammatical
structure as a guide to logical form. A notable instance of such
confusion arises in connection with the syntactical properties of
phrases of the form "the so-and-so."

If the phrase, "The present king of France," be compared,
in respect of identity or diversity of type, with a personal name,
say that of Stalin, it will be found that the noun clause may be
substituted for the name without producing nonsense.[23] More
generally, it is a fact that some descriptive phrases and some
nouns can replace each other in some or all contexts without
producing nonsense. If the theory of types were to be relied
upon to provide a sufficient criticism of ordinary language, it
would be necessary to conclude that "Stalin" and "The present
king of France" are syntactically similar.[24] This conclusion is
maintained in a more colloquial form by anybody who claims
that "The present king of France" names or denotes a person.

Upon such a foundation of identification of the syntactical
properties of the descriptive phrase and the name, curious argu-
ments have sometimes been erected. Since "The present king

---

[23] This statement would need some qualification for complete accuracy. It is
not easy to provide an account of the theory of descriptions that shall succeed in
being tolerably brief. The best short version known to me is that of Professor
L. S. Stebbing in her *Modern Introduction to Logic*, 2nd edition, 144-158 ("The
analysis of descriptions") and 502-505 ("Logical constructions"). Cf. also G. E.
Moore's article (in the present volume) on "Russell's 'Theory of Descriptions'."

[24] Or that Stalin and the present King of France belong to the same type.

of France" refers to a person who does not exist, it must be conceded that there are *non-existent persons* who can appear as subjects of true propositions. Though non-existent, they must accordingly be capable of sustaining predicates. Thus it is certain, by the law of excluded middle, that one of the two propositions, "The present king of France is a parent" and "The present king of France is childless," is true. And there must be countless other properties by which the non-existent present king of France is characterised (among them the property of being under discussion in this paper). It can scarcely be doubted that whatever is characterised by properties is not a mere nonentity, that in order to be a subject of which characters are genuinely predicable it is required to have some kind of objective "being," not to be confused with the vacuity of sheer nothingness on the one hand or the full actuality of "existence" on the other.

The argument culminates, then, in the assertion that the present king of France has some shadowy mode of participation in the world—some tenuous sort of "reality" compatible with non-existence. And, if so much prove acceptable, the stage is set for similar argument in defense of the right to a recognised objective status of fictions, self-contradictory entities and even nonentity itself. Hamlet and the Snark, the philosopher's stone and the round square, being all characterised by predicates, must all, in some versions of this position, have their being in a multiplicity of distinct limbos, realms of *Sosein, Aussersein* and *Quasisein* in which to enjoy their ambiguous status of partial or quasi-existence.[25] The exploration and portrayal in "a terminology devised expressly for the purpose" of such *Lebensräume* of Being, will, of course, provide philosophers of this persuasion with endless material for mystification and dialectical ingenuity.

That arguments so remarkable should have appealed to some philosophers is a matter of historical record; and many another argument in good standing to-day might be shown to involve

[25] The classical source of this argument is Meinong's *Ueber Gegenstandstheorie* (1904). For a sympathetic exposition cf. J. N. Findlay's *Meinong's Theory of Objects* (1933), especially Ch. 2.

patterns of thought essentially similar. The suppression of such invalid trains of inference, against which the theory of types provides no protection, is the main object of Russell's theory of descriptions.

This part of Russell's program may still be plausibly interpreted as a contribution to the reform of common syntax; improvement of the vocabulary of ordinary language (which will be remembered as the second plank of the platform) is provided rather by the doctrine of logical constructions. Although this is intimately connected both in origin and content with the theory of descriptions, it requires the use of certain epistemological considerations which need not be invoked in the case of the latter.

2. *The theory of descriptions as a metaphysically neutral technique of translation.* That the theory of descriptions can be construed as a method of logical translation, capable of justification independently of adherence to any disputable epistemology, is a point that is commonly overlooked by critics. The reader may be reminded that Russell's contribution to the interpretation of descriptive phrases consists in the circumstantial demonstration that every sentence containing a descriptive phrase can be translated into another sentence having the same meaning but a different, and normally more complex, grammatical form. Thus, to take the familiar illustration once again,

(5) The present king of France is married

becomes

(6) Exactly one thing at present reigns over France and nothing that reigns over France is not married.[26]

The features upon which the usefulness of this procedure depends is the absence in the expanded form (6) of any ostensible reference to an alleged constituent (a "non-existent person") designated by the original phrase "The present king of France." Not only has the descriptive phrase disappeared in the course of translation, but no part of the expansion of (5)

---

[26] Here again some accuracy has been deliberately sacrificed. Cf. Stebbing, *op. cit.*, foot of 157, for a better statement.

can be identified as capable of abbreviation by the original descriptive phrase. Thus the procedure is not one of definition, in the dictionary sense, of the phrase "The present king of France," but rather a method for recasting every sentence in which the original phrase occurs.[27]

Mastery of the character of the translations appropriate to the different kinds of contexts in which descriptive phrases may occur having once been achieved, a permanent protection is provided against the blandishments of grammatical analogy which lend the doctrine of Realms of Being its spurious plausibility. Reference to the expanded form (6) above shows that the original sentence (5) differs quite radically in form from such a sentence as "Stalin is married." It becomes obvious that adherence to the principle of excluded middle is consistent with the assertion that *every* ascription of a predicate to the present king of France results in a false statement; more generally, a valuable instrument is thereby provided for the expulsion of illegitimate inferences and the clarification of ideas, as the successful application of methods essentially similar to a variety of other philosophical problems amply demonstrates.[28]

It is important to recognise that the enjoyment of such welcome benefits exacts no prior commitment to any epistemological theses. The gist of the method is the proof of the equivalence in meaning of given sentences. Only if appeal to some philosophical principle is involved in verifying the truth of any such proposed translation will it be necessary to deny that the method is epistemologically neutral.

Now the manner in which the equivalence of two *English* sentences is established does not differ in principle from that involved in proving the correctness of a translation from one European language into another. In both cases there is more or less explicit and direct appeal to congruence of behavior and linguistic utterance in cognate situations. The criteria are of a sociological order and may, for that very reason, provide a

---

[27] There is no reason, however, why the notion of definition should not be extended so as to cover the kind of reduction involved in the example cited.

[28] A good example is G. E. Moore's article, "Is existence a predicate?" *Aristotelian Society Proceedings*, Supplementary Vol. 15 (1936), 175-188.

basis for agreement between philosophers elsewhere advocating very diverse epistemological or metaphysical doctrines. Since an idealist and a materialist can agree upon the correct translation of a passage from Homer, there seems to be no reason why they should have much more difficulty in coming to an understanding about the soundness of a proposed translation within their native tongue; they might both therefore make equal and equally good use of the methods provided by the theory of descriptions. It is not extravagantly optimistic to hope that, once the theory has been separated from the more specifically metaphysical components with which it is associated in Russell's presentation, it may ultimately achieve a measure of common agreement (without prejudice to eventual differences of opinion concerning the interpretation and value of the method) such as may be found in the elementary propositional calculus or the other well-established branches of symbolic logic.

3. *The doctrine of logical constructions and its reliance upon the principle of reducibility to acquaintance.* It is to be noted that the foregoing non-controversial portion of Russell's theory is concerned with the logical expansion of *logical symbols*. When sentence (5) was equated with sentence (6), such words as "present," "king," "France," etc., occurred *vacuously* (to use a convenient term of Dr. Quine's[29]); they were present merely as illustrative variables indicating how "The X of Y is Z" might, *in general*, be translated. Thus the translations offered by the theory of descriptions provide further insight into the manner in which the logical words "the," "and," "of" are used in ordinary language; but no information is yielded concerning the syntactical relationships of non-logical material words.

The shift from the consideration of logical to that of non-logical or material words corresponds exactly to the line drawn in this brief exposition between the theory of descriptions and the doctrine of logical constructions; it will now be shown that when this boundary is crossed the validity of an epistemological principle concerning the reducibility of knowledge to acquaintance becomes relevant to the criticism of Russell's method.

[29] W. V. Quine, *Mathematical Logic*, 2.

Anybody who maintains, with Russell, that tables are logical constructions, or that the self is a logical construction, is claiming *at least* that sentences containing the material words "table" or "I" submit to the same type of reductive translation as was demonstrated in connection with descriptive phrases.[30] If tables are logical constructions it is necessary that every sentence containing the word "table" shall be capable of transformation into another sentence from which that word is absent and no part of which could be abbreviated by the word. It is quite certain that *some* material words, such as "average," satisfy such a condition; and it would seem initially plausible that some elements of vocabulary do and others do not admit of such reduction. If this were the case the claim in respect of any specific X that it was a logical construction would seem to require a specific demonstration. On Russell's principles, however, it can be known in advance of specific investigation that the entities referred to by the vast majority, if not indeed the totality, of the words of ordinary language *must be* logical constructions.

For very much more than mere translation of the kind specified is implied by Russell's contention that tables are logical constructions: the procedure must, on his view, have a *direction*, determined by progressive approach towards a *final translation*. A sentence is a final translation only if it consists entirely of "logically proper names" (demonstrative symbols) for "ultimate constituents;" it may then conveniently be referred to as a *pictorial sentence*.[31] To say that X is a logical construction is to claim that sentences containing "X" may be *finally* translated, in this drastic sense, into pictorial sentences.

What are these "ultimate constituents?"[32] They are, on Russell's view, precisely those entities "with which we can be acquainted;" more specifically, sense-data (particulars) now pre-

---

[30] Russell of course did not use so linguistic a version. Cf. the statement in the text with the following typical utterance: "The real man, too, I believe, however the police may swear to his identity, is really a series of momentary men, each different one from the other, and bound together, not by a numerical identity, but by continuity and certain intrinsic causal laws." (*Mysticism and Logic*, 129)

[31] The term is due to Stebbing.

[32] "Neither the word [a proper name] nor what it names is one of *the ultimate indivisible constituents of the world*." (*Analysis of Mind*, 193. Italics supplied.)

sented to us and universals characterising sense-data with which we are or have been acquainted. The assurance that every sentence can be finally translated into a pictorial sentence is provided by the principle that "every proposition which we can understand must be composed wholly of constituents with which we are acquainted."[33]

The reasons should now be obvious for distinguishing between the theory of descriptions and the theory of logical constructions. The latter predicts that sentences containing "table" will prove to admit of translation into pictorial sentences in which each element refers to an object with which we are acquainted. But ordinary language contains no logically proper names, and can therefore provide no pictorial sentences.[34] The verification of the thesis here requires the invention of a new vocabulary departing drastically in character from that which it is to replace.

The case for the validity of the doctrine of logical constructions accordingly is quite different from that which supports the theory of descriptions. The latter is established by empirical grounds manifested in achieved success in translation; the former is, in the absence of the successful provision of the new vocabulary desiderated, rather the expression of a stubborn aspiration, whose plausibility rests entirely upon the supposed truth of the principle of reducibility to acquaintance.

No mention has hitherto been made of the metaphysical consequences of the doctrine of logical constructions. The reader will hardly need to be reminded that Russell has drawn such consequences freely, characteristically maintaining that matter, the self, and other minds (to cite some striking instances of alleged logical constructions) are "symbolic fictions" or even "myths."[35] But for these supposed consequences it is unlikely

---

[33] *The Problems of Philosophy*, 91.

[34] "We cannot so use sentences [i.e., pictorially] both because our language is not adapted to picturing and because we usually do not know what precisely are the constituents of the facts to which we refer," Stebbing, *op. cit.*, 157. ". . . no word that we can understand would occur in a grammatically correct account of the universe," Russell, *Philosophy*, 257.

[35] The following are typical statements: "The persistent particles of mathematical physics I regard as logical constructions, symbolic fictions . . ." (*Mysti-*

that Russell's theory of constructions would have received the critical attention which has been lavished upon it. If, as the next section will try to show, the principle of reduction to acquaintance has no evidential support, discussion of these alleged consequences becomes redundant.[36]

*4. Criticism of the principle of reducibility to acquaintance.* Since the various formulations of the principle which Russell has given[37] hardly vary except in unimportant details of phraseology, the version of 1905 might be taken as standard: ". . . in every proposition that we can apprehend (i.e., not only in those whose truth or falsehood we can judge of, but in all that we can think about) all the constituents are really entities with which we have immediate acquaintance."[38]

The confidence with which this principle is presented for acceptance contrasts strikingly with the baldness of the grounds offered in its defense. "The chief reason," says Russell, "for

---

*cism and Logic*, 128); ". . . matter, which is a logical fiction. . . ." (*Analysis of Mind*, 306); ". . . [Desire] merely a convenient fiction, like force in mechanics . . . ." (*op. cit.*, 205).

[36] The standard argument against Russell's attribution of a fictitious status to logical constructions (viz., the proof that "X is a logical construction" does not entail "X does not exist"), though accurate, does less than justice to Russell's point, however misleadingly expressed. The critics of Russell's language of "fictions" would not allow that the average man is a "fiction" or "unreal;" but they would be prepared to admit that the average *unicorn* is "unreal" (though no doubt stigmatising the choice of terms as perverse). Now there is a sense in which the plain man would want to claim that both the average man *and* the average unicorn are fictions, because the phrases referring to them can be dispensed with in a complete account of the world. And more generally, if 'X' is a dispensable symbol it is natural to say something like: " 'X' is a mere symbolic expedient, corresponding to nothing ultimate and irreducible in the world." It is this kind of statement that Russell wishes to make. Now, if all non-pictorial sentences were finally translatable, it would be natural to say that the world consists only of particular sense-data and the universals by which they are characterised, and to attribute the apparent presence of *other* entities to unwarranted inferences drawn from the nature of the symbols used in abbreviating pictorial sentences. It would, in short, be natural to say that facts about tables are *nothing but* facts about objects of acquaintance. This is the gist of Russell's position.

[37] "On Denoting," *Mind*, Vol. 14 (1905), 492; *Mysticism and Logic*, 219, 221; *The Problems of Philosophy*, 91. Cf. J. W. Reeves, "The Origin and Consequences of the Theory of Descriptions," *Proceedings of the Aristotelian Society*, Vol. 34 (1934), 211-230.

[38] *Mind*, Vol. 14, 492.

supposing the principle true is that it seems scarcely possible to believe that we can make a judgement or entertain a supposition without knowing what it is that we are judging or supposing about."[39] And in another place, after this statement is repeated almost verbatim, there is added merely the comment: "We must attach *some* meaning to the words we use, if we are to speak significantly and not utter mere noise, *and the meaning we attach to our words must be something with which we are acquainted.*"[40]

Whatever persuasiveness attaches to this defense of the principle can be shown to arise from equivocation upon the crucial words "know," "mean," and "acquaintance." It may be just permissible so to use the term "acquaintance" that the sentence "I know the meaning of X" is synonymous with "I am acquainted with X," where the word "meaning" is used in the sense it has in *ordinary language.* This is hardly a sense of "acquaintance" which can be relied upon not to engender confusion, but a philosopher may nevertheless find its introduction expedient. In this sense of the word, however, the assertion that "the meaning we attach to our words must be something with which we are acquainted" is merely the tautology that "the meaning of our words must be the meaning of our words." This can hardly be Russell's intention in the passages cited. Since we understand the word "Attila" we may be said either to "know the meaning of the word" or, alternatively and synonymously, to "be acquainted with Attila." Now Attila is neither a sense-datum nor a universal capable of characterising sense-data; it is impossible, then, for anybody to be acquainted with Attila in the narrow technical sense of acquaintance which makes Russell's principle, whether true or false, something more than a mere tautology. If his assertion is to have any content, he must be interpreted as meaning "it seems scarcely possible to believe that we can make a judgement without knowing *by acquaintance* what it is that we are judging about" and "it is

[39] *Mysticism and Logic*, 219.
[40] *The Problems of Philosophy*, 91 (italics supplied). I am not aware of any other defense of the principle by Russell.

impossible that our words should have meaning unless they refer to entities *with which we are acquainted*."

The alleged defense of the favoured principle ("the chief reason for supposing the principle true") is now seen to be a mere repetition of that which was to be demonstrated. One of two things must be the case. Either Russell is using the term "meaning" in one of its customary senses; in that case the argument adduced in favour of the principle is refuted quite simply by pointing out that "Attila" *means* a certain person with whom we are *not* acquainted in Russell's sense. Or, alternatively, a new sense of meaning is implicitly *introduced* in which only objects with which we are acquainted can be meant by words: in that case the argument is a *petitio principii*. In the other case the principle remains unproven.

5. *Grounds for rejecting the principle of reducibility to acquaintance.* It is likely that the reasons why the principle, in default of persuasive argument in its defense, should have seemed to so many philosophers self-evident are connected with the supposed necessity of "directness" in relations of meaning and knowing. Underlying Russell's position throughout is the conviction that in all genuine knowledge or meaning there must be some such ultimate fusion of intimacy between the knower and what is known as is provided by the notion of "acquaintance."

Let the validity of such an approach be tested in some less controversial area. Suppose it were argued that "every proposition about the *possession* of material objects must be reducible to a proposition about *contact* with objects" on the ground that "it seems hardly possible to believe that we can hold an object without really being in contact with it." Would it not be clear in such a case that there was being introduced a restricted and misleading sense of "holding" or "possession," in virtue of which it becomes logically impossible to hold anything except the surface with which one is in contact? And would it not be quite as clear that the mere introduction of a stipulation concerning the meaning of a term could succeeed in demonstrating precisely nothing?

It may be objected that the analogy is unsound; and it is true that there might be *independent* grounds for supposing the relationship of *meaning*, unlike that of physical possession, to be necessarily direct. But although this may be allowed as an abstract possibility, neither Russell nor anybody else has yet provided good grounds for believing it to be anything more. And there are good opposing reasons for rejecting the principle.

Whenever sentences containing a symbol (such as "the present king of France" or "the average man") can be translated in such a manner that the symbol neither appears explicitly nor can be identified with any portion of the translation, it will be convenient to speak of the symbol as being *dispensable*. Now there is good reason to believe that "table" and "I" are not dispensable symbols, i.e., that there are truths concerning tables and the self which are not capable of being expressed without the use of these or synonymous symbols. It can be demonstrated, in connection with quite elementary examples of deductive theories, that "auxiliary" or "secondary" symbols can be introduced in such a way that they are not capable of *explicit* definition in terms of the basic experiential terms of the theory.[41] This does not render them undefined, in a wide sense of that term, since the mode of introduction of the auxiliary symbols into the system provides both for their syntactical relations with associated symbols and for inferential relations between the sentences in which they occur and the "primary" observational sentences of the system. This seems to be precisely the situation in respect of such scientific terms as "energy," "entropy," and "field," none of which are "dispensable."[42] There appears to be no *a priori* reason why this should not be the case also in respect of the names of material objects and other terms of ordinary language.

Indeed a careful scrutiny of the attempts made (especially by phenomenalists) to prove that words denoting material objects are dispensable will render this last suggestion something more than plausible. For these attempts invariably termi-

---

[41] Cf. Ramsey's discussion of the place of explicit definitions in a theory. (*Foundations of Mathematics*, 229).

[42] Further detail would be needed to prove this statement.

nate in sceptical conclusions. When Russell, in his latest book, undertakes to provide a phenomenalistic analysis of "you are hot,"[43] he arrives at a proposition which in order to be known to be true requires the speaker to know *inter alia* that the hearer is aware of a multitude of events in the same sense of "aware" in which he himself is aware of events and, further, that whole classes of events which *could* be perceived exist in the absence of such perception. Now neither of these truths could be known by acquaintance; the conclusion drawn is that the original proposition analysed is not *strictly* known to be true. At best we can "assume" its truth, "in the absence of evidence to the contrary."[44] But to assume or postulate the truth of a proposition is only to *hope* that it may be true. There are circumstances in which the truth of the assertion "you are hot" is *certain;* nothing could be more absurd than to doubt that this remark, when addressed to a philosopher in the warmest chamber of a Turkish Bath, may sometimes be both true and known to be true. Now if the truth of the principle of acquaintance requires the rejection of even a single certain truth, there would seem to be sufficient reason to abandon it.

## D. The Notion of the "Ideal Language"

*1. The character of the "ideal language."* An examination of the character of that "ideal language" which Russell recommends as the goal of the philosophy of language provides a very precise test of the value of his early doctrines. For the "ideal language" is, by definition, the symbolism which would be entirely free from the philosophical defects which Russell claims to find in ordinary language. If language "had been invented by scientifically trained observers for purposes of philosophy and logic,"[45] just this symbolism would have resulted. And it would be "logically perfect"[46] in the sense of conforming to "what logic requires of a language which is to avoid contradiction."[47] The character of the ideal language is

---

[43] *An Inquiry into Meaning and Truth,* 280-282, 284-291.
[44] *Ibid.,* 292.
[45] *The Analysis of Mind,* 193.
[46] *The Monist,* Vol. 28, 520.
[47] *Contemporary British Philosophy,* Vol. I, 377.

calculated, then, to reveal in a vivid fashion the benefits to be expected from a successful outcome of Russell's program of reform.

The discussion of the preceding sections should have made clear the features which would be manifested by such a paradigm of philosophical symbolism. Every symbol will be a "logically proper name" denoting objects of acquaintance: "there will be one word and no more for every simple object and everything that is not simple will be expressed by a combination of words."[48] How closely will these logically proper names for ultimate constituents resemble the words at present in use? By definition, they must be unintelligible in the absence of the entities they denote. Thus no proper names, in the familiar *grammatical* sense, can qualify for inclusion in the ideal language, just because, in virtue of referring to complex series of causally related appearances, they function as logical descriptions. The descriptive character of such a name as "Napoleon" is recognised by the circumstance that the name is intelligible to persons who never met the Corsican.[49]

Similar considerations would seem to disqualify all other types of words in the ordinary language. The names of universals characterising sense-data (e.g., the name of a specific shade of colour) might seem to be exceptions; but it would be hard to deny that even these have meaning in the absence of instances of the universals they denote. Now if universals are among the ultimate constituents, as Russell claims, they must be represented in the ideal language by arbitrary noises of such a character that it is logically impossible that they should be uttered in the absence of instances of the universals concerned.

The attempt might be made to construct illustrative instances of sentences of the ideal language composed entirely of demonstratives, by inventing such words as "thet" and "thot" to supplement the present meagre stock of "this" and "that."[50] But even "This thet thot"[51] would still convey to a hearer some

---

[48] *The Monist*, Vol. 28, 520.

[49] *The Analysis of Mind*, 192-193.

[50] As suggested by John Wisdom, *Mind*, Vol. 40, 204.

[51] Somewhat more drastic than Wisdom's "This son that, and that brother thet, and thet mother thot, and thot boy, and this kissed Sylvia" (*Ibidem*).

such meaning as "Something with which the speaker is acquainted has some relation, with which the speaker is acquainted, to some other thing with which he is acquainted."[52] The proposition understood by the hearer would not then be the proposition intended by the speaker; the "perfect sentence," having meaning only to the speaker and to him only at the time of utterance, would be perfectly unintelligible. If this criticism is based upon a misinterpretation of Russell's intention, and if it were permissible for the names of such ultimate constituents as are universals to be intelligible at a variety of times and to more than a single person, it would still be necessary that the names of particulars should be private; and communication would be possible only by the grace of some kind of pre-established speaker-hearer ambiguity in virtue of which what was a logically proper name for the one functioned as a description for the other.

What becomes under such conditions of the intention that the ideal language shall be "completely analytic and . . . show at a glance the logical structure of the facts asserted or denied?"[53] Such a system, containing "no words that we can [at present] understand"[54] would be so remote from our present means of expression and so unsuited to perform the functions of unambiguous and logically accurate communication which may be desired of an efficient language, that to urge its capacity to provide "a grammatically correct account of the universe"[55] is to be extravagantly implausible. The "ideal language" in practice would resemble a series of involuntary squeaks and grunts more closely than anything it is at present customary to recognise as a language.

It is by no means certain that Russell ever seriously supposed that the ideal language could be realised; and some of his remarks suggest that he regarded it on occasion as a mere device of exposition.[56] If, as has been argued above, the ideal language is not capable of realisation, it becomes impossible seriously to

[52] Cf. Wisdom's discussion of this point, op. cit., 203.
[53] The Monist, Vol. 28, 520.
[54] Philosophy, 257.
[55] Ibidem.
[56] Cf. The Monist, Vol. 28, 520.

defend indefinite progression towards such an "ideal" as a desirable procedure for the philosophical criticism of language.

It is not difficult to see, in retrospect, why Russell should have been led into this untenable position of defending as the aim of the philosophy of language the construction of a language which could never work. For the "ideal language" would satisfy perfectly the intention to make the relation of "picturing" the sole essential basis of symbolism. Whatever else Russell is prepared to regard as "accidental" in language, he is unwilling to abandon the notion that language must "correspond" to the "facts," through one-one correlation of elements and identity of logical structure. But there is no good reason why we should expect language to correspond to, or "resemble," the "world" any more closely than a telescope does the planet which it brings to the astronomer's attention.

2. *Consequences of abandoning the pursuit of an "ideal language."* To abandon the image of language as a "picture" of the world, which has, on the whole, wrought so much mischief in the philosophy of language, is to be in a position to make the most intelligent use of the products of Russell's analytical ingenuity.

For it would be both unfair and ungrateful to end without acknowledging the pragmatic value of the techniques invented by Russell. Rejection of the possibility or desirability of an "ideal language" is compatible with a judicious recourse to the methods of translation and analysis which have been criticised in this paper. It is a matter of common experience that philosophical confusion and mistaken doctrine are sometimes connected with failure to make type distinction or to reveal, by the technique of translation, the correct deductive relations between sentences of similar grammatical, though differing logical, forms. And where such confusion is manifested it is helpful to follow Russell's new way of "philosophical grammar." It will be well, however, to be unashamedly opportunistic, making the remedy fit the disease and seeking only to remove such hindrances to philosophical enlightenment as are demonstrably occasioned by excessive attachment to the accidents of grammar and vocabulary. In this way there is some hope of avoiding the

temptation to impose, by way of cure, a predetermined linguistic structure—of seeking to eliminate the philosophical ills of the language at present in use by proposing an "ideal language" which never could be used. Nor need such a program be aimless. For the object will be to remove just those linguistic confusions which are actually found to be relevant to doctrines of philosophical importance.

MAX BLACK

DEPARTMENT OF PHILOSOPHY
UNIVERSITY OF ILLINOIS

**7**

*Philip P. Wiener*

## METHOD IN RUSSELL'S WORK ON LEIBNIZ

# METHOD IN RUSSELL'S WORK
# ON LEIBNIZ

S PINOZA'S dictum that Peter's opinion of Paul tells us more about Peter than about Paul should be modified when Peter's mind is of the same cast as Paul's. Thus, Russell's *Critical Exposition of the Philosophy of Leibniz* tells us a good deal about both Russell and Leibniz, insofar as both were concerned with the central rôle of method in philosophy. We see from the following quotation that Russell in 1900, when he published his lectures on Leibniz, rejected Leibniz's attempt to base philosophy on logic, but so stealthily do ideas grow on one, that "the Ariadne's thread" of Leibniz's philosophy, logic in its most formal and mathematical sense, became for many years the chief preoccupation of Russell and the essence of philosophy for him.

As a mathematical idea—as a Universal Algebra, embracing Formal Logic, ordinary Algebra, and Geometry as special cases—Leibniz's conception has shown itself in the highest sense useful. But as a method of pursuing philosophy, it had the formalist defect which results from a belief in analytic propositions, and which led Spinoza to employ a geometrical method. For the business of philosophy is just the discovery of those simple notions, and those primitive axioms, upon which any calculus or science must be based. The belief that the primitive axioms are identical leads to an emphasis on *results,* rather than premisses, which is radically opposed to the true philosophic method. There can be neither difficulty nor interest in the premisses, if those are of such a kind as "A is A" or "AB is not non-A." And thus Leibniz supposed that the great requisite was a convenient method of deduction. Whereas, in fact, the problems of philosophy should be anterior to deduction. An idea which can be defined, or a proposition which can be proved, is of only subordinate philosophical interest. The emphasis should be laid on the

indefinable and indemonstrable, and here no method is available save intuition.[1]

Despite the similar intellectual interests of these two versatile minds, ranging from logic and the philosophy of the sciences to ethics, history, and politics, there is the greatest difference between them as persons. Leibniz acquired his title to nobility by flattering powerful princes and church officials and by defending their feudal privileges; whereas Russell, though born an aristocrat, has always defended the democratic tradition and courageously opposed political and church authoritarianism at the cost of that very type of worldly success which was so dear to Leibniz. In their theories of education, Leibniz wrote only for powerful jurists and rulers, but Russell has tried to reach all citizens.

In what follows, I shall indicate what can be learned from Russell's work on Leibniz's philosophy about the development of Russell's philosophic views, especially on the question of method, which he himself has considered the core of philosophy. But I wish also to examine the method employed by Russell in characterizing the philosophy of an important figure in the history of modern philosophy, because this method has certain distinctive merits and some limitations, as I see them, for the critical history of thought.

At Cambridge in the late 1890's, Russell (and G. E. Moore) were powerfully reacting to the Hegelianism of Lotze and Bradley, and, as a result, the first formulations of the new logical realism appeared. Bradley had followed the Hegelian attempt to feed Platonic universals to an omnivorous Absolute which swallowed both universals and individuals in disregard of the more balanced diet of the sciences and of ethical utilitarianism. Russell himself was not to be emancipated from Platonic notions of mathematics and ethics for many years to come;

---

[1] B. Russell, *A Critical Exposition of the Philosophy of Leibniz,* (1st edition, 1900; 2d edition, 1937, pp. 170-171. All page references here are to second edition.) Russell declares, in his preface to the second edition, that he now believes in the analytic nature of necessary propositions. It is encouraging to know that Russell's intuitionism, which may have been due to the influence of Bradley, was not incorrigible, as is the case with so many intuitionist philosophies.

Platonism was also deeply engrained in Leibniz's philosophy. What repelled Russell in the idealism of Leibniz was not such Platonic notions in themselves, but the scholastic theology and anti-individualistic ethics which Leibniz (and Hegel) infused in their writings, notions which Russell properly regarded as inimical both to scientific inquiry and to the political freedom of individuals. The Leibnizian (and Hegelian) conception of a metaphysical logic and ethics was distinctly opposed to the empiricistic and individualistic approach of Locke, Hume, and their successors. Russell, as an heir to this individualistic tradition, submitted to sceptical scrutiny the formidable arguments which Leibniz used to buttress theology with formal logic and scholastic metaphysics with a divinely created hierarchy of monads. This task was rendered all the more difficult by the great prestige enjoyed by the distinguished Leibniz as a mathematician, logician, and classical philosopher.

It would be interesting to know whether Russell's abandonment of Platonism in ethics (which he attributes to reading Santayana's criticisms of his philosophy) was connected with his shift to nominalism in metaphysics. Historically, the belief in absolute goodness has been associated with belief in necessary empirical truths. However, Leibniz should have been an exception, insofar as he argued for analytical necessity in logic and metaphysics, but for irreducible contingency in empirical science. Although Russell was opposed to the theological ground of Leibniz's apriorism, he did not question the Platonic elements in Leibniz's metaphysics, but showed how they were inconsistent with Leibniz's doctrine of contingency. The alternative would be to put logic, ethics, and empirical science on a contingent, operational basis. But Russell, who was just beginning to study modern logic, was not yet ready for a conception which owes its contemporary development to the American logician and founder of pragmatism, Charles S. Peirce.

Regarding logic, in a Platonic way, as the core of philosophy, Russell had to separate out from the mass of Leibniz's writings a coherent logical structure in order to show that the main defects of Leibniz's philosophy were due to flaws in that structure. This procedure implied a Platonic theory of metaphysical

truth such as Leibniz himself had adopted in his *a priori* proofs of God's existence, immortality, and free-will. It is only incidentally that the more purely historical considerations of Leibniz's philosophy as an expression of the science and social institutions of his day enter into Russell's work. But that is because Russell sharply distinguished, again in a Platonic way, pure philosophy from pure history, when in fact—but here I am expressing my own opinion—philosophy and history are not "pure" disciplines. I thus find myself admiring Russell's penetrating analyses of the logical structure of Leibniz's thought, as well as Russell's empirical insights into the more wordly interests of Leibniz's theology, ethics, and politics, without understanding what relation, if any, Russell meant to assert or to imply as holding between the two versions of the philosophy of Leibniz, which the latter held "one for himself and one for the admiration of princes and (even more) of princesses." It is true that mathematics, especially the infinitesimal calculus, and formal logic, especially the *characteristica universalis,* greatly influenced Leibniz. Furthermore, what elicited Russell's admiration of Leibniz as a philosopher was his discovery that "Leibniz's system does follow correctly and necessarily from five premisses," which Russell states as the basis of Leibniz's real philosophy; such rare logical rectitude "is the evidence of Leibniz's philosophical excellence, and the permanent contribution which he made to philosophy." We are also told:

What is first of all required in a commentator is to attempt a reconstruction of the system which Leibniz should have written—to discover what is the beginning, and what the end, of his chains of reasoning, to exhibit the interconnections of his various opinions, and to fill in from his other writings the bare outlines of such works as the *Monadology* or the *Discours de Métaphysique.* This unavoidable but somewhat ambitious attempt forms one part—perhaps the chief part—of my purpose in the present work. (2-3)

Yet there is a clear and explicit recognition by Russell of certain historical facts, e.g., that Leibniz's philosophy did change from a youthful scholasticism to the atomism of Hobbes and Gassendi, and finally, to his monadology (70). However, it is also clear that Russell was more interested in logical structures

than in such historical questions. "Since the philosophies of the past belong to one or another of a few great types—types which in our own day are perpetually recurring—we may learn, from examining the greatest representative of any type, what are the grounds for such a philosophy." (xii) Bradley's (or Lotze's) idealism was an example of one of the types of philosophy alluded to here. In any case, Russell wished to exhibit the logical structure of a possible, and to him important, philosophy, and found the nearest exemplification of the type of idealistic arguments current in his own time in the mature views of Leibniz "held, with but slight modifications, from January 1686 till his death in 1716. His earlier views, and the influence of other philosophers, have been considered only in so far as they seemed essential to the comprehension of his final system." (3)

Just as there are for Russell two versions of Leibniz's philosophy, the one offered for the approval of state and church officials, and the other intended for more serious logicians like Russell, so there are two kinds of inconsistencies which Russell indicates in Leibniz's system: those due to Leibniz's political fears of admitting consequences necessarily entailed by his premises, but "shocking to the prevailing opinions of Leibniz's time;" secondly, those due to formal contradictions among Leibniz's premises, which for Russell form a "greater class of inconsistencies." (4)

Russell exhibits the first class of inconsistencies simply by drawing the shocking conclusions, e.g., that Leibniz's premises lead to Spinozism, and the second class by showing that Leibniz's real philosophy is reducible to five premises, the first of which (every proposition has a subject and a predicate) is inconsistent with the fourth and fifth (the Ego is a substance, and perception yields knowledge of an external world). We now have three philosophies of Leibniz: the one used to convince the princes, the one that appeared consistent to Leibniz but which he concealed from the world, and the inconsistent system which was concealed from himself, but which Russell's logical analysis has uncovered. Logical realism implied that the real Leibniz was this last inconsistent one. However, it seems meaningless to ask which is the real philosophy of Leibniz, since they are

all contained in Leibniz's writings and their significance depends on the way they function in discourse. The first Leibniz belongs to seventeenth-century political history; the second to the history of logic which dates back to Aristotle;[2] and the third Leibniz belongs to the Cambridge neo-realism of Russell and G. E. Moore. These versions of Leibniz raise an important question. On Russell's analysis, Leibniz's system is inconsistent. Therefore, Leibniz could have proven *any* proposition. Then why did Leibniz in fact deduce only a certain class of propositions from five inconsistent premises? The answer cannot be given by logical analysis of the internal structure of Leibniz's thought.

Russell's logical atomism (in its earliest form) shared with Leibniz's "alphabet of knowledge" the assumption that there are absolute logical beginnings; for example, he finds in the *Discourses on Metaphysics* "the logical beginning" of Leibniz's system (7). The phrase quoted is self-contradictory, as Hegel once pointed out, and as modern logic and Russell now would claim. Given a specific text, we say that it contains statements from which the other statements are deducible, and only relative to that deductive order are the first statements "the logical beginning" of the reasoning exhibited in the text. The seventeenth-century Leibniz did employ a large variety of arguments and diverse modes of exposition which start from theological, ethical, and metaphysical as well as scientific premises Russell's success in reducing the second apparently coherent Leibniz to a system that begins with only five premises is evidence, I should say, of Russell's excellence in logic, and is his contribution to the study of Leibniz's philosophy as well as to the method of writing the critical history of philosophy. It is extremely useful to reduce a complex system of writings to a few statements, but the products of distillation will not resemble the raw materials from which they are made, because of ingredients subtracted or added by the critic or historian. Thus, there is no one-one correspondence between the simple set of five premises of Russell's Leibniz and the more complex mean-

[2] Cf. Vailati Scritti "Sul carattere del contributo apportato de Leibniz allo sviluppo della Logica Formale," 619 ff., quoted in my "Notes on Leibniz's Conception of Logic and Its Historical Context," *Philosophical Review*, vol. 48 (Nov. 1939), 567-586.

ing of Leibniz's arguments considered in their historical context. But it is true that by means of such a set of premises as Russell has made out we are able to trace more clearly a certain structure in an important part of Leibniz's arguments. The relationship here is similar to that between a mathematical system and its physical applications. But before we can know how appropriate any deductive device is to a given empirical situation, we should know how frequently we can apply it to a class of similar situations. Hence, to know the relative importance of scientific logic and theology in Leibniz's thinking, we should inquire how frequently we find him having recourse to one or the other in order to solve certain problems. The critical historian of philosophy will have first to ascertain what would constitute a solution to these problems, as Russell did.

Russell, like Aristotle in relation to his predecessors as given in the first book of the Metaphysics, but more consciously and explicitly, looked upon the writings of Leibniz as important only when they bore upon the problems with which he was himself concerned, regardless of the peculiar historical meaning these problems had for Leibniz. For example, Russell very clearly discerns five distinct meanings of matter in Leibniz's writings and two meanings of resistance (ch. VII), but is more concerned to show how Leibniz confounded them than to trace the prior and subsequent history of these meanings. Of course, the historian of ideas can do this if, and only if, he has made the preliminary analysis which Russell has made.

Russell explained later that his method of characterizing Leibniz is one he would not use in characterizing a different sort of philosopher like Santayana:

In attempting to characterize philosophers, no uniform method should be adopted. The method, in each case, should be such as to exhibit what the philosopher himself thinks important and what, in the opinion of the critic, makes him worthy of study. There are some—of whom Leibniz is the most important example—who stand or fall by the correctness of their reasoning and logical analysis; the treatment of such philosophers demands minute dissection and the search for fallacies.[3]

[3] "The Philosophy of Santayana," in Volume Two of *The Library of Living Philosophers*, ed. Schilpp, 453.

One of the subjects Leibniz himself thought important—theology—is certainly not what his critic, Russell, thinks makes him worthy of study; but the other—logic—was considered both by Leibniz and his critic as of paramount importance, and was subjected to minute dissection by Russell. It is doubtful, however, whether Leibniz would have turned atheist, if he had read Russell's criticisms, and hence, there is no *necessary* connection between Leibniz's theological beliefs and his logic. But there are, in the history of human thought, empirical or probable connections, and all the evidence points to the influence of ethics and theology on Leibniz's use of logic and even on his physics. Consider, for example, the pride Leibniz expresses in his dynamic view of matter as endowing physical bodies with direction and final causes. This theological motive in no way detracts from the soundness of Leibniz's logical criticisms of Descartes' physics (152-153).

Most historians of thought seem to regard the goal of their study as learning the language spoken or written by past thinkers, without themselves thinking through what these thinkers were writing about. Submissive "participation" in the utterances of a past thinker seems to be a substitute for thinking through the problems dealt with. Russell's more philosophical, because more critical, view regards the history of philosophy as the development of a limited number of possible types of thought represented by different individual thinkers. He could have made clearer the fact that in any one philosopher like Leibniz there is a mingling of types sometimes productive of a fruitful and new synthesis, but more often not, because of failure to note inconsistencies. It is a logical problem to note these inconsistencies, but it is not as problems *of* logic that we find them in the history of thought. I believe that Russell does treat certain logical problems in his critical exposition of Leibniz as though they were the same problems of logic which were foremost in discussions at Cambridge about 1899. However, there was no great harm done to Leibniz at this point, since Leibniz did attach a great deal of importance to the problems of logic as he conceived them, i.e., to the general nature of propositions (attributive and relational), types of reasoning

(syllogistic and asyllogistic), truths (necessary and contingent, analytic and synthetic), knowledge (intuitive and symbolic, adequate and inadequate, clear and confused, distinct and obscure). But most of these so-called problems of logic were mixed up with questions of metaphysics and psychology set in a cultural context which was different in Leibniz's age than in Russell's. When Russell properly indicates the Spinozism implicit in Leibniz's premises and its incompatibility with the existence of individuals, he was aiming at the metaphysics and ethics which idealists like Bradley advocated. It was scoring against the late nineteenth-century philosophy of "objective idealism" for Russell to prove that the first premise of Leibniz's system (the subject-predicate theory of propositions) was inconsistent with the premises that the Ego is a substance and that perception gives knowledge of an external world.

Furthermore, Russell proved that Leibniz's failure to develop an adequate logic of relational propositions led Leibniz to regard relations as merely mental, with the absurd consequence that the relations in and among monads which God is supposed to know intuitively must be strictly meaningless (14). That this was not a question of pure logic, either for Russell or Leibniz, ought to be obvious to anyone who has the slightest acquaintance with the concern about God's existence which both philosophers have shown in their writings. In several passages Russell's historical sense shows itself alive to the rôle of theology in Leibniz's philosophy; for example, in a footnote to his chapter on "Leibniz's Philosophy of Matter" (78), Russell indicates how extra-logical theological questions were mixed with questions of scientific logic in Leibniz: "Leibniz appears to have been led to this discovery [that the essence of body is not extension] by the search for a philosophical theory of the Eucharist." In order to show that the Cartesian theory of matter as extension was false and inconsistent with both transsubstantiation and consubstantiation, Leibniz held to the belief in the existence of the vacuum, but was quite perturbed when he had to abandon the latter belief because it conflicted with his teleological principle of continuity and plenitude. I should add that there was in the seventeenth century no major philosophical

or scientific issue that was not discussed as having theological implications. This *historical* fact does not affect the *logical* validity of the arguments advanced, many of which were repetitions of arguments dating back to Plato and Aristotle, whose theology was pagan. Russell is quite right in distinguishing, for the sake of clarity, historical from logical questions; but since there is no actual separation nor identity of the two sorts of questions, it is equally important to have a clear conception of the relation of history to logic. At about 1900 and for the many years to which he held to Platonism, Russell apparently held only necessary relations as clearly conceived; and since there is no necessary connection between Leibniz's theological beliefs and his logic, there seemed to Russell to be none but a purely adventitious relationship between the two. But I should like to offer the following general considerations in order to throw some light on the relationship between the historical and logical versions of the philosophy of Leibniz mentioned above.

Let us note that there is an historical development in logic itself as there is in the case of any science. The logical works of Aristotle, Leibniz, Russell, and Whitehead are monumental landmarks in the cumulative history of logic, despite Kant's mistaken notion that logic was a completed science. Russell's own views as to the logic of mathematics underwent considerable improvement between the first (1900) and second (1937) editions of his book on Leibniz. This sort of scientific development is correlated with the historical development of mathematics and not with the economic or religious history of modern Europe, despite Marxian and theodicic philosophies of history. But certain aberrations of logic and science, which occur in dialectical and scholastic philosophies of science, are correlated with and explained by political and theological interests. For example, there is a striking logical similarity between the totalitarianism and authoritarianism of Communist and Catholic ideologies. The violent opposition between them is correlated with and accounted for by the conflicting political interests of these systems of regimenting individual thought and conduct. Let us apply this principle, (suggested or implied by Russell,) that

wherever aberrations of reason or scientific logic occur, there is some external (extra-scientific) historical factor at work, to the two versions of Leibniz's philosophy which Russell has so brilliantly expounded, but whose relation to each other he has not explained. Russell sometimes attempts an explanation by referring merely to Leibniz's dual personality, but this psychological fact is historically an effect rather than a cause. Sometimes Russell refers more illuminatingly to the pervasive conflict between the progressive work of scientific logic and the retarding influence of seventeenth-century theology and politics. These occasional references suggest inquiries into the historical Leibniz which are quite as important as deducing from the logical structure of a selected portion of Leibniz's views what Leibniz *should* have said further, if he had not let himself be influenced by external causes.

When generalized, the methodological principle involved here (and suggested by Russell's work on Leibniz) has the significance of a first law of inertia for intellectual history, which I shall express very loosely on the analogy (not to be taken too literally) of Newton's first law of motion: "Any mind at rest in certain premises or moving along certain lines of thought determined by these premises will continue to rest content with these premises or develop in lines consistent with them unless acted upon by external historical forces." It is in the light of some such principle (which assumes absolute logical beginnings as Newton assumed absolute physical space and time) that we can understand the point Russell makes so frequently in his work, namely, that Leibniz's philosophy when it departed from its major premises did so because of historical (political and theological) influences. The inconsistencies of Leibniz's system can then be explained by reference to these historical influences. For example, in attacking Leibniz's four proofs for God's existence, Russell notes that "only one of these, the Argument from the Pre-established Harmony, was invented by him, and that was the worst of the four" (172). Why so good a logician as Leibniz should have offered such vulnerable proofs is for Russell understandable only in terms of Leibniz's desire to please ecclesiastical authority. Even a theologian like Francesco

Olgiati today can see through the superficiality of Leibniz's religious arguments. In his recent scholarly work on Leibniz, Olgiati rejects the thesis of Baruzi and Carlotti that Leibniz's philosophy was essentially religious by proving that "the religiosity of Leibniz was only a magnificent pyrotechnical spectacle."[4]

Olgiati also rejects Russell's (and Couturat's) thesis, that Leibniz's philosophical system was an outgrowth of Leibniz's logical studies, by insisting on the importance of the historical works of Leibniz and his sense of historical development, expressed by Leibniz in his law of continuity (*natura non facit saltos*) and dictum *"le présent est gros de l'avenir, et chargé du passé."* Olgiati was impressed by Louis Davillé's work on *Leibniz historien, essai sur l'activité et la méthode de Leibniz* (1909) and article "Le développement de la méthode historique de Leibniz" (*Revue de Synthèse historique,* 1911). But Davillé and Olgiati forget that time and historical development were subsumed by Leibniz under preformationist and immanent mathematical rules supposed by Leibniz to govern biological heredity as well as continuous series. Leibniz's idea of internal development of individual organisms was extended to cultural history in the subsequent romantic philosophies of history of Lessing and Herder, Goethe, Fichte, Schelling, and Hegel. In any case, an organic philosophy of history is as inconsistent as Leibniz's Platonism is with an empiricist study of the diverse factors that make for specific historical changes.[5] The dynamics of intellectual history requires the delineation and analysis of empirical factors that accelerate certain ideas.[6] Such a factorial

---

[4] F. Olgiati, *Il Significato Storico di Leibniz* (Pubblic. della Università Cattolico del Sacro Cuore, Milano 1938): "La religiosità di Leibniz fu solo un magnifico spettacolo pirotecnico." (p. 62) Olgiati may not be as detached as Russell in judging a Protestant.

[5] Cf. my "Methodology in the Philosophy of History," *Journal of Philosophy* (June, 1941). Also J. Rosenthal, "Attitudes of Some Modern Rationalists to History," (*Journal of the History of Ideas,* IV, 4 [Oct. 1943], 429 ff.) contains a most penetrating and critical analysis of Leibniz's anti-historicism.

[6] As a possible 'second law of motion' for intellectual history, following Gabriel Tarde and C. S. Peirce, the acceleration of the spread of ideas, it may be said, varies directly with the extra-logical social needs which determine the evolutionary survival value of ideas, and inversely with the mass of established conventions that resist change.

and empirical analysis is suggested by Russell in his preface to the first edition of his work on Leibniz:

Questions concerning the influence of the times or of other philosophers, concerning the growth of a philosopher's system, and the causes which suggested his leading ideas—all these are truly historical: they require for their answer a considerable knowledge of the prevailing education, of the public to whom it was necessary to appeal, and of the scientific and political events of the period in question.[7]

The rather sharp separation of formal from historically empirical considerations in Russell's treatment of Leibniz's philosophy often appears by sudden juxtaposition of the results of Russell's logical analysis of Leibniz's views alongside of Russell's historical insight. Consider, for example, the following two statements:

"A monism is necessarily pantheistic, and a monadism when it is logical, is as necessarily atheistic. Leibniz, however, felt any philosophy to be worthless which did not establish the existence of God." (p. 170) Why Leibniz felt this way we are left to surmise from the casual references Russell makes to Leibniz's political career. Now Russell, who is undoubtedly much more honest intellectually and morally than the successful Leibniz, was able to see through the duplicity of the German diplomat. A very clear example of Leibniz's dishonesty is seen in his relations to the philosophy of Spinoza (who had with some reluctance shown Leibniz the manuscript of his *Ethics*). Leibniz in private correspondence with Spinoza praised his work, but in correspondence with prominent officials, condemned Spinoza as atheistic and immoral. Yet he borrowed Spinoza's central notion of metaphysical substance and the internality of relations. Russell not only exposed Leibniz's plagiarism but also showed how it led to inconsistencies with Leibniz's attempt to save the individual soul and grant it freedom and immortality. For it is logically impossible to adopt Spinoza's notion of substance and endow individuals with any but a transitory and absolutely determined existence. A similar objection may be

---

[7] Cf. A. O. Lovejoy, "Reflections on the History of Ideas," *Journal of the History of Ideas*, I, 1 (1940) for a similar but more detailed analysis of the method of historiography.

made against Hegelian and Marxian theories of freedom, but most historians of philosophy are either baffled or overcome by dialectics.

Russell's method of formal analysis is best suited to finding hidden premises and inconsistencies in a system like Leibniz's. The limitation of that method consists in its inability to correlate the formal structure of thought with its historical genesis and setting. Couturat had set out to trace the history of Leibniz's logical studies by a minute search and examination of unpublished manuscripts of Leibniz at the same time that Russell was performing his anatomy of the published works and letters of Leibniz. It was not a mere coincidence that Couturat should have found independent corroboration of Russell's thesis by discovering the key to Leibniz's entire metaphysics in his notions of a universal mathematics and alphabet of human thought in extension of the syllogism. For Couturat like Russell was a logician and was bound to select from a huge mass of unpublished manuscripts (still not edited completely) exactly those writings of Leibniz dealing with logical questions. Cassirer, who wrote his book on Leibniz after Russell and Couturat had finished theirs, aimed at a different interpretation of Leibniz's conception of logic. Having in mind the controversy between Cartesians and Leibnizians over *vis viva*—and no historian of science can minimize the significance of this dispute over the foundations of seventeenth-century physics—Cassirer pointed out the dynamic and teleological character of the physical world for Leibniz. He was thus led to criticize Russell and Couturat for having divorced the *formal* structure of Leibniz's philosophy of science from its *material* content, given by Leibniz's theory of activity and entelechy as the essence of things. Dewey in his work on *Leibniz's New Essays* (1888), written under Hegelian influence, also had regarded organic development and unity as the key concepts of Leibniz's philosophy, thus overlooking Leibniz's contribution to formal logic. Leibniz did try to base physical and moral contingency upon the ambiguous teleological principle of sufficient reason; e.g., he applies the latter to the law of least action in his deduction of the law of the refraction

of light, and to proving free-will in ethics. But Leibniz also warned against resorting in physical theory to any but mechanical causes. The inconsistency of Leibniz's attempt to base physics both on a metaphysical principle of final causes and on an empirical doctrine of contingency enables one to find passages in Leibniz to justify both the formal and material interpretations of Leibniz's theory of science offered by Russell and Couturat, on the one hand, and by Dewey and Cassirer on the other. The real issue here is between the logical and Platonic realism of Russell and the neo-Kantian spiritualism of the Marburg school to which Cassirer belonged. The latter school, founded by Hermann Cohen and Natorp, sought to improve Kant's theory of knowledge, which separated the method of physical sciences from that of ethics, by providing an idealistic synthesis. Russell should think Kant was sounder than the neo-Kantians on this point. However, I believe that Russell's logical atomism is too absolute a pluralism for the methodology of the physical and social sciences (under which I should include ethics), for it makes scientific method or rational criticism useless in evaluating human needs and goals.

The absolutism of Leibniz and Russell proceeded from erecting the scientific knowledge of their times into eternal truths. For example, Leibniz had three orders of space and time: (1) in the mind of God, (2) in the perceptions of each monad, and (3) objective space and time among monads after they are created. In Russell's *Essay on the Foundations of Geometry* (1897), we find three absolute orders of space: (1) in the pure constructions of geometry, (2) in psychology, and (3) in physical space which was Euclidean; with respect to time, Russell regarded simultaneity as "obviously" an irreducible relation between perceptions (130). Thus it is evident that the limitations of Leibniz's and Russell's theory of knowledge consisted in converting the science of the times into eternal principles of knowledge. A theory of knowledge can be no more general in its validity than the scope of the scientific knowledge it claims to comprehend. Russell has himself abandoned the absolutistic view of space and time and the

Kantian view that necessary propositions of mathematics are synthetic, which he held when he wrote on Leibniz. Now, since he admitted that his own ideas about philosophy were inseparable from his interpretations of Leibniz's philosophy,[8] we cannot regard all of his interpretations of Leibniz as final.

Russell started as a Platonist but turned to a more empiricistic nominalism under the influence of operationalist developments in the logic of the sciences. Leibniz, on the other hand, started as an atomist, but turned to a more "realistic" metaphysic in keeping with the seventeenth-century belief that science like art held the mirror of man's mind up to nature. In Russell's theory of knowledge, logical analysis has broken the mirror into so many atomic sense-data that it makes no sense to talk about mind as a mirror at all. The analysis of meaning becomes a matter of logical construction in which sense-data and universals serve as neutral and transparent building blocks, and truth involves a rather obscure relation of logical correspondence. Thus, Russell has effectively criticized the simple mirroring relation that Leibniz's monads have to each other in their divinely pre-established harmony. But a certain sort of Platonism still haunts Russell's theory of truth by logical correspondence in which atomic statements stalk like ghosts of eternal truth.

By the thesis of absolute logical beginnings, I mean the assumption that a deductive system of ideas *must* start with certain unique premises which "contain" the system. Plato and his followers obtained unique premises by intellectual intuition. Plotinus added a touch of mystical ecstasy to the Platonic intellectual act of apprehending the Form of the Good. Even Aristotle with his empirical naturalism found it necessary to postulate that the order of logical demonstration was fixed by the unalterable zoological order of natural species which was inverse to the order of knowledge "for us." The seventeenth-century philosophers repeated these Greek patterns of thought in various forms expressed by Italian and Cambridge neo-

---

[8] "For unless we have clear ideas about philosophy, we cannot hope to have clear ideas about Leibniz's philosophy." (*Op. cit.*, 11.)

Platonists, by Descartes' clear and distinct ideas, by Spinoza's identification of the order and connection of ideas with the order and connection of things, which we have already seen was adopted by Leibniz in the doctrine of absolute simples and his universal alphabet of knowledge. This thesis was not the exclusive property of so-called rationalists; for in the British empiricists we find psychological entities (Locke's ideas, Berkeley's sensations, Hume's impressions) playing the same logical rôle of absolute beginnings. Mach and the early logical positivists (Wittgenstein, Carnap), also postulated protocol and atomic propositions as absolute logical beginnings. It was only the development of an operational logic implicit in Leibniz's notion of a "calculus ratiocinator" and furthered by methodological studies of the foundations of geometry and arithmetic (Boole, Peirce, Poincaré, Hilbert, Tarski) which enables us to abandon the thesis of uniquely determined and privileged axioms as absolute logical beginnings. The methodology of deductive systems permits one to start with any statements that obey a consistent set of rules of formation and transformation. The variety of deductive systems thus generated gives the scientist a richer choice of systems to apply to a given problem. Preference for any one of these becomes a problem relative to pragmatic considerations rather than a quest for absolutely predetermined, self-evident premises. All of these now obvious logical considerations were lacking in Russell's first analysis of Leibniz; but I was surprised to find no mention of them in Russell's preface to the second edition of his work.

Without these vestiges of absolute logical beginnings Russell's method could have more effectively divested Leibniz's organic hierarchy of its theological and political arrogance. But much of Russell's insight into Leibniz's thought proceeds from a profounder source in Russell than his method of logical atomism. It seems to me to have its roots in an historical and political soil, richer and freer than the one in which Leibniz flourished. A few years ago I eagerly looked forward to learning from Russell himself, within the public halls of a municipal college, the answers to the questions which had disturbed me

in reading his treatise on Leibniz's philosophy. But the very sort of persons, to whom Leibniz had always catered for support, intervened and insisted on the divine prerogative of their pre-established harmony.

PHILIP P. WIENER

DEPARTMENT OF PHILOSOPHY
COLLEGE OF THE CITY OF NEW YORK

8

*Albert Einstein*

REMARKS ON BERTRAND RUSSELL'S
THEORY OF KNOWLEDGE

# 8

## BEMERKUNGEN ZU BERTRAND RUSSELLS ERKENNTNIS-THEORIE

ALS die Schriftleitung mich aufforderte, etwas über Bertrand Russell zu schreiben, bewog mich meine Bewunderung und Verehrung für diesen Autor sogleich Ja zu sagen. Der Lektüre von Russells Werken verdanke ich unzählige glückliche Stunden, was ich—abgesehen von Thorstein Veblen—von keinem andern zeitgenössischen, wissenschaftlichen Schriftsteller sagen kann. Bald aber merkte ich, dass es leichter sei, ein solches Versprechen zu geben als zu erfüllen. Ich hatte versprochen, etwas über Russell als Philosophen und Erkenntnis-Theoretiker zu sagen. Als ich vertrauensvoll damit angefangen hatte, erkannte ich schnell, auf was für ein schlüpfriges Gebiet ich mich gewagt hatte, als ein Unerfahrener, der sich bis jetzt vorsichtig auf das Gebiet der Physik beschränkt hatte. Der Physiker wird durch die gegenwärtigen Schwierigkeiten seiner Wissenschaft zu Auseinandersetzung mit philosophischen Problemen in höherem Masse gezwungen als es bei früheren Generationen der Fall war. Von diesen Schwierigkeiten wird zwar hier nicht gesprochen, die Beschäftigung mit ihnen ist es aber in erster Linie, die mich zu dem im Nachfolgenden skizzierten Standpunkt geführt hat.

In dem Entwicklungsprozess des philosophischen Denkens durch die Jahrhunderte hat die Frage eine Hauptrolle gespielt: Was für Erkenntnisse vermag das reine Denken zu liefern, unabhängig von den Sinneseindrücken? Gibt es solche Erkenntnisse? Wenn nein, in was für einer Beziehung steht unsere Erkenntnis zu dem von den Sinnes-Eindrücken gelieferten Rohmaterial? Diesen Fragen und einigen andren mit ihnen innig verknüpften Fragen entspricht ein fast unübersehbares Chaos

8

# REMARKS ON BERTRAND RUSSELL'S
# THEORY OF KNOWLEDGE*

W HEN the editor asked me to write something about
Bertrand Russell, my admiration and respect for that
author at once induced me to say yes. I owe innumerable happy
hours to the reading of Russell's works, something which I
cannot say of any other contemporary scientific writer, with
the exception of Thorstein Veblen. Soon, however, I discovered
that it is easier to give such a promise than to fulfill it. I had
promised to say something about Russell as philosopher and
epistemologist. After having in full confidence begun with it, I
quickly recognized what a slippery field I had ventured upon,
having, due to lack of experience, until now cautiously limited
myself to the field of physics. The present difficulties of his
science force the physicist to come to grips with philosophical
problems to a greater degree than was the case with earlier
generations. Although I shall not speak here of those difficulties,
it was my concern with them, more than anything else, which
led me to the position outlined in this essay.

In the evolution of philosophic thought through the cen-
turies the following question has played a major rôle: What
knowledge is pure thought able to supply independently of sense
perception? Is there any such knowledge? If not, what pre-
cisely is the relation between our knowledge and the raw-
material furnished by sense-impressions? An almost boundless
chaos of philosophical opinions corresponds to these questions
and to a few others intimately connected with them. Never-
theless there is visible in this process of relatively fruitless but
heroic endeavours a systematic trend of development, namely

* Translated from the original German by Paul Arthur Schilpp.

philosophischer Meinungen. In diesem Prozess relativ unfrucht-
barer heroischer Bemühungen ist doch ein systematischer Zug
der Entwicklung erkennbar, nämlich eine steigende Skepsis ge-
genüber jedem Versuch, durch reines Denken etwas erfahren zu
können bezüglich der "objectiven Welt," der Welt der "Dinge"
im Gegensatz zu der Welt blosser "Vorstellungen und Gedank-
en." In Parenthese sei gesagt, dass hier wie bei einem echten
Philosophen das Anführungszeichen (" ") gebraucht wird, um
einen illegitimen Begriff einzuführen, den der Leser für den
Augenblick zu gestatten ersucht wird, obgleich er der philoso-
phischen Polizei suspekt ist.

Der Glaube, dass es möglich sei, alles Wissenswerte durch
blosses Nachdenken zu finden, war im Kindeszeitalter der
Philosophie ziemlich allgemein. Es war eine Illusion, die ein
jeder leicht begreifen kann, wenn er für einen Augenblick
davon absieht, was er von der späteren Philosophie und der
Naturwissenschaft gelernt hat; er wird sich nicht darüber
wundern, wenn Plato der "Idee" eine Art höhere Realität
zuschrieb als den empirisch erlebbaren Dingen. Auch bei
Spinoza und noch bei Hegel scheint dies Vorurteil als belebende
Kraft die Hauptrolle gespielt zu haben. Es könnte sogar einer
die Frage aufwerfen, ob ohne etwas von solcher Illusion über-
haupt Grosses auf dem Gebiet des philosophischen Denkens
geschaffen werden kann—wir aber wollen so etwas nicht fragen.
Dieser mehr aristokratischen Illusion von der unbeschränkten
Durchdringungskraft des Denkens steht die mehr plebejische
Illusion des naïven Realismus gegenüber, gemäss welchem die
Dinge so "sind," wie wir sie mit unseren Sinnen wahrnehmen.
Diese Illusion beherrscht das tägliche Treiben der Menschen
und Tiere; sie ist auch der Ausgangspunkt der Wissenschaften,
insbesondere der Naturwissenschaften.

Die Überwindung dieser beiden Illusionen ist nicht unab-
hängig voneinander. Die Überwindung des naïven Realismus
ist verhältnismässig einfach gewesen. Russell hat diesen Prozess
in der Einleitung seines Buches *An Inquiry into Meaning and
Truth* (Seiten 14-15) in wunderbar prägnanter Form so
gekennzeichnet:

We all start from "naïve realism," i.e., the doctrine that things are

an increasing scepticism concerning every attempt by means of pure thought to learn something about the "objective world," about the world of "things" in contrast to the world of mere "concepts and ideas." Be it said parenthetically that, just as on the part of a real philosopher, quotation-marks are used here to introduce an illegitimate concept, which the reader is asked to permit for the moment, although the concept is suspect in the eyes of the philosophical police.

During philosophy's childhood it was rather generally believed that it is possible to find everything which can be known by means of mere reflection. It was an illusion which any one can easily understand if, for a moment, he dismisses what he has learned from later philosophy and from natural science; he will not be surprised to find that Plato ascribed a higher reality to "Ideas" than to empirically experienceable things. Even in Spinoza and as late as in Hegel this prejudice was the vitalizing force which seems still to have played the major rôle. Someone, indeed, might even raise the question whether, without something of this illusion, anything really great can be achieved in the realm of philosophic thought—but we do not wish to ask this question.

This more aristocratic illusion concerning the unlimited penetrative power of thought has as its counterpart the more plebeian illusion of naïve realism, according to which things "are" as they are perceived by us through our senses. This illusion dominates the daily life of men and of animals; it is also the point of departure in all of the sciences, especially of the natural sciences.

The effort to overcome these two illusions is not independent the one of the other. The overcoming of naïve realism has been relatively simple. In his introduction to his volume, *An Inquiry Into Meaning and Truth*, Russell has characterized this process in a marvellously pregnant fashion:

We all start from "naïve realism," i.e., the doctrine that things are what

what they seem. We think that grass is green, that stones are hard, and that snow is cold. But physics assures us that the greenness of grass, the hardness of stones, and the coldness of snow, are not the greenness, hardness, and coldness that we know in our own experience, but something very different. The observer, when he seems to himself to be observing a stone, is really, if physics is to be believed, observing the effects of the stone upon himself. Thus science seems to be at war with itself: when it most means to be objective, it finds itself plunged into subjectivity against its will. Naïve realism leads to physics, and physics, if true, shows that naïve realism is false. Therefore naïve realism, if true, is false; therefore it is false.

Abgesehen von der meisterhaften Formulierung sagen diese Zeilen etwas, an was ich vorher nie gedacht hatte. Bei oberflächlicher Betrachtung scheint nämlich die Denkweise von Berkeley und Hume in einem Gegensatz zu der Denkweise der Naturwissenschaften zu stehen. Aber Russells obige Bemerkung deckt einen Zusammenhang auf: Wenn Berkeley darauf fusst, dass wir nicht "Dinge" der Aussenwelt durch unsere Sinne direkt erfassen, sondern dass nur mit der Anwesenheit der "Dinge" kausal verknüpfte Vorgänge unsere Sinnesorgane erreichen, so ist dies eine Überlegung, die ihre Überzeugungskraft aus dem Vertrauen auf die physikalische Denkweise schöpft. Wenn man nämlich die physikalische Denkweise auch in ihren allgemeinsten Zügen bezweifelt, so besteht keine Notwendigkeit, zwischen das Objekt und den Akt des Sehens irgend etwas einzuschieben, was das Objekt von dem Subjekt trennt, und die "Existenz des Objekts" zu einer problematischen macht.

Dieselbe physikalische Denkweise sowie deren praktische Erfolge waren es aber auch, welche das Vertrauen in die Möglichkeit erschüttert hat, die Dinge und ihre Beziehungen auf dem Wege blossen spekulativen Denkens zu verstehen. Allmählich setzte sich die Überzeugung durch, dass alles Wissen über Dinge ausschliesslich eine Verarbeitung des durch die Sinne gelieferten Rohmaterials sei. In dieser allgemeinen (und absichtlich etwas verschwommen redigierten) Form wird dieser Satz gegenwärtig wohl allgemein akzeptiert. Diese Überzeugung beruht aber nicht etwa darauf, dass jemand die Unmöglichkeit des Gewinnens von Realerkenntnissen auf rein

they seem. We think that grass is green, that stones are hard, and that snow is cold. But physics assures us that the greenness of grass, the hardness of stones, and the coldness of snow, are not the greenness, hardness, and coldness that we know in our own experience, but something very different. The observer, when he seems to himself to be observing a stone, is really, if physics is to be believed, observing the effects of the stone upon himself. Thus science seems to be at war with itself: when it most means to be objective, it finds itself plunged into subjectivity against its will. Naïve realism leads to physics, and physics, if true, shows that naïve realism is false. Therefore naïve realism, if true, is false; therefore it is false. (pp. 14-15)

Apart from their masterful formulation these lines say something which had never previously occurred to me. For, superficially considered, the mode of thought in Berkeley and Hume seems to stand in contrast to the mode of thought in the natural sciences. However, Russell's just cited remark uncovers a connection: If Berkeley relies upon the fact that we do not directly grasp the "things" of the external world through our senses, but that only events causally connected with the presence of "things" reach our sense-organs, then this is a consideration which gets its persuasive character from our confidence in the physical mode of thought. For, if one doubts the physical mode of thought in even its most general features, there is no necessity to interpolate between the object and the act of vision anything which separates the object from the subject and makes the "existence of the object" problematical.

It was, however, the very same physical mode of thought and its practical successes which have shaken the confidence in the possibility of understanding things and their relations by means of purely speculative thought. Gradually the conviction gained recognition that all knowledge about things is exclusively a working-over of the raw-material furnished by the senses. In this general (and intentionally somewhat vaguely stated) form this sentence is probably today commonly accepted. But this conviction does not rest on the supposition that anyone has

spekulativem Wege tatsächlich bewiesen hätte, sondern darauf, dass der im obigen Sinne empiristische Weg allein sich als Quelle der Erkenntnis bewährt hat. Galilei und Hume haben diesen Grundsatz zuerst mit voller Klarheit und Entschiedenheit vertreten.

Hume sah, dass von uns als wesentlich betrachtete Begriffe, wie z.B. kausale Verknüpfung, aus dem durch die Sinne gelieferten Material nicht gewonnen werden können. Er wurde durch diese Einsicht zu einer skeptischen Einstellung gegenüber jeglicher Erkenntnis geführt. Wenn man seine Bücher liest, wundert man sich, dass nach ihm viele und zum Teil hochgeachtete Philosophen so viel Verschwommenes haben schreiben und dankbare Leser finden können. Er hat die Entwicklung der Besten nach ihm nachhaltig beeinflusst. Man spürt ihn durch bei der Lektüre von Russells philosophischen Analysen, deren Scharfsinn und schlichte Ausdrucksweise mich oft an Hume erinnert hat.

Die Sehnsucht des Menschen verlangt nach gesicherter Erkenntnis. Deshalb erschien Humes klare Botschaft niederschmetternd: Das sinnliche Rohmaterial, die einzige Quelle unserer Erkenntnis, kann uns durch Gewöhnung zu Glauben und Erwartung aber nicht zum Wissen oder gar Verstehen von gesetzmässigen Beziehungen führen. Da trat Kant auf den Plan mit einem Gedanken, der zwar in der von ihm vorgebrachten Form gewiss unhaltbar war, aber doch einen Schritt zur Lösung des Hume'schen Dilemmas bedeutete: Was an Erkenntnis empirischen Ursprungs ist, ist niemals sicher (Hume). Wenn wir also sichere Erkenntnis besitzen, so muss dieselbe in der Vernunft selber begründet sein. Dies wird z.B. behauptet bezüglich der Sätze der Geometrie und bezüglich des Kausalitätsprinzips. Diese und gewisse andere Erkenntnisse sind sozusagen ein Teil des Instrumentariums des Denkens, müssen also nicht erst aus den Sinnesdaten gewonnen werden (d.h. sind Erkenntnisse "a priori"). Heute weiss natürlich jeder, dass die genannten Erkenntnisse nichts von der Sicherheit, ja inneren Notwendigkeit, an sich haben, wie Kant geglaubt hat. Was mir aber an seiner Stellung dem Problem gegenüber richtig erscheint, ist die Konstatierung, dass wir uns mit gewisser

actually proved the impossibility of gaining knowledge of reality by means of pure speculation, but rather upon the fact that the empirical (in the above mentioned sense) procedure alone has shown its capacity to be the source of knowledge. Galileo and Hume first upheld this principle with full clarity and decisiveness.

Hume saw that concepts which we must regard as essential, such as, for example, causal connection, can not be gained from material given to us by the senses. This insight led him to a sceptical attitude as concerns knowledge of any kind. If one reads Hume's books, one is amazed that many and sometimes even highly esteemed philosophers after him have been able to write so much obscure stuff and even find grateful readers for it. Hume has permanently influenced the development of the best of philosophers who came after him. One senses him in the reading of Russell's philosophical analyses, whose acumen and simplicity of expression have often reminded me of Hume.

Man has an intense desire for assured knowledge. That is why Hume's clear message seemed crushing: The sensory raw-material, the only source of our knowledge, through habit may lead us to belief and expectation but not to the knowledge and still less to the understanding of law-abiding relations. Then Kant took the stage with an idea which, though certainly untenable in the form in which he put it, signified a step towards the solution of Hume's dilemma: Whatever in knowledge is of empirical origin is never certain (Hume). If, therefore, we have definitely assured knowledge, it must be grounded in reason itself. This is held to be the case, for example, in the propositions of geometry and in the principle of causality. These and certain other types of knowledge are, so to speak, a part of the instrumentality of thinking and therefore do not previously have to be gained from sense data (i.e., they are *a priori* knowledge). Today everyone knows of course that the mentioned concepts contain nothing of the certainty, of the inherent necessity, which Kant had attributed to them. The

"Berechtigung" beim Denken solcher Begriffe bedienen, zu welchen es keinen Zugang aus dem sinnlichen Erfahrungsmaterial gibt, wenn man die Sachlage vom logischen Standpunkte aus betrachtet.

Nach meiner Überzeugung muss man sogar viel mehr behaupten: die in unserem Denken und in unseren sprachlichen Äusserungen auftretenden Begriffe sind alle—logisch betrachtet—freie Schöpfungen des Denkens und können nicht aus den Sinnes-Erlebnissen induktiv gewonnen werden. Dies ist nur deshalb nicht so leicht zu bemerken, weil wir gewisse Begriffe und Begriffs-Verknüpfungen (Aussagen) gewohnheitsmässig so fest mit gewissen Sinnes-Erlebnissen verbinden, dass wir uns der Kluft nicht bewusst werden, die—logisch unüberbrückbar—die Welt der sinnlichen Erlebnisse von der Welt der Begriffe und Aussagen trennt.

So ist z.B. die Reihe der ganzen Zahlen offenbar eine Erfindung des Menschengeistes, ein selbstgeschaffenes Werkzeug, welches das Ordnen gewisser sinnlicher Erlebnisse erleichtert. Aber es gibt keinen Weg, um diesen Begriff aus den Erlebnissen selbst gewissermassen herauswachsen zu lassen. Ich wähle hier gerade den Begriff der Zahl, weil er dem vorwissenschaftlichen Denken angehört, und an ihm der konstruktive Charakter trotzdem noch leicht erkennbar ist. Je mehr wir uns aber den primitivsten Begriffen des Alltags zuwenden, desto mehr erschwert er uns die Masse eingewurzelter Gewohnheiten, den Begriff als selbständige Schöpfung des Denkens zu erkennen. So konnte die für das Verständnis der hier obwaltenden Verhältnisse so verhängnisvolle Auffassung entstehen, dass die Begriffe aus den Erlebnissen durch "Abstraktion," d.h. durch Weglassen eines Teils ihres Inhaltes, entstehen. Ich will nun zeigen, warum mir diese Auffassung so verhängnisvoll erscheint.

Hat man sich einmal Humes Kritik zu eigen gemacht, so kommt man leicht auf den Gedanken, es seien aus dem Denken alle jene Begriffe und Aussagen als "metaphysische" zu entfernen, welche sich nicht aus dem sinnlichen Roh-Material herleiten lassen. Denn alles Denken erhält materialen Inhalt ja durch nichts anderes als durch seine Beziehung zu jenem sinn-

following, however, appears to me to be correct in Kant's statement of the problem: in thinking we use, with a certain "right," concepts to which there is no access from the materials of sensory experience, if the situation is viewed from the logical point of view.

As a matter of fact, I am convinced that even much more is to be asserted: the concepts which arise in our thought and in our linguistic expressions are all—when viewed logically—the free creations of thought which can not inductively be gained from sense-experiences. This is not so easily noticed only because we have the habit of combining certain concepts and conceptual relations (propositions) so definitely with certain sense-experiences that we do not become conscious of the gulf—logically unbridgeable—which separates the world of sensory experiences from the world of concepts and propositions.

Thus, for example, the series of integers is obviously an invention of the human mind, a self-created tool which simplifies the ordering of certain sensory experiences. But there is no way in which this concept could be made to grow, as it were, directly out of sense experiences. It is deliberately that I choose here the concept of number, because it belongs to pre-scientific thinking and because, in spite of that fact, its constructive character is still easily recognizable. The more, however, we turn to the most primitive concepts of everyday life, the more difficult it becomes amidst the mass of inveterate habits to recognize the concept as an independent creation of thinking. It was thus that the fateful conception—fateful, that is to say, for an understanding of the here existing conditions—could arise, according to which the concepts originate from experience by way of "abstraction," i.e., through omission of a part of its content. I want to indicate now why this conception appears to me to be so fateful.

As soon as one is at home in Hume's critique one is easily led to believe that all those concepts and propositions which cannot be deduced from the sensory raw-material are, on account of their "metaphysical" character, to be removed from

lichen Material. Letzteres halte ich für völlig wahr, die darauf gegründete Vorschrift für das Denken aber falsch. Denn dieser Anspruch—wenn er nur völlig konsequent durchgeführt wird— schliesst überhaupt jedes Denken als "metaphysisch" aus.

Damit Denken nicht in "Metaphysik" bezw. in leeres Gerede ausarte, ist es nur notwendig, dass genügend viele Sätze des Begriffssystems mit Sinnes-Erlebnissen hinreichend sicher verbunden seien, und dass das Begriffssystems im Hinblick auf seine Aufgabe, das sinnlich Erlebte zu ordnen und übersehbar zu machen, möglichste Einheitlichkeit und Sparsamkeit zeige. Im übrigen aber ist das "System" ein (logisch) freies Spiel mit Symbolen nach (logisch) willkürlich gegebenen Spielregeln. Dies alles gilt in gleicher Weise für das Denken des Alltags wie für das mehr bewusst systematisch gestaltete Denken in den Wissenschaften.

Es wird nun klar sein, was gemeint ist, wenn ich Folgendes sage: Hume hat durch seine klare Kritik die Philosophie nicht nur entscheidend gefördert, sondern ist ihr auch ohne seine Schuld zur Gefahr geworden, indem durch diese Kritik eine verhängnisvolle "Angst vor der Metaphysik" ins Leben trat, die eine Krankheit des gegenwärtigen empirizistischen Philosophierens bedeutet; diese Krankheit ist das Gegenstück zu jenem früheren Wolken-Philosophieren, welches das sinnlich Gegebene vernachlässigen und entbehren zu können glaubte.

Bei aller Bewunderung für die scharfsinnige Analyse, die uns Russell in seinem letzten Buche *Meaning and Truth* geschenkt hat, scheint es mir doch, dass auch dort das Gespenst der metaphysischen Angst einigen Schaden angerichtet hat. Diese Angst scheint mir nämlich z.B. der Anlass dafür zu sein, das "Ding" als "Bündel von Qualitäten" aufzufassen, wobei nämlich die "Qualitäten" dem sinnlichen Rohmaterial zu entnehmen gesucht werden. Der Umstand nun, dass zwei Dinge nur ein und dasselbe Ding sein sollen, wenn sie inbezug auf alle Qualitäten übereinstimmen, zwingt dann dazu, die geometrischen Beziehungen der Dinge zu einander zu ihren Qualitäten zu rechnen. (Sonst wird man dazu genötigt, den Eiffelturm in Paris und den in New York als "dasselbe Ding"

thinking. For all thought acquires material content only through its relationship with that sensory material. This latter proposition I take to be entirely true; but I hold the prescription for thinking which is grounded on this proposition to be false. For this claim—if only carried through consistently—absolutely excludes thinking of any kind as "metaphysical."

In order that thinking might not degenerate into "metaphysics," or into empty talk, it is only necessary that enough propositions of the conceptual system be firmly enough connected with sensory experiences and that the conceptual system, in view of its task of ordering and surveying sense-experience, should show as much unity and parsimony as possible. Beyond that, however, the "system" is (as regards logic) a free play with symbols according to (logical) arbitrarily given rules of the game. All this applies as much (and in the same manner) to the thinking in daily life as to the more consciously and systematically constructed thought in the sciences.

It will now be clear what is meant if I make the following statement: By his clear critique Hume did not only advance philosophy in a decisive way but also—though through no fault of his—created a danger for philosophy in that, following his critique, a fateful "fear of metaphysics" arose which has come to be a malady of contemporary empiricistic philosophizing; this malady is the counterpart to that earlier philosophizing in the clouds, which thought it could neglect and dispense with what was given by the senses.

No matter how much one may admire the acute analysis which Russell has given us in his latest book on *Meaning and Truth,* it still seems to me that even there the spectre of the metaphysical fear has caused some damage. For this fear seems to me, for example, to be the cause for conceiving of the "thing" as a "bundle of qualities," such that the "qualities" are to be taken from the sensory raw-material. Now the fact that two things are said to be one and the same thing, if they coincide in all qualities, forces one to consider the geometrical relations between things as belonging to their qualities. (Otherwise one is forced to look upon the Eiffel Tower in Paris and that in

anzusehen.[1]) Demgegenüber sehe ich keine "metaphysische" Gefahr darin, das Ding (Objekt im Sinne der Physik) als selbständigen Begriff ins System aufzunehmen in Verbindung mit der zugehörigen Zeit-räumlichen Struktur.

Im Hinblick auf solche Bemühungen hat es mich befriedigt, dass im letzten Kapitel des Buches doch herauskommt, dass man ohne "Metaphysik" nicht auskommen könne. Das einzige, was ich daran zu beanstanden habe, ist das schlechte intellektuelle Gewissen, das zwischen den Zeilen hindurchschimmert.

<div align="right">

ALBERT EINSTEIN

</div>

SCHOOL OF MATHEMATICS
THE INSTITUTE FOR ADVANCED STUDY
PRINCETON

[1] Vergl. Russells *An Inquiry into Meaning and Truth*, S. 119-120, Kapitel "Proper Names."

New York as "the same thing.")[1] Over against that I see no "metaphysical" danger in taking the thing (the object in the sense of physics) as an independent concept into the system together with the proper spatio-temporal structure.

In view of these endeavours I am particularly pleased to note that, in the last chapter of the book, it finally crops out that one can, after all, not get along without "metaphysics." The only thing to which I take exception there is the bad intellectual conscience which shines through between the lines.

ALBERT EINSTEIN

SCHOOL OF MATHEMATICS
THE INSTITUTE FOR ADVANCED STUDY
PRINCETON

[1] Compare Russell's *An Inquiry Into Meaning and Truth*, 119-120, chapter on "Proper Names."

9

*John Laird*

ON CERTAIN OF RUSSELL'S VIEWS CONCERNING
THE HUMAN MIND

## ON CERTAIN OF RUSSELL'S VIEWS CONCERNING
## THE HUMAN MIND

HAD I had the time and the nerve I should have liked to discuss what I took to be most significant in Russell's philosophical achievement and not, as I am going to do, certain of his views which happen to be nearest the perspective of my own limited interests. I should also have liked to make a comprehensive survey of the chosen theme and not, as I mean to do here, to confine myself, in the main, to one particular volume. Mr. Schilpp, however, when he cabled me his request for the present paper had to impose a time limit, although otherwise leaving me as free as a man could wish to be. The time limit was not ungenerous, but it was a restriction. So I think I may say that I had certain solid reasons for the choice I have made and was not actuated wholly by sloth and timidity.

I am going to discuss some of the arguments in Russell's *Analysis of Mind*—not all, since I have not the space for that, but some which are not unimportant. This seems to me a legitimate undertaking. Russell may have changed a good many of his opinions on the subject since 1921, when the book appeared. It looks to me as if his latest book *An Inquiry Into Meaning and Truth* is rather different in some of its implications. On the whole, however, the *Analysis of Mind* is an adequate and tolerably stable account of an important part of Russell's middle or late-middle philosophy. It is a full-dress or, at least, a fairly dressy statement of the results of his conversion from English to American "new realism" *in re* the human mind, that is, of a very radical conversion, in respect of mental analysis, as compared with the confident and debonair statements of so late a

book as *The Problems of Philosophy* (1912). Its main contentions regarding the human mind are very similar indeed to those of his *Outline of Philosophy* (English edition, 1927). It is mentioned with approval in his Tarner Lectures (*The Analysis of Matter*, 1927, p. 240n). So it cannot reasonably be regarded as an ephemeral thing, a *livre de circonstance*, the outcome of a mood.

The book begins with an investigation into the Brentano-Meinong schema of act-content-object. Realists, Russell says, either suppress both "act" and "content" (if they are of the American type) or suppress the content but not the act (if they are of the British type, as represented by Moore in his early "Refutation of Idealism" or by Russell himself in *Problems*). Russell himself, he now says (p. 20), "remains a realist as regards sensation but not as regards memory or thought." In so far, however, as he remained a realist he had become converted to the new realism of the Americans.

Some remarks may be made about this schema.

It seems to fit memory, belief, and propositional "thought," and I shall postpone discussion of this matter. *Prima facie*, however, it seems to be very ill-adjusted to what we call "feeling" and emotion, and also to sensing, perceiving, and imaging unless we hold, with some philosophers, that all these processes, including even sensing, necessarily involve some sort of judgment or belief.

Take the first point first. With regard to feeling and more generally to emotion, most analytical psychologists find no difficulty at all in the conception of objectless feelings, feelings that refer to nothing. You need not (they say) be pleased *at* or *with* anything. You may just be pleased in the particular way in which you *are* pleased. If you allow that in general you are pleased *with* something, or in other words that your feelings are seldom if ever wholly blind, this circumstance need not be explained by anything intrinsically pointing in the feeling. It is quite sufficient if the feeling is accompanied by (or at any rate if it is interfused with) something in the way of cognition. Again, even if you may attend to your sorrow, and give an introspective description of what it feels like to be in the dumps, it is prepos-

terous to hold (they say) that you cannot feel sad without attending to your sadness in this way. Therefore the feeling may, and commonly does, exist without an act of that kind. If it does not require *such* an "act," why should it require any "act" at all?

As regards perceiving and other such cognitive processes, the most plausible sort of "act" would be an "act" of attention or, as Russell has recently said (*Inquiry*, p. 51), of "noticing." It seems difficult to deny that, if you attend, you must attend *to* something, that is, that the very meaning of attention includes attention *to* some "object." It would be strange, however, if this "object" were a "content" *of the "act*," if when you attend to what you describe as a blue patch, the patch were contained in your "act." The "act" seems to be essentially alio-referent. The natural and the plausible analysis in this case is Locke's, that is, a doctrine of "operations of the mind" directed upon certain "immediate objects" (cf. Russell in *Problems*, p. 73). According to this analysis it would be a question for further inquiry whether these "direct" or "immediate" objects were either mental states, or "in the mind" in some special sense (cf. Berkeley, *Principles*, para. 49) or in *no* sense. They are not "in" the *act* in any plausible sense, and, although some of them (or most of them in certain respects) may refer, directly or obliquely, to some physical object, this may be reasonably held to be an extrinsic property, and therefore additional to the original analysis, not properly a part of its core.

We may next consider why, in those respects in which he remained a realist, Russell abandoned his British (new) realism and naturalised himself, in a spiritual way, on the American continent. The reasons he gives are that cognitive "acts" in sensing or imaging cannot be observed empirically and are not required on theoretical grounds. The "content" suffices.

The first of these reasons is blunt. In *Problems* (e.g., p. 77) Russell had spoken quite gaily of "my seeing the sun" as "an object with which I have acquaintance." Now he abolishes all such alleged "objects" and says they are fictions of malobservation.

The thing, one might suppose, could be very easily tested. Let anyone try whether he can "see" (i.e., observe) his seeing

as something empirically distinguishable from the speck or the patch which he sees. There is, however, at least one empirical obstacle. When one sees (to keep to vision) one can certainly observe certain muscular and other bodily sensations connected with the process of seeing. These, however, Russell and others would correctly say, are just sensa and are not "acts" in the relevant sense. Eliminate them analytically and it may be very difficult to say with any confidence what is observably left. Still, many competent philosophical psychologists have made the attempt in good faith and with an adequate knowledge of this particular snag. Some of them, though not the majority, say that "acts" are observed in such cases. The others give an unqualified "No."

This is unsatisfactory. If one attributes sinister motives (i.e., theory-bred mal- or non-observation), one can attribute such motives to either party. It would be pleasanter if there were something better to offer than the counting of "Ayes" and "Noes." Here, however, the requirements of theory (of which I shall speak later) are irrelevant. For theory might require something unobservable. Let us stick to the question of possible empirical observation.

Sometimes it is said that acts, being essentially alio-referent, could not *also* be self-referent and so that the alleged empirical observation must be a fiction. This, I think, is not a good argument; and Russell, if I have not mistaken his meaning, does not use it. Grant that an act of inspection could not inspect itself and you have still no good reason for denying that another act belonging to the same self might inspect the said act of inspecting. The Ego, according to most psychologists, is quite sufficiently complex for that. Again the inspecting and the inspected acts might be simultaneous. So there is no need to appeal to memory.

A much more important type of question arises, I think, when we ask whether *if* we "see our seeing" we *inspect* our seeing in the same general way as we inspect black dots or blue patches, and indeed whether, although "conscious" of it, we inspect it at all. In other words, we have to ask whether we should not distinguish between self-acquaintance and self-inspection.

In the main European philosophical tradition "reflexive" knowledge (more accurately, self-acquaintance) was distinguished from and contrasted with non-reflexive other-knowledge, and the contrast was very seriously intended. Locke was a rebel when he said that reflexive self-acquaintance, "though it be not sense, yet it is very like it and might properly enough be called internal sense" (*Essay*, II, 1, para. 4), and described it as "that notice which the mind takes of its own operations and the manner of them" (*ibid.*) or (ch. 6) as what happens when the mind "turns its view inward upon itself and observes its own action," even if none of these statements is quite as definite as "seeing our seeing." The rebel may have been wrong and the traditionalists right. If they were right, their analysis would be not that "operations of the mind" can be inspected like colours, or are the objects of a distinct alio-referent act of awareness, but that our acquaintance with them is of a totally different order, not involving any duality of act and object and yet, like our feelings, something which not only may be but also (as many would say) *must* be a part, or at least an empirically experienced modality, of what we commonly call our "consciousness." We feel sorrow in the sense in which we run a race or construct a construction, not in the sense in which we hit or miss a target; but, when we feel it, we feel it "consciously" and may very well doubt whether an "unconscious" feeling (so-called) is anything other than an unfelt feeling, that is to say, anything other than a piece of nonsense.

If this analysis of reflexive acquaintance be allowed to be possible, several consequences follow. I shall mention two of them here.

The first concerns cognitive acts, and its general purport is that we might be reflexively acquainted with cognitive acts, even in such simple instances as sensing, although we could not inspect them in any ordinary sense of inspection. I think myself that we *are* so acquainted with attentive acts of sensing and do not agree with Russell (*Inquiry*, p. 50) that "noticing consists mainly in isolating from the sensible environment." However, I'm not at all confident about that.

The second is that, if our empirical self-acquaintance is most

accurately described in the way in which we describe conscious feelings (which may be more or less discriminating, and less or more vague), we should have to do in that case with a part or modality of what we commonly call our "consciousness," in which the referential sense of "conscious of" may be wholly absent and in which an adverbial description is usually more appropriate. It is generally better to say "I am painfully conscious" than "I am conscious of a pain," although the latter, of course, is quite good current English. The question would then arise whether, in the case of sensing, if "acts" are suspect, "objects" are not suspect too, whether instead of renouncing both "acts" and "contents" in this case, as Russell the convert proposes to do, we should not instead renounce "acts" *and* "*objects*," retaining "content" and interpreting "content" in the way in which *feeling* would be interpreted in the reflexive fashion. If so, the correct analysis would be neither "I am conscious of a blue patch" nor "blue patch here-now" but "I am blue-patchily conscious." This sounds awkward, but is not an unusual philosophical analysis, though it is seldom stated quite in that way. One question is whether there is anything against it *except* its linguistic awkwardness. Another question is whether, if there are serious objections to it in the case of sensed blue patches, there are not equally serious objections to any other analysis of, say, toothache. If so, different sensations would have to be analysed in fundamentally different ways; and that is not impossible.

When he deals with the question whether acts, even if they were beyond any possible sort of empirical observation, are required for any tenable theory of philosophical psychology, Russell says (p. 18) that "Meinong's 'act' is the ghost of the subject or what was once the full-blooded soul" and denies that either the ghost or its former incarnation is needed for the theory of knowledge. This large question has several parts, some of which I may mention here.

In general, if anyone set about to discuss Soul, or Self, or Ego, he would suppose that he was discussing something existent which had various intrinsic characteristics and also had extrinsic connections. He would not be exclusively concerned, and, very likely, would not be chiefly concerned with the problem of the

minimum that is needed for a theory of *cognition* to be viable. The nature of the latter question may be indicated roughly by asking, "What is the very least that must be assumed about 'I' if sense is to be made, e.g., of the statement: 'I' who am now watching and hearing these actors on the stage believe that 'I' am the same 'I' that recently arrived at the theatre in a taxi?" That is a legitimate and an important question. It is not, however, the only important question in this matter, and most Ego-investigators would be equally interested in a host of other statements in which "I" occurs, whether or not such statements had any direct bearing upon the minimal assumptions an epistemologist has to make, and even if the epistemological irrelevancies in such statements (or what seemed to be irrelevancies) were a positive embarrassment to epistemologists. Thus, with regard to the dispute about reflexive self-acquaintance mentioned above, the question is not primarily whether such reflexive self-acquaintance must be assumed if epistemology is to work, but whether it occurs or not.

One of the questions which Russell briefly mentions here (p. 18) and examines more fully in some other places is whether the inveterate grammatical use of the first personal pronoun (e.g., "I noticed this") implies, when it is fully examined, that there must be an entity called "I" additional to what philosophers often call "its" acts and experiences. He replies in the negative, and, since I should like to agree with him, my inclinations are all in favour of a purr of joyful assent. In view of what I have just said, however, I am bound to remark that the question, for me, refers to *all* that, to use F. H. Bradley's terms, can reasonably be regarded as the "psychical filling" of the Ego and is not exclusively cognitive. I think that selves are very peculiar and very highly integrated "bundles" of what Broad calls "sympsychic" experiences. Even if, as Russell has recently maintained in *Inquiry* (e.g., chap. VII), it would be possible to give a consistently impersonal account of "egocentric particulars," I should not believe that, in fact, any human experience *was* impersonal.

But perhaps I am running on too fast. What Russell, in the context, is most anxious to say is that in the crucial instance of

sensation, the sensum is all that need be supposed to exist, and that there is no need whatever to suppose that the analysis of sensation requires either an act of sensing as well as the sensum, or an Ego to apprehend the sensum. The sole fact in the case (he thinks) is the *occurrence* of the sensum.

This is vital to Russell's position and is a cornerstone of the metaphysical theory (a form of neutral monism) which he advocates. I do not know whether it is feasible to discuss the problem directly and in itself without any metaphysical frills. But I shall try to say something on that head.

I do not know whether anyone ever held that an occurrence *as such* implied a "mental" act, i.e., that the mere fact that something occurs had this analytical implication. If there are such people I shall not try to argue with them. Many would say, however, that when an occurrence is an appearance there is some such implication.

More elaborately, what such people say is often something like this: If you assert that "*x* appears" you imply (a) that *x* shows itself and (b) that it shows itself *to* an observer. As regards (a) there is no contradiction in something (a potato, say) existing without showing itself. Therefore, if anything is such that it shows itself by the mere fact of existing, it must be a quite special sort of thing. As regards (b), that particular consequence would follow from the assumptions that "showing itself" means showing itself to inspection and that inspection is always a case of something inspecting something *else*.

In view of what I have said about "feeling" and about "reflexive self-acquaintance," I should deny the inevitability of the assumptions contained in (b); but I think that what is asserted in (a) has to stand. An occurrence, I should say, need not be an apparition. Therefore, if an occurrence is an apparition, it *may* be, and I think it *is*, a very special sort of occurrence. Indeed, I don't see any good ground for denying that an apparition is or implies a *mental* occurrence, this statement allowing either that the apparition is a feeling which shows itself reflexively by the mere fact of being a *feeling* (i.e., felt), or that it is shown non-reflexively to something else, whether act, or bundle of sym-psychic personal experiences, or Ego in some other sense.

I do not see that there is much more to be said in terms of the direct methods I am here attempting to use. There is very little point in saying, Russell-wise, that visual sense-appearances are very like the appearances on a sensitive photographic plate. By calling the plate "sensitive" you are importing quite a strong analogy; and as for the "appearances," it is clear, in any ordinary sense of language, that the appearances of a star in some astronomer's photograph are appearances in the same sense as the star itself, that is to say, they "appear" when some one looks at them. Otherwise, they do not appear at all. Again, direct methods are not very easy in the particular case of sensation because, according to Russell and most other good authorities, pure sensations are never observed by adults who are capable of telling the tale. What is observed by grown-up people is *perceived;* and percepts are overlaid and/or fused with images, associations, interpretations, etc. You can prove that there must *be* a sensational core or "datum" in your percept; but you cannot observe it in its native innocence.

In any case there is surely nothing odd or paradoxical about the conclusion that sense-occurrences are a very special class of occurrences. There are no other occurrences which are at all likely to hearten a neutral monist, that is, a philosopher who is disposed to maintain that certain entities (alleged to be ultimate and the only ultimates) are amphibious, being capable of being "material" in one context and "mental" in another.

Consider a number of philosophical disputes about sensation. Berkeley says, "There was a sound, that is, it was heard." The plain man, if naïvely realistic, would say, "Not at all; hearing the sound gives evidence of the sound's existence, but winds might roar and waves splash on the beach although no living creature heard them." Philosophers retort, "Is there any likelihood at all that an unheard sound would be a *sound?* Some of our misguided colleagues speak as if the only conceivable difference between *sensibile* and *sensum* were the irrelevance that someone is aware of the sensum, which awareness (they say) is extrinsic to the sensum and does not affect its intrinsic characteristics in any way. They are wrong. Unsensed green is just like unfelt toothache, a meaningless conjunction of words. Try to

apply your distinction between *sensa* and *sensibilia* to *passiones* and *patibilia*, and see where you get."

Let us turn to the metaphysical side of Russell's contentions in this place.

Russell's metaphysical contention on its negative side is that there is no mind-stuff, and, more particularly, that "consciousness" is not a stuff but a function. We may keep to the negative argument for the time being, since the positive argument is a general sketch of Russellian neutral monism.

The terms Russell uses in this context were largely derived from certain of William James's later essays, now very well known. Some of them are more provocative than instructive. Among these is the term "stuff." Russell seems to like it, and returns to it in various parts of his argument. So far as I have noted, he does not define it, and his readers may be excused if they have some little curiosity about how he would or could define it.

If it is fair to say with Russell that "acts" are the ghosts of the Subject or Ego, it would be equally fair, I opine, to say that "stuff" is the dust of "substance." Russell's metaphysical theory of substance, as I understand him, is that "substance" is a name for specific clotting of events. That doesn't help us much in these stuffy arguments. There might easily be clots of mental events. In certain senses Russell would hold that there were. So we need something more than this to have "stuff." What more?

If "stuff" meant the classical ὕλη, there never would *be* any stuff that was just "stuff" and nothing more. "Stuff," according to this interpretation, is that without which "forms" would be void. If pure "stuff" existed it would be utterly formless stuff, which is impossible, however flocculent the "stuff" might be supposed to be. Even differentiated "stuff" would be meaningless; for to be differentiated in any degree is to be formed in that degree. Hence mental stuff would contain a *contradictio in adiecto*, and could not help us here.

I gather from several of Russell's statements (e.g., on p. 113) that he holds, "If no stuff, then no intrinsic characteristics." This is interesting in various ways. In general one would suppose that $x'$ and $x''$ cannot be identical if anything is true of $x'$ which is

not true of $x''$. This would include extrinsic properties as well as intrinsic characteristics. Russell's affection for intrinsic characteristics at this point seems to me to be rather odd. Despite his objections to the "axiom of internal relations" he does commit himself in this book to the statement (p. 247) that if $x'$ and $x''$ had no intrinsic difference their effects must be "precisely similar."

From "if no stuff, then no intrinsic characteristics" one can infer, "If intrinsic characteristics, then stuff." This principle seems to me to lead to strange conclusions. It would entail, for instance, that what Russell calls "belief-feeling" (which, he says, *has* observable intrinsic characteristics) has "stuff" in it.

The entire line of argument seems odd to me. Take the following propositions: "Jones has mechanical characteristics, since he will fall precisely like a stone if dropped from an aeroplane." "Jones has vital characteristics, for he is alive, not dead." "Jones has mental characteristics because he reflects, infers, loses his temper, and so on." All these propositions about Jones are true, and the three sets of characteristics are not the same. Can it seriously be inferred that Jones is composed of mechanical "stuff" *plus* vital "stuff" *plus* "mental" stuff? I cannot think I am bound so to conclude; but the only respect in which I have cooked this affair when I stated these three true propositions about Jones is my omission of the adjective "intrinsic" as qualifying "characteristics." That omission *might* be crucial. But is it? I have shown, with regard to the third proposition about Jones, that Russell does hold that Jones's belief-feelings *have* intrinsic characteristics. I find it difficult to believe that Jones's mechanical and vital characteristics are in no respect "intrinsic" or how, if they weren't intrinsic, they could be wholly extrinsic in view of Russell's statement on p. 247.

Sometimes, instead of speaking about "stuff," Russell speaks about "ingredients" (or "ultimate ingredients") and about "ultimate constituents." These terms also would be the better for definition. It is hardly enough to call them "items in stuff" (e.g., p. 284). In view of Russell's elaborate accounts of "logical atoms," "hard data," and the like, this request may seem pretty cool; and perhaps it is. Let me say then that I am puzzled

about Russell's argument concerning "stuff" and do not find it easy to translate the term either into his technical language or into any other.

Since I am so doubtful about "stuff" and "mind-stuff," I am not inclined to go on with the discussion whether or not "consciousness" is stuffy. Anything I have to say about its functional analysis had best come later.

Up to the present, my readers may complain that I have started a few hares, some of them pretty lethargic, but have done little or nothing that is either downright destructive of Russell's argument, or at all promising as a basis for alternative construction. I agree. In the main, if I could show that the situation is more fluid than Russell says it is, I should be well content. In a positive way the chief, if not the only, contention I have advanced is that reflexive self-acquaintance (particularly in feeling) has escaped, or very nearly escaped, Russell's attention. It is time, therefore, to consider what Russell has to say about feelings.

His discussion of them occupies two chapters, the third on "Desire and Feeling," the fourteenth on "Emotions and Will." The gist of these chapters, I think, may be stated, not inaccurately, as follows:

If by "feeling" one means pleasure and pain, local bodily pains like toothache or bellyache are organic sensations proper, "items" as separable as any sensation is. In contrast with these, all pleasures, whether (as we say) "bodily" or "mental," and all "discomforts" (most of which are commonly regarded as "mental pains") are neither separable items nor an algedonic (i.e., pleasure-pain) tone suffusing certain processes. On the contrary, they are merely names for the success or failure, temporary or final, of an impulsive, instinctive, desiring or other such process which, having started, moves restlessly towards quiescence. We are "conscious" of these, Russell says, if we hold correct beliefs about what would, in fact, induce such quiescence. If, on the other hand, "feeling" is interpreted more widely to include emotions, the James-Lange theory of emotion or something very like it, is readily defensible. According to Russell, emotions, almost certainly, are organic sensa.

As regards pleasure-pain Russell's contention that local aches are sensations is widely accepted, but it is not clear to me that local bodily pleasures (call them "titillations," if you are nervous about ambiguity) are not on precisely the same footing. As regards what are often called "mental" pleasures and pains, it seems likely that these are not "separable items"—the phrase, I allow, may be something obscure—and that the language of algedonic tone is much more appropriate to them. Such "tonic" descriptions, however, seem to me to be quite obviously correct as a piece of description; and Russell's alternative account appears to omit what should not be omitted.

It has long been a subject of brisk philosophical discussion whether all pleasures and pains presuppose and, so to say, merely register the success or failure of antecedent impulsive process, understood or misunderstood. The usual answer is that some do and some don't. The pleasures arising unexpectedly from fragrance in the air, or from unsought beauty in the landscape, might be supposed to prove the reality of the negative case. The same would be true of the pleasure one may have on seeing one's favourite author praised by a judicious critic, especially if the writer be caviare to the general public. These instances might be challenged, however, on the ground that the unexpected delights of sweet smells or of charming landscapes are *general* exhilarants, and that, in the case of the applauded writer, the general mass of tendencies that are bound up with our own pride and self-esteem are stimulated quite a lot. (*Mutatis mutandis*, this would hold of depressing surroundings well enough.)

Let us suppose then that Russell's account of the matter is correct in what it includes. Is there the least reason for supposing that it is also correct in its exclusions? Allow that there is a one-one correlation between the success or failure of impulsive process and our feelings of pleasure and of pain. Does that tell us what pleasures and pains *feel like*? And don't we know what they feel like? If there is any hard datum in these matters, this one would seem to me to be adamantine.

I think that similar comments should be made about "feeling" in the wider sense which includes emotions and also desires in

so far as these are felt and are not simply defined as "motions towards." No doubt, if emotions *are* organic sensa, Russell would be fully entitled to say, as he does (p. 279), that they have intrinsic characteristics which may be described. He is also fully entitled to accept the James-Lange theory with as little diffidence as an admittedly controversial subject allows. But he doesn't say much in support of the James-Lange theory. It is hardly impressive to say that Angell may have answered Sherrington. And few who accept the James-Lange theory would have the effrontery to aver that the surge of organic sensa which, according to the theory, *is* the emotion, evinces separable sensation-items. At the most what would be evinced would be a vague tumult of organic sensa impossible to identify as such except by an act of faith together with an obstinate incredulity about what the devil they could be if they weren't organic sensa.

Most psychologists, including plain men when they turn psychologists, have no difficulty at all in distinguishing between many of the intrinsic characteristics of many emotions and the cruder, more isolable organic sensa which may be intertwined with them. Poets, for instance, have been heard to say that the pit of the stomach is where they are hit hardest when the Muse is not propitious; but they are never supposed to mean that this sensitive area exhausts these very trying emotions. There is a rich descriptive literature about the *feel* of emotions, the best of it coming from writers who are not professional psychologists, but who, in spite of that (?), are gifted observers of human nature. If it is just conceivable that they may be describing subtle cadences of organic resonance it is quite impossible to say with justified confidence that they *are* doing so—except on grounds of a theory which is very unconvincing if any credible alternative can be offered.

·Russell himself quite happily accepts what he calls belief-feelings, familiarity-feelings, and others of the kind because, he says (e.g., p. 233), these are not postulated but "actual experienced feelings." It is incredible to me that a familiarity-feeling is a separate or separable sensation or, for that matter, a sensation at all. In other words, I submit that Russell accepts *certain* feelings and allows that they have observable intrinsic charac-

teristics although they are *not* sensations and are *not* images. I suggest that much in the descriptive literature of emotions describes emotional feelings on the same sort of evidence as Russell accepts in the case of belief-feelings. It is quite irrelevant to say that such descriptive work may have led psychologists to a dead end and that behaviourism, for the moment at least, has a more promising programme. The question is whether these things are so, not whether they are useful for the architectural purposes of a theorist.

This is all I mean to say about the preamble to Russell's metaphysics of neutral monism. In rough outline the theory itself proceeds as follows: Sensations and images are the stuff of all that there is, and there is no intrinsic characteristic invariably present in sensations but absent from sensory images. That is all that is stuffy in the theory. The rest is function, context, and relation (principally causal) and not "stuff." More in detail, both mind and matter are "logical constructions," not substantial things or even shadows. Matter is a logical construction from sensations (not from images) and, still more specifically, a logical construction from those sensations which come nearest (in a very Pickwickian sense) to being "public" to many observers and are most amenable, functionally, to transmogrifications that suit the laws of physics. These same sensations, and any others which like organic sensa may seem rather more private, and images are the stuff of minds, the said minds being logical constructions taking their cue from their *biographical* causal context.

A good deal might be said about this. It might be argued, for instance, that, even if mind and matter were reached by construing the implications of sensa, there is no sufficient justification for reifying the cognate accusative, that is to say, for calling them "constructions" *tout court;* and I shall have something more to say about "stuff" versus "function." For the moment, however, the most urgent job would seem to be an investigation into Russell's views about the biographical relationships of his neutral stuff.

This includes habit and association; but I don't think Russell gives a very close analysis of habit, and his account of association

seems to me to be a good deal less precise than the account many associationists were accustomed to give before the days of the logical-analytical method. Russell's more resolute analysis in this matter is given to the term "mnemic," borrowed from Semon and flattered perhaps by a certain unearned increment derived from a learned language.

Semon's mnemic philosophy eventually reached a theory of engrams, that is, of permanent traces in the brain. Russell admits, as Semon himself did, that physiological engrams are largely conjectural at the present stage of our knowledge. Therefore he does not assert their existence. But he hankers after them rather ardently. In principle, if they exist in sufficient quantity and detail, the biographical relationships of neutral stuff would be physiological, and "mind," in nearly all important ways, if not quite in all, would be a behaviouristic, that is a materialistic, construction. Psychologists would come nearer to the ultimate stuff of things than physicists commonly do, but the palm would go to materialism. If, on the other hand, mnemic connection is not physiologically engrammatic, there is room for the logical construction of minds which are not material.

Supposing then that we decline to take shelter in hypothetical modifications of brain tissue, Russell asserts that the simple straight-forward thing to say is that in mnemic causation the past (some would prefer to say *our* past) is a part cause of the effect. That is the mnemic explanation of the difference between burnt and unburnt children when next they are near a fire. The statement must be taken literally. "I do not mean merely," Russell says (p. 78) "—what would always be the case—that past occurrences are part of a *chain* of causes leading to the present event. I mean that, in attempting to state the *proximate* cause of the present event, some past event or events must be included."[1] This is Russell's alternative to Bergson, whom he calls "obscure and confused" (p. 180) or a trafficker in "mere mythology" (*Outline*, p. 206).

Bergson may have been confused; and Russell seems to be clear. What many people would say, however, is that Russell's

[1] *Italics*, Russell's.

clear account is clearly an impossibility. The past is dead and so cannot act. Old-fashioned British realists (like myself) would say that past events may be observed, not as they exist now (for now they don't exist), but as they *were,* and any historian would say that they could sometimes be investigated by later inquirers. But few would maintain that they could operate after they had ceased to be. No doubt if you say, as Russell does, that causes and "operations" are only uniformities of sequence you would, on any theory, have certain correlations if the past, even remotely, had anything to do with the present. Many believe, however (and I confess I retain the prejudice), that causes and effects must be temporally continuous. If this be so, Russell's doctrine falls.

If it were suggested that the conception of persistent psychical as distinguished from persistent physiological engrams, however difficult it may be, is easier to accept than this doctrine of a dead past yet acting, Russell's answer is that, if the psychical be the conscious, conscious "acts" and the like do in fact vanish without observable trace. Thus, casting about for examples, I can attend now to the fact that *papillon* is the French for 'butterfly' and *Schmetterling* the German. I am not always attending to these names. When I'm not attending to them they seem just to disappear from my consciousness, and when I am soundly asleep or anaesthetised it may seem that my sympsychic bundle is a complete non-entity. The same would seem to be true of my feelings. When I don't feel my toothache it stops.

I don't deny that these difficulties are very serious, despite the insouciance of psychoanalysts about them. What is not clear to me, however, is that, on Russell's theory, physiologists, behaviourists, and materialists are in better case. Their explanations, according to Russell, are in terms of a logical construction construed from sensory data which, as given, are momentary and perishing. If sensa are feelings, as the toothache example shows, the problem is precisely the same for the logical construction "mind" as for the logical construction "matter." If, not being feelings, they are apparitions which exhaust their nature in appearing and don't exist when they don't appear, I can see no relevant difference between the two logical constructions.

In certain passages in his various works Russell shows a wistful sympathy with the attempt to construct a universe for himself from his own private evanescent sense data. If he could do this for his heaven and for his earth he could also do it for his "mind."

As I said at the beginning of this essay, I did not intend to make a comprehensive survey of Russell's *Analysis of Mind*, but only to examine certain parts of it. I have now said most of what I wanted to say, and the remainder of the essay will be slighter and more general in its character.

The last few chapters of Russell's book are busied about the "meaning of 'meaning'" in cases in which Russell is not a realist, i.e., in cases in which (as he thinks) we neither *are* what we are said to "mean" nor are able to inspect it directly. Thus in memory we remember *now* but mean or refer to what is gone. Russell, as we have seen, rejects the contention of some British realists that we can directly inspect past events we formerly experienced, and so has to provide a theory of extrinsic reference to what is meant in the memorial way. Similarly in the case of belief he uses the "act-content-object" schema in a modified form which substitutes "feelings" for "acts." In the believer, he says (p. 233), there are two present occurrences, the believing and what is believed. From these the "objective" of the belief must be distinguished, e.g., Caesar's crossing of the Rubicon, which could not conceivably be a present occurrence in any twentieth century mind.

In this matter I should like to repeat the comment I made before, namely that the first term in Russell's threefold schema is neither a sensation nor an image but in Russell's words (*ibid.*) "an actual experienced feeling." The point, I think, runs pretty deep. On p. 243, for instance, Russell gives an account of a series of "attitudes that may be taken towards the same content," doubting, believing, supposing, expecting, and so forth. These would commonly be described as "mental" attitudes, and of course Russell would have every right so to describe them, at this late stage of his argument, provided that they squared with his own account of "mind." If, however, as I am maintaining, these attitudes are *not* sensations and are *not* images but *are*

"actual experienced feelings," I submit that he is peopling the "mind" with stowaways whose very existence he began by denying.

A comment I should like to make upon Russell's general theory of "meaning" is much more likely than its predecessor to be a prejudice of my own. Such as it is, however, I propose to make it. The brunt of Russell's argument here, I think, is behaviouristic. There is "meaning," he says, when something acts as a sign, and it acts as a sign when it causes appropriate action. (The term "appropriate" needs definition and receives some.) My comment would be similar to what I said about "appearances." In my opinion Russell gives us *Hamlet* without the Prince of Denmark. The behaviouristic view, to put it crudely, is that the clouds mean rain because they cause you to take out your umbrella. I should deny both that the clouds mean rain and that they cause you to take out your umbrella. The clouds don't "mean" at all. It is you who invest them with significance, you who are a mental being as they are not. Again, they don't cause you to take out your umbrella any more than a red light at a traffic junction causes motor cars to stop. The drivers do that when they *notice* the red light. If what they noticed was a figment of their own imaginations they would still stop their vehicles. I admit, of course, that Russell's behaviourism is not crude, and that, since it is based upon sensations and images, and not upon physical clouds, etc., much of the above criticism is *prima facie* irrelevant. But I think that the gist of it remains.

However that may be, Russell's analysis of meaning is mainly functional. The circumstance gives one an excuse for some further comments upon functional theories of the human mind.

On page 195 Russell says:

The notion that actions are performed by an agent is liable to the same kind of criticism as the notion that thinking needs a subject or ego. . . . To say that it is Jones who is walking is merely to say that the walking in question is part of the whole series of occurrences which is Jones. There is no *logical* impossibility in walking occurring as an isolated phenomenon, not forming part of any such series as we call a person.

Allowing for the slap-dash brevity of his statement, I should like, cordially and respectfully, to agree. But if this, in outline, be the correct analysis, why not go all functional and dispense with "stuff?" There is a place for "stuff" in certain analyses. It seems reasonable to say that, if a brownish fluid which looks like treacle acts like mustard gas, the stuff in it is not the stuff of treacle. Metaphysics, however, does not seem to me to be the place for these stuffy arguments, any more than for discussions about raw and manufactured articles. In a metaphysical sense you must be able to say, "There is," i.e., to distinguish between the actuality of functioning and its mere conception. That, however, is much more recondite than "stuff;" and it should be more recondite. As it seems to me, if you begin to ask, metaphysically, "What kind of stuff could alone function in such and such a way?," you are setting yourself an impossible task because you are mixing up two antagonistic questions.

Let us apply this to the human mind. The answer in general would be, "Mental is as mental does. There are mental doings, usually if not invariably sympsychic and clotted so far as we know. If these doings have intrinsic characteristics reflexively self-manifesting, why not? Let us describe them as best we can."

It may still be asked, "Even if you are rather sniffy about 'stuff', are you not holding that 'conscious is as mental does'? And what evidence have you for that opinion?"

I agree that so far as my various statements are not merely critical they would amount to saying that "consciousness," that very complex phenomenon, has ultimately to be defined by the possibility of reflexive self-acquaintance, such reflexive self-acquaintance being frequently very dim. I agree further that I don't see how I could begin to attempt to prove that mental functions (such as "inferring," let us say) could only occur where there is conscious doing. I doubt very much whether an "unconscious wish," say, really is a wish and also whether an "unconscious inference" really is an inference; but if psychoanalysts and other friends of the "unconscious" were to say that something unknown could arrive pretty much where conscious doings seem to arrive, without itself being conscious in any

ordinary sense, I don't know how to gainsay them. I am like Locke who didn't see his way to denying that an omnipotent God *could* "superadd" thinking to "matter." If God could do the trick, the thing might occur. And if I were asked, "What happens to your knowledge of the French or German for 'butterfly' when you are not consciously thinking about French or German or butterflies?"; or again, "How do saints differ from sinners when both are sound asleep?", I should not be able to say very much in terms of actual consciousness. I shall conclude these remarks with two observations, the first of a type usual in histories of philosophy, the second wholly personal.

The parallel between Hume's statement, at the beginning of his *Treatise*, that "all the perceptions of the human mind resolve themselves into two distinct kinds, which I shall call impressions and ideas," and Russell's doctrine that the stuff of existence consists without remainder of sensations and images, is too close to escape anyone's attention. Where the two differ in this fundamental matter is chiefly in this, that Hume professed to operate with impressions and ideas of reflexion as well as with sense-impressions and the ideas that mimic them, whereas Russell professes to operate with the latter only. Whether the extensive use that Hume made of impressions of reflexion (e.g., in providing the impression from which the idea of necessary connection was derived) is plausible or not, he had tactical advantages in being able to use them at all, advantages that are scarcely offset by Russell's superior logical weapons and by the greater flexibility of twentieth as opposed to eighteenth century science. In any case I have tried to argue that "reflexiveness" *is* a property of mental events. Another point that should be noted is that Hume, like Russell, accepted stowaways which, according to his principles, had no official existence. Thus time, according to Hume, was not an impression (or copy of one) but a "manner" of impressions, and belief was neither an impression nor an idea but "that certain *Je-ne-sais-quoi*, of which 'tis impossible to give any definition or description but which every one sufficiently understands."

My personal remark is just this: Over thirty years ago I had the privilege of being, in some sort, Russell's pupil at Trinity

College in Cambridge—I say "in some sort," because it was no part of his duty to teach me or of mine to be taught by him. I could not try to compute the extent of this privilege. It meant discussion after discussion with one, who, young as he was, was already one of the three or four preëminent philosophers of Europe; and that was but a part of what it meant to us. I can make no return for his patience or for the generosity with which he gave me so much of his time. But I should not like to miss the chance of expressing my gratitude. So I never thought of declining Mr. Schilpp's invitation. I regret the inadequacy of what I have said, and the limited range of its theme; but my intentions in writing this essay are as grateful as my recollections of that year in Cambridge.

JOHN LAIRD

University of Aberdeen
Aberdeen, Scotland

10

*Ernest Nagel*

RUSSELL'S PHILOSOPHY OF SCIENCE

## RUSSELL'S PHILOSOPHY OF SCIENCE

RUSSELL'S writings on the philosophy of science exhibit one persistent feature: his explicitly avowed use of the maxim "Whenever possible, substitute constructions out of known entities for inferences to unknown entities,"[1] a maxim which elsewhere he calls "the supreme maxim in scientific philosophising." Acting upon this precept, he has attempted to show that the ostensible objects of science are "logical fictions," capable of definition in terms of appropriately selected elements. I wish in this essay to examine the type of analysis which Russell has brought to bear upon the logical problems of physics as a consequence of his adoption of this maxim. However, Russell has repeatedly called attention to the fact that it was the fruitfulness of certain logical techniques in the foundations of mathematics which led him to adopt the maxim as the supreme guide in philosophy. I shall therefore briefly consider those techniques, as they are employed in the context of Russell's reconstruction of pure mathematics, preliminary to the discussion of his analysis of physics.

### I

1. Russell's by now classic studies on the foundations of mathematics brought to a conclusion what was, at the time

---

[1] *Contemporary British Philosophy*, First Series, edited by J. H. Muirhead, London and New York, 1925, p. 363. Subsequent references to this book will be abbreviated to *CBP*.

In this essay the following abbreviations will be used for the titles of books by Russell: *FG* for *An Essay on the Foundations of Geometry*, Cambridge, England, 1897; *IMP* for *Introduction to Mathematical Philosophy*, London and New York, 1920; *P* for *Philosophy*, New York, 1927; *AM* for *The Analysis of Matter*, London, 1927; *OKEW* for *Our Knowledge of the External World*, Second Edition, New York, 1929; *PM* for *The Principles of Mathematics*, Second Edition, New

of their publication, a revolution in traditional conceptions of mathematics. As is well known, the explicit thesis for which those studies supply overwhelming evidence is the essential identity of logic and pure mathematics. In exhibiting that identity, Russell also established the untenability of certain influential theories of knowledge which were based upon historically wide-spread views as to the nature of mathematics. For by clearly distinguishing between pure mathematics, whose propositions contain only logical terms, and applied mathematics, whose propositions contain descriptive (or empirical) as well as logical terms, he cut the ground from under the claims of dogmatic rationalism, Kantian apriorism, and types of sensationalistic empiricism. On the other hand, Russell's own analyses seemed to require the adoption of an extreme form of Platonic realism, since his detailed justification of mathematics as a body of valid propositions appeared to be cogent only on the hypothesis of the "independent reality" of universals and relations. Indeed, it was in considerable measure because of this supposed connection between such a realism and Russell's major thesis about mathematics, that the logico-symbolic techniques he employed so brilliantly were believed to require definite philosophical commitments, so that the use of those techniques became the center of philosophic controversy.

Nevertheless, some of Russell's most notable achievements in the analysis of mathematical notions exemplified a tendency opposed to Platonic realism. His analysis of the notion of cardinal number, for example, showed that it was unnecessary to assume the "existence" (or "subsistence") of a specific type of entity to correspond to the notion; and, accordingly, he showed that, without affecting the structure or validity of mathematics, the "ultimate population" of Platonic objects may be supposed to be smaller than had been thought.

In effecting such economies, Russell was in fact carrying on a great tradition in mathematics. Thus, the "extension" of the number-concept in the history of mathematics was first accompanied by the postulation of special *kinds* of number (the ra-

tional fractions, the signed numbers, the irrationals, the imaginaries, the infinitesimals, and so on) to serve as the objects "discovered" by mathematicians. But the subsequent work of such men as Hamilton, Von Staudt, and Weierstrass made it evident that the postulation of such numbers as distinctive sorts of entities was unnecessary, since the required "entities" can all be defined in terms of familiar arithmetical notions and operations. Accordingly, when Russell declared

> Every one can see that a circle, being a closed curve, cannot get to infinity. The metaphysician who should invent anything so preposterous as the circular points [at infinity], would be hooted from the field. But the mathematician may steal the horse with impunity,[2]

and when, years later, commenting on the mathematician's occasional practice of postulating what is required, he noted that "The method of 'postulating' what we want has many advantages; they are the same as the advantages of theft over honest toil,"[3] he was doing less than justice to the tendency which the history of mathematics illustrates of eventually supplanting dubious "inferences" by suitable "constructions." Russell's maxim of philosophizing simply makes explicit a long-range trend of mathematical development.

2. For the sake of definiteness, the operation of Russell's technique for avoiding needless postulations in mathematics will be illustrated in three cases. First, the cardinal numbers. The cardinal numbers are generally admitted to be predicable of classes, two classes being assigned the same number when they are similar (i.e., when their members can be correlated in a one to one fashion). It seems natural, therefore, to regard the cardinal number of a class as the property which that class has in common with classes similar to it; and, on this view, a cardinal number is sometimes said to be obtained "by abstraction" from the classes possessing it. However, there seems no good reason for supposing that similar classes have *just one* property in common rather than a *set* of properties. There is even room for doubt whether at least one such property "exists;" for in as-

[2] *FG*, 45–6.
[3] *IMP*, 71.

suming the existence of such a property we are assuming, according to Russell, "a metaphysical entity about which we can never feel sure that it exists or that we have tracked it down."[4] In order to avoid these difficulties he therefore defined the number of a class as the *class* whose members are classes similar to the given class. Since it can be proved that there is only one such class of classes, the first difficulty vanishes; and since this class possesses all the formal characteristics expected of cardinal numbers, while at the same time its existence is "indubitable," it no longer is necessary "to hunt for a problematic number which must always remain elusive."[5]

Consider next Russell's definition of the real numbers, for example, of the irrational number which is the square-root of two. It is well known that the square-root of two is not an integer and that it cannot be a rational number. What, then, is it? Prior to Russell's analysis it was customary to regard it as the *limit* of certain series of rational numbers, or more generally, as a distinct kind of entity whose "existence" was assumed for the sake of satisfying certain mathematical relations. For example, the rational numbers, if ordered according to magnitude, form a series. In many cases this series can be decomposed into two ordered classes, such that one of the rational numbers separates their members; thus, the two classes, rationals less than two-thirds and rationals greater than two-thirds, are separated by the rational number two-thirds. On the other hand, consider the two ordered classes of rationals, rational numbers whose squares are less than two and rational numbers whose squares are greater than two; in this case, no rational number effects the separation. It again seems "natural" to suppose that there must be a number, though not a rational one, which "lies between" these two classes. But what cogent grounds have we for assuming the "existence" of such a number? Russell argued that we have none, and that it is only the influence of irrelevant spatial imagination or the seductiveness of certain algebraic operations which lends an air of plausibility to such an assumption. The assertion of the "existence" of a new kind of number is thus an unwar-

[4] *IMP*, 18.
[5] *IMP*, 18.

ranted "inference," and introduces something problematic and elusive into mathematics. On the other hand, the existence of the *class* of rationals whose squares are less than two is *not* disputable, for this class is "constructed" out of "known" elements. Accordingly, since the mathematical properties usually attributed to irrational numbers can be shown to belong to that class, Russell defined the square-root of two as identical with that class of rational numbers.

The notion of class plays a fundamental rôle in these two examples. But, according to Russell, classes, like cardinal and real numbers, are not part of "the ultimate furniture of the world" (since they are neither "particulars" nor properties or relations of particulars), and must thus be regarded as "logical constructions." He therefore required a definition of classes

which will assign a meaning to propositions in whose verbal or symbolic expressions words or symbols apparently representing classes occur, but which will assign a meaning that altogether eliminates all mention of classes from a right analysis of such propositions. We shall then be able to say that the symbols for classes are mere conveniences, not representing objects called "classes," and that classes are in fact . . . logical fictions.[6]

Russell achieved his objective by devising as translations for statements explicitly about *classes* other statements which mention only certain *properties* possessed by the individuals that would ordinarily be said to be members of those classes. Before illustrating Russell's procedure, a certain difficulty in effecting such translations must be mentioned. A given property (e.g., being human) determines uniquely just one class (i.e., the class of men); but the same class will be determined by two or more non-identical properties, if those properties are formally equivalent—that is, if every individual which possesses one of the properties also possesses the other, and conversely. Thus, the two non-identical properties of being human and being a featherless biped determine the same class. Hence, in order to effect the desired translation of a statement about a class, some device must be introduced so that in the new statement no one

6 *IMP*, 181f.

special property is mentioned *in exclusion* of other properties which also may determine the class in question. With this explanation in mind, but omitting fine points, Russell's general procedure may be illustrated as follows. The statement "The class of points in a plane is as numerous as the class of lines in a plane" is explicitly about two classes, one of which is certainly determined by the *property* of being a point in a plane and the other by the *property* of being a line in a plane. The approximate translation proposed for this statement is:

There exist at least two properties such that one of them is formally equivalent to the property of being a point in a plane, the other is formally equivalent to the property of being a line in a plane, and such that for every individual which has the first property there is just one individual with the second property, and conversely.

Although for the statement here chosen a somewhat simpler translation of the requisite kind can be given, the indicated translation illustrates the sort of complexity which Russell believed is required in general. In any event, the proposed translation makes no mention of any classes; and, accordingly, the assumption that classes "exist" as special kinds of entities is not required.

Let us finally state what appears to be the general pattern of the procedure of substituting "constructions" for "inferences." Let "$S_1$" be a statement, employed in some definite context $T_1$, which contains explicitly the expression "$C$," where this expression symbolizes some entity $C$; that is to say, "$S_1$" would normally be supposed to be about $C$. Under what circumstances is $C$ (the *entity*, not the *expression* "$C$") to be regarded as a "logical construction" or "logical fiction?" Suppose there exist a set of entities $a_1, a_2, a_3, \cdots$, and a set of relations $R_1, R_2, \cdots$; suppose, further, that a statement "$S_2$" can be formed which contains mention of these entities and relations but does not contain the expression "$C$;" and suppose, finally, that in the context $T_1$ the statement "$S_2$" is logically equivalent to "$S_1$." If these conditions are satisfied, $C$ is a logical construction out of the specified entities and relations. It will be noted that the above three examples conform to this schematism. It is clear that the statement "$S_2$" cannot, in general, be obtained from "$S_1$" by simply

replacing "C" in the latter by a more complex expression without altering the rest of "S₁;" the formulation of "S₂" involves, in general, a radical recasting of "S₁."

3. A number of observations can now be made on Russell's use of his maxim of philosophizing in his reconstruction of mathematics. Although Russell substitutes "constructions out of known entities for inferences to unknown entities," he can maintain an attitude of theoretical neutrality with respect to the existence or non-existence of such things as numbers and classes. As he himself says, "When we refuse to assert the existence of classes we must not be supposed to be asserting dogmatically that there are none. We are merely agnostic as regards them: like Laplace, we can say, '*je n'ai pas besoin de cette hypothèse*.'"[7] The maxim thus expresses a principle of caution and economy, and the techniques which implement it cannot by themselves help to decide what "exists" and what does not. Those techniques assume that certain entities and relations are in some sense "given."

It is well known, however, that in developing a mathematical system there is usually considerable leeway as to what materials may be taken as primitive and what is to be defined. From a formal point of view, the characterization of something as a "construction" must always be viewed as *relative* to the base selected. Accordingly, it seems as correct to regard the cardinal numbers as *primitive* (relative to a system, like Hilbert's, in which certain concepts of logic as well as of mathematics proper are taken as basic) as it is to regard them as *constructions* (relative to a system, like Russell's, in which concepts of logic are the sole primitives). Which base is in fact adopted will in general depend on matters that are not exclusively logical: upon issues of technical efficiency, upon certain more inclusive practical requirements, and often upon antecedent commitments as to what is "metaphysically" or "epistemologically" ultimate. From such a formal point of view, Russell's reconstruction of mathematics is primarily the systematization of a large body of propositions, in which remarkable economy is achieved in showing the various relations of dependence between different por-

---

[7] *IMP*, 184.

tions of mathematical doctrine; and Russell's claim that the concepts and propositions of general logic are sufficient for developing formally the rest of mathematics is hardly debatable. But, seen in this light, his technique for avoiding needless postulations is simply one device among others for attaining a maximum of inclusiveness and generality with a minimum of special assumptions. From this point of view at least, the issue he frequently raises as to whether numbers and classes "exist" in some ontological sense does not appear to be relevant to the problem under consideration.

On the other hand, Russell's reconstruction of mathematics may also be viewed as an attempt to *analyze* mathematical notions so as to exhibit their relevance to everyday affairs and science. It is this point of view which is paramount when Russell declares that that sort of definition of cardinal number is required which will make possible the "interpretation" of statements like "There were twelve Apostles" or "London has six million inhabitants." And he maintains that his logical definition of the cardinals "makes their connection with the actual world of countable objects intelligible."[8] Accordingly, the fundamental issue which arises in this connection is whether Russell's analyses state what is "meant" by mathematical expressions, not simply in the context of the formal development of mathematics, but in the context of statements about the empirical world; in other words, the issue is whether Russell's analyses explicate the *use* of mathematical expressions in the context of procedures such as counting and measuring.

Unfortunately, Russell does not always keep this issue at the center of his concern, and as a consequence it is often most puzzling to know just what he is doing when he says that he is "defining" the various concepts of mathematics. Thus, in commenting on the definition of cardinal number which he and Frege developed, he declares:

The real desideratum about such a definition of number is not that it should represent as nearly as possible the ideas of those who have not gone through the analysis required in order to reach a definition, but

[8] *PM*, Introduction to the Second Edition, vi.

that it should give us objects having the requisite properties. Numbers, in fact, must satisfy the formulae of arithmetic; any indubitable set of objects fulfilling this requirement may be called numbers.[9]

Russell is surely right in saying that a definition of number need not reproduce the "ideas" of those who use numerical expressions, since most people do not know *how* they use them. But it seems to me a serious blunder to maintain that "any indubitable set of objects" which satisfy the formulae of arithmetic may be called numbers—*if* the business of "logically constructing" numbers is to be something other than a purely formal exercise, and *if* the resultant analyses are to express the way or ways in which "number" is employed. From the point of view of the present approach, it is important to bear in mind the observation that an analysis or "logical construction," which is adequate for one context in which an expression is used, is not necessarily adequate for another context, and is unlikely to be adequate for all contexts. It does not follow, therefore, that definitions of the various numbers which are suitable for developing mathematics formally and systematically are suitable as analyses of them in other domains where they are used.

Two special difficulties which aggravate the analysis of mathematical concepts are worth noting in this connection. In the first place, many mathematical expressions are employed only within some more or less formalized system of mathematical statements, and have no clear or direct connections with statements which formulate matters in the actual world. The *use* of such expressions within the symbolic system may be governed by fairly explicit rules of operation, although no interpretation for those expressions may be feasible which would make the latter symbolical of anything known to occur in any part of the environment. In other words, such expressions may have an important function within what may be called a "calculus," without being "in themselves" in any way "representative." Many students (like Hilbert and Hermann Weyl) have accordingly eschewed the doubtless "natural" desire to interpret them in terms of something familiar, and have been content to

[9] *OKEW*, 222.

exhibit the rôles which specific calculi (containing such expressions) play in the system of scientific formulations. In any event, the interpretation of such expressions as denoting entities, allegedly "constructed" out of "indubitable" elements, appears to be a gratuitous enterprise. The second difficulty is that in actual practice many mathematical expressions have no *precise* use, however precisely they may be defined in terms of the basic notions of a formalized system. Analyses of what such expressions "mean," when such analyses yield something "constructed" in a precise way out of definite things or operations, must therefore be viewed as *proposals* as to how those expressions *might* be used. A proposal, however, is not to be judged in terms of truth or falsity, but in terms of its convenience and effectiveness in achieving specific objectives. And if Russell's definitions are such proposals, as I think some of them are, the issue he raises with respect to them, whether the "entities" corresponding to them are "inferred" or "constructed," does not appear to have much point.[10]

One final observation. If an entity is a logical construction, then a symbol representing that entity is theoretically capable of elimination from any statement in which that symbol occurs. It has already been noted that, if an entity can be shown to be a logical construction, considerable economy can be effected in developing mathematics. However, it is also worth noting that a gain in economy in one detail may have to be bought at the price of complicating the structure of mathematics in other details—perhaps even at the price of requiring dubious assump-

---

[10] Whether Russell's definitions of the various kinds of numbers do explicate the use which is made of the latter in everyday affairs and science, is a highly debatable question. I think that his definitions of the specific finite cardinals do express satisfactorily at least part of what is involved in the use of such statements as "I have ten fingers," "There is only one even prime," or "New York is more than 200 miles from Boston," although I am less sure than he appears to be that certain *ordinal* notions are not involved in that use, as Norman R. Campbell and Hermann Weyl have suggested. On the other hand, I am quite unconvinced that Russell's analysis of the irrationals is the appropriate one for "interpreting" such statements as "The diagonal of this square is equal to the square-root of two inches." For, although in explicating the sense of such a statement reference to a set of rational numbers is required, I do not think that this reference is to an *infinite series* of rationals.

tions concerning "the ultimate furniture of the world." Now in fact some of Russell's definitions, when these are taken as exhibitions of the structure of mathematical objects in terms of "indubitable" elements of the "actual world," do seem to me to have this dubious character. If the "existence" of a real number is doubtful when it is conceived as a special *kind* of thing, is its "existence" better warranted when it is identified with an *infinite series* of rationals? Again, Russell is not sure that classes "exist." But, in his translations of statements ostensibly about classes, he does not hesitate to introduce existential quantifiers with respect to *properties*—a procedure which requires him to assume the existence of an indeterminate *range* of properties. Is this assumption, construed in the "realistic" fashion that Russell adopts, so obvious that it may safely be taken as a metaphysical foundation for mathematics? I am not suggesting that Russell's definitions are not adequate for the purposes of systematizing formal mathematics; and fortunately I am not required on this occasion to propose a more satisfactory "metaphysics" for mathematics than his. I raise these questions only to call attention to the complex issues which await us when we employ his supreme maxim of philosophizing in a metaphysical rather than a methodological spirit.

## II

1. Russell's concern with the positive sciences is dominated almost exclusively by "the problem of the relation between the crude data of sense and the space, time, and matter of mathematical physics."[11] Like many of his contemporaries, he has been impressed by the highly abstract character of physical theory, and by the *prima facie* difference between the manifest traits of the world which are exhibited in our daily experience with it and its constitution as reported by the theoretical sciences. The theories of classical physics already provided ample materials for embroidering this difference; those theories employed such notions as that of instantaneous velocities, point-particles, mathematically continuous motions, and perfectly rigid and elastic bodies, although there appears to be nothing in our

[11] *OKEW*, viii.

common experience to which these notions are applicable. But it was the advent of relativity theory and quantum mechanics, with their novel geometries and chronometries and their revolutionary conceptions of matter and causality, which supplied the chief stimulus to Russell's preoccupation with the problem.

However, the "critique of abstractions" for which the problem apparently calls may take several different forms. Russell's conception of the task of such a critique is controlled entirely by his view that the familiar concrete objects of daily life, no less than the abstract and remote entities of theoretical physics, are logical constructions. His approach to the problem must be clearly differentiated from so-called "operational" or "functional" analyses of scientific concepts—analyses which take "common-sense" knowledge and "common-sense" objects for granted. Something must therefore be said at the outset about the general pattern of Russell's views.

Like most philosophers, Russell believes that any discussion of the relation between theoretical physics and experience starts with admitting the familiar facts of common knowledge. But he maintains that on the one hand this knowledge is vague, complex, and inexact, and that on the other hand some types of its "data" are more certain and more "indubitable" than others. In order to obtain a secure foundation for knowledge we must therefore separate out those beliefs which are "inferred" from or "caused" by other beliefs, from the beliefs which are both logically and psychologically prior to all others. The "hardest" or "most certain" of all data (that is, data which "resist the solvent influence of critical reflection") are the truths of logic and the particular facts of sense.[12] The logical starting point of a philosophical inquiry into physics must therefore be with our immediate, direct perceptions. The problem of the relation of theoretical physics to the facts of experience can therefore be amplified as follows:

The laws of physics are believed to be at least approximately true, though they are not logically necessary; the evidence for them is empirical. All empirical evidence consists, in the last analysis, of perceptions; thus the world of physics must be, in some sense, continuous

[12] OKEW, 75.

with the world of perceptions, since it is the latter which supplies the evidence for the laws of physics. . . .

The evidence for the truth of physics is that our perceptions occur as the laws of physics would lead us to expect—e.g., we see an eclipse when the astronomers say there will be an eclipse. But physics never says anything about perceptions; it does not say that we shall see an eclipse, but something about the sun and the moon. The passage from what physics asserts to the expected perception is left vague and casual; it has none of the mathematical precision belonging to physics itself. We must therefore find an interpretation of physics which gives a due place to perceptions; if not, we have no right to appeal to the empirical world.[13]

Russell's problem has therefore a two-fold aspect. One phase of it consists in finding an "interpretation" for physics which will make its propositions relevant to the crude materials of sense; and, as will appear, this concern leads Russell to adopt the view that all the objects of common-sense and developed science are logical constructions out of *events*—our perceptions being a proper sub-class of the class of events. The other phase of the problem consists in justifying the truth-claims of physics; and this concern leads Russell to examine what data may serve as the most indubitable foundation for our knowledge, and to a discussion of the causal theory of perception as the ground for assuming the existence of events that are not perceptions. The two aspects of the problem are not independent, since the resolution of the second depends in part on the answer to the first, whereas the first requires that the "indubitable entities" (which it is the business of the second to specify) are already available. However, in the remainder of the present section I shall briefly examine some of Russell's views on perceptive knowledge; the discussion of his analysis of scientific objects will be left for the final section.

2. According to Russell, the original datum of experience consists of perceptions which are held to be known "non-inferentially;" included in this original datum are such items as specific shapes and colors, and relations like something being earlier than something else or something being above something

13 *AM*, 6–7.

else. Common-sense objects like tables and books, on the other hand, must be regarded as in some sense "inferred." They are said to be "inferred," not because we have actually inferred them, but because our knowledge of them rests upon correlations between perceptions. These correlations are not invariable, and since we may be led to entertain false expectations by relying on them we do not "genuinely know" common-sense objects.[14] The proper comment upon this conclusion, so it seems to me, is to insist that we sometimes *do* know physical objects like tables and chairs, in a perfectly good and familiar sense of "know," in spite of the fact that we may sometimes be deceived about them. But this is not the issue I now wish to raise, important though it is. The question I want to put is whether, in distinguishing between perceptions as primitive and physical objects as derivative from perceptions, Russell is doing logic or psychology. Russell's *problem* certainly requires the distinction to be one of logic, for his aim is to *define* physical objects in terms of sensory qualities. From this point of view it is clearly *irrelevant* whether in the genesis of our knowledge the apprehension of discrete sensory qualities comes before or after the apprehension of configurations of qualities. Russell himself frequently makes it plain that it is not questions of psychology with which he is concerned.[15] Nevertheless, he also says that the primitive data of knowledge must not only be logically but also psychologically prior to the knowledge he regards as derivative. Thus, he declares that the "space" into which all the percepts of one person fit is a "constructed space, *the construction being achieved during the first months of life.*"[16] And here Russell is obviously talking psychology. However that may be, the empirical evidence drawn from modern psychology is certainly unfavorable to the notion that perceptions are psychologically primitive. On the contrary, that evidence supports the view that sensory qualities and relations are obtained only as the end-products of a

---

[14] *AM*, 186.

[15] See, for example, his quite explicit statement on this point in his "Professor Dewey's 'Essays in Experimental Logic'," *The Journal of Philosophy*, Vol. XVI (1919), 8 ff.

[16] *AM*, 252, italics not in the text.

deliberate process of discrimination and analysis, a process which is carried on within the framework of a "common-sense" knowledge of physical objects.

What reasons are there for regarding perceptions as the most indubitable data of knowledge? As far as one can ascertain, Russell rests his case on the simple dictum that what is more primitive is also the more certain. Thus, he asserts that

When we reflect upon the beliefs which are logically but not psychologically primitive, we find that, unless they can on reflection be deduced by a logical process from beliefs which are also psychologically primitive, our confidence in their truth tends to diminish the more we think about them.

And he concludes that "There is . . . more need of justifying our psychologically derivative beliefs than of justifying those that are primitive."[17] Why should this be so? Russell's answer is: because the derivative beliefs are non-demonstratively "inferred" from the primitive ones and are therefore less certain than the premises from which they are drawn, and because a belief is the more certain the "shorter" is the causal route from the cause of a belief to the belief.[18]

These views seem to me to rest on unsatisfactory evidence. Russell calls those data "hard" which resist the solvent influence of critical reflection. But in order to undertake such reflection, it is necessary to employ *some* principles in terms of which the attribution of "hardness" to specific data is to be evaluated; and such principles, if their authority is to count for anything, must be better warranted than the materials under judgment. However, such principles can themselves be warranted only by the outcome of our general experience, and their certainty—of whatever degree this may be—cannot therefore be a consequence of their being psychologically primitive. Russell's entire argument, moreover, is based on a principle of reasoning which I find most debatable—the principle that the conclusion of a non-

[17] *OKEW*, 74–5.

[18] *IMT*, 164, 200. He also says: ". . . A given reaction may be regarded as knowledge of various different occurrences. . . . The nearer our starting point [in the process leading to a certain event in the brain] is to the brain, the more accurate becomes the knowledge displayed in our reactions." *P*, 132.

demonstrative inference cannot be more certain than any of its premisses. Quite the contrary appears to be the case in general. To take a simple illustration, if a number of witnesses testify to the occurrence of some event, the proposition that the event did occur may be more certain than any single item in the testimony, provided those items are independent. It is indeed partly in terms of the principle embodied in this example that the credibility of scientific theories is augmented. And if one accepts it as generally valid, little ground remains for the view that our psychologically primitive beliefs are also our most certain ones.[19]

Russell is not unaware of how difficult it is to identify primitive, "non-inferred" data. Thus, he notes that the records of any observation or experiment always involve an "interpretation" of the facts by the help of a certain amount of theory. He also acknowledges that "perceptions of which we are not sufficiently conscious to express them in words are scientifically negligible; our premisses must be facts which we have explicitly noted."[20] And elsewhere he insists that "a form of words is a social phenomenon," so that a person must know the language of which it is a part, as well as be exposed to certain stimuli, if he is to make true assertions.[21] The admission of the socially conditioned character of significant perception would normally be considered as a good ground for rejecting the view that perceptions are psychologically primitive. Nevertheless, Russell believes that it is possible to whittle away the element of interpretation in perceptive knowledge, and that "we can approach asymptotically to the pure datum."[22] But if pure data can be reached only asymptotically—and that means they are never *actually* reached—why is it important to try to base all our knowledge upon them? Moreover, Russell admits that some "interpretations" which accompany perceptions "can only be

---

[19] On some of the difficulties in the view that the "shortness" of the causal route between a belief and its cause can be taken as a measure of the certainty of the belief, see my "Mr. Russell on Meaning and Truth," *The Journal of Philosophy*, Vol. XXXVIII (1941).

[20] *AM*, 200.

[21] *P*, 262.

[22] *IMT*, 155.

discovered by careful theory, and can never be made intro-spectively obvious;" and he thinks that such interpretations, at any rate, "ought to be included in the perception."[23] One cannot therefore help asking: If our actual data involve an element of "interpretation" and "inference," how in principle can we exclude physical objects as objects of knowledge on the ground that physical objects involve an element of "inference?" The distinction between the primitive and the "inferred" certainly shows the mark of being irrelevant to a working epistemology.

In any event, by his mixing up questions of logic with those of psychology Russell compromises at the very outset his program of exhibiting common-sense and scientific objects as logical constructions. That program presumably requires the analysis of these objects as structures of elements which are experientially accessible. If such an analysis is to be more than a formal logical exercise, those elements cannot simply be *postulated* to exist; and Russell's psychologically primitive "pure data" apparently have just this status.

3. Russell introduces another distracting confusion when, in order to establish the importance of regarding physical objects as constructions, he argues the case for an epistemological dualism and against "naïve realism." The truth or falsity of epistemological dualism does not seem to me germane to the question whether physical objects are analyzable into structures of specified entities. I shall therefore comment only briefly on the following views central to Russell's epistemology: that our percepts are located in our brains; that the causal theory of perception is the ground for inferring the existence of unperceived events; and that our knowledge of physical objects is "inferred" from percepts in our brain.

Russell maintains that, although it may be natural to suppose that what a physiologist sees when he is observing a living brain is in the brain he is observing, in fact "if we are speaking of physical space, what the physiologist sees is in his own brain."[24] This seems to me incredibly wrong if the word "see" is being

[23] *AM*, 189.
[24] *P*, 140.

used in the ordinary sense in which we talk about seeing a physical object; and it is this ordinary sense of the word which Russell is employing when he supposes a physiologist to be observing a brain. There might indeed be a sense of "see" in which I see my own brain, though I have not the slightest inkling as to what that sense is. I do know, however, that I have never seen any portion of my own brain, and that I have seen many physical objects—where the statement that I have not seen one but seen the other is to be understood in the customary sense of "see." To deny the facts expressed by the statement seems to be absurd; and such a denial can be understood only if we suppose that the person making the denial is misusing language. Moreover, such facts seem to me basic for every sound epistemology and every sound interpretation of science; and, however difficult it may be to do so, the findings of physics and physiology must be interpreted so as to square with them.

The evidence Russell offers for the causal theory of perception derives whatever plausibility it has from the tacit assumptions of common-sense knowledge; accordingly, it is not this theory which can justify such common-sense assumptions as that our perceptions may have unperceived causes. Russell's chief argument for that theory consists in showing that if we accept the theory we can formulate the course of events in "simple causal laws." For example, he declares that if many people see and hear a gun fired, the further they are situated from it the longer is the interval between the seeing and the hearing. He thinks it is therefore "natural to suppose that the sound travels over the intervening space, in which case something must be happening even in places where there is no one with ears to hear."[25] But why does it seem "natural" to suppose this? Does not the "naturalness" receive its support from the experimental confirmations which are found for such assumptions in the context of our manipulating physical objects? Russell also thinks that, although the phenomenalist view (that there are no unperceived events) is not logically impossible, it is an implausible view, because it is incompatible with physical determinism.[26] But why is the assumption implausible that

[25] *AM*, 209.
[26] *AM*, 214.

"imaginary" or "fictitious" entities are causally efficacious? If the implausibility does not rest upon the findings of disciplined experience, embodied in common-sense knowledge, upon what can it rest?

Though Russell speaks much of "inferring" things, it is not clear in what sense he believes physical objects to be "inferred" from perceptions. He uses the term "inference" in at least the following distinct ways: in the ordinary sense of logically deducing one proposition from another; in the familiar sense of asserting a proposition on evidence which makes that proposition probable; in the sense in which something which is perceived with an "accompanying interpretation" is obtained from something else that is supposed to be perceived directly or without interpretation; and finally, in the sense in which something that is a logical construction is obtained from entities out of which it is constructed. It is evident that when Russell says that the sun is inferred from our percepts, he does not mean that it is inferred in either of the first two senses specified, and he repeatedly asserts that he does not mean it in these senses. On the other hand, he declares that

So long as naïve realism remained tenable, perception was knowledge of a physical object, obtained through the senses, not by inference. But in accepting the causal theory of perception we have committed ourselves to the view that perception gives no immediate knowledge of a physical object, but at best a datum for inference.[27]

In this passage Russell is apparently using the third sense of "inference;" and when he uses the term in this way he sometimes talks of an inference as an unconscious physiological process. But elsewhere he also says that "Modern physics reduces matter to a set of events. . . . The events that take the place of matter in the old sense are inferred from their effect on eyes, photographic plates, and other instruments. . . ."[28] And in this passage what is "inferred" is a physical object,

---

[27] *AM*, 218. Cf. also: "Our knowledge of the physical world is not at first inferential, but this is only because we take our percepts to *be* the physical world." *P*, 130.

[28] *P*, 157.

viewed as a construction out of such events as perceptions. Russell does not therefore distinguish between the last two senses of "inference" listed above, and as a consequence it is difficult to extract a coherent formulation of how physical objects are inferred from percepts. However that may be, if our knowledge of the sun is "inferred" in the third sense of the term, the inference is presumably grounded in the causal theory of perception, and therefore in the procedures involved in common-sense knowledge of things. On the other hand, if that knowledge is "inferential" in the fourth sense, the fact that the sun is a logical construction (if it is a fact) in no way prejudices the claim that we do have knowledge of it; for the exhibition of the sun as a construction out of events like perceptions obviously requires knowledge of the sun.

### III

1. It is a common error of Russell's critics to interpret his view that the physical world is a logical construction, as if he intended to deny that there are physical objects in the ordinary sense of this phrase. For this misunderstanding he is at least partly to blame. Thus he declares: "Common sense imagines that when it sees a table it sees a table. This is gross delusion."[29] Again, commenting on Dr. Johnson's refutation of Berkeley, he maintains that "If he had known that his foot never touched the stone, and that both were only complicated systems of wave-motions, he might have been less satisfied with his refutation."[30] And elsewhere he says that on the view he is recommending, "the 'pushiness' of matter disappears altogether. . . . 'Matter' is a convenient formula for describing what happens where it isn't."[31]

There are indeed several not always compatible tendencies struggling for mastery in Russell's use of his supreme maxim for philosophizing. One of them is that represented by the conception of experience according to which the objects of what is immediately "known" are in the brain; a second is the view

[29] *ABC*, 213.
[30] *P*, 279.
[31] *P*, 159.

that if something is a logical construction, it is *we* who have constructed it in time; another is stated by the conception that so long as some "indubitable set of objects" can be specified which will satisfy given formulae, then any object in that set may be substituted for the "inferred" object satisfying those formulae; and a fourth is the view that an object is a construction when it is *analyzable* into a structure of identifiable elements.

It has already been argued that the first of these tendencies is essentially irrelevant to (or at any rate, can be kept distinct from) the use of Russell's maxim. The second is often explicitly disavowed by Russell himself, though he often betrays his disavowal. But before examining the incidence of the remaining two tendencies upon his reconstruction of physical theory, I want to comment on the passages cited from Russell in the opening paragraph of this section. Is it a delusion when, under appropriate circumstances, we claim to see a table? A table may indeed be a logical construction; but in the sense in which we ordinarily use the words "see" and "table," it may be quite true that we do see a table: this mode of expressing what is happening is the appropriate way of putting the matter. Again, if when Dr. Johnson kicked a stone his foot never touched the stone, what *did* his foot do? To say that his foot never touched the stone, because both his foot and the stone were systems of radiation, is to *misuse* language; for in the specified context the words "foot," "stone," "kicked," and "touched" are being so used that it is correct to say Dr. Johnson kicked a stone and therefore his foot touched it. To be sure, under some other circumstances, and for the sake of certain ends, it might be advisable to use a different language in describing what had happened. But it obviously cannot be wrong to employ ordinary language in accordance with ordinary usage. And finally, it seems to me grotesque to say that the "pushiness" of matter can disappear as a consequence of a new analysis or redefinition of matter. We have learned to apply the word "pushy" to certain identifiable characteristics of material objects; and such a use of the word is correct, simply because that is the usage that had been established for it. Whatever may be the

outcome of analyzing material objects, their identifiable properties will remain their identifiable properties, and it will be correct to apply the standardized expressions to them. It will certainly not be correct to designate a physical body as a formula.

2. Let us turn to Russell's re-interpretation of physics. The first question I want to ask is what marks, if any, distinguish something which is a construction from something that is not. Russell seems to suggest at least two. One is the suggestion that something is a construction when it has properties which satisfy some mathematical formula or equation. He says, for example,

> The electron has very convenient properties, and is therefore probably a logical structure upon which we concentrate attention just because of these properties. A rather haphazard set of particulars may be capable of being collected into groups each of which has very agreeable smooth mathematical properties; but we have no right to suppose Nature so kind to the mathematician as to have created particulars with just such properties as he would wish to find.[32]

One doesn't know how seriously to take such statements, especially since they imply, what is questionably the case, that it is we who invariably manufacture the properties which are convenient for the purposes of mathematical physics. It is certainly not evident what right we have to suppose that we have no right to suppose that Nature created at least some of them. It is one thing to say that for the sake of developing mathematical physics we have *isolated* certain features of things and ignored others; it is quite another thing to maintain that what we have selected we have also manufactured. Moreover, it is not clear why, on this criterion, the events out of which electrons and other objects are said to be constructions should not themselves be regarded as constructions. After all, as will be seen presently, they too have remarkably smooth mathematical properties: they fall into groups having exquisitely neat internal structures.

The second suggestion is more important. According to it, something is a construction when it is complex. Accordingly, since physical bodies as well as scientific objects like electrons

---

[32] *AM*, 319. At another place Russell proposes as a supplement to Occam's razor the principle "What is logically convenient is likely to be artificial." *AM*, 290.

are analyzable—indeed, on Russell's view into relations between ultimate simples—whereas perceptions and other events are not, the former are constructions out of the latter. The "ultimate furniture of the world" thus consists of a very large, perhaps infinite, number of events which have various specific relations to each other. When described in terms of spatio-temporal characteristics, these "particulars" are assumed to have quite small spatial and temporal dimensions. Moreover, some of these particulars (though not all) are perceived, and at least some of their qualities and relations are also immediately apprehended. Events, their simple qualities and their relations, are thus the building materials, the "crude data," in terms of which physics is to be "interpreted."

Russell admits that, although he believes his particulars are simples, in the sense that they have no "parts" or internal "structure," it is impossible to prove once for all that they are such. And although he also admits that simples are not directly experienced "but known only inferentially as the limit of analysis," he maintains it is desirable to exhibit objects as constructions out of simples. His belief in the existence of simples rests on self-evidence: "It seems obvious to me . . . that what is complex must be composed of simples, though the number of constituents may be infinite."[33] Against such a view it is arguable that simplicity is a relative and systemic notion, and that the justification for taking anything to be a simple rests on the clarification, the systematization, or the control of subject-matter which follows from a given mode of analysis. The issue is, however, not of great importance for the sequel. An issue of more serious concern is raised by Russell's admission that simples can be known only as the limits of analysis. For in the first place, he must also admit that we cannot in consequence literally *begin* with simples, trace through sequentially the complex patterns of their interrelations, and so finally reach the familiar objects of daily life. And in the second place, it becomes difficult to understand, even if we did succeed in exhibiting objects as constructions out of simples, just what such an analysis contributes to bridging the gulf between the propositions of physics and the familiar world

[33] *CBP*, 375.

of daily experience. However, Russell's subsequent analyses are not vitally affected by these doubts: whether events are ultimate particulars or not, the important part of his claim is that at least some of them are perceptions, and that they are relevant to the analysis only because of their relations to other things, and not because of a demonstrated lack of internal structure.[34]

One point is clear: Russell does not exhibit the logical structure of the physical world *entirely* in terms of entities which he regards as "known," since his particulars include events that are not perceptions. Such events are held by him to be "inferred," largely on the strength of the causal theory of perception and in order to avoid the "implausible" consequences of a radical phenomenalism. Russell's own remark on the inclusion of unperceived (and therefore "inferred") events into the ultimate furniture of the world is one that many of his readers must have whispered to themselves: "If we have once admitted unperceived events, there is no very obvious reason for picking and choosing among the events which physics leads us to infer."[35] How many needless excursions into sterile epistemological speculations could have been avoided if this remark had been taken seriously! But the remark does make it plain that the significance of exhibiting things as constructions does not consist in circumventing the need for making inferences or in denying the existence of physical objects. The remark shows that the importance of the enterprise lies in *analyzing* or *defining* the sense of such expressions as "physical object," "point," "electron," and so on.

3. Russell's definition of physical object as a class of classes of events, related by certain laws of "perspective" and causal laws, is well known. It is unnecessary to dwell upon it here. It is sufficient to note that his analysis is motivated by the desire to show the otiose character of the traditional assumption of

---

[34] Russell declares in this connection: "Atoms were formerly particulars; now they have ceased to be so. But that has not falsified the chemical propositions that can be enunciated without taking account of their structure." *AM*, 278. The first sentence in this passage is seriously misleading, since it suggests that whether something is a particular or not depends on the state of our knowledge, and that therefore a construction is something made by us.

[35] *AM*, 325.

permanent, indestructible substances which mysteriously under-
lie the flux of events. I shall, however, examine his analysis of
points (or point-instants), in order to suggest what seems to
me a fundamental criticism of the approach to the "critique of
abstractions" which Russell credits to, and shares with, White-
head.

There is an obvious need for an analysis of points, if we are
to become clear about the way in which the formulations of
theoretical science are applied to matters of concrete experience.
The term occurs in physical geometry, mathematical dynamics,
and many other theories; and those theories are admittedly
successful in organizing and predicting the course of events. At
the same time, there seems to be nothing in our experience
which corresponds to the term. The postulation of points as
unique types of existences will not solve the problem, since
such a postulation does not answer the question just how points
are connected with the gross materials of experience. As Russell
says, "What we know about points is that they are useful tech-
nically—so useful that we must seek an interpretation of the
propositions in which, symbolically, they occur." His own answer
to the problem consists in specifying certain "structures having
certain geometrical properties and composed of the raw material
of the physical world."[36]

In outline, Russell's definition of point-instants is as follows:
Every event is "compresent" with a number of others; i.e.,
every event has a common "region" with an indefinite number
of other events, although the latter do not necessarily overlap
with each other. If five events are compresent with each other,
they are said to be related by the relation called "co-punctuality."
If in a group of five or more events every set of five events
has the relation of co-punctuality, the group is said to be co-
punctual. And finally, if a co-punctual group cannot be enlarged
without losing its co-punctual character, the group is called a
"point." It only remains to show that points so defined exist;
and to show this it is sufficient to assume that "all events (or at
least all events co-punctual with a given co-punctual quintet)
can be well-ordered"—an assumption that Russell proceeds to

[36] AM, 290, 294.

make.[37] And since it turns out that points thus specified satisfy all the usual mathematical requirements, Russell believes he has satisfactorily exhibited the logical construction of points.

Nevertheless, the analysis is to me very perplexing. Let me first call attention to an observation already made. Events, in the sense in which Russell uses the term, are the *termini* of analysis, and if they are apprehended by us at all they are not apprehended as psychological primitives. In this sense, therefore, events are not the "raw materials" of adult experience, whatever else might be the case for infants and other animals. If a point is what Russell defines it to be, the physicist who wishes to make a concrete application of statements about points must therefore first proceed to *isolate* the material (events) in terms of which points are to be eventually identified. In order to carry through this process, the physicist will certainly have to make use of the distinctions and findings of gross, macroscopic experience. But this is not all. Assuming that events have been isolated, co-punctual groups of events must next be found. However, since a co-punctual group may have an indefinite number of event-members, the assertion that a given group is co-punctual will in general be a *hypothesis*. The situation does not become easier when the physicist next tries to identify those co-punctual groups which are points: the assertion that a class of events is a point will be a conjecture for which only the most incomplete sort of evidence can be available. If, as Russell believes, the existence of physical objects involves "inference," those inferences pale in comparison with the inferences required to assert the existence of points.

I now come to the serious basis of my perplexity: Russell's definition exhibits no concern whatever for the way in which physicists *actually use* expressions like "point." In the first place, it is certainly not evident that physicists do in fact apply the term to structures of events. On the contrary, there is some evidence to show that they employ it in a somewhat different fashion, using it in connection with bodies identifiable in gross experience and whose magnitudes vary from case to case ac-

[37] *AM*, 299. A class is said to be well-ordered if its members can be serially arranged in such a way that every sub-class in this series has a first member.

cording to the needs of specific problems. To be sure, the application of the term is frequently sloppy and vague, and its rules cannot in general be made precise. But the vagueness and sloppiness are facts which a philosophy of science must face squarely, and they cannot be circumvented by an ingenious but essentially irrelevant proposal as to how the term *might* be used.

This brings me to another phase of the difficulty. It has already been noted that Russell does not always distinguish between two distinct views as to what is required in order to exhibit the logical structure of an object: on one of them, the logical construction of an object is exhibited when some "indubitable set of objects" is specified which satisfies a given formula; on the other view, the logical construction of an object is exhibited when statements about that object are so interpreted that the interpretations make explicit how those statements are *used* (or alternately, what those statements "mean"). The difference between these views is profound; and if the supreme maxim of philosophizing is to eventuate in clarification and not simply in a highly ingenious symbolic construction, it is the second view which must be adopted. Certainly Russell himself must have imagined himself to be acting upon this second view when he claimed that his account of the cardinal numbers made intelligible their application to the world of countable objects. On the other hand, his definition of points and other scientific objects conforms only to the requirements of the first view, and thereby offers no indication of the connection between the abstractions of physics and the familiar world. Like the definitions given by Whitehead with the aid of the principle of extensive abstraction, Russell's definitions formulate what are in effect another set of abstract formulae, quite out of touch with the accessible materials of the world. His "interpretation" of the equations of physics thus yields only another mathematical system, with respect to which the same problems that initiated the entire analysis emerge once more.[38]

---

[38] One need only compare Russell's definitions of points with such analyses as those of Mach concerning mass and temperature or those of N. R. Campbell concerning physical measurement, to appreciate the difference between an analysis which is quasi-mathematics and an analysis which is directed toward actual usage.

4. One further set of general issues remains to be discussed. One of these issues arises in connection with Russell's redefinition of matter (common-sense objects, electrons, etc.) so as to avoid the hypothesis of an underlying permanent substance. He declares:

The events out of which we have been constructing the physical world are very different from matter as traditionally understood. Matter was expected to be impenetrable and indestructible. The matter that we construct is impenetrable as a result of definition: the matter in a place is all the events that are there, and consequently no other event or piece of matter can be there. This is a tautology, not a physical fact. . . . Indestructibility, on the other hand, is an empirical property, believed to be approximately but not exactly possessed by matter. . . .[39]

And elsewhere he asserts that "Impenetrability used to be a noble property of matter, a kind of Declaration of Independence; now it is a merely tautological result of the way in which matter is defined."[40] Russell is of course right in calling attention to the fact that many propositions in physics as well as in everyday discourse are not contingent, since they are definitional in nature. It is not always clear which propositions have this character, and the difficulty in identifying them arises partly from the fact that the body of our knowledge can be organized in different ways. For example, if the equality in weight of two objects is defined in terms of their being in equilibrium when placed at the extremities of a lever which is supported at its midpoint, the law of the lever is a truistic consequence of this mode of measuring weights. But if the principle of the lever is now

---

It is also interesting to note that Russell criticizes one of Eddington's interpretations of certain equations in relativity theory in a spirit analogous to the criticism which the above paragraph makes of him. Eddington reads these equations to signify that electrons adjust their dimensions to the radius of curvature of the universe, and maintains that this adjustment can be ascertained by "direct measurement." Russell's remarks are as follows: "Now the electron may be, theoretically, a perfect spatial unit, but we certainly cannot compare its size with that of larger bodies *directly*, without assuming any previous physical knowledge. It seems that Prof. Eddington is postulating an ideal observer, who can see electrons just as directly as . . . we can see a metre rod. In short his 'direct measurement' is an operation as abstract and theoretical as his mathematical symbolism." *AM*, 92.

[39] *AM*, 385.

[40] *P*, 279. See also *ABC*, 185, and *CBP*, 366.

a definition, the law of spring balances (Hooke's law) is not, and is empirically contingent. It is, however, possible to define the equality of weights in terms of Hooke's law, so that, although this law now becomes a definition, the law of the lever acquires the status of a contingent physical principle. Accordingly, to say that a law is a convention or tautology requires supplementation by a specification of its function in a particular systematization of physics, where the system of physics as a whole is not itself accepted on definitional grounds. It is thus not obvious that in every use of the words "impenetrability" and "matter," the impenetrability of matter is a logically necessary truth. For example, it is an empirical fact that a mixture of equal volumes of alcohol and water occupies a volume less than the arithmetical sum of the two, whereas a mixture of two equal volumes of water occupies a volume equal to this sum. If the concept of impenetrability is applied to this case, the impenetrability of matter appears to be a contingent truth. The point is, of course, that an "interpretation" of physics which leads to equating a logically necessary proposition with one that is contingent cannot be correct.[41]

---

[41] Russell is often careless in some of his judgments as to which propositions are definitional. His definition of physical object leads him to say that "Things are those series of aspects which obey the laws of physics," (*OKEW*, 117), from which it would seem to follow that the laws of physics are definitions. Indeed, he does say that "Almost all the 'great principles' of traditional physics turn out to be like the 'great law' that there are always three feet to a yard," (*ABC*, 221). This is palpably absurd when taken without serious qualifications, and in this connection one must remind Russell of one of his own jibes against certain philosophers: "Dr. Schiller says that the external world was first discovered by a low marine animal he calls 'Grumps', who swallowed a bit of rock that disagreed with him, and argued that he would not have given himself such a pain, and therefore there must be an external world. One is tempted to think that, at the time when Professor Dewey wrote, many people in the newer countries had not yet made the disagreeable experience which Grumps made. Meanwhile, whatever accusation pragmatists may bring, I shall continue to protest that it was not I who made the world." In "Professor Dewey's 'Essays in Experimental Logic'," *The Journal of Philosophy*, Vol. XVI (1919), 26. On the other hand, Russell himself recognizes the limitations in the view that physics is a huge tautology. In a penetrating brief critique of Eddington, he notes that the allegedly tautological character of the principles of the conservation of mass and of momentum holds only "in the deductive system [of physics]: in their empirical meanings these laws are by no means logical necessities." *AM*, 89.

A second general issue arises in connection with a technical detail in Russell's interpretation of physics. If the objects of theoretical physics are all constructions, then the symbols referring to them in the statements of physics are theoretically *eliminable*. Unfortunately, Russell has not formulated the translations of the requisite sort for specific statements which occur in treatises (e.g., statements like "Zinc arsenite is insoluble in water"), although he has of course indicated the general procedure to be followed in constructing such translations. There are, however, fairly good reasons for doubting whether the elimination of symbols for constructs can be carried through without introducing assumptions of a dubious character. These reasons are based on the fact that in various parts of mathematics as well as in the empirical sciences certain expressions are usually so defined that in general they cannot be eliminated by the help of methods customarily accepted. For example, so-called "functor-expressions" like "the sum of," are often defined recursively, so that such expressions cannot be eliminated from statements like "The sum of $x$ and $y$ is equal to the sum of $y$ and $x$." And if the so-called "dispositional predicates," like "soluble," are introduced into physics by the help of conditional definitions, as Carnap has suggested, an analogous difficulty arises with respect to them. To be sure, the desired elimination can be effected, provided we are willing to employ variables of a sufficiently high type; but the use of such variables appears to involve an "ontology" which it is not easy to accept. In particular, if we recall Russell's definition of classes and his view that a physical body is a class of classes of events, a statement about a body must finally be replaced by a statement about a property of properties—that is, about a property which is at least of type two. But does the assumption that there is such a property contribute much toward "assimilating" physics to the crude materials of perception? It seems to me, therefore, that, instead of making the elimination of symbols for constructs the goal of the logical analysis of physics, a more reasonable and fruitful objective would be the following: to render explicit the pattern of interconnections between constructs and observations, on the

strength of which these latter can function as relevant evidence for theories about the former.

I have been stressing throughout this essay the limitations of Russell's approach to the logical problems of science, and I have not thought it worth while to underscore their well-known excellencies. No student of his writings can fail to acknowledge the great service Russell's analyses have rendered to an adequate understanding of the mathematical sciences. He has made plain the highly selective character of physical theories, as well as the intricate transformations and reorganizations of sensory material which are involved in their use. He has exhibited the semi-arbitrary character of many symbolic constructions and the definitional nature of many physical propositions; and he has devised powerful techniques for isolating, and in some measure reducing, such arbitrariness and conventionality. Russell has not said the last word upon these matters; but he has certainly inspired a great multitude of students to try to say a better one. If the example of his own splendid devotion to independent thinking counts for anything, it is safe to believe that he would not prefer to have a different estimate placed upon his efforts.

ERNEST NAGEL

DEPARTMENT OF PHILOSOPHY
COLUMBIA UNIVERSITY

II

*W. T. Stace*

RUSSELL'S NEUTRAL MONISM

# RUSSELL'S NEUTRAL MONISM

## I. Neutral Monism in General

BY neutral monism I understand the theory that mind and matter are not two radically different kinds of entities, but that both are constructed out of the same "stuff." It is not, of course, denied that there is *some* difference between the mental and the physical; since to deny this would be a patent absurdity. But it is alleged that the difference is one of *relations*, not of *stuffs*. The neutral stuff, or the bits of it which may be called neutral entities, may be arranged in different ways according to different types of relation. A group of neutral entities arranged in one way, by virtue of one set of relations, will be a piece of matter. The same neutral entities arranged in another way, by virtue of another set of relations, may constitute a mind or a series of mental events. The neutral entities considered by themselves, apart from either set of relations, are neither mental nor physical. That is why they are called neutral. Out of a given set of dominoes one may make either a square or a rectangle of unequal sides. There is, of course, a difference between the square and the rectangle. But the "stuff" of which each is made is the same, namely the dominoes. The difference lies in the spatial relations which order the dominoes in the two cases. This analogy with neutral monism is correct except that in the case of the square and the rectangle the two sets of relations are both spatial, whereas there is no version of neutral monism according to which the differentiating relations of the mental world are merely spatial. *What* are the ordering relations of the mental and material worlds respectively is one of the great questions for neutral monism—a question to which different versions of the theory may give different answers.

It follows from what has been said that any neutral monism must contain three parts:

(1) *A Theory of the Neutral Stuff.* This must tell us what kind of entities the neutral entities are.

(2) *A Theory of Matter.* The main question which this theory will have to answer will be: what kind of relations are the relations which, when they hold between a set of neutral entities, constitute that set a material object? It will have to show how the material object is constructed out of the neutral stuff by virtue of these relations.

(3) *A Theory of Mind.* The main question to be answered here will be: what kind of relations are those which, when they hold between a set of neutral entities, constitute that set a mind or a mental phenomenon? It will have to show how mental phenomena are constituted by these relations out of the neutral stuff.

There are different versions of neutral monism, and they differ just in the answers they give to these three questions. The most important versions are those of William James, the American neo-realists, and Russell. James, so far as I know, was the original inventor of the whole idea, and he set forth his version of it in his book *Essays in Radical Empiricism.*

Neutral monism appears to be inspired by two main motives. The first is to get rid of the psycho-physical dualism which has troubled philosophy since the time of Descartes. The second motive is empiricism. The "stuff" of the neutral monists is never any kind of hidden unperceivable "substance" or *Ding-an-sich.* It is never something which lies *behind* the phenomenal world, out of sight. It always, in every version of it, consists in some sort of directly perceivable entities—for instance, sensations, sense-data, colours, smells, sounds. Thus, if matter is wholly constructed out of any such directly experienceable stuff, there will be nothing in it which will not be empirically verifiable. The same will be true of mind.

## II. The Development of Russell's Neutral Monism

The most complete single exposition of Russell's version of neutral monism is found in his book, *The Analysis of Mind,*

published in 1921. But, as the title implies, the book is mainly concerned to develop that half of the theory which seeks to construct mental phenomena out of the neutral stuff. The theory of matter, which is the other half of Russell's neutral monism, is rapidly sketched in the same book; but for its more elaborate exposition we have to go back to Chapters 3 and 4 in his earlier book *Our Knowledge of the External World,* written in 1914. These two books will therefore be the chief sources on which I shall rely in this essay.[1] It is not certain that the theory of matter elaborated in the earlier book and that outlined in the later book are quite identical. But the differences, if any, are slight, and will not affect any of the contentions which I shall put forward in this paper.[2]

I shall not be concerned to discuss any opinions which Russell developed after 1921. I do not know whether he now maintains any of the views which will be the subject of examination here. And the question need not trouble us. For even if he should now repudiate the whole of his neutral monism, yet the opinions which constitute it, and which found expression between 1914 and 1921, were important in the development of twentieth century philosophy and, as such, are profoundly interesting and worthy of study.

[1] *The Analysis of Matter* (1928), though it is true that it contains some elements of neutral monism, belongs on the whole to a later phase of Russell's thought, in which scientific realism and the causal theory of perception have finally gained the upper hand. I understand that Russell himself does not recognize that there is any important difference between what I would thus distinguish as two phases of his thought. But I find it impossible to reconcile the emphatic assertion of the causal theory of perception which marks *The Analysis of Matter* with such a passage as the following, taken from *The Analysis of Mind* (98): "Why should we suppose that there is some one common cause of all these appearances? As we have just seen, the notion of 'cause' is not so reliable as to allow us to infer the existence of something that, by its very nature, can never be observed. . . . Instead of supposing that there is some unknown cause, the 'real' table, behind the different sensations of those who are said to be looking at the table, we may take the whole set of these sensations (together possibly with certain other particulars) as actually *being* the table." For these reasons I have excluded *The Analysis of Matter* from consideration in this article.

[2] One difference is that in the earlier book the account of matter is put forward tentatively as a "hypothetical construction" which is to fulfill certain functions, but does not necessarily claim to be true; whereas in the later book the same account is put forward as a theory claiming truth.

On the other hand Russell's writings before he published his neutral monism are of great interest to us since they disclose how it gradually developed. I shall briefly trace this development in the present section.

In *The Problems of Philosophy* (1912) Russell advocated theories which were remote from neutral monism. In the first place, he accepted Moore's distinction between the mental act of being aware and the sense-object *of* which one is aware. The former he called the *sensation,* the latter the *sense-datum.* This means that Russell was then a psycho-physical dualist, not a monist at all. In the second place, the theory of matter which this book contained was that of generative realism. When we perceive a material object, what we directly sense consists of sense-data. The qualities of these sense-data, both primary and secondary, are dependent upon two factors, the physical object on the one hand and our sense-organs, brain, nervous system, etc., on the other. Thus the redness of a red object is the effect of two joint causes, the physical object and the optical apparatus of the perceiver. And the apparent shape or size of the thing seen is likewise the effect of two joint causes, one of which is the physical object, the other the position in space of the body of the perceiver relatively to the object. And since the perceived qualities are thus dependent for their existence as much on the presence of a perceiving organism as on that of the physical object, it follows that the physical object *by itself* has none of these perceived qualities, either primary or secondary. It must, however, have some intrinsic properties, since otherwise it would be nothing at all. What can we know of its intrinsic properties? Nothing, except that they *correspond to* the perceived properties. There must be one quality corresponding to red, another to green. There must be one property corresponding to roundness, another to squareness. We may call these latter characters "shapes" if we like, but they can be no more like the sort of shapes we perceive than redness is like the intrinsic quality which corresponds to it. Presumably if we perceive one thing as larger than another, there must be between the two physical objects some real relation which corresponds to, but is quite unlike, what we mean by the perceived relation of "larger than." Of

what sort these intrinsic qualities and relations are in themselves we cannot form the slightest idea.

To transform the ideas of *The Problems of Philosophy* into neutral monism two revolutionary changes are required. First, as regards the theory of matter, the physical object conceived as the cause (or part-cause) of sense-data must be got rid of, and we must be left with nothing but the sense-data, "aspects" or "appearances," themselves. The sum total of these must then be declared to *be* the piece of matter. (Russell never did arrive at *exactly* this phenomenalistic standpoint, but as a first rough approximation to a statement of his later position it will do.) The second change required will concern the theory of mind. It must consist in the repudiation of the mental act of awareness (or any other kind of mental act) as distinguished from the sense-datum, in other words the repudiation of "consciousness." Mind and the mental will then have to be identified with some arrangement of the sense-data, aspects, or appearances which also, in the new scheme, are to be constitutive of matter.

Russell did not make both these leaps at once. In the first edition of *Our Knowledge of the External World* (1914) the dualistic belief in consciousness is retained. But there now appears for the first time the more or less phenomenalistic theory of matter which was later, in *The Analysis of Mind*, to be incorporated into the author's neutral monism. Thus one half of his neutral monism, namely the theory of matter, was thought out first, and the second half, namely the theory of mind, came seven years later. He was not yet, in 1914, a neutral monist.

The new theory of matter is complicated and I do not propose to expound it in detail here. I shall assume that my reader is acquainted with it. I shall merely tabulate those essential features of it which are necessary to the understanding of what is to follow.

The theory of matter expounded in *The Problems of Philosophy* conceived that there are, in regard to every piece of matter, two things to be taken into account. The first is the physical object itself with its intrinsic properties, the nature of which we can never know. The second is the sense-data, aspects, or appearances which we perceive. It may help us imaginatively

if we conceive of the physical object as a centre or nucleus, with the sense-data, aspects, or appearances existing in rings all around it. We now strike out the nuclear physical object and we declare the rings of sense-data to *be* the piece of matter. It just *is* the sum of its appearances. But a peculiar and essential part of Russell's new view is that the appearances or aspects which now constitute the material object do not exist at the place where the material object is (i.e., at the place where it is ordinarily supposed to be) but rather at the places where they are, or could be, perceived. The circular brown sense-datum which is the appearance of a penny as seen by an eye one foot from "the place where the penny is" is, not at "the place where the penny is," but on the contrary at the place where the eye or brain of the perceiver is. A foot to the right of his head there exists in empty space an unseen elliptical aspect of the penny, and if he moves his head there he will see that aspect. Ten feet away from "the place where the penny is," along the straight line passing through the centre of the penny at right angles to its flat surfaces, there will be a circular aspect of the penny, which will be considerably smaller than the one the perceiver saw when his head was a foot from the penny. When he moves his head to this more distant point in space he will see this smaller round appearance. Thus the aspects of the penny are spread out all over space. And at "the place where the penny is" (in ordinary speech) there is nothing, only a "hollow centre." In this account I have, for the sake of simplicity, neglected the fact that the public space in terms of which the account is given, is, according to Russell, "constructed" by us out of private spaces.

Russell does not tell us why he abandoned the theory of matter of *The Problems of Philosophy* and adopted this new theory. But the reason is easy to guess. He has become more empirical. He is dissatisfied with the *Ding-an-sich*-like character of the physical object of the first theory. So he gets rid of it from his philosophy. Matter is now to be constituted out of empirically verifiable elements, namely sense-data and unperceived aspects which are somehow or other *like* sense-data. It is a movement away from realism towards phenomenalism, al-

though, as we shall see, it never arrives at a pure phenomenalism.

The second of the two revolutionary changes, or leaps, which Russell had to make in order to pass from the position of *The Problems of Philosophy* to neutral monism, was the abandonment of "consciousness." This change is made in the *Analysis of Mind* (1921), which was written under the influence of the American neo-realists. In 1928 a second edition of *Our Knowledge of the External World* was issued, and in that edition Russell struck out all references to the distinction between sensations and sense-data, thus bringing the theory of that book in line with his neutral monism.

I shall assume that the reader is, in general, acquainted with Russell's neutral monistic theory of mind and shall only outline those points which are relevant to what I want to say. For the sake of simplicity let us imagine a material universe consisting of only two objects, a penny, which we will call A, and a square table, which we will call B. They will be some distance apart, say ten feet. Then A will consist of a vast number of circular and elliptical aspects ($a_1a_2 \ldots a_n$) radiating outwards from "the place where A is;" and B will consist of a vast number of square and various perspectivally distorted squarish aspects ($b_1b_2 \ldots b_n$) radiating from "the place where B is." At any other point in space a radiating line of aspects from A will intersect with a radiating line of aspects from B. At any such point of intersection there will be one aspect of A, say $a_{12}$, and one aspect of B, say $b_{20}$. This collection of aspects, namely, one of A and one of B, will constitute a "perspective" of the universe. At every other point in space there will be some other perspective. If we now increase the number of material objects in our universe from two to any number we please, this will make no difference to the fact that at every point in space there will be a perspective of the universe.

If now we add that the aspects (of all things) are the neutral entities of Russell's monism, we shall see that there are two ways in which these neutral entities may be collected into groups or bundles. We may collect together in one group all the aspects which radiate from a common centre and which are related to

one another by the laws of perspective. Such a bundle will constitute a momentary material object. Or we may collect together all the aspects (of all things) which exist together at any point in space, i.e., at any point of intersection of the radiating lines. Such a bundle will constitute a perspective. Thus a material object and a perspective are both constructed out of the same neutral stuff, the aspects, and they differ from one another only by virtue of the different kinds of relations which subsist between their members. And this, as we saw, is the essential idea of neutral monism.

But a perspective is not yet a mind. If it were, there would be a mind at every point in space. To transform a perspective into a mind two further steps are necessary. First, at the point in space where the perspective is there must be a brain, nervous system, and sense-organs. Secondly, there must be added "mnemic phenomena" which apparently arise at that point because there is an organism at that point. "We will give the name of 'mnemic phenomena'," says Russell,

to those responses of an organism which, so far as hitherto observed facts are concerned, can only be brought under causal laws by including past occurrences in the history of the organism as part of the causes of the present response. . . . For example: You smell peat-smoke, and you recall some occasion when you smelt it before. The cause of your recollection, so far as hitherto observed phenomena are concerned, consists both of the peat-smoke (present stimulus) and of the former occasion (past experience).[3]

In other words, mnemic causation is a peculiar kind of causation in which there is an interval of time between the cause and the effect without (so far as is known) any intervening chain of causes. It is action at a distance, the distance, however, being a time-interval instead of a space-interval. Thus at any point where there is a perspective, plus an organism, plus mnemic causation, there is a mind.

This gives us, however, only a *percipient* mind, a mind capable so far of nothing but perceptions of material objects. What is still required is an account of mental phenomena other than perception, e.g., desire, instinct, general thinking, believing,

[3] *The Analysis of Mind*, 78.

reasoning, emotion, etc. Russell, in a series of further chapters, attempts to analyse all these in such a way as to do away in each case with the necessity for "consciousness." Some of them are explained behaviouristically, others by attempting to reduce them to sensations and images. The up-shot of the whole is that there is nothing in mind except sensations (= aspects) connected by mnemic causation, and images. I shall not go into the detail of these various reductions.

I shall now comment on this scheme under the heads of the three parts which must, as we saw, be included in any neutral monism, namely its theory of the neutral stuff, its theory of matter, and its theory of mind.

### III. The Theory of the Neutral Stuff

Russell's neutral stuff consists of "aspects." In the *Analysis of Mind* he generally calls the neutral entities "sensations." It must be remembered that he has now given up the distinction between sensations and sense-data, and that in consequence he uses the word sensation for such entities as coloured patches and sounds. An aspect of a material object, when it is being perceived, consists, of course, of sense-data or sensations, so that we may say indifferently that neutral entities are aspects or sensations. This is plain sailing so long as the aspect is perceived. But we shall find that there is grave difficulty in understanding the nature of an unperceived aspect, and the identification of it with sensations will become very doubtful. For the moment, if we stick to the idea that both the material object and the mind consist of sensations grouped according to different relations, the main tenor of Russell's neutral monism is clear enough.

This theory of the neutral stuff differs both from that of James and that of the American neo-realists. James included what Russell calls sensations, and also at least some universals, such as mathematical entities. The neo-realists included sensations, universals, propositions, mathematical and logical entities. Russell includes only sensations, i.e., particulars, not universals or propositions of any kind. Concerning universals he says very little in *The Analysis of Mind*. On page 228 he writes "I *think* a logical argument could be produced to show that universals

are part of the structure of the world, but they are an inferred part, not a part of our data" (a doctrine quite different from that offered in *The Problems of Philosophy*). Since they are not data, they are not experienced, and therefore cannot be parts of the neutral stuff. Nor are they ever mentioned as such in the elaboration of the theory.

We have now to note that Russell's neutral monism is not a *pure* neutral monism at all. For according to a purely neutral monistic theory of the world there is *nothing*, either in mind or in matter, which is not wholly constructed out of the neutral stuff. Russell departs from this formula in two respects. In the first place, although sensation, which is the neutral stuff, is the most important component of mind, it is not the only component. He also admits "images." Mental phenomena are not reduced sheerly to sensations, but to sensations and images. Now images are not part of the neutral stuff at all. They are never found in the physical world. They are purely subjective. In a pure neutral monism there should, of course, be nothing which is purely subjective. It is true that images are like sensations, and may be derived from them. Still, as being found solely in the realm of mind, they constitute a departure from the strict program of neutral monism.

On the other side of the picture it is, to say the least, doubtful whether, on Russell's theory, matter can be said to be composed solely of the neutral stuff of sensation. Is the unperceived "aspect" in any sense a sensation? I shall discuss this in the next section and we shall find that the whole theory is, at this point, involved in grave difficulties, if not in actual inconsistencies. At this point I will merely quote a passage which includes reference to Russell's departures from neutral monism in regard to both mind and matter.

The American realists are partly right, though not wholly, in considering that both mind and matter are composed of a neutral-stuff which, in isolation, is neither mental nor material. . . . But I should say that images belong only to the mental world, while those occurrences (if any) which do not form part of any "experience" belong only to the physical world.[4]

[4] *Analysis of Mind*, 25.

The reference in the last clause of this sentence is presumably either to unperceived aspects, or to the "scientific objects" of the physicist, or to both. I shall have more to say on this topic later. For the moment I wish only to note that the admission of physical entities which are not composed of the neutral stuff is—as Russell himself of course realizes and intends—a second departure from neutral monism. It is true that the words "if any" seem to throw doubt on this. In a later passage he writes "I contend that the ultimate constituents of matter are not atoms and electrons, but sensations, and other things similar to sensations as regards extent and duration."[5] I shall not stop at this point to unravel these obscurities, but will simply note that Russell's philosophy at this period seems to fall into a scheme of the following kind.

| Purely Physical Entities | Neutral Entities | Purely Mental Entities |
| --- | --- | --- |
| Occurrences (if any) which do not form part of any experience. | Sensations (which enter into both mind and matter) | Images |

The neutral monist part of Russell's theory appears in the middle column, the departures from it in the columns on the left and the right.

It should not be necessary to explain that the statement that Russell's theory is not *pure* neutral monism is not in any sense a criticism of it. It is mere description. Russell simply thinks that neutral monism is partly right and partly wrong. And this, of course, might be true.

## IV. The Theory of Matter

1. The theory of matter may be considered as aiming at three objectives, and our estimate of it will depend partly on what we consider to be the value of these objectives if reached, partly upon whether we consider that Russell successfully reaches them. The first objective (which the theory of matter shares, of course, with the theory of mind) is to abolish psycho-physical dualism. The second is to give an account of material objects in terms of verifiables only. There is to be no hidden substrate, no mysterious *Ding-an-sich*. The thing is to be composed of sensible

[5] *Ibid.*, 121.

appearances and aspects only. The third objective is to solve the ancient epistemological problem of the relativity of sensation.

2. Most of what I have to say about the attempt to abolish dualism will fall more naturally under the head of the theory of mind; I will postpone full discussion of it to the next section. Here I shall content myself with two remarks. First, it is quite obvious that the "impurity" of Russell's neutral monism, referred to in the previous section, renders it impossible for him to abolish dualism. For if there are in the physical world "occurrences which do not form part of any experience," and which never fall within the circle of any mind, it is clear that we have dualism again. Secondly, I do not myself regard this as the slightest objection to Russell's theory. This is because I regard dualism as both inevitable and unobjectionable. I do not know why philosophers want to make out that as few as possible kinds of things exist in the world, if possible only one; and I regard this as a mistaken objective of philosophy. The point, however, is that I do not see how Russell can have it both ways; can have one foot in the dualist camp and the other in the monist. The most that can be said is that if Russell is able to show that matter consists largely, though not wholly, of sensations, and that mind also consists largely, but not wholly, of sensations, then he will have "lessened the gulf" between them, or "thrown a bridge" from one to the other—whatever these metaphorical expressions may mean, and whatever this achievement may be worth.

3. The second objective is to give an account of matter in terms of verifiables only. The importance of doing this will be obvious to any empiricist. Let us consider only the question whether Russell succeeds in it.

The material object is constructed out of perceived and unperceived aspects. As regards the perceived aspects there is no difficulty. They are complexes of sense-data or, as Russell now calls them, sensations. Hence they are, of course, verifiables. But what sort of entities are the unperceived aspects?

It might be possible to hold that the unperceived aspects are in all ways exactly like perceived aspects, except that they do not happen to be perceived. The unperceived red patch would then be red in the same sense as the perceived red patch is red.

In that case the unperceived aspect might fairly be regarded as a verifiable. For although it would not, of course, be possible to observe it when it is unobserved, yet it would, even when unobserved, be an entity of exactly *the same sort* as observed entities are. It would be the sort of thing which we do constantly observe, although, at certain times, it does not happen to be observed. Apparently Russell has at times attempted to think of "sensibilia" in this way.

But this is not the theory which is maintained in *Our Knowledge of the External World,* and I do not find any signs of it in *The Analysis of Mind.* It is important to notice that it is only possible to hold such a view if we adopt the selective type of realism. We may briefly distinguish generative and selective realism as follows. According to generative realism—it will be remembered that Russell advocated this in *The Problems of Philosophy*—the perceived qualities of sense-data are effects of two joint causes, the physical object and the perceiving organism. Hence this type of realism must hold that the perceived qualities of things cease to exist when we are not perceiving them. The view of selective realism is quite different. The sense-organs are not in any way concerned in causing sense-qualities to exist. The sense-qualities actually exist in the object, whether it is perceived or unperceived, just as common sense supposes. What the sense-organ does is to *select* which of the sense-qualities we shall perceive. Thus when my colour-blind friend sees as green what I see as red, we are to suppose (apparently) that the object itself really is both green and red; and that my optical apparatus shuts out the green, allowing me to see only the red, whereas my friend's optical apparatus shuts out the red and allows him to see only the green.

There are grave objections to selectivism, but that is not the present point. The point is that this theory does allow one to hold that things objectively have all the qualities which we perceive in them, and that they have them even when they are not perceived by any organism. The generative theory renders any such belief *impossible*, since it holds that the presence of a sense-organ is necessary for the coming into existence of the sense-qualities.

Hence Russell could not consistently hold that unperceived

aspects have the same characters as perceived aspects, unless he first abandoned the generative theory of his earlier days and adopted selectivism. Not only is there no evidence of such a change, but certain passages in *Our Knowledge of the External World* render it clear that he still holds the generative view. Thus he writes, "it must be admitted as probable that the immediate objects of sense depend for their existence upon physiological conditions in ourselves, and that, for example, the coloured surfaces which we see cease to exist when we shut our eyes."[6] Some pages later he points out that two men sitting in a room will see "two somewhat similar worlds," i.e., two different aspects of the same room. If a third man enters and sits between them he will see a third intermediate world, i.e., a third aspect. "It is true," he goes on,

that we cannot reasonably suppose just this world to have existed before, because it is conditioned by the sense-organs, nerves, and brain of the newly arrived man; but we can reasonably suppose that *some* aspect of the universe existed from that point of view, though no one was perceiving it.[6a]

Both passages say plainly that Russell is adopting the generative hypothesis. The second passage says, though less plainly, that the unperceived aspect does not possess the same sort of characters as do the perceived aspects. Hence the interpretation that the unperceived aspects are verifiables because they are exactly the same sort of things as the perceived aspects, except that they do not happen to be perceived, falls to the ground.

There are many passages in Russell which suggest an entirely different interpretation. According to this view the unperceived aspects are to be identified with the etheric or spatial radiations of the physicist. This would render intelligible the above-quoted statements that sense-qualities arise only where there is a sense-organ, for this appears to be the view commonly held by physicists. To quote from Russell. "The definition of a 'momentary thing' involves problems concerning time, since the particulars constituting a momentary thing will not all be simul-

---

[6] *Our Knowledge of the External World* (second edition), 68.
[6a] *Ibid.*, 93.

taneous, but will travel outward from the thing with the velocity of light."[7] And from a later page,

What it is that happens when a wave of light reaches a given place we cannot tell, except in the sole case when the place in question is a brain connected with an eye which is turned in the right direction. In this one very special case we know what happens: we have the sensation called "seeing the star." In all other cases, though we know (more or less hypothetically) some of the correlations and abstract properties of the appearance of the star, we do not know the appearance itself.[8]

The unseen occurrence is called in the last sentence an "appearance"—although it is not appearing to anyone—and the word appearance is sometimes used by Russell as synonymous with aspect.

If one wishes to adopt this interpretation one may be puzzled by another passage which I have already quoted. "I contend that the ultimate constituents of matter are not atoms or electrons, but sensations and other things similar to sensations as regards extent and duration." At first sight this looks as if Russell is rejecting all such "scientific objects" as atoms, electrons, and the radiations which proceed from them. It looks like a pure phenomenalism according to which matter is nothing but complexes of sense-data and other entities similar to them in extent and duration, and in which "scientific objects" will presumably have to be regarded as pragmatic fictions justified only by their predictive value. This would, of course, be inconsistent with the identification of unperceived aspects with radiations.

But the passage can be interpreted otherwise. Russel *may* mean that he does not believe in atoms and electrons but *does* believe in the radiations which are commonly said to issue from them. This would suggest the view that there is no solid entity (atom or electron) which radiates vibrations. There is nothing but the vibrations themselves radiating from a "hollow centre." The electrons and atoms—if one wishes to reintroduce the terms—may now be identified with the radiations themselves. And this view of atoms and electrons has actually been quoted

[7] *Analysis of Mind*, 126.
[8] *Ibid.*, 134.

with approval by Russell elsewhere.[9] In that case the vibrations may be identified with the unperceived aspects, and the statement that "the ultimate constituents of matter are not atoms or electrons" may be meant to reject only the something-at-the-centre-which-emits-vibrations theory of atoms and electrons.

Further, the statement that the real constituents of matter are sensations "and other things similar to sensations *as regards extent and duration*" (italics mine) provides another clue. It seems to mean that the unperceived aspects have in common with the perceived aspects only the characters of "extent and duration," in short, the so-called primary qualities. In a sentence already quoted, he has told us that "the coloured surfaces which we see cease to exist when we shut our eyes." Putting the two passages together we get the result that Russell is apparently simply supporting the scientific tradition which bifurcates the primary and secondary qualities. The perceived aspects have the primary and secondary qualities, the unperceived aspects have only the primary. Epistemologically this might be rendered possible by supposing that the generative hypothesis is correct as regards secondary qualities whereas the selective hypothesis applies to primary qualities. Two men see the table top as having different shapes because the positions of their bodies select different shapes. But they see it as having different colours because the optical apparatus of one differs from that of the other. This combination of generativism and selectivism is in many ways attractive. It seems to agree with science and with a sophisticated common sense.

We may briefly sum up the interpretation of Russell which is here suggested. The material object is nothing but the collection of all its aspects, perceived and unperceived. The perceived aspects are sensations, or complexes of sense-data having primary and secondary qualities. The unperceived aspects are simply the radiations of the physicist. They have the primary, but not the secondary, qualities. When we perceive an object, the spatial position of our body selects the shape and size, and the sense-organs acted on by the radiations generate the colour

[9] See *Philosophy*, 157.

and other secondary qualities. At the centre from which the aspects radiate there is nothing, and this accords with that interpretation of atoms and electrons which identifies them with what would otherwise be considered their effects, i.e., with the radiations which are supposed to issue "from them." The electron, on this view, is what it does.

I do not know whether all this *is* what Russell means. It *might* be nothing but a fancy of mine which I have thrust upon him. The truth is that Russell's writings are extremely obscure. The beautiful prose which he writes carries one easily along and gives rise to the delusion that what he is saying is extremely simple. Actually it is far otherwise. In the present case I can only say that the interpretation which I have offered seems to me the most likely. It harmonizes a number of tendencies and passages which on the surface seem bafflingly inconsistent with one another. It brings together in a self-consistent view his phenomenalism, his realism, and his strong desire to reconcile his philosophical views with the doctrines of physical science.

But now, if this interpretation is accepted, how shall we evaluate his theory of matter? The first thing to note is that it lays itself open to Berkeley's criticism that it is impossible to separate primary and secondary qualities. The unperceived aspect has the primary qualities but not the secondary. This objection, however, might be cured. The real point which Berkeley made was not, as he supposed, that primary qualities cannot exist without secondary qualities, but that they cannot exist without *some* other qualities. To say of a material object that it has no characters other than shape, size, duration, and motion, is to make it equivalent to a region of empty space, i.e., to nothing, and moreover to a nothing which is supposed to be in motion. To make it *something*, Berkeley supposed, it must have some other characters, for instance colour. But Berkeley's point could be met if we supposed that the unperceived aspect, besides having the primary qualities, has intrinsic qualities which are unknowable to us but which *correspond to* perceived secondary qualities. *Perhaps* this is what Russell means. I am aware of no passage in his writings which definitely supports the supposition, but it accords with the views advocated in *The Problems of*

*Philosophy,* and it seems the only course open to Russell to make sense of his doctrine.

The next question to ask is whether Russell's theory, thus interpreted, achieves his objective of constructing matter out of verifiables only. The answer is that it most certainly does not. The whole object of the theory, we understood at the beginning, was to get rid of hidden substrates, *Ding-an-sich*-like physical objects with unknowable intrinsic qualities. But now all this, which we were to get rid of, is back again on our hands. The only advance made on the theory of *The Problems of Philosophy* is that for the solid *Ding-an-sich*-like *thing* at the centre with its intrinsic qualities, we have substituted *Ding-an-sich*-like *aspects,* with their intrinsic qualities, radiating from the centre throughout space. This change in no way makes the theory more empirical. The unverifiable character of the old solid "physical object" is simply transferred to the new airy and fluttering "aspects."

Thus viewed, the supposed effort of this second phase of Russell's career to be more empirical and phenomenalistic, the supposed intent to construct matter out of verifiables only, turns out to be nothing but a fraud. There is a great blowing of trumpets. There is a great air of being empirical and of having no traffic with unverifiable entities. There is conjured up before our mind's eye the picture of a piece of matter composed of nothing but sensations or sense-data, of sensible aspects spreading out through space. It is true, one is given to understand, that some of these aspects are not perceived. They are, however, very much the same sort of things as sensations. If we are simple enough, we may be satisfied with this and suppose that we have an empirical and phenomenalist account of matter. We shall not notice that the whole subject of the unperceived aspects is hastily glossed over in a few very brief and evasive passages; and that when we press our question regarding them, the subject is quickly changed. But we must sternly insist on pressing the question: are these unperceived aspects entities having verifiable characters like the perceived aspects, or are they not?

It seems that only two replies are possible. One is that un-

perceived aspects are exactly like perceived aspects except that they do not happen to be perceived. The second is along the lines of the interpretation which I have offered as being the most likely and the most consistent with what Russell actually says. If the first alternative is chosen, then it necessitates a thorough-going selectivism. This is inconsistent with what Russell says. What is more serious, it will involve us in all the grave troubles of the selective theory. I have no space to expound these here. I have discussed them elsewhere,[10] and Professor H. H. Price's book *Perception*[11] may also be consulted on the subject. If the second alternative is chosen, it completely destroys the empirical character of the theory and the claim to construct matter out of verifiables.

It seems to me that actually Russell has a hankering for both interpretations. Always his philosophy wavers unhappily between phenomenalism and scientific realism. In the end the scientific realism always wins. The theory of *Our Knowledge of the External World* has at first sight the appearance of being a revolutionary change from that which was offered in *The Problems of Philosophy*. Actually the two theories are, if our interpretation has been correct, almost identical, save that unverifiable aspects spread throughout space are now substituted for an unverifiable physical object at the centre. From the position of scientific realism Russell has from time to time held out fluttering and ineffectual hands towards phenomenalism. But he has never embraced it. His traffic with phenomenalism has been no more than a mild and insincere flirtation.

4. We have still to enquire whether Russell achieves his objective of solving the problem set by the relativity of sensation. This question can be answered very shortly. "Difficulties have arisen" he writes "from the differences in the appearance which one physical object presents to two people at the same time." After adding that these differences have been made the basis of arguments in favour of the view that we cannot know the real nature of objects, he claims that "our hypothetical con-

---

[10] *The Nature of the World*, 118-120.
[11] *Perception*, 40-53.

struction"—i.e., his theory of matter—"meets these argu-
ments"[12]—i.e., it solves the problem of the relativity of sen-
sations.

Let us briefly state the problem which has to be solved. When
two people simultaneously view an object, it is assumed by com-
mon sense that they both see the same identical thing. But the
appearance which one of them sees may be red and circular,
the appearance which the other sees may be green and elliptical.
The common sense view that they are seeing the same thing
entails that the circular red thing exists *at the same point of
space* as the elliptical green thing. This is, however, impossible,
since green and red exclude one another, and round and ellipti-
cal exclude one another. Suppose we symbolize by $x_1$ and $x_2$
any two mutually exclusive and clashing characters, (such as red
and green, round and elliptical, loud and soft characters of
sound, large and small appearances of the object close to us and
far away respectively, etc.) then the problem arises from the
fact that the common sense view of the world entails that $x_1$
and $x_2$ exist simultaneously at the same place, and that this seems
to be plainly impossible.

Obviously there is only one possible principle for solving
the problem, namely to suppose that $x_1$ and $x_2$ *do not exist at
the same place.*

Berkeley successfully solved the problem by using this prin-
ciple. According to him $x_1$ and $x_2$ are not in the same place,
because they exist only as sensations *in two different minds.* Two
different minds are not, of course, in two different places. Minds,
according to Berkeley, are not in space, but different spaces are
in different minds. Hence for him $x_1$ is in the private space of
one mind, whereas $x_2$ is in the private space of another mind.
Therefore they are not in the same place and they do not clash.
When I say that Berkeley "successfully" solved the problem,
I do not of course mean that his solution is "true." I mean only
that, whether true or false, it is an hypothesis which does ac-
count for the facts.

Russell's solution proceeds on the same principle—that $x_1$
and $x_2$ are not in the same place. That is the whole point of his

[12] *Our Knowledge of the External World,* 102.

supposition that the aspects which constitute the material object are spread out through space and do not all exist together at the centre, i.e., at the place where common sense supposes the object to be. The circular aspect which I see ($x_1$) exists at the place where my head is. The elliptical aspect which you see ($x_2$) exists ten feet away at the place where your head is. Thus $x_1$ and $x_2$ exist at two different places where they cannot clash. One might say that Russell merely varies Berkeley's solution by substituting "in your head" for "in your mind." Russell's theory, accordingly, does succeed in solving this problem.

It might be objected that, although Russell's theory does explain the relativity of shape, size, and all those characters whose sensed variations are correlated with *variations in the spatial position of the sense-organ*, it fails to explain the relativity of colours, tastes, and all those characters whose sensed variations are correlated with *variations, not in the position, but in the physiological structure or condition of the sense-organ*. For, although on Russell's theory two different shapes will be in two different places, yet two different colours, such as the red which I see and the green which my colour-blind friend sees, may have to be located in the same place. For if I make way for my friend so that his head can occupy the very same position which mine occupied a moment ago, then he will see a green aspect in the very same position as that from which I saw a red aspect a moment before. Hence the green and the red must really be in the same place.

But the objection is capable of being answered if we assume, as previously suggested, that Russell is a selectivist as regards primary qualities and a generativist as regards secondary qualities. The aspect which I and my friend see has a shape (which appears the same to us both), but it has in itself no colour. When my eye is in position to see it, red colour is generated on it; and when, a moment later, my friend's eye is in that position, green colour is generated on it. Thus the green and the red, though they both exist in the same place, exist there successively and not simultaneously. Hence there is no clash.

Any theory which holds that $x_1$ and $x_2$ are not in the same place is bound to be "queer" and to seem absurd to common

sense. For the proper definition of queerness in a philosophical (or scientific) theory is "departure from the beliefs of common sense." The further a theory is from those beliefs the queerer it is. This is all we *mean* by queer. Hence Berkeley's theory is queer and so is Russell's. But if it is realized that *any* solution of the epistemological problem *must* proceed on the principle that $x_1$ and $x_2$ do not exist simultaneously at the same place, and that this principle flatly contradicts common sense, and that queerness means nothing but departure from common sense beliefs—if, I say, all this is realized, it will be seen to follow that any true solution of the epistemological problem must necessarily be queer. "The truth about physical objects," Russell has said, "*must* be strange."[13] It is easy to poke fun at Russell's theory of matter on the grounds that, according to it, the penny exists at every part of the universe except where the penny is, and that Russell's brain, being a material object, is all over the universe, and that he, consequently, is "a terribly scatter-brained fellow." All such criticisms I regard as cheap and worthless, for they all depend merely on the queerness of the theory. But queerness is not a fault in an epistemological theory. The absence of it is.

## V. The Theory of Mind

1. The second half of Russell's neutral monism, the theory of mind, is designed to show that—apart from images—the constituents of mind are the neutral entities of sensation. His avowed object is to get rid of "consciousness," to give an account of all mental phenomena, such as perception, memory, thinking, reasoning, desire, emotion, will, without postulating anywhere the element of consciousness.

In one sense it is manifestly ridiculous to deny the existence of consciousness. It is plain that the word consciousness is a good English word which means *something*. It is not a noise which fails to refer to anything whatever in the world, and which people sometimes make without any reason while they talk, like a grunt or a wheeze. It is plain that when I say "I am conscious of the things around me" I am not saying nothing. I

[13] *The Problems of Philosophy*, 59.

am saying something, and something which is certainly true. And it is plain that there is some difference between a man who is awake and in possession of his faculties and the same man when he has been knocked senseless by a hammer-blow on the head. We express this difference, whatever its nature, by saying that the man in the first case is "conscious" and in the second case "unconscious." Obviously this is a real, and not an imaginary, difference. In this sense there plainly is such a thing as consciousness, and no sensible philosopher, least of all Russell, would deny it. If there are any philosophers who do deny it, they cannot be refuted by any argument. They can only be advised to see their doctors.

What is it, then, that the neutral monist is denying when he denies the existence of consciousness? The answer is that he is denying that consciousness is an "entity," or "stuff," or "substance," or even an "event," of a radically different kind from the entities, stuffs, substances, or events which make up the physical world. He is repudiating that sort of absolute qualitative difference between mind and matter which has been asserted by many philosophers since the time of Descartes. To suppose, for instance, that matter is in essence spatial and non-thinking, whereas mind is in essence thinking and non-spatial, is to suppose a complete gulf between the two. They have, on this view, absolutely nothing in common.

What is the objection to such a view? Of course to Descartes's particular version of dualism it may be objected that it involves the unempirical notion of substance. But dualism can easily be purged of this. We might well construct a dualistic theory of mind and matter on purely phenomenalistic lines. Matter might be constructed out of sense-data, and mind might be constructed out of introspective data. These latter might be radically different from sense-data. They might, for example, be non-spatial. Substances would be got rid of, but we should still have a completely dualistic theory.

Of course neutral monists would deny that any such introspective data, wholly distinct from sense-data, can ever be detected, or that they exist. That is a question of fact on which opinions differ. But it is not this which is the root-objection to

dualism as such. There is no doubt that at the bottom of the common dislike of dualism there is believed to be some sort of *a priori* objection. It is thought that, apart from questions of fact, dualism is in some way philosophically or logically objectionable.

It is very difficult to understand why philosophers should feel this. There certainly are a very great number of quite different kinds of data in the world. For instance, visual data are radically different from the data of sound, and these again from the data of smell. Visual data are certainly spatial, whereas it is at least doubtful whether the data of smell are (though I do not claim that this makes them 'spiritual'). There is an impassable gulf set between the different data of the different senses. The connection between them is only that of correlation. So far as I can see, it is just as much "dualism" to admit the existence of two such radically different kinds of data as those of smell and sight as it is to admit the existence of both visual data and introspective data. The connection between introspective data and visual data (or other data of sense) might well be that of correlation, as is the connection between the different kinds of sense-data. So where in the world is the *a priori* objection to admitting the possibility of introspective data alongside the others?

It may be said: The sense-data all have it in common that they are *sense*-data. They are all, in that respect, alike. But the so-called introspective data would not be sensuous at all. They would be utterly different from any data given in sense. Hence it is not true that there is as great a gulf between visual data and olfactory data as there would be between introspective data and those of sense. Sense-data all belong in one general category, but introspective data would fall outside it in some radically different category.

This argument assumes that there is some character common to all sense-data which may perhaps be called "sensuousness." I cannot, however, find in data any quality of sensuousness. They seem to be all called sense-data owing to the extrinsic and accidental fact that they are all perceived normally

through one or other of the physical senses. I cannot myself see that there is anything at all in common between, say, sounds and smells. And if they are thus utterly unlike, if the gulf between them is absolute, then introspective data cannot be more unlike sense-data than "utterly unlike," nor can the gulf be greater than an absolute gulf.

Perhaps the objection really is that the introspective data are suspected of being 'spiritual', in some way, whereas the sense-data are 'merely' sensuous. This seems to put a gulf between them; and of course claims to superior spirituality are apt to be irritating. Personally I should put forward no such claims on behalf of introspective data—not at any rate as part of the theory of knowledge. For spirituality is a value-category, and epistemology is not concerned with values. Spirituality is not, at any rate in my opinion, a quality which data may have on a par with colour, hardness, and the like. It may be that, as moralists have always declared, the mind is in some way more noble than the body. But this nobility, however it is to be interpreted, must surely belong to the mind as an organized whole, not to the humble data out of which it is constructed. However that may be, the alleged nobility of mind cannot surely be made the basis of a reasonable objection to dualism.

I can therefore find absolutely no rational ground for objecting a priori to dualism. Accordingly I conclude that the strong feeling that, apart from any question of fact, there is some logical or philosophical objection to dualism as such, must have its source in some kind of prejudice. And it is quite easy to suggest the possible sources of an anti-dualistic bias.

First, as a matter of history, dualism has come down to us loaded with religious associations. And I believe that anti-dualistic philosophers are largely motivated by a feeling of fear, perhaps largely subconscious, that the admission of a psycho-physical dualism will entrap them again in what they regard as discarded superstitions. Dualism suggests the "soul," and everybody now knows that we don't have souls. It further suggests that the soul may be independent of the body, and might be made the basis of a claim to immortality—another out of date

idea. There is no knowing where an admission of dualism might not end. It might even land us—though I hesitate to suggest anything so indecent—in belief in God.

It is plain that in all this there is no rational argument, nothing but anti-religious prejudice. A belief in introspective data has no implications of the kind suggested. For instance, if the introspective data are correlated with sense-data—as they certainly are, if they exist at all—then the mind constructed out of introspective data will be no more independent of the body than the data of one sense are independent of the data of another. Let me remind the reader that it is just as unphilosophical to allow one's opinions to be dictated by anti-religious feelings as it is to allow them to be dictated by a pro-religious bias.

A second source of prejudice is the medieval idea that a cause must *resemble* its effect, that cause and effect cannot be radically different in kind. Descartes expressed one aspect of this idea when he said that a cause must have in it as much reality as its effect. The idea that cause and effect must be alike is a piece of pure prejudice, not born out by facts. Lightning is the cause of thunder, yet the two are totally unlike, one being a complex of visual data, the other a complex of auditory data. Cold is utterly unlike the solidity which it causes in water. It was this baseless medieval belief which gave rise to the supposed "impossibility" of interaction between mind and body, and to the whole rubbish heap of literature about parallelism, epiphenomenalism and the like. And this supposed impossibility of interaction between two radically different kinds of entity has been one of the strongest influences working against dualism. I am not saying that Russell has himself been directly influenced by this second kind of prejudice, though I should not be surprised if he has been unconsciously influenced by the first. I have been discussing the question of the causes of the prejudice against dualism quite generally.

In the light of these considerations it does not seem to me that Russell's aim of reducing mind to a conglomeration of sensory neutral stuff constitutes in any way a valuable or important objective. Of course if there *is* only one kind of stuff

in the world, not two, it is important that we should know this fact—assuming that any philosophical knowledge is important. But if a survey of the facts shows that there exist two, or many, kinds of stuff, this should be accepted with natural piety. There is nothing especially valuable or meritorious in aiming at a monistic theory.

2. But now we have to consider whether Russell actually does succeed in getting rid of 'consciousness'. I hold that not only Russell's but *any* neutral monism, past, present, or future, is foredoomed to failure in this attempt. This can be shown by considering the general program of neutral monism, without taking into account the particular versions of James, the American realists, or Russell. For the neutral monist is not a crude materialist. He admits a difference between mind and matter; only he says that it is a difference of relations and not of stuffs. He must therefore face the question: what sort of relation, or relations, holding between neutral entities, constitute them mental events? Let us call this relation, or relations, R. Different versions of neutral monism may give different accounts of R. But they must all necessarily admit that R is a *unique* relation. By a 'unique' relation I mean one which cannot be reduced to physical relations and which cannot be found in the physical world. R must be a unique relation, for if it were not, it would fail to differentiate between mind and matter, which is precisely its function in the theory. R is to be the sole *differentium* of the species 'mental phenomenon' as distinguished from the species 'material phenomenon'. And this *differentium* cannot of course be found among material phenomena.

R, then, must be a unique non-physical relation. It cannot be itself a neutral entity. It must be purely subjective. But, when we have admitted this, we have admitted the existence of something which is purely mental, subjective, and non-physical as the essential characteristic of mind. This is to admit to dualism. Why now trouble to deny the existence of other subjective factors of consciousness? At most neutral monism, if accepted, shows that what is peculiar and essential to mind is not a unique non-sensory stuff but rather a unique non-sensory relation. Over this I no longer care to dispute. It may be of

academic interest to decide whether what is unique in mind ought to be classified as a 'relation' or a 'stuff'. But in either case the uniqueness (= non-physicality) remains, and we have a clear dualism.

It may be asked how this purely general argument applies to Russell's particular version of neutral monism. It is not difficult to find the answer. To begin with, the type of relation which makes the difference between a piece of matter and a "perspective" is a spatial, i.e., a physical relation. For the "bundles" of aspects which respectively constitute material objects and perspectives are collected together merely on two different spatial plans. Those which radiate from a common centre and are related to each other by the laws of perspective are pieces of matter. Those which are found at points of intersection of lines of aspects radiating from different centres are perspectives. But a perspective is not a mind. There must be added a brain and nervous system. These too are purely physical, and we do not yet get a mind. Mind arrives only with the addition of "mnemic causation" and "mnemic phenomena." One might simply point out that mnemic phenomena are merely what most people call memory, and that to introduce memory here is simply to introduce a non-physical or mental event or relation. But if we have to talk Russell's language we shall say that what is introduced here is a kind of causation which skips over periods of time, so that the cause may exist today, the effect twenty years hence, with no intermediate causal links. This is certainly a relation never found in the physical world. It is a wholly peculiar and unique character found only in mind. Personally I should hold that this is an utterly inadequate account of what is unique in mind. But it is certainly sufficient to establish the point of this discussion, namely that the relation R must be a unique relation never found in the physical world.

3. Of the much-debated question whether one *can* introspect consciousness, i.e., whether introspective data actually ever are observed, I do not propose to write at length here. My own opinion is that introspective data are observable. I have discussed this matter elsewhere. I shall content myself on this occasion by asking two questions.

First, how does any neutral monist know that the relation R exists? Since it is not found in the physical world it cannot have been discovered by external observation, and I do not see how it can have been discovered at all except by introspection. If so, it is an introspective datum of an entirely non-physical and non-sensuous kind. It is true that it is a relation and not a stuff, but that does not prevent it from being a datum. Many relations are data. In the particular case of Russell the question becomes: how does Russell know that "mnemic phenomena" exist?

My other question depends upon a different point. Suppose that I hold a false opinion. I may believe, for example, that Russell is now President of the United States. Now I certainly do *know* that I hold this opinion. My question is how do I know this? It is impossible to answer that "knowing that I hold this opinion" is simply identical with "holding this opinion," and that holding this opinion can be analysed into sensations and images. "Knowing that I hold this opinion" cannot be identical with "holding this opinion," because the first is a case of knowing, and is *true*, whereas the second, the opinion, is *false*.

A behaviourist may say that I know my opinion because I hear myself say the words which express it or otherwise notice some of my own behaviour. But this explanation, though it may *sometimes* be true, is very implausible if taken as the whole explanation.

I fail to see how the question can be answered except by admitting that I do, sometimes at least, introspect my opinions.

4. There is one feature of human thought, namely its *generality*, which can never be explained by any theory which sees in mental phenomena nothing but a conglomeration of sensations and images. The reason why no such theory can explain generality is obvious. Every sensation and every image is nothing but a particular. One cannot make sensations and images general either by adding to their number (a million images are no more general than one image) or by making them vague (= having shadowy outlines).

This is what Berkeley failed to see, and Russell's theory of general ideas is only Berkeley's brought up to date. According to Berkeley what happens when I use the word "man" as a

general term is that I have an image of a particular man, who will be either white or black, tall or short, etc., and that this particular image *represents* to me all other men. It is not clear how the factor of "representing" is to be explained on this theory. Is it another image? But we may suppose that point to be explained. The real difficulty lies in understanding my knowledge, or belief, that this image represents "all other men." I must, in order to know or believe this, somehow have in my mind the idea of "all other men." And I do not see how, on the theory, I can have this except by having in my mind the images of all other men—millions and millions of images. And this is certainly preposterous.

It will not do to say that in addition to the original particular image I have the images of *some* other men, perhaps one or two. For I shall then have to know that these additional images represent all the other men of whom I have no images. And how can I know this without having images of them?

But these difficulties, great as they are, do not yet bring us to the problem of generality. For the idea of "any man" is not the same as the idea of "all men." And even if we could carry in our minds images of all the actual men who have lived, will live, or are alive now, we should not have achieved the general idea of "any man." For any number of particular images, however great, still lie in the region of particularity. In order to have, in the form of images, the idea of any man, I should have to have images, not only of all actual men, but of all *possible* men also. And this is plainly an absurdity.

Russell's theory is more sophisticated than Berkeley's. But its fundamental principle is the same, and it is subject to the same criticism. Russell improves on the image which, according to Berkeley, represents other men, by making it vague in outline like a composite photograph. He admits this does not solve the problem, for the vague is not the general. In addition to this vague image, he says, you must have

particular images of the several appearances . . . you will then not feel the generalized picture to be adequate to any one particular appearance, and you will be able to make it function as a general idea rather than a

vague idea. If this view is correct, no new general content needs to be added to the generalized image. What needs to be added is particular images compared and contrasted with the generalized image.[14]

This is no solution at all. I am to have in my mind one vague image and several other images more precise and with sharper outlines. I compare these and realize that the vague image is not adequate to the others. This gives me only the knowledge that this particular image (the vague one) is vaguer, less precise, than the others. I still only have *particular* ideas. Russell says that we shall then "not feel the generalized image to be adequate to *any* one particular appearance" (my *italics*). He only seems to have solved the problem because he cunningly, and without the slightest warrant, slips in the word "any" here. By doing this he just jumps the problem. It is evident that by comparing the vague image with the other two or three less vague ones I can only learn that it is inadequate to those two or three less vague ones. How can I learn that it is inadequate to other particular men of whom I have no image? How can I learn that it is inadequate to *any* particular image? It is Berkeley's problem over again, and Russell's additions and sophistications do nothing to solve it. I conclude that Russell's theory is incapable of explaining the generality of thought, and that no torturing and twisting of particular images or sensations, whether vague or clear, can ever produce anything except particular images and sensations.

5. The greater part of this paper has consisted in adverse criticisms. And it is true that in my opinion Russell's neutral monism has to be rejected both on the side of its theory of matter and on the side of its theory of mind. This does not, of course, mean that we learn nothing from it. It is profoundly suggestive and instructive. I take it as self-evident that Russell's thought on these matters has contributed vastly to the philosophical achievement of our generation, that it has profoundly stimulated enquiry, that it is full of interesting and fruitful ideas, and that it is likely to remain a landmark in the history of philosophy. This, I have no doubt, is the opinion of most

[14] *The Analysis of Mind*, 221.

of Russell's contemporaries. If it were not so, the publication of this volume could hardly be justified. And if I have dwelt more on what I consider to be the faults of his philosophy than on its merits, this is because the merits of his work are obvious and well-known to everyone.

W. T. STACE

DEPARTMENT OF PHILOSOPHY
PRINCETON UNIVERSITY

12

*Andrew Paul Ushenko*

# RUSSELL'S CRITIQUE OF EMPIRICISM

# RUSSELL'S CRITIQUE OF EMPIRICISM

## 1. Introduction

THIS Essay is concerned exclusively with *An Inquiry into Meaning and Truth,* to be referred to as the *Inquiry,* for I understand that Russell is not prepared to defend his comments on empiricism in the form in which they appeared in earlier publications. The restriction does not make my task much easier, even quantitatively; although the Index of the *Inquiry* refers under the heading of "Empiricism" to fifteen pages only, the fact is that the whole book is essentially about empiricism. Russell's general position is not unlike the attitude which modern mathematical logicians take towards the theory of intuitionism in mathematics: they cannot accept this theory because this would mean throwing overboard important branches of mathematics, yet they want a minimal departure from the logical rigour of the intuitionist standards. An examination of Russell's *Inquiry* will show that this work is a systematic search for points where empiricism does not do justice to what is generally taken to be knowledge, together with an attempt to provide justification for these points with the least deviation from empiricism. Thus viewed the book is a unified whole. This is important to note, because so many critics, among them myself in *Philosophy and Phenomenological Research* (September, 1941), have complained of conflicting tendencies or of a lack of unity in the *Inquiry.* These complaints are unjust, and I, for one, have no more doubts that the book under consideration is one of Russell's best.

I am unreservedly in agreement whenever Russell finds a fault with current empiricism. With characteristic critical effi-

cacy he can find defects along such divergent lines of empiricism as Neurath's linguistic coherence theory of truth, Dewey's instrumentalism, or Carnap's identification of truth with verifiability, and he is also able to detect the basic shortcomings of the ideas which have inspired all these theories. The constructive parts of the *Inquiry*, where Russell lays the foundations of a liberal empiricism, are, I think, more doubtful than his arguments of adverse criticism, and at several points I was tempted to take issue with the author. I did not yield to the temptation, because I do not consider the existing alternative theories any more plausible; and I have neither space nor desire to work out in this paper an alternative statement of my own. Thus I am ready to go with Russell as far as he leads us, but I believe he does not go far enough; and at the crucial point where he stops, in dealing with reference to events that are not experienced, I recommend a further step toward conceptualism.

An exposition of Russell's criticism of the principles which are characteristic of modern empiricism will be found in Section 4. The preceding two sections take up the preliminary matters of terminology. Sections that follow the exposition, except the last one, clear up certain misunderstandings which the text of the *Inquiry*, in spite of its excellent style, has not prevented. In the last section a theory of concepts is outlined as a further development in a direction which Russell's work has left open for exploration.

## 2. TERMINOLOGICAL COMMENTS

For a better understanding of all philosophical terms, with the exception of "proposition" and "logical analysis," which are used in the expository section, the reader is referred to the original text of the *Inquiry*; the explanations below may be of some help, but are in many respects insufficient.

An "experience" must be understood as a personal experience, yet, except when it is so stated, not as an experience of one's mental states, but as a set of sense-data or sensible facts, which, although private to an observer, are his only means of building up a conception of an external world. In other words, in dealing with experiences our concern is primarily the sensible field, the

data of observation, and not those of introspection. Furthermore the word "experience" designates non-linguistic sensible occurrences, at least when sentences describing experiences are contrasted with the experiences described. An experience can be contrasted with a sentence describing it, because the former can be known, in the sense that it is capable of being noticed, without the aid of words. For example, in listening attentively to a symphony I have auditory experiences; I notice and, in this sense, I know each sound as it comes in due course, and I know such things without using words. So much for a sensible experience. Experience, however, is a broader concept than sensible experience. For an experience of a sensible fact is usually accompanied or even transformed by intervention of memory-images and expectations. Hence a complete experience under the name of "perceptive experience" is contrasted with an experience which is its sensory core:

I do not like to use the word "perception" for the complete experience consisting of a sensory core supplemented by expectations, because the word "perception" suggests too strongly that the beliefs involved are true. I will therefore use the phrase "perceptive experience." Thus whenever I think I see a cat, I have the perceptive experience of "seeing a cat," even if, on this occasion, no physical cat is present. (p. 151)

The word "fact" stands for any occurrence or event whether experienced or not. Some writers use "fact" when they want to state that such and such is the case; for instance, they might refer to the fact that Caesar was assassinated. This is not Russell's use; to Russell the fact is the event of Caesar's assassination.

There are two kinds of perceptual judgments: first, sentences describing perceptive experiences, as in "There is a cat;" second, sentences describing the sensible core of perceptive experiences, the latter are called "basic propositions." "There is a feline patch of colour" is a basic proposition corresponding to the perceptual judgment "There is a cat."

In the preceding paragraph the words "sentence" and "proposition" are interchangeable, but in many contexts of the *Inquiry* they are not. I shall indicate Russell's distinction between them in an independent discussion of propositions.

### 3. The Proposition and Logical Analysis

A proposition can be defined as the meaning of a declarative sentence; but this definition, to be acceptable, must be cleared of a certain ambiguity. There is more than one sense in which a declarative sentence may be said to have a meaning. Suppose you assert something true, then there is a fact which accounts for the truth of your sentence. The sentence, as the *Inquiry* puts it, indicates the fact, and the latter may be said to be the meaning of the sentence. This is not the sense of meaning in my definition of a proposition. Then again a declarative sentence is an expression of one's personal belief that such and such is the case. The state of mind which a sentence can thus express is identified in the *Inquiry* with "the proposition expressed by the sentence," or with "the significance of the sentence." I am not using "the meaning of a sentence" for "the significance of a sentence" thus understood. Finally, the utterance of a sentence may be accompanied by images which may be said to form at least a part of the meaning of the sentence. I am not concerned with meaning in the sense of images either. The main reason why I do not want to identify a proposition either with what a sentence indicates or with mental states or images that go with it is communicability. A proposition is communicable if it can be conveyed by means of print to any qualified person, if necessary with the aid of translation. A perceptual judgment, such as "This is blue," is not a proposition in my sense because it can be communicated, if at all, only to those who perceive the thing that I am pointing to in uttering the judgment. A typical proposition is something which is understood as one reads a printed sentence. I pick out at random a book which opens on an article on "Biology," and I notice the following sentence: "The rediscovery of the Aristotelian biology is a modern thing." The author may or may not have images associated with this sentence; if he has, they are not constituents of the proposition, since I can understand the sentence without, I believe, any image coming along with the understanding. And, of course, since I happen not to know who the author is, I do not know, and don't care to know, in what frame of mind he has published his statement. Furthermore, not being a student of

the history of biology, I cannot tell whether the statement indicates any fact. What is it then that I, or any other reader, who knows the dictionary meanings of the words involved and does not enrich them with private associations or information that may come with professional training, can understand when reading the quoted sentence? First of all, the statement is understood as a claim to truth or an assertion. I don't mean that the sentence is taken to be asserted by its author; for all I know the writer might have introduced his sentence in order to proceed to disagree with it. Nor do I mean that the reader must assert the sentence as he reads it. Even if the reader were qualified, as I am not, to accept (or reject) the sentence, he would merely be agreeing (or disagreeing) with an assertion that is already there and is not his. The sentence "asserts itself," although this is a metaphorical way of explaining the fact that the reader can interpret a declarative sentence as claiming truth and at the same time disown its claim. Since then, in order to understand a sentence, one must interpret it as an assertion, what one understands, the proposition, must be distinguished from the sentence itself. A sentence, as so many typographical marks on paper, cannot assert or do anything; to become a vehicle of assertion it must be invested, by means of a mental projection on the part of the reader, with the conceptual function of reference to fact, a function of which there is no likeness in the modes of operation of extra-mental occurrences such as marks on paper. For a claim to truth, being a reference from discourse to things outside discourse or from language to non-linguistic facts, is reference beyond words and therefore cannot be just words; it involves a conception of a relation between linguistic and non-linguistic occurrences. To illustrate the point by the sentence quoted above, there is an assertion there because the sentence is interpreted as referring the description "Modern rediscovery of Aristotelian biology" to a non-linguistic fact. The illustration is typical. A proposition can be defined as a claim to truth, to the effect that a certain description or descriptive phrase has (or does not have) realization, i.e., describes (or does not describe) some non-linguistic fact. Hence any proposition is an "existence-proposition" (or a contradictory of an "existence-proposition"),

that is to say, it can always be formulated by a sentence of the following kind: "There exists (or there does not exist) something, i.e., some fact, which corresponds to (or is described by) the description concerned." And logical analysis shows that all "existence-propositions" and therefore all communicable propositions involve apparent variables when stated by means of symbolic formulas.

Logical analysis is a procedure to determine the structure of a proposition in the course of which a given sentence is replaced by another. Since overtly nothing but sentences appear in this procedure, the view that there is no need for propositions may appear to have an empirical basis, but only if one overlooks the point that replacement of one sentence by another is stultified unless it is understood that, whereas the original sentence does not do justice to the proposition, the sentence which completes the analysis renders the form of the proposition explicit and thereby brings out its full import. In other words, the purpose of logical analysis is to establish an adequate formulation of a proposition, which presupposes the existence of propositions as distinct from their verbal embodiment in sentences. Any analysis requires enumeration of the undefined or ultimate elements in terms of which the complexes to be analyzed can be resolved or accounted for. Accordingly, in logical analysis there are basic logical forms which singly or in combination with one another must be capable of exhibiting the structure of any proposition. We are in a position, in the main due to Russell's works, to give a list of basic logical forms. They are: the conjunctive "and" (symbolized by a dot), the operation of negation "It is false that. . . ." (symbolized by the curl), and the existential prefix "There exists an $x$ such that. . . ." Let me now illustrate the use of these basic logical forms in analysis. First, all compound forms can be transformed into a conjunction or a negation or a combination of both. For instance, the implication "If it is warmer, the thermometer will rise" can be transformed into "It is false that it is warmer and the thermometer will not rise." Second, any non-compound proposition can be formulated in terms of a single or multiple occurrence of the existential prefix and of the curl. "Men exist" can be analyzed

into "There is an *x* such that *x* is human." "I bought a book" becomes "There is an *x* such that *x* is book-like and *x* was bought by me." "All men are mortal" is translated into "It is false that there is an *x* such that *x* is human and not mortal." One of Russell's most striking achievements in logic is his treatment of singular propositions. Thus "The moon is bright" is to be ana-lyzed into "There is an *x* such that *x* is lunar and it is false that there is a *y* which is both lunar and distinct from *x* and it is false that there is an *x* which is lunar and not bright." Logical analysis is complete if and only if the sentence arrived at cannot be transformed into another sentence with a greater number of existential prefixes.

My use of the term "proposition" is more in accord with the terminology of Russell's earlier writings than with the *Inquiry*, although a definition which brings out the element of assertion may be likened to the view that the proposition is a state of possible belief expressed by a sentence. The difference remains in that I do not take assertion in a subjective psychological sense, but as an impersonal conceptual act. I do not know whether Russell would approve of my way of presenting the matter of logical analysis, but it seems obvious that I have said nothing that does not agree with his own practice of analysis in his publications on logic.

### 4. EMPIRICISM

Russell rejects two principles of modern empiricism, the identification of truth with verification and the identification of meaning with verifiability. The principle that only an experience can determine the truth or falsehood of an empirical (non-analytic or non-tautologous) statement is the basis of "pure empiricism," and Russell doubts whether anyone accepts it without qualification or modification, because the objections against it are overwhelming. The main difficulty of pure em-piricism is its conflict with scientific common sense; pure em-piricism does not do justice to knowledge, "if our knowledge is to be roughly coextensive with what we all think we know." For in matters which we take to be knowledge we rely not only on our personal observations, but, with due caution, on judgments

of memory and on the testimony of other people. Of course, a veridical memory is an after-effect of a personal observation and a veridical testimony of another person may be derived from his experience; but the point is that the pure empiricist cannot admit the truth of these statements, since they do not describe any of *his* personal experiences.

"For me now, only my momentary epistemological premisses [assertions of what I now perceive and, perhaps, remember] are really premisses; the rest must be in some sense inferred. For me as opposed to others, my individual premisses are premisses, but the percepts of others are not." (p. 168)

In order to adjust pure empiricism to what is generally recognized as empirical knowledge, one may try to supplement pure empiricism not only with the principles of demonstrative inference but also with the principles of probable inference, induction and analogy. Induction and analogy will indeed save an empiricist from epistemological momentary solipsism, but they are insufficient to account for the procedure of science. For science assumes the existence of unperceivable events, such as sound-waves in the air. The proof that such unperceivable events are not inferred by induction is the fact that they can be, and have been, treated by some writers, at the cost of great theoretical complication and awkwardness, as fictions convenient for prediction and correlation of experiences. Science, however, as practiced by the great majority of scientists, accepts the existence of unperceived events precisely because this position allows for much simpler explanation than the alternative hypothesis of convenient fictions. This means that science makes use of the principle of simplicity, which in some cases involves such non-demonstrative premisses as the stipulation of a continuous causal chain of events from the physical source to observation (cf. p. 379). The *Inquiry* mentions two more instances of what may turn out to be non-demonstrative principles or premisses: "what is red is not blue," "if A is earlier than B, B is not earlier than A." Pure empiricism is untenable for yet another reason: to establish the truth of a sentence by verification one must confront this sentence with another whose truth is seen directly. To take an example, while working in

my study, I can assert that "there is a piano in the living room;" to verify this assertion I walk into the living room and, at the sight of the piano, I say: "This is the piano." This latter statement verifies the original sentence, but need not itself be verified; at least if taken in the sense of "This looks like a piano," it is known to be true directly.

"But if an observation is to confirm or confute a verbal statement, it must itself give ground, in some sense, for one or more verbal statements. The relation of a non-verbal experience to a verbal statement which it justifies is thus a matter which empiricism is bound to investigate." (p. 19)

Failure to undertake this investigation is not peculiar to pure empiricism; it also undermines the second principle of empiricism, i.e., the thesis that the meaning of an empirical sentence is the method of its verification.

Again, when it is said that "the meaning of a proposition is the method of its verification," this omits the propositions that are most nearly certain, namely judgments of perception. For these there is no "method of verification," since it is they that constitute the verification of all other empirical propositions that can be in any degree known. . . . All those who make "verification" fundamental overlook the real problem, which is the relation between words and non-verbal occurrences in judgments of perception. (p. 387)

However, the principle that meaning is verification, when stated unguardedly, has a peculiar and conspicuous weakness of its own, viz., there is no distinction drawn in it between words and sentences.

. . . All necessary *words* . . . have ostensive definitions, and are thus dependent on experience for their meaning. But it is of the essence of the use of language that we can understand a sentence correctly compounded out of words that we understand, even if we have never had any experience corresponding to the sentence as a whole. Fiction, history, and all giving of information depend upon this property of language. Stated formally: Given the experience necessary for the understanding of the name "$a$" and the predicate "P," we can understand the sentence "$a$ has the predicate P" without the need of any experience corresponding to this sentence; and when I say that we can understand the sentence, I do not mean that we know how to find out whether it is true. If you

say "Mars contains inhabitants as mad and wicked as those of our planet," I understand you, but I do not know how to find out whether what you say is true. (p. 386f.)

In a more guarded version of empiricism the meaning of a sentence is identified with the statement of its truth-conditions. "If we knew what it would be for a given sentence to be found true, then we would know what its meaning is." (Carnap, quoted in *Inquiry,* 387f.) But even in this formulation the principle remains essentially the same. For what would be the meaning of a statement of a truth-condition? It cannot be said, without an infinite regress, that this meaning consists of *its* truth-conditions. One might suggest that to state truth-conditions is to give more or less specific directions of how to verify the statement. In fact in a passage, quoted on p. 391 of the *Inquiry,* Carnap speaks of experiments as conditioning the truth of a scientific statement. Yet he does not seem to realize that before the relevance of an experiment to a statement can be established, this experiment must be recorded in a judgment of perception. "He does not tell us what it is that we learn from each experiment." (p. 392) Thus Carnap's version, like the outright identification of meaning with methods of verification, suffers from a disregard of sentences which describe a single experiment or a single observation.

And so empiricism is forced back upon undertaking an examination of the relation between a single non-verbal experience and a sentence describing it. The question is, can this relation be accounted for in terms of empiricism, i.e., must all the words involved in a sentence which describes an experience have their meanings derived from experience. Russell answers "No," if experience is to be limited to sense-experience, because sense-data have nothing to do with the meaning of logical constants such as "or" and "not." But Russell's own extension of empiricism, arrived at by including introspection with experience, gives a plausible empirical derivation to "or" and "not" as well as to the remaining elements of logical analysis, with a possible exception of the existential prefix.

As regards meaning: we may, on the usual grounds, ignore words that have a dictionary definition, and confine ourselves to words of which

the definition is ostensive. Now it is obvious that an ostensive definition must depend upon experience; Hume's principle, "no idea without an antecedent impression," certainly applies to learning the meaning of object-words . . . it applies also to logical words; "not" must derive its meaning from experiences of rejection, and "or" from experiences of hesitation. . . . (p. 368)

There remain existential prefixes or apparent variables to be explained on the basis of empiricism. Now we may observe that these elements of logic have a double function in empirical statements: (1) they make explicit the element of generality connoted by general words,—as Russell puts it, ". . . the function of variables is exactly that of general words" (p. 302); (2) they are used to refer to events outside experience. The element of generality can be derived from the data of introspection; according to Russell, it corresponds to what is common to reactions to specific instances which are of the same kind designated by a general word (cf. the argument on p. 382 of the *Inquiry*). Many judgments of perception which involve existential prefixes appear to introduce into description nothing but generality. For example, when you look at a drawing of a circle, you say "This is circular" or "There is an $x$ such that $x$ is circular," and either of these sentences is fully justified by perception; the second sentence expresses less than, and is a part of, what is expressed by the first. But when a judgment of perception refers to something which is not experienced, the understanding of this reference can hardly be reducible to any actual datum within experience. "This is a cat," for instance, goes beyond what could really be given in perception and what would be adequately described as "This is a feline patch of colour;" logical analysis shows that the former statement is to the effect that "There is an $x$ such that $x$ is feline and is perceived through this particular patch of colour" (cf. pp. 173, 271f., 278). What is true only about some judgments of perception is invariably true with regard to communicable empirical propositions, since the latter describe events that are absent.

Let me now enumerate Russell's conclusions about empiricism. The principles identifying truth with verification and meaning with verifiability are both false; contemporary empiri-

cism unduly ignores judgments of perception; these judgments cannot be justified by experience unless experience includes introspective as well as sense-data; whereas words to be meaningful must be derived from experience, their combinations in a sentence can be understood even if the sentence as a whole does not describe any fact; finally, reference to events that are not experienced is a problem which needs to be further analyzed.

## 5. Is Empiricism Self-Refuting?

The observation that theoretical propositions go beyond experience leads Russell to say that the theory of empiricism is "self-refuting." I do not think, however, that "self-refuting" is meant to be taken literally. But let me quote the relevant passage.

I will observe, however, that empiricism, as a theory of knowledge, is self-refuting. For, however it may be formulated, it must involve *some* general proposition about the dependence of knowledge upon experience; and any such proposition, if true, must have as a consequence that itself cannot be known. While, therefore, empiricism may be true, it cannot, if true, be known to be so. This, however, is a large problem. (p. 207)

If empiricism were literally self-refuting, it could not be true. Nor could Russell say, if he meant to employ "self-refuting" literally, that empiricism is "not logically refutable." (p. 382) But the main point to note is that, if the theory of empiricism is to conform to Russell's own doctrine of types, it must be concerned with knowledge of a lower type than itself, i.e., it is not intended to apply to itself. Hence, "self-refuting" is to be taken rather as "self-stultifying." Let the empiricist thesis (to the effect that knowledge depends on experience) be of the $n$th order or type, then knowledge, to which this thesis is supposed to apply, will consist of propositions of various orders lower than the $n$th order. Now the empiricist thesis is an empirical proposition and its only relevant difference from the empirical propositions with which it is concerned is that of logical type. And since the empiricist thesis, as the empiricists themselves must admit, is not reducible to a description of experiences, it would be *unreasonable* to insist that among other empirical propositions, which also differ in logical type from

one another, every single one must be reducible to experience. They may be in fact so reducible, but there is no reason to believe it.

But if empiricism, at least in the radical version of momentary empiricism or solipsism, is unreasonable, if, as Russell says, "no one is willing to adopt so narrow a theory," can it really be logically irrefutable? At one time I used to think solipsism to be verbally inconsistent, because, I argued, to assert that "Everything is my experience," one must use the words "my" or "I" with a meaning which is correlative to "non-I," which, in its turn, would be meaningless unless there were something other than myself. I knew of no convincing refutation of this argument until Russell pointed out to me that solipsism can be stated without recourse to personal pronouns, by first giving an enumeration of one's own personal experiences and then adding: "And there are no other events." Russell's assertion that solipsism is not logically refutable is found on p. 376 of the *Inquiry*. Nevertheless, I think that solipsism would be logically irrefutable only to a person who can himself take the part of the solipsist. And I, for one, can not. For knowing myself I *know* that I could not originate such an absurd view as solipsism. Therefore I know that I must have learned of solipsism from someone else.

### 6. MEANING AND TRUTH IN MATHEMATICS

The *Inquiry* has refuted the empiricist identification of truth with verification and of meaning with verifiability and not the analogous assertion of the finitists that proof constitutes both the truth and the meaning of a mathematical statement. But there is no reason to expect the finitist to be in a better position than the empiricist. Consider as an example of a mathematical statement which is not only meaningful but generally believed to be true, although no one has yet been able to prove it, the famous four-color problem, the statement, that is, that "given any division of the plane into co-exclusive regions, one can always mark the regions with one of the numbers 1, 2, 3, 4 in such a way that no two adjacent regions will have the same number." Another example is Fermat's last theorem. If the

finitists should argue that neither the four color proposition nor the Fermat theorem are fully understood so long as they remain without proof, one can retort that, however imperfect one's understanding of the theorems in question, it is undoubtedly some understanding, which amounts to saying that the theorems have *some* meaning. If examples are not sufficient to convince the empiricist, let him turn to a formalized postulational system of logic and mathematics. The postulates of such a system are given without proof, and, as Gödel has shown, within the system, if it is to be consistent, there are formulas which cannot be either proved or refuted. A further contention, which some finitists have combined with the claim that meaning and truth are identical with demonstration, and which, perhaps, follows from their claim, is the assertion that a description of a proof would result in, and therefore be identical with, an actual demonstration. This additional assertion is no more plausible than the main claim, as can easily be shown by means of an example. Consider the formula for the sum of the first n integers; we may know that this formula is proved by mathematical induction and understand this method of demonstration without going into the proof itself.

### 7. Truth-Conditions and Logical Analysis

Russell's rejection of the identification of meaning with truth-conditions may be confronted with the observation that his own practice of analysis consists in the employment of a method whereby one arrives at the truth-conditions of the sentences to be analyzed. Thus, one might say, Russell's analysis of "The moon is bright" would result in specifying three truth-conditions: that there exists at least one moon, that there exists at most one moon, and that the condition of brightness is satisfied. But analysis, so understood and illustrated, is logical analysis, and logical analysis stops short at unanalyzed meanings once the elementary forms of logic have been reached. Logical analysis aims at exhibiting the structure of propositions, although of course as the form becomes explicit so does the content enframed in it. Now it may well be that each time an elementary logical form is made explicit, the corresponding content turns out to

be a statement of one truth-condition, so that logical analysis can be carried on so long as more truth-conditions of the statement remain to be stated; nevertheless, when all truth-conditions which can be given in terms of elementary logical forms are established, logical analysis comes to an end and the resulting statements of truth-conditions must be taken as meaningful, even though they are not resolvable into a set of further truth-conditions. In other words, logical analysis must perforce leave unanalyzed, and therefore without a statement of their truth-conditions, those component meanings of the analyzed proposition which have acquired in the process of analysis an elementary logical form of existence-propositions. On the other hand, these elementary existence-propositions may still be analyzable in epistemology or from some other extra-logical point of view. For example, the elementary existence-proposition "there is an $x$ such that $x$ is guilty of murder" can be further analyzed by a criminologist,—to take one extra-logical standpoint,—who could say that the proposition means that "there is an $x$ such that $x$ is guilty of poisoning or of stabbing to death or of shooting, or etc." But suppose someone attempts a further logical analysis by enumerating the conditions under which "there exists an $x$ such that $x$ is guilty of murder" would be true. Suppose, for the sake of argument, that the necessary and sufficient truth-condition is the existence of an eye-witness to the murder. Then, one might argue, the sentence "there exists an $x$ such that $x$ is guilty of murder" can be transformed into "there is a $y$ such that $y$ was a witness to the murder." This transformation, however, is no advance in logical analysis, for both sentences exemplify the same logical form of an existence-proposition.

"Thus to know what it would be for the sentence to be found true is to know what it would be for some man to see some other man committing the murder, i.e., to know what is meant by another sentence of the same form." (p. 389)

This discussion explains the sense in which a sentence is said to "involve" an apparent variable: if complete logical analysis transforms the sentence into an existence-proposition, no other analysis can change its logical form, i.e., eliminate the apparent

variable or introduce another in addition to it. How badly this point has sometimes been misunderstood can be seen from the following quotation from Dr. E. Nagel's article, "Mr. Russell on Meaning and Truth," (*The Journal of Philosophy*, v. 38, No. 10, p. 266):

Mr. Russell's argument is difficult to follow, and I am not clear as to what he thinks he has established. Taken quite strictly, the sentence "this dog is ten years old" surely does not *contain* an apparent variable, and the issue then is just what Mr. Russell means when he says that it nevertheless "involves" one. He may simply mean that a sentence of the form "There is an *x* such that *x* is ten years old" follows from the sentence "This dog is ten years old" . . . ; but . . . the above two sentences are not logically equivalent, for the second does not follow from the first; and yet Mr. Russell gives the impression that the first sentence formulates an analysis of what is said by the second. . . .

I hope the reader will see that Dr. Nagel's first sentence would be, in Russell's theory, only a component in the logical analysis of the second; that a full analysis of the latter would be given by some such sentence as "There is an *x* such that *x* is perceived by means of this canoid patch of colour and is ten years old;" and that "This dog is ten years old" *involves* an apparent variable in the sense that the outcome of the full logical analysis of the proposition *contains* an apparent variable.

## 8. Perceptual Judgment and Causation

Perceptual judgments, especially "basic propositions" such as "redness-here," form the foundation of Russell's justification of empirical knowledge. According to Russell "basic propositions" cannot be false, except for the trivial reason of misusing words, because their utterance is caused by what they mean, by sensible experience. Some competent critics think that this validation of perceptual judgments assumes scientific causation, and is not fit to serve in any endeavor to justify science, since the principle of causation is not only one of the empirical propositions but needs justification more than any other. In a general way I can answer these critics by pointing out that in his account of "basic propositions" Russell does not use "causation" in the sense of scientific causation. However, in

order to make this answer more specific let me develop it in connection with Dewey's adverse criticism in an article on "Propositions, Warranted Assertibility, and Truth" (*The Journal of Philosophy*, v. 38, No. 7). On p. 171 of the article Dewey writes:

If I understand Mr. Russell aright, he holds that the ultimacy and purity of basic propositions is connected with (possibly is guaranteed by) the fact that subject-matters like "redness-here" are of the nature of perceptual experiences, in which perceptual material is reduced to a direct *sensible* presence, or a *sensum*. . . . However, Mr. Russell goes on to ask "What can be meant when we say a 'percept' causes a word or sentence? On the face of it, we have to suppose a considerable process in the brain, connecting visual centres with motor centres; the causation, therefore, is by no means direct." It would, then, seem as if upon Mr. Russell's own view a quite elaborate physiological theory intervenes in any given case as condition of assurance that "redness-here" is a true assertion. And I hope it will not appear unduly finicky if I add that a theory regarding causation also seems to be intimately involved.

Dewey overlooks here several passages of the *Inquiry* which warn the reader that "causation" can be used in different senses. (Cf. pp. 72f., 173, 280, and 291). Thus the scientific sense of "causation," i.e., the unobservable functional correlation of observable as well as unobservable events, which is explained in a discussion of "continuous intermediate causal chains" (on p. 379f. and in an account of perception on p. 146), must be contrasted with "causation" in the sense of a "transaction," which is observable within experience, between a sensum and a sentence which describes this sensum. The second sense of "causation" is fully explained on pp. 72ff. of the *Inquiry*, and it is the only sense which is relevant to the assurance that a basic proposition is a true assertion. When Russell, in the passage quoted by Dewey, explains that causation, which leads from visual to motor centers, is indirect, he obviously cannot mean observable causation, since he is concerned with a physiological causal correlation of events within the body of the person who asserts the sentence "redness-here;" throughout the passage in question Russell *assumes* the principle of scientific causation and is not aiming at its justification. Dewey's lack of under-

standing of Russell's distinction between scientific causation and observable causation leads him to further wrong observations on p. 178 of his article:

> In the case, previously cited, of *redness-here*, Mr. Russell asserts, as I understand him, that it is true when it is caused by a simple, atomic event. But how do we know in a given case whether it is so caused? . . . The event *to be* known is that which operates, on his view, as . . . verifier; although the proposition is the sole means of knowing the event!

The answer to Dewey's "How do we know?" is, of course, "By direct observation." And it is not true that, for Russell, "the proposition is the sole means of knowing the event." On the contrary, Russell explains on p. 58f. that one can know an event by noticing it and without using words. Dewey's remarkable disregard for the relevant texts culminates in his "verdict" that "any view which holds that all complex propositions depend for their nature of *knowledge* upon prior atomic propositions, of the nature described by Mr. Russell, seems to me the most adequate foundation yet provided for complete scepticism."

## 9. WORDS AND CONTEXT

Russell's principle, that although isolated words must have ostensive definition, there need be no experience corresponding to the sentence as a whole, can be challenged on the grounds that words have no meaning, i.e., cannot be used with a meaning— except as abbreviations of complete sentences—in isolation from the context of a sentence. The "contextualist thesis," from which this challenge may spring, is opposed to the view that, even in complete isolation from the context of sentences, a word may be used with some such intersubjective meaning as a class-concept or a composite-image. The issue is not concerned with subjective images which may be associated with words; nor is there a denial that words can be considered in isolation, and that when someone so considers them he can know that they are meaningful in the sense of capable of being used with meanings in certain contexts. This may still be vague, but I do not know of any contextualist argument which is either precise or conclusive. There is, to take one example, H. Reichenbach's argument (in *Experience and*

*Prediction,* p. 20), which is short enough to be quoted in full:

> . . . Indeed, if we speak of the meaning of a word, this is possible only because the word occurs within propositions; meaning is transferred to the word by the proposition. We see this by the fact that groups of isolated words have no meaning; to utter the words "tree house intentionally and" means nothing. Only because these words habitually occur in meaningful sentences, do we attach to them that property which we call their meaning; but it would be more correct to call that property "capacity for occurring within meaningful sentences."

I do not see, however, how this argument proves anything more than that words are meaningful in meaningful contexts, and meaningless in meaningless contexts; nothing has been proved concerning the meanings of words isolated from any verbal context. Perhaps the following argument will appear more convincing. We observe that a word has different uses, senses, or shades of meaning in different contexts; also except for the context we cannot tell with which of its possible meanings a word is being employed; hence we conclude that, since a meaning cannot combine several incompatible things, a word in isolation cannot be used with a meaning. For instance, when I say "My belief lasted a second," the word "belief" designates a mental state of believing; whereas "belief" in the sentence "My belief has been generally accepted" means the object of my belief. And since without the aid of a context the sense with which "belief" is used cannot be determined, it would seem that in isolation this word cannot be used with a definite meaning. Much more, of course, remains to be said before this kind of argument can be called a proof.

But even if we assume without proof that words have no meaning in isolation, the assumption does not seriously endanger Russell's position. In the first place, the "contextualist thesis" is dealing with reified meanings of words, i.e., with entities of some kind; whereas Russell's phrase "the meaning of an object-word" may be just "short-hand" for some such convention as follows: "A word is said to have a meaning when one has acquired, by means of conditioned reflex, the habit of taking the same overt or incipient attitude towards the word which one would take in the presence of the object designated

by this word." Secondly, Russell's "words in isolation" are not independent of sentences, since, on the contrary, they stand for implicit basic propositions. For example, "Lightning!" functions like the sentence "There is lightning!" On p. 32 of the *Inquiry* we read:

> At the lowest level of speech, the distinction between sentences and single words does not exist. At this level, single words are used to indicate the sensible presence of what they designate. It is through this form of speech that object-words acquire their meaning, and in this form of speech each word is an assertion.

And again on p. 92: "Every single word of this language [i.e., of the object-language] is capable of standing alone, and, when it stands alone, means that it is applicable to the present datum of perception."

Thus it would seem that Russell's principle, that words in isolation must derive their meaning from sensible experience, amounts to the statement that words which function as basic propositions describe experience, which is hardly anything more than a tautology.

Derivation from experience is a condition of the primitive use of the object-words, and Russell is aware of the fact that "words are used in many ways." (p. 29) In order to explain other uses of words Russell has recourse to sentences about sentences and to mental attitudes, and his explanation appears to be as plausible as any other theory of meaning of which I know, except when it comes to the analysis of existence-propositions and their reference to events that are not experienced. The analysis, I believe, requires the admission of concepts.

## 10. CONCEPTS AND EXISTENCE-PROPOSITIONS

Russell points out that "Empiricists fail to realize that much of the knowledge they take for granted assumes events that are not experienced." (p. 272) But if all object-words derive their meaning from experience, how can anyone assume or even speak of unexperienced events? The feat is performed by means of apparent variables in existence-propositions. With this answer both Russell and I agree, but I believe that much more has to

be added to protect our opinion from Dr. Nagel's criticism, who, at the end of the passage quoted earlier, writes as follows:

"By transforming a sentence without variables into a sentence with variables, the relation of the latter to what it indicates is no less a problem (if it is a problem) than the relation of the former to what it formulates." (267)

I am not sure whether I fully understand Russell's position, but it would seem that he wants the apparent variable to take the place of external reference in the sense of dispensing with the latter. My position, on the other hand, is that an apparent variable takes the place of conceptual reference only in the sense of symbolizing it.

To argue for concepts I must give some explanation of what I mean by a pure concept, and I hope the following will suffice for the purpose of this section. Take a sentence in which every object-word is derived from experience; replace one of these words by a symbol whose meaning is not dependent on experience; if, after the substitution, the sentence remains a meaningful assertion, the meaning of the symbol is a pure concept. Let the reader use the letter '$a$' to name or designate this page; then he can say "$a$ is rectangular." Now let "$a$" in this sentence be replaced by the complex symbol "There is an $x$ such that $x$ . . .;" within the context of the resulting sentence the meaning of this complex symbol is a concept. As may be seen from this example, a concept need not be a meaningful entity in isolation; but I think that in the context of a sentence it must be meaningful if the sentence as a whole, and all constituents (other than the concept) within it, are meaningful. Yet to admit the presence of pure concepts might appear to be giving up the grounds of empiricism altogether; and I should not be surprised if Russell's procedure were found to be an attempt to get along without pure concepts.

As the reader asserts (1) "$a$ is rectangular," he can also describe his perception, less specifically, by (2) "There is an $x$ such that $x$ is rectangular." Since (2) is deducible from (1), but not vice versa, the former must say less than the latter; also, unlike (1) which can be understood only in the presence of $a$, (2) is communicable to outsiders without loss of meaning. Now

since (1) has no external reference, i.e., no reference outside the perception of *a*, that part of (1) which finds its expression in (2) should likewise be free from external reference, even if to an outsider (2) seems to refer to something beyond experience. Next let the reader observe that statements about events that no one has experienced are of the same form as (2), and therefore, like the latter, only seem to refer to something outside experience. "We may say generally: when I am in a state of believing, that aspect of the believing which seems to refer to something else does not really do so, but operates by means of apparent variables." (p. 278)

The argument of the preceding paragraph, which I take to be a summary of pp. 276 ff. of the *Inquiry*, depends on the premiss that (2), in being asserted by the percipient of *a*, has no external reference. But there is an ambiguity here. A reference to *a* is not external to the reader's experience, but it is external to that part of his experience which is described by (2). His assertion of (2) involves a reference external to statement (2), since *a* is not a constituent of this statement. Bearing in mind this ambiguity I should expect the correct argument to proceed rather in the reverse direction: Since to an outsider (2) involves external reference and since to a percipient of *a* (2) means the same thing as to an outsider, it only seems that the percipient understands (2) as if it were free from external reference. Furthermore, to say that a sentence seems to refer to something external, we must understand what it would be like to refer to something beyond our experience; and since the question is not whether the reference happens to be true, but whether it is possible in the sense of being meaningful, an intelligible apparent reference is no different from a real one.

But, perhaps, Russell's denial of real external reference means no more than a denial that one can actually reach absent events, i.e., that events outside experience can nevertheless be within the experience that one has in referring to them; in other words, Russell may have merely meant that in the complex relationship of reference one of the terms, which is the object that one refers to, must be a substitute for the actual

but absent event, since one cannot relate within a proposition entities to one another unless they are present to be só related. If this is Russell's position, it is mine also; furthermore, although a substitute for an absent event may be an apparent variable, the understanding that the apparent variable functions as a substitute can be hardly anything but a conception. It is noteworthy that Russell is not satisfied with resting his case on apparent variables, but is trying to explain how they operate; and his explanation, I think, leads to a purely conceptual construction.

Let us revert to the illustration "you are hot," which avoids irrelevant difficulties. This may be taken to mean "there is a hotness related to my percept of your body as, when I am hot, the hotness of me is related to my percept of my body." When I am hot I can give a proper name to my hotness; when you are hot, your hotness, to me, is an hypothetical value of an apparent variable. There are here two stages. Suppose I represent my percept of my body by $a$, my percept of your body by $b$, my hotness by $h$, the relation which I preceive between $a$ and $h$ by H, then "you are hot" is "there is an $h'$, such that $bHh'$."

There is here a hypothetical sentence "$bHh'$," which I cannot utter, because I have no name "$h'$" in my language. But there is also, if you are hot, an actual occurrence, which is hypothetically named by the hypothetical name $h'$, and this occurrence is actually so related to $b$ that its relation to $b$ would be a verifier of the sentence "$bHh'$" if I could pronounce this sentence . . . . (p. 280f.)

Thus to explain how an apparent variable operates in a sentence which seems to refer to someone else's hotness, I must introduce another variable, a hypothetical name, which I might use as a real name, if I only could directly experience another person's sensations. Is there any real progress towards elimination of pure concepts in this procedure; and isn't a hypothetical name, a would-be name, just as much a concept as the notion of an unexperienced event? There is a difference. Although I can assume that an unexperienced event is an actual occurrence, a hypothetical name is only a possible name, not supposed to be used by anyone else outside my experience. Whether this difference is a progress depends on whether, first, Russell means to reduce reference to actual but unexperienced

events to experienced words that are only possible names, and, secondly, if such reduction is intended, whether what appears to be a concept of a possible or hypothetical entity can be explained without residue in terms of sensible experiences. This raises the difficult question of the meaning of "possibility."

## 11. POSSIBILITY AND SUBJUNCTIVE CONDITIONALS

A way of defining "possibility" in terms of observations or actual values of a variable is explained on p. 43 of the *Inquiry:*

> I maintain that, in all cases of possibility, there is a subject which is a variable, defined as satisfying some condition which many values of the variable satisfy, and that of these values some satisfy a further condition while others do not; we then say it is "possible" that the subject may satisfy this further condition. Symbolically, if "$\varphi x$ and $\chi x$" and "$\varphi x$ and not $\chi x$" and each true for suitable values of $x$, then, given $\varphi x$, $\chi x$ is possible but not necessary.

Let us see how this method of dealing with possibility applies in the case of a hypothetical name '$h$'.' We can use $\varphi x$ to represent the condition "$x$ is a letter," and $\chi x$ to stand for the further condition "$x$ is a name of an event." Then, if we have used the letter '$a$' to name an event in our experience, we can say "$\varphi'a$' and $\chi'a$';" and, if we know that no one has ever used '$c$' as a name of an experience, we shall say "It is false that $\varphi'c$' and $\chi'c$';" but we can only treat '$h$'' as we treat the variable $x$, i.e., we can only say that some such letters as '$h$'' name events while others don't. In other words, to say that "$h$' is a possible name" is no more than saying that "$x$ is a possible name," which, in its turn, amounts to the existence-proposition "There is an $x$ such that $\varphi x$ and $\chi x$." Thus, since Russell's treatment of possibility must end with an existence-proposition, although possible names have been introduced in order to dispense with external reference of existence-propositions, the conclusion is that the treatment is not effective for the latter purpose.

I think that the difficulty of accounting for possibility in terms of actual data without falling back on a reference to unexperienced events can be most clearly shown as the difficulty of translating a subjunctive conditional into a material implication. To say that '$h$'' is a hypothetical name is to assert the sub-

junctive conditional "If I were perceiving a certain event, I would name it $h'$." The corresponding material implication is "If I perceive a certain event, I shall name it $h'$." The two conditional forms are not equivalent, i.e., they do not convey the same proposition. The consequent of the material implication can be actually verified at the time when the event to be named by '$h$' occurs; but the subjunctive conditional is asserted with no expectation of an eventual verification, and it would still be asserted even if one knew that verification were impossible. Again, the material implication is a truth-function of its two component-propositions, "I perceive a certain event" and "I shall name the event $h'$;" whereas the subjunctive conditional is an indivisible whole, since neither "I were perceiving a certain event" nor "I would name the event $h'$" are complete meanings or propositions. The difference seems to me to be sufficiently essential to make the task of translating the subjunctive conditional form into a truth-function hopeless; but I am not sure whether the *Inquiry* would unreservedly support this conclusion.

The introduction of the subjunctive conditional form on p. 35 of the *Inquiry* suggests the possibility of reduction to a truth-function:

Consider next such a sentence as "I should be sorry if you fell ill." This cannot be divided into "I shall be sorry" and "you will fall ill"; it has the kind of unity that we are demanding of a sentence. But it has a complexity which some sentences do not have; neglecting tense, it states a relation between "I am sorry" and "you are ill." We may interpret it as asserting that at any time when the second of these sentences is true, the first is also true.

The neglect of tense suggests an intention to treat the sentence in question as a material implication. On the other hand, although such an intention may be there, the same passage provides some grounds for an objection against taking the subjunctive form to be a material implication. The material implication "If you are ill, I am sorry" is the contradictory of the conjunction "You are ill and I am not sorry," and either of these compound propositions has as much unity as the other, each being a truth-function of the same components. Yet Russell

points out that the subjunctive conditional has the unity of a single sentence, whereas, as he puts it in the paragraph immediately preceding the quoted passage, a conjunction consists of two assertions. Whatever Russell's real position at this stage of his *Inquiry*, there are other passages where a tendency to distinguish subjunctive conditionals from material implications takes an almost definite shape. Already on p. 87 we come across the following contrast:

"It seems, therefore, that it is impossible for a mortal to give verbal expression to every observable fact, but that, nevertheless, every observable fact is such that a mortal could give verbal expression to it."

The contrast can perhaps be paraphrased as follows. Whereas the subjunctive conditional form "If $x$ were observable, $x$ would be nameable" is true for every value of $x$, the material implication of the form "If $x$ is observed, $x$ is named" must be sometimes false. Even more decisively, and in a much more important connection, the opposition between the two conditional forms is brought out, at a later stage, in its bearing upon the different interpretations of empirical knowledge by a phenomenalist and a common-sense scientist. Only the phenomenalist, in order to eliminate the notion of unobserved occurrences, attempts a translation of all sentences about unobservables into material implications whose terms are without exception observable:

Some philosophers might argue that, when I say "the book is in the drawer," I only mean "if any one opens the drawer he will see it"—where "opening the drawer" must be interpreted as an experience, not as something done to a permanent drawer. This view, right or wrong, is one which would only occur to a philosopher, and is not the one I wish to discuss. (p. 293)

Recourse to material implication in phenomenalism is then contrasted with the use of subjunctive conditionals by common sense and science:

Common sense imagines travelling round the moon (which is only *technically* impossible), and holds that, if we did so, we should either see or not see the mountains in question . . . [The question is whether there are mountains on the other side of the moon.] . . . The astronomer may

say: mountains on the further side of the moon would have gravitational effects, and might therefore conceivably be inferred. In both these cases, we are arguing as to what would happen in the event of a hypothesis which has not been verified in our experience. The principle involved is, in each case: "In the absence of evidence to the contrary, we shall assume the unobserved portions of the universe to obey the same laws as the observed portions." But unless we have an independent definition of truth concerning what is unobserved, this principle will be a mere definition, and the "unobserved portions" will be only a technical device, so long as they remain unobserved. The principle only says something substantial if it means "what I shall observe will be found to resemble what I have observed," or, alternatively, if I can define "truth" independently of observation. (p. 306f.)

The second half of this passage shows, among other things, that unless one is ready to fall back on the material implication "If I shall observe events, they will be found to resemble my past experience," one makes use of subjunctive conditionals to assert that physical laws operate beyond the field of observation, which involves reference to unobserved events; and it would seem that we must therefore admit that in a sense reference to unobserved events is an ultimate or unanalyzable concept. My impression that Russell is close to drawing this conclusion is further confirmed by his observation, on p. 274, that it is possible to distinguish between realism and phenomenalism, even though experience gives no ground for preferring one hypothesis to the other. The understanding of the difference between the two hypotheses must be a pure concept, since it cannot be derived from anything in experience.

The differentiation between subjunctive conditionals and material implications can be used to add one more point to Russell's score against the uncompromising empiricists. Russell has pointed out that empiricists are forced to extend the denotation of the word "experience" from momentary personal perception to the experience of mankind, and he also noted that they speak of events which are in principle observable. But to speak of events which are in principle observable is to use the subjunctive conditional form "$x$ would be observed if certain conditions were satisfied," and now that we know this form

to be, in effect, another way of referring to unobserved events, we can say that empiricists, who admit verifiability in principle, are, without knowing it, converted into full-fledged realists.

The main point of this section can be given in one statement. If a subjunctive conditional proposition is not translatable into a material implication, if, therefore, the former contains something which is not a description of perceptive experiences, this untranslatable residue must be either a conception of pure disposition or, although this may be essentially the same, a conceptual reference to actual but unexperienced events.

## 12. CONCEPTS AND EMPIRICISM

Since by definition pure concepts are independent of sensible experience, there are at least three interrelated questions which must be answered before conceptualism can be made plausible: How can concepts be relevant to empirical knowledge, how can they refer beyond conceptual context to actual occurrences, and how can one concept be distinguished from another with nothing in experience to illustrate their difference? The answer given below is in the main a summary recapitulation of what has been set forth at much greater length in Ch. 4 of my book *The Problems of Logic* (1941).

Although pure concepts are not derived from sensible experience, they are derived from our experience with empirical propositions, from the understanding, that is, of the structure or form of an empirical existence-proposition. In the first place, we can distinguish the logical types of the formal elements within the structure of a proposition, and the distinctions of logical types must be purely conceptual, since, as Russell himself shows in the quotation to follow, they cannot be established as distinctions among the words within the sentence which is a sensible embodiment of the proposition.

"All symbols are of the same logical type: they are classes of similar utterances, or similar noises, or similar shapes, but their meanings may be of any type, or of ambiguous type, like the meaning of the word 'type' itself." (p. 44)

Consider the form of an empirical existence-proposition, "There is an $x$ such that $fx$," based on the propositional func-

tion "$fx$," where $f$ is a first-order function. The purely formal difference of type between $f$ and $x$, together with the understanding that the propositional function is to be applied to empirical matters, makes it clear that $x$ symbolizes a thing and $f$ some property or relation between $x$ and other things. Thus we establish that the existential form is the form of an assertion that the property or relation $f$ is realized in the thing symbolized by $x$; the concept, basic to conceptual reference, is that of a thing. The word "thing," as I use it here, must be taken in a very general sense, so that "This thing is a material thing" is not a tautology and "This thing is a sense-datum" may be a true statement. And the concept thing, when so generally understood, is part of the meaning of any object word when the latter is used with a meaning. For example, we mean by a sphere "a thing which is spherical" and by a plant "a thing which is vegetable." To show that an object word breaks up in this manner is important as a corrective against the widely spread prejudice that the sole function of a word or concept is description. The function of the word "spherical" or of any other adjective is indeed purely descriptive; but the modus operandi of the concept thing is entirely different; its function is to supply the object of description, a thing is that which is to be described by adjectives. The distinction between the descriptive and the "objective" functions of words and concepts helps us to understand how external reference is possible: reference as a constituent of a proposition is not external to the proposition, since a proposition cannot transcend itself, but it is external to the purely descriptive elements within the proposition, i.e., reference is from the description to the thing described. The concept thing is more than a substitute for events which are not concepts, and it can function as a substitute, because the concept is also a mode of presentation in perceptual judgments. Although pure concepts by definition cannot describe sensible experiences, they are involved, as the analysis of the sentence "There is a dog" shows, in descriptions of perceptive experiences. And even a basic proposition can be contrasted with the sensible experience which it describes, because the proposition, unlike the experience, involves concepts.

Let me explain this by means of an illustration. Imagine a diagram of a cross-section of a ring or doughnut and use the letter '*a*' to name your image; you then can say "*a* looks like a ring." The image, which you designate by the name '*a*,' could be noticed without using words or symbols, but, as you single it out by the judgments "This is *a*" and "*a* looks like a ring," you really mean that "This thing is *a*" and "The thing *a* looks like a ring." The implicit presence of the concept thing in your judgments is betrayed through a further analysis of the image, as when you observe that "*a* consists of one thing which is inside another thing" (i.e., of two concentric circles). The office of the concept thing within a basic proposition is even more conspicuous in the case of indistinct perception, when we say "There is something there," and, upon closer examination, add "That thing was a picture of two concentric circles." But again the concept thing in these statements does not describe the corresponding sense-datum; if it did, the datum itself would contain a conceptual element; the function of the concept is to present the datum, or elements within it, for description and further analysis, and also for subsequent reference in exist-ence-propositions. The concept can represent an experience or event in an existence-proposition because it could present it in an antecedent perceptual judgment. Experiences are pre-sented as things, i.e., in the conceptual form or frame of thing-hood, and the concept thing is more than a substitute for an absent event, since it literally is a part of the event as subject to discursive thought, i.e., a formal mode in which the event can be thought of and described. Also because of being a formal mode of entry into thought, the concept thing is discoverable within the form or structure of an empirical proposition.

Conceptualism, as sketched here, is not hostile to a liberal empiricism or realism; there is no implication of arbitrary or Kantian imposition of concepts upon experience which is intrinsi-cally foreign to them; conceptual articulation of facts is under-stood to conform to an antecedent disposition in them (to be analyzed into a definite pattern of things with properties and relations). But of course articulation or analysis is a mode of presentation which is not the mode of pre-analytic data. The

*Inquiry* takes a step towards conceptualism by recognizing that the structure of existence-propositions, although meaningful, is not a duplicate of the structure of sensible experience. I do not know whether Russell is ready to accept the further point, that there are non-descriptive elements of form symbolized by apparent variables; but I believe that an assimilation of this point within the context of the ideas of the *Inquiry* would prove to be to their advantage.

<div align="right">A. USHENKO</div>

DEPARTMENT OF PHILOSOPHY
PRINCETON UNIVERSITY

13

*Roderick M. Chisholm*

# RUSSELL ON THE FOUNDATIONS OF EMPIRICAL KNOWLEDGE

# RUSSELL ON THE FOUNDATIONS OF EMPIRICAL KNOWLEDGE

THE notion of epistemological order is central to all of Russell's major writings on the theory of knowledge, from the *Problems of Philosophy* in 1912 to the *Inquiry into Meaning and Truth* in 1940. Russell assumes that there is a distinction between "primitive" and "derivative" knowledge, that in some sense the latter is "based upon" or "presupposes" the former, and that the principal task of the epistemologist is to arrange what we think we know in an epistemological order, starting in every case with what comes "epistemologically first in my existing knowledge now."[1] I believe that this group of assumptions is essential, not only to Russell's own theories about knowledge, methodology, and science, but also to most contemporary discussions of these questions. Although Russell has discussed this topic more thoroughly and adequately than any other philosopher, I feel that much of what he says about it is unclear and ambiguous and that the problem involves a number of difficulties of which he is not fully aware. In the present paper, I wish to discuss and interpret the development of Russell's views on this question, to compare them with what other philosophers have said, and, so far as is possible, to evaluate them. I shall discuss, first, the conception of epistemological priority which runs through all of his works and, secondly, the relation to this of the theory of basic propositions developed in the *Inquiry*.

In the *Problems of Philosophy* Russell stated that primitive knowledge does not depend for its evidence upon any other

[1] Cf. *The Problems of Philosophy*, 39; *An Inquiry into Meaning and Truth*, 15, 17; *The Analysis of Matter*, 180.

knowledge and is "intuitive" or "self-evident," but this definition was hardly satisfactory since he added that there are two types of self-evidence, only one of which is basic. (pp. 182-5) In the *Inquiry* he asserts that the epistemologist should be interested primarily in a certain subclass of "psychological premisses," a psychological premiss being a proposition expressing a belief not derived from any other belief. He adds, however, that since the philosopher purports to be concerned with knowledge and not with mere opinion, "we cannot accept all psychological premisses as epistemological premisses, for two psychological premisses may contradict each other, and therefore not all are true;" consequently all psychological premisses "must be subjected to analysis." (*Ibid.*, pp. 164-5) They must be "true so far as we can ascertain" and must "on reflection appear to us credible independently of any argument in their favour." (*Ibid.*, pp. 164, 17) Russell believes that, in some sense, basic knowledge provides the *justification* for our other claims to knowledge; the order of knowing, which should be distinguished from the order of discovery, has something to do with cognitive *validity*.[2] In order to understand Russell's proposals, we must ascertain both the type of "analysis" to which psychologically primitive beliefs must be submitted and the sense in which such beliefs can be said to provide the "justification" for the rest of our knowledge.

Some of Russell's statements have suggested that he understands a proposition to be epistemologically basic and thus to express primitive knowledge, only if it is about experiences which have a certain "close" or "direct" connection with their stimuli. He has frequently written that the epistemologist should distinguish those effects which are directly connected with their stimuli from those which are the result of habit and interpretation. If we are able to free ourselves from the effects which habit and interpretation exercise upon perception, we can arrive at a "sensory core" which is due solely to the stimulus. In *Philosophy*, he distinguishes sensation from perception by

[2] Cf. *Philosophical Essays*, 146; *The Problems of Philosophy*, 210; *Our Knowledge of the External World* (second edition), 75; *An Inquiry into Meaning and Truth*, 16.

reference to the sensory core and he seems to suggest that a basic proposition is one describing what the stimulus would have produced, had there been no previous experience to make interpretation possible. (p. 204) But in the *Analysis of Matter*, he states quite explicitly that, since the element of interpretation can be eliminated only "by an elaborate theory," the hypothetical sensory core which would remain "is hardly to be called a 'datum,' since it is an inference from what actually occurs." (p. 189) The task of determining the sensory core, which is "by no means an easy matter," is a problem for the psychologist.[3] The criteria of epistemological priority must be such that an epistemological premiss is easily recognizable as such and the application of these criteria must not presuppose a knowledge of any particular science, for scientific knowledge must itself have an epistemological foundation.

Russell claims to arrive at primitive or basic knowledge by means of "methodological doubt." In some passages, he implies that a proposition is epistemologically basic if it is not inferred from any other proposition and if it seems incapable of doubt. Those propositions which do not survive the sceptical process are epistemologically derivative. This emphasis on "Cartesian doubt" characterizes all of Russell's epistemological writings, and he has repeatedly asserted that philosophy and the theory of knowledge should be defined in terms of methodological scepticism.[4] An instance of this procedure is his demonstration, in the *Inquiry*, that the *Protokollsätze* of Neurath are not epistemologically basic. Neurath held that the proper form of such propositions is exemplified by the following: "Otto's protocol at 3:17: [Otto's word-thought at 3:16: (In the room at 3:15 was a table perceived by Otto)]." Such a proposition, according to Russell, does not refer to genuinely "hard" data, is capable of doubt, and therefore cannot be genuinely basic; for possibly Otto was looking at a mirror-image or perhaps he was drugged and only thought he saw a table. Russell has

[3] *The Analysis of Mind*, 140.
[4] Cf. *The Problems of Philosophy*, 233-235; *Our Knowledge of the External World* (second edition), 75-77, 258; *Philosophy*, 1, 163-167, 239; *An Inquiry into Meaning and Truth*, 16.

frequently employed this type of argument. In the chapter entitled "Philosophic Doubts," in *Philosophy*, he wrote that a man standing on a street-corner should never feel confident that he is talking with a policeman, for "it is clear that a maker of wax-works could make a life-like policeman and put a gramaphone inside him." (p. 9)[5] In the *Inquiry* he writes that "a man possessed of intellectual prudence will avoid such rash credulity as is involved in saying 'there's a dog'," for hypnosis, a blow in the face, an artificial excitation of the optic nerve, or a technicolor machine could cause the type of experience which a man has when he feels confident that he's looking at a dog. (p. 188) All of these possibilities, Russell admits, are remote, for the occurrence of the suggested conditions is, in most cases, extremely improbable. "But such considerations ought not to be necessary where protocol-sentences are concerned." (*Ibid.*, p. 182)

Russell's intention in such instances is to show that all propositions about material things can be doubted and to exhibit another class of propositions which, although they may not be completely self-evident and indubitable, are more nearly so than any proposition about a material thing. A man may be able to doubt that he really sees a dog, but can he doubt that he is observing a dog-shaped patch of color?

Suppose, now, having been impressed by the method of Cartesian doubt, he tries to make himself disbelieve even this. What reason can he find for disbelieving it? It cannot be disproved by anything else that he may see or hear, and he can have no better reason for believing in other sights or sounds than in this one. (*Ibid.*, p. 189)

The proposition which expresses the man's belief concerning the patch before him is epistemologically basic for him; it is what comes epistemologically first in his knowledge at the time he is observing the patch. Presumably it has that characteristic which, in Russell's earlier writings, was labeled by such terms as "self-evident" and "obvious," but Russell does not say that such propositions are "certain." He states (i) that they are the least doubtful of propositions and (ii) that there is no other

---

[5] Cf. *The Analysis of Matter*, 205.

type of proposition from which they can be inferred. He some-times emphasizes one of these contentions and sometimes the other, but both are unclear and give rise to unfortunate inter-pretations.

Although a number of other philosophers have defined the order of knowing in terms of methodological scepticism,[6] the relevant meaning of the term "doubt" remains obscure. It might mean disbelief or it might mean suspension of belief. Neither alternative is satisfactory. If the fact that people have been known to make life-like figures from wax leads Russell to *disbelieve* (i.e., to believe it to be false) that a policeman is standing on the corner, then, according to the usual criteria of rationality, he is considerably less reasonable than the common-sense man who "perceptually accepts" such an experience as revealing a policeman. Now it is obvious that Russell does not intend to say quite this. But is his contention any more plausible, if we interpret "doubt" in terms of suspension of belief? In the first place, as Peirce objected to Descartes, it is impossible to dispel by a mere maxim any of the tremendous mass of common knowledge and belief accumulated during one's lifetime; those philosophers who think we can "pretend to doubt in philosophy what we do not doubt in our hearts," as though doubting were as easy as lying, are practicing either pedantry or self-deception.[7] And secondly, although some propositions about material things are obviously doubtful, there are an indefinite number of other such propositions which are, for all practical purposes, wholly indubitable. G. E. Moore has enumerated examples in his "Defence of Common Sense."[8] I know for certain that this is a hand, that that is a clock on the mantelpiece, that I have existed for a number of years, and so on. In stating that such proposi-tions are *not* certain and ought to be doubted, Russell would seem to be saying one of two things: (i) he might be asserting something which, according to the ordinary standards of

[6] Cf. George Santayana, *Scepticism and Animal Faith*, 10, 108, 110, 292; H. H. Price, *Perception*, 1, 3, 147; Rudolf Carnap, *Scheinprobleme in der Philosophie*, 15; Edmund Husserl, *Ideen zu einer reinen Phänomenologie und phänomenologischen Philosophie*, 182-3; *Méditations Cartésiennes*, sec. 17-18.

[7] C. S. Peirce, *Collected Papers*, 5.416 and 5.156.

[8] *Contemporary British Philosophy*, Second Series.

reasonable men, is entirely arbitrary or irrational; or (ii) he might merely be advocating a revision of our language habits and, in particular, recommending a drastic change in the use of the expressions "doubt" and "know for certain."[9] Finally, it is not clear what he means by saying that such propositions must always be "inferred," since I do not now infer that this is a hand, for example, in the obvious sense in which a detective might infer that the murderer walked with a limp.

Despite Russell's extreme statements, however, there is good reason to believe that he does not intend to advocate an extreme scepticism, that he is not primarily concerned in these discussions with linguistic conventions, and that his critics have been misled by a superficial interpretation of his writings. The sense in which he regards "This is a brown patch" to be epistemologically prior to "This is a dog" can be shown, I believe, without his exaggerated emphasis upon the notions of "doubt" and "scepticism." Russell is not, of course, the first philosopher to attribute epistemological priority to propositions which express what is given in immediate experience. Other philosophers, who have not professed to be sceptics, have contended that the ultimate basis and final test for every claim to synthetic knowledge is constituted by those "presentations" or "qualia" which are the discriminable and repeatable elements of immediate given experience.[10] Even Moore, who emphasizes the certainty with which we can know propositions about material things, distinguishes this knowledge from its evidence and at least intimates that this evidence is to be found in our direct experience of sense-data.[11]

The notion of "sense-datum," although it has been considerably maligned in recent years, does not itself present any serious difficulties. It can be clearly exhibited by means of what Price calls the Phenomenological Form of the Argument from

---

[9] Cf. A. E. Murphy, "Moore's 'Defence of Common Sense'," *The Philosophy of G. E. Moore, The Library of Living Philosophers,* Volume 4; Norman Malcolm, "Certainty and Empirical Statements," *Mind,* n.s., Vol. LI, No. 201.

[10] Cf. C. I. Lewis, *Mind and the World Order,* ch. 2.

[11] *Op. cit.,* 284-285.

Illusion.[12] This familiar argument purports to prove that, even in veridical perception, the content which is experienced at any particular time cannot be identified with the material thing which is perceived at that time. To take the stock example: consider what it is that a man sees when he walks around a table. From one corner of the room, the shape of the table's surface may take the form of a rhomboid; but from a position directly above the table, the surface may seem to be square. And at the points which the man could occupy between each of these positions, the surface may exhibit intermediate shapes. We usually indicate this type of situation by saying that, when the observer thus changes his position, the physical object *seems* to change its shape, although in actuality it does not. The following conclusions appear to be warranted by situations of this kind: (i) that *something* is changing; (ii) that this something is the content of the subject's direct awareness; and (iii) that it is not *identical* with the material object which is being seen, nor with any part of it.[13] We have no trouble in distinguishing changes in the object from changes in that of which we are directly aware, for either type of change can occur when the other does not. This type of situation may be expressed in the "sense-datum terminology" as follows: the man who sees an object which appears to change is directly sensing a series of sense-data which have different shapes and which succeed each other. The meaning of the term "sense-datum," then, is reasonably clear. What is unclear is the sense in which our acquaintance with sense-data may be said to take precedence over our knowledge of things.

Some philosophers have argued that the experience of sense-data is *not* epistemologically basic and it is in the light of their criticisms that what I take to be Russell's view can best be understood. C. I. Lewis admitted that, although the data of immediate experience serve as the ultimate basis of, and the final criterion for, every claim to synthetic knowledge, they are nonetheless not that with which the epistemologist *begins* his investigation. The datum *from* which the epistemologist pro-

[12] H. H. Price, *Perception*, 27.
[13] Cf. C. D. Broad, "Phenomenalism," *Proceedings of the Aristotelian Society*, Vol. XV (1914-15), 231.

ceeds is *preanalytic,* but it is not epistemologically primitive. Our starting point is not "the thin given of immediacy," but is, rather, "the thick experience of the world of things," the world of trees, houses, voices, and violins.[14] The direct experiences which are epistemologically fundamental are *postanalytic* data, for we arrive at patches of color and immediately given sounds only by analysis and abstraction from our thick experience of the world of things. We don't perceive a rhomboid and then infer it to be the appearance of a table; we perceive a table and then we may notice that it presents the appearance of a rhomboid. It is the table that we remember and concentrate upon, despite the fact that in perceiving the table from this position, we are *ipso facto* presented with a sense-datum in the form of a rhomboid. In a recent criticism of contemporary empiricism, John Wild used this distinction to prove that our experience of sense-data is not epistemologically basic. If what we really experience are trees, houses, and tables, then, according to him, the post-analytic datum is by no means "the whole of the given," and any theory such as Russell's, far from being "an adequate, phenomenological account of the given," is an arbitrarily narrow construction which viciously abstracts from "the *thick* experience of the world of things *as it is given.*"[15] Wild's objection is that the sense-data, to which Russell and other philosophers attribute epistemological priority, are only that *by means of which* the truly given is presented. When the observer, in our example, sees a rhomboid from one corner of the room, the experience of this shape is the means by which the table, if it *is* a table, is given. The sense-data constitute the *id quo,* the table the *id quod.* It is the table which is truly given, according to Wild, and it is thus false to say that the sense-data are epistemologically basic. Whether our experience of the sense-data or that of the object should be designated by the term "given" does not particularly matter; what does matter is the question why one, rather than the other, should be said to be epistemologically prior.

14 C. I. Lewis, *op. cit.,* 54.
15 John Wild, "The Concept of the Given in Contemporary Philosophy," *Philosophy and Phenomenological Research* (September 1940), 71, 75, 77.

The outcome of Russell's "methodological doubt" is to show that, in some sense, conditions are *possible* under which our observer might legitimately wonder whether he sees a table. It is *logically* possible that the visual experience which our observer has from the corner of the room is really the experience of a mirror-image or a product of Russell's wax-works. That is to say, there is no *contradiction* in asserting that he has the visual experience in question, but does not really see a table; for there is more to the table than what can be seen from the corner. This is presumably all that Russell means when he says that the belief about the table is *inferred* and the belief about the sense-datum is not inferred; the belief about the sense-datum presumably refers to the immediate experience alone, whereas the belief about the table refers beyond it. Russell does not succeed in showing any more than this, but in at least two places he intimates that this is all he wants to show;[16] and, indeed, I believe that this is almost sufficient for his theory of epistemological priority. What is further necessary is to note the procedure our observer would follow if he *were* to doubt whether it is a table that is given preanalytically and wished to check further. He would, in most cases, seek further sense-data. He would look to see how the thing appeared from another position, for example. Although the preanalytic datum, the *id quod*, will remain constant as the observer approaches it, the *id quo*, the postanalytic datum, will change. He may approach the object in order to produce such a change and his subsequent belief about the *id quod* will depend upon the sense-datum or *id quo*, which is then empirically given.

Those sense-data which are postanalytically given, therefore, may be called "prior" in the sense that they are that to which we appeal in order to overcome our doubts, or strengthen our beliefs, about the material objects which are preanalytically given. When there *is* doubt about the nature of a material thing preanalytically given, this doubt can be resolved in certain important types of cases, by attending to a sense-datum postanalytically given. And it can be resolved in other cases by an appeal to a different preanalytic datum; for instance, if the

[16] *Philosophy*, 212, 267.

observer "perceptually accepts" certain sense-data as those of a cat walking under the table (i.e., if the cat is given preanalytically), this may suffice to destroy the observer's doubt. But a material thing preanalytically given can never serve as evidence against a belief which is concerned solely with the sense-datum postanalytically given here and now. The observer's belief that he sees a table, the surface of which is really square, could not cause him to doubt that, from his present position, he sees a datum in the shape of a rhomboid.[17]

The point of this, then, is that in order to establish the epistemological priority of our beliefs about immediately presented sense-data, Russell needed only to indicate that it is *logically* possible for any particular datum not to "belong to" the material thing to which we attribute it, i.e., that no sense-datum as such entails the existence of any material thing, and to describe the procedure which in fact we *do* follow when we find ourselves entertaining the kind of doubts which Russell advocates. It was not necessary to declare it advisable or "intellectually prudent" to carry our doubts as far as we are able, or even to claim the psychological powers of doubting all propositions about material things. This interpretation is consistent with Russell's professed aim, not to discredit common sense, but to expose its epistemological foundations.[18]

The essential thing is to recognize that, whenever it is impossible to resolve doubt about a material thing by appealing to *other* material things, we must "fall back upon" some further sense-datum, an *id quo* which is postanalytically given, and,

---

[17] If the observer has been in the room before, however, his belief may cause him to "fill in" his experience in such a way that, from his present position, he directly experiences a sense-datum he would not experience if he didn't have the belief. It might, in fact, cause him to see a *square* from the corner of the room; therefore it would be a square which was given postanalytically. This influence which past experience, or "habit and interpretation," exercises upon the content of direct experience involves no theoretical difficulties for the present conception of sense-data, since the "sensory-core" theory has been explicitly repudiated. Russell notes on p. 414 of the *Inquiry* that *sensation* is not fundamental in epistemology. We can express the influence of past experience by saying that the sense-data which a person may directly apprehend depend in part upon the nature of his previous experience. Cf. A. J. Ayer, *The Foundations of Empirical Knowledge*, 121-123.

[18] Cf. *The Analysis of Matter*, 182.

instead of trying to look "through" it at another preanalytic datum, we must consider it on its own account as a specific quale which is directly presented. It is in this sense that, with respect to the actual processes of confirming and verifying our beliefs, the postanalytic datum which is given here and now takes precedence over any preanalytic data. It is capable of serving as a test for beliefs about the preanalytic datum, but the converse process does not occur. Russell apparently means something of this sort when he states, in the *Inquiry,* that basic propositions "appear credible independently of any argument in their favour." (p. 17) Thus the sense-datum which is given postanalytically may be said to be epistemologically prior to the material thing which is given preanalytically. Similarly, the sense-data now given postanalytically may be said to take precedence now over any sense-data which have been experienced in the past or are expected to be experienced in the future.[19] *If* any particular memory judgment is questioned or put in doubt, the ultimate test must always be a datum which is presented postanalytically here and now. The memory judgment may be substantiated by another memory judgment, or by a judgment about a material thing which is preanalytically given; but, if the substantiating judgments themselves are put in question, the final test, if there can be a test at all, will be a datum which is an element of the present postanalytic given. This, I take it, is what Russell has in mind when he speaks of "primitive knowledge." The next question to be considered is whether this knowledge is capable of formulation in propositions which can serve as the ultimate premisses of science.

Russell assumes that anything which can be learned from immediate experience and serve as a part of the ultimate foundation of empirical knowledge is capable of being expressed in propositions. He assumes further that such propositions are synthetic, since their assertion is warranted, not by purely logical or syntactical considerations, but by what it is that happens to be given or presented in immediate experience. There are serious difficulties, however, in saying that a proposition is syn-

[19] Cf. Hans Reichenbach, *Experience and Prediction,* 281-282.

thetic and refers *only* to the given. Of those philosophers who have treated this question, Russell is most clearly aware that there are such difficulties and, in consequence, his discussion involves a number of unique complications.

The members of the Vienna Circle, who have been especially concerned about such matters, have endeavored to escape its more troublesome complications by going to opposite extremes. On the one hand, Carnap, in *Testability and Meaning*, endeavored to construe "observation sentences" as hypotheses which refer beyond any particular given experience and which are capable of partial verification or falsification only after "a few observations."[20] As Russell notes in the *Inquiry*, these sentences cannot be said to be epistemologically basic, since a number of different occurrences are relevant to their verification. If it is possible to formulate in sentences the knowledge acquired during each separate experiment or observation, then such sentences are more fundamental than Carnap's "observation sentences." "Unless each experiment taught us something, it is difficult to see how it could have any bearing on the truth or falsehood of the original sentence."[21] Moritz Schlick, on the other hand, hoped to escape such problems by means of his theory of "constatations," wherein he suggested that the constatations which express our awareness of immediate experience are really not propositions at all, but are a "third thing" mediating between ordinary scientific propositions and the experiences upon which they are based.[22] This theory left the problem completely unsolved. If constatations are not logically deducible from propositions (and therefore not themselves propositions), what does it mean to say that propositions are based on them? And if we can

[20] *Philosophy of Science*, Vol. 3 (1936), 454.

[21] *Inquiry*, 392. Although Russell uses the word "learn" in this connection, he states elsewhere that he prefers "to use the word 'know' in a sense which implies that the knowing is different from what is known, and to accept the consequence that, as a rule, we do not know our experiences." (*Ibid.*, 59) This suggests that Russell would now discard the expression "knowledge by acquaintance" and that "primitive knowledge" is not itself knowledge. These terminological questions do not especially matter; the essential point is Russell's recognition of the fundamental significance for the rest of our knowledge of this type of apprehension.

[22] Cf. C. G. Hempel, "On the Logical Positivist's Theory of Truth," *Analysis*, Vol. 2, No. 4, 53ff.

say nothing about immediate experience, what is the significance of the constatations?

A proposition may be said to be epistemologically basic, if it is synthetic, expresses what is immediately or postanalytically given at a particular time, and if it does not refer beyond what is thus given. Russell notes the following essential characteristics of a *basic proposition:*

> It must be known independently of inference from other propositions, but not independently of evidence, since there must be a perceptive occurrence which gives the cause and is considered to give the reason for believing the basic proposition. . . . It has a form such that no two propositions having this form can be mutually inconsistent if derived from different percepts.[23]

Obviously those basic propositions (if there are such things) which one believes at any particular time are not sufficient for the deduction of all of the knowledge which one may be said to possess at that time. In the *Inquiry,* therefore, Russell uses the term *epistemological premiss* as a general term, to cover not only basic propositions but also those other synthetic propositions which are necessary for the deduction of such knowledge. For

[23] *An Inquiry into Meaning and Truth,* 172, 174. It should be noticed that Russell does not *define* a basic proposition as one which is certain or incapable of doubt. This confirms my suggestion that, in discussing epistemological priority, Russell over-emphasizes "methodological scepticism." Indeed, he states in one place that "since we can never be completely certain that any given proposition is true, we can never be completely certain that it is an epistemological premiss." (*Ibid.*, p. 166.) He writes in another place: "The essential characteristic of a datum is that it is not inferred. . . . I am prepared to concede that all data have *some* uncertainty, and should, therefore, if possible, be confirmed by other data. But unless these other data had some degree of independent credibility, they would not confirm the original data." (*Ibid.*, 155, cf. also 397, 399).

In discussing basic propositions, it is important to distinguish Russell's theory of epistemological priority from the theory of language and truth developed in the *Inquiry.* Russell himself is not clear about the distinction. He defines the meaning of "object words" (words which occur in the lowest language in the hierarchy of languages) in terms of a certain type of causal relation which they bear to experiences, and he sometimes seems to assume that a basic proposition must necessarily be expressed in words which have these characteristics, but he gives no reason for this assumption. I believe that this semantical problem is not strictly relevant to the present topic and I shall not consider whether the sentences, which express basic propositions, have the properties of sentences in Russell's object language.

instance, some memory judgments and some "non-demonstrative principles of inference" must be assumed as epistemological premisses.[24] Russell is not clear about the cognitive status of these other premisses, but this problem need not concern us, since he admits that "for me now, only my momentary [perceptive] epistemological premisses are really premisses; the rest must be in some sense inferred." (*Op. cit.*, p. 168) Our concern is with those propositions which are "really premisses." Is it possible to formulate our immediate knowledge in propositions which are synthetic, which do not refer beyond the given sense-data, and which are capable of standing in logical relations with the propositions of science?

A number of philosophers, who have called themselves empiricists, have questioned whether a proposition which does not refer beyond the given can be synthetic. A. J. Ayer, for instance, wrote in *Language, Truth, and Logic:*

> If a sentence is to express a proposition, it cannot merely name a situation; it must say something about it. And in describing a situation, one is not merely "registering" a sense-content; one is classifying it in some way or other, and this means going beyond what is immediately given. (p. 127)

Reichenbach used the same argument in *Experience and Prediction* (*cf.* p. 176). According to this objection, if an alleged basic proposition does not refer beyond the given sense-datum, it is really not a proposition at all; whereas if it does refer beyond the datum it is not basic. The assumption is that the least one can mean, in saying "This is red," is something like, "This is similar in color to the object of my original ostensive definition of the word 'red'." (We may regard the reference to our "original ostensive definition" as schematic, intending merely to convey the principle that all predications are comparisons.) I believe that this objection is effectively met by means of Russell's argument concerning the regress of similarities.[25] This

---

[24] See especially chapters IX and XI of the *Inquiry;* also p. 24.

[25] Cf. *The Problems of Philosophy,* 150-151; *An Inquiry into Meaning and Truth,* 68-69, 345ff. Russell uses this argument to prove that there is one true universal (i.e., identity). It is more significant, however, if we interpret it as proving that there must be at least one predicate which is non-comparative. Some

argument may be put as follows: In saying that this is similar to the original shade, what do I mean by "similar?" Do I mean that the relation which this has to the original shade is similar to the relation which was the object of my original definition of the word "similar?" I must mean something like this, if all predications are comparisons. But if it be granted that similarity is constituted by a relation to a standard pair of similars, the same problem will arise with respect to the second-order similarity. It can be readily seen that this position is incompatible with the assumption that human beings can know anything. In order to learn whether a given datum is similar to the standard red, I would have to find out whether the relation which this bears to the standard is similar to the standard first-order similarity; but in order to learn that, in turn, I would have to discover whether the relation which this instance of similarity bears to the first-order similarity is similar to the standard second-order similarity, and so on *ad infinitum*. The assumption that all predications are comparisons entails that one must complete an infinite regress before one ever has reason to make a predication. Paraphrasing Russell, we may conclude that, since "similar" must be admitted as a non-comparative predicate, it is hardly worth while to adopt elaborate devises for the exclusion of other non-comparative predicates. There is no fundamental difficulty, therefore, in saying that a proposition may be synthetic without referring beyond the present experience. More serious problems arise when we consider how a basic proposition ought to be formulated.

One might be tempted to interpret a basic proposition as a subject-predicate proposition, whose subject-term refers to a sense-datum and whose predicate-term refers to one of the "properties" or "characteristics" of the sense-datum. C. D. Broad, for instance, asserts that, in being aware of sense-data, we "prehend" certain *particulars* which are *characterized* by certain qualities. It might be argued in defense of this view that,

---

philosophers have denied that it proves the former point, but I believe that it unquestionably does prove the latter.

[20] Cf. *Scientific Thought*, 241; *Examination of McTaggart's Philosophy*, Vol. II, 20ff. See also G. E. Moore, "A Reply to My Critics," *The Philosophy of G. E. Moore*, *The Library of Living Philosophers*, Volume 4, 657-660.

since our primitive beliefs must be *about* something, we cannot believe simply "redness" but have to believe something to *be* red. The proposition which formulates such a belief apparently asserts that there is *something* which is red and, since the proposition must be synthetic if it is to express what is basic in empirical knowledge, the "something" can hardly be identical with redness. Thus, according to this view, in the basic proposition "This is red," the "this" designates the sense-datum which is presented and the "red" designates one of the sense-datum's characteristics. As Russell notes in the *Inquiry*, on such a view the "this" (Broad's "particular") "becomes a substance, an unknowable something in which properties inhere, but which, nevertheless, is not identical with the sum of its properties." (p. 120)

It is clear that such a view presents a number of serious problems. If sense-data are particulars manifesting their qualities, then one might plausibly infer that they have other qualities which they do *not* manifest. Consequently, Broad was forced to admit that a given sense-datum might well have parts with which he is not acquainted; H. H. Price, who adopted a similar view, went so far as to raise the question whether a visual sense-datum, e.g., a "red patch," has a rear as well as a front surface; and G. E. Moore has even suggested that a sense-datum might *seem* to be different from what it really is.[27] If we have to admit all of this, it is quite possible that each of the traditional problems of perception can be reformulated with respect to our perception (or "prehension") of sense-data, and so on, possibly without end. We could ask, for example, whether our knowledge of sense-data is direct or indirect, mediate or immediate. Indeed, some higher-order dualist might point out that, since we know only the appearances of sense-data, the universe must contain, in addition to things-in-themselves, unknowable sense-data-in-themselves. If we are to avoid such manifest absurdities, we must find a way of formulating basic propositions without employing subject-terms which designate unknown particulars.

[27] C. D. Broad, "Knowledge by Acquaintance," *Proceedings of the Aristotelian Society*, Supplementary Volume II, 218; H. H. Price, *Perception*, 106; G. E. Moore, *Philosophical Studies*, 245.

Instead of viewing the ultimate data of knowledge as particulars manifesting their characteristics, Russell adopts the "subjectivist principle" of Whitehead and of some of the critical realists, repudiating the particular and retaining only the characteristics. According to this view, we are confronted, in a perceptual situation, by the universal itself and not by a mere instance of it. Thus Russell writes in the *Inquiry:* "We are supposing that there are only qualities, not also instances of qualities. Since a given shade of color can exist at two different dates, it can precede itself. . . ." (p. 126) He then suggests that the basic proposition " 'this is red' is not a subject-predicate proposition, but is of the form 'redness is here'; that 'red' is a name, not a predicate." (p. 120) According to Russell's theory, sense-datum-terms are proper names denoting repeatable universals. An alternative formulation is "I-now see redness," provided the "I-now" is understood as synonymous with "here" and not as synonymous with "Otto," "Carl," or "Rudolf." We may say "There is something which is redness and is here," or, in other words, "$( \exists x) (X =$ redness . x is here-now)."

Russell and Whitehead maintained, in *14 of *Principia Mathematica,* that "it would seem that the word 'existence' cannot be applied to subjects immediately given," but they added that, in philosophy, it is quite possible that some meaning of the term could be found which would be applicable in such contexts.[28] Russell now appears to be content that he has found such a meaning, for he writes as follows in the *Inquiry:* "When I experience an occurrence, it enables me to know one or more sentences of the form '*fa*,' from which I can deduce 'there is an x such that *fx*'." (p. 298) Thus we may assume that Russell would accept the proposed formulation for basic propositions: "$( \exists x) (X =$ redness . x is here-now)." If this formulation is acceptable, the basic proposition can be regarded as synthetic without construing the sense-datum as a substantive having properties or manifesting characteristics. Unhappily, however, this formulation brings to focus a more perplexing problem, since it contains what Russell calls an "ego-centric word," re-

[28] Volume I, 175. Compare George Santayana, *Scepticism and Animal Faith,* 34 ff.

ferring to an "ego-centric particular." We have to say that the quality or sense-datum which is the object of the given experience, is *here-now*, or present to *me-now*.

Ego-centric words, Russell writes in the *Inquiry*,[29] are words such as *this, that, I, here, now, past, future*, whose denotation is "relative to the speaker." All of them, as he shows, can be defined in terms of "this" or "I-now." Such words appear to escape the usual logical and semantical categories. "This," for instance, has some of the characteristics of a proper name, but it cannot be a proper name in any strict sense, for it preserves a constant meaning in spite of the fact that its designatum is constantly changing. It "applies to only one object at a time, and when it begins to apply to a new object it ceases to be applicable to the old one." (*Inquiry*, p. 136) It cannot be regarded as a general concept, since it has but one instance at a time. If it were a general concept, its instances would be covered by it eternally, not merely momentarily. And if we attempt to construe it as a description, we shall encounter one of two difficulties. Either we shall surreptitiously introduce another ego-centric word, or we shall deprive ourselves of its principal use and significance; e.g., if we were to define it as "the object of attention," it would then "always apply to everything that is ever a 'this,' whereas in fact it never applies to more than one thing at a time." (*Ibid.*)

If the existence of ego-centric words meant only that the usual classification of terms is more narrow than it ought to be, the difficulties which they present might not be serious, but such words also raise fundamental problems concerning the truth of the propositions in which they occur. We like to believe that propositions are constant in their truth-value, that once true a proposition is eternally true. But, although at the moment "Redness is here-now" (or its more extended equivalent) may be true, it is very probable that, if I turn my head, I shall have to say that "Redness is here-now" is false. It can be objected, then, that such propositions, being true only "at a time," are

---

[29] Pp. 134ff. One of Russell's earliest treatments of this problem is his discussion of "emphatic particulars" in "The Philosophy of Logical Atomism," *The Monist*, Vol. 28 (1918) and Vol. 29 (1919). See especially pp. 55, 524-526, 377-378.

not amenable to logical treatment and consequently are highly suspect as scientific propositions and hardly more satisfactory than Schlick's "constatations." This difficulty, of course, is not generated by acceptance of the subjectivist principle; for, even if the notion of a sense-datum as being a bare subject of predicates, were retained, it would still be necessary to employ ego-centric words, at least implicitly, in the formulation of basic propositions. The only means of specifying in a basic proposition, *which* substantive datum is presented, is to say that it is *this* datum or is *here-now*.

Karl Britton, in his *Communication* (p. 198), suggested, but did not explicitly advocate, the following method for eliminating ego-centric words from sentences formulating basic propositions. Instead of saying "Redness is here-now," we might simply leave a "gap" or "hiatus" to designate the place-time where redness occurs. However, he did not specify the status of the "gap," or "hiatus," and apparently we would have to regard it as occupying a half-way position between an unbound variable and a term designating an actual spatio-temporal locus in the physical universe. Such a compromise, of course, is impossible.

Russell in the *Inquiry* proposes two quite different solutions to the problem of ego-centric particulars. He suggests a way of avoiding ego-centric words in the formulation of basic propositions. And he also appears to suggest a method of eliminating ego-centric particulars from physics. The later proposal does not pertain directly to the present problem. It is based upon the theory that the variation in the applicability of ego-centric words is a function of the temporal relation between our actual utterances of sentences containing such words and the physical events which are the *causes* of such utterances. "Thus the difference between a sentence beginning 'this is' and one beginning 'that was' lies not in their meaning but in their causation." (*Inquiry*, p. 140) In the one case the causation of the utterance is "direct," or "as direct as possible," and in the other it is "indirect." Whether this proposal accomplishes anything may be questioned, but in any case it is not relevant to the epistemological problem under consideration. There is a distinction between the fact or "physical event," which is the *utterance* of a sentence,

and the fact which the sentence thus uttered is *about*. It may be true that the difference between a basic proposition in the present tense and one in the past tense lies essentially in the causation of their utterances, but recognition of this fact does not provide us with a means of formulating basic propositions without the use of ego-centric words. If our propositions must themselves make reference to the causation of sentential utterances, they cannot be epistemologically basic. Accordingly, Russell proposes a further theory, which he presents as a possibility, disclaiming any attempt to prove it to be necessary. It involves the three following parts:

(i) A basic proposition, say, "This is hot," asserts, neither that hotness is a characteristic inhering in a substantive-datum nor that it is a quality or universal which is simply here-now. It asserts that hotness is a quality or a universal which is a member or part of a "bundle" of qualities which are compresent during a basic perception. If the type of formulation which I have suggested is adopted and if the bundle is designated by 'W', the basic proposition becomes: "There exists something which is identical with W and hotness is a part of it."

(ii) The subject of the proposition is the bundle itself, which Russell would specify uniquely by the proper name, "W." Russell assumes, or at least hopes, that if the compresent qualities which compose the bundle W "are suitably chosen or sufficiently numerous, the whole bundle will not occur more than once, i.e., will not have to itself any of those spatial or temporal relations which we regard as implying diversity, such as before, above, to the right of, etc." (*Ibid.*, p. 159) It should be recalled that, according to Russell's theory of qualities, spatial and temporal relations do not strictly imply diversity. However complex the bundle of qualities may be, there is no contradiction in stating that the present occurrence of it is not unique, even though there may be reason for thinking it doubtful that the complex will ever recur. (Cf. *ibid.*, pp. 120ff)

(iii) If our basic proposition asserts that hotness is part of W, and if W is a complex quality and hotness a relatively simple quality which is one of W's constituents, the basic proposition appears to be analytic, just as "Rational animals are animals"

is analytic. The third part of Russell's theory, then, is an attempt to reconcile this with the fact that a genuinely basic proposition must be a synthetic proposition which is, in some sense, a report of our direct experience and which functions as a part of the ultimate basis of our knowledge of the natural world. He writes as follows:

Although "W" is, in fact, the name of a certain bundle of qualities, we do not know, when we give the name, *what* qualities constitute W. That is to say, we must suppose that we can perceive, name, and recognize a whole without knowing what are its constituents. In that case, the datum which appears as subject in a judgment of perception is a complex whole, of which we do not necessarily perceive the complexity. A judgment of perception is always a judgment of analysis, but not an analytic judgment. It says "the whole W, and the quality Q, are related as whole-and-part," where W and Q are independently given. . . . *All* judgments of perception are of this form, and . . . what, in such propositions, we naturally call "this," is a complex which the judgment of perception partially analyses. It is assumed, in saying this, that we can experience a whole W without knowing what its parts are. (*Ibid.*, pp. 160, 419-420)

I cannot feel that this ingenious theory has any plausibility. First of all, the assumption that whatever it is that we *do* experience can be said to have, in any sense whatever, parts which we do *not* experience comes dangerously close to the substantive theory, which Russell rejected. Even if it be granted that we experience *parts* and not *qualities* of the datum, the view that the datum is not identical with, but is more than, what we actually experience is subject to most of the difficulties of Broad's and Price's views, according to which we experience or "prehend" characteristics of a substantive-datum. Unless Russell were willing to adopt something like Leibniz's distinction between "perception" and "apperception," wherein perception is construed as "subconscious" apperception (a view which would seem to be out of accord with almost everything that Russell has written about mind), the unexperienced parts of an experience must remain enigmatic.

Moreover, Russell's suggestion involves certain assumptions about the nature of experience which it is hardly possible to ac-

cept. If his theory is to serve those purposes for which he intended it, then, as he admits, *all* judgments of perception will have to be judgments of analysis. In order to establish this, he attempts to show, in Chapter XXIV of the *Inquiry*, that there are times when we experience parts *as* parts of a whole and that there is a real sense in which we can be said to experience wholes along with the parts. But even if we do grant that *some* judgments of perception are judgments of analysis, this admission certainly does not warrant the claims, first, that *all* judgments of perception are thus judgments of analysis; secondly, that in *every* basic perception we experience the whole *without* experiencing all of its parts; and thirdly, that such wholes never recur. Russell admits that, if this theory is to be satisfactory, "it is necessary that, among the qualities constituting W, there should be at least one which does not recur, or one subordinate complex which does not recur." (*Ibid.*, p. 424)

During a completely successful blackout, it may be assumed, my visual field is a single undifferentiated mass of blackness. It would seem to be quite possible for the content of my other sense-fields, in such a circumstance, to be so meagre that I couldn't formulate my perceptive judgment as "Blackness is part of W," where W must include further qualities such that the entire group has never before been experienced in combination. Nonetheless, my assertion of the presence of blackness ought to be a significant proposition about what is given. It is true, of course, as Russell urges in another place (*ibid.*, p. 66), that the sentences which we utter in order to convey or communicate even the most simple of experiences are always "more abstract" than that to which they refer. If I assert that this is red, for example, my assertion conveys nothing about the size or shape of what I see and therefore it does not exhaust the content of my percept. But this fact is hardly relevant to the doctrine in question, which is not a linguistic one. Russell's theory of basic experience concerns, not those sentences which are actually uttered in the attempt to describe experiences, but what it is that is there to be described. It may be that, in every case, the given comprises more than we are able to mention, but it does not follow from this that it has that complexity and the

individuality which Russell's theory requires. Despite Russell's detailed concern with this problem, then, I feel that he has not yet provided us with a final solution.

The only alternative is an appeal to "time-qualia," which Russell does not mention. Nelson Goodman proposed such a theory in his *Study of Qualities*.[30] This theory assumes first, that we immediately experience *times*, in the sense in which we immediately experience colors, sounds, and so on, and, secondly, that we are constantly experiencing different times and can never experience the same time twice. If these assumptions are correct, we have a method for eliminating ego-centric words (Goodman calls them "indicator words") and substituting tense-less sentences for the sentences in which such words occur. This substitution is easy in principle. Instead of saying that "S is P" is true at time t, we say that "S is P at time t" is true. The verb "is" as it occurs in the sentence is tenseless, in accordance with the four-dimensional spatio-temporal view of the universe, and refers to past, present, or future.[31] Since it is theoretically possible to have a different name for each distinct "time-quale," just as it is theoretically possible to have a different name for each distinct "color-quale," then, if this theory is correct, we can employ such names in our basic propositions and thus avoid ego-centric words. Instead of saying "Hotness is here-now," for instance, we could say "Hotness is at time 31,157,435."

I do not know whether Russell would care to accept this theory.[32] The assumption of time-qualia seems to involve at least as many problems as does Russell's bundle-theory. If it is true that we do experience times, can we say that we never experience the same time twice? Obviously, the time at which a given experience occurs cannot repeat itself, but this tautology does

---

[30] Ph.D. Thesis, Harvard University Library (1940), pp. 595ff.

[31] Cf. W. V. Quine, "Designation and Existence," *Journal of Philosophy*, Vol. XXXVI, No. 26, 701ff., and Goodman, *op. cit.*, 569ff.

[32] Although Russell does not mention time-qualia, he does recognize space-qualia in the *Inquiry*. "Places in visual space, according to our present theory, are qualities, just as colours are." (p. 285) I gather from his discussion of time in Chapter VI, however, that he would not accept the time-qualia theory. In Chapter XVI, he discusses the relation of experiences to "places" or "points" in time, but here he is talking about *physical* space-time, which, of course, cannot be a subject for basic propositions.

not guarantee the truth of the present proposal. One must distinguish between the statement that it is logically impossible for the time *of* the experience to recur and the statement that it is impossible for the time-quale (if there is such) *within* the experience to recur. The second statement does not follow from the first and it is difficult to see how it could be demonstrated. Identical spatial qualia can be experienced in different places within physical space; similarly, why cannot identical temporal qualia be experienced at different places within the physical time-series? It is not logically impossible for a given time-quale to repeat itself. (Such an impossibility would obtain only if time-qualia were defined in terms of the physical time-series. If this were done, however, words referring to such qualia would also refer implicitly to physical time and thus be out of place in basic propositions, which, according to Russell, do not refer beyond the immediate experience.) If it is true that repetition of time-qualia never does occur, this is a most interesting fact and one which, for our theories, is singularly fortunate. The solution to this problem is not obvious and it cannot be provided by stipulation. The only evidence in favor of such a conclusion must come from introspection, and by the very nature of the case, the amount of favorable evidence obtainable at any time must of necessity be extraordinarily slight.

RODERICK M. CHISHOLM

U. S. ARMY

**14**

*Harold Chapman Brown*

# A LOGICIAN IN THE FIELD OF PSYCHOLOGY

# A LOGICIAN IN THE FIELD OF PSYCHOLOGY*

## I

MR. RUSSELL was aroused from his dogmatic slumber, or at least from the effects of a sound British education in Locke, Berkeley, and Hume, to a re-examination of the nature of Mind by the materialistic tendencies of American behaviorism, typified by John B. Watson and Dewey, and the "anti-materialistic" tendencies of modern physicists, exemplified by Einstein. The materials for the reconciliation of this apparent conflict he finds in the neutral stuff theory of the American New Realists and in the writings of William James. This background is important, for it defines the realm within which his thought moves, as his predilection for mathematical logic determines his methods.[1]

Of the three major writings concerned with the nature of mind, the first, *The Analysis of Mind,* is largely occupied with the refutation of an abandoned belief: "the theory that the essence of everything mental is a certain quite peculiar something called 'consciousness', conceived either as a relation to objects, or as a pervading quality of psychical phenomena."[2] Its conclusions are: mind and matter are alike logical constructions, not distinguished by their material; psychological causal laws are distinguished by *subjectivity* and *mnemic causations;* consciousness is not an universal characteristic of mental phenomena; and mind is a matter of degree exemplified in the number and complexity of habits.[3] There is nothing in the sum-

---

* The reader is referred to an editorial notation concerning the author of this essay in the Preface to this volume. *Ed.*

[1] *Analysis of Mind* (1921), Preface.

[2] *Ibid.,* 9.

[3] *Ibid.,* full summary, 307-308.

mary, unless it is the stress on causal laws, that is in essential conflict with Hume.

The *Philosophy* (1927) does not substantially change the position taken in the earlier work. In reaction against Dr. Broad's use of the theory of emergence, mind is re-defined "in a physical way" as "the group of mental events which form part of the history of a certain living body" and "in the psychological way" as "all the mental events connected with a given mental event by 'experience', i.e., by mnemic causation" which is "almost exclusively associated with matter having a certain chemical structure."[4] Matter is an aspect of what Mr. Eddington calls a "material-energy-tensor," something that can be treated sometimes as energy and sometimes as matter. The effect of this statement is to give a certain primacy to the physical aspect of the neutral stuff, by implication at least. Thus, where the *Analysis of Mind* ends with the suggestion that psychology is somehow nearer than physics to what actually exists,[5] the conclusion of the *Philosophy* tends toward a reversal of this relation. However, it is reasserted that since data are percepts, on logical grounds Berkeley may yet be right and this conclusion is rejected only by an act of what Santayana calls "animal faith."[6]

These two stages of Mr. Russell's theory of mind have been very thoroughly examined by Professor Lovejoy in his *Revolt Against Dualism*.[7] Although I do not share the position motivating Professor Lovejoy's examination, the thoroughness of his analysis and the accuracy of his criticism leave little to be desired. It might greatly clarify Mr. Russell's intent if he would answer these criticisms at some length. Professor Lovejoy's summing up is that

the universe which is depicted in his [Mr. Russell's] latest works consists—upon final analysis—of two mutually exclusive and wholly dissimilar classes of particular existents. To one of these belong all the sensible qualities, feeling, and thought-content; and though the entities

[4] *Philosophy* (1927), 286-287.
[5] *Analysis of Mind*, 308.
[6] *Philosophy*, 290.
[7] *The Revolt Against Dualism* (1930), Chs. VI-VII, 190-257.

composing this world are not in a single universal Newtonian space, certain among them, namely, those given through sight and touch, have special relations to one another. To the members of the other class we may not ascribe either sensible and affective qualities or, in the same sense of the term, spatial relations; in the sense in which they may be said to be in "space," they are in a different space. The members of the former world do not conform to physical laws; they are, in short, "outside physics." The first world is the world of experienced content; the other is the metempirical physical world behind the content and causally prior to it. A universe made up of two orders of being thus contrasted and thus related is in all essentials the familiar world of dualistic philosophy. . . .

. . . Though propounded as a solution of the psychophysical problem, it [Mr. Russell's theory] obviously also has an epistemological liability: it must be such as to render the fact of knowledge intelligible, or at least conceivable. But this liability the theory does not meet. . . . It places the entire material of his knowledge inside his head—or would so place it, if it were not that his head, too, disappears in the process. All that is presented in my perception, or in any cognition, being, upon this hypothesis, a bit of my brain, it is manifestly only my brain that I know —if, indeed, I can be supposed to know that.[8] Not merely the qualities but also the relations of both perceived and inferred objects should, according to the theory, be embraced within those limits. . . .

Yet Mr. Russell himself is, on occasion, equally insistent upon the transcendence of the object of perception or of inferential knowledge. The causal theory of perception which he holds manifestly implies this. . . . Mr. Russell thus presents us with two incompatible views about the position of the visual *cognoscendum* relatively to the body of the knower. When he is preoccupied with the psychophysical problem he arrives— under the influence of his desire to unify the mental and the physical— at a conclusion on this point which contradicts the conviction to which he is led by his reflection on the problem of perceptual knowledge—the conviction which is "as certain as anything in science."[9]

Mr. Russell's latest work that touches upon the problem of

[8] Strictly speaking, I can't be! What is known is merely an "event" not even in the brain, since the brain has really disappeared along with the head! It is hard to start on the road with Locke and not end up with the most extreme conclusions of Hume. Mr. Russell has a disconcerting habit of shying away from his own logic when he sees it has led him to an undesirable conclusion—yet he never seems to lose faith in his logic!

[9] A. O. Lovejoy, *loc. cit.,* 254-256.

mind is his *Inquiry into Meaning and Truth* (1940). The problem here is primarily epistemological, but rather than review the materials Professor Lovejoy has treated so adequately, I shall confine my remarks primarily to the account of mind as it appears in this volume. It is curious that there is in it no specific reference to that criticism and no apparent effort made to deal with the difficulties raised. Its distinguishing features are a reaction to Logical Positivism and a new stress on the theory of language. Mr. Russell here classifies himself with those philosophers "who infer properties of the world from properties of language"[10] among whom he includes Parmenides, Plato, Spinoza, Leibniz, Hegel, and Bradley. Fortunately for Mr. Russell, there are none of them in a position to offer objections to this classification. I should expect protests from all except the first and last of those on his list, and possibly from them.

In agreement with the earlier writings, there is a tentative acceptance of "whatever science seems to establish"[11] with the suggestion that the justification of the assumption may be investigated later. However, since the whole argument is built on this assumption, it cannot be abandoned without destroying the whole theory. And it is not—although the ghost of Berkeley still hovers in the background and the wailings of the banshee of Logical Positivism are occasionally ominous.

The situation is first stated as in the earlier writings: in the case of "seeing the sun" . . .

At every moment a large number of atoms in the sun are emitting radiant energy in the form of light waves or light quanta, which travel across the space between the sun and my eye in the course of about eight minutes. When they reach my eye, their energy is transformed into new kinds: things happen in the rods and cones, then a disturbance travels along the optic nerve, and then something (no one knows what) happens in the appropriate part of the brain, and then "I see the sun."[12]

It is only so far as there is "resemblance," if any, between "see-

---

[10] *Inquiry Into Meaning and Truth* (1940), 430.
[11] *Ibid.*, 146.
[12] *Ibid.*

ing the sun" and "the sun" that the latter can be a source of knowledge concerning the former.[13] We shall return to this question of "resemblance" later. For the present it is sufficient to note that the "thing that happens in the appropriate part of the brain," partly due to the stimulus and partly due to a certain filling out by habit, etc., constitutes a "perceptive experience" and is closely related to cognition, and that since "my perceptual whole W is, from the standpoint of physics, inside my head as a physical object" one wonders how a physical object can know another physical object by resembling it, and perhaps Mr. Lovejoy's problems as to Mr. Russell's head are still with us, even if the "space-time whole and part is too elaborate and inferential a concept to be of much importance in the foundations of theory of knowledge."[14]

Since perceptive experience may be translated into words, i.e., a proposition, and is a direct causal consequence of a physical object giving rise to it, Mr. Russell should be prepared to accept the extreme form of Logical Positivism as represented by Neurath and Hempel which limits empirical fact to the meaning " 'A occurs' is consistent with a certain body of already accepted propositions;" but a sturdy "animal faith" makes him rebel: "If I go into a restaurant and order my dinner, I do not want my words to fit into a system with other words, but to bring about the presence of food."[15] Evidently the whole story of perception has not been told and Mr. Russell is always impeded in telling it by his predilections for "atomic" analysis, i.e., the effort to isolate facts from their natural context in order to understand them, and must from time to time relapse to such faith to avoid patent absurdity.

It is no wonder, then, that Mr. Russell is frequently troubled by the philosophy of John Dewey, but is fundamentally barred from understanding that philosophy. He has some understanding of his own difficulty when in his essay on "Dewey's New Logic"[16] he locates it in his desire to see knowledge as "a part

[13] *Ibid.*, 147.

[14] *Ibid.*, 428.

[15] *Ibid.*, 186.

[16] *The Philosophy of John Dewey*, The Library of Living Philosophers, Vol. I (1939), 155.

of the ends of life" and, failing to grasp Dewey's treatment of ends, denies that Dewey can in any way do so. Yet at the same time he does want knowledge to have some practical value, as in the case of ordering dinner cited above. He is apparently an instrumentalist—and we shall find more support for this conclusion—who finds it one of the ends of life to value his instrument as an object of contemplation although he is ready to use it when no one—including himself—is looking. He seems to be incapable of deciding to relapse into the British tradition and follow his logic to the position of Hume, or to explore wholeheartedly the possibilities of emergent naturalism or dialectical materialism.

Admiration for American Philosophy pushes him toward the latter alternative. Professor Savery[17] quotes him as writing:

To my mind, the best work that has been done anywhere in philosophy and psychology during the present century has been done in America. Its merit is due not so much to the individual ability of the men concerned as to their freedom from certain hampering traditions from the Middle Ages . . . sophisticated America, wherever it has succeeded in shaking off slavery to Europe . . . has already developed a new outlook, mainly as a result of the work of James and Dewey.

It is this influence that pushes him toward materialism as the appropriate background for a properly stated instrumental theory of knowledge, and Professor Savery classifies him as a materialist on the ground that for him "each event is extended in three dimensions and has a duration."[18] Professor Savery means, of course, that he, like Dewey, is in line with "the recent revival of materialism in its historical forms,"[19] not that he is an 18th century materialist and sagely attributes his failure to recognize this to the fact that "Materialism has been grossly misrepresented by historians of philosophy who stem, for the most part, from Hegelian idealism," noting especially "the neglect of Engels on the part of the academic philosophers."[20]

[17] *Ibid.*, 482.
[18] *Loc. cit.*, 512.
[19] *Ibid.*, 512.
[20] *Ibid.*, 511-512.

There is some evidence of this neglect on the part of Mr. Russell, since in his essay on "Dewey's New Logic" he suggests parenthetically that Engels never understood dialectical materialism[21]—a statement that would be difficult for one who had read the Dialectics of Nature to justify. However, I think Mr. Russell can correctly claim that the term, materialist, at most can only apply to him about half of the time, the half when his "animal faith" is on top.

However, it is not important to insist upon the word *materialism*, for word phobias that have become established are very strong, as every student of propaganda technique knows. The important thing about Mr. Russell's terminology is that it leads him to set man and his mind over against the world, and therefore generates difficulties in understanding how mind can function in the world. Since he is not willing to accept solipsism, he must accept the existence of some sort of a physical world and the existence of other men in it beside himself, with minds— in some sense of the word *mind*. Yet the causal chain leading from physical objects to perceptions somehow stops abruptly with a somewhat mysterious event in the brain. This brain event constitutes pre-verbal knowledge,[22] and even if the processes go on to verbalization, knowledge is still there as an end in itself and his "emotional belief" is satisfied.

If, on the other hand, Mr. Russell had held clearly the naturalistic or materialistic view of man as a physical object amongst other physical objects and interacting with them, he would have been brought closer to Dewey and to the danger of defining knowledge as "acting appropriately," or at least leading to appropriate action, which he rejects as "vague" since " 'appropriate' can only be defined in terms of my desires."[23] This is not quite true, for the word *appropriate* involves two components: a correct appraisement of a situation, and a utilization of that appraisement for the satisfaction of desires. It would be more accurate to say, as I think any instrumentalist would, that knowledge is a *condition* of appropriate action. As Mr.

---

[21] *Ibid.*, 143.
[22] *Inquiry into Meaning and Truth*, 58-59.
[23] *Ibid.*, 60.

Russell's examples here show, the "behavioristic" test of knowledge would require both a knowledge of the agent's desires and his appraisement of the situation. But I do not want to become involved in an examination of Mr. Russell's epistemological theories. I merely wish to emphasize these two unreconciled trends in his basic conception of mind.

For a definition of mind it is necessary to turn back to the *Philosophy*.[24] Here we are told: mind is a group of mental events and

mental events are events in a region combining sensitivity and the law of learned reactions to a marked extent. . . . The primary mental events, those about which there can be no question, are percepts. . . . They give rise to knowledge-reactions, and are capable of having mnemic effects which are cognitions

and "These causal properties, . . . belong to some events which are not apparently percepts . . . any event in the brain may have these properties." At any rate a mind "is connected with a certain body . . . and it has the unity of one experience," i.e., mental events are tied together by mnemic causation which is "almost [?] exclusively associated with matter having a certain chemical structure."

In reacting to Mr. Broad's materialistic emergent theory of mind, Mr. Russell seems to be a little hesitant about his decision. He is certain that mind is not a structure of material units, but the emergent question seems to hang upon the character of the law of mnemic causation. "If mnemic causation is ultimate, mind is emergent. If not, the question is more difficult,"[25] and the conclusion is not made clear. The discussion is complicated by Mr. Broad's confusion of an assumed non-inferential character as the mark of an emergent rather than of qualitative novelty which is the usual characterization of an 'emergent', a confusion which also prevents Mr. Russell from grasping the utility of the concept for interpreting the significance of dialectic changes or emergent levels in the physical world, although he does admit that "for the present materiality

[24] *Philosophy*, 285ff.
[25] *Ibid.*, 289.

is practically, though perhaps not theoretically, an emergent characteristic of certain groups of events."[26] Was it not Bruno who said, if the first button is buttoned wrongly, the whole vest sits askew? It seems to me that this failure to appraise correctly the theory of emergence is a source of increasing difficulties from which not even Mr. Russell's later traffic with logical positivism can extricate him.

For example, since his account of sensation and perception begins with a tentative acceptance of the "comfortable dogmatism" of physics and physiology, the chain of causal occurrences leads from a "book" or "cat," as common sense understands these words, to the sense organ, brain processes, and the mysterious "image" which has got to be like the object to know it, but can't be like it since "naïve realism leads to physics, and physics, if true, shows that naïve realism is false."[27] That is, he assumes, the greenness, hardness, and coldness that we know are quite different from the characteristics of the causal conditions from which the chain started. Locke would have agreed, but this is not a *necessary* interpretation of the findings of physical science even though many scientists would accept it. On the basis of an emergent theory, a scientist may be interested in the structural and quantitative relations of an event and find it useful to direct his attention to them exclusively, without thereby asserting that the qualities of the event are unreal as actual aspects of it. A bed is no less a bed because we may be interested in its dimensions, structure, and the materials of which it is made.

Following this line of thought, there is no reason why, when a physicist describes a book as an integration of molecules, atoms, electrons, and protons, or of "material-energy-tensors," he should not be understood to be analyzing a structure that really *has* the sensed qualities of a book as emergent properties; and there is no reason why such properties must be assumed to disappear or to be unreal because such analysis is possible. In other words, the physicist's analysis—in a much more subtle form— may be in kind like that of the housewife skilled in cooking who

[26] *Ibid.*, 284.
[27] *Inquiry into Meaning and Truth*, 15.

eats a new kind of cake at a friend's, figures out what it is made of and how, and goes home to add a recipe to her collection. If Mr. Russell's, and Mr. Eddington's, interpretation of the meaning of scientific analyses is correct, we might as well eat the ingredients of our cakes and save the cook her trouble; but, if the emergence theory is valid, her efforts really produce something of a new qualitative character and should be rewarded—as they are. If "materiality" emerges, why may not the qualities given in sensation also emerge and characterize the material emergents?

Any step toward accepting such a view involves a re-examination of sensory qualities from the point of view of distinguishing those that are reproductions, say at the sense organ, of qualities emergent in the physical world, and those which are qualities of the organism itself that "emerge" because of changes caused in the organism by some sort of contact with its environment. Color can be consistently understood as belonging to the first class, since sensory variations are due to differences in the media through which the light waves pass—or retinal difference in the case of color blindness—and felt temperature to the second, since the room that is hot to me may be cold to you.[28] Whether the qualitied organic locus should be put in the region of the sense organ, in a nerve process, or sometimes in the musculature is perhaps open to discussion. I believe there is reason to prefer the first of these except in the case of affective states; but if it is true that a man with both retinae destroyed can still 'see stars' as the result of a blow, it might be necessary to consider seriously the possibility of such qualities being an attribute of brain processes. I know no conclusive evidence on this point, for there is always the possibility that an introspective report may represent a retained word habit. At least Helen Keller makes no reference to such phenomena in her account of her early sense experiences. It would take us too far afield to elaborate the implications of this suggestion here. I only mention it because it offers a possible escape from the mysterious brain events that so frequently lure Mr. Russell toward solipsism with their Siren song.

[28] I have developed this suggestion further in another place: *Philosophical Review*, Vol. XLII, No. 2, (March, 1933).

Whatever the status of these sensed qualities, they soon get rounded out into perceptive experiences in which they remain as a mere sensory core.[29] This rounding out is described as due to habits, or perhaps "innate reflexes" in animals. They are then accompanied by "expectations" or "beliefs"—"which may be purely bodily states" and "must be classed as cognitions." Since this account is described as "talking science," it is surprising that Mr. Russell's interest in the American New Realists did not lead him to examine Mr. E. B. Holt's *Animal Drive and the Learning Process*,[30] for there is need of some clear-cut physiological psychology to clarify these statements. Instead, he seems to throw his theory of sensation into hopeless confusion, since "a visual sensation is never pure: other sensations are also stimulated in virtue of the law of habit"—by which he means that "when we see a cat, we expect it to mew, to feel soft, and to move in a cat-like manner," and thus the visual sensation is corrupted by associated sensations of "mewing," "softness," and "cat-like motion."[31] It is true that we may expect to get such sensations at some time from the actual cat, if we continue our observations; but they are not now present to sully the purity of what, in parody of a statement elsewhere, we might call the present "feline patch of color." This looks like Locke's process of building ideas from sensations, but, since representation is emphasized, it does not combine well with the behavioristic taint retained from Watson on which the importance of the perceptive experience depends. If we move on to modern physiological psychology, it would be necessary to maintain that there is not even awareness of the "sensory core" until there has been a discharge of nervous energy into motor paths, and then the consequences are incipient actions, themselves the source of kinaesthetic sensations that constitute the feeling of expectancy.

To "see a cat" is not an example of a mere sensory experience or of a perceptive experience without this build up. In this Mr. Russell would probably agree. An infant with healthy eyes might sense a "feline color patch" which would lead to random

[29] *Inquiry into Meaning and Truth,* 151.
[30] E. B. Holt, *Animal Drive and the Learning Process* (1931).
[31] *Inquiry into Meaning and Truth,* 149.

movements and perhaps to kinaesthetic expectation of a 'something'. He does not yet "see a cat." The 'something' only gains specific meaning as concrete behavior patterns develop as a result of manipulations, and further sensory contacts develop further patterns. Eventually a sufficient repertoire of such patterns is obtained so that the object is taken to be what an adult means by the word "cat." If seeing has led to touching, and touching has been followed by certain quick cat-like movements resulting in a scratch, learned avoidances may be established, but no scratch-sensation is involved in the seeing, although with the development of adequate verbal symbols, the shrinking may be verbalized as "a fear of being scratched." Similarly, when we say an object *looks* hard or soft, wet, cold, slippery, smooth, or sticky, we do not mean that we experience these sense qualities as *associated* with the visual quality, but that we are prepared to *take account* of such characteristics in the seen object through behavior patterns which the visual stimulus has acquired by conditioning in past experiences. The conditioned responses may not really fit the situation, the object that looks hot or heavy may be light or cold; so it is quite correct to avoid the implication that the "beliefs" generated as a result of the sensory stimulus are true.

It is to be noted that the expectations or beliefs that "may be pure bodily states"[32] have now become a "certain condition of mind and body."[33] It is not quite clear whether the mental component is merely the sense quality of the core, its associated qualities, or the kinaesthetic sensory conditions involved in some potential response. The colloquial expression used in suggesting a test for the truth of the perceptive experience of "seeing a cat"—"pick it up by the tail to *see* [*italics* mine] if it mews"[34]—suggests the sort of interpretation I have given above. It suggests also that Mr. Russell's cats are logical rather than zoological entities. Did you ever pick a cat up by the tail?

The correspondence of the sensation to the physical conditions that produced the causal chain leading to its occurrence is

[32] *Ibid.*, 150.
[33] *Ibid.*, 239.
[34] *Ibid.*, 152.

verified by actions brought about through some of the expectations, or behavior patterns, that have been acquired by acting. The formulation of the belief in words is then very close to what Professor Dewey means by "warranted assertibility," and it is difficult to see why Mr. Russell has such a profound reaction against this concept. His assertion seems to be that it is sufficient for truth that there is a sensory core with belief accompaniments that are theoretically, although perhaps not practically, open to verification; although he admits that without verification we can't know that they are true. Professor Dewey is interested in the processes of verification that would warrant our asserting an idea as true, or at least probable—and probability is all Mr. Russell claims to attain in matters of fact. Their statements are not contradictory, but represent a difference in interest. I cannot believe that Professor Dewey would ever claim a "warranted assertibility" for such a proposition as "Caesar is dead," if some "method of inquiry" did not indicate that such an event had probably occurred, or that Mr. Russell would ever worry seriously about the truth of such a proposition as "Caesar lost three hairs from his left eyebrow on his twenty-first birthday" if, as I assume, no method of investigation could in any measure warrant the assertion. Dewey's emphasis comes from an interest in knowing as a part of the life processes of human beings, and Mr. Russell's from a desire to abstract from such processes. Such differences in interest are not contradictions in theory.

One further comment seems to be pertinent. The claim is made[35] that the Hegelians and the instrumentalists hold among other things that "in all our knowledge there is an inferential element," and this position is rejected on the ground that it "renders the part played by perception in knowledge inexplicable" and "underestimates the powers of analysis." I doubt if any instrumentalist would care to be lumped with Hegelians in quite this summary fashion. However, Mr. Russell is agreed that inference plays a part in perceptive knowledge; for in describing the seeing-a-cat experience he says "physics . . . allows us to *infer* [*italics* mine] that this pattern of light, which, we will suppose, looks like a cat, probably proceeds from a region in which the

[35] *Ibid.*, 154.

other properties of cats are also present,"[36] and the test is experiment. The only element of the experience that is without an inferential component is the sensory core, and this is specifically asserted to lack the characteristics that we associate with the word "cognition." This sounds like good instrumentalism, and it is puzzling when later on[37] we find judgments of perception characterized as "immediate," although Mr. Russell is then concerned with a much more complicated case of inference than that involved in simple perception. I utterly fail to understand the attribution of a coherence theory of truth to instrumentalists. The problem of the psychological basis of inference will come up for discussion again in connection with Mr. Russell's theory of language; but for the present I wish to return for some further comments on the notion of "believing."

Granted that the sensory core of a perceptive experience acquires by habit—I should prefer to say, through the mechanisms of conditioning—a certain filling out by bodily states of expectation or belief, it is worth noting that these beliefs have various degrees of strength that are manifest in degrees of reluctance or readiness to pass over into action in relevant circumstances. When there is no feeling of resistance or hesitancy in such passing over, all distinction between knowledge and belief is absent, in so far as the person acting is concerned. In the knowing state the consequent action does not appear to him as an experiment; but to 'merely believe' is to be in some measure prepared to meet surprise or failure, to be *trying out* the belief, i.e., to be experimenting. Personal knowing states do not, of course, guarantee the reality of the knowledge; but to find that one does not know what he was confident that he knew, comes as a distinct shock, whereas in recognized believing we are more or less prepared for misadventures. Hence there are two uses we make of the word knowledge: first, a personal or subjective use to designate ideas the implications of which for action we accept without hesitation in relevant circumstances; and, secondly, to designate ideas so generally tried out and socially accepted that a person would be called prejudiced or uninformed

[36] *Ibid.,* 152.
[37] *Ibid.,* 299.

if he did not accept them. The distinction is sometimes expressed as the difference between personal opinions and established truths, but in specific cases the line is not always easy to draw. It is highly doubtful if attainable knowledge is ever anything more than an extreme confidence in belief.

It is psychologically interesting that ideas get their accepted status as belief or knowledge from either of two causes: an emotional condition of the person having them, or observational and experimental evidence. A mixture of both is, of course, possible. Extreme examples would be the 'knowledge' of a doting mother that her little Willie is really a good boy, although other children and the neighbors tell mean stories about him. She may 'know' this so surely that she is quite impervious to contrary evidence. Here the knowledge-feeling has its main basis in her emotion. On the other hand, my belief that my cigarette is still lighted is evidentiary and based on what happens when I look at it, try to smoke it, etc., and my emotional state has nothing to do with the question. Beliefs based on emotion may happen to be true, but there are good grounds in the history of human experience to be wary of them. Yet Mr. Russell uses them quite freely not only to escape from Berkeley, and perhaps from Dewey, but even to justify his reliance on the ultimate character of logical processes. In this he is quite Hegelian. An anthropologist, such as Lévy-Bruhl, or a physicist, such as Bridgman, would not be so confident of the absolute character of logic.

The belief in the importance of the resemblance character of the sensory core of the perceptive experience adds complications and difficulties in understanding Mr. Russell's use of such terms as "image," "idea," "word," and "meaning." Since physics proves that a sensory experience can't really be *like* the physical source of the causal chain leading up to its occurrence, apparently the whole burden of rendering these terms significant is thrown on the expectations or beliefs aroused. We are told that "the inferences drawn from the sensory core have a higher probability than those drawn from the other parts of the perceptive experience,"[38] on the ground that "in order to infer from my

[38] *Ibid.*, 153.

visual experience the light-frequencies at the surface of the cat, I need only the laws of physics;" but the discovery and the development of belief in these laws has required an enormous number of prior belief patterns and verifications, and would seem to be far more difficult to attain than the verified expectancy that the sensory core means something that will "mew rather than bark" in the case of the cat—and hardly as certain, when the proper verifications have been made in each case. "Probability" is a tricky word, but it is hard to see why it is not more probable that I am correct when I say "I see a Siamese cat that can be expected to make certain noises," than when I say "I see a region of the material-energy-tensor where certain light processes are going on."

Certainly in the ordinary use of the word 'perception' the sensory core takes a very subordinate place to the belief patterns aroused. Thus I can perceive a skunk by sight, touch, smell, or hearing—provided my senses have been properly educated—and the differences in the sensory cores are comparatively insignificant for my 'expectations.' These different sense cores help bring about perceptions of the same thing, in so far as the specific stimuli have attained the same repertoire of beliefs, or action-patterns. Without such patterns the sensory core would at best be a mere 'that' and not a part of any perception, and there is good reason to believe that without them it would not even be sensed. It is these associated beliefs that give it meaning and transform it into an image. Resemblance-character, if occurrent, is merely an accident. Also, perceptive experiences grow and change in the processes of living. Thus a sensory core that might start by evoking a belief that something is moving in the grass, may develop to indicate: it is an animal; it may be a ground squirrel; no, it is a hunting cat; with transformations of the expectancy at every step. This becomes very similar to Professor Dewey's method of inquiry that transforms the object, at least as known, at every step of its advance.

Possibly Mr. Russell has in mind something equivalent to what I have called a repertoire of action patterns when he says: "Images are usually sufficiently vague to be capable of 'meaning' any member of a rather ill-defined class of possible or

actual percepts."[39] Although the percept was something "in the head."[40] Now, as an example, he continues "Such an image of a fox as I can personally form would fit any ordinary fox"— which is surely not in his head—and we now have a new definition of percepts "as events having a certain kind of spatio-temporal relation to a living body with suitable organs."[41] The percept has become, in ordinary language, anything that is a source of stimuli to sense organs. The image here seems to be the same thing as the sensory core, and its "meaning" spreads out through the organism as incipient actions corresponding to the behavior patterns it has come to control.

If there is any difference between the core of a perceptive experience and an image, it seems to be that the sensory core, in the case of the image, need not have the same simple chain of causation leading to its occurrence that is present in the case of a perceptive experience. In the above example, the image arises from hearing a man say "I saw a fox." Mr. Russell is apparently a strong visualizer, so the auditory stimulus for him may produce a preliminary 'foxial color patch' or it may directly set off the appropriate expectation patterns with no sensory core beyond the heard sounds. In the latter case the sensed word is just as satisfactory an 'image' as the normal visual sensory core would have been, especially since the visual impression cannot really resemble the object that started the train of causation resulting in its occurrence. The important thing is to have the proper belief-attitudes function. Both image and word act as symbols and are as such functionally the same in respect to the belief-attitudes involved. Unless a word is also accepted as an image, an image is no different from the sensory core of a perceptive experience except in the fact that it may occur as the result of a somewhat different causal chain.

If this is so, the difference between an image and an idea also tends to vanish, for an idea is merely an image where the sensory core may be different from that aroused in the ordinary perceptive experience and the related belief-attitudes have be-

[39] *Ibid.*, 301.
[40] *Philosophy*, 137.
[41] *Inquiry into Meaning and Truth*, 357.

come emphasized. That is, to "have the idea of a fox" it is sufficient that the appropriate belief-attitudes be innervated, although this may take place as a result of some internal changes in the organism that need not be clearly related to any perceived external event or even to the words of a friend, as when the idea appears in the course of day-dreaming. The sensory core is likely then to be a word. So words can operate as ideas, if we mean by a word not a mere noise but a noise that has taken over the significance of some experience. Thus Mr. Russell describes an automobile driver as responding to the exclamation "there is a red light" exactly as he would have done if he had seen it.[42] "There is in him a conditioned reflex which leads him to respond to the words 'red light' as he responds to the sight of a red light." In this fact lies the justification for relating thinking to inner conversation. Mere inner recitals of word-like sounds could never fulfil the function of thinking; but if thinking is problem solving, then subvocal linguistic activities can be a psycho-physiological device for building up new behavior patterns innervated by the language used. Mr. Watson has never adequately developed this point. Thus the verbalizations, 'if there is a red light but no policeman is in sight and no one is at the crossing' may resolve itself into the pattern of action 'I can break the law safely at this time and will do so since I am in a hurry to get home.'

The term 'meaning' relates primarily to the behavior patterns involved. In relation to language these are "causal properties of noises acquired through the mechanism of conditioned reflexes"[43] and "no essential word in our vocabulary can have a meaning independent of experience."[44] We are told that meanings may be "learnt by confrontation with objects;"[45] but it should be added, to be consistent with the above, that confrontation must be followed by manipulation, or some sort of trial reactions to the object, since this is the only way in which conditioned reflexes may be acquired. It is curious that in dis-

[42] *Ibid.*, 241.
[43] *Ibid.*, 263-264.
[44] *Ibid.*, 363.
[45] *Ibid.*, 28.

cussing the perceptive experience of 'seeing a cat' some verifica-
tion is called for, yet we are told that for judgments of per-
ception "there is no 'method of verification'!"[46] I do not think
that the contradiction is avoided by reason of the fact that in
this latter passage Mr. Russell is discussing propositions which
he assumes can only be "verified by means of other propositions"
and so require basic judgments not verified but tested by experi-
ment to bridge the gap between words and non-verbal occur-
rences. It may be more convenient to verify some propositions
by other propositions; but I doubt if there are any propositions
that cannot, theoretically, be tested by experiment, unless they
are non-sense propositions. Mr. Schlick's quoted assertion that
"the meaning of a proposition is the method of its verification"
does not lead to the difficulties of an infinite regress, but is quite
in harmony with Mr. Russell's own statements, if Schlick means,
as I assume, that the meaning-implied actions—or conditioned
reflexes—are the instrumentalities through which verification
can be brought about. They are not the method, but determine
the method of verification.

In short, the situations represented by the terms perceptive
experience, image, idea, word, and meaning have this in com-
mon: in each there is a sensory core and associated beliefs or
conditioned reflexes that have become attached to it in the course
of past experiencing and are, so to speak, stripped for action as
a result of the conditions that produce the sensory element. In
the perceptive situation the causal chain leads directly from the
object or situation through the sensory stimulus to relevant
behavior patterns; by the term image, attention is directed to
the sensory element and in a lesser degree to its meaning, but
not to the causal chain that led to its occurrence; in the case of
an idea, the emphasis is on the meaning, and the character of
the sensory element and the conditions under which it arose are
in the background; the word is simply a noise that by the
processes of conditioning has been substituted artificially for the
naturally occurrent sensory element; and the term meaning re-
lates almost wholly to the acquired behavior patterns disregard-
ing the sensory element to which they have become attached.

[46] *Ibid.*, 357.

Mr. Russell sometimes forgets this account of the meaning of a word. He gives the following account of his childhood experience in learning the meaning of the word "hot":

There was an open fire in my nursery, and every time I went near it someone said "hot;" . . . they used the same word when I perspired on a summer's day, and when, accidentally, I spilled scalding tea over myself. The result was that I uttered the word "hot" whenever I noticed sensations of a certain kind. So far, we have nothing beyond a causal law: a certain kind of bodily state causes a certain kind of noise.[47]

I do not believe Mr. Russell was ever quite so mechanical in his responses. This description is much over-simplified but correct enough so far at is goes.[48] But it is not, however, an account of learning the meaning of the word "hot." Those who uttered the word to him were in all probability not merely trying to get him to echo back the word-sound but to get it attached to certain behavior patterns, so that a certain caution in action would be engendered toward hot things met in the future and unpleasant experiences would thus be avoided. This response-learning was the primary meaning of the word. It is quite common for children in learning such words to acquire an avoidance pattern of response with an extension of the meaning of the word to other things to be avoided, such as sharp knives, etc., and only later learn to distinguish between avoiding the hot, avoiding the sharp, etc. In this sense the general is often learned before the particular. At any rate, the power to evoke such responses is the meaning of the word according to his own theory, although the denotative element might be taken as part of its meaning.

A similar over-simplification appears in Mr. Russell's account of a perceptive experience. Nobody but a logician looking for an example merely "sees a cat." One sees a cat walking on the back fence, trying to get into the chicken yard, or sleeping by the fireside while one is engaged in writing a paper, changing one's clothes, going to dinner, or something of the sort. Of the possible repertoire of action patterns attached to the sensory stimulus, a selection takes place according to some sort of disposition previously acquired to cats, and affected by his present

[47] *Ibid.,* 157-158.
[48] Cf. E. B. Holt, *loc. cit.,* 39-40.

occupation. One might turn away, watch it with amusement, make ingratiating noises, or angrily drive it away. The repertoire of action patterns attached to a sensory core by past experiences is somewhat indefinite; but the ones actually going over to action are selected by the present conditions of the perceiver and his present relations to the perceived object. Nothing less is ever involved in any perceptive experience.

Certain peculiarities of Mr. Russell's theory of language have undoubtedly influenced his theory of mind and so must be dealt with here from that point of view. In *Analysis of Mind*, he was satisfied to find the origin of language in root words, and in *Philosophy*, he becomes highly ironic toward philosophers "who have a prejudice against analysis"[49] and contend that the sentence comes first and the single word later. This is in serene disregard of philologists[50] and of educators who have studied the language of children.[51] Also, one would expect a man who is a lover of analysis to begin with a whole and distinguish the parts in their relations within it rather than to tear out the parts and examine them in isolation. Yet this latter method is apparently Mr. Russell's method of analysis, and the result is that the character of the whole is never recovered, for it is replaced by an additive sum and not by an integration of its elements. This method shows its effects in his whole theory of mind. Something might have been learned as to this from a study of Marx and Engels—or even from Hegel.

In the *Inquiry into Meaning and Truth*, Mr. Russell is ready to concede that "only sentences have intended effects" and that "At the lowest level of speech, the distinction between sentences and single words does not exist."[52] His atomistic habits are, however, so set that he proceeds very much as if the natural order was words, sentence-syntax, and expression, whereas the natural order of analysis should be expression, words, and sentence syntax. Even the apparent use of a single word by a child is really a sentence in intent, although incompletely

[49] *Philosophy*, 51.

[50] Otto Jespersen, *The Philosophy of Grammar.*

[51] M. E. Smith, *University of Iowa Studies in Child Welfare*, Vol. 3, No. 5, 1926.

[52] *Inquiry into Meaning and Truth*, 32.

articulated. "Mama!" means "mama pick me up" or "mama come," etc., according to the inflection of the voice.

In the living use of language, beautifully exemplified in Malinowski's supplementary essay to *The Meaning of Meaning*, language is usually a prod directed to someone other than the speaker. Mr. Russell is not in fundamental disagreement with this view, for at the beginning of his chapter on "Language as Expression"[53] he says: "Language serves three purposes: (1) to *indicate* facts, (2) to *express* the state of the speaker, (3) to *alter* the state of the hearer." The classification is not very satisfactory, for it omits the important use of language as an instrument of thinking, and its third point really includes (1) and often (2).

In the case of "indicating" facts, one would not take the trouble to indicate them, or be able to select the facts to be indicated, if the act was not intended to shape the action of the auditor in line with some interest of the speaker, although such action may be remote. In the most trivial case, the casual expressions of a relaxed mood such as "that's a pretty flower" or "there's an interesting cloud formation," fulfill the half-intended function of getting a common focus of attention that eases a sense of awkwardness, or loneliness, that most people feel when silent in the presence of others, unless they are intimate friends. In the pedagogical situation, I am sure, Mr. Russell intends to bring people to think differently because they have read what he has written. Certainly factual education in science is intended to affect those educated either in carrying on further research or in making practical applications of what they have learned.

Expressions of the state of the speaker are sometimes only pseudo-linguistic, analogous to animal cries; only they are usually stereotyped by language-using human beings. Such utterances may be made by persons alone, or in disregard of the presence of others. If overheard by others, they may call forth desirable reactions of sympathy, shared fear, etc., or undesired laughter. Sometimes they are intended to warn or to bring about coöperation. In more complicated cases self-expression may

[53] *Ibid.*, 256.

result in oratory or poetry, where there is a definite intent to affect others and produce a mood in them that may alter their lines of behavior either toward oneself, toward some feature of the environment, or toward a social situation. This is the most common use of propositions that are "significant but not true."[54] At least the state of the hearer is altered and consequently later action should be; although I am not sure that Mr. Russell would accept the close relation of emotion to action that I believe is real, and which a more adequate conception of analysis would have made relevant.

Alteration of the state of the hearer is then an aspect of both of the other uses of language. It is clearly the aim of commands, requests, encouragements, and warnings. But even in these cases the ultimate purpose may be to alter the state of the speaker, as when I say "shut the door" so that I may cease to be cold, or ask how to get to a certain place to remove a condition of uncertainty or conflict in myself. Such expressions are likely to contain ingratiating elements such as "please," or "will you be so kind as to," or threatening elements such as "you must," etc., which are all half-conscious recognitions of the relation of mood to action. Language has many devices not only for evoking moods but also for producing attitudes of certainty, uncertainty, confidence, security, and the like, all of which attitudes are a part of the change of state brought about in the hearer. They require psychological understanding as living occurrences before they can be represented in logical formulae.

I cannot quite follow Mr. Russell when he says that "At the lowest level of speech, the distinction between sentences and single words does not exist. At this level, single words are used to indicate the sensible presence of what they designate."[55] If the single word really does not exist, then we apparently have what philologians call holophrastic speech, and anything that looks like a word is really a sentence-word. This seems to be the case in childen's early speech, at least before they learn that to increase their vocabulary by learning the names of things is to increase their power to influence the action of others in line with

[54] *Ibid.*, 369.
[55] *Ibid.*, 32.

their own interests. The sense of language as an instrument of self-assertion by which mastery of the environment can be increased is probably the most primitive idea of language for both the child and for primitive man, and for both it is a form of magic because of their exaggerated notion of its effectiveness. But just as Mr. Russell never begins the analysis of mind with the study of acts of living conscious behavior to pass from that to specific reactions as a part of such behavior, so he never begins the study of language with living language but with a logician's specimens. His method perfectly exemplifies Jean Paul Richter's witty characterization of the Englishman as one who finds out what a camel is by going out and shooting a specimen which he brings home and dissects, proudly pointing out the parts and saying "That is a camel!"

In accepting the primacy of change, as Mr. Russell does in describing objects as events, it might be expected that he would be interested in the processes of change; but this would require an interest in historical process that seems to be entirely lacking in him. This may be a reaction against the somewhat artificial and pedantic historicity of Hegel. However, it is not always well to pour out the baby with the bath. The analysis of the historical development of both mind and language, both with relation to the cultural history of mankind and to ontogeny, can give a certain understanding of specific processes that cannot be attained by any manipulation of logical processes. If this method had been followed, neither his conception of logic nor of grammar would have quite that element of transcendentalism which they now possess and which is not in harmony with his general conclusions.

For the philosophy of language the real problem is how primitive holophrases get disintegrated into sentences or come to be replaced by them. There are many clues to this process to be found in an all-out application of our knowledge of the formation of conditioned reflexes—a subject Mr. Russell treats somewhat gingerly. One basic point should be kept in mind: if we neglect possible animal languages, the users of language are men, with basic similarities in their physiological make-up, and living in the same physical world. At least they all must eat, and to do this they have to take account of the character of the world

in which they live. Language develops as an instrument to further coöperative endeavor in fulfilling this and other basic demands of life. It follows that a developing structure of language will be determined by the success or failure of the kinds of analyses language-users hit upon in their experiments intended to meet the specific problems their environment and particular needs raise. Different languages have solved these problems in different ways; hence the great differences in syntactical structures that have been attained, and the broad similarities that result from the fact that their activities are carried on in the same physical world. A language is therefore a record of the cultural history of a people and in some degree a measure of the level of development they have attained. Without knowing Bantu or Patagonian, I am certain that it would be difficult, if not impossible, to translate Einstein's physical theories into either of them. Probably the complex relational elements involved in Mr. Russell's symbolic logic require a degree of complexity in the analysis of experience that would make it unintelligible to either of these peoples in their present level of cultural development and unexpressible with their present linguistic equipment. This implies, of course, not a racial, but a cultural limitation.

Logic, like language structure, is really a pattern of nature reflected in the processes of mind. It has been developed in human organisms through interactions between themselves and the physical world, so it is marked by the characteristics of the physical world, the nature of the human nervous system, and the animal drives that have instigated human actions. The logic pattern is the more universal among mankind because it more closely reflects the characteristics of the physical world, whereas the linguistic pattern is more closely related to human interests. But if this is so, the question that motivates Mr. Russell's last chapter of the *Inquiry*[56] should be replaced by another question. Instead of asking: "What can be inferred from the structure of language as to the structure of the world?" the correct question is: Why, or in what degree, does the structure of the world make a certain language pattern useful in a certain state of the cultural development of the people using it? Where Mr. Russell's ques-

[56] *Ibid.*, 429-438.

tion raises grave problems if one should try to answer it with reference to a variety of languages having comparatively unrelated syntactical structures, the substituted question can throw much light on the significance of particular forms of linguistic usage. Analogous questions can be asked with respect to the structure of mind. In Mr. Russell's form it would probably result in Hegelianism or in some sort of German Romanticism; but the substituted question would give results quite in harmony with the aims of his philosophy.

In summary: Mr. Russell's main difficulties seem to me to spring from his early preoccupation with symbolic logic; and the result is the distorted conception of analysis that has furnished the theme for much of what I have written above. As corollaries to the consequent methodological confusion, there are (1) an inability to get free from the atomic thought-model of the British Empiricists which seeks to compound ideas out of impressions almost as a chemical formula suggests that molecules may be constructed out of atoms by utilizing their affinities and valencies; (2) a substitution of a logical manipulation of ideas for an analysis of their factual background and a replacement of their living meaning by the verbalisms of logical positivism; and (3) an absence of the historical and genetic understanding of the processes by which the properties of mind have come into being that must be a part of any philosophy that is based on such a conception of changing reality as is presented by modern physical, biological, and social sciences.

The differences between my criticisms of Mr. Russell and Professor Lovejoy's should be evident from the above. That Mr. Russell has left his theory full of inconsistencies, as Mr. Lovejoy asserts, is, I think, undeniable. He has, however, the gift of clear and forceful literary style, and, on Bacon's principle that truth emerges more quickly from error than from confusion, I owe much to Mr. Russell. He may think it a back-handed tribute, but I have him to thank for freeing me from the blandishments of symbolic logic with which I was once intrigued; and from the vivid but halting efforts of his animal faith to state a physiological theory of mind, I have discovered many problems

that have deepened my appreciation of the importance of Mr. E. B. Holt's *Animal Drive and the Learning Process*. Whatever clarity as to the nature of mind I now have is due to Mr. Russell, Mr. Holt, and to the analytic methods of dialectical materialism.

HAROLD CHAPMAN BROWN

DEPARTMENT OF PHILOSOPHY
STANFORD UNIVERSITY

15

*John Elof Boodin*

RUSSELL'S METAPHYSICS

## RUSSELL'S METAPHYSICS

BERTRAND RUSSELL'S philosophical writings are delightful reading. Whatever may be Russell's place in philosophy, his literary writings certainly deserve a place in any anthology of English prose. By this statement I do not mean to belittle Russell's contribution to philosophy. No contemporary writer has done more to stimulate interest in philosophy than Russell, and we are all indebted to him. His contribution to logic, perhaps, overshadows his contributions to other branches of philosophy because of its massiveness. But he has enriched brilliantly and suggestively every branch of philosophy.

I am concerned with metaphysics. Historically metaphysics includes cosmology; and owing to the modern interest in science, the emphasis today is on cosmology or the philosophy of nature. This field has been greatly enriched by Russell's lucid commentaries on science. In this brief sketch, I shall treat metaphysics as including cosmology. Russell does not often use the terms metaphysics or cosmology, but the broader term, philosophy, which is rather an indefinite domain. It includes, besides metaphysics, such topics as epistemology, logic, ethics and esthetics. Logic, including mathematics, occupies a distinct place in Russell's philosophy and is treated rather as a preparation for philosophy than as a part of philosophy. Russell thus follows in the footsteps of Plato.[1] Epistemology occupies a large place, and a great part of Russell's philosophical writings might be classed

[1] Plato did not have an exaggerated opinion of mathematicians as philosophers, greatly though he esteemed mathematics. In the *Republic*, he asks: "Did you ever know a mathematician who can reason?" By reasoning he means what he calls dialectic or metaphysical reasoning—reasoning about the ultimate meaning of things, not just formal logic.

as epistemology. But throughout there are certain metaphysical assumptions or implications which give credibility or the opposite to his treatment of the problem of knowledge.

In the history of thought, especially of modern thought, it is very important to make explicit certain metaphysical assumptions that are not defined but taken as tradition. Take, for example, the assumption of inert substance. It furnished the basis of the agnosticism of Locke and of many of his successors, including Hume and Kant. Berkeley denied the assumption of inert substance as meaningless and thought that he found a short-cut to idealism. One of the most momentous contributions of recent science is the conception of matter as energy, though its implications have not generally been recognized in philosophy. If "a thing is what it does," as Lotze put it, we can get acquainted with things, to some extent at any rate. I am using this illustration to suggest that the impasses of epistemology are generally due to undefined metaphysical assumptions and that we need metaphysical criticism. I surmise that one of the reasons that Russell does not often use the term metaphysics is that metaphysics in the past has often been uncritical of its assumptions. The positivists have brought from central Europe an uncritical metaphysics and condemned all metaphysics, being at the same time unmindful of their own uncritical assumptions which, though they may seem more up to date, are not necessarily more reasonable than the old assumptions. (I refer to physicalism.)

Russell's conception of a field of philosophy is not always clear. We are told as late as 1914, that "philosophy is a study apart from the other sciences: its results cannot be established by the other sciences, and conversely must not be such as some other science might conceivably contradict."[2] I cannot see what domain would remain for philosophy unless it would be angelology. What Russell evidently had in mind were certain mathematical concepts. A large part of Russell's most systematic work on philosophy—*Our Knowledge of the External World*—is devoted to the mathematical treatment of the Continuum and Infinity. We are told that to men engaged in the pursuit of science, "the new method, successful already in such time-honoured

[2] *Our Knowledge of the External World* (1914), 256.

fields as number, infinity, continuity, space and time, should make an appeal which older methods have wholly failed to make."[3] But he suggests, further, that "physics, with its principle of relativity and its revolutionary investigations into the nature of matter" opens a new field for interpretation. Certainly, this field cannot be isolated in the way that Russell suggests philosophy should be.

It is a bygone superstition, as Russell has later recognized, that mathematics, as such, gives us an insight into reality. The mathematical continuum has nothing to do with the physical or metaphysical continuum, as H. Poincaré has pointed out.[3a] The mathematical continuum is essentially discrete. It is an order concept. Furthermore, there is no next in a mathematical continuum. There is always an infinite number of entities between any two, whereas in a physical continuum, there is nothing between. Newton's absolute space, which Einstein rechristens as space-ether, may be taken as a type of physical or metaphysical continuum. According to Einstein,

the ether of the general theory of relativity is a medium which is itself devoid of all mechanical and kinematical qualities but helps to determine mechanical electromagnetic events . . . . This ether may not be thought of as endowed with the quality characteristic of ponderable media, as consisting of parts that may be tracked through time. The idea of motion may not be applied to it.[4]

It was Leibniz's confusion of the two types of continua that led him to postulate an infinite number of monads between any two monads. That is what happens from mathematicizing nature.

The infinite furnishes an interesting sport for the mathematician. The question whether infinite collections exist is still debated among mathematicians. But the mathematical concept of infinity tells us nothing about the finitude or infinity of the world. That question must be settled on empirical grounds. It is not an *a priori* matter, as Kant supposed. Geometry is not con-

[3] *Ibid.*, 262.

[3a] See the author's "Cosmic Attributes," *Philosophy of Science* (January, 1943), 3.

[4] Einstein, A., *Sidelights of Relativity* (1922), 17.

cerned with space as Kant, who thought that Euclidian geometry determines space, supposed. To quote Russell:

It was formerly supposed that Geometry was the study of the nature of the space in which we live. . . . But it has gradually appeared, by the increase of non-Euclidian systems, that Geometry throws no more light upon the nature of space than Arithmetic upon the population of the United States.[5]

Mathematics is a fascinating game of logic, as Russell has shown; and it can be made an instrument of research, but only by selection. It does not dictate to reality. Metaphysics must liberate itself from mathematics, or, rather, from mathematicizing philosophers, who confuse logic with metaphysics. This charge, however, cannot be laid to Russell.

Following Leibniz, Russell treats space and time as relational. Russell has been careful to point out that space and time may be taken in different senses. He distinguishes between subjective or private space and time and physical or public space and time. In either type a good case can be made for the relational theory of space and time, though it would still remain to distinguish the *quale* of spatial or temporal relations. This *quale* is not itself relational. And it is this *quale* with which the metaphysician is concerned. What distinguishes spatial from temporal relations and these from other relations? Unless we can find the distinguishing difference, we have mere tautology. We keep repeating that spatial relations are spatial relations and temporal relations are temporal relations. We must find the metaphysical basis of spatial relations or of temporal relations.[6]

The mathematical analysis of spatial or temporal relations in nature, as Russell well knows, cannot be determined *a priori*. Mathematics furnishes us possibilities; it does not decide facts. Whether relations are discrete or continuous, finite or infinite, etc., must be settled by evidence. Mathematics is not concerned with the empirical world. After all, mathematics is entitled to its own world. There is nothing so admirable about the factual

[5] *Mysticism and Logic* (1929), 92.
[6] I have dealt with the metaphysical meaning of space and time in "Cosmic Attributes," *Philosophy of Science*, Jan. 1943, pp. 1ff.

world. The mathematicians are not to blame if metaphysicians confuse types.

The trend of Russell's philosophy shows a decreasing faith in formal logic and an increasing respect for what he takes to be scientific fact. Russell's odyssey in science is a fascinating study which cannot be given here. There is a strain of Platonism in his earlier period which goes very well with an exaggerated respect for mathematics. Even as late as 1914, in his important Lowell Lectures, there is evident a nostalgia for Platonism in his belittling of time:

> Nevertheless, there is some sense—easier to feel than to state—in which time is an unimportant and superficial characteristic of reality. Past and future must be acknowledged to be as real as the present, and a certain emancipation from slavery to time is essential to philosophic thought . . . . A truer image of the world, I think, is obtained by picturing things as entering into the stream of time from an eternal world outside, than from a view of time which regards time as the devouring tyrant of all that is. Both in thought and feeling, to realize the unimportance of time is the gate of wisdom. But unimportance is not unreality.[7]

I side rather with Shakespeare that the important thing is *timeliness*. But the panorama of Platonic forms and essences soon fades upon the somber background of a naturalistic world view.

It is evident that Russell became more and more impressed with physics and recognized correspondingly the formal and instrumental character of mathematics. With this shift in emphasis, philosophy comes to have a more empirical function. He comes to the conclusion: "Philosophy is distinguished from science only by being more critical and more general."[8] His later books, for example, *Analysis of Mind*, 1921; *Analysis of Matter*, 1927; *An Outline of Philosophy* (American edition, *Philosophy*), 1937; etc., become commentaries on contemporary science. His faith in science remains unshaken, though science has been changing with bewildering rapidity. In 1914, he could write:

[7] *Our Knowledge of the External World* (1914), 181.
[8] *Philosophy* (1927), 297.

The law of gravitation, at least as an approximate truth, has acquired by this time the same kind of certainty as the existence of Napoleon, whereas the latest speculations concerning the constitution of matter would be universally acknowledged to have as yet only a rather slight probability in their favour.[9]

That was on the eve of the new relativity, to which Russell has given enthusiastic and unconditional adherence; and Russell had not as yet become impressed with the revolutionary progress in the realm of matter, though he showed proper enthusiasm when he became acquainted with it. Russell deserves great credit for his zeal in making the results of physics known to the world. His knowledge of mathematics enables him to follow the new developments in detail in a way few philosophers can do and his marvellous style makes the new discoveries read like a novel. My feeling, however, is that he would have done more for philosophy if he had been more sceptical about the new science. I do not mean to cast any slur on the scientists. They have been doing their very best for science. The question is: what have they done for metaphysics?

We must now examine the recent developments in science which form the basis of Russell's present philosophy.[10] We must inquire: What metaphysical import have these developments? We shall fasten our attention on crises in science. A crisis in thought may be more instructive than the attempts to rationalize it. There have been two such crises in the recent history of science: the Michelson paradox and the Bohr paradox. The Michelson paradox led to the Relativity theories; the Bohr paradox led to wave mechanics and quantum mechanics.

The Michelson experiment, in the latter part of the nineteenth century, is too familiar to need restatement. The experiment was designed to show the motion of the ether in relation to the earth. That could only be done by showing the relative motion of light, since light was supposed to be a motion of the ether.

[9] *Our Knowledge of the External World*, 72. (Open Court ed., 1915, pp. 67-68.)

[10] I am sketching these developments in my own language in order to bring out the problems which I have in mind. I take it for granted that the reader is familiar with Russell's masterly treatment in *A B C of Relativity, Analysis of Matter*, etc.

But the result of the experiment was a great shock. It made no difference to the velocity of light whether a body (the earth, for example) moves in the same direction as the light or in the opposite direction or the transverse direction, nor does it make any difference whether the source of light moves or is stationary. Here was a paradox that called for explanation or hushing up. The efforts at explanation aimed to save the classical conception of velocity of light, viz., that entities—waves or particles— travel through space from point to point. We remember the Fitzgerald-Lorentz contraction which was intended to show why the motion of the earth makes no apparent difference to the velocity of light. The difficulty now was to find the absolute velocity of the earth, since not only is the earth moving round the sun, but the sun is moving and our galaxy is moving and perhaps our supergalaxy.

Here is where Einstein came in with his special theory of relativity. This was a great simplification. You could always regard your own frame of reference, the earth for example, as stationary, as observers before Copernicus had done, and attribute the motion, with the apparent contracting of the lengths and the retardation of the durations—the clock intervals—to the other body or bodies under observation. But if you should choose to imagine yourself as making your observations from the sun, as Copernicus did, then the earth and other bodies, moving with reference to the sun, would have to take the blame. Motion is supposed to be relative, so it doesn't matter which body is supposed to be moving. Since you can get rid of motion in a wink by merely shifting your frame of reference, some have been inclined to regard motion as an illusion, though if there is no motion at all it is difficult to understand how the illusion of relative motion could arise. The special theory of relativity is silent upon this point.

The special theory of relativity has been called a "dodge" by Sir Arthur Eddington. The question which it dodges is: Does light travel? If so, in what sense? P. W. Bridgman drew the inference from the Michelson experiment that light does not travel:

We are familiar with only two kinds of thing travelling, a disturbance in

a medium, and a ballistic thing like a projectile. But light is not like a disturbance in a medium, for otherwise we should find a different velocity when we move with respect to the medium, and no such phenomenon exists; neither is light like a projectile, because the velocity of light with respect to the observer is independent of the velocity of the source.[11]

What is true of light is, of course, true of all radiation:

In essence the elementary process of all radiation, perceived as radiation, is twofold. There is some process at the source and some accompanying process at the sink, and nothing else, as far as we have any physical evidence; furthermore the elementary act is unsymmetrical in that the source and the sink are physically differentiated from each other.[12]

What is clear is that light does not travel in the sense that material entities travel.

Here we have a scandal, comparable to that in the fifth century B.C., when Hippasos of Metapontion discovered the incommensurability of the diagonal of a square with the side and upset the whole Pythagorean theory of number, and with it the metaphysical system based upon it. The story is that Hippasos, as a reward for his discovery, was taken out and drowned by his fellow Pythagoreans. It was not convenient to drown Bridgman, but his interpretation has been very effectively suppressed. You ask: Why should I bother about a heresy like this? And my answer is that all progress comes by heresies and this heresy points to something fundamental.

I cannot see that the special theory has made any contribution to metaphysics, whatever value it may have to science as a dodge. I asked a distinguished physicist what fact the special theory had discovered and he replied at once: "It has shown that mass increases with velocity." And then he thought and added: "But that is a matter of frame of reference." J. J. Thomson had proved experimentally, at the beginning of the century, that the mass of an electron increases with the velocity. He thought first that the entire mass of the electron is due to velocity, but he soon found that he must take account of "resting mass." What is peculiar to the special theory is the unique place of the velocity

[11] *The Logic of Modern Physics* (1927), 164.
[12] *Ibid.*, 164, 165.

of light. It predicted that particles approximating the velocity of light would have a sudden increase of mass and that nothing could move with the velocity of light, because then it would acquire infinite mass. The prediction had partial verification in the case of beta particles from radium. These have a velocity of 98% of that of light and the mass is as predicted.[13] But why is light a limiting velocity? If the velocity of light is like a material motion, as is assumed, then light (which travels with the velocity of light) should have infinite mass and we should be killed like flies. This is only another proof that light does not travel in the sense that material particles travel.

Does the general theory of relativity have any metaphysical significance? It is, of course, impossible to give an account here of the general theory, which is a theory of gravitation. It had its source in problems which the Newtonian theory could not explain. As a matter of fact, the only problem whose nature was really understood was the irregularity (on Newtonian principles) of the perihelion of mercury. The curvature of light in the neighborhood of the sun and the deviation of light, coming from the sun, towards infra-red, were consequences which Einstein predicted. Einstein, however, did not take the equations out of his hat. The gravitational mass of the sun was known and he also knew that, except for the immediate neighborhood of the sun, the Newtonian equations, based upon the inverse square, worked. Einstein called his theory "a correction," though in the end the Newtonian equations were regarded as a limit.

Einstein adopted Minkowski's combination of space and time into space-time, i.e., into four coördinates or numbers, three numbers for measurement of the spatial relationship and one for the temporal. The significant aspect is the junctions of space-time or of the numbers. We may regard the combination of space and time measurements as a convention which has proved useful in a certain domain of physics, where we are dealing with continuous properties of the physical world, or with what Russell calls "chrono-geography."[14] The method is not relevant to discontinu-

[13] This seems to be a physical fact; but according to the special theory you could shift your frame of reference to the beta particle and then the velocity and increase of mass would be in its environment.

[14] *Philosophy,* 284.

ous facts, such as electrons and Planck's quantum. The same would be true for any emergent discontinuities in nature. And the world is full of such discontinuities, from the electron to a new idea in a man's brain. It has been Einstein's ambition to unify all the facts of physics under general relativity. In his Nottingham address, June 7, 1930,[15] he thought that space would "eat up matter," i.e., that he could reduce physics to geometry. But in this he has failed.

Einstein's gravitational hypothesis scored a brilliant success. It met satisfactorily the three problems which he had raised. But what is its metaphysical significance? The combination of space-time is a convention and has no metaphysical significance. How far it is applicable remains to be seen. It cannot be applied to the discontinuities in nature. And these seem to be the facts with which we are mostly concerned. The only absolute continuum, of which we know, is space. According to Einstein matter changes the geometry of space in its immediate neighborhood. If space or space-ether is such as Einstein describes, i.e., if "it has no parts that can be tracked through time" and if "it has no mechanical or kinematical properties," it is difficult to see how it could be altered by matter. But, after all, space is an empirical entity and we must be prepared to discover new properties. We know, however, that matter is granular. If matter is the cause of the curvature of space, why shouldn't matter produce a discontinuous lattice in space, rather than the continuous type required by Einstein's equations? In that case matter would "eat up" geometry, rather than the opposite. It is true that we can use differential equations in dealing with gravitational phenomena, but so can we do in thermodynamics, where the basis is evidently discontinuous. The differences may average out in dealing with large numbers.

Russell, in the interest of his positivism, takes the extreme position that gravitation is reduced to "crinkles" in space-time. He is thus able to eliminate matter. But isn't that ingratitude to matter? According to Einstein, matter is the "cause" of the curvature of space or space-time. After all, something must determine "crinkles," for the gravitational field certainly varies.

[15] Reported in *Science*, June 13, 1930, pp. 607, 608.

The fact is that the "curvature" or "crinkles" are merely metaphors for the equations, which seem to work. I am concerned with the physical or metaphysical character of nature, not with metaphors.

It is not possible, at present, to say what physical or metaphysical significance we can attribute to the general theory of relativity. There is, however, one implication or inference that Einstein makes which is highly significant. And that is that inertial mass (or resting mass), as contrasted with kinetic mass (which varies with motion), is a function of all the matter in the universe. That means that all the matter in the universe is immanent in every particle.

I challenge Russell's assertion that relativity theory has banished cosmic space and cosmic time. I have to fall back on Einstein. As regards space, "Newton might no less have called his absolute space 'ether'; what is essential is merely that, besides observable objects, another thing which is not perceptible must be looked upon as real to enable acceleration or rotation to be looked upon as real."[16] I have already given Einstein's characterization of this cosmic space-ether. If Einstein requires cosmic space, he no less requires cosmic time. Unlike Newton, he does not merely rely on his imagination for his uniform cosmic time. Einstein points to a specific example in nature of a cosmic clock. "He chose the atom as the specific thing. Doubtless the reason was the apparent simplicity of the vibrating mechanism of an atom, as shown by the precise equality of the frequencies emitted by all atoms of the same element."[17] Bridgman suggests that we might select "the life period of a radioactively disintegrating element" as the basis of our clock. We know that radioactivity is independent of motion, heat and all other physical conditions. As a matter of fact, the geologist uses radioactive disintegration as the most reliable basis for calculating the age of the earth. Another cosmic measure of time is the Foucault pendulum, "the invariance of the plane of which is always essentially determined by the rest of the universe" (to quote Bridgman). I think I may say that cosmic space and cosmic time are as important in the new

[16] Einstein, *op. cit.*, 17.
[17] P. W. Bridgman, *The Logic of Modern Physics*, 177.

physics as in classical physics, and the evidence has become clearer.

Another crisis, comparable to the Michelson crisis, occurred in the world of microphysics. Nils Bohr, a young physicist, was working with Rutherford who had evolved the picturesque conception of the atom as a miniature solar system, with a nucleus in the centre and satellites moving around the nucleus. For the sake of simplicity, we may take the hydrogen atom. The nucleus is the proton, consisting of positive electricity and the one satellite is a negative electron. Bohr made an important change in the model about 1913. He found that the orbits, in which the satellite electron could revolve, follow Planck's quanta numbers. But something really happens only when the electron shifts from one orbit to another. When it shifts from an outer to an inner orbit, there is emission of radiation. When the shift is from an inner orbit to an outer, there is absorption of energy. We must keep in mind that the electrons, for Bohr, are material entities and that the intervals of the orbits are spatial intervals. The circular motion of the electrons produces no effect (contrary to classical theory) and soon drops out of the picture, so far as further interest is concerned. The only events which we know are the emission and the absorption of energy.

The startling discovery was that *the shift of an electron from one orbit to another is instantaneous.* By this time scientists had become hardened to paradoxes and there was no such remonstrance as there was to the implication, brought out by Bridgman in the case of the Michelson experiment, that light does not travel. Perhaps the electron seemed too small to be taken seriously. The chemists went on working with the paradox and had brilliant results.

But the mathematical physicists saw the challenge and took it up. The solution offered by Schrödinger interests me most, because it is a metaphysical or physical solution, at least in the first stage of the problem. Schrödinger proposed, instead of a particle, a wave—not a wave that travels, because that would raise again the problem of the instantaneous shift, but a stationary continuous wave, like a mathematical wave. The Schrödinger wave does not move. Events occur only when there are "beats" or conflicts

of waves. A wave is present throughout space. It is immanent in the cosmos. We can think of one wave in terms of three dimensions. When we have a relation between two waves the word, dimension, changes its meaning, because now we require three more dimensions to describe the relation. For every additional wave, we require three more dimensions. Although a wave is present throughout physical space, there is a superposition of waves and the conflict of waves would account for the decrease of intensity in proportion to the square of the distance. Physics becomes harmonics. Pythagoras' dream of assimilating physics to music or music to physics was in a way of being realized. There are, of course, various problems; but the important thing is that the theory, at any rate in its early stages, moves on a physical plane. When the discussion shifts levels, or rather types, from metaphysics to epistemology, and the waves become waves of probability, I have no further interest in it. Epistemological waves are in peoples' heads. They are methods of prediction; and my interest is in metaphysics.

I can understand Schrödinger's conception more clearly when I think of it in terms of his gestalt theory which is fundamental in his conception of nature. Schrödinger's gestalt, or whole-form, is intrinsic to nature, not like the forms of classical physics—the vibrations of a membrane, the antennae field—which, in the first place, are due to external conditions and for the most part derive from the objective of the experimenter. "In the second place, the assumed field-function is regarded as a collective sum of separate values." As Schrödinger conceives the gestalt, the characteristic functions (*Eigenfunktionen*)—as illustrated in atoms and molecules—are due not to incidental or conditional factors but are "determined by nature." In other words: "The characteristic functions are due to the immanent patterns which determine the observable occurrence."[18] These immanent atomic patterns are determined by the whole structural field of the cosmos. Since light (radiation) is a dynamic function of the cosmic gestalt or whole-structure, it is independent of space-time relativity.

[18] *Die Naturwissenschaften* (June 28, 1929), 489.

After this preliminary survey, we come now to the heart of Russell's metaphysics. The crucial concept is that of *event*.

Everything in the world is composed of "events;" that at least is the thesis I wish to maintain. An "event," as I understand it, is something having a small finite duration and a small finite extension in space; or, rather, in view of the theory of relativity, it is something occupying a small finite amount of space-time. If it has parts, these parts, I say, are again events, never occupying a mere point or instant, whether in space or in time, or in space-time. When I speak of an event, I do not mean anything out of the way. Seeing a flash of lightning is an event; so is hearing a tire burst, or smelling a rotten egg, or feeling the coldness of a frog.[19]

He goes on to illustrate further: "Particular colours and sounds and so on are events; their causal antecedents in the inanimate world are also events."[20]

The illustrations are more illuminating than the definition. The definition is atomic. One space-time entity is regarded as an event. But I recognize only an encounter or an operation as an event. Heraclitus called it "exchange."[21] We would call it inter-action. One entity, even though it be conceived as a space-time entity, cannot be an event. In his illustrations, Russell gives examples of events. A flash of lightning is certainly an event, but it involves interactions of several entities. On the other hand, "particular colours and sounds" are not events from my point of view, but are functional aspects of rather complex events with their space-time relations. Entities are really abstractions. Nothing concerns us except transactions, or encounters, which we call events. We analyze these transactions into entities and relations, but these only exist in transactions.

Russell's philosophy is based upon events. But an event, to become a fact for science, must be observed or leave traces of action which can be observed. Events do not observe themselves.

---

[19] *Philosophy*, 276.

[20] *Ibid.*, 277.

[21] Heraclitus' metaphor of "exchange" was borrowed from the market place. Bridgman's metaphor of operation was borrowed from the laboratory. This definition of event agrees with Einstein's statement that it is only the *junctures* of space-time series that concern physics.

If they did, we should not have the Heisenberg dilemma. It should be noted that Russell does not ask: What is an event operationally? He merely defines it, as a mathematician would define it. In that way he escapes the Heisenberg dilemma, viz., that observation is an operation and requires light, and light modifies the nature of the event. Heisenberg himself approached the problem from the point of view of classical physics. He then found that it complicates the situation if you throw light upon it in order to observe it. The mathematician does not have to worry about Heisenberg's problem. The mathematician's light is purely intellectual and does not disturb the entities he observes. In short, he is not concerned with factual conditions. He lives in a world of abstractions. He makes his own world. Ask him how many dimensions there are, and he answers: "That is as I choose. That is part of the game." That is why a mathematician, like Leibniz, can give us such a strange world, with its windowless monads which behave just as though they had windows; and know it! At least Leibniz, the mathematical god, knows it, because he chose to make them that way. The mathematician is a magician. He can create a world out of nothing. All he needs to do is to say: "Let there be!"[22] That is why he is so dangerous in metaphysics and why so much mischief has been done by mathematicians in philosophy. Of course, mathematicians ordinarily distinguish their play world from the world of fact. Otherwise they would be subjects for psychiatry. It is only in metaphysics that they are allowed to confuse fact and fancy, because they talk a language that very few, if any besides themselves, comprehend. It is the great merit of Russell that he uses a language that a scientifically trained man can understand.

How does Russell use his conception of events in accounting for our knowledge of the external world?

I conceive what happens when we see an object more or less on the following lines. For the sake of simplicity, let us take a self-luminous object. In this object, a certain number of atoms are losing energy and radiating it according to the quantum principle. The resulting light-waves . . . consist of events in a certain region of space-time. On coming

[22] In one respect he is limited: he is obliged to respect the law of contradiction. But so was the scholastic god.

in contact with the human body, the energy of the light-wave takes new form, but there is still causal continuity. At last it reaches the brain, and there one of its constituent events is what we call a visual sensation.[24] This visual sensation is popularly called seeing the object from which the light-waves started—or from which they were reflected if the object was not self-luminous.[24]

Between the self-luminous body and the brain of the percipient, "there are successive events at successive places."[25] But "the only events in the whole series about which I can say anything not purely abstract and mathematical" is the visual sensation. Since there is supposedly a long chain of events "between an external event and the event in us which we regard as the perception of the external event," we cannot "suppose that the external event is exactly what we see or hear; it can, at best, resemble the percept only in certain structural respects."[26] We can reverse the process:

Now let us start from the sensation. I say, then, that this sensation is one of a series of connected events travelling out from a centre according to certain mathematical laws, in virtue of which the sensation enables me to know a good deal about events elsewhere. That is why the sensation is a source of physical knowledge.[27]

There is here no difficulty, he thinks, about interaction of mind and body.

It all seems clear so long as we stay in the realm of orthodox physics. But it is an illusory simplicity. Events, as predicated in physics between Sirius and my brain, are not on a par with the sensation of light. The hypothetical intermediate events are constructs. Only the sensation, according to Russell, can be said to be real. It is supposed to be the only real "stuff" of things. But first of all it is psychical. To quote Russell:

... all data are mental events in the narrowest and strictest sense, since they are percepts. Consequently all verification of causal laws consists

[23] I would use the term, event, only for such an encounter, i.e., for something that can be observed.

[24] *Philosophy*, 148-149.

[25] *Ibid.*, 150.

[26] *Ibid.*, 294.

[27] *Ibid.*, 150.

in the occurrence of expected percepts. Consequently any inference beyond percepts (actual or possible) is incapable of being empirically tested. *We shall therefore be prudent if we regard the non-mental events of physics as mere auxiliary concepts, not assumed to have any reality, but only introduced to simplify the laws of percepts.*[28]

To ask whether our sensations or percepts are like the hypothetical constructs which are projected as their causes seems like a meaningless question. It is asking whether a color is like an equation.

Russell cannot solve the problem by contrasting physical or common space with subjective or private space. "The coloured pattern that we see is not 'out there', as we had supposed; it is in our heads, if we are speaking of physical space."[29] But physical space is not something experienced as is private space. All that we experience of nearer and farther or earlier and later is in our private space. Public space, with its perspectives, is merely an ideal construction, and it is difficult to see what basis there can be for such a construction in a private space which is merely in our heads. Leibniz solved the problem of correlating the subjective events and their relations within his monad with those of other monads by invoking his god (always accommodating, since he is merely a definition). But Russell is an atheist, and his only way out of the impasse is to fall back on his dogmatic faith in physics. That may seem question begging, since he admits that the world of physics, on his view, is merely an ideal construction, in order to simplify his description of his subjective world. He does not like solipsism; but his philosophy certainly condemns him to it, remonstrate as he may.

To sum up Russell's results so far: Sensations or percepts, in a certain region of the brain, are the ultimate facts. But a region of the brain and the brain itself, according to Russell, are constructs for our convenience in simplifying our subjective data. To put these hypothetical constructs on a par with the subjective data, as figuring in one chain of causality, is to confuse types. The sensations or percepts are the only real facts, on Russell's view.

But are they facts? Does anyone observe a sensation? We have

[28] *Ibid.*, 290. *Italics* are mine.
[29] *Ibid.*, 13.

sensory experiences of some sort of world. The baby's "big blooming confusion," of which William James speaks, is not something in a region of the baby's brain, so far as we can ascertain. It seems to be objective to the baby's experience of it. It is something to which it reacts more and more selectively. When the baby sucks anything it can get hold of, it probably does not feel that it is sucking a sensation in some region of its brain. It reacts to something external. This something is apparently an extensive and moving manifold. It is especially moving things which instinctively attract the baby's attention. But it is attracted also to loud noises, to pain and other abrupt changes in its environment. Its world has various sensory aspects. It is warm or cold, sweet or bitter, it is bright or dark, with various other sensory characters. To react differentially in any precise way, it must wait for physiological development, such as the coördination of the eyes and the correlation of sight with touch. It must, further, wait for the development of habits and memories—what Russell calls mnemic causation. But from the beginning of its experience there is no reason to suppose that it locates its "big blooming confusion" in its head. It is biologically oriented to an environment. Sensations in a region of the brain are fictions in Russell's mind, the result of his physics. The abstraction of qualities, to be used as predicates, comes only with later experience, especially with the development of language.

In the latest phase of his development, Russell becomes a thorough positivist. Everything—things and selves—can be reduced to a "string of events." "Some strings of events make up what we regard as the history of one body; some make up the course of one light-wave; and so on."[30] The only events, however, that have factual significance are sensations. Physical events are nothing but mathematical constructs. Matter resolves itself in his interpretation of the general theory of relativity into "crinkles" in space, in other words, into equations. There is no thingness anywhere.

Russell uses the word causality a great deal, but in a Pickwickian sense. "The conception of cause—however loath we may

[30] *Ibid.,* 110.

be to admit that—is derived from the conception of 'will'."[31] And that is sufficient to condemn it, for has he not shown in the *Analysis of Mind* that will can be reduced to sensations? All we need is a succession of events (and, of course, equations of probability).

We have here a return to Hume, with resources of mathematics of which Hume was ignorant. The result is atomistic, even though the conception of the methematical continuum is introduced, for this after all is atomistic. The often repeated criticism of Hume, that a succession of perceptions is not a perception of succession, holds equally in regard to Russell's atomism. Here again we have an instance of a forgotten theology. Hume got his atomism of the succession of discrete separate entities from Malebranche. But Malebranche had a God who created the world anew in each instant of time and so furnished a rationale of the connectedness. Russell and Hume have nothing but the succession of atomic events. Russell's favorite illustration is that of the cinema. We all know that the pictures on the cinema screen have no causality. But one who knew only the succession of pictures could learn to predict. An even more picturesque illustration is the shadows cast on the blind in Oscar Wilde's "The Harlot's House:"

> Like strange mechanical grotesques,
> Making fantastic arabesques,
> The shadows raced across the blind . . .
> "The dead are dancing with the dead."

We may say that of the objective cat of common sense, we have not even the grin, we have only our private sensation of a grin.

It seems to me that Russell's neutral monism is an illusion. Our sensory awareness—"sensation" as Russell calls it—is real. But it is not identical with a mathematical equation. The two are different types. The equation of electromagnetic waves is supposed to describe part of a condition of our sensory awareness of light, but only part; for the physiological structure of retina, optic nerve, ganglia and cerebrum are also part of the condition,

---

[31] *An Inquiry into Meaning and Truth* (1940), 293f.

so much so that a flash of light can be produced by a blow on the head without the specific external stimulus. If a "sensation" is an emergent, how can it figure as a cause in a physical chain of events from a self-luminous object like Sirius? We cannot jump thus from the realm of direct experience to the realm of physics. I am reminded of William James' statement that he would rather have one raisin than the most elaborate bill of fare. The two are not commensurable. Neither is a "sensation" and an equation. I cannot agree, therefore, with Russell in the following statement: "There is, therefore, an important sense in which we may say that, if we analyze as much as we ought, our data, outside psychology, consist of sensations."[32] According to my view, sensory experiences are emergents from the physiological and physical conditions. They are not transcripts of the physical world.

At any rate, Russell's statement is clear. It is not confused as is E. Mach's statement. Mach regards the sensations as the only physical facts. Everything else is shorthand. "The physicist deals with sensations in all his work."[33] But how do we come to attribute "sensations" to an external world? Mach's reason is certainly a bit naïve. The same sensory aspects which we observe in nature, we can also observe on our own or on somebody else's retina. "I see, therefore, no opposition of physical and psychical, no duality, but simply identity."[34] It does not occur to Mach that observing the image of green grass on my retina is no more psychological than looking at the green grass directly. In one respect, he is right: the sensory aspects, as we observe them in nature, are objectively real. He does not, because of his naïveté, cut us off from the external world; whereas for Russell the "sensations" or "percepts" are in a region of the brain, and we are cut off from any first hand knowledge of the external world. Yet Russell only follows out his physical or metaphysical theory of perception to its logical conclusion.

To speak of the "stuff" of things is but a fiction from the functional point of view. Things are as they function. If they

[32] *The Analysis of Mind*, 299.
[33] *The Analysis of Sensations* (1897), 193, 194.
[34] *Ibid.*, 195.

function as mind, we can attribute mind to them, which is tautology. So with matter. We cannot say that the same "stuff" is now mental, now physical, because there is no "stuff." Russell's neutral "stuff" is the ghost of the old substance theory. The only facts we know are functions.

Russell's analysis of mind seems as unsatisfactory to me as his analysis of matter. "If we have been right," he says, "in our analysis of mind, the ultimate data of psychology are only sensations and images and their relations. Beliefs, desires, volitions and so on, appeared to us to be complex phenomena consisting of sensations and images variously related."[35] But sensations are fictions. They are not observable facts. There are sensory aspects. But they are emergents of physiological and physical factors; and since physiological factors must be counted as part of the physical world, the sensory aspects must be considered as aspects of the physical world.

Both Russell and Mach have failed, it seems to me, to grasp what is mental. What is mental centers in the fact of *interest* without which there could be no perception. Associative habits, so far as they are psychological facts and part of mnemic causation, depend upon interest. I do not deny that there are physiological habits and there may be physical habits, if C. S. Peirce is right that "matter is mind hide-bound with habit." But such habits become psychological facts only when they are taken account of by some interest.

The basis of interest is conation. Conation, as the basic psychological fact, has been set forth by G. F. Stout, especially in his *Analytical Psychology*. It had already been made the basic principle of behavior, even of cosmic behavior, by Schopenhauer. Conation is known as urge or striving and is revealed all the way from the instinctive urge for food to the urge for knowledge or the urge for beauty. Even the "conditioned reflex" could not be understood without conation or urge, as Pavlov pointed out in criticism of American behaviorism which pretended to be based upon Pavlov's experiments. If the dog had no urge for a steak in the way of hunger, i.e., if he were indifferent, the mere presentation of a steak and the ringing of a bell would establish no

[35] *Analysis of Mind*, 299, 300.

association, so that afterwards his mouth would froth upon the ringing of a bell. From the spectator's point of view, a conation appears as a cycle of movements. But why the cycle of movements? To the actor it is felt as a specific restlessness which, when successful, finds its realization in an appropriate object. It is true that the human infant lacks proper organization at first for satisfying its particular wants. It requires society as part of its mechanism. But lower animals have specific mechanisms for carrying out the drive. Even the chicken starts pecking as soon as it has burst its shell.

We may say that it is the conation, with the feeling which accompanies its success or failure, that is the ultimate psychological fact.[36] Sensory experience becomes psychological as it is woven into an interest. Imaginative revival is made possible only by interest. Only experiences that are part of an interest become psychologically associated and only associated experiences can be revived. Conation is the basis of the learning process and therefore of imaginative revival. As Russell says: "Learning is only possible when instinct supplies the driving force."[37] Instinct is, at any rate, the primary driving force. As elements are associatively integrated by some interest into sentiment and character, the system gathers momentum through the acquired habits, and the whole complex must be taken as the drive. There is a long distance between the elementary drive of curiosity and the drive for scientific knowledge, and the elementary drive takes on a new character in its increasing complexity, but it is still a conative drive to satisfy curiosity.

Consciousness, as the term is used by Anglo-American philosophers, should be dropped out of our vocabulary, since it is merely a source of confusion.[38] Awareness or responsiveness is a character of the parts of nature throughout nature—in inorganic

[36] See the author's *A Realistic Universe* (1916, 1931), 164ff.

[37] *Analysis of Mind*, 54.

[38] It is too much to hope that philosophers will agree (though I think I would have Russell's support) to drop the term consciousness (except as an equivalent of awareness). The ambiguity of the notion of consciousness has supplied philosophers with too much of their material for controversy (or dialectic, as they call it). What would become of the endless controversies concerning idealism and realism, if for consciousness we substituted awareness or responsiveness? Would we still have to ask: "Does consciousness exist?"

chemistry and in living things. In living things the awareness takes on a cumulative character in the way of habit and, in late evolution, of memory, but that is due to specific organization, not to the awareness. Conation is certainly not limited to consciousness, as the term is used by philosophers. This has been conclusively proven by Freud. There is awareness of suppressed tendencies at a lower level of psychological organization, and this manifests itself as restlessness and inchoate dissatisfaction, which disturbs life at higher levels.

There are various strata or levels of awareness, as Swedenborg was the first to point out and as the Freudians of our day have made clear. These strata may become largely isolated with serious complications, until integration into one personality can be effected. For Swedenborg there are higher levels than those of our customary life; and it is from these higher cosmic levels that creative inspiration comes.

No doubt nature's workings are complex and difficult to follow, and we are far from having rationalized them scientifically. But there is no need of making the problem absurd by initial assumptions. We live and act in a responsive environment. That is a fact which every plant or animal "knows," if we judge from its behavior. What we call inorganic things also respond qualitatively and quantitatively to their environment. They act and react in a precise way to the properties and to the temporal and spatial relations within specific contexts. But their action is stereotyped. It is not apparently modified in any permanent way through action and reaction. A stone falls in the same way, a chemical element responds in the same way in similar conditions, no matter how often the action is repeated. Such is not the case with animal organisms. Their action modifies their behavior. Such learned action, unlike inorganic responses, is not precise at first. A habit must be formed. Such organisms act by trial and error.

What I want to emphasize is that nature does not consist in separate and distinct entities, as Hume held and as Russell seems to imply. Awareness is an ultimate and pervasive character of nature. The magnet responds to the loadstone, the organism responds to light and to other stimuli. There is no solipsism in

nature. The question is: what sort of responsiveness? It is clear that the responsiveness in nature is not just responsiveness in general, but responsiveness to the qualitative and quantitative character of the environment. The greater part of the responsiveness of nature, including that of our organism, is determinate. It does not, fortunately for us, have to be learned. We could not live if we had to learn all our physiological reactions. In that narrow field of variable behavior, where we are obliged to learn, we must learn to respond to the properties and relations of the environment as they are. It is thus that we come to differentiate our world into types. We learn to respond differently to living things from non-living things. We learn to respond to a minding organism as we learn to respond to a live wire. It is the character of some things to respond as minds, i.e., with meaning and purpose and not as mere automata. Minding organisms have specific structures and properties as truly as a chemical compound, such as $H_2O$, with the advantage that minding organisms may communicate their structure directly to those who know how to read the code, whereas in the case of chemical compounds we are obliged to formulate the structure for ourselves and to try it out without any interested help from the compound. But one structure is as objective as the other.

Whether we are concerned with inorganic structure or mental structure, we must recognize fields and not just separate entities. It is the immortal glory of Faraday that he broke down the isolation of nature. Nothing lives to itself or can be understood by itself. Nature exists in fields—gravitational fields, electromagnetic fields, etc.,—of which we are parts. The organism is not just a collection of parts, with their separate functions. But the organism acts as a whole-field determining the internal balance and the exchanges with the environment, as Claude Bernard showed. The cerebrum must be understood as a field, in relation to its parts and in relation to the total field of the organism and its environment. The minding organism is the organism at a certain level of organization. To communicate with other minding organisms is to become part of their field, inadequate as our means of interpreting these relations may be. The interaction of fields is a metaphysical reality, or there could be no rapport. The

feeling of sharing, of empathy, is more fundamental than the symbols. It is what gives reality to the symbols. We share mind, not merely bodily noises, though these latter are instrumental to the real sharing.

The existence of other minds is not a problem to unsophisticated people. As Russell says: "In actual fact, whatever we may try to think as philosophers, we cannot help believing in the minds of other people, so that the question whether our belief is justified has a merely speculative interest."[39] But, later, Russell felt that the belief requires justification. On his own theory, that the mind consists in "sensations" in a region of the brain, there can be no justification. Indeed, I cannot see how the problem could arise. Russell suggests analogy as a basis for the inference to the existence of other minds. On Russell's theory of mind I do not see how analogy could arise, since that implies another body, and our subjective sensations would make such comparison impossible. But if we accept the possibility of analogy dogmatically, does that solve the problem? Such analogy would involve a looking-glass knowledge of the behavior of our own body and such knowledge would be impossible to the young child or to animals, and it is rather indefinite in adults. Russell has taken behaviorism as a psychology too seriously. A behavioristic psychology should be strictly physiological. It would deal with physiological automata responding to other physiological automata. I do not see how such a procedure could raise the problem of other minds or of any mind.

If we say that we proceed by analogy, the question arises: analogy to what? Analogy to physiological functioning would not take us far, since we know very little about the functioning of the nervous system. We have begun to discover that our knowledge is mostly wrong. Instead of thinking in terms of synapses between particular neurons, we find that we are obliged to think in terms of fields. Adrian suggests introducing the conception of waves to make plausible the formation of an image. At any rate, psychology has made considerable strides without much knowledge of physiology. Aristotle located the psychological functions in the heart, and thought of the brain as a

[39] *Our Knowledge of the External World,* 101-102.

refrigerator for cooling off the blood, but he made lasting con-
tributions to the psychological sciences—psychology, logic, ethics
and esthetics.

If we start with mind as conation, we can see how communi-
cation has arisen. The lyric song of the frogs, millions of years
ago, aroused an emotional response in other frogs. The behavior
with which the hypothesis of analogy starts is, basically, instinc-
tive expression. In animal life instinct calls to instinct in hunger,
sex, fear, anger. The corresponding emotion is aroused in other
animals by induction of some sort. Noises and gestures figure and
are modified, especially in the higher animals. They are the
code. The noises are the most important because of the greater
possibility of modification, so that when we speak of communica-
tion, we think of language primarily. Gestures play a limited
part. But whether the expression is noises or gestures, what
makes it significant is the conation which is expressed. It is the
responsive urges or antagonisms which make other minds a
reality to us.

It is our conative awareness that gives basis to our conception
of causality. Our only first-hand acquaintance with causality is
in the realizing of an urge, with the kinesthetic sensations that
are stimulated in the process. Conation is not a ghost, but the
directed movement of an organism. It is in the awareness of
initiating and controlling our bodily movements that we become
conscious of causality. Russell has himself given expression to
this fact. After speaking of the cruder sense of causality in the
correlations of our senses (insofar as this is not merely physio-
logical) he says: "Then there are such facts as that our body
moves in answer to our volitions. Exceptions exist, but are cap-
able of being explained as easily as the exceptions to the rule
that unsupported bodies in air fall."[40] Dr. Henry Head found
that, in a case where one side was paralyzed, there might still
be the consciousness of initiating a movement of the paralyzed
hand, upon command to do so, but because of the failure of the
organism to function in an integral way the movement would
not take place, though the patient because of his past experience
might suppose that the movement had occurred and even had

[40] *Ibid.*, 238.

a picture in his mind of the supposed location of his hand after movement. But the failure does not discredit the consciousness of initiation. When the brain is very much disintegrated the patient, Dr. Head found, could not distinguish two compass points. But no one would say that the failure of the disorganized nervous system to make such discrimination invalidates the discrimination of the normal nervous system. He would still say that the normal discrimination had objective validity. The same is true of the consciousness of causality. We should not let behaviorism or any other prejudice prevent us from giving our organism full credit for its information.

The awareness of the unity and continuity of a self can not be accounted for as a mere string of events, as Hume and Russell seem to think. The mere succession of events could not produce an awareness of succession, and the awareness of cumulative continuity is something more than a string of events. I agree with Russell that "the unity of a body is a unity of history—it is like the unity of a tune, which takes time to play, and does not exist whole in any one moment."[41] In the history of an organic thing, the past persists in the present. The rings of a tree's growth persist as part of its cumulative life. In a psychological organism, the results of past experience persist as habit and memory and are part of its cumulative functioning. But, as in music, the past is transformed and integrated into the movement of life. And, as in music, there is a time-form which indicates the further development. As Russell says, the tune "does not exist complete in one moment." Neither does a self. The future is part of its completion. It is true that the precise form of the future is created in the process. The completion of a tune, of a self, has an element of novelty. It is not just a projection of the preceding moment, but is felt as a possibility in the movement as a whole. What we call the past is also transformed. The rings of a tree, the earlier parts of a tune, the former habits and memories of a self are transformed in the process. What is really substantial is the whole. And the whole is a time-whole. The history of a self is a whole-field—not merely a spatial field, but also a temporal field. This is some-

[41] *Philosophy*, 110.

thing different from a string of events. We can·discern a string
of events, but they are not separate events. They are aspects of
a cumulative movement. As in a tune, the tones fuse with other
tones into new unities and all are aspects of the cumulative form
of the whole, so in the cumulative movement of a self.

I would suggest wholism as an alternative or supplement to
Russell's atomism. The "sensations" are not isolated in a region
of the brain. The evidence shows that the cerebrum acts as a
whole. Dr. S. I. Franz has shown that there is cross-education
between the hemispheres of the brain, so that when there is a
paralysis of one half of the body, including the hemisphere of
the opposite side, it is possible to re-educate the other hemisphere
in a remarkably short time, and through that re-education even-
tually to bring back the other hemisphere into normal function-
ing. The researches of Franz and Lashley have shown that the
old topographical conception of the brain is untenable. "The
results," according to Franz, "point to the conception of brain
function as an activity of many parts of the brain working to-
gether."[42] Destruction of some areas need not interfere with this
integration.

We cannot look upon perception as an isolated operation in
some region of the cerebrum. No doubt the cerebrum is an im-
portant condition of perception. But, in the first place, the
cerebrum must be understood as a whole-organization. It does
not act merely as parts. Dr. Henry Head has shown that the
cerebrum acts as "a schema" which involves a considerable
integrity of the cerebrum. When the cerebrum is largely dis-
integrated by disease or accident, it no longer responds to a
stimulus by differential reaction in regard to localization in two
and three dimensions or to grades of intensity or to rhythm, but
reverts to the primitive all-or-none reaction.[43] Kant was right in
saying that there is a structural condition for spatial, temporal
and causal perception and reaction. But we now understand
what that structural condition means. It is *a priori* in that it is
brought about by the evolutionary process in ontogeny and
phylogeny, and it is a condition of the learning process in the

[42] See the author's *Three Interpretations of the Universe* (1934), 236 ff.
[43] See the author's *Cosmic Evolution*, 142 ff.

individual. But it is a fact which we can empirically study and verify. It has scientific meaning. It is not deduced *a priori* as Kant's categories.

In the second place, the cerebrum must be understood in relation to the total situation, including lower ganglia, sense organs and environment. We must think of the cerebral schema as a field which is immanent in the subcortical centres, the sense organs and the external stimulus (when we deal with a perception of nature). Else the relation would be as futile as the relation of Kant's forms and categories to nature. The evolution of our brain has taken place within the matrix of nature. Its structure is not shot out of a pistol (or out of Kant's brain). On the contrary, there is community of our brain with nature, so that we can now say that the epicritic structure of our brain is immanent in nature—having been induced through a long process of evolution into our brain. Or we may put the matter the other way; we may say that nature, with its gradations of intensity, its spatial order, its temporal rhythm, its causal connectedness, is immanent in its general features in our brain. This is merely saying that we are part of nature, pervaded by its field relations, though intellectually it is taking us a long time to discover the fact, and we are still at the beginning.

What I sense is not a patch in the brain, but the total situation, including not only the cerebrum, but also subcortical centres, the excitement of the sense organs and the external stimulus; but this total situation is a fact for me because selected by my interest. For the perception of a thing, such as a table, there is involved, not merely sensory experience, but also mnemic causation, i.e., the association of the sense aspects, not only within a matrix of personal interest but also within a social matrix of common interest, which makes a group of sense aspects mean a table. Here language plays a large part.

We have seen that Russell's metaphysical assumptions (accepted under the name of science) make any perception of the external world impossible. Would it not be better to start with the naïve view of common sense and to develop its implications? Why not treat the irresistible convictions of the race—the feeling of community with nature and with our fellowmen—with re-

spect and try to understand them, instead of wandering off into a fairyland of speculation as Leibniz did? We must, of course, be critical in so doing, since metaphysical assumptions have a way of percolating into what we call common sense. But I believe that the common sense view, on the whole, is sound and can be substantiated by science.

We must remember that the macroscopic world is the world of our experience. As Sir Arthur Eddington says: "Molar physics always has the last word in observation, for the observer himself is molar."[44] The microscopic world is largely hypothetical and must in the end find its substantiation in the macroscopic world of our sense experience. I think the common sense view is right that the world exists as we experience it, even though that view may run counter to many metaphysical assumptions (some of which are supposed to be scientific). Common sense is right that there is an external world and that it has the properties and relations which we perceive. If we perceive it as colored, extended, durational, it is such.

I recognize that common sense is not a systematic philosophy, and its meaning is not always clear. Common sense would doubtless say, not only that things are as I perceive them, but that they are such, whether at the moment I happen to perceive them or not. But if you challenged common sense, the reply would doubtless be: Come and see or touch or smell, etc. You could substitute a moving camera for a personal observer and thus record a series of changes in nature, but this would only vindicate to common sense that nature, when not observed, is going on as when it is observed. Common sense is not concerned with existence in the abstract. It probably would not understand what you mean if you ask: what is nature in the absence of any organism like ours to react upon it? What properties would it have? After all, even the scientist must fall back at last upon observation. This earth, of course, existed before any organism could sense or observe it. For millions of years there were changes going on—gravitational changes, chemical changes, electrical changes—which we try to reconstruct in order to understand the present situation. But we can do so only in a general lan-

<hr>

" The Philosophy of Physical Science (1939), 77.

guage, which has meaning for us, after all, only in terms of our present data. When we say that the world exists as we experience it, we are obliged to qualify our statement by adding: *our human world*. We cannot know what the world seems like to a jellyfish or to an angel. But that does not invalidate the world as perceived in our perspectives. Kant had in mind what the world would be like to an omnipotent god who created his own object. And so he became an agnostic.

There is, I think, more community in the world than Russell's atomistic science would indicate. When the common sense man believes that he sees Sirius *now* and not as dated eight years back, I am inclined to side with common sense. I select an hypothesis so as to clarify common sense. In some sense I think that my eye and brain are "in contact" with Sirius, as G. N. Lewis holds. I spoke before of Bohr's discovery that the shift from one orbit to another in the atom is instantaneous, and I also referred to Schrödinger's explanation in terms of waves— stationary waves like mathematical waves—which are immanent throughout space, the only events being "beats." It seems quite possible that a shift in Sirius, which I see as blue light, is an instantaneous event as between me and Sirius, though the intensity varies with the square of the distance, because of superposition of waves. The destruction of Sirius would mean instantly the destruction of the blue flash which I see. But whether the flash from Sirius is a dated message or instantaneous, I am certainly part of the electromagnetic field of Sirius and through it have immediate experience of the blue light of Sirius.

Since light is not relative to anything else, it must, somehow, be a whole-function of the cosmos. It exemplifies cosmic immanence. I have spoken of Einstein's theory of inertial mass (as contrasted with mass acquired through velocity) as being a function of all the matter in the universe. This would be another instance of cosmic immanence. According to Hermann Weyl, the mass of the electron and the structure of atoms is determined by "cosmic curvature." (Otherwise we could not account for their universality.) This I take to mean the immanence of cosmic structure. These illustrations will serve to show that nature is not merely strings of events in space and time. Nature

gives evidence of connectedness in a way that transcends space-time in the relative sense. Cosmic immanence is an hypothesis which may be set over against space-time atomism. Perhaps this is only the familiar dualism of wave and particle.

I would not say that everything is immanent in everything. I think that is a meaningless statement, since the interactions in nature require not only plurality but certain specific conditions. It was Anaxagoras who said that "there is a portion of everything in everything." He supposed, because the bread that we eat can build up blood, flesh, bone, hair and nails, that the "germs" or properties must be literally present in the bread. He knew nothing about creative synthesis; and that is forgivable since it was only in the second half of the nineteenth century that creative synthesis was recognized by chemists, and that G. H. Lewes used the term emergence for the creation of new forms and properties, though William Harvey had long before used the term epigenesis in embryology for that fact and Aristotle had plainly implied it. At any rate, after Harvey, there was no excuse for Leibniz's theory of preformation which was founded in theology and extended to the whole universe. (Leibniz, with a poor microscope and a strong imagination, thought he could see the miniature animal in its protoplasmic beginnings.) A. N. Whitehead, in building up a world from universals, immanent in everything, harks back to Anaxagoras.

There can be no doubt, I think, that there is genuine pluralism and interaction, with emergence, in the conditions of nature, of new properties and new structures; but it is not mere chance. There are large ways in which we have evidence of immanence of cosmic structure. The repetition in nature of "measure and number" (to use Plato's expression), as illustrated in the rhythm of electrons and quanta and in the universality of atomic structure, indicates cosmic guidance.

As you would expect, there is but little room for emotion in the metaphysics of this philosopher of science. Yet in a recent utterance Russell does recognize that science is not enough. "Science," he says, "won't tell you the ends of life; these you have to derive from your own emotions."[45] But does our instinc-

[45] *The World Man Lives In* (1929), 20.

tive emotional nature have no cosmic significance? Whence the feeling for simplicity in a multiplex world, the craving for order in the midst of confusion, the demand for unity in apparent chaos? These feelings have been the inspiration of the pioneers of science. But they certainly are not scientific inductions. Are they not begotten of the cosmos that brought us forth?

When Russell endorses St. Paul's hymn to love in the thirteenth chapter of *First Corinthians*, he is no doubt thinking only of human love; but love is certainly a fact of nature. Throughout the realm of life love calls to love—though it be only for a brief lyric moment—that life may go on. If a loveless universe could produce this illusion, it would do itself too much credit. Love must, somehow, be a cosmic fact—a small voice in a tragic world—and the only fact that relieves the tragedy.

JOHN ELOF BOODIN

DEPARTMENT OF PHILOSOPHY
THE UNIVERSITY OF CALIFORNIA AT LOS ANGELES

16

*Justus Buchler*

RUSSELL AND THE PRINCIPLES OF ETHICS

# RUSSELL AND THE PRINCIPLES OF ETHICS

THE thought of this century has not yet crystallized out of its components. Considered individually, psychoanalysis, recent physics, the crisis of capitalist liberalism, and the persistent thunder of jazz syncopation seem to have effected a distinctive atmosphere, with notorious characteristics of instability, vacillation, and general uncertainty. Together they have synthesized no coherent product. We have partially become free of the nonsense that labeled one or another segment of the age as "transitional," having begun to perceive that special perspective can regard any age as transitional to another, be it one of stress and fever or one of great dogmatic unanimity. Soon, no doubt, the time will be endowed with official traits, and a spirit will be hypostatized for it by some dominant historiographical influence. Yet, in spite of all this, it seems meaningful to select some thinkers as more representative of the century than others; and if a single choice had to be made, it could hardly be a better one than Russell. The reason is not that he is to be identified positively with each major tendency. Nor is it that he is eclectic; he is not, and in any case, eclectics mirror nothing. He has been able to assimilate sympathetically some of the accents of the time, and has fastened himself intently on some of its weaknesses. Most of all, he has drunk deeply of its paradoxes, so deeply that, though he discerns them with rare clarity, he emerges with a parallel set of his own.

Morally, the present witnesses a grotesque combination, embedded in both individual conduct and social norm, of aspiration toward material ends on the one hand and superstitious asceticism on the other, of unprecedented pretense to humanitarianism on the one hand and unprecedented capacity for de-

struction on the other. These paradoxes find curious counterparts in Russell's thinking. The discrimination of one end from another, he maintains, neither is nor can be a matter for science to determine; yet his pages burn with the implicit admonition that wisdom in the selection of ends is the essential human *desideratum*. The notion of personal salvation, being an "individualistic" and "aristocratic" ideal, cannot, "however interpreted and expanded,"[1] be a basis for the conception of the good life; yet elsewhere Russell is convinced that, in his own words, contact with what is eternal—an individualistic moral goal—is the crown of the good life. Divergent emphases of this kind do not represent strict contradictions. Formally they are quite reconcilable. But so are the paradoxes of the age. Like his time, Russell has not worked the divergencies into a unified rationale of conduct, and has even receded into a methodological pessimism. He is a remarkable philosophic translation of conflict in the twentieth century, if not of the twentieth century's conflicts.

In his ethical consciousness Russell is close to the world. Too often even empiricists make the applicability of their moral hypotheses a matter of confident expectation, and scorn to become too specific lest their generalizations seem less general. The stuff of morality has never escaped Russell. Local ordinances, press propaganda, abuses in education have never been too insignificant to constitute the material of analysis. This primacy of the fact rather than the rule of conduct, instead of obscuring the forest and rendering him distant from ethical generalization, has qualified Russell for, among other things, a potent attack on the roots of conventional morality. Conventional morality means more to him than simply a set of intellectually disrespectable predicates—the uncritical, the irrational, the non-theoretical. It means the cultured Englishman flogging the anguished African, the complacent clergyman blessing his wife with a child per year on the consoling theory that if she died he could always serve God by marrying again. Conventional morality is power morality in one guise or another, insidious when organizationally cloaked with official piety, like Christian-

---

[1] *What I Believe*, 62.

ity, with its conception of God "derived from the ancient Oriental despotisms . . . a conception quite unworthy of free men;"[2] its threats of unquenchable hell-fire and eternal unforgiveness; its authoritarian demonstrations of might; its division of the sheep and the goats; its behest of love coupled with the careful nursing of fear, mystery, and death. A metaphysics that enables one to deduce from the mere existence of the universe that rabbits have white tails in order to be easily shot at, is morally convenient and logically simple, but to Russell's mind a historical nightmare.

In the light of this moral consciousness, what kind of ethical theory arises? Does it apply experimental standards to the evaluation of conduct? Is it part of a thorough-going naturalism? What is its analysis of human nature? These questions are far-reaching, no matter whose ideas are under consideration; for a moral attitude that rests on an ill-defined or meager theory fails to justify itself intellectually and must invoke either intuition, which is as free and empty as the wind, or brute force, which is an escape from ethical controversy into the realm of the biological.

Since his explicit abandonment of the earlier position which, following Moore, held goodness and badness to be intrinsic properties of objects, Russell has connected essentially the notions of moral value and desire. He says, for example, "Primarily, we call something 'good' when we desire it, and 'bad' when we have an aversion from it."[3] What he means by "primarily" is not clear. If this is a statistical statement, one which purports to describe how most people actually use the word "good," it is false. Most people determine value by choice, not by desire. They regard as best what they choose, not what they want; and as right, what they choose to do, not what they want to do. By and large, men make choices contrary to their desires. To some extent this is due to reflection on the untenability of desires, but for the most part it is due to the fact that men respect authority more than their own judgment. Russell, recognizing that an individual's desires conflict, reminds us that he

[2] *Why I Am Not a Christian*, 30.
[3] *An Outline of Philosophy*, 242.

comes to desire what others desire, and hence to call that "good." But men also call "good" what social authority desires and what they themselves do not, and they also call "bad" what authority forbids even when they desire it to the utmost. More significant yet, they will regard their own desires as bad, and to the extent not merely of *calling* them "bad" but of *believing* them to be bad. The alternative to the view that value and desire are in actual usage most often associated is the view that they *ought* to be associated, on logical and psychological grounds. Perhaps this is what Russell does mean, for he says: "Since all behaviour springs from desire, it is clear that ethical notions can have no importance except as they influence desire."[4] In other words, presumably: the predicate "good" relates ultimately to behavior, and it is psychologically true that all behavior originates with some desire; hence "good" is essentially connected with, or ought to be used in connection with, desire. Here observation of usage, though a somewhat different usage from the afore-mentioned one, is recognized as a necessary but not a sufficient condition.

Russell maintains that a judgment of value is not a statement of desire but an expression of desire, not an assertion but an exclamation. Thus "When I say 'hatred is bad', I am really saying: 'Would that no one felt hatred'."[5] Differences in the choice of ends cannot be reconciled by an appeal to facts, because nothing is said about facts and there is no basis for the appeal; the matter is wholly one of desire. ". . . In a question as to whether this or that is the ultimate Good, there is no evidence either way; each disputant can only appeal to his own emotions, and employ such rhetorical devices as shall rouse similar emotions in others."[6] Since ethical sentences do not affirm, since they are neither true nor false, they cannot be subject-matter for science. Science can decide which means is in fact a means, but can say nothing about ends. "There are no facts of ethics."[7] Accordingly "when we assert that this or that has 'value', we

[4] *What I Believe*, 30.
[5] *Power*, 247.
[6] *Religion and Science*, 241.
[7] *Power*, 247.

are giving expression to our own emotions, not to a fact which would still be true if our personal feelings were different."[8] "Since no way can be even imagined for deciding a difference as to values, the conclusion is forced upon us that the difference is one of tastes, not one as to any objective truth."[9] Ethical expressions, Russell believes, are to a certain extent impersonal. They are expressions of desire coupled with the correlative desire that others should desire the same. An ethical judgment "must have to do with the sort of world that would content me, not only with my personal circumstances."[10] It must be "an attempt to give universal, and not merely personal, importance"[11] to the desire expressed. Russell, in the last analysis, does not maintain that ethical judgments lack content. Exclamations too may signify, in the way that a dog's bark may, with a difference of degree and complexity.

What justification is there for ruling a part of language, and a well-established part, out of the domain of assertive or factual communication and characterizing it as emotive or evocative? Established forms do not of themselves, it is true, imply intelligibility from a logical or cognitive standpoint. Judgments about "God" and "the soul," for instance, though deeply rooted in feeling and social usage, do not necessarily possess intelligible content. Can value judgments be consigned to this general category of language? Russell sometimes seems to speak as if his strictures on value judgments applied only to judgments of "intrinsic" value, judgments of "what is good and bad on its own account, independently of its effects."[12] If all moral judgments were, in practice or otherwise, judgments of this kind, they would certainly belong to the category mentioned. That ethical language does not function with such an intent is plain from an examination of its behavioral effects. Russell in any case does not confine his view of judgments about ends to judgments about "intrinsic" ends; and this is clear from the following statement, if not from the opinions already cited:

[8] *Religion and Science*, 242.
[9] *Ibid.*, 250.
[10] *Power*, 247.
[11] *Religion and Science*, 244.
[12] *Ibid.*, 242.

"All moral rules must be tested by examining whether they tend to realize ends that we desire. I say ends that we desire, not ends that we *ought* to desire. What we 'ought' to desire is merely what someone else wishes us to desire."[13]

The attack on established linguistic forms and special areas of human vocabulary is rarely the outcome of deliberate linguistic analysis but rather the methodological expression of a social or metaphysical revolt. The analyses that flood the Platonic dialogues, for example, represent the protest of a viewpoint in itself highly sceptical, yet seeking absolute standards against the shifting relativism of the sophists and the superstitions of the current morality. The attack on the language of theology and theological metaphysics has always been part and parcel of the naturalistic tradition, to mention no other; and the construction of a logic of language designed to invalidate absolutism in its many forms was a prime motive of pragmatism and positivism. Russell, thinking of the tyranny of unconditional moral imperatives and the myopic rules of local moralities, and weighing the pervasive historical influence of these doctrines on everyday conduct, understandably concludes that moral judgments are expressions of private emotion and habitual response, of the attempt to universalize desire through the unconscious jargon of exhortation. That with so rigorous an influence there should be such great diversity of judgment, seems to lend force to Russell's subjectivism.

Now it is quite clear that if there is no presupposition at all, tacit or otherwise, which two disputants share, their disagreement on the choice of ends is absolutely undecidable. It is equally clear, however, that without common presuppositions concerning system of reference, technique of measurement, and account of observed results, no question of fact at all is decidable. The usual reply to this analogy is that in the one case there *are* common presuppositions, whereas in the other there are not; that in the one there is an external basis for decision, whereas in the other there is only the irreducible subjective factor of differing desire. Factual disputes are settled by the logical compulsion of the evidence appealed to. Russell holds that disputes

[13] *What I Believe*, 29.

about ends are settled only by physical and psychological compulsion, "by an attempt to change men's feelings."[14]

Why we should look unquestioningly for uniformities, classes, statistical ratios, and predictable sequences in the physical world and antecedently despair of similar results in the realm of conduct is methodologically still mysterious. But not historically. The concept of human nature is not fashionable today. For one, it seems to suggest the outworn idea of a fixed human essence uninfluenced by geography and social communication. For another, we are still in the throes of the romantic tradition, abetted by social uncertainties of an extreme kind. We take moral conflict for granted, and the wars of the age seem to have convinced us that survival alone decides such conflict. The notion of a distinctively human perfection has a remote sound to all but theologians, and a minority of them at that. Hence Russell's ridicule of the view that one man can tell another what he ought to desire. It does not seem to occur to him that men are persuaded and dissuaded in their choices by the clarification of these choices and the exhibition of their concomitants, that they abandon some desires for others and find satisfaction in the substitution, that they are intellectually as well as forcibly convinced that they ought not to want what they do or even ought to want what they do not, and that their discovery of new desires with an attendant increase in satisfaction is hardly ever of their own making alone. All this is unintelligible apart from the conception of a human nature operating within a specified environmental range. Unintelligible too without such a conception are the very conceptions of political science and therapeutic psychology. In practice, of course, statesmen and psychoanalysts assume it, and so does Russell. And so, in spite of their division on other counts, do most classical moralists.

Whether language in use has testable reference is determined not by simple inspection of its terms (for theoretically any term can be endowed with empirical reference) but by examination of the behavioral habits associated with the usage. Human nature may be defined by the circumstantial limits of these habits. To such limits does the language of ends implicitly refer. Even if

[14] *Power*, 249.

the language of moral conduct were not as elliptical and abbreviated as it is, this reference would necessarily be implicit. It is easy to forget that a great matrix of theoretical assumptions is also necessarily implicit in the simplest "factual" judgment. When Russell says that in the language of ends the user expresses what he wants and what he wants others to want, he too is pointing at something implicit, but at an incomplete and somewhat distorted meaning. The user purports to assert *that* he and others *do* or *would* or *could* want what he specifies. His assumption, fully articulated and expanded, is that all who share his choice or preference will succeed in the removal of obstacles and problems, in the adjustment of their conflicts, in the adaptation of their will to circumstances, in the attainment of stable satisfaction—that certain common human tendencies, given the proper conditions, will manifest themselves. When Russell states his own fundamental moral maxim, "The good life is one inspired by love and guided by knowledge,"[15] he is not, if I may presume to correct his own theoretical assurance, exclusively expressing his own desire and his craving of unanimity. That such a statement should be solely biographical in content, and not assertively biographical either, is a travesty of language if of nothing else. Russell considers his theory of value judgments to be an application of the experimental attitude. Actually it violates that attitude. For it proposes to reject as empirically unverifiable language that is non-assertive, failing in this very rejection to ascertain assertiveness by examination of the empirical function of language, and overlooking the essential condition of empirical meaning, the correlation of language with actual conduct.

Moral language and theological language are not in the same category even so far as popular usage is concerned. Theological language has a formal, rote character; the language of moral judgment is one form of behavioral response to living situations. Judgments about God and the soul are traditionally references to unknowables; value judgments are capable of elaboration in terms of qualities or acts, their effects, and their relation to a general human or specifically assumed standard. Interroga-

---

[15] *What I Believe*, 20.

tion of an evaluator inevitably results in indefinitely expansible statements about the grounds of the choice. Not, of course, that value judgments, statistically speaking, *always* occur in a living framework of conduct; but neither are theological judgments *always* extra-experiential. The argument for the methodological identity of the two kinds of statements is often based on the view that both are "emotive" expressions. So they are; but so are all judgments, actually or potentially, in varying degrees.

Russell's view that disputes about ends cannot be decided evidentially, by an appeal to sharable experience, but only by the imposition upon one will of some tradition or some other will, is influenced by his frequent thinking in terms of the historical rôle of power moralities. But it follows more fundamentally, I think, from a number of tacit and dubious psychological assumptions that he makes. Men's desires, he supposes, are what they are, and there the matter ends. A man may not always know what is best for him, but he always knows what he wants. Even when he has conflicting desires, he is aware of the alternative desires and of the fact that there is the conflict. From this it is an obvious consequence that differences about ends can be settled only by brute compulsion. Aristotle's famous statement that "we deliberate not about ends but about the means to ends"[16] makes precisely the same assumption—that men know *what* they want and merely do not know *how to get* what they want. Russell at one point makes a distinction between "ethical argument" and "ethical education," the latter consisting in "strengthening certain desires and weakening others."[17] Unfortunately this is not, as one might at first think, an escape from the assumption in question. Russell thinks not in terms of supplying or defining desires for men but in terms of "strengthening" and "weakening" desires already well-defined; not in terms of clarifying a common basis of choice but of "rousing feelings,"[18] employing "rhetorical devices,"[19] or bringing "the collective desires of a group to bear upon individuals."[20]

[16] *Nicomachean Ethics*, Bk. III, Ch. 5.
[17] *What I Believe*, 33.
[18] *Religion and Science*, 247.
[19] *Ibid.*, 241.
[20] *Ibid.*, 243.

The theory that the moral agent is an infallible judge of what he wants (let alone of what is best for him) occupies its secure place in ethical history less because of a conviction that actual conduct supports it than because of its effectiveness in the opposition to absolutism and authoritarianism, and to a somewhat lesser extent because it is thought to be the psychological basis of democratic theory. Once it is perceived that the assumption is hardly the essence of a naturalistic ethics it loses much of its attractiveness. Russell is keenly aware of the individual's struggle to harmonize the desires within him, but hardly aware of the struggle to achieve coherent desire. He shares the tradition which regards men as indivisible centres of intent, radiating desires that are multifarious but identifiable. Even Plato, who perceived the enormous significance of logically incompatible aims, did less than justice to inchoate aims. This whole philosophic tendency springs in part from a further dogma, that a desire must be a desire *of* something. But a desire may have a direction and no object; and even its direction, as novelists have seen better than philosophers, may be buried within conscious but unanalyzed sentiments. Volition, desire, and preference may be inarticulate. An inarticulate preference is no paradox. For a conscious state may involve an implicit and unconscious choice.

"All human activity," says Russell, "springs from two sources: impulse and desire."[21] Often he conveys the impression that the succession of conscious states is identical with the succession of desires, and an atomistic conception of states is also present. But to suppose that the springs of conduct are a set of drives (impulses and desires) by which men are motivated is vastly to oversimplify the facts. Men have impulses, and perhaps definitely directed impulses, but these are from the beginning plunged into torrents of compulsion. That part of a man's activity which Russell would ascribe to a positive impulse is more often a response than a drive, a struggle to stand up rather than a readiness to run. The individual cannot be dissolved into a collection of circumstances, but plainly he is so submerged in them to begin with that activity, voluntary or involuntary, is for

[21] *Principles of Social Reconstruction* (American ed. *Why Men Fight*), 12.

the most part best regarded as drawn from him rather than contributed by him. It is not primarily because the individual's desires conflict that, as Russell says, he desires what others desire. He *starts out* with what others desire—then his desires conflict. Men do not simply "appeal" to authority except methodologically speaking; they become aware of its presence. Whether this way of looking at the matter explains a greater number of facts of conduct, I do not know. But it has fundamental advantages for ethical analysis. First of all, it avoids the suggestion that there is a sharp line between achievement and frustration in human conduct. The tendency to interpret involuntary conduct, for example, in terms of a sum of impulses leads to the view that a given impulse is either satisfied or curbed, that it either is or is not checked by desire and will. The concept of moral development and unification (character) comes to imply discrete changes, adding up to some resultant when opposing changes are neutralized or stabilized. Or, impulses and desires emanate from a principle prior to them in some sense: according to Russell, they "proceed from a central principle of growth, an instinctive urgency. . . ."[22] For Russell's twins, "impulse and desire," I would substitute compulsion and imagination. As a "spring" of conduct the latter superficially appears to be not basic enough, or too highly refined. But imagination in its broadest sense is not to be confused with that much-eulogized source of artistic or scientific creativity. The movement of imagination is a trait in the lowliest. It encompasses the tentative, groping, indecisive aspect of activity and purpose; the course of random experimentation; the almost subconscious search for possibilities. Conduct in terms of these broader categories lends itself more favorably to interpretation in terms of continuous development, and the concept of character becomes at least as intelligible as the concept of biological growth. Achievement and frustration become complex relational predicates and cease to be qualities of atomic purposes or drives. The notions of impulse and desire are useful and even indispensable, but they are an inadequate basis for a theory of moral conduct.

Further analyzing the foundations of conduct, Russell says:

[22] *Ibid.*, 24.

"The activities of men may be roughly derived from three sources, not in actual fact sharply separate one from another, but sufficiently distinguishable to deserve different names. The three sources I mean are instinct, mind, and spirit. . . ."[23] The life of mind is "the life of pursuit of knowledge," the life of spirit that of impersonal feeling and the religious consciousness. Impulse and desire, I take it, are the sources of conduct in the sense that they are the modes of initial stimulus; instinct, mind, and spirit are the sources in the sense that they are the categories to which all kinds of conduct are reducible. Though Russell acknowledges the fluidity of the latter division, he is once again careless of its comprehensiveness. Which category, for example, can embrace that most pervasive of traits, the addiction to custom? Or the rationalization of caprice? Certainly not instinct, if we would avoid the almost inevitable consequence of interpreting all conduct as instinctive. Equally not mind. We cannot legitimately speak of any "pursuit" or of inquiry, and if knowledge supervenes, it cannot but be accidental. The traits in question may relate to what is "mental" but not to the "life of mind." Ecclesiastical orthodoxy has traditionally ascribed every act of any religious consequence to the working of "spirit." But mechanical adherence to even religious custom is quite alien to the life of the spirit in Russell's sense. To be sure, Russell says that instinct, mind, and spirit have each their corruption as well as their excellence. Corruption, however, turns out to be not degeneration but misdirected and inhuman development. Thus the corruption of mind is not a decline into the uncritical but rather the pursuit of the merely critical, the isolation of thought from emotion and impersonal feeling. Similarly, the corruption of spirit in Russell's sense is not the mechanization or misinterpretation of the religious attitude but its overdevelopment and separation, as in asceticism.

Let us return to the general philosophic consequences of Russell's theory of value expressions, with its dualism of the unverifiably moral and the verifiably factual. It is interesting to observe that positivists who share this dualism and absolutists who reject it are alike inclined to another dualism of broader

[23] *Ibid.*, 205.

import. Russell's own version is in simple and forthright terms: "The philosophy of nature is one thing, the philosophy of value is quite another."[24] So far as the former is concerned, man is a part of nature. "His thoughts and his bodily movements follow the same laws that describe the motions of stars and atoms."[25] But so far as the philosophy of value is concerned, "Nature is only a part of what we can imagine; everything, real or imagined, can be appraised by us, and there is no outside standard to show that our valuation is wrong."[26] Hence, "It is we who create value, and our desires which confer value. In this realm we are kings, and we debase our kingship if we bow down to Nature. It is for us to determine the good life, not for Nature."[27]

This combination of naturalism from one standpoint with dualism from another cannot maintain itself successfully. The assertion that "nature is only a part of what we can imagine" follows from an antiquated materialistic use of the term "nature" as synonymous with "physical nature" or "physical world." What, precisely, is denoted by "outside standard" and by "our?" Is the desire that arises to conflict with a present desire "outside"—outside "us?" This is absurd in view of the fact that our desire A may arise to conflict with our desire B in the same way that B conflicts with A. Hence the conflict of desires, like any individual desire, lies within the scope of "our," our human, valuation. Yet must we presumably refrain from regarding this as part of a "natural" framework of valuation? And must we refrain from regarding any desire as a "natural desire?" Juxtaposition of the following pair of quotations, in which I have italicized the especially relevant passages, is rather striking: (1) "Undoubtedly *we are part of nature, which has produced our desires,* our hopes and fears, in accordance with laws which the physicist is beginning to discover. In this sense we are part of nature; in the philosophy of nature, we are subordinated to nature. . . ."[28] (2) "*It is we who create value, and our desires*

---

[24] *What I Believe*, 14.

[25] *Ibid.*, 1.

[26] *Ibid.*, 16.

[27] *Ibid.*, 17.

[28] *Ibid.*, 14-15.

*which confer value.* . . . It is for us to determine the good life, not for Nature."[29] A comparison shows that if flagrant contradiction is to be avoided, the term "desire" cannot have the same meaning in both passages. And in fact it is quite clear that in the first it refers to a physical phenomenon, causally produced, like all physical phenomena; in the second, it refers to something psychico-moral and quite different, the product of a mysteriously autonomous agent of dubious metaphysical status. Russell's dualism apparently stems from a revulsion against the dogma of natural law, with its ambiguous, perversely interpretable implications. Had Russell explicitly distinguished between this rationalistic concept and a scientific theory of human nature, some of the awkward foregoing conclusions might have been avoided and his metaphysics of conduct might have profited. "Human nature" in Russell's hands rarely avoids a dualistic flavor. The emphasis is on *human* nature—as opposed to Nature in the large—rather than on human *nature*—the moral as a dimension of the natural. That Russell's moral philosophy is naturalistic in its orientation is perfectly obvious. But like all theories that inhabit an unsystematic structure, it produces progeny of questionable ancestry.

The lurking conviction of a general human standard emerges in Russell spasmodically but unmistakably. He says, for example, that in their blindness to the factor of animal vitality, "the ascetic saint and the detached sage fail . . . to be complete human beings."[30] This follows from his principle that "Instinct, mind, and spirit are all essential to a full life."[31] What is a "complete" man and a "full" life? Clearly these terms do not mean here what they mean when we speak of "complete" equipment or a "full" box. They imply a standard for human values —not a fixed rule nor even a "working hypothesis" but a set of necessary conditions for the attainment and stable preservation of any good at all. Had Russell generalized some of his insights methodologically this conclusion would have come to the sur-

---

[29] *Ibid.,* 17.
[30] *Ibid.,* 28.
[31] *Principles of Social Reconstruction,* 208.

face. Not so very long before his subjectivism got the upper hand, and when he was concerned less with the method of ethics than with the discrimination of central values, he expressed the rudiments of a theory of common conduct. He observed, for instance, that, although no specific demonstration can be employed to show that one of two antithetical attitudes on the part of men is more "rational" than the other, it would be empirically true that a "world of Walt Whitmans would be happier and *more capable of realizing its purposes* than a world of Carlyles."[32] Not that Russell ever did fail to accumulate an assemblage of human traits prominent enough to match any. We find him asserting that men by nature possess "a certain amount of active malevolence;"[33] that men as men seek power and glory; that desires are classifiable as "finite" and "infinite" (insatiable),[34] desires and impulses as "creative" and "possessive;"[35] that all conduct derives from instinct, mind, and spirit. These concepts soon appear as the bases of social science—and Russell soon is far removed, philosophically if not temporally, from the ethics that follows his theory of value judgments and its value-nature dualism.

The impulses and desires of men, "in so far as they are of real importance in their lives," are connected and unified by "a central principle of growth, an instinctive urgency leading them in a certain direction, as trees seek the light."[36] The fundamental moral need of a man is that this movement be allowed to develop. Whatever impediments or misfortunes confront him, he remains a free and potentially full man so long as there is no "interference with natural growth."[37] Russell, however, goes on to say that

this intimate centre in each human being . . . differs from man to man, and determines for each man the type of excellence of which he is capable. The utmost that social institutions can do for a man is to make

[32] *Ibid.*, 36. (My *italics*.)
[33] *What I Believe*, 67.
[34] *Power*, 11-12.
[35] *Principles of Social Reconstruction*, 234.
[36] *Ibid.*, 24.
[37] *Ibid.*, 24.

his own growth free and vigorous: they cannot force him to grow according to the pattern of another man.[38]

Here a latent optimism comes to the foreground. Some impulses, Russell recognizes, have to be socially checked in the interest of other men, and some must be checked by self-discipline; but in the main, the unimpeded development of natural individual growth produces a harmonious society. This conclusion is the outcome of faith rather than a theory of human nature, but it requires, once more, an implicit assumption about the limits of individual conduct—an assumption which, being implicit, gradually filtered out of Russell's thought.

The concepts that define Russell's law of growth need considerable clarification. He distinguishes between impulses and desires "which do not grow out of the central principle"[39] in an individual and those which do. Since he also holds it to be morally desirable that as a rule the former—e.g., drug-taking—be curbed by self-discipline, it becomes more than a minor question where the line is to be drawn, or indeed, how the difference is to be determined. Whether an impulse or desire does grow out of the central principle would not seem to depend upon how pervasive or how widely-experienced it is; for this would exclude a tendency like artistic creation and would include a tendency like the immediate overt expression of rage. The ideal of full growth, says Russell, "cannot be defined or demonstrated; it is subtle and complex, it can only be felt by a delicate intuition and dimly apprehended by imagination and respect."[40] So far as this applies to the individual man, it is a sensitive statement of an important truth, that the logical merit of cautious judgment has essential relevance to human understanding. It is also a refreshing alternative to the attitude that glibly concludes what the individual's niche should be in a well-ordered society antecedently determined. But so far as the statement legislates against the attempt to define tendencies that cross individual lines, it represents the precarious position that the goal of knowledge must sometimes be abandoned when the ex-

---

[38] *Ibid.*, 24.
[39] *Ibid.*, 24.
[40] *Ibid.*, 25.

pedient of feeling is available. The view that some types of things cannot be or are best not defined has no more logical justification than the view that some types of things cannot or ought not to be explained. The appeal to intuitive signification is as stultifying as the appeal to miracles. Russell's position here seems to be that it is not possible to formulate, in Platonic-Aristotelian manner, conditions of excellence (or virtue) but only to feel specific manifestations of it. Such a position is faithful to an age in which cataclysmic changes have come to be taken for granted and in which anthropological knowledge has matured. But its methodological deficiencies are not erased by this consideration.

The more general notion of "natural growth" is left undefined by Russell. Or perhaps I should say that it is defined implicitly, and largely in political terms, by a detailed consideration of the individual's relationship to the institutions of war, education, marriage, property, and religion. This procedure always has the advantage of concreteness. But in a moral context particularly it makes for ambiguity, and it is unsatisfactory in a larger philosophical sense. Russell's own objection to the concept of natural law is based on its imprecision, which alone makes it a cloak for special interests and power moralities. If Russell's concept of natural growth is to be judged not by its precision as a concept but by the specific moral context into which it fits, we should similarly judge the concept of natural law by the specific moral values to which each historical exponent of the concept adhered. Such a procedure is important but insufficient. One job done well—and Russell does it magnificently—does not, philosophically speaking, obviate consideration of another.

In an overall survey of Russell's ethics one is impressed by the moral weight that he assigns to individual approval. He makes little attempt, however, to analyze the structural factors within such approval. His earlier intuitionism served to bring the factor of a *sense* of approval to the fore, and historically speaking most forms of intuitionism at least have had the merit of a similar recognition. They have largely vitiated this merit by giving to intuitive approval an unwarranted cognitive status, by supposing it to be self-guaranteeing, and by ignoring its col-

laboration with reflection. Hume, in his classic formulation of the interplay between reason and sentiment, characterized the latter as the "final sentence" passed on what the former discloses. Dewey, following Hume, cites a "direct sense of value" which, arising during and after "mental trial" of possibilities and consequences, "finally determines the worth of the act to the agent."[41] Now neither Hume nor Dewey and Russell depart from a tendency to particularize this ultimate factor of choice in the agent. They suppose that it consists either in a particular sense or in particular occasions of direct sensing. Dewey, it is true, asserts that since it is part and parcel of the process of deliberation it is not an independent, complementary psychological element. But he never gives it the form of anything more than a specific act, feeling, or exercise. "Many and varied direct sensings, appreciations take place."[42] Accounts of this kind distort the nature of individual approval.

Every moral choice is the expression of a guiding moral tone. This guiding tone is the fundamental directed sensibility of an individual with respect to moral situations. Choice that is spontaneous is not genuine approval, even though it be the result of a deliberation. As a man does not believe simply by asserting that he does, so he does not value simply by feeling assent. The guiding tone underlying all valuation is not a fixed property, innate or acquired. Though it involves a propensity to feel in particular ways, it is not itself a particular feeling or a mere flavor of consciousness. The tone that emerges in the complex of native endowment, experience, compulsion, and imagination is variable and plastic. It is not to be confused with "character," a more general term that fails by itself to convey the presence of a developed and directed sensibility. The intellectual value of the two concepts is, however, the same. Both render intelligible specific acts and specific choices, and both help to distinguish between mere behavior and moral conduct. The guiding tone of an individual is what accounts for his *contingent* as well as his *characteristic* choices. "Intuition," "direct sense of value," "appreciation," even Hume's "sentiment," inadequately repre-

[41] *Ethics*, 303.
[42] *Ibid.*, 303.

sent the general factor in choice. These labels and the views they represent have served to obscure the presence of prior inclination. If goodness comes home to the individual in positive satisfaction, this can hardly consist in merely a direct instance of feeling; it must consist in a modification or ratification of some underlying temper. The guiding tone and the guiding principles embedded in an individual's conduct are closely related. Both may be more or less explicit in the individual's awareness. In his capacity as moral agent his guiding principles—the policies according to which he acts—are reflected in his moral tone. The concept of tone represents no hypostasis of individual intuitions but rather the continuous basis of any choice. Ultimate approval does culminate in feeling. But guiding tone explains why a given feeling is likely to be that feeling and not another.

Is the concept of tone I am posing embraced in Russell's principle of growth, the "consistent creative purpose or unconscious direction"[43] which, as he says, integrates an individual's life? Natural growth suggests the inclination of an individual's drives but not the consummation of his moral judgments and conflicts. Like the concept of character, it leaves room but does not provide for the factor of general sensibility. The principle of growth is formulated in essentially biological terms, whereas the idea of tone lays greater stress on psychological and social dimensions. The former, if it were to do justice to the phenomenological presence of the moral·situation, would have to be supplemented by a general principle of judgment and satisfaction.

An ethics like Russell's, based largely on opposition to clericalism and dogmatic religion, is confronted with the problem of an attitude to the compelling moral values that religion sometimes embodies. Naturalists have been inclined to feel secure in their methodological warfare with revelation, miracle, and rationalistic proofs of deity, but a little uncomfortable before the injunctions of humility and love. The values seem to be so indubitable and universal that philosophers have shrunk from the task of transferring them to a different context. When they have done so, as in the case of Santayana, they have too often

[43] *Principles of Social Reconstruction,* 229.

emerged bearing a bizarre remnant of prayer and sacrament, or a theologized politics. One wishes that Russell, immune to the emotional aura of Christianity and extraordinarily perceptive of the nuances of conduct, could have translated systematically the empirical import and application of the old concepts and demonstrated their greater felicity in a better philosophic environment. The necessity of avoiding the ethics of maxims and unanalyzed sentiments has never been greater than in the present. When Cardinal Schuster preached Mussolini's invasion of Ethiopia hand in hand with "Love thy neighbor," on the ground that the Bible meant "thy neighbor, not a Hottentot," he did more than express a perverse local interest. He symbolized the philosophic crumbling of a prepared, religionized ethics. A mind like Peirce's could characterize love as "the ardent impulse to fulfill another's highest impulse" and with the same breath open up new avenues of religious ambiguity in defining "our neighbor" as "one whom we live near, not locally perhaps, but in life and feeling."[44] Russell is too deeply agitated by the effects of traditional morality to give sufficient speculative attention to salvaging its ethical foundation. But he is not unarmed with a deeply felt religious alternative.

Twentieth century thought has produced its own picture of the moral ineptitude of dogmatized morality. Long before Dewey's severance of the religious attitude from supernaturalism, Russell declared his conviction that traditional religion is incompatible with the life of spirit; and before Santayana's complete expression of the position that spirit is an aspect of rationality, Russell defined spirit in terms of liberation without renunciation. Not renunciation but "readiness for renunciation when the occasion arises" is essential to spirit. Yet spirit "is in its essence as positive and as capable of enriching individual existence as mind and instinct are. It brings with it the joy of vision, of the mystery and profundity of the world, and above all the joy of universal love."[45] Russell has never quite revivified the moral splendor of the position he held over a quarter of a

[44] *The Philosophy of Peirce: Selected Writings*, 362; or *Collected Papers*, VI, 192.
[45] *Principles of Social Reconstruction*, 222.

century ago. Later he could define love as "an indissoluble combination of the two elements, delight and well-wishing."[46] But on the earlier view such a definition would have been regarded as incomplete and as an emphasis on instinct uninformed by thought or spirit; as conducive to making man no more than "a slave to the life of the species."[47] In the spiritual man "Instinct becomes a reinforcement to spiritual insight. . . . His spirit divines in all men what his instinct shows him in the object of his love."[48] It was thought unusual of William James that he could dwell on matters of immediate import while ascending religious heights. Russell's capacity for this is less spectacular, but it has a deeper ring and it finds more definite representation in his theory. The courage to be lonely in the pursuit of thought is on his view a phase of rational society and the solution of human problems. His indictment of conventional morality, though a response to its repression of instinct and its repugnancy to thought, stems principally from its foreignness to spirit, the force that makes for impersonal feeling and that harmonizes mind and instinct. Spirit by its very definition bridges the gap between the world and the eternal.

The world has need of a philosophy, or a religion, which will promote life. But in order to promote life it is necessary to value something other than mere life. Life devoted only to life is animal, without any real human value, incapable of preserving men permanently from weariness and the feeling that all is vanity. If life is to be fully human it must serve some end which seems, in some sense, outside human life, some end which is impersonal and above mankind, such as God or truth or beauty. Those who best promote life do not have life for their purpose. They aim rather at what seems like a gradual incarnation, a bringing into our human existence of something eternal, something that appears to imagination to live in a heaven remote from strife and failure and the devouring jaws of Time. Contact with this eternal world—even if it be only a world of our imagining—brings a strength and a fundamental peace which cannot be wholly destroyed by the struggles and apparent failures of our temporal life.[49]

[46] *What I Believe*, 24.
[47] *Principles of Social Reconstruction*, 220.
[48] *Ibid.*, 221.
[49] *Ibid.*, 245.

The profoundest of naturalists, Spinoza and Aristotle, stressed moral emancipation as realizable within the flux of the world. With this tradition Santayana and Russell ally themselves in the main. But Russell after a certain point departs from it. Like his predecessors he would define the possibility of a divine element in human experience. But they find salvation in the intellect—in the self-sufficiency of *speculation*, in the *intellectual* love of God. Unlike Santayana, who speaks for himself and these ancestors who had made the end reason, Russell speaks also for his time; for the drift if not the content of the whole century, and even above his own voice. The life of the spirit itself—Russell's intended voice, expressed in the foregoing passage—is a recognition of reason but not a celebration of it. Ultimately the claim of impulse and desire, not of reason, is what Russell most effectively champions. He is the representative of aspirations and cravings suppressed in an age that flatters itself on the freedom to contemplate its inhibitions. The crushed inwardness of the ignorant man, the thwarted purposes of the herded man, both in the wake of technological mastery, are the moral phenomena by which Russell is aroused. This is not simply a case of the animality rising and announcing itself as loudly as the rationality. The moral status of the biological has been enunciated quite as fully and elegantly by others. It is the ripening into consciousness of this animality that Russell articulates, its maturation into concrete desires and vital drives.

Russell's theory of moral liberation declares the ultimate insufficiency and turmoil of animality. It perceives the tragedy that, though animality must become free, it inevitably moves toward slavery. This theory does not imply "escape." It locates the good within activity and community. It extols the creative life as against the possessive, and it formulates a goal of harmony, within the individual and between the individual and society. But the life of the spirit is not the consummation of this harmony. It is not the peace of the understanding, and not the freedom of the contemplative man; for in spite of where Russell would lead it, it is not a last stage in the principle of growth. It is a peace from which the cry of pain has not been eliminated. Russell's eternal world is a haven of refuge in the

midst of the political world, not an ideal of natural human perfection. It is a "bringing" into human existence of something really alien to it, "something that appears to imagination to live in a heaven remote from strife and failure and the devouring jaws of Time." Man must even create the haven for himself. Hence Russell calls for "contact with this eternal world—even if it be a world of our imagining." Everything is tainted with a consciousness of perplexity, and the life of the spirit comes as the fruit of rebellion rather than as the echo of quietude. Not judiciousness but courage is the note most congenial to Russell. For better or for worse, *sophrosyne*, which to another age was the key of moral freedom, is as distant from his temper as the lyre is from the drum.

Justus Buchler

Department of Philosophy
Columbia University

# 17

*Edgar Sheffield Brightman*

## RUSSELL'S PHILOSOPHY OF RELIGION

# RUSSELL'S PHILOSOPHY OF RELIGION

## I

IF one is to judge by Russell's published writings, his chief
interests are in mathematics, logic, epistemology, ethics,
and politics. He has probably given less rigorous attention to
philosophy of religion than to any other branch of philosophy,
except perhaps aesthetics. In view of the cosmopolitan scope of
his travels, of his thought, and of his fame—Metz calls him
"the only British thinker of the age who enjoys world-wide
repute"[1]—Russell's relative neglect of religion is the more
striking. In fact, he once told a group of inquiring students that
he hardly recalled having written anything on the subject other
than his "Free Man's Worship" and the Home University
Library booklet on *Religion and Science*. But relative neglect
by a Russell amounts to more than the life-work of many a man.
His treatment of religion has been sufficient to arouse extensive
and somewhat acrimonious discussion.

The most important items dealing directly or indirectly with
religion are named in the footnote below, with the date of their
first publication and the abbreviation by which they will be
quoted in this essay.[2] These writings, continuing over a range

[1] Seventeen of his works have appeared in German translations.

[2] "Proofs of the Existence of God." Ch. XV of *A Critical Examination of the
Philosophy of Leibniz* (1900): *Leibniz.*
"The Free Man's Worship" (*Independent Review,* 1903): *Free Man.*
*Problems of Philosophy* (1911): *Problems.*
"The Essence of Religion" (*Hibbert Journal,* 1912): *Hibbert.*
"Religion and the Churches" (*Unpopular Review,* 1916): *Churches.*
*Principles of Social Reconstruction* (1916): *Principles.*
*Mysticism and Logic* (1917): *Mysticism.*
*What I Believe* (1925): *What I Believe.*

of forty years, are a sign of some sort of interest. That interest may not be systematic or constructive; it may have yielded a meager philosophy of religion; but it has at least been persistent, if not exactly sympathetic. In this last respect Russell's interest in religion displays some likeness to Hume's, for each man manifested a lifelong concern about religion while entertaining almost lifelong skepticism about the truth of religious beliefs. In Boswell's deathbed interview with Hume,[3] called by E. C. Mossner "the most sensational 'scoop' of the eighteenth century," he secured a statement from Hume that the latter "had never entertained any beleif [sic] in Religion since he began to read Locke and Clarke," although he had been religious when young. Russell himself tells us that when he was a youth he "for a long time accepted the argument of the First Cause," until at the age of eighteen (in 1890—just before he became a student at Cambridge) he read in John Stuart Mill's *Autobiography* the sentence: "My father taught me that the question, Who made me? cannot be answered, since it immediately suggests the further question, Who made God?" Russell believed Mill's sentence to reveal the fallacy in the argument for the First Cause.[4] Hume was rendered skeptical of religion by merely beginning to read Locke and Clarke; Russell gave up the First Cause for a trivial question about the cause of the First Cause, and seems thereafter not to have explored seriously the possibility of there being a God, except in his study of Leibniz's theistic argument. Although Hume's thought about religion was much more searching and "reverent" than Russell's ever was, each abandoned religion at an early age for slender reasons— evidence of an initially loose grip on religious thought and experience—and yet each persisted in returning, so to speak,

---

"Effort and Resignation." Ch. XVI of *The Conquest of Happiness* (1930): *Happiness.*

*Religion and Science* (1935): *Religion.*

*Why I am not a Christian* (1940): *Why Not.*

Other writings will be cited less frequently than the foregoing.

[3] First printed by G. Scott and F. A. Pottle in *Private Papers from Malahide Castle* (New York: Privately Printed, 1928-1934), and quoted by E. C. Mossner, *The Forgotten Hume* (New York: Columbia University Press, 1943).

[4] *Why Not,* 6.

to the scene of the crime. That Russell was from the start but slightly attached to religion is further illustrated by his conviction that the main actual reason for belief in God is that people are taught the belief from early infancy; and that the next most powerful reason is the wish for security.[5] It is possible that Russell's religious education was not too thorough,[6] and it is certain that desire for security is not one of his prominent traits; thus the bottom easily fell out of his religion, as it did out of Hume's.

## II

In the investigation of any subject, two possible methods lie open to the investigator, the external and the internal. The method of external criticism is that of a nonparticipant. If the visible effects of Naziism are detrimental to our best interests and our cherished convictions, we may well reject the system on purely external grounds, without a clear understanding of why Nazis accept Naziism. When it comes to grasping a great cultural undertaking like science, the purely external critic is at a serious disadvantage. A William Jennings Bryan may be roughly aware of a contradiction between the theory of evolution and his theory of the meaning of Chapter I of Genesis; yet no scientist would be particularly concerned about Mr. Bryan's opinions regarding evolution. Russell, of course, is a great thinker; Bryan was not. Nevertheless, Russell's religion is not wholly unlike Bryan's science—externally apprehended and roughly understood. It is no crime to be an external critic. We must take most of our knowledge second-hand. The philosopher's business is to unify all experience, yet he cannot know all experience directly. All the more reason for being careful to consult the best sources for his indirect knowledge. No one head can carry all man knows. Unfortunately there is little evidence that Bryan sought out the best scientific authorities in order to secure objective knowledge of evolution; and Russell also seems to have remained at a pretty remote distance from primary

[5] *Why Not*, 14. An ardent foe of mathematics might adduce both of these points as grounds for mathematical skepticism.

[6] As he testifies in his essay in *Living Philosophies* (1930).

sources of religious insight. His method has been mainly external; he thus enjoys the advantages and the disadvantages of the man from Mars.

Internal criticism, by way of contrast, rests on the attitude of the participant. His participation may be mainly objective and intellectual, and hence imaginative and remote from the object, like the experience of empathy. Such a method is used by the good historian who makes one see why this group or that nation acted, believed, lived, and died as it did, regardless of whether or not the historian personally approves the ends sought. Or, on the other hand, the critic's participation may be subjective; it may be based on personal experience and sympathy with the values prized in the cultures under investigation. Subjective internal criticism, based on such participation, is just about a *conditio sine qua non* of any adequate understanding of certain subjects. Lacking subjective appreciation, any external, or even empathic internal, criticism of such fields as democracy or science, for example, is likely to lack concreteness. On the other hand, subjective appreciation may blind the critical faculties and create irrational prejudice. It is clear that Russell is not, and since 1890 has not been, equipped for a participant's view of religion. Whether this frees him merely from prejudice or also from sympathetic understanding remains to be seen. It means that his treatment of the subject is to a great extent critical in the negative sense, rather than constructive.

### III

Russell's critical philosophy of religion consists largely of considerations leveled against historical Christianity. He has apparently devoted little study to non-Christian religions or to the essence of universal religion—the Idea which makes any religion religious. It is true that in *Religion* he mentions three aspects of "each" of the great historical religions, namely, a Church, a creed, and a code of personal morals (p. 8). These aspects are abstractly stated, and become concrete only when he is discussing Christianity. In *Why Not*, he sets forth the essentials of Christianity as being: belief in God, belief in immortality (but not necessarily in hell, since the Privy Council has ruled

it to be non-essential), and a belief about Christ—at a minimum, the belief that he "was, if not divine, at least the best and wisest of men" (pp. 4-5). Russell makes clear that he rejects all three of these beliefs. In fact, he impresses one here as being more concerned to reject than to define, more concerned to express his dislike for Christianity than to present an explanation of what Christianity is.

The reasons which Russell assigns for his rejection of Christian beliefs are numerous. They are, first of all, psychological. Holding, as he does, that there are no cogent or persuasive intellectual grounds for belief, he finds it natural to combat emotion with emotion. Reverence for tradition and desire for security are emotions that he does not feel strongly enough for them to hold him to religion. On the other hand, he feels emotions hostile to Christianity, which are a sufficient rebuttal in kind to the emotional argument for it. Russell's righteous indignation is especially aroused by the (truly absurd) idea that " we should all be wicked if we did not hold to the Christian religion,"[7] an idea which doubtless has been held by many misguided religionists, but which is far from essential to Christianity, or to any religion. In fact, a believer cannot speak of the goodness of God save by appeal to some prior human experience of goodness; and to argue that goodness is only what God commands, that it is good only because God commands it, and that we are wickedly ignorant until God supernaturally reveals to us his goodness and our sin, is a monstrous series of doctrines. In an emotional mood, Russell does not inquire whether the falsity of the idea that all men are sinners apart from knowledge of Christ is sufficient to dispose of Christianity. He simply rejects the idea and seems to regard this rejection as contributing to a refutation of an untenable Christianity.

The psychological mood leads Russell to another argument which he develops much more fully, namely, the moral. On moral grounds, Christianity is to be rejected. "The Christian religion, as organized in its Churches," he says, "has been and still is the principal enemy of moral progress in the world."[8]

[7] *Why Not*, 21.
[8] *Why Not*, 22.

In support of this sweeping assertion, which he grants that his readers may not accept, he cites the Roman Catholic prohibition of divorce, even when an inexperienced girl is married to a syphilitic man. This argument and others to a similar effect in *Religion* are all based on facts, as far as they go; but they are special pleading. Granted that religious prohibitions have had tragic or immoral effects, does it follow that these effects have been the predominant and characteristic attitude of Christianity —Catholic or Protestant—toward human suffering, or that religious prohibitions are the principal enemy of moral progress?

One could, if one wished to construct a rebuttal, build up an analogous argument against the science of medicine. Was not the science of medicine to blame for centuries for the cruel loss of life of mothers in childbirth? Did not physicians fight against the antiseptic discoveries of Lister and even of Pasteur? Do not organized physicians today often oppose socialized medicine? Yet, such an attack on medicine would scarcely be more reckless than Russell's on Christianity. Has Russell ever tried to raise money in the United States for a hospital or a Community Chest? If so, he has probably found that religious believers are about the only citizens who respond freely and without pressure to this particular form of moral progress.

Frequently Russell urges as a moral defect in religion the fact that it is supported by endowments and that salaries are paid to the clergy. It is odd for a thinker to suppose that this is a defect in religion, without also seeing that it is equally a defect in education and in every endowed institution. If the clergy should not be paid salaries, why should the teacher or the physician or the writer be paid? Russell's concern on this point is a main theme of *Churches* and frequently recurs in his writings. It has no logical or ethical force. What is a general argument against everything is not a special argument against anything.

Not all of Russell's moral attack on religion, however, is quite so lacking in cogency as the foregoing. Occasionally he will admit that "in certain times and places [religious belief] has had some good effects."[9] He approves the maxim, "Love

---

[9] *Free Thought and Official Propaganda* (1922), 3.

thy neighbor as thyself."[10] He lists numerous others of the sayings of Jesus as "very excellent," concluding with, "If thou wilt be perfect, go and sell what thou hast, and give to the poor." Russell observes that these maxims are not much practiced. Such concessions, however, do not lessen the force of Russell's attack on Christian morality in both practice and theory. In sheer bulk, this attack looms up as a large part of Russell's thought on religion. He regards religion (like nationalism) as a great enemy of honest thought[11] and of sound morals. On the one hand, he finds Christian ethics too high for practice,[12] and on the other, the doctrine of the sinlessness of Christ has led to dishonest judgments about him.

It is unfortunate that in the course of a discussion of the moral defects of Christ's teaching he commits himself to the standpoint of those who doubt whether Christ ever existed and who add that, if he did, "we do not know anything about him."[13] These words do not express the verdict of sober historians. Russell therefore has committed himself to a loose judgment, although surely not a dishonest one. More serious are his charges against the moral excellence of Christ. Russell condemns the belief in hell, the "vindictive fury" of Jesus against those who did not like his preaching ("ye generation of vipers, how can ye escape the damnation of hell?"), the teaching that the sin against the Holy Ghost is unpardonable, the cursing of the fig tree, and the injustice to the Gadarene swine. An unbiased mind would not deny that there are moral difficulties in every item mentioned by Russell; what he would question would be the validity of a critical method which rejects all Christianity and all religion because objections to the absolute moral perfection of Jesus can be urged on the basis of a literal and uncritical acceptance of the records about him.

In view of Russell's brilliant contributions to logic and epistemology, one would expect him to apply logical and

[10] *Sceptical Essays* (1928), 121.

[11] Cf. art. in *The Nation*, vol. 113 (1921), pp. 701-702. In *Religion* he cites the conflicts between religion and science, but admits that "the warfare is nearly ended" (246 f.). See *Has Religion Made Useful Contribution to Civilization?* (1930).

[12] *Sceptical Essays* (1928), 103.

[13] *Why Not*, 16.

epistemological considerations to the criticism of religion. That he does not do this more than casually is doubtless to be ascribed to the fact that he thinks that religious belief does not arise from intellectual considerations. Nevertheless, it is to be noted that his respect for the logical force of religion has become less as time has gone on. In *Problems* (1911) he holds that questions "of the profoundest interest to the spiritual life" must remain insoluble with our present powers. Such questions as the permanence of consciousness and the importance of good and evil to the universe have, he says, no answer that is "demonstrably true." In spite of this, Russell closes this book with a profoundly religious reference to the mind as "capable of that union with the universe which constitutes its highest good" (250). Most modern empirically-minded thinkers would agree that demonstrable truth, in the sense of logically necessary proof, is unattainable alike in religion, in philosophy, and in science. One might regard these ideas of Russell's as prolegomena to a theory of rational belief.

Russell's thought has moved toward "reasonable belief," experiment, and what one might call faith, in the realm of ethics and social philosophy, but not in religion.[14] In religion, he has applied the most rigid standard—either complete demonstration or no truth—what Matthew Arnold and Borden P. Bowne after him called "a method of rigor and vigor." In *Problems* we found Russell agnostic; in "The Free Man's Worship" (1903), it is true, he had seemed to be completely skeptical, with his picture of "a hostile universe," yet he had granted that some of the things we desire are "real goods." By 1917, when he reissued *Free Man* in *Mysticism*, he says that he feels less convinced than he did in 1903 of the objectivity of good and evil—and he had shown precious little conviction then! In 1935 he reached the conclusion that questions of value, which of course are germane to ethics as well as to religion, "cannot

[14] In a notable remark, Russell says that "the desire to discover some really certain knowledge inspired all my work up to the age of thirty-eight." He had been shocked because Euclid had to start with axioms. During the First World War, "for the first time I found something to do which involved my whole nature," namely, work for peace, and for other social and moral reforms. See *Living Philosophies*, 11-12.

be intellectually decided at all."[15] Values "lie outside the realm of truth and falsehood." "Science has nothing to say about 'values'" (223), and "what science cannot discover, mankind cannot know" (243). Thus on epistemological grounds, Russell arrives at a complete ethical and religious skepticism. We can know nothing about good and evil; the Promethean Free Man is utterly deflated. The last word is *Ignorabimus*.

The conclusion thus reached is strangely inconsistent with Russell's own commitment "since the age of thirty-eight" to values, such as freedom, happiness, kindness, and justice. It is hard to believe that he means literally that there is no way of knowing whether these values are preferable to slavery, misery, cruelty, and injustice. If he would say that the preference for the 'higher' values is purely arbitrary and irrational, then his further criticisms of religion on axiological grounds cannot be seriously meant. In the famous *Free Man*, for example, he rejected ordinary religion on the ground of the combined indifference and cruelty of the universe; but if cruelty and indifference cannot be known to be disvalues, the argument collapses. Perhaps his most intensely felt objection to religion is his judgment of the insignificance and general worthlessness of man. Resorting to the device of a capitalized word, he ridicules the evidence for the goodness of Cosmic Purpose in the fact that "the universe has produced US."[16] In 1903, Russell was all but apotheosizing heroic Promethean man; in 1935, man is, in Russell's eyes, more destructive and less beautiful than lions and tigers; less efficient in the Corporate State than ants; and, by virtue of human cruelty, injustice and war, inferior to larks and deer. Man, then, is "a curious accident in a backwater." Even Mr. Winston Churchill, he implies, could hardly say: "Look at me: I am such a splendid product that there must have been design in the universe."[17] The existence of bishops, one gathers, is for Russell almost a proof of atheism. Yet all this argument falls into nothing if there is no knowledge about values at all!

Russell's axiological criticisms, however inconsistent they may

[15] *Religion*, 243.
[16] *Religion*, 221.
[17] *Why Not*, 10.

be with his own value-skepticism, possess one transcendent merit. In them, namely, he puts his finger on the essential issue of religion: What is the value of personality? If personality and all of its spiritual aspirations are despicable and worthless, then there is manifestly nothing to religion. If, however, in spite of man's weaknesses and vices there is something in him that points toward ideal value, that something is where religion sets in. The question arises whether Russell's skepticism about values is really as complete as he would have us believe. His attack on personality consists in an appeal to ideals which personality acknowledges and admires: beauty, social co-operation, kindness, justice, and peace. If he finds those values embodied in some ways more successfully in the non-human than in the human world, he might well be led thereby to reaffirm the objectivity of values and discern traces of God in nature. If, on the other hand, he means seriously to maintain his value-skepticism, this present argument can be regarded only as an *ad hominem*. He should argue that there is no way of knowing whether man is important.

It is very rarely that Russell directs his thought toward the metaphysical aspects of religion. His youthful rejection (in 1890) of the argument for a first cause was followed by one serious wrestle with the metaphysics of theism, and one only, although it was strictly confined to theism as presented by one man, Leibniz. In *A Critical Exposition of the Philosophy of Leibniz* (1900, new ed., 1937), Russell devotes Chapter XV to "Proofs of the Existence of God." Russell finds "four distinct arguments in Leibniz, which attempt to prove the existence of God." "They are: The Ontological Argument, the Cosmological Argument, the Argument from the Eternal Truths, and the Argument from the Pre-Established Harmony." Russell remarks that only one of these was invented by Leibniz, and it was the worst of the four. Since this chapter is historical and critical it is not necessary to recite all of its details in order to understand the light it sheds on Russell's own philosophy of religion.

Here several points are noteworthy. (1) Russell starts in by stating that Leibniz appeals to "the lazy device of an Omnip-

otent Creator." That is to say, Russell considers only the arguments for an omnipotent deity, rejecting them all. Even if he is right, he could not be said to have considered all the possibilities until he examined the evidence for a God whose purpose is good, but whose power is limited. The conception of such a God has been proposed and discussed by such philosophers as John Stuart Mill, Hastings Rashdall, William James, William Pepperell Montague, Paul Elmer More, Alfred North Whitehead, Charles Hartshorne, and others. Russell's arguments are not relevant to such a view of God.

(2) For Leibniz, Russell holds, it is "quite essential to show that God's existence is a necessary truth." Since, however, necessity inheres only in formal logical relations, it is easy for Russell to show that belief in Leibniz's God is not necessary. Russell does not examine the wide-spread point of view—common to pragmatists and personalists, as well as to many others—that the futility of the quest for necessity does not entail the futility of a quest for probable knowledge or warranted belief.

(3) Early in the chapter, Russell remarks that "a philosophy of substance . . . should be either a monism or a monadism." "A monism," he goes on, "is necessarily pantheistic, and a monadism, when it is logical, is necessarily atheistic." It is indeed remarkable, if this be so; for McTaggart would be almost the only logical monadist in history. Monadism and theism have usually been closely united. But Russell holds that the impossibility of creation follows from the assumed validity of the ontological argument and its implication that all substances always entail all their predicates, so that if there are monads they are uncreated existents. This argument has little force for the empirical mind.

(4) An enlightening remark is Russell's statement that the "physico-theological proof" or the argument from design is "more palpably inadequate than any of the others" (183). Doubtless Russell means that this argument, relying as it does on contingent empirical facts, lacks more palpably than the others the element of strict logical necessity. On the one hand, no one would challenge this statement; but, on the other, a theism derived from empirical probability rather than from

*a priori* necessity would in no way be deterred by it. Any theism worth its salt would welcome a factual basis. Russell is doubtless able to show defects in Leibniz's reasoning; but Russell's critics can point out that refutation of Leibniz is far from being refutation of theism.

## IV

Turning now from Russell's criticisms of religion and religious belief, let us try to explore his positive attitude toward religion. He is undoubtedly hostile to traditional and institutional Christianity. Is he equally hostile to the essence of religion? It is possible to argue forever about the essence of religion, and come to no conclusion; but all will agree that religion is a concern about values, their dignity and their destiny. Inquiry about Russell's religion is inquiry into his attitude toward values.

We have already seen that, in one phase of his thought, he insists that there is no way of knowing validly about values; but we have also seen that he appeals to values and their assumed validity in his criticisms as well as in his own practical commitments. We have found him avowing an increasing skepticism; but he does not entirely escape from the dialectic of value. "When me they fly, I am the wings."

No one who surveys the lifework of Russell can doubt either the sincerity of his opposition to many traditional values or his devotion to the values that he acknowledges. First and foremost among Russell's values (as among Plato's) is truth. Loyalty to truth, especially to scientific method and to the analyses which lead to logical atomism, is the outstanding goal and norm of his thought as it was expressed in his autobiographical sketch in *Contemporary British Philosophy*. Furthermore, in spite of cynical remarks about human personality as unworthy of the cosmic purpose of a God, Russell's life has been notable for its devotion to human values, individual and social. Human happiness, justice, freedom, and co-operation have been objects of his loyalty, ever since he defied the universe in their behalf in the *Free Man*. There are those, like Henry Nelson Wieman, who would define religion in terms of growth; measured by

this standard, Russell's life and thought are religious.

By this time, however, the reader may stir impatiently and inquire whether a man cannot have any decent aspirations without being tarred with the stick of religion, especially if he assures us that he is an enemy of religion. In reply to this fair challenge, evidence is available to show that religion has had a positive and profound influence on Russell. "I was myself," he says, "educated as a Protestant, and one of the texts most impressed upon my youthful mind was: 'Thou shalt not follow a multitude to do evil'. I am conscious that to this day this text influences me in my most serious actions."[18] In his essay on "Useless Knowledge," Russell writes: "For those to whom dogmatic religion can no longer bring comfort, there is need of some substitute, if life is not to become lusty and harsh and filled with trivial self-assertion."[19] Here he is visibly groping for a non-dogmatic religion. When he writes on "The Ancestry of Fascism," he readily grants that organized religion is "one very important element which is on the whole against the Nazis," and he mentions favorably the Christian doctrines of humility, love of one's neighbor, and the rights of the meek.[20] This is not fully in harmony with the one-sided denunciations of religion which we have found elsewhere in his writings.

Russell grants that "modern democracy has derived strength from the moral ideals of Christianity."[21] He acknowledges that "we owe to Christianity a certain respect for the individual; but this is a feeling towards which science is entirely neutral."[22] A favorable judgment on Christianity appears in the following:

The educational machine, throughout Western civilization, is dominated by two ethical theories: that of Christianity and that of nationalism. These two, when taken seriously, are incompatible, as is becoming evident in Germany. For my part, I hold that, where they differ, Christianity is preferable, but where they agree, both are mistaken.[23]

[18] *Dial*, 86(1929), p. 44.
[19] *In Praise of Idleness and Other Essays* (New York: W. W. Norton and Company, 1935), 52. Afterwards referred to as *Idleness*.
[20] *Idleness*, 119.
[21] *Idleness*, 132.
[22] *Idleness*, 192.
[23] *Idleness*, 235.

In *Power* (1938), he remarks that "the world owes something to the Gospels, though not so much as it would if they had had more influence" (241). Here is ample proof of a higher appreciation of religion than appears in the more hostile utterances.

In four sources, however, we find the profoundest expression of Russell's positive view of religion. The best known is the oft-quoted *Free Man,* dating from 1903. Familiarity with it may be presupposed. Profounder from a religious standpoint, if less brilliant as literature, is the essay, "The Essence of Religion," published in the *Hibbert Journal* in 1912. Then, there is much of value in *Principles of Social Reconstruction* (1916). Finally, one must include the chapter on "Effort and Resignation" in *The Conquest of Happiness* (1930). Neither *What I Believe* (1925) nor *Religion and Science* (1935) is very illuminating on positive religion, preoccupied as each book is with negative and external criticism of traditional ideas.

These sources, especially the *Hibbert* article, reveal as the four essentials of Russell's religion: a sense of infinity, a sense of membership in the whole, resignation, and social justice.

The sense of infinity refers to "the selfless untrammelled life in the whole which frees man from the prison-house of eager wishes and little thoughts."[24] Infinity and membership in the whole are thus inseparable. This quality of infinity is one aspect of human experience. It is universal and impartial. The other aspect of man's life is finite, self-centered, particular. Man's soul is "a strange mixture of God and brute, a battle ground of two natures." The experience of the infinite is "like the diffused light on a cloudy sea," "sudden beauty in the midst of strife, . . . the night wind in the trees." By contrast, patriotism is an unsatisfactory religion "because of its lack of universality" and infinity.[25] The resemblance between Russell and Dewey at the zenith of their religion is striking, for Dewey speaks of "the freedom and peace of the individual as a member of an infinite whole. Within the flickering inconsequential acts of separate selves dwells a sense of the whole which claims and dignifies

[24] *Hibbert,* 46-47.
[25] *Principles,* 57.

them."[26] Both men have a sense of the infinite, and both experience the feeling of membership in the whole as religious.

Russell's deepest religious experience is in harmony with the light by which all mystics live. That Russell himself was aware of this is evident from his essay on "Mysticism and Logic." Here is the empirical root of that undogmatic religion which he was seeking. Russell was never able to distinguish between dogma as traditional belief and dogma as a rational interpretation of religious experience; but at bottom he has been a more religious man than his theories or his attacks on religion would suggest. From his mystical sense of infinity and of membership in the whole flows the third trait of his religion, namely, resignation. In *Happiness* (1930), Russell writes: "Christianity taught submission to the will of God, and even for those who cannot accept this phraseology, there should be something of the same kind pervading all their activities."[27] Religious resignation is not approval of all that is; it consists rather in "freedom from anger and indignation and preoccupied regret."[28] Resignation is the attitude of a participant, not of an outsider. Russell has recently pointed out that the trait of aloofness, which he finds in Santayana, may be wise, but is inferior to the attitude of service, "which is a heritage of Christianity, and one which is essential to the survival of intelligence as a social force."[29]

Hence arises the fourth phase of Russell's religion, which we have called social justice, and he calls love. "Any adequate religion," he tells us, "will lead us to temper inequality of affection by love of justice, and to universalize our aims by realizing the common needs of man."[30] He wants "a new religion, based upon liberty, justice and love, not upon authority and law and hell-fire." *What I Believe* is that "the good life is [one] inspired by love and guided by knowledge" (58).

The total life of religion, as Russell conceives it, is "the life

[26] John Dewey, *Human Nature and Conduct* (1922), 331.
[27] *Happiness*, 236.
[28] *Hibbert*, 56.
[29] In P. A. Schilpp (ed.), *The Philosophy of George Santayana* (1940), 474.
[30] *Principles*, 58.

of the spirit." He finds three sources for human activity, which he calls instinct, mind, and spirit. "Art starts from instinct and rises into the region of the spirit; religion starts from the spirit and endeavors to dominate and inform the life of instinct."[31] The spirit is defined as reverence, worship, a sense of obligation to mankind, and the feeling of imperativeness. Deeper than these, is a sense of mystery or hidden wisdom and glory. The end thus served is not merely human life, but something beyond the human, "such as God or truth or beauty."[32] "By contact with what is eternal," he concludes, "we can make our own lives creative." Such genuinely religious ideas and experiences reveal a side of Russell that is unsuspected by many of his readers.

## V

After this survey of Russell's religious thought, there remains the question whether he has given expression to a consistent philosophy of religion. The only answer that can be given to this question is that he has not done so. His moods and attitudes are conflicting; his evaluations are conflicting. Only in the negation of specifically Christian or theistic faith is he steadily consistent.

No man can be expected to remain temperamentally constant. Changes of mood are human, natural, and fitting. But Russell's moods vary beyond the usual limits. Sometimes his writings reveal a studied indifference to religion. The objective indifference that the most pious Christian might cultivate in presenting a secular subject is to be expected in any writer; Russell often surpasses such objectivity by neglect of religious ideas even in contexts where they are relevant. On the other hand, there are times when he loses *sang froid* completely and becomes, as in *Why Not*, the supercilious pamphleteer, using trivial arguments, glaring exaggerations, and prejudicially selected instances; wit, animosity toward the Church, and desire to make a point combine, when Russell is in this mood, to make of him an unattractive and unpersuasive foe of religion. On the other

[31] *Principles*, 205-207.
[32] *Principles*, 245.

hand, his anti-religious mood becomes higher and more serious when his moral indignation is aroused and he attacks the church for its dishonesties and injustices. In none of these moods, however, is any philosophic understanding of religion manifested or attempted.

Russell comes closer to an interpretation of religion when in the historical mood, as in the surveys of the development of relations between religion and science in *Religion*. Here the account is objective, and is often accompanied by judicious criticism. Due credit is given both to religion and to science at most points, although the attitude to science is that of a participant, whereas religion is observed externally. The philosophical, as contrasted with the historical, judgments in this book, however, are almost purely negative. In this mood, Russell is chiefly concerned to point out the errors in traditional religious thought rather than to discover what truth and value there may be in religion. In fact, it is in *Religion* that Russell asserts most strongly the relative worthlessness of personality and the impossibility of any knowledge of values.

When Russell presents his own religious convictions a totally different mood is revealed. Whether in *Free Man*, or in *Hibbert*, or in *Principles*, Russell avows a sincere and moving faith in the value, the dignity, and the possibilities of life which prove convincingly that, on one side of his nature, at least, he is a genuine religious mystic, combining reverence and resignation with prophetic fervor. Here we have the light he lives by; but nowhere does he attempt to use these items of his religious experience as clues to the nature of the real. Whether he is Ajax defying the lightning, Prometheus against Zeus, Mahomet practicing Islam, Hindu saint losing himself in Nirvana, or Hebrew-Christian prophet of social justice—and he is all of these—his faith is seen in a glass darkly. His is almost a *credo quia absurdum*.

The three fundamental questions of religion remain in a state of dialectical opposition in Russell's thought.

Is there a rational knowledge of value? No, he says in *Religion;* since science is indifferent to value, value norms are unknowable. Yes, his life says. His devotion to social and

mystical values, his criticisms of conventional religion, presuppose commitment to known ideals. Values can be experienced, criticized, and tested, if we are to judge by Russell's social and political interests.

Is personality valuable? No, he says in *Religion;* it is an accident in a backwater, unworthy to be the work of a God. Yes, say the *Hibbert* article and his loyalty to truth and beauty and justice. Unless personality is valuable, all work for peace and moral reforms which "involved my whole nature" was aimless and futile.

Is there a God? No, he says in all of his criticisms of religion; an omnipotent being would not have created such a world as this. Yes, is his unvoiced, but empirical answer. His appreciation ɔf the religious sense of mystery and of the life of the spirit, and the need for something more than human are experiences of the divine. There may be an objective power for beauty and truth at work ordering the chaos of things and even struggling toward higher levels of evolution. There may be a finite God. Has not Russell said that man is both brute and God?

In each case, unfortunately, Russell's preoccupation with negative aspects has prevented his giving due attention to the empirical evidence and possibilities of positive aspects of religion. Is it possible that Russell is one in whom the "quest for certainty," and the intellectual asceticism which it imposes, is so urgent and imperative a demand that the quest for adequacy is crowded into the background? Logic triumphs over mysticism; rigor and vigor over value, personality, and experience. If the brilliant mind of Russell were to be directed toward an empirical philosophy of religion—of his own religion—the result would doubtless be illuminating.

EDGAR SHEFFIELD BRIGHTMAN

DEPARTMENT OF PHILOSOPHY
BOSTON UNIVERSITY

18

*Eduard C. Lindeman*

RUSSELL'S CONCISE SOCIAL PHILOSOPHY

# RUSSELL'S CONCISE SOCIAL PHILOSOPHY

THERE exists no difficulty in designating Bertrand Russell as a social philosopher. He has stated specific goals with respect to all of the major categories usually considered to be the constituents of social policy. Concerning the five primary categories of social policy, namely Eugenics, Euthenics, Politics, Economics and the Law, Bertrand Russell has expressed both specific and somewhat unconventional opinions respecting all save the last. He does not appear to have been deeply interested in either the nature or the process of the law as such.

A distinguishing mark of a social philosopher is to be found in an adopted cluster of values which describes his sense of direction. It seems to be generally true that within this cluster a single value stands out as the guiding principle; whatever organization and self-consistency is to be found in any philosopher's value-system seems to be derived from this one value which acts as *leader*. Here again Bertrand Russell presents no serious difficulties to the interpreter. His dominant value has always been Freedom. All of his social policies derive from and may be explained in terms of his overwhelming belief in liberty for the individual person.

Not all social philosophers are so constituted as to be capable of participation in social action. Bertrand Russell has had no hesitancies here. He has taken positions on social issues and he has suffered the usual consequences when his opinions have run counter to those of the majority, or of those in power. Like our own Thoreau, who was also a social philosopher, he went to jail for his convictions. Still more significant, he actually carried some of his social beliefs into experimental practice. For example, he organized and operated a school for children in which

his principles of education were exemplified. I shall only allude to his more private experiments in the realm of marriage and family life which, unhappily, have elicited more public interest than his basic philosophy. Certainly no contemporary philosopher of first rank has received so much attention in the public press. Besides, Bertrand Russell has also played the rôle of active publicist both here and in his own land and over a long period of time. There is scarcely a large-sized city in the United States in which he has not lectured or debated.

I mention all of these various items of clarity and objectivity at the outset of my essay because I should prefer, after one or two more general references of this type, to confine myself as far as possible to an impersonal appraisal of those elements in Russell's social philosophy which seem to me to possess relevancy for the present and the future. For this main purpose it seems to me desirable to eliminate biographical and personal factors.

I see no necessary relation between Russell's epistemology or his metaphysics and his social philosophy. In the light of his metaphysical ideas he might as easily become a conservative absolutist as an experimental relativist. There is nothing in his epistemology and the logic which must rest upon it which is incompatible with what might be called the neo-Hegelian viewpoint. His progressiveness in education, for example, bears no relation to the pragmatic movement of the nineteenth and twentieth centuries. Indeed, he insists upon dissociating himself from the pragmatists. His pacifism during World War I is less confusing. In this realm he followed an arbitrary principle and took the unpleasant consequences. When I say that I find no necessary relation between these two phases of his life and thought, namely, his eagerness to experiment in the social sphere and his conception of truth and knowledge, I see now that I must amend my assertion. The one element of inter-connection is his conception of the nature of science. He has been essentially a positivist, but not an ordinary one. I must refer to one of the very important consequences of his peculiar variety of positivism. He makes a sharp distinction between science and morals. In fact, he carries his distinction so far as to make an absolute

separation, a substantive dualism. It will be necessary to return to this issue later, since it is at this point that the great confusion of our time centers.

Russell belongs to that group of contemporary thinkers which holds that science is essential but that it contains no basis for the belief in progress. This is a difficult thesis to understand. From what standpoint can it be said that science is useful or necessary and at the same time neutral? I have no difficulty in understanding those who insist that science has been and is in essence a demoralizing influence, although I disagree sharply with their viewpoint. What leaves me utterly puzzled, however, is the attitude of a man like Russell who understands so much about the development of scientific concepts and practices and then, at the point of human applications, relegates science itself to the realm of detachment and other-worldliness which seems to be comparable only to early and naïve theologies. It is because I feel so deeply about this problem that I now warn my readers that I shall be constrained to return to it again.

Bertrand Russell needs to be understood, presumably, in terms of certain personalistic and stylistic attributes which set him off as an unusual and fascinating being. He is obviously an exceedingly complicated personality with a terrific need for simplicity. This combination frequently produces a kind of genius. His tendency to over-simplify breeds a variety of prose which is enticing and even at times lyrical. Some of his over-simplifications are, using a bit of American idiom, "slick," some are shrewd and illuminating, and some are downright falsifications.

## RUSSELL AND THE MARXIST DOGMA

The acid test of a social philosopher's relation to the course of civilization in this period of history (roughly spanning the years beginning at the middle of the last century and ending with the era immediately following the present war) is to be found in his attitude toward the Marxist dogma and its overt consequences. The major social disturbances of this period, particularly in the Western world, may be traced to the social philosophy of Karl Marx. Indeed, it may even be said that

Marxism has had no formidable rival as a social theory throughout this era until, of course, the rise of Fascism. Whether or not future social historians will describe Fascism as a function of, or a direct and necessary response to Communism, it will be impossible in the future to discuss the first without including the second. Bertrand Russell, using his favorite yard-stick of freedom, brings them into a conjoint relation, since they appear to deny individual liberties to an equal degree. But, he recognizes also important distinctions.

Russell's objections to the Marxists' doctrine are both logical and temperamental. The method by which Marxists inter-fuse *materialism* with *idealism* in order to construct their dialectical formula for interpreting history and social change he rejects completely. His rejection, as I understand it, is based upon the argument from necessity; that is, he sees no necessity for this formula, since other and more objective interpretations of history are available. He also assumes that the Marxian theory of value and surplus value have both been disproved by experience. He accounts for these theories in terms of Marx's adroit synthesis of Ricardo's theory of rent and the Malthusian theory of population, both of which have turned out to be false. It is, therefore, a logical inference that if the two major factors of an integration have become untenable, it must be true that the synthesis derived from them must also be discarded. These are Russell's primary and logical criticisms of Marxist philosophy. His temperamental opposition, which is probably more important, springs from his belief that (a) the authoritarian element in Marxist doctrine and its tendency to promote infallibility is completely contrary to the scientific spirit, (b) Marxist doctrine glorifies the manual worker at the expense of the intellectual, (c) there is great danger in the Marxist policy of class-warfare and hatred as a means towards progress, both of which being anti-humanistic and psychologically perverse, and (d) that there exists a deep-seated incompatibility between Marxist doctrine and the democratic ideal, especially the ideal of intellectual liberty. These are all fundamental criticisms, that is, if one admits that emotional and temperamental factors belong in the same equation with logical and intellectual ones.

What Russell seems to be saying is: In the first place, I dis-approve of Marxism because I believe it to be a fallacious con-ception of reality, and in the second place, I simply do not like what it does to persons. If these two parts of his reasoning were reversed in order, it would probably constitute a more realistic statement of his position.

## Fascism Completely Rejected

There will no doubt be many debates among scholars of the future regarding the heritage of Fascism. At present it appears to be a bastard philosophy. Suspicion has it that its parents are Capitalism and Communism, but both claim complete innocence. As a matter of fact, each insists that whatever Fascism may finally be named, they should be exonerated. In the early days of Italian Fascism, Mussolini was fond of stating that Fascism was a doctrine compounded of the teachings of Hegel, Machia-velli and William James. In what manner these disparate philosophies of absolutism, opportunism and pragmatism came to amalgamation was never clearly described by Il Duce. By this time he may have discovered that these ingredients have refused to coalesce. Bertrand Russell admits that his aversions to Communism are less complicated than are his objections to Fascism. In the case of Communism he merely objects to the means proposed for reaching goals which he himself approves, whereas in the case of Fascism he rejects both the means and the ends. Fascism is, according to Russell, capitalistic, nationalis-tic and anti-democratic. Many of its tactics, as well as some of its doctrines (as for example state planning) were taken directly from the Communists, and this should not be surprising, since both Communism and Fascism are based upon the assumption that the end does justify the means. Here again, the tempera-mental factor in criticism enters. Russell's chief objection to Fascism is its doctrine of fundamental distinctions between human beings. Aryans versus non-Aryans, the *Herrenvolk* versus the menials, the *élite* versus the masses. He is also an-noyed by the lack of order and clarity in that curious combina-tion of notions which now calls itself Fascism. Communism has a respectable history and belongs within the family of philo-

sophic ideas. Fascism, on the contrary, is a "psychoanalysis" and not a genuine philosophy. Russell rejects Fascism completely. His misgivings concerning Communism, although not amounting to denial, are sufficiently profound to constitute virtual rejection.[1] Is there, then, a form of society to which he gives allegiance?

## UTOPIA IN REVERSE

Social philosophers are often tempted by the prophetic muse. They may be ever so ironic about the existing order, but underneath they too are moved by the "visionary mania" which leads to Utopia. In this respect Bertrand Russell is a sign of something contrary: he has written his Utopia in reverse, a description of the future society which he believes has a good chance of realization, but which he contemplates with something akin to horror. This foreboding pattern of the future[2] is called *Scientific Society*. It will be a planned society, artificially constructed and managed by trained technologists, the power politicians of the future. These managerial experts will already know from their studies of advertising, propaganda or what goes by the name of education, the press, the cinema and the radio, how to control all basic human responses. This practical knowledge will have come into their hands by means of a synthesis of psychoanalysis and behaviorism, Freud and Pavlov.

Once having mastered the techniques for controlling mass behavior, these ruling technicians will make provisions for social stability in an exceedingly simple manner, namely by breeding the type of human being who will be content to live in such a society. Approximately twenty-five percent of the women of each generation and five percent of the men will be used for breeding purposes and all others will be sterilized. Since these children will not be reared by their parents but by employees of the state, the maternal and paternal impulses will soon disap-

---

[1] In describing in psychological terms why the Marxist type of revolution through class conflict cannot succeed, Russell writes as follows: "There is no alchemy by which a universal harmony can be produced out of hatred." *Proposed Roads to Freedom* (1919), 149.

[2] Described in detail in Part Three, Chapters XII to XVII in *The Scientific Outlook*, published in 1931.

pear. The managers will derive intense satisfaction from the pleasure which comes from planning, and for the rest there will be provided a wide range of sports and amusements, among which the chief may be sex which will have been rendered "destitute of social importance." (p. 253) No subversiveness will be tolerated, and in order to prevent any variety of plotting among possible friends the authorities will furnish strategically located "governmental microphones" for ubiquitous censors. In this scientific society art and literature probably could not flourish; there would be pleasure but no joy; knowledge but no love, and power without delight. Having described this social monstrosity, Bertrand Russell then admits that "in the end such a system must break down either in an orgy of bloodshed or in the rediscovery of joy;" but it is difficult to see how either of these eventualities might be brought about, given the conditions already described. "There is, I think," writes Mr. Russell, "a real danger lest the world should become subject to a tyranny of this sort, and it is on this account that I have not shrunk from depicting the darker features of the world that scientific manipulation unchecked might wish to create." (260) From this sentence we are to assume, as indeed our author has instructed us to do, that this terrifying picture of the future is "not to be taken altogether as a serious prophecy." (260) This is what is likely to happen if scientific technique is not checked. Consequently, our attention must now be directed toward the preventives, the checks, since Russell himself disavows the society he has visioned.

He defines a *scientific society* as one in which the rulers produce the results intended, and "the greater the number of results that it can both intend and produce, the more scientific it is." (227) This definition holds, presumably, regardless of the character of the results intended and produced. This simple definition represents all that Bertrand Russell ever asks of science and the scientist. "The sphere of values," insists Mr. Russell, "lies outside science, except insofar as science consists in the pursuit of knowledge." (266) Here we have, perhaps, the most candid of all statements affirming "moral isolationism"[3] for scientists.

[3] A phrase used recently by Professor Harold Larrabee in a paper read before the Conference on the Scientific Spirit and Democratic Faith.

## A Social Philosophy, Minus Dynamics

It is precisely at this point that my greatest sense of dissatisfaction arises with respect to Bertrand Russell's complete philosophic outlook. I admire his clarity of thought and especially his felicities of expression. My respect for his courage and audacity is profound, and particularly do I praise his temerity in attacking the more difficult problems of philosophy, as for example, those arising from the so-called new physics, not to mention those which shock the conventional and timid thinkers. Bertrand Russell is a brave thinker and a bold one. But, he does not furnish us with a single authentic lever for action. A social philosophy which does not lead to social action is incomplete. If science is to be the chief source of dynamics for the coming age, and if scientists are to have nothing to do with values, from whence are values to come? Certainly not from religion, not if Bertrand Russell has anything to say about it, because for him religions spring from fear and are the remnants of superstitions. Where are we to find the checks which will prevent science from producing this horror world which Russell describes so glowingly? There is but a single source, namely education; but alas, the promise is slender indeed and is contained in this wistful sentence:

The new powers that science has given to man can only be wielded safely by those who, whether through the study of history or through their own experience of life, having acquired some reverence for human feelings and some tenderness towards the emotions that give colour to the daily existence of men and women. (268)

But, are these persons of reverence and tenderness to be scientists? Obviously not. This probability has already been ruled out by Russell himself. Who, then, are the ones who will be designated to stem the tide of a brutalizing science? Patently, these must be "soft" persons chosen from the ranks of artists and scholars, persons devoid of all desire for power. How are these tender ones to check the scientists who care only for the consequences which they have purposed? There is no answer, and we are left, as Russell so often leaves us, entertained and enlightened but unmotivated.

The difficulty with Russell's viewpoint is to be found, I believe, in his habitual dualism. I have not made a careful study of his epistemology, especially of the earlier years, and hence I do not know whether this habit of dualism is rhetorical or fundamental. Over and over, he emphasizes the easy polarities. Knowledge and ignorance, good and evil, freedom and slavery, science and something which is not science. So long as he permits himself these simple dichotomies, it will not be possible to build a functional social philosophy out of his social philosophizing. If the scientists are to be entirely exonerated from all consideration of value, then Russell is correct in both his analyses and in his prophecies. If scientists have nothing to do with the ends of life, then those ends will become, using one of Russell's telling phrases, "something dusty." If he should ask another question, the question for example which Ralph Waldo Emerson asked, namely, "What manner of man does science make?"[4] he would at once find himself on a new trail. But, he cannot ask this question. He cannot ask it because to him science stands completely outside the realm of the personal. Science is not a form of common sense, a variety of experience comparable to other experiences, but something which stands *above* and *beyond*. The type of society in which the scientist works and has his being must remain for him a matter of complete indifference. A scientist who is also interested in politics would be, in substance, an anomaly.

## LEISURE AND CULTURE

Leisure is one of the social problems which has concerned philosophers almost universally. Bertrand Russell, in addressing himself to this question, begins with a quixotic title, namely, *In Praise of Idleness*.[5] There exist, he states, only two varieties of labor, namely, "altering the position of matter at or near the earth's surface relatively to other such matter" and "telling

[4] *The Complete Works of Ralph Waldo Emerson*, Centenary Edition, Boston & New York, 1904, Vol. VI, page 284. Another of Emerson's concerns was stated thus: "Something is wanting to science until it has been humanized." Vol. IV, p. 10.

[5] This is the title of his book on the subject, published in 1935. It is in this volume, curiously enough, that Russell has set forth his considered objections to Communism and his criticism of Fascism.

other people to do so."[6] Here we have the typical quality of Russell's humor at its best. What he accomplishes with sallies of this order is to demolish in one fell swoop the whole edifice of uncritically-accepted moralisms. We have been taught to believe that virtue inheres in work. Russell tells us that virtue, on the contrary, resides in leisure, that "the road to happiness and prosperity lies in an organized diminution of work."[7] Russell's brand of socialism may well be said to begin at this very point. He believes that modern technology is capable of producing a high standard of living for all, that machines should do the major work, and that a man should not be rewarded for his presumed virtues but rather for his efficiency in production.

As usual, Russell over-simplifies his socio-economic equation in this manner:

I suppose that, at a given moment, a certain number of people are engaged in the manufacture of pins. They make as many pins as the world needs, working (say) eight hours a day. Someone makes an invention by which the same number of men can make twice as many pins as before. But the world does not need twice as many pins; pins are already so cheap that hardly any more will be bought at a lower price. In a sensible world, everybody concerned in the manufacture of pins would take to working four hours instead of eight, and everything else would go on as before. But in the actual world this would be thought demoralizing. The men still work eight hours, there are too many pins, some employers go bankrupt, and half the men previously concerned in making pins are thrown out of work. There is, in the end, just as much leisure as in the other plan, but half the men are totally idle, while half are still overworked. In this way, it is insured that the unavoidable leisure shall cause misery all round instead of being a universal source of happiness. Can anything more insane be imagined?[8]

I call this an over-simplification, because it omits some of the important factors; but it is, as a matter of fact, an excellent description of the manner in which our contemporary conceptions of work and leisure have come into existence. In striving to dignify labor we have succeeded in degrading leisure. So long

[6] *In Praise of Idleness*, 12.
[7] *Idem.*
[8] *Ibid.*, 16-17.

as this condition exists we shall not be capable of devising suitable plans for leisure. Even the modern Russians, according to Russell, have not learned this fundamental lesson; they give special honor to the manual worker; they merely substitute Dialectical Materialism for God in the moral context. Communists would not say, with Isaac Watts:

> For Satan finds some mischief still
> For idle hands to do

but they would imply that the opponents of the Communistic State might be assumed to be effective substitutes for Satan. According to Russell we have allowed ourselves to be perverted by the "cult of efficiency," and hence we have no valid form of judgment to make of the productive enterprise. There is, he insists, but one valid judgment to make with respect to economic production, namely, "the pleasure it gives to the consumer."[9] I presume that we may deduce from this a preliminary theory of the nature of leisure as a form of earned freedom. From this it follows that if leisure and liberty are to be equated, there should be no hint of regimentation in the free time of those who have somehow earned the right to be thus free. This brings us to the leisure problem as it was viewed by the Greeks.

As befits a philosopher, Russell, having stated his social theory, proceeds at once to a solution which is philosophic in essence. He does not wish the famous dictum of Francis Bacon to be taken too seriously, nor universally; knowledge may be power but it may also be fun. If leisure were used for purposes of non-purposeful knowledge, we should at once be on the trail of a kind of leisure which would soften the hard heart of the world. Russell wants an architecture, especially pertaining to homes, which will be appropriate to the new leisure. He wants houses made as scientifically efficient as factories but conceived in beauty and designed for the leisure of all members of the family group. Russell scarcely goes further than these suggestions in proposing a program for cultural leisure; this is not surprising, since he is not a pragmatic person; aside from his espousal of what might be called an "innocent" form of social-

[9] *Ibid.*, 25.

ism, his only genuinely activist interest has been concentrated upon education, and we may assume that it was his belief that a properly educated person would have no serious difficulty with his leisure, provided he might live in a decent society.

## Education Is The Good Life

In the realm of education, Russell speaks not merely as a theorist, but also as a practical experimenter. He has actually operated a school for young children, an undertaking from which most philosophers would shrink with fear and trembling. It is one thing to write bravely about education as it should be and quite another to subject one's self to the ordeal of translating one's precepts into action. Here, as in so many other instances, Russell reveals an undaunted spirit.

In his major treatise on education[10] he allows theory and practice to intermingle. He states the general aims of education and then, having divided these objectives into two primary strands (character and intelligence), he proceeds to indicate how to attain these ends at various genetic levels. In this manner he combines both the *"how"* and the *"for what purpose"* questions of education into a single and flowing treatment.

Insight with respect to the ends of education as conceived by Russell may be gained by analyzing one of his preliminary affirmations which reads thus:

The real issue is: should we, in education, aim at filling the mind with knowledge which has direct practical utility, or should we try to give our pupils mental possessions which are good on their own account?[11]

We encounter once more a typical Russell dualism in this sentence. Education has two sides, not many. The choice is between utility and enjoyment, as though these two qualities of experience were somehow and irrevocably dissociated and in conflict. Having stated the dilemma, his favorite form of logic, he thereupon proceeds to point out why different people differ on this issue. Aristocrats, for example, want the latter type of education for themselves and the former (utilitarian) for the lower classes.

[10] *Education and the Good Life,* published in 1926.
[11] *Ibid.,* 23.

Democrats, on the contrary, desire to have what is useful and what is ornamental divided on a somewhat equal basis. In the next place, human nature seems to exist in two compartments. There are persons who care only for material goods and others who care for mental delights. And, finally, among educators there are those who insist that intrinsic knowledge (non-practical) is completely valueless, whereas others insist with equal fervor that this so-called "useless" knowledge is the only variety which in the long run can nourish the spirit of man and thus keep him human. Russell, fortunately, does not fall on either side of his artificially constructed dilemma. He knows that scientific and practical knowledge cannot save us, but he also knows that we cannot live in this world at all at this stage of our development without additional amounts of science and technology. He appears to take for granted, however, that this latter type of training needs little encouragement and that we are much more likely to fail for want of what might be called education for character and intelligence.

Pupils should be regarded as ends, not means. The school exists for them and not they for the schools. The end to be desired is a good character, or if we were to use a modern terminology, a good personality. A good personality consists of vitality, courage, sensitiveness, and intelligence. Vitality is not to be regarded as mere physical strength but rather as the ability to take an interest in the outside world and to enjoy existence. Courage is contrasted with fear and repressions. Sensitiveness is a corrective for merely animal vitality and courage. Intelligence begins with curiosity and is inclusive of open-mindedness, truthfulness, capacity to coöperate with others, and to stand alone with one's convictions if necessary to maintain personal integrity.

Russell's treatment of such problems as fear, punishment, truth-telling, et cetera, conforms in general to the precepts known in this country under the title of *progressive* education. Character building, as conceived by Russell, should be nearly complete by the age of six. From this period onward emphasis should be placed upon intellectual development; even moral

questions may now be subsumed within the intellectual realm and should, as a matter of fact, receive no further attention as and of themselves.

Disinterested curiosity is the key to intellectual growth. There need be no ulterior purpose for the acquisition of new knowledge; the goal of intellectual curiosity is knowledge for the sake of knowledge. This form of intelligence (regarded by Russell as being intrinsic as distinguished from ulterior knowing) automatically produces the desirable quality of open-mindedness. Ability to concentrate one's attention, patience, and exactness—these are traits which arise naturally and almost automatically from this type of "genuine" education. Some degree of specialization is to be permitted after the fifteenth year, but the criterion is to be, not the curriculum, but rather the pupil; if he shows an inclination towards special studies, this wish should be gratified; if, on the contrary, he shows no such signs, he should continue with "all-around" education. The three areas of specialization are (a) classics, (b) mathematics and science, and (c) modern humanities.[12] In all these matters there is but a single source of motivation, adventurous interest. "The great stimulus in education is to feel that achievement is possible. Knowledge which is felt to be boring is of little use, but knowledge which is assimilated eagerly becomes a permanent possession."[13]

Russell has devoted much less attention to the perplexing questions centering about so-called higher or university education. What he says is, however, pertinent. He begins with the assumption that only a minority of the population is capable of profiting from education prolonged as far as the age of twenty-two. Who, then, are to be selected for higher education? Certainly not those whose chief qualification is the ability of their parents to pay the costs. At the age of eighteen a boy or girl is capable of doing useful work; if the State conscripts them for study instead of work, there should be assurance that the investment is sound.

Before one is to say who shall attend universities, a prior

[12] *Ibid.*, 278 and 279.
[13] *Ibid.*, 290.

query arises, namely, what *are* universities? Russell, once more resorting to his favorite duality, believes that universities may exist for two purposes: "on the one hand, to train men and women for certain professions; on the other hand, to pursue learning and research without regard to immediate utility."[14] Teachers in universities should themselves be engaged in research and should not be required to become adepts in pedagogy. Whether the student enters the university for the pursuit of "pure learning" or for professional training, he should be chosen because he possesses the required skill and not because he belongs to a special class or happens to be the offspring of parents of wealth. I stated above that these notions of Russell's regarding higher education were pertinent, and my inference was to the effect that these are precisely the types of questions which are likely to be centers of excited discussions during the years to follow the current war. I say this because what Russell is here defining is, patently, his conception of democratic education.

## THE INNOCENCE OF RUSSELL'S SOCIALISM

My choice of adjective in a previous sentence requires explanation. I said that Russell's variety of socialism was "innocent" and by that I mean that he dissociates himself completely from those types of socialism (or communism) whose leaders are willing to deprive men of liberty or condone the use of violence. If he can have socialism plus democracy, he will welcome the future, but if he is asked to take socialism without democracy, he will choose democracy even though it is associated with a faulty economy. This thesis is repeated in all three of the volumes in which his ideological position is interpreted,[15] and it seems certain that this attitude has not been altered.

His rejections are sharp and clear. He rejects Fascism because it is irrational, anti-democratic, nationalistic, capitalistic, and has its roots not in historic philosophy but rather in psychoanalysis.

[14] *Ibid.*, 306.
[15] *Proposed Roads to Freedom*, published in 1919; *Prospects of Industrial Civilization*, 1923 (written in collaboration with Dora Russell); and *Power*, 1938. In addition to these three works it should be added that among the most considered of his ideological statements are those to be found in Chapters V, VI, and VII in the collection of essays published under the title: *In Praise of Idleness*, 1935.

He rejects Marxian Socialism because he cannot accept dialectical necessity in historical change; nor can he accept the Marxian theory of value and surplus-value, the undue glorification of manual labor, class war, and hatred; in addition he opposes Marxism on the ground that it is basically anti-democratic, disposes of liberty and asks its adherents to revert to the belief in one man's infallibility, in this case Marx himself. But he does not at this point, happily, fall into the error of believing that Fascism and Marxism are the only alternatives confronting us. He believes that socialism and democracy are reconcilable.

Socialism, as conceived by Russell, is "primarily . . . an adjustment to machine production demanded by considerations of common sense, and calculated to increase the happiness, not only of proletarians, but of all except a tiny minority of the human race. . . ." Further, socialism is to be defined as a combination of economic and political power. "The economic part consists in State ownership of ultimate economic power, which involves, as a minimum, land and minerals, capital, banking, credit and foreign trade. The political part requires that the ultimate political power should be democratic."[16] This type of socialism is bolstered, he believes, by the following arguments: (a) the profit-motive is bound to break down, (b) leisure cannot be properly distributed under the profit motive, (c) economic insecurity will persist so long as the profit motive continues, (d) the world cannot tolerate longer the existence of idle and parasitic people, (e) education must be democratized if democracy itself is to survive, (f) the arts cannot flourish until democratic socialism is achieved, (g) the numerous public services which cry for accomplishment cannot be undertaken under the "haphazard operation of the profit motive," and (h) war cannot be stopped so long as competitive economics persist.[17]

From a philosophic viewpoint it is evident that Russell's reasoning about the social order proceeds from certain conceptions respecting the nature of power. It is not surprising, therefore, that he should have devoted an entire volume to this issue

[16] Page 122, Chapter V., *In Praise of Idleness:* the chapter is called "The Case for Socialism."

[17] *Ibid.*, 125-147.

alone.[18] The varieties of power considered include *priestly, kingly, naked, revolutionary,* and *economic;* also power is expressed as control over opinion, as creed, as moral codes, as government, and as private organizations among individuals. As might be expected from a thinker schooled in the philosophic discipline, Russell mistrusts all power save that which derives from wisdom[19] and consent. There are, nevertheless, distinct power philosophies. Philosophers, being nothing more than human beings with a special preoccupation, seek wisdom for varying purposes. Some desire merely to know, and to prove that the world is knowable; some seek happiness, some virtue, and some a synthesis of these two; some desire a union with God or with other human beings; some seek beauty, and finally there are philosophers who seek power, Machiavelli, Thrasymachus, and Fichte for example. Pragmatism is a power philosophy.[20] Likewise Bergson's creative evolution, and obviously Nietzsche's anti-Christianity.

Scattered throughout these chapters of *Power,* which, by the way, Russell calls *A New Social Analysis,* are notions about Democracy which the contemporary student may ponder with profit. A sample may tend to stimulate an appetite:

. . . democracy gives a man a feeling that he has an effective share in political power when the group concerned is small, but not when it is large; on the other hand, the issue is likely to strike him as important when the group concerned is large, but not when it is small.[21]

There can be no question concerning Russell's adherence to the democratic doctrine, but he is capable of treating it with biting sarcasm, as for example in sentences of this variety: "The most successful democratic politicians are those who succeed in abolishing democracy and becoming dictators."[22] Following this

---

[18] *Power* (1938).

[19] Which, oddly enough, seems greater among primitive than among modern civilizations.

[20] At this point Russell inserts one of his misleading although entertaining aphorisms. He writes, "For Pragmatism, a belief is 'true' if its consequences are pleasant." *Power,* 268.

[21] *Power,* 291.

[22] *Ibid.,* 47.

sharp witticism he reminds his readers that Lenin, Mussolini, and Hitler owed their rise to democracy. His chief misgivings regarding modern democracies seem to revolve around the notion that the people can, under democratic conditions, be easily deceived and manipulated, and precisely because they believe the government is *theirs*. The power of propaganda reduces the masses to impotence. It must be admitted, of course, that these criticisms are partially true; but one should then ask two questions, namely, (a) would the circumstances be worse or better under non-democratic rule, and (b) what correctives are available?

## Towards World Government

We are all likely, during the coming years, to test our social philosophers according to the help and encouragement they can offer us with respect to peace and world organization. Although we may find it difficult in the world which follows upon World War II to accept and act upon the advice proffered by Bertrand Russell, we shall once more find in him clarity and straightforward admonition. His basic principle is simplicity indeed, and these are his words: "I believe that the abolition of private ownership of land and capital is a necessary step toward any world in which the nations are to live at peace with one another."[23] But one should not conclude from this premise that Russell, like so many over-simplifiers, rests his case at this point. He insists that the causes of war are multiple, not singular, and that these causes go so deeply into the roots of human nature that most orthodox Socialists are not capable of conducting an inquiry into the origins of war. One of these multiform causes Russell himself recognizes and denotes readily, namely, race prejudices and hatred. In this current War we have come to see with a fearsome gravity how true is this conclusion.

Russell believed in the necessity of a League of Nations[24] but he did not believe that the League which was in process of for-

[23] *Proposed Roads to Freedom* (1919), 150-151.

[24] He still believes in world organization and has only recently endorsed a plan for World Federation; this plan, however, does not rest upon ideological grounds and assumes that world peace is possible without resolving the ideological conflict. See *The World Federation Plan: A system to win this war and win the peace to come*, by Ely Culbertson.

mation when he wrote his essay on "International Relations"[25] could succeed unless it were to be quickly followed by a succession of other related reforms, such as general disarmament. In fact, it was then his conviction that all basic reforms must move along as a common world front if peace were to be sustained. The fundamental reform required is, of course, a new set of motivations on the part of men and women. What is needed before a world of peace can become reality is a new development in human nature. Since Russell believed that human nature was capable of alteration, and since he also believed that the most effective instrument for this purpose was education, we find here, as in so many other contexts, a typical consistency. The final sentences of the essay[26] from which I have quoted in these two paragraphs is a glowing tribute to his deep-seated faith:

A world full of happiness is not beyond human power to create; the obstacles imposed by inanimate nature are not insuperable. The real obstacles lie in the heart of man, and the cure for these is a firm hope, informed and fortified by thought.

\* \* \* \* \* \* \* \*

As this essay was brought to its conclusion, I went to hear Bertrand Russell lecture at the Rand School for Social Science. There stood the social philosopher in the midst of an admiring audience of adults. He enjoyed what he was doing, and he was teaching. There was liveliness in the atmosphere. It was the type of teaching-situation which one hopes for in adult surroundings: an engrossed cluster of students eagerly intent upon extracting meaning from the flowing sentences of a ripened scholar. A light touch of humor graced his ideas and made them seem less profound than they probably were. My effort was to "catch" the appropriate atmosphere of this man, this thinker, this teacher. I cannot find the precise words for my purpose. It summed itself up somehow in my mind in this manner: Here is a social philosopher for whom society failed to provide a suitable rôle and a drama big enough for his acting talents. He has remained at one and the same time too close to people and too remote.

EDUARD C. LINDEMAN

NEW YORK SCHOOL OF SOCIAL WORK
COLUMBIA UNIVERSITY

[25] Chapter VI of *Proposed Roads to Freedom* (1919).
[26] *Ibid.*, 163.

19

*V. J. McGill*

RUSSELL'S POLITICAL AND ECONOMIC
PHILOSOPHY

# RUSSELL'S POLITICAL AND ECONOMIC PHILOSOPHY

## I. Pessimism and the Theory of the Passions

THE concept of power overshadows all of Russell's political and economic writings. In a long series of popular volumes he often declares against the evils of nineteenth century competitive capitalism, but also condemns monopoly capitalism, present or to come. At the same time he is fearful of the centralization of power under what he calls "State Socialism," and often points to the Soviet Union as an example of how the lust for power can be as dangerous as the passion for possessions. Of the details of economic theory one hears very little. Some economists are occasionally touched on in historical perspective, but only Marx is given anything like a full-length critique. Guild socialism and even syndicalism are regarded as preferable to Marxism, but the economic theories of these movements are barely mentioned, whereas Marxian theory and Soviet socialism come in for repeated, if cursory, criticism. So adverse is Russell's recent judgment of present-day socialism, that his critique of capitalism seems, by comparison, to fade into tolerance.[1] Evidently he has become convinced that the thirst for Power is the primary danger to mankind, that possessiveness is evil mainly because it promotes the power of man over man. Any society, therefore, which seems to him to strengthen organizational control and central power is, *ipso facto*, suspect.

In 1902 Mr. Russell expounded his theory of Power very eloquently in "A Free Man's Worship."

Shall we worship Force, or shall we worship Goodness? [he asks.] If Power is bad, as it seems to be, let **us** reject it from our hearts. In

[1] See, for example, *Power, A New Social Analysis* (London), 1938.

that lies Man's true freedom; . . . In action, in desire, we must submit perpetually to the tyranny of outside forces; but in thought, in aspiration, we are free, free from our fellow-men, free from the petty planet on which our bodies impotently crawl, free even, while we live, from the tyranny of death. . . . To defy with Promethean constancy a hostile universe, to keep its evil always in view, always actively hated, . . . appears to be the duty of all who will not bow before the inevitable. But indignation is still a bondage, for it compels our thoughts to be occupied with an evil world; and in the fierceness of desire from which rebellion springs there is a kind of self-assertion which it is necessary for the wise to overcome. (*Mysticism and Logic*, 50f)

The better counsel is resignation and retreat to contemplation. The teachings of Schopenhauer and the Stoics are wiser than the Promethean philosophy of revolt. Drastic withdrawal from the world is made necessary by the irresistible tyranny of nature and the insatiable desires of man. Russell's pessimism is thus grounded physically and psychologically.

The first ground of pessimism reduces to the second. The question whether the planet will crash or freeze in ten million years is not a "living option," nor, as Shaw could see clearly enough, do most people want to face the boredom of endless life. The real problem is to increase longevity and ward off disease and natural disaster, and what is needed for this is a much more efficient organization of society. Unfortunately, if Mr. Russell's pessimistic view of human nature is accepted, any fundamental change for the better begins to appear precarious or impossible.[2] A lucid sun-lit skepticism, based upon a theory of the passions which tends always to fatalism, forms the persistent background of many volumes with a melioristic purpose. As in the case of Montaigne, Condillac, and Voltaire, it is the brilliant disclosure of human folly and perversity which is remembered, not the occasional remedies suggested. Disbelief in any human regenera-

---

[2] Mr. Russell sometimes speaks of the possibility of transforming the world into a paradise, in a short span of years, by a proper use of science and a better organization of society; but this prospect soon fades as he reveals to us, at every turn, the ruinous effects of power and possessiveness. Science, he admits, might perform miracles in the interests of peace, but it is more likely to act in the interest of war (*Icarus*). Society might be altered to the heart's desire were it not for ubiquitous greed and aggressiveness (*Power*).

tion, like a figure in the bass insistently repeated, easily drowns out the short-lived themes of hope and reconstruction, which are heard, with only slight attention or, like the assurances given to bankrupts or the bereaved, with little conviction.

War, for Mr. Russell, is probably the worst of evils. But in his opinion, war is not primarily caused by the ambition of governments, by diplomatic tangles, nor economic conditions, any of which, with courage and planning, might be overcome, but by human nature, which, in the opinion of most psychologists, is here to stay. Speaking of the First World War, he states that it "has grown, in the main, out of the life of impulse. . . . There is an impulse of aggression, and an impulse of resistance to aggression."[3] Blind impulse is the source of war, but it is also the source of science, art and love.[4] "War grows out of ordinary human nature. Germans, and also the men who compose Governments, are on the whole average human beings, actuated by the same passions that actuate others, not differing from the rest of the world except in their circumstances."[5] Blind impulse not only drives nations to war but also generates the quasi-intellectual motives which are used, both by invading and defending nations, to justify their resort to arms.[6] So strong is the impulse which leads men to fight, that some moral equivalent must be found in peace time, as a deterrent of future wars,[7] and efforts must be made to direct this dangerous passion into "love, the instinct of constructiveness, and the joy of life," and so reform human nature to peaceful pursuits.[8] How this is to be done Mr. Russell does not adequately explain, and indeed his constructive effort is always abstract and scant, and spends itself in a few paragraphs. It might even seem that he prefers to postpone the

[3] *Why Men Fight*, 14. (The original edition of this volume in England was called *Principles of Social Reconstruction* (London, 1916), hereinafter referred to as *PSR;* present quotation is from *PSR,* 19.)

[4] *Ibid.,* 12. (*PSR,* 17.)

[5] *Ibid.,* 5. (*PSR,* 11.)

[6] *Ibid.,* 10. (*PSR,* 15.)

[7] *Ibid.,* 100. (*PSR,* 95-96.)

[8] It is a little paradoxical that Russell in his theory of education recommends that impulsive life, which "leads to war," be strengthened and released from restraints and inhibitions. It is clear, at any rate, that his theory of sublimation needs development and *Präzisierung*.

struggle. After all, "our institutions rest upon injustice and authority."[9] "What can we do for the world while we live?" he asks. "We cannot destroy the excessive power of the State or of private property. . . . We must recognize that the world is ruled by a wrong spirit,"[10] and we must wait till that which is now thought by the few is the thought of many.

The aggressive instinct had some support from psychologists in 1916 when the above views were first written, but not in 1938, when they were repeated. Naturally the militarists insist on an ineradicable impulse to war as a matter of professional honor and foresight, but it is difficult to see why Mr. Russell, with so little evidence to go on, should agree with them. Having granted the main premise, he has no sufficient answer to their conclusion that war is inevitable. And when Mr. Russell fails to mention "the life of impulse" as the source of war he tends to cite other very unlikely causes. Socialism, he says, will not put an end to war.

Ants are as completely Socialistic as any community can possibly be, yet they put to death any ant which strays among them by mistake from a neighboring ant-heap. Men do not differ much from ants, as regards their instincts in this respect, wherever there is a great divergence of race, as between white men and yellow men.[11]

Race hostility is modifiable but so exceedingly strong that even if a real league of nations were established and private property abolished, wars might still occur. Mr. Russell offers no evidence for the theory of instinctive hostility of races, and no counter-evidence, of which there is an abundance.[12] He does not say why he thinks economic causes are inadequate to explain the facts, nor why he believes that, since ants fight, men must. He does not defend the parallel he draws between the purely instinctive behavior of ants and planned socialism. In instances too numerous to mention, he concedes militarist premises abandoned by

[9] *Why Men Fight*, 19. (PSR, 23.)

[10] *Ibid.*, 245. (PSR, 224.)

[11] *Proposed Roads to Freedom* (New York, 1919), 152. See also *Justice in War-Time* (London, 1916), 65.

[12] See for example, *When Peoples Meet* by Alain Locke and Bernhard J. Stern (ed.), (N.Y., 1942) and Otto Klineberg, *Race Differences*, (N.Y., 1935).

psychologists, thus creating unnecessary difficulties for his pacifist position,[13] and for his ideal of future peace.

If the instincts of aggressiveness and possessiveness bedevil Mr. Russell's treatment of war, they also invalidate much of his political economy. The former instinct, expanded into "the love of power," is most explicity expounded in *Power, A New Social Analysis,* and in *Freedom vs. Organization,* although it also plays a leading rôle in his other writings, whether as Faust or Mephistopheles. The book, *Power,* opens with romantic claims that man's desires are infinite and that "what we need for lasting happiness is impossible for human beings;" claims which appear to be, in spite of Schopenhauer, either mistaken or irrelevant. Probably the extent to which Mr. Russell agrees with the great misanthrope, while choosing the optimist Marx as his chief adversary, is not always appreciated. It is significant that Mr. Russell states the thesis of his whole book in explicit opposition to Marx. With the idea that he is opposing a basic Marxian theory he argues that men pursue wealth only up to a certain degree of satiation, and then turn all their attention to power. He writes:

The error of Marxist economics is not merely theoretical, but is of the greatest practical importance. . . . It is only by realizing that love of power is the cause of the activities that are important in social affairs that history . . . can be rightly interpreted.

In the course of this book I shall be concerned to prove that the

[13] Russell's pacifism could not withstand the impact of recent events. In a letter to the *New York Times* (Feb. 11, 1941) he wrote that: "Down to and including the time of Munich, I supported the policy of conciliation. . . . I went further than the majority in believing that war should, at this moment in history, be avoided, however great the provocation. I changed later through the influence of the same events that changed Chamberlain, Lord Lothian, Lord Halifax and most of the previous advocates of peace. In view of what has happened since, it would seem that it might have been better for the world, if Germany had been opposed at an earlier stage; but I still think the arguments for the policy of conciliation were very strong."

The letter shows that Mr. Russell still tends to think of politics as a rational business, in spite of his many warnings that it is not. Thus he construes the Munich pact as simply another intellectual mistake, neglecting the sociological forces at work. He implies that those who had long urged sanctions against the Axis and had condemned in advance the forces which brought forth the Munich pact, were right, but only accidentally so.

fundamental concept in social science is Power in the same sense in which Energy is the fundamental concept in physics.[14]

Mr. Russell defines Power "as the production of intended effects" and it follows that all our successful voluntary actions result from Power or "the love of Power." If we imprison a man, bribe him by rewards, or influence him by arguments, these are simply different manifestations of Power. According to the definition, in fact, even smoking a cigarette, writing a love letter, waving good-by, singing a song, or publishing a book on the evil effects of Power, are all expressions of Power, so long as we intend them. *But an instinct which explains all of our successful acts, explains none of them.*

Power, as thus defined, is not dangerous and destructive unless human intentions are, but Mr. Russell's illustrations show that he thinks they mostly are. He regards Power as evil unless it is shared more or less equally, and as very dangerous even when it is thus shared; for under a democracy one man will have greater ability than others and hence exert undue power over them. Mr. Russell's Power theme actually implies a version of the doctrine of original sin. It also leads to the following difficulty.

Suppose certain men join a movement to disestablish Power, or to distribute it more equally among the people! If they are successful, they carry out the behest of Power, becoming themselves as powerful, in terms of Mr. Russell's definition, as any tyrant. Even though they spread the good life to millions, the more successful they are, the more usurpatious and dangerous. Schopenhauer, faced with the similar difficulty of explaining how the omnipotent Will to Life can be extinguished by the Intellect, which is only its expression, resorted to allegory:

A Wanderer pursues a certain path with a lantern in his hand; suddenly he sees an abyss before him and turns back. The Wanderer is the Will to Life, the lantern, the Intellect; by the light of this the Will sees that it has taken the wrong way, and that it stands before an abyss, and so it turns and goes back.

Mr. Russell's answer is no more satisfactory than Schopen-

[14] *Power*, 10.

hauer's. A part of the omnipotent Will to Power is transformed into the kind of Power which sets men free from Power. The men who have probably had more power than any others, Mr. Russell states, are Buddha, Christ, Pythagoras, and Galileo.[15] It is instructive to observe that, among the men who exert this emancipating power, only religious men and pure scientists are cited. Men of action are viewed unfavorably, whether they advance by "naked power" or by persuasion, whereas pure scientists, detached artists and dreamers are regarded with tolerant love. For Mr. Russell, as for Schopenhauer, the great men of history are those who attempt to free men's minds. Freedom is mainly subjective.

Russell's theory of social mechanics is obliged to explain why the same instinct impels some men and some societies to seek Power, and others, to escape from it. Nietzsche, developing the same theory in his *Will to Power,* is much more resourceful than Mr. Russell. Nietzsche's interpretation of the Christian stress on loving kindness and humility as a disguised and inverted striving for Power, although certainly one-sided, is at least an attempt to meet the difficulty. Of course, there is little that Russell can say. He can maintain, as instinct theory sometimes does, that the aggressive instinct in some men and some societies is weak and perverted; but no means exist to confirm such a claim. Or he can argue that physical and social circumstances in which individuals and societies find themselves determine all the multifarious forms which Power takes; but in this case the question arises whether it would not be better to drop this mysterious, unconfirmable instinct, and rely on the social and physical facts which can be investigated by scientific methods. Instead of accounting for the difference between Buddha and Caligula by two kinds of Power-seeking, one of which sets men free whereas the other enslaves, it seems sensible to analyze the historical conditions and social formations. But when this is done, the Power-drive becomes an unnecessary and supernumerary assumption.

The problem is to explain and predict human behavior, and not merely to classify it on convenient pegs. Mr. Russell empha-

[15] *Power,* 284.

sizes the aggressive and possessive instincts, but it is not surprising that he refers to many others.[16] Some psychologists in the past were inclined to add an instinct to explain every new type of behavior considered, even hunting, hand-washing, fact-finding, wearing clothes, and tasting sugar. When the instinct wave was at its height, James listed about thirty, and Thorndike almost forty. McDougall was contented with thirteen, and other psychologists tried to make out with a much smaller number, the Freudians with two. Russell, in 1938, following the fashion of Schopenhauer, Nietzsche, and other romantic philosophers, attempted to reduce all the instincts to one, the love of Power. American psychologists, by this time, had definitely turned away from instinct theory. Innate, unlearned modes of behavior, which have a physiological basis, and are universal in the human species, but also present in the higher animals, proved exceedingly difficult to find. Mr. Russell's favorite instincts of aggression and acquisitiveness, for example, could be shown to have no clear physiological basis, and to be anything but universal. The Iroquois might go to war for the love of fighting, but data presented by Boas indicate that this is probably an exception, not the rule, other motives being usually found. Plunder and the procuring of horses and cattle are sometimes incentives, but acquisitiveness, too, is far from universal, and the Esquimaux seem to get along very well without either of Mr. Russell's main instincts. Existence of societies in which war is unknown and much property is communal, and such institutions as Potlach, show that aggressiveness and possessiveness often fail to appear, and when they do appear, display the widest diversity from society to society. Nothing can be predicted, then, from the statement that these instincts have occurred, since they entail no consistent pattern of behavior; and no (non-verbal) statements about their occur-

---

[16] In *Bolshevism: Practice and Theory*, 132, the leading "passions" or "instincts" are acquisitiveness, the love of power, vanity and rivalry; in *Political Ideals* the things men desire are admiration, affection, power, security, ease, outlets for energy. Other books give slightly different lists of instincts, but acquisitiveness and the love of power always appear, and are assumed to be the most important. It should be noted that Mr. Russell uses "instinct," "passion," "impulse," and "desire," etc., interchangeably, and there is thus no need for nice distinctions.

rence, or causal efficacy, can be confirmed, since they have no known physiological basis.[17]

## II. THE CRITIQUE OF CAPITALIST SOCIETY AND SOCIALISM

Mr. Russell's theory of power and possessiveness is perhaps not so important in itself, as in the uses to which he puts it. The theory affords justification for the pervasive skepticism and pessimism found in his books, and for his static or cyclical view of history which dwells upon the sad ebb and flow of passions; it supplies the main reason for condemning, or disparaging any institution which possesses real power and seeks more, especially when this institution upholds ideals similar to Mr. Russell's. The same theory explains his sympathy with guild socialism, and even syndicalism and anarchism, and it affords a basis for his zealous and persistent criticism of Marxian theory and Soviet socialism; it partly accounts for his dislike of the machine and industrialization and his love of China, China economically backward, easy-going, and unambitious; for machines and industrialization, he claims, greatly increase the gamut of power, and render those in authority unfeeling and inconsiderate. Finally, Russell's theory of the passions makes clear why his approach to social problems is, in spite of frequent use of historical illustrations, characteristically abstract and unhistorical.

Mr. Russell's approach to social problems can be illustrated by his discussion of the state. The chief function of the state is to protect its citizens internally, by law and the police, and externally, by the army and navy. The state is necessary

since anarchy which precedes law gives freedom only to the strong; the conditions to be aimed at will give freedom as nearly as possible to every one. It will do this, not by preventing altogether the existence of organized force, but by limiting the occasions for its employment to the greatest possible extent.[18]

The positive function, assumed by some modern states, of organizing freedom, that is, of creating alternative avenues of

---

[17] There is probably a physiological structure for rage, although it is difficult to distinguish from the pattern of fear; but apparently none for Mr. Russell's indefinite power instinct, nor, of course, for possessiveness.

[18] *Why Men Fight*, 44-45. (*PSR*, 46.)

activity and enjoyment, is barely mentioned, and without enthusiasm. Whereas hundreds of pages in his books are devoted to the evils of the state, and the desirability of curbing its excessive power, only a few remarks are made on the *positive* function of the state. It builds sewers, educates children, encourages science and sometimes corrects economic injustice, Mr. Russell admits, but warns that even in serving the community, the state grows more powerful.

. . . If all these powers are allowed to the State, [he asks,] what becomes of the attempt to rescue individual liberty from its tyranny? . . . Politics and economics are more and more dominated by vast organizations in the face of which the individual is in danger of becoming powerless. The state is the greatest of these organizations and the most serious menace to liberty.[19]

The remedy proposed is that "the positive purposes of the State, over and above the preservation of order, ought as far as possible to be carried out, not by the State, itself, but by independent organizations," to which men voluntarily choose to belong "because they embody some common purpose which all their members consider important."[20] Only by this means, Mr. Russell maintains, can organization and liberty be combined, but he warns that the state is, apparently by nature, jealous of lesser organizations which must deprive it of power if they are to succeed. The remedy must be sought

by a method which is in the direction of present tendencies. Such a method would be the increasing devolution of positive political initiative to bodies formed voluntarily for specific purposes, leaving the State rather in the position of a Federal authority or a court of arbitration. The State will then confine itself to insisting upon some settlement of rival interests: its only principle in deciding what is the right settlement will be an attempt to find the measure most acceptable, on the whole, to all the parties concerned.[21]

In the first place, Mr. Russell apparently misread the tendencies of his time. There was no tendency in 1916, when the

[19] *Ibid.*, 72. (*PSR*, 71.)
[20] *Ibid.*, 72-73. (*PSR*, 72.)
[21] *Ibid.*, 77. (*PSR*, 75.)

above lines were first published (in the English edition), to a devolution of state authority, or to its transfer to voluntary organizations. The trend then and since, as Russell elsewhere states, has been toward a vast increase in the authority and organizational control exercised by federal governments. Yet at the same time, there has been an unprecedented growth of voluntary organizations, especially of trade unions. It is not true that these organizations can only increase in strength by wresting power from the state, for they can restrict the power of employers. Nor is it true, as Mr. Russell's abstract *laissez faire* notion of freedom seems to imply, that what one man or organization gains in power, another must lose in freedom. If we conceive freedom concretely as the maximum number of *actual* avenues of opportunity opened up to citizens, it is clear that voluntary organizations and the state may simultaneously grow in power, while freedom of the individual is not limited but increased.

This is what has happened, and the process has been accelerated in many directions by the war. The enormous increase of state power in England has been accompanied by greatly augmented influence of trade unions. Labor has acquired important representation in the governnment and War Council, and an increasing influence on war output and the conditions of work. Through its Joint Production Committees, representing labor and management, it has improved production and the utilization of machinery and worked to eliminate waste. The unions do not wait for the initiative of management and the government, but instead, often drive them on to increased efforts. At the same time, nurseries for 52,000 children of working mothers have been established, and much progress made in solving consumer problems.[22] In short, labor participation in the management of industry, nurseries for children, and greater independence for their mothers, and other ideals of Mr. Russell, have made great strides, precisely at a time when the government has assumed more power. Individual freedom has not diminished, since both the trade unions and the government have facilitated work for

[22] Harlan R. Crippen, "Workers and Jobs in Wartime Britain," *Science and Society*, Summer 1942.

a cause in which almost everyone believes. To be free is not to escape from responsibility. Freedom is the maximum degree of opportunity that an organization can supply its members, using all the resources available to it in a given historical period. The British people, at the present time, are not doing what they would want to do under other circumstances, but they *are* doing what they want to do under the Axis threat. Their participation in the War is voluntary, based upon ideals which they consider most important, yet it is directed and controlled by the state. This is a possibility excluded by Mr. Russell, probably because of his abstract conception of power and freedom. He regards the state as a geographical unit, and patriotism as an irrational tribal emotion. Only by weakening the state can we secure "power for voluntary organizations, . . . [that] embody some purpose which all their members consider important, not a purpose imposed by accident or outside force."[23] The opposite appears to be true in the present War in which the state, which Mr. Russell believes tyrannous by nature, and bent on world expansion, is becoming so far as England is concerned, a "voluntary organization" which, though it has greatly increased its own power, also encourages in heightened degree, the power and initiative of lesser organizations.

What is true in war-time was also true, in great measure, before the War. In the United States, the NIRA (section 7a) gave impetus to an unprecedented development of the trade union movement, while the various boards of conciliation and finally the NLRB, set up by the government to arbitrate labor-management disputes, have greatly increased the efficiency of unions. But national planning and the multiplication of agencies, required to carry out labor laws and other social legislation, have concentrated administrative machinery in Washington and greatly augmented the power of the Chief Executive. Many powerful persons and groups oppose this centralization of power, but not the trade unions nor the liberal friends of labor. Those who complain of bureaucracy and waste, government regimentation of business men and pampering of the idle, or charge the administration with tyranny, violation of personal liberties and states

[23] *Why Men Fight*, 72-73. (*PSR*, 71.)

rights, are identified with interests often genuinely hostile to labor.

Whatever William Morris and Gandhi or Thoreau and Mr. Belloc may have thought about it, advanced societies are now committed to industrialization, bureaucracy, and vast impersonal organizations. In the present War, which brings latent economic tendencies to unmistakable proportions, it is apparent that democratic capitalism, socialism, and fascism all require a centralized economy, although exceedingly important differences exist, the first two differing far more from the third, than they do from each other. Mr. Russell, however, seems to oppose industrialization, bureaucracy and vast organizations, whatever the regime or the period of history may be.

The members of the government have more power than the others, even if they are democratically elected; and so do officials appointed by a democratically elected government. The larger the organization the greater the power of the executive. Thus every increase in the size of organizations increases inequalities of power by simultaneously diminishing the independence of ordinary members and enlarging the scope and initiative of the government.[24]

The plausibility of this passage seems to depend, again, upon the assumption that there is a fixed fund of power and freedom in the state, so that every addition to the power of an official, or of the government, entails a proportionate loss of freedom to citizens. But this is true, as we have seen, only when freedom and power are understood in a very abstract mechanical sense. If there were a "law of the conservation of power and freedom," which held for every state, corresponding to the law of the conservation of energy, which is supposed to hold for every closed system, then Mr. Russell's contention that all states, and all vast organizations, are hostile to individual freedom, would have some justification. This is not the case. The increase in the power of a government can, and often does, increase the power and freedom of its citizens, and of their voluntary organizations.

Although quite a number of true and interesting statements can be made about all classes, it is doubtful whether any can be

[24] *Power*, 164.

made about *all* states or *all* organizations. Even though love of power and acquisitiveness were present in all societies, and in all individuals—which is not the case—very little would follow. It might follow that the Arapesh, Trobriands, Classical Athenians, feudal serfs, contemporary fascists and socialists behave very much alike, but this is too obviously false to be interesting. If love of power is known to exist in a given society, it might be inferred that the more energetic would rise to power, but this would tell us nothing about the resulting behavior, which might be Potlach feasts, competitions in verse, religious upheavals, conformity to equalitarian standards, war, trade union organizing work, or almost anything. That men love power implies nothing that we did not know before. Even the hunger drive, which is known to exist in all societies and in all individuals, tells us only that men will engage in some activity or other to get food, but almost nothing about the nature of this activity, even if we know the terrain.

Mr. Russell's pessimistic deliverances about all states or *the* State, do not advance our understanding of actual behavior, nor give a basis for prediction. They rest upon the mistaken theory that there are two instincts, the love of power and acquisitiveness, which are hostile or fatal to individual freedom.[25] The same theory explains Mr. Russell's favorable attitude toward anarchism, particularly as expounded by Kropotkin. The aim of quickly abolishing the state and all other forms of coercion appeals to him, but he sees its utopian character. "Attractive as this view is," he says, "I cannot resist the conclusion that it results from impatience and represents the attempt to find a shortcut toward the ideal which all humane people desire."[26] Mr. Russell does not himself describe a longer road to this

---

[25] When Mr. Russell, on occasion, insists that these instincts can be reformed, he robs his pessimism of its rational support. His main argument against "State Socialism" also collapses, since, if instincts can be transformed, socialism with its elaborate checks on power and acquisition and its thorough revision of education, would be likely to succeed. Or at least it would be extremely difficult to prove that it could not succeed. The reform of the passions is a persistent thought with Mr. Russell. If it were fundamental, we should hear more of the method to be used and less of pessimism.

[26] *Proposed Roads to Freedom*, 118.

ideal, and is dissatisfied with the Marxian position. "The views of Marx on the State are not very clear. On the one hand he seems willing, like the modern State Socialists, to allow great power to the State, but on the other hand he suggests that . . . the State, as we know it, will disappear."[27] Russell finds it difficult to suppose that a state can wither away as a result of being strengthened. Far from declining under socialism, he believes the oppressive power of the state is destined to increase. "Given an official caste, however selected, there are bound to be a set of men whose whole instincts will drive them toward tyranny. Together with the natural love of power, they will have a rooted conviction . . . that they alone know . . . what is for the good of the community."[28] In later writings, reviewing the Russian scene, he sees only the Will to Power behind the moves of the Soviet leadership. But Soviet policies admit of other interpretations. The Marxian theory of the withering away of the state is not incomprehensible. The state must first be strengthened (a) to provide protection against foreign and domestic enemies, for these are the shoals on which every past socialist state has foundered, (b) to secure an economy of abundance,[29] (c) to educate the population to an understanding of the new order, (d) to facilitate the development of a scheme of national planning and administration so efficient that coöperative techniques and predispositions can gradually take the place of authority.

One prerequisite of freedom in the contemporary world, which Mr. Russell does not sufficiently recognize, is over-all planning. Without a comprehensive plan, alternatives of action are confused or restricted, and a man cannot choose to do the best thing, because he does not know which is best, or lacks the necessary training, or because society has not made the best course of action available. Evidence from penology and many other fields

[27] *Ibid.*, 113-114.

[28] *Ibid.*, 128.

[29] (a) and (b) are interdependent. The influential Soviet philosopher, M. Mitin, could write in 1939 that "the gradual transition from socialism to communism" was already taking place (*Pod Znamenem Marksizma*, 1935, 11), in spite of the great centralization of power in the Soviet Union. Since then the ideal of abundance, which Mitin stressed almost exclusively, has been put aside for defense, and intended progress delayed, possibly for generations.

goes to show that men behave poorly, not because of an indiscriminate love of Power, but as Plato thought, because they do not know, and are not habituated to, what is best. Over-all planning, however, requires an elaborate centralization of administration and, as things are today, an increase of its power. The practical alternative is not a strong state or a weak one. The question is whether a strong state shall represent the identical interests of fascist leaders and huge industrial empires (such as Goering's), as in Germany, or be subject to popular control, as in democratic countries.

Apprehensive of Power as such, Mr. Russell was naturally attracted to anarchism, syndicalism and guild socialism, though he warned that the first was utopian, the second impractical and dangerous, whereas the third, which was his favorite, he dismissed with a few remarks. To understand what he meant we should need to turn to the works of G. D. H. Cole and other erstwhile Guild Socialists. Probably Mr. Russell's social inspiration was not very different from that of other liberal intellectuals of his time. In 1889, before the development of monopoly capitalism had transformed the conditions of progress, and hopes could take a milder, less titanic shape, Beatrice Webb wrote:

It was this vision of a gradually emerging new social order, to be based on the deliberate adjustment of economic faculty and economic desire, to be embodied in an interlinking dual organization of democracies of consumers and democracies of producers—voluntary as well as obligatory, and international as well as national—that seemed to me to afford a practicable framework for the future cooperative commonwealth.[30]

Like Beatrice Webb, Mr. Russell continually reminds us that "men do not live by bread alone" and that the new social order must include freedom and cultural opportunity as well as economic well-being. Like her, he insists upon the importance of trade unions, coöperatives, women's rights, internationalism and other such causes. But while Mrs. Webb devoted a lifetime to research on labor's conditions and prospects, and to the practical

[30] *My Apprenticeship*. (London 1926), 381.

problems of labor leadership and organization, and remained in close touch with the practical prerequisites of progress, Mr. Russell made extensive contributions to philosophy and symbolic logic and stood consciously aloof, perhaps by inclination, from the exactions of concrete problems as from the mêlée of political life.[31]

In the last twenty years the hopes of Guild Socialism have grown dim and wistful, discussion has subsided, and Mr. Russell, like G. D. H. Cole, has probably abandoned the theory.[32] In the same period Soviet Socialism has become the center of a political controversy comparable in violence only to the disputes around the French and American Revolutions. Mr. Russell's

[31] Mr. Russell has given a very interesting glimpse of his outlook on life in the Introduction to *Selected Papers of Bertrand Russell.* After describing his five weeks in Russia, he remarks that "The Bolshevik philosophy appeared to me profoundly unsatisfactory, not because of its communism, but because of the elements which it shares with the philosophy of Western financial magnates." After Russia, teeming with vast plans of industrialization, he visited backward non-industrial China and was charmed. "In that country I found a way of life less energetically destructive than that of the West, and possessing a beauty which the West can only extirpate." The problem raised is serious. ". . . it can only be solved by a community which uses machines without being enthusiastic about them." With apparent regret he remarks upon the passing of the heredity principle in politics and economics, and the modern abandonment of the monkish ideal of contemplation. "At the same time," he adds, "when I examine my own conception of human excellence, I find that, doubtless owing to early environment, it contains many elements which have hitherto been associated with aristocracy, such as fearlessness, independence of judgment, emancipation from the herd, and leisurely culture. Is it possible to preserve these qualities, and even make them widespread, in an industrial community? And is it possible to dissociate them from the typical aristocratic vices: limitation of sympathy, haughtiness and cruelty to those outside a charmed circle? These bad qualities could not exist in a community in which the aristocratic virtues were universal." The implied ideal is anarchism, i.e., every man an aristocrat, and Mr. Russell indicates in *Proposed Roads to Freedom* that he is aware of aristocratic tendencies in anarchism.

With regard to his aptitude for concrete studies, he remarks: "I hoped to pass from mathematics to science. . . . But it turned out that while not without aptitude for pure mathematics, I was completely destitute of the concrete kinds of skill which are necessary in science. . . . Science was therefore closed to me as a career."

[32] "Guild Socialism passed under a cloud," Mr. Cole says, "not because the National Building Guild collapsed, but because it ceased to have any relevance to the immediate situation which the working classes were compelled to face." *The Next Ten Years in British Social and Economic Policy* (London, 1929), 159.

insistent criticism of socialism and Soviet power, like Burke's *Reflections on the French Revolution,* expressed personal ideas, but also the will of powerful forces entrenched throughout the world in opposition to the new order. Burke could never forgive the French Revolution its rationalism nor forget that it had affronted the Queen and established a new order on a preconceived plan; nor could Mr. Russell forgive the Bolsheviks their rationalism,[33] and their deliberate assumption of power. Before 1917 he feared that socialism would not work; after that he seemed to fear that it would. In speaking of his trip to Russia in 1920, he says:

> I went to Russia a Communist; but contact with those who have no doubts has intensified a thousandfold my own doubts, not as to Communism itself, but as to the wisdom of holding a creed so firmly that for its sake men are willing to inflict widespread misery.[34]

The "widespread misery" was evidently something which he feared in the future. Of the poverty he saw about him in Moscow he is careful to state that the Allied intervention and the Allied blockade were wholly responsible, not the Soviet Government.[35] His impression of Moscow in one of the hardest years of the Revolution, when foreign commentators were predicting momentary collapse, was as follows: Every one works hard, but there is no insecurity. Theatres, opera, and ballet are admirable and some seats are reserved for unionists. There is no drunkenness or prostitution, and women are freer from molestation than anywhere else in the world. "The whole impression is one of virtuous, well-ordered activity."[36] It should be emphasized

---

[33] See, for example, *The Problem of China* (Introduction), for mysterious circumstances of human nature which the rationalism of the Bolsheviks cannot understand.

[34] *Bolshevism: Practice and Theory,* 41.

[35] *Ibid.,* 94 to 100. The British trade delegation to Russia in the same year, 1920, gave the same report. "In 1918-19," their statement reads, "there were over a million cases of typhus fever and no town or village in Russia or Siberia escaped. . . . The soap, disinfectants, and the medicines needed for the treatment of these diseases have been kept out of Russia by the blockade. Two or three thousand Russians died of typhus alone. One half of the doctors attending on typhus died at their posts." (30) Russell, like these trade unionists, worked for the lifting of the blockade.

[36] *Ibid.,* 94.

again that these observations were made at a time when Polish armies invading Russia were aiming toward Moscow, and the country was still completely disrupted by the World War and civil wars. Mr. Russell, however, saw little to find fault with. He states that: "The average working man, to judge by a rather hasty impression, feels himself the slave of the Government, and has no sense whatever of having been liberated from tyranny."[37] But this observation, which is hard to credit in view of the rôle of the workers in the October Revolution, Mr. Russell himself describes as "a rather hasty impression." Few unfavorable *observations* appear in Russell's writings, nothing to account for his adverse conclusions. His objections to Soviet socialism are not usually based upon the complex political and economic facts, which he seldom attempts to ascertain or to verify, but upon an *a priori* theory of the passions. He does not so much argue that socialism in Russia is not succeeding as that it can't succeed. Human passions are the root of all evil. "At bottom, the obstacles to a better utilization of our new power are all psychological, for the political obstacles have psychological sources."[38]

In the one or two instances in which Mr. Russell cites authorities on Soviet socialism, the result is not very rewarding. Describing the disastrous long range effects of the "fanatical creed" of the Soviets, for example, he warns that "a creed which is used as a source of power inspires, for a time, great efforts, but these efforts, especially if they are not very successful, produce weariness, and weariness produces skepticism. . . ." In substantiation he quotes Eugene Lyons' account of the disillusionment which swept over Russia as the First Five Year Plan failed to yield "promised comforts;" "I watched skepticism spread like a thick wet fog over Russia," Mr. Lyons says. "It chilled the hearts of leaders no less than the masses." To counteract increasing dislocation of industry and wastage of energies, enthusiasm for the Plan was imposed upon the workers, as a duty, with penalties for failure. "People under dictatorships . . . are condemned to a lifetime of enthusiasm" (*Assignment in*

[37] *Ibid.*, 100.
[38] *Selected Papers of Bertrand Russell* (N.Y., 1927), xvi.

*Utopia*). Mr. Lyons is also quoted to support the claim that Soviet leadership and bureaucracy have paralyzing effects on human initiative and freedom; but no contrary opinion is cited, and no evidence is given. Mr. Lyons' *Assignment in Utopia,* however, is only one interpretation of the facts, and Mr. Lyons himself, only two years before, had given a very different interpretation in his *Moscow Carrousel,* where he described the disinterestedness of key Soviet leaders and their devotion to the people.

If anything has been made clear by recent events, it is that enthusiasm in Russia is genuine, that the remarkable initiative of soldiers, workers, and guerillas, which has won reluctant praise even from the enemy, is real; that, whereas other governments lose campaigns because they fear to arm the people, the Soviet Government has not only distributed weapons, but taught tens of thousands of its citizens the arts of wrecking, sabotage, and guerilla warfare. It seems clear enough today that the Soviet Government does not retard science and art, as Mr. Russell assumes it must, but rather affords them great encouragement, whether they have immediate utility or not.[39] Many have come to see, too, that what Mr. Russell refers to as the "fanatical creed" of the Soviets was in reality a kind of relentless conviction that the nation could meet the impending invasions and escape enslavement only by an unprecedentedly rapid development of its resources, under socialism. At present Soviet leaders are not·called "fanatics," but "realists." Attitudes toward Soviet Russia have recently been altered by reports of distinguished British and American observers who have had an opportunity of seeing the country at first hand, and under the most favorable of circumstances. Many other influences have been at work. It is possible that Mr. Russell's views may also have changed, and that further comment is gratuitous. The regret would remain that his approach to the Soviet Union was not more inductive. Had he made use of the Soviet research by

[39] Mr. Russell complains that "In Russia the pursuit of practical aims is even more wholehearted than in America." He regrets that the "only non-practical study is theology," i.e., Marxism. (*In Praise of Idleness,* New York, 1935, p. 40). Mr. Russell forgets that America and Russia lead the world in pure mathematics.

Beatrice and Sidney Webb, to whom he often refers as authorities in labor history and trade union practice, his arguments, if not his opinions, could have taken a different turn.

Mr. Russell's main objection to Soviet socialism is that it stifles the freedom of the individual and of minority groups. His concern for minority opinion indeed sometimes leads him to think of democracy as nothing but the preservation of minority rights. Yet it is obvious that minorities who have a voice in capitalist countries are usually groups with sufficient means to buy advertising and to break into print and that the minorities who count are often hostile to the majority. The situation is confusing at first glance. Socialism with its humanitarian claims should protect minorities at least as well as other social systems do, yet speculators, rich farmers, and rentier minorities who enjoy many privileges under capitalism, have none under socialism. These actual minorities rightly make a great impression on liberals, for their tragedies, as Sholokov has so powerfully shown, are real. The fallacy arises when these actual minorities are confused with minorities in the abstract and the Soviet Government, or the majority block of workers and peasants, is depicted as the enemy of minorities as such. Although the October Revolution cancelled the rights of certain minorities, which had for centuries advertised their claims and legitimate expectations, it also conferred rights on a vast number of inarticulate minorities, not often defended by officials or the press. Too often it is forgotten that the majority, although expressing a common purpose, is itself nothing but minorities, and that a policy of protecting the rights of every minority against the power of the majority results in anarchy, which, in practice, means rule by the strongest minorities.

Among the minorities liberated by Soviet Power are those who were underprivileged or oppressed by the Tsarist regime. Vice-President Wallace, in a recent speech,[40] listed races, women, and school children as groups which have won their rights in Russia, in some respects more completely than elsewhere. Na-

[40] At Madison Square Garden, Nov. 8, 1942. From the *New York Times*, Nov. 9, 1942.

tionalities, trade unions, and many lesser groups could be added. "Russia," Mr. Wallace says, "has probably gone further than any other nation in the world in practicing ethnic democracy." He also recognizes the great advance made by Russia in economic democracy, in democracy of education and in democracy in the treatment of the sexes.

When Mr. Russell looks at Russia, on the other hand, he sees no democracy of any kind. He continually implies that strong centralized power is inconsistent with democracy, and he charges that Marxists, in emphasizing economic gains, have forgotten that political power can prove a greater oppressor than the private employer. In recent years he points to Russia as a fulfillment of his warning. In a typical passage he states: "The tyranny of the employer, which at present robs the greater part of most men's lives of all liberty and all initiative, is unavoidable so long as the employer retains the right of dismissal with consequent loss of pay."[41] He adds that: "This evil would not be remedied, but rather intensified, under state socialism, because, where the State is the only employer, there is no refuge from its prejudices such as may now accidentally arise through the differing opinions of different men."[42] The situation, according to Mr. Russell, must be particularly serious in Soviet Russia where "government by a Party" has been reduced, he says, "to one man rule,"[43] for it implies that some one hundred and ninety million souls must depend, for life and happiness, on the caprice of one man. The idea of one-man rule of a vast modern nation is a common one, but no authority has explained how it is possible. Many say that Hitler is the one-man ruler of Germany, which implies that victory depends only on his removal; but fascism obviously has deeper roots, and so have socialism and capitalist democracy. Increasingly it is being recognized, as the War progresses, that, just as Hitler represents the predatory power of big German industrialists and Junkers, so Stalin symbolizes the embattled power of the vast majority of Russian people, workers of hand and brain, of the city and the country.

[41] *Political Ideals,* 51.
[42] *Ibid.,* 55.
[43] *Power,* 195.

But the anarchistic temper, which hates power as such, is disposed to condemn both regimes equally.

The government is not, as Mr. Russell thinks, the only employer in Soviet Russia. As the Webbs have pointed out:

There are several hundred USSR trusts and combines, and no one of them is exactly like the others. More diverse still are the thousands of separate enterprises, whether factories or institutes, mines or farms, oil fields or power stations, which are independently conducted . . . unassociated with any trust or combine.[44]

There are village, municipal and provincial enterprises, none of which are subject to the People's Commissars. The constituent republics, the trade unions, and some forty thousand coöperative societies also conduct numerous undertakings, offering a great variety of employment. The absence of unemployment and the actual shortage of labor in Russia oblige thousands of Soviet employers to compete for workers, to offer incentives and improved conditions. The universal system of government stipends for students enables workers to prepare themselves for technical, more remunerative positions, while their trade union protects their pay and conditions of work, if they choose to remain on the same job. The Webbs concluded after extensive research that

the eighteen millions of trade unionists, whilst not actually entrusted with the management of their several industries, do control, to a very large extent, in their constant consultation with the management, and with all the organs of government, the conditions of their employment—their hours of labor . . . and the sharing among themselves of the proportion of the product that they agree should be allocated to personal wages.[45]

There are other features of Soviet socialism that one would have expected Mr. Russell to mention. For example, he criticizes the electoral system of democratic capitalism on the ground that the issues and candidates are too remote from the interests and knowledge of the voter, who is consequently at the mercy of phrases and demagogues. He advocates a functional or occupational basis for elections, points to trade union democracy as the

[44] Beatrice and Sidney Webb, *Soviet Communism, A New Civilization?* (New York, 1937), Vol. II, 771.
[45] *Ibid.*, Vol. I, 302.

model, and advises that the electoral unit be based upon "some common purpose." Yet he condemns Soviet democracy which, from the very beginning, emphasized the factory soviets and the agricultural village soviets as the electoral and basic policy-forming units. The delegates elected by the factory and village soviets, it is worth noting, are not professional politicians, but fellow workers, who get a few days off to attend the sessions, and who can be held to strict account when they return to their benches and tractors. These and other electoral provisions one should expect Mr. Russell to approve. But instead, he deplores the dismissal of the Constituent Assembly[46] which was not elected by functional units, but which embodied the electoral weaknesses he sought to correct.

It will be remembered that the Bolsheviks were obliged to dissolve the Constituent Assembly because, as Lenin said, it "revealed its readiness to postpone all the acute and urgent problems that were placed before it by the Soviets."[47]

The dismissal of the Constituent Assembly was, however, peremptory, and this is probably part of Mr. Russell's complaint. Although he seems to imply that Power as such is bad, it is the employment of "Naked Power" which he believes most inexcusable, even when it is also being used by the enemy. Indeed, he once advocated passive resistance to a German invasion of England.[48] Revolution is unjustifiable, of course, especially the October Revolution. He continually warns that revolution jeopardizes far more than it can gain, and that ballots are more fruitful in the long run than violence; and he implies that revolutionists deliberately plan violence when they could have used peaceful methods. This popular theory, however, is difficult to maintain with regard to the American, French, or October Revolutions, and it is interesting to note that Lenin explicitly

[46] Mr. Russell says that "Until the Bolsheviks dismissed the Constituent Assembly at the beginning of 1917, it might have been thought that parliamentary democracy was certain to prevail throughout the civilized world." (*Power*, 206). By this act, he implies, the Bolsheviks not only destroyed democracy in Russia, but prepared for its overthrow in Europe.

[47] V. I. Lenin, "Dissolution of the Constituent Assembly." Speech delivered to the All-Russian Central Executive Committee, Jan. 19, 1918. *Lenin, Stalin, 1917: Selected Writings and Speeches* (Moscow, 1938), 709.

[48] *Justice in War-Time* (London, 1916), Chapter, "War and Non-Resistance."

rejected it. Explaining why the October Revolution was obliged to go beyond the overthrow of Tsardom, he said:

Nothing, therefore, is more ludicrous than the assertion that the subsequent development of the revolution and the subsequent revolt of the masses were caused by some party, by some individual, or . . . by the will of a "dictator." The fire of revolution flared up solely because of the unparalleled misery and incredible sufferings of Russia and all the conditions created by the War, which bluntly and inexorably faced the toiling people with the alternative; either a bold, desperate and fearless step, or ruin—death from starvation. . . .[49]

Arguments to the effect that *no* revolution is justifiable are *a priori*. They depend upon a very abstract use of such terms as power and freedom, order and disorder, and a neglect of concrete conditions. Revolutions in the occupied countries of Europe are naturally approved by the United Nations today, since they serve the best interests of the liberating armies and of the people themselves. "Ballots are better than bullets" is obviously true, but only when the alternative exists.

### III. Criticism of Marxian Political Economy

Russell's economic philosophy is inspired by many of the ideas which animated the radicalism of the eighteenth and nineteenth centuries, but it dissents from rationalism and the belief in progress. It is pervaded by skepticism and distrust of organization, and utopian hopes are soon followed by resignation. Rarely leaving the level of abstract ethical and psychological principles, he frequently concludes with the formula: If men in general changed their attitudes in this or that respect, socialism and peace could soon be realized, for "there is no outward reason" which prevents it. If men preferred their own happiness to the pain of others, nothing more would be needed.[50] But, as

[49] *Op. cit.*, 707.

[50] The following is a typical passage: "If a majority of every civilized country so desired, we could, within twenty years, abolish all abject poverty, . . . the whole economic slavery which binds down nine-tenths of our population. . . . It is only because men are apathetic that this is not achieved, only because imagination is sluggish, and what always has been is regarded as what always must be. With good-will, generosity, intelligence, these things could be brought about." *Political Ideals*, 35.

we have seen, his pessimistic view of human nature leaves him little confidence that the subjective changes which he believes necessary, and perhaps sufficient, to his goal of a better world, can ever be brought about. Even when he sees his ideals materializing in men and institutions of a new order, his suspicion of human passions prevails. He deplores means used, without inquiring whether they are necessary, fails to check "facts" which he admits are often manufactured,[51] and comes to doubt whether the new world with its new forms of Power will be even as good as the old.

Russell mentions a variety of economists in passing, and gives a brief historical account of Ricardo, Malthus, Bentham, Mill and others, but the only economist he favors with recurrent criticism in a whole series of books is Marx. One reason for this was that Russell has a keen awareness of the injustice suffered by labor, as documented, for example, in such books as Engels' *The Condition of the Working Class in England* and Hammond's *The Town Labourer;* and he knows, at the same time, that traditional capitalist economics is not the pure impartial science it pretends to be.

Marx, [Russell says,] was the first intellectually eminent economist to consider the facts of economics from the standpoint of the proletariat. The orthodox economists believed that they were creating an impersonal science, as free from bias as mathematics. Marx, however, had no difficulty in proving that their capitalist bias led them into frequent errors and inconsistencies.[52]

Moreover, Russell holds that "the belief in private property" is one of the greatest obstacles to fundamental progress and that "its destruction is necessary to a better world."[53] His maturing conviction was that "Industrialism cannot continue efficient much longer without becoming socialistic."[54] Thus in spite of his very critical attitude toward Marxism, Russell repeatedly describes

[51] See *The Underworld of State* (London, 1925), Introduction. Here Russell speaks of news factories in Europe which make a business of turning out false information about Soviet Russia. In *Bolshevism* and other books he recognizes the unreliability of newspaper accounts of conditions in the Soviet Union.

[52] *Freedom vs. Organization,* 187.

[53] *Prospects of Industrial Civilization,* 145.

[54] *Ibid.,* 99.

himself as a socialist of one kind or another and even tells of going to Russia as a convinced communist.[55] He wishes socialism or communism to succeed but insists upon impossible conditions. He calls for decentralization, or devolution, of state and bureaucratic authority, and for *laissez aller* philanthrophy, even for enemies. He wants to see the pure scientist freed from the practical demands of industrialization and he wants to see the pure artist released from public responsibility to follow his creative impulse wherever it may lead. Indeed both should be supported by society, although not answerable to it in any way.

Although Mr. Russell is attracted to some aspects of Marxism, his judgment is usually very adverse and he offers rather familiar objections. Even in his first book, *German Social Democracy* (1896), Russell begins with a critique of Marxism. Here as in later writings much of his criticism miscarries because he fails to realize consistently that, in analyzing essential tendencies within capitalist economy, Marx followed the approved scientific method of abstracting temporarily from complicating factors and from counteracting tendencies.

As to the origins of Marxism, Russell claims that as Marx, in economic theory, "accepted in their crudest form the tenets of orthodox English economists so, in his view of human nature, he generalized their economic motive so as to cover all departments of social life,"[56] and he implies that Marx accepted the labor theory of value uncritically and historical materialism without proof. This does not seem to be correct. Historical materialism, for one thing, should not be identified with the vulgar theory that all human actions have economic inspiration or even that all entrepreneurial actions have.[57] The *predominant* influence of economic conditions is heavily documented in the historical writings of Marx and Engels. Russell himself in a recent work goes so far as to say that "the economic interpretation of history . . .

[55] *Bolshevism: Practice and Theory.* Preface.

[56] *German Social Democracy* (London, 1896), 8.

[57] Thus Engels wrote: "We make our own history, but in the first place under very definite presuppositions and conditions. Among these the economic ones are finally decisive. But the political, etc., ones, and indeed even the traditions which haunt human minds also play a part, although not the decisive one." (Engels to Joseph Bloch. London, Sept. 21, 1890).

seems to me very largely true, and a most important contribution to sociology." He adds, however, that "I cannot regard it as *wholly* true, or feel any confidence that all great historical changes can be viewed as developments,"[58] and he presents certain rather fantastic illustrations of occasional individuals who single-handed changed the course of history. Thus he suggests "that if Henry VIII had not fallen in love with Anne Boleyn, the United States would not now exist. For it was owing to this event that England broke with the Papacy, and therefore did not acknowledge the Pope's gift of the Americas to Spain and Portugal."[59] Before reaching such a conclusion, Marxist method would insist upon a careful examination of the political-economic developments inspiring England's break with the Papacy, and an evaluation of the material means of Spain or Portugal to maintain control of America. Only in the course of such a study would the true efficacy of personalities emerge.

More important than these genial thrusts at the Marxian view of history, are Russell's more studied criticisms of the theory of value, the theory of wages and the theory of surplus value. With regard to Ricardo's theory of value, Russell states that it holds "say for the manufacture of cotton cloth as it was in Ricardo's day. . . . On the whole, the price would be determined pretty accurately by the amount of labor involved in making it."[60] The value of a painting by Leonardo, on the other hand, could not be so determined, for it probably cost no more labor than any wretched daub. In general, the labor theory of value tends to hold under conditions of free competition, but not when monopoly appears. Mr. Russell believes that this criticism should embarrass Marx as well as Ricardo,[61] but Marx, at any rate, has made it pretty clear that calculation of the socially necessary labor time is not intended to account for the price of

[58] *Freedom vs. Organization* (New York, 1934), 191.

[59] *Ibid.*, 199.

[60] *Freedom vs. Organization*, 106-7.

[61] As against Ricardo, Jevons also argues that the prices of ancient books, coins, etc., do not conform to the labor theory of value and that "even those things which are producible in any quantity by labor seldom exchange at the corresponding values." *The Theory of Political Economy* (1871), 163. Such criticism does not, apparently, apply to Marx who carefully distinguished between value, price of production and market value (*Capital*, III, 210).

every commodity on the market. He indicates frequently that price fluctuates about value, but cannot be identified with it. But perhaps Mr. Russell wishes to discuss the "*value*" of Leonardo's painting. In this case he seems to make the common mistake of supposing that the value of an article such as a Leonardo painting is determined by the labor time *used* to produce it, whereas Marx repeatedly stated that its value is determined by the labor time *socially necessary* to produce it. Thus Marx warns:

> Some people might think that if the value of a commodity is determined by the quantity of labour spent on it, the more idle and unskilful the labourer, the more valuable would his commodity be, because more time would be required in its production. The labour, however, that forms the substance of value, is homogeneous human labour, expenditure of one uniform labour-power. The total labour-power of society, which is embodied in the sum total of the values of all commodities produced by that society, counts here as one homogeneous mass of human labour-power, . . . The labour-time socially necessary is that required to produce an article under the normal conditions of production, and with the average degree of skill and intensity prevalent at the time. . . . Each . . . commodity, in this connection, is to be considered as an average sample of its class.[62]

As for Russell's objection that the labor theory of value is approximately true under conditions of free competition, but not under monopoly, it will be remembered that Marx expounded value in Volume I of *Capital* in relation to Simple Reproduction, a system of free competition.[63] When monopoly enters the picture, raising the price above the price of production, and above the value of the commodities affected by such a monopoly, still the limits imposed by the value of commodities would not be abolished thereby. The monopoly price of certain commodities would merely trans-

[62] *Capital*, I, 45-6. The idea of socially necessary labor time as defined here seems so clear that one wonders why Russell finds it difficult. (*German Social Democracy.*)

[63] Mr. Russell evidently regards Jevons' conception of value, the "final degree of utility," i.e., the satisfaction afforded by the last infinitesimal quantity of the existing stock, as much superior to Marx's theory of value, yet it assumes free competition, and does not apply to monopoly conditions, which is precisely the fault he finds with Marx's theory.

fer a portion of the profit of the other commodities to the commodities with a monopoly price. A local disturbance in the distribution of the surplus value among the various spheres of production would take place indirectly, but they would leave the boundaries of surplus value itself unaltered.[64]

Mr. Russell sometimes misses the complexity of Marx's analysis. Having made up his mind that the *Communist Manifesto* contains the essence of Marx's and Engels' doctrine, he is impatient with the technicalities and complications of *Capital*. He argues, for instance, that Marx was *logically* mistaken in thinking that the labor theory of value would be established if it were true that labor power is a component of all commodities, and *factually* mistaken in thinking that labor power is the only such common component, for utility is also present in all commodities.[65] Doubtless Marx would have been wrong had his argument been as simple as this, but clearly it was not.

The theory of value, the theory of wages and the theory of surplus value are bound up together and Mr. Russell objects to all of them. One of Marx's mistakes, according to Russell, was to omit from his argument for the theory of surplus value the premise, "Wages are proportional to labor time" which is necessary to his conclusion that "exchange value is measured by labor time." Ricardo, in his 'proof that value is measured by labor', assumes, Russell says, that "wages are proportional to labor time" and thus concludes that

exchange value is measured by labour time. Marx keeps the conclusion, exchange value is proportional to labour time without an essential step in the argument, namely wages are proportional to labour time. He says, on the contrary, wages are equal to the cost of the labourer's necessaries, and are independent of the length of the working day.[66]

---

[64] *Capital*, III, 1003.

[65] *German Social Democracy*, 17-18. Unfortunately, Mr. Russell has nowhere examined the inherent difficulties of the marginal utility analysis. Although he probably accepts Jevons' view that "Final degree of utility determines value," he neglects to consider the problem of determining values on the basis of hedonic calculations. This is curious for the reason, *inter alia*, that Jevons' view *assumes* the permanence of the societal structure which Mr. Russell wants to see changed.

[66] *German Social Democracy*, 18. Russell puts the argument more briefly in *Freedom vs. Organization* (202): "Although the capitalist does not have to pay

The answer to this objection depends upon Marx's distinction, which Russell ignores, between the use-value and exchange-value of labor, as a commodity. The entrepreneur makes use of labor power in the process of production, and can use it for a longer period than is necessary to pay for its keep, its exchange-value. The worker may in six hours' work embody in the product socially necessary labor time (as a social average) equivalent to the value of his necessaries, but the entrepreneur is able to use his labor power another three hours, let us say. Thus labor power produces its own exchange-value in six hours and surplus-value in the three remaining hours. The exchange-value of the labor power is measured by the labor time socially necessary to produce the laborers' necessaries, while the exchange-value of the product is measured by the labor time necessary to produce the product. By and large, the exchange-value of the product exceeds the exchange-value of labor power which produces it. Otherwise there would be no surplus value and no profits. Only in a competitive society in which laborers owned the means of production and sold their own products would the two exchange values be equal.

Russell points to difficulties in Marx's theory of surplus value but his efforts have not shown that any is insuperable. He argues that if Marx were right every capitalist must wax rich and competition cease, and that the theory of surplus value thus stands in contradiction with the theory of the concentration of capital.[67] But this is plainly a misconception. Marx did not insist that the rate of exploitation must be 100%, as his production tables might suggest, but only that it will tend to be as high as

for the last six hours, yet, for some unexplained reason, he is able to make the price of his product proportional to labor-time required for production." In 1859 Marx stated this same objection, which was popular even at that time (*A Contribution to the Critique of Political Economy*. 1904, p. 71): "If the exchange value of a product is equal to the labor-time contained in it, then the exchange value of one day of labor is equal to the product of that labor. In other words, wages must be equal to the product of that labor. But the very opposite is actually the case. Ergo, this objection comes down to the following problem: How does production, based on the determination of exchange value by labor-time only, lead to the result that the exchange value of labor is less than the exchange value of its product?"

[67] *German Social Democracy*, 15.

competition, and other counteracting factors, permit. But Russell asks: "What is to hinder competition from lowering the price to a point where a business is only just profitable?"[68] Accumulation, the argument might run, increases the demand for labor, may produce labor scarcity and increase wages indefinitely. Accumulation might thus reduce surplus-value to an amount so negligible that capitalism could no longer be said to exploit labor. The answer is that in opposition to this trend, there are counteracting tendencies, emphasized by Marx, such as the tendency to maintain and increase the reserve army of labor.

"The industrial reserve army, during the periods of stagnation and average prosperity, weighs down the active labour-army; during the periods of over-production and paroxysm, it holds its pretensions in check."[69] Should this reserve army dwindle through expansion of capital, devices are always at hand: technological progress, the installation of labor-saving devices, importation of cheap labor, preferably from non-capitalist areas, employment of women and children at depressed wages and even the encouragement of large families by censoring birth control literature. Technological unemployment, which in recent times tended to increase at a rate comparable to the rate of capitalist accumulation is itself, perhaps, a sufficient guarantee of a vast reserve army of labor in peacetime. Marx's argument does not depend on Malthus' theory of population, as Russell contends.[70] Marx dissociated his economics from this "libel on the human race" at a time when its prestige was at its highest, and not on moral, but theoretic, grounds. Since then it has been completely discredited.

Surplus-value may dwindle, Mr. Russell argues, and wages may rise. Marx forgets that:

labour, unlike other commodities, is not produced by capitalists, but produces itself. Its cost of production, therefore is determined wherever wages are above starvation level, by the remuneration at which it thinks

[68] *Ibid.*, 18.
[69] *Capital*, I, 701.
[70] *Freedom vs. Organization*, 202.

it worth while to produce itself, . . . Hence arises the possibility ignored by Marx, of raising wages by trade unions and other methods, which are possible within "the capitalist state."[71]

Russell's interpretation of Marx in this passage, is not an uncommon one, but mistaken. It is not true, as Mr. Russell repeatedly states, that Marx held a minimum subsistence theory of wages or the "iron law" of wages, or that he "accepts without question the law that wages must always (under a competitive system) be at a subsistence level."[72] Marx maintained that the value of labor power is equivalent to the value of the necessaries of the laborer but clearly indicated that "necessaries" must be understood historically:

The number and extent of the labourer's so-called necessary wants, as also the modes of satisfying them, are themselves the product of historical development, and depend therefore to a great extent on the degree of civilization of a country, more particularly on the conditions under which, and consequently on the habits and degree of comfort in which, the class of free labourers has been formed. In contradistinction therefore to the case of other commodities, there enters into the determination of the value of labour-power a historical and moral element. Nevertheless, in a given country, at a given period, the average quantity of the means of subsistence necessary for the labourer is practically known.[73]

Mr. Russell therefore cannot be right in saying that "if there exists, or has existed, a set of labourers whose wages were not at starvation level, the argument [i.e., Marx's argument] breaks down."[74]

Nor is it correct to say that Marx neglected the possibility "of raising wages by trade unions and other methods," although it is true that this possibility is methodologically excluded by Marx in preliminary stages of analysis. As early as 1847 his interest in associations of laborers for betterment of their condition was

[71] *German Social Democracy*, 22.
[72] *Freedom vs. Organization*, 202.
[73] *Capital*, I, 190.
[74] *German Social Democracy*, 21-22.

shown by his part in The Democratic Association. He tended to think of freedom as the main objective, but freedom was to be won through economic victories and he praised the American trade union movement with its primarily economic goal. As trade unionism has developed, many writers have contributed to this phase of Marxian theory, without *prima facie* invalidating other phases. Even the law stating a *tendency* to "increasing misery," does not, if the historical nature of labor's necessaries is kept in mind, conflict with trade union achievements. Mr. Russell's objection to the theories of value, wages and surplus-value, at least in the cursory form in which they are stated, do not appear to be as fatal as he supposes, and the same might be said of his criticisms of other Marxian tenets. With regard to the law of the concentration of capital, for example, Russell complains that although, as Marx predicted, "big businesses have grown bigger and have over a great area reached monopoly, yet the number of shareholders in such enterprises is so large that the actual number of individuals interested in the capitalist system has continually increased."[75]

The number of shareholders has increased, but has their share of the total investment? And what is their share in the earnings, and in the control of enterprise which determines the distribution of dividends? These are the relevant questions. They can be answered by statistical studies such as the Temporary National Economic Committee Reports,[76] which give impressive testimony to the rapid concentration of capital.

The same kind of studies would be needed to deal with other questions raised by Mr. Russell. Consider again the question as to the relation between value and price. Marx did not contend, as Mr. Russell seems to think, that there is an identity between value and price (except in special, well-defined cases), but only that there is a *tendency* for price to return to the value level. To disprove this something more is needed than mere reference to the frequent disagreement of value and price,[77] or

[75] *Proposed Roads to Freedom*, 26.

[76] See especially the "Report of the Executive Committee." It should be said that Russell himself in 1938 recognized that ownership of stock does not mean control and quotes Berle and Means in substantiation. (*Power*, 300.)

[77] *Freedom vs. Organization*, 203f.

to the fact, which has nothing to do with the case, that monopolies are motivated in determining price, not by the labor involved in the commodity, but by what the traffic will bear.[78] The question is whether monopoly prices approximate to values over a considerable period. If careful investigation of price levels showed that there is no general tendency of prices of commodities to vary with the labor time socially necessary to their production, this would be sufficient to disprove the theory. Russell has not presented evidence of this kind. Internal evidence is likewise lacking in many cases. Russell neglects the text. In Volume III of *Capital*, for example, he would have found his objections to the theory of ground-rent at least carefully considered. While this much contested theory may be wrong, until Marx's elaborations and rejoinders have been considered, it cannot be said that Russell has proved that it is.

As we have seen, Russell is impatient with the theoretic developments and expedients of *Capital*, although he admires its stirring indictment of the wage system and of the condition of the poor. Like G. D. H. Cole he attempts, while discarding the political economy, to give a moral explanation of Marx's teaching. "The theory of surplus value," he says, "seems to spring more from Marx's desire to prove the wickedness of capital than from logical necessity."[79] As an expression of moral indignation at the inadequate share of the product that goes to labor, Mr. Russell has no fault to find with the theory of surplus value, but there is nothing surprising in this. As Marx pointed out long ago (1859), English socialists have a bent to interpret surplus value in moral terms, and then to appeal to society for correction of the glaring injustice. English economic reform has subsequently preferred the moral appeal of Marxism to its theory, but Marx had already rejected this interpretation and had carefully distinguished his view from utopian socialism. The moral appeal of *Capital* is not irresponsible, but rests upon a theory of objective conditions which gives it a basis for success.

[78] *Ibid.*, 202.

[79] *German Social Democracy*, 15. See also *Freedom vs. Organization*, 203f. and *Proposed Roads to Freedom*, 18.

CONCLUSION

Mr. Russell contended in his first book *German Social Democracy* in 1896, that he had completely refuted key economic theories of Marx. Instead of allowing his refutation to stand, however, he repeatedly returned to the attack in later writings, although he adds no new arguments and does not attempt to defend non-Marxian theories, such as marginal utility, which he regards as much superior. Nor has he attempted to strengthen or correct his arguments by reference to the extensive literature which deals with the objections he raised in 1896. He is disposed in later books to restate his old arguments hurriedly, devoting major attention to the social theory of Marxism. Apparently Marxian economics is interesting to Mr. Russell, and also objectionable to him, largely because it is the basis of Marxian Socialism. His principal criticism of Marxian Socialism, as we have seen, is that it insists upon the necessity of strong central government in certain historical periods. But the criticism of strong central government is based upon an abstract theory of the passions.

The "passions of acquisitiveness, vanity, rivalry and the love of power are the basic instincts," Mr. Russell says, "the prime movers of almost all that happens in politics."[80] The theory of instincts is evidently untenable and has been repudiated by contemporary psychologists but it haunts all of Russell's social writings. Although they contain brilliant discernments, rapier-like thrusts at human perversity and much subtle reading of human desires, the psychology of power and possessiveness impoverishes the whole. Although Russell's work in the foundations of mathematics will probably last for centuries, his political and economic philosophy has obvious debilities. Attracted by the ideals of freedom in Proudhon, Kropotkin and the French syndicalists, Mr. Russell lacked their faith in human nature, and could not believe either anarchism or syndicalism a practical solution. At the same time he set no hopes in reformed capitalism or Marxian socialism, for both systems implied an augmentation of Power and, as it seemed to him, a consequent loss of individual

[80] *Bolshevism: Practice and Theory*, 133.

freedom. His theory of human passions thus left him no course but to waver, with many fine intellectual excursions, between solutions he regarded as impractical and solutions he regarded as undesirable.

V. J. McGILL

DEPARTMENT OF PHILOSOPHY
HUNTER COLLEGE

**20**

*Boyd H. Bode*

## RUSSELL'S EDUCATIONAL PHILOSOPHY

# RUSSELL'S EDUCATIONAL PHILOSOPHY

## I

FOR the American public the name of Bertrand Russell is rapidly acquiring a connotation that has a Mephistophelian quality. Like his literary prototype, Mr. Russell is unmistakably a dangerous person. He is subversive; he is the spirit that denies. Or, to take a more modern comparison, his sallies are in the nature of commando raids which are directed against any point that happens to be convenient and which aim to do the greatest possible damage in the shortest possible time. Whether the theme of his discourse be religion or patriotism or citizenship or capitalism or matrimony or education or some other phase of our social order is a secondary matter; it is fairly safe to assume beforehand that some hoary tradition is going to take a beating. What makes this especially reprehensible is that it is difficult to thwart Mr. Russell's sinister purpose by withholding our attention. Reading Mr. Russell's engaging discourses is to the right-minded citizen something like witnessing a risqué play; he knows that he should not be there at all, but he remains anyhow, at the peril of his immortal soul.

It must be added at once, however, that Mr. Russell's appeal is not due solely, or perhaps even mainly, to his literary skill. His iconoclasm is merely the reverse side of his deep and abiding concern for human freedom, a concern which is likely to strike a responsive chord in those who come within the range of his voice. There is an undeniable truth in his contention that social organization as it actually exists is to a large extent a conspiracy against freedom. From the moment that a child is born he is subjected to a process of initiation into a group culture which

decides in advance what he is to believe and how he is to act. The variations in these cultures are an indication of their character. They are a combination of sense and nonsense, of historical accident and the inertia of custom, of sheer superstition and the bias of vested interests. Whatever the character of a particular culture, it sets the pattern for the development of all its members. By and large, all the social pressures are in the direction of conformity. The good child is the docile child, who does what he is told and who has no thought of questioning the beliefs of his elders. Freedom in important matters disappears under the weight of social disapproval. Education becomes a process of moulding the individual in conformity to a pre-established pattern; or, as someone has said, it becomes the art of taking advantage of defenseless childhood.

Perhaps this exploitation of childhood is inevitable in any case, imitativeness and custom being what they are. But it is sure to be intensified and to become a conscious purpose whenever or wherever there are special interests to be protected. Of these special interests the two outstanding instances are the State and the Church. The State is interested in education for citizenship; and "Citizens as conceived by governments are persons who admire the *status quo* and are prepared to exert themselves for its preservation."[1] Religion in the Western world is concerned, initially, not with citizenship, but with saintliness; yet as religion becomes institutionalized it likewise becomes a bulwark of the *status quo*.

There is undoubtedly, in those who accept Christian teaching genuinely and profoundly, a tendency to minimize such evils as poverty and disease, on the ground that they belong only to this earthly life. This doctrine falls in very conveniently with the interests of the rich, and is perhaps one of the reasons why most of the leading plutocrats are deeply religious. If there is a future life and if heaven is the reward for misery here below, we do right to obstruct all amelioration of terrestrial conditions and we must admire the unselfishness of those captains of industry who allow others to monopolize the profitable, brief sorrow on earth.[2]

The road to freedom, therefore, is a road away from the old loyalties and the old patterns of thinking and judging. Mr.

[1] *Education and the Modern World*, 13.
[2] *Ibid.*, 108.

Russell's pattern for education and the good life collides with our traditional culture all along the line. He is a rebel because tradition is so largely an enemy of spiritual values.

> Religion encourages stupidity, and an insufficient sense of reality; sex education frequently produces nervous disorders, and where it fails to do so overtly, too often plants discords in the unconscious which make happiness in adult life impossible; nationalism as taught in schools implies that the most important duty of young men is homicide; class feeling promotes acquiescence in economic injustice; and, competition promotes ruthlessness in the social struggle. Can it be wondered at that a world in which the forces of the State are devoted to producing in the young insanity, stupidity, readiness for homicide, economic injustice, and ruthlessness—can it be wondered at, I say, that such a world is not a happy one?[3]

This sets our problem. It is the familiar problem of the relation between the individual and the surrounding group culture. It is a problem which, as Mr. Russell says, meets us everywhere —in politics, in ethics and in metaphysics, as well as in education. But it has a certain simplicity in education because it is in this field that the forces of exploitation are so clearly discernible. The state wants good citizens; the church wants prospective saints or priests; the spirit of the Renaissance wants gentlemen; and a snobbish democracy—at any rate, according to Mr. Russell —wants "an education which makes a man seem like a gentleman."[4] This shameless struggle for the possession of the minds and hearts of helpless children is, in essence, a repudiation of morality, since the rights of children are ignored. The purpose of the struggle is to fortify vested interests, to create loyalties which will protect special values without giving the individual any voice in the matter whatsoever. The child is, in very truth, the Forgotten Man. In terms of the relation between the individual and society, the pupil is overwhelmed and submerged by external demands; he is a means to an end, the clay on the potter's wheel. The result of all this is a spurious morality, a morality in which conduct is divorced from consideration of consequences. As long as education is dominated by its present controls, there is little chance of escape from a world-wide

[3] *Ibid.*, 239, 240.
[4] *Ibid.*, 15.

situation which "has become so intolerably tense, so charged with hatred, so filled with misfortune and pain that men have lost the power of balanced judgment which is needed for emergence from the slough in which mankind is staggering."[5] The pathetic feature of all this is that it is precisely the impulses of loyalty, self-sacrifice and devotion which are being diverted to ignoble ends. What civilization needs is protection against The Harm That Good Men Do.[6]

A new orientation in education is therefore imperative. Although educational opinions represent an endless diversity, we need to bear in mind that, as Mr. Russell puts it, "there is one great temperamental cleavage which goes deeper than any of the other controversies, and that is the cleavage between those who consider education primarily in relation to the individual psyche and those who consider it in relation to the community." Hence "the question arises whether education should train good individuals or good citizens."[7]

This is the basic question, but unfortunately, it soon appears that the question is not reducible to a simple "either-or." As Mr. Russell points out, "the amenities of civilised life depend upon co-operation, and every increase in industrialism demands an increase in co-operation."[8] There must be internal cohesion within the state; which is to say that there must be education for citizenship. Over against this necessity stands the claim that education is for the sake of producing good individuals. The problem lies in the reconciliation of these two requirements. Metaphysicians, such as those of the Hegelian school, have indeed assured us that there is no real antithesis between the good citizen and the good individual. That is as may be. Excursions into the field of metaphysics for solutions of our everyday problems have a way of making confusion worse confounded. According to Mr. Russell, "it is difficult to deny that the cultivation of the individual and the training of the citizen are different things."[9]

[5] *Ibid.*, 240.
[6] *Sceptical Essays*, Chapter IX.
[7] *Education and the Modern World*, 9.
[8] *Ibid.*, 25.
[9] *Ibid.*, 10.

Just how different they are must be determined by an examination of their respective claims.

## II

What constitutes the good of the individual? In general terms, this good consists in the satisfaction of the demands made by the three main aspects or constituents of our human nature—intellect, emotion and will. "First and foremost," says Mr. Russell, "the individual, like Leibniz's monads, should mirror the world."

The man who holds concentrated and sparkling within his own mind, as within a *camera obscura*, the depths of space, the evolution of the sun and the planets, the geological ages of the earth, and the brief history of humanity, appears to me to be doing what is distinctly human and what adds most to the diversified spectacle of nature.

Why knowledge should have this high rating Mr. Russell does not pretend to explain or justify, "except that knowledge and comprehensiveness appear to me glorious attributes in virtue of which I prefer Newton to an oyster."[10]

This, then, is the first constituent. Presumably, however, Mr. Russell would agree that the possession of knowledge is in itself no more desirable than the possession of, say, a junk-pile. It must be experienced as a "glorious attribute." Knowledge divorced from emotion is knowledge without glamor. "It is not enough to mirror the world. It should be mirrored with emotion; a specific emotion appropriate to the object, and a general joy in the mere act of knowing."[11] To acquire and possess knowledge is "distinctly human," and this is presumably the reason why the cultivation of the intellect is normally accompanied by "joy in the mere act of knowing;" at any rate, the acquisition of knowledge and the corresponding emotion go hand-in-hand as basic constituents in the good of the individual.

A third constituent or element remains to be considered. It is the element of will, which symbolizes the possession of power. There must be scope for the exercise of power if the good of the

[10] *Ibid.*, 10 f.
[11] *Ibid.*, 10, 11.

individual is to come to fruition. This likewise must be accepted as a self-evident proposition. If proof be demanded for all this, we can point to the conceptions of Deity in which men have attempted to formulate their notions of perfection. These formulations are projections of what men have considered the perfect good of the individual, and this perfect good consists essentially in knowledge, emotion, and power, widened to the utmost. "Power, Wisdom and Love, according to the traditional theology, are the respective attributes of the Three Persons of the Trinity, and in this respect at any rate man made God in his own image."[12]

So far so good. But now the problem of citizenship begins to emerge. It is through the element of will or power that our lives impinge on one another. As Mr. Russell says:

The elements of knowledge and emotion in the perfect individual as we have been portraying him are not essentially social. It is only through the will and through the exercise of power that the individual whom we have been imagining becomes an effective member of the community.

Since men have to live together in the same universe, a moral basis must be provided. But here the analogy of the individual with Deity is of no help. The problem of "citizenship" seems to be as acute with the Deity as with ourselves. At any rate, theologians have had considerable difficulty in justifying the ways of God to man. Man is, indeed, like God in being endowed with will, but "even so the only place which the will, as such, can give to a man is that of dictator. The will of the individual considered in isolation is the god-like will which says 'let such things be'."[13]

The good of the individual becomes a problem because men have to live together. There would be no such problem if each individual could be made the god of his own self-contained universe—a universe guaranteed not to intersect with any other universe. This conception of the good is suggested initially by the comparison of the individual with Deity. Such a guarantee, however, is obviously out of the question, and so the moralist has to assume the task of devising a foreign policy for each of these aspiring deities. The analogy of statecraft suggests that each

[12] *Ibid.*, 11.
[13] *Ibid.*, 12.

individual, like the modern state, should try to make himself as nearly self-subsistent as circumstances will permit, in order to safeguard his sovereignty and his interests. Since the various states have to get along somehow on the same planet, recourse will necessarily be had to treaties and understandings, and even, on occasion, to ostentatious professions of mutual loyalty and brotherly love. This kind of thing, however, rarely deceives a statesman who knows his business. Treaties and agreements are essentially makeshifts, which are necessitated by the fact that no one of the high contracting parties can have the whole planet all to himself.

Some moralists have been disposed to think that the problem of moral conduct must be solved along such lines as these; but not Mr. Russell. "Nationalism," he says, "is undoubtedly the most dangerous vice of our time—far more dangerous than drunkenness, or drugs, or commercial dishonesty, or any of the other vices against which a conventional moral education is directed."[14] If nations have no right to consider themselves "in isolation," the same may be said for the individual. In other words, the "god-like will" is not the answer. This kind of will is no more social than knowledge and emotions; at any rate it is not obviously so. The whole problem of evil is the problem of reconciling divine power with the requirements of what we ordinarily consider to be moral and social standards.

So far the problem of evil has defied solution. Perhaps this fact should be construed as a warning against Mr. Russell's method of determining the good of the individual. It leads us into a mess which is even worse than that of the theologian. The latter as a last resort may take refuge in the "mysterious ways of Providence;" but the moralist cannot do so. When our fellow men do not behave as we think they should, we cannot be content to plead that appearances are not to be trusted, that the behavior of which we disapprove may be animated by purposes too profound and too inclusive for our limited comprehension. Still less is it open to us to argue that a god-like will should not be hampered by merely moral considerations. It would probably be wiser not to start with a god-like will at all.

The reason why Mr. Russell starts with such a will is, as he

[14] *Ibid.*, 133.

explains, not to recommend an ideal of Olympian isolation, but rather to make us "aware of all our potentialities as individuals before we descend to the compromises and practical acquiescences of the political life." After Mr. Russell has discovered these potentialities, however, he apparently does not know what to do with them. Since the political life is an unavoidable necessity, morality seems to sink to the level of the "compromises and practical acquiescences" which he so much dislikes. When the individual becomes a citizen, it becomes immoral for him to try to have a god-like will. The citizen

is aware that his will is not the only one in the world, and he is concerned, in one way or another, to bring harmony out of the conflicting wills that exist within his community. . . . The fundamental characteristic of the citizen is that he co-operates in intention if not in fact.[15]

Which is to say that the citizen does not act like a dictator. Bringing "harmony out of conflicting wills" is a process of discussion and conference for the purpose of ascertaining what the final collective will is to be. This can be condemned as "compromise and practical acquiescence" only if we start with a god-like will and then find that we have staked out too much territory.

The antithesis is clear. On the one hand we have the god-like will which says "let such things be." On the other hand we have the will of the citizen, which emerges from the process of bringing harmony out of conflicting wills. This is regarded as an inferior kind of will because it is assumed to involve acquiescence in the plans and purposes of others, which in turn is regarded as a kind of spiritual tyranny. How are these two kinds of will to be reconciled? Apparently Mr. Russell regards the problem as insoluble. The best that can be hoped for is that the co-operation which is demanded of the citizen, "should be secured without too great a diminution of individual judgment and individual initiative."[16]

This discrepancy between the two kinds of will, which Mr. Russell leaves unresolved, determines in large measure his attitude in matters of education. His sympathies are with the individual as over against the environment, both physical and

[15] *Ibid.*, 12.
[16] *Ibid.*, 236, 237.

social. With respect to the material world, the conflict is not, indeed, a conflict of wills, but rather a conflict between the individual will and the impersonal forces of nature; yet the result is pretty much the same. Nature has no regard for spiritual values and so we are confronted with a choice between defiance and surrender. In comparison with nature, man is but an atom; yet he has it in his power to turn his back on nature and build for himself an ideal realm of beauty and truth; and in so doing he can pluck victory from defeat.[17] With respect to the world of social relationships he is somewhat more conciliatory, yet the emphasis remains at the same place. Knowledge is given a central place; freedom is identified with absence of restrictions; a good society is a society in which no one would be compelled to work.[18] Self-fulfilment through practical and co-operative activity nowhere receives comparable recognition, nor do the occasional contemptuous references to the "herd" indicate any yearning for co-operation. If unfriendly critics see in all this a hang-over of an aristocratic tradition, the reason is presumably that the latter likewise has its roots in the antithesis between the individual and the community.

What complicates the situation, however, in the case of Mr. Russell, is that this antithesis is not maintained throughout. Although coercion is often a threat to individual freedom, this is not invariably true. Coercion may be required in the interests of self-development. The god-like will may, for some mysterious reason, require discipline for its own good. Mr. Russell approves of compulsion in such matters as cleanliness, punctuality, respect for property, routine, learning the three R's, and the like. More specifically he says:

The capacity for consistent self-direction is one of the most valuable that a human being can possess. It is practically unknown in young children, and is never developed either by a very rigid discipline or by complete freedom. . . . The strengthening of the will demands, therefore, a somewhat subtle mixture of freedom and discipline, and is destroyed by an excess of either.[19]

[17] *Philosophical Essays.* Chapter on "A Free Man's Worship."

[18] *Proposed Roads to Freedom,* 193.

[19] *Education and the Modern World,* 38, 39; cf. also *In Praise of Idleness,* Chapter 12.

At this point Mr. Russell is in open disagreement with a certain "lunatic fringe" in education, which is disposed to regard any form of compulsion as an infringement on the sacred rights of childhood. But although Mr. Russell exhibits more common sense, the latter might perhaps be credited with a greater sense of logical consistency. A will can hardly be regarded as god-like if it requires improvement at the hands of pedagogs. If coercion is to have even *prima facie* justification, it is necessary to shift from the will of the individual to the will of the citizen, i.e., the will which results from the effort to secure a common program through voluntary co-operation. It is only through such a shift that coercion can change from rank imposition to a means of grace. It is a shift which implies that the good of the individual and the good of the citizen are basically identical.

Where does this leave us? In terms of Mr. Russell's approach, we are supposed, first of all, to become aware of our potentialities as individuals through reflections on the nature of the godhead. Then when this fails to carry us the whole way, we betake ourselves to the kindergarten in order to consider the development of children as members of a social group. In the former case our attention is focused on the god-like qualities which inhere in our nature as individuals. In the latter case the development of potentiality is made to depend on participation in an unspecified pattern of group living. By moving back and forth Mr. Russell avoids the necessity of developing a consistent doctrine in terms of either point of view.

The point at issue here is so basic as to warrant elaboration. The problem, as stated by Mr. Russell in a chapter especially devoted to it,[20] is the problem of combining the fullest individual development with the necessary minimum of social coherence. This calls for concessions on both sides. On the one hand, the requirements of social coherence must be held to a minimum so as to present the least possible obstacle to individual development. On the other hand, it must be recognized that

individualism, although it is important not to forget its just claims, needs, in a densely populated industrial world, to be more controlled, even in individual psychology, than in former times. . . . A sense of citizenship,

[20] *Ibid.*, Chapter 15. "The Reconciliation of Individuality and Citizenship."

of social co-operation, is therefore more necessary than it used to be; but it remains important that this should be secured without too great a diminution of individual judgment and individual initiative.[21]

The point that is left obscure in this formulation of the problem is the meaning of "a sense of citizenship, of social co-operation." One possible interpretation is that the ideal of the individual development remains unchanged, but that plain common sense requires us to take account of the conditions under which it is to be achieved. In this modern industrial world the ideal becomes a pipe-dream unless we manage to exploit all manner of human relationships as a means to this end. From this point of view the only difference between Mr. Russell's ideal person and an unscrupulous politician or industrial promoter is a difference in ends or goals. In both cases such phrases as "a sense of citizenship, of social co-operation," are merely euphemisms for the rankest kind of individualism. It is individualism that is "controlled" by calculating intelligence. If anything more is intended, then individualism is not merely "controlled," but it is transformed into something else. That is, individual development is not antithetical to citizenship but is bound up with it, and the problem of "reconciliation" becomes a product of the philosopher's perverted ingenuity.

Mr. Russell's method of reconciliation consists in holding fast to the abstract principle of individual development but to surrender it in detail as specific situations may require. When the question of the relation of the individual to the State is under consideration, he is disposed to be uncompromising. The emphasis then is all to the effect that the State must interpose no obstacles to growth or individual development. The possibility that the State should have any function or obligation to cultivate "a sense of citizenship, of social co-operation," is slurred over or ignored altogether. As far as the State is concerned, the reconciliation of individuality and citizenship is to be achieved by methods that are essentially negative. They center on the elimination of "the harm that is done to education by politics." This harm "arises chiefly from two sources; first, that the interests of some partial group are placed before the interests of

[21] *Ibid.*, 236f.

mankind; second, that there is too great a love of uniformity, both in the herd and in the bureaucrat."[22] Dominance by a special group results in wars and in the cultivating of superstitions; emphasis on uniformity is a device for the imposition of pre-determined standards.

Here Mr. Russell's individualism is in full stride. There is, indeed, a passing reference to something called "the interests of mankind," but nothing is made of the idea. More specifically we are not told whether these interests are identical with the interests of individual development or antithetical to them, which is precisely the point at issue. If they are identical, then the doctrine of individualism needs to be revised so as to have a different center; if they are antithetical, then the State surely has more positive and extensive functions than the protection of individual development. In either case, we need to find out what these "interests of mankind" are and adjust our thinking accordingly. As it is, Mr. Russell remains essentially a liberal of the traditional type in the field of political theory, i.e., he is a person who is more sensitive to restrictions on his personal activities than to the promotion of a social order which is truly an embodiment of "the interests of mankind."

In the field of education, which is one of Mr. Russell's abiding interests, the attitude is quite different. Here no hands-off policy is advocated; it does not even suffice to maintain a positive program for the purpose of developing individual capacities to the utmost. Education must, indeed, remove obstacles to growth and provide opportunity for growth, and it must also use positive means for the development of individual capacities. But in addition to all this, it must also train useful citizens. In other words, when it comes to education, the individualism of Rousseau is too rich for Mr. Russell's blood. An educational program that is adequate will provide for all these various aspects in combination.

Three divergent theories of education all have their advocates in the present day. Of these the first considers that the sole purpose of education is to provide opportunities of growth and to remove hampering influences. The second holds that the purpose of education is to give culture to the individual and to develop his capacities to the utmost. The

[22] *Ibid.*, 225.

third holds that education is to be considered rather in relation to the community than in relation to the individual, and that its business is to train useful citizens. . . . No actual education proceeds wholly and completely on any one of the three theories. All three in varying proportions are found in every system that actually exists. It is, I think, fairly clear that no one of the three is adequate by itself, and that the choice of a right system of education depends in great measure upon the adoption of a due proportion between the three theories.[23]

This view has a certain quality of reasonableness, but it obviously emphasizes our previous difficulty. In education, as contrasted with politics, training for citizenship is entirely in order. Why this should be commendable in the schools and a deadly sin elsewhere is not made clear. But what is more important, education for individual development and education for citizenship are both recommended without any attempt to show how the two are to be "reconciled." What is needed is not merely an enumeration of the tasks or obligations resting upon education, but a genuine synthesis. But instead of laying down a clear-cut principle for educational and social theory, Mr. Russell bypasses the whole issue. This is all the more regrettable since it is at just this point that educational guidance is most needed in these troubled times. In political parlance, Mr. Russell "passes the buck" to the classroom teacher, in the form of a recommendation that "due proportion" be observed. He neither surrenders the view that the good of the individual is to be determined by considering the individual "in isolation," nor does he move on to a theory of the good in terms of the synthesis which he concedes to be necessary. As a result "individuality" and "citizenship" remain antithetical in Mr. Russell's mind. "Considered *sub specie aeternitatis*, the education of the individual is to my mind a finer thing than the education of the citizen; but considered politically, in relation to the needs of the time, the education of the citizen must, I fear, take the first place."[24]

### III

The import of the foregoing discussion is that Mr. Russell's conception of the relation between the individual and the com-

[23] *Ibid.*, 28, 29.
[24] *Ibid.*, 27.

munity must be revised if an adequate theory of education is
to emerge. The point at issue is not whether there are real con-
flicts between the individual and the community, but how these
conflicts are to be interpreted. For Mr. Russell the individual
and the community tend to become antithetical because the
former is identified with certain "abstract" qualities, whereas
the latter is regarded as the embodiment of a culture or set of
traditions. Even a cursory view of tradition, however, suggests
that a different interpretation is possible. Our Occidental cul-
ture, for example, contains the element or constituent of Chris-
tianity, which, as Mr. Russell reminds us, was not and is not
always in harmony with the other elements. When discords
occur they may be viewed either as a conflict between the in-
dividual (or a minority) and the community, or they may be
taken as resulting from differences of opinion with respect to
the nature and authority of religion in the common culture. In
the latter case the conflict is a conflict between a certain concep-
tion of the meaning of the culture as held by an individual or a
minority and a different conception as held by the rest of the
group. If this is a tenable view, then the problem of social and
educational theory takes on an entirely different character. It
becomes a problem of providing a suitable basis for restoring the
unity of the common life that has been lost. The cleavage then
is not a cleavage between an abstract individual and the com-
munity but a cleavage within the culture or the tradition itself.

It is a commonplace that tradition is apt to break down in the
presence of new circumstances. If my memory of history serves
me right, the ancient Jews used to hold that it was wrong to
conduct warfare on the Sabbath. This belief became known to
their enemies, who naturally exploited this knowledge by se-
lecting the Sabbath as the preferred day for launching their
attacks; and by so doing they scored easy victories. The Jews
thereupon reconsidered the whole matter and arrived at the
conclusion that the Lord could not have intended the regula-
tions regarding the Sabbath to apply to the business of fighting.
Although history, as far as I know, is silent on this point, it is
not unlikely that this conclusion met with some opposition, on
the part of those whom we now designate as conscientious ob-

jectors. Superficially such objectors might appear to be rank individualists; the philosophically-minded among them might argue, as Mr. Russell does, that religion is an affair of the individual, that it has to do with the development of potentialities inherent in the individual psyche, and that the compatibility of self-development with the demands of the community is at best a dubious matter. A more plausible explanation is that these objectors found themselves out of luck because they were defending an interpretation of tradition which no longer commanded the assent of the majority.

It is true that the majority is more often on the side of conservatism than of reform; but this does not change the nature of the issue. In this country, for example, the principle of free contract became an established tradition. With industrialization and the rise of large corporations, however, this tradition did not work so well, and much agitation ensued for the recognition of labor unions. In this case, tradition was too firmly entrenched to be easily dislodged. Labor leaders were charged with being "subversive," with being destructive of our liberties, in short, with being enemies of our "American way of life." The appeal was to tradition. What is of special importance in the present connection, however, is that the innovators likewise took their stand on tradition, viz., the tradition of equality of opportunity. This particular instance will bear generalization. Every new movement or proposal has its roots in the past; it, too, is in a position to invoke tradition in some way or other. The trouble with the hundred per cent patriots is in their estimate of percentages. What Mr. Russell conceives to be a conflict between the individual psyche and the community turns out to be a conflict within tradition itself; it symbolizes the growing pains of a tradition that cannot stand still.

The conflicts are conflicts of values within the tradition, which raises the question of procedure in dealing with them. One procedure obviously is to give preferred status to certain values and declare that the values thus selected must be protected at all costs. This is the procedure on which Mr. Russell and his dearest enemies—the State and the Church—seem to be agreed; the trouble is that they do not agree on the values that are to be

thus protected. The State identifies the central value with loyalty to the group, and therefore sees to it that nationalism and patriotism in the conventional sense are taught in the schools. The Church insists that the belief in a supernatural origin and basis for mundane things is a *sine qua non*, and organizes education accordingly. Mr. Russell, after surveying the situation, selects those values which are revealed to him *sub specie aeternitatis*. Those values are essential which man would have if man were God; even though Mr. Russell objects to having this taken seriously in the schools.

The net result of all this is that education everywhere in democratic countries is in a state of confusion. The reason presumably is that democracy cannot be harmonized with the idea that any values are to be given preferred status and declared sacrosanct. Recognizing a value as a value is not the same as providing it with a halo and rendering it immune to criticism and revision. Loyalty to the State is essential, but the Axis countries have shown us what happens when this is made an absolute. Religion in the sense of devotion to a way of life is likewise essential, but when this is translated into dogma and creed, we get mediaevalism all over again, not to mention any other examples. Respect for the individual and for personal liberty is deeply embedded in our tradition of democracy, but when this is based on metaphysical speculations regarding the development of our human potentialities in a transcendental world, we are reduced to a choice between a silly veneration for childhood and a hand-to-mouth form of opportunism, which is not made respectable by being called "due proportion."

The simple fact of the matter is that our tradition or culture is cracking under the strain which is being put upon it. In some way or other our present-day education recognizes all these values, but it has no clear-cut principle for dealing with the conflicts among these values, which must inevitably occur. Education widens horizons, but it does not lessen the confusion. Mr. Russell's emphasis on individual development does not furnish the needed principle, but merely keeps us from facing the problem. The one-sidedness and excesses of the progressive movement in education are evidence that the evils of authori-

tarianism and regimentation are not corrected by the simple device of stressing individual development.

If we start with the proposition that the alleged conflicts between the "individual psyche" and the community are in fact conflicts within the tradition or culture which constitutes the unifying element of the community, a second procedure or mode of approach opens up. Previous to these conflicts all is harmony, not because the individual finds himself undisturbed in the exercise of his god-like faculties "in isolation," but because participation in the common purposes of the community is the medium through which he achieves moral and spiritual stature. This may be less god-like, but it appears to be more in accord with the facts. In a static environment, such as the heaven of popular imagination, the identification of the individual with his community is both complete and permanent, so that the problem of protecting the psyche against encroachment does not arise. What we have instead is the problem of making heaven sufficiently attractive to induce people to want to go there. At any rate, life on this earth has to be lived in an environment, both physical and social, which does not stay put. No form of social organization can be adequate for all time; which is just another way of saying that conflicts are bound to appear. Something must then be done by way of changing the tradition or culture so as to make it fit the new conditions. No culture can escape entirely from the necessity of reinterpreting itself. The favorite way, historically speaking, of readjusting a culture is to decide in advance which values are to be regarded as eternal and immutable. This is generally done by having recourse to a fourth-dimensional reality, such as the will of God or a cosmically guaranteed racial superiority, or a psyche viewed *sub specie aeternitatis,* or what not. The alternative procedure is to try to restore the identification of the individual or of minority groups with an inclusive common purpose by enlarging or reconstructing this common purpose. The task for each individual is then, in Mr. Russell's language, "to bring harmony out of the conflicting wills that exist in his community." If we rule out all metaphysical adventures, the only way to do this, it would seem, is to redirect or reconstruct these various wills so

that they will coalesce in a common program. This is a process of constantly revising the common life in the light of changing conditions, on the basis of no other principle than to overcome conflicts by constantly widening the area of common interests among men.

This is not the proper occasion for elaborating this point of view. What is important to note is, first, that we are not compelled to choose between the position of Mr. Russell and those of his chief adversaries, the State and the Church. This is fortunate, since in terms of guidance for the teacher Mr. Russell's theory of education is the most confused and unsatisfying of the three; which is perhaps the reason why his favorite method of defending it is to make onslaughts on the others. Secondly, the alternative procedure offers both a distinctive method for dealing with conflicts and a distinctive criterion for progress as well as for the distinction between right and wrong. In so doing it makes the task of education considerably more definite. This task may perhaps be indicated by saying that education must provide the conditions for the discovery and release of capacity and it must likewise promote insight into the problem which is created by the need of constantly reinterpreting our cultural heritage. This problem is, of course, the problem of determining whether conflicts are to be adjusted by constantly extending the area of common concerns or in some other way. In other words, education will have its center in the problem of the meaning of democracy. The schools are the agency upon which democracy must chiefly rely for the constant re-examination of its own meaning, if it is to have a rational hope of survival.

## IV

The fact that the individuals composing a group are moulded by their common culture is presumably beyond dispute. Moralists and others have long emphasized the astonishing differences in customs and mores in different communities. Like all other living things every culture grows and changes. But while the culture moulds individuals, it is in turn moulded by them. Discrepancies or inadequacies in the culture constitute a challenge

to philosophers to show how the culture is to be reinterpreted or reconstructed.

This problem, as Mr. Russell indicates, is in some sense the problem of the relation between the individual and the community. Everything depends on how the individual is conceived, i.e., whether the individual is identified with a "psyche" which is set over against the community in wholesale fashion or with some element or constituent in an inclusive experiential situation. This issue is involved in the contention that the conflicts which Mr. Russell reads off in terms of individual psyche *versus* community are in fact splits or cleavages within the culture.

The latter point of view has far-reaching implications of a philosophical kind. The individual psyche which figures in Mr. Russell's scheme of things becomes an abstraction, since the individual achieves status as a human being only by becoming a "function" of the larger life of the community. To use a term that once was popular in philosophical circles, the relation of the individual to his environment is "organic." This term has much the same meaning as the "field" concept in physics, if we are careful to bear in mind that it never occurs to the physicist to provide a transcendental or extra-experiential basis for the unity of the field. Such distinctions as individual and environment, subjective and objective, truth and error, arise as distinctions within the field; they are not as distinctions based on a blanket contrast between the individual psyche and the world at large. They arise in connection with focal points within the field which have become disturbed and consequently require attention. It is the specific difficulty which sets the conditions both for the content of these various distinctions and for the reinterpretation or reconstruction that is required.

If we start by lifting the individual out of the context which alone gives meaning to individuality and place him in a relation of antithesis to the community, as is done by Mr. Russell, the resulting problems become insoluble. The knowledge relation becomes ubiquitous and has to be explained as a form of "correspondence" or "transcendence;" a relationship which has to be provided with an underpinning by recourse to a fourth-dimen-

sional reality, "where all cows are black." With respect to matters of conduct, the solution for the cultural conflict that is to be healed must then be drawn arbitrarily either from the side of the "community" or from the side of the "individual psyche;" which is to say that the solution becomes a rationalization of the prejudices or preferences of the philosopher who happens to be on the job. These references take the form of appeals to the ordinances of God, or natural law, or inalienable rights, or the quality of the bloodstream, or perhaps to an intrinsic quality inherent in a particular culture, which can be fully experienced and appreciated only by those who have had the good fortune to be reared in it. In some form or other, these divergent philosophies all trace back to something called the nature of reality, viewed *sub specie aeternitatis*. Philosophy too makes strange bed fellows; to borrow the comment of a political observer, they share the same bunk.

Despite all the blood that has been shed over the problem of truth, some reference to this problem seems unavoidable in the present connection. The problem of education in general and of democratic education in particular is concerned basically with the relation between the individual and the community; and this problem in turn links up with the question of truth. The basic issue here is whether truth and knowledge are matters which arise within the experiential field or are "antecedent" to it. The chief purpose of this reference to the pragmatic position, however, is not to argue the point, but to register a complaint. Whether the position is tenable or not, it is entitled to a hearing on its merits. It is obviously no refutation of pragmatism to show that it departs from the traditional concept of truth. But, instead of examining the pragmatic concept and comparing it with tradition, the critics have found it much simpler to charge that pragmatism identifies truth with some attendant feature, such as "satisfaction" or "success" or "practicality." In the early days of the movement this was understandable, and to some extent perhaps excusable. It is proverbially difficult in philosophical discussions to reach common understandings. Preconceived ideas and habits of thinking are too strongly entrenched. Foreigners were disposed to regard pragmatism as basically a

philosophical justification of our go-getting tendencies. When William James used the expression "cash value" in discussing truth there was audible comment from across the Atlantic: "Ah, those Americans! They are always thinking of money."

The sensible thing to do, perhaps, is to dismiss grotesque misinterpretations with a smile. When they are constantly repeated, however, they cease to be amusing and take on the quality of pernicious propaganda. Moreover, a man of Mr. Russell's stature may reasonably be expected to distinguish between literary form and total depravity. Perhaps Mr. Russell has not stumbled in public over the meaning of "cash value," but he has done so in situations that were quite similar. Let us grant for the sake of the argument that James's literary talents sometimes interfered with the requirements of strict academic statement. Other writers, notably Mr. Dewey, have not come short on this point. With painstaking elaboration and monumental patience Mr. Dewey has explained again and again how problems arise in the context of specific situations, and how the operations of knowing are conditioned both by the controlling purpose and by the "facts in the case." That is, the issue concerns the nature of knowledge and truth. Instead of addressing himself seriously to the problem posed by the pragmatic theory, however, Mr. Russell has recourse to cheap caricature. Truth becomes what it is "convenient to believe;"[25] truth is what pays;[26] truth is determined by "success."[27] To put it differently, the antithesis between the individual psyche and the community, which is the noxious skeleton in Mr. Russell's philosophical closet, bars the way to understanding. This antithesis compels him to make hash of the pragmatic point of view. It does not permit him to deal with this point of view in terms of its own basic approach.

With respect to the educational bearings of Mr. Russell's philosophy, it seems fair to say that this antithesis dominates the scene. Criticism of this antithesis should not be permitted to obscure the significance or the extent of Mr. Russell's influence

[25] *Education and the Modern World*, 23.
[26] *Sceptical Essays*, 64.
[27] *The Philosophy of John Dewey* (Vol. I of this *Library*), 152 *et seq.*

in the field of education. He has argued forcefully for the recognition of the rights of the individual at a time when such recognition is sadly needed. He has contributed much insight and stimulation for the benefit of teachers engaged in education on the level of the earlier years of childhood. All this may be gratefully conceded without removing the misgiving that Mr. Russell's educational philosophy is becoming increasingly remote from the requirements of associated living in our modern society. It is no accident that the concept of "liberalism" is in need of salvaging. The modern "liberal" is all too often as blind and inept with respect to the problems of democracy in an interdependent world as the most hide-bound traditionalist. The concept of the relation between the individual and the community calls for radical revision, in the interests of education and in the interests of the entire future of our civilization.

BOYD H. BODE

COLLEGE OF EDUCATION
OHIO STATE UNIVERSITY

**21**

*Sidney Hook*

BERTRAND RUSSELL'S PHILOSOPHY
OF HISTORY

# BERTRAND RUSSELL'S PHILOSOPHY OF HISTORY

ALTHOUGH not the most important of Bertrand Russell's intellectual interests, the philosophy of history is one of his oldest. In the very first of his published works, *German Social Democracy* (1896), it is markedly in evidence in the form of a criticism of orthodox Marxism. It is developed in fugitive writings of a popular character over a period of forty years until the publication of *Freedom versus Organization* (1934), a brilliantly written and much neglected book, which contains the most extensive discussion of the subject from his pen.

Compared to the great concern with history manifested during the nineteenth century, contemporary philosophers, particularly Anglo-American philosophers, have been singularly indifferent to theories of history and historical causation. Problems of logic, biology, psychology, and scientific theory have occupied the foreground of their attention. Only in recent years, under the shattering impact of the rise of Fascism, has there been an awakening of interest in large views on history. In this respect Bertrand Russell is among the few conspicuous and laudable exceptions among contemporary philosophers. He did not wait until the fateful character of mistaken theories of history became palpable, to develop a reflective philosophy of history.

Nonetheless, except when he is criticizing philosophies of history he believes to be mistaken, Russell offers relatively little analysis of *doctrines* concerning history. Straightforward exposition of his own leading ideas on history is scanty and ambiguous. His philosophy of history, therefore, must be construed from his specific studies of the social, political, and intellectual

history of Europe and America,—studies, which not infre-
quently fail to confirm his announced views. The reason for the
unsystematic character of his ideas on history is in part traceable
to the fact that his historical writing has been ancillary to politi-
cal interests. In virtue of social and family tradition, and of a
temperament quick to resent injustice and oppression, Russell
has been passionately concerned with politics. In affairs of state
he is to the manner born. His political experience, rather than
familiarity with the theories and problems of history as dis-
cussed by previous philosophers, has been the chief stimulus
leading him to historical reflection. Although this has its advan-
tages in terms of timeliness and in enhancement of the quality
of Russell's style,[1] it also gives an impression of occasional char-
acter, as if his writings on history had cost him less in intellec-
tual effort than his other works. This intellectual half-hearted-
ness about the problem of history is reinforced by certain
philosophical attitudes which I shall touch on below.

## I

Like most widely used expressions in philosophy, 'the phi-
losophy of history' is ambiguous. I shall understand it to mean
a theory of the main causal factors which have influenced his-
torical events, the rise and decline of institutions, traditions,
ideologies and similar cultural phenomena. In this sense
Bertrand Russell has a definite philosophy of history. He has
not concerned himself with what are often called epistemologi-
cal questions of history, such as the nature of historical method
and of historical knowledge. He has assumed that the problem
of the validity of knowledge is the same for all fields, and that
history differs from, say, biology or geology in the same way
as they differ from physics, i.e., in subject matter, *not* in re-
quiring a special kind of logic or generic method of inquiry. If
he is familiar with the work of Rickert, Windelband or Max
Weber, and with the problems they discussed, his writings show
no sign of it. Nor is Russell concerned with what is often called
the 'metaphysics of history,' the nature of the historical individ-

[1] Bertrand Russell's style is worth an essay by itself. In respect to clarity, wit
and incisive force, he is indisputably one of the great masters of English prose.

ual, historical time and the significance of historical experience. In spirit and procedure, but not in conclusions, he is closely akin to scientific philosophers of history who have attempted to discover the laws of historical behavior. He differs from most of them, however, in believing that the results of historical study are very meagre, and that one of the few things we can learn from history is that there are no valid historical laws.

If one approaches Bertrand Russell's ideas on history not as events in his biography but in the light of his more technical philosophical ideas, it seems surprising that he should be so intensely interested in history. His general philosophy, in its Platonic phase, appears to provide no adequate place for history. From the philosopher who said that "to appreciate the unimportance of time is the gateway of philosophical wisdom,"[2] one hardly expects that degree of preoccupation with the temporal minutiae of the historical process which Russell has consistently shown. And when he abandoned Platonic realism for a kind of unfrocked Berkeleyanism, his skepticism concerning the conclusions of science—considered from the standpoint of complete logical rigor—would seem to rule out in advance anything that might be called scientific knowledge of history.

There is, of course, no strict logical connection between Russel's philosophical views and his views on history. Yet the former are psychologically responsible for certain attitudes which he brings to bear on the subject-matter of history. These betray themselves in a characteristic bias towards rationality— not merely as an ideal of what ought to be but as an expectation of what is. In consequence of his monumental work in logic and mathematics, when he considers other subject matters he unconsciously applies to them an exalted ideal or demand of validity which they cannot fulfill. In fact, any field in which non-demonstrative inference is employed is regarded as imperfect, lacking that quality of reasonableness and intelligibility which are so apparent in logic and mathematics as soon as we get beyond, or above, their foundations. This makes not only belief in the existence of an external world a sheer "prejudice" from the standpoint of strict logic but the whole of science a glorified fallacy of affirming the consequent, acceptable to us

[2] I am quoting from memory.

because of its fruitfulness. In his analysis of the methods of science, Russell is constantly amazed that although we know so little we can control so much. This indicates that his notion of what constitutes valid knowledge is derived not so much from the actual procedures and inferences of fruitful scientific inquiry as from mathematics and logic where all inferences are deductive. The skepticism which this involves as far as knowledge of the physical world is concerned—a skepticism from which Russell often shrinks—cuts even deeper in regard to knowledge of the historical world because of the greater complexity and irregularity of its events. This has a curious result. Because he is philosophically convinced that history cannot yield the connections and relations which are necessary for genuine knowledge, his historical theory tends to slight connections and relations which constitute the little knowledge we do have, knowledge of which he makes good use. Because he demands too much, he is content with too little. He frequently gives the impression that history is a field in which almost anything might happen—which is pretty much how it would appear to a geometer turned historian. This mood is reinforced by a moral evaluation of human actions in history which he shares with Gibbon, his favorite historian. It is reflected in the lines from Milton with which Russell introduces his major historical work, *Freedom versus Organization:*

> Chaos umpire sits
> And by decision more embroils the fray
> By which he reigns: next him high arbiter
> Chance governs all.

One might very well reach this depressing conclusion as a result of concrete historical studies. But, as we shall see, Russell's own historical accounts,—that is, when he writes history and does not talk about it,—fail to confirm it. It is true that, as an historian, one of Russell's shortcomings is his too great readinesss to invoke "chance" events in explaining the course of history. Yet at the same time when he follows the lead of evidence, he recognizes more determinism in history than his theory of history provides for.

It is not alone Russell's interest in pure logic which has in-

fluenced his approach to history. His concern with the methods of physics has also left its mark. If we aim at exactitude in the solution of physical problems, the number of variables that can be handled is small. In history, however, the number of variables that enter into an historical problem is usually very much larger, and conclusions cannot be stated with anything like the degree of precision possible in the physical sciences. In his historical writing Russell has a tendency to reduce unduly the number of variables in an historical situation, to treat them one at a time, and to neglect their reciprocal relationships. For example, he treats the foreign policy of nations in the period from 1814 to 1914 as if it was completely in the hands of individuals who might have done with it as they pleased; while the domestic policy of nations is in the main explained by the growth of industrialism. Almost all other historians, and Russell himself in places, present the domestic and foreign policy of modern nations as integrally related to each other, and as following in the main from the same set of causes.

Despite the freshness, color and penetrating insights with which Russell's historical writings abound, they suffer from a certain thinness. He is at his best in handling intellectual history, particularly in criticizing ideas, but his social and cultural history lacks full-bodied richness when compared with the work of the best professional historians. He is certainly aware of the complex interrelationships between the phases of the historical process, but the history which emerges from his pages seems to be made up of loosely woven strands that fall apart too easily.

## II

In his preface to *Freedom versus Organization*, Russell lists "the main causes of political change from 1814 to 1914." The term "political" is here taken in the broadest sense and includes social and cultural changes. His scattered comments on other periods in world history, both in this and earlier works, indicate that he believes the same generic causes have operated before and after the century to which he devotes major attention. These causes are (1) economic technique, (2) political theory or ideals, (3) individuals of outstanding capacity or strategic posi-

tion, and (4) chance events, of which latter the birth of important historical figures is presumably a sub-class.

Despite the fact that he believes it is possible to "trace the effects of large causes without oversimplification," he nonetheless insists that "history . . . is not yet a science, and can only be made to seem scientific by falsifications and omissions." (p. viii.) There are some surprising things about these remarks, aside from the difficulty of understanding what it is to write unscientific history which correctly traces effects without oversimplification. The most surprising is the assumption that because history is not yet a science, it cannot be scientific.

That history is not yet a developed science is obvious. One may even be skeptical of the likelihood that it will ever approach the science of physics in systematic character and scope, quantitative exactness, and power of prediction. Nonetheless it is just as obvious that some historical accounts are better warranted by the nature of the available evidence than are others. And since this evidence is evaluated by the same pattern of inquiry which holds for all fields of tested knowledge, it is a gratuitous purism to deny that history can have scientific character. If physics is taken as a model, invidious comparisons can be drawn between it and large parts of biology, not to mention almost the whole of psychology. I do not wish to exaggerate the reliability of historical knowledge or claim for it anything approaching the status of a full-fledged science. In part the question of what knowledge we shall regard as scientific, is a conventional matter; in part,—especially when we are challenged as to whether we really do have reliable historical knowledge or truth,—it is not. And insofar as it is not a conventional matter, we cannot ignore the significance of the fragmentary nature of much historical work, the absence of agreement on fundamental principles among historians, and conflicting interpretations of special periods. But this makes it all the more important to vindicate the fact, against excessive relativizations of history, that investigations in the field of history *can* be conducted on the same objective plane as in other disciplines, particularly since such investigation may extend the areas of agreement on historical issues. Where nothing can be proved, everything may be be-

lieved. This is, indeed, very convenient for present-day totali-
tarian revisions of history which substitute systematic myths for
the record of the past. But although history is written by the
survivors, some survivors have lied about it.

Taking history in the large sense to include social phenomena
as well, it is possible to point to many important predictions (or
reconstructions of the past), which historians have made on the
basis of certain hypotheses about social and individual behavior,
predictions which have been amply confirmed. Bertrand Russell
himself is one such historian. In his remarkable and courageous
book, *Bolshevism: Practice and Theory*,[3] which revealed a keen
eye for historically significant data, he made many predictions
about the course of the Russian Revolution that have turned out
to be substantially accurate. These predictions about the future
were not apocalyptic like those Tolstoy made a few years before
the first World War, or emotional hunches like Burckhardt's
about the rise of "terrible simplificateurs" in the twentieth cen-
tury. They were based upon social and psychological principles
which Russell believed to have general validity. And what is
true for some of Russell's historical writing is also true for some
of the writings of other historians whom he relies on.

"Falsifications," of course, are death to any theory of history
which pretends to be scientific, but "omissions" are another mat-
ter. Once the historian defines his problem clearly, then, unless
he is ruled by the monistic dogma of universal interrelation, he
will have to omit or ignore many features of his subject matter,
*just as every other scientific inquirer does.* He cannot explain
everything about it. The only question here is whether his
"omissions" are relevant to the problem he is seeking to clarify,
or whether they qualify the scope and generality of the con-
clusions he reaches. If "omissions" *necessarily* were a sign that
we had fallen short of the truth,—an Hegelian dictum—what
passes for scientific knowledge in any field would possess little
validity.

The possibility of a scientific study of any subject matter de-

[3] New York, 1920. Remarkable, because it was written so close to the events
it described, and courageous, because it involved a break with previous cherished
views, his own and those of his intimate political circle.

pends upon our ability to discover some general laws which furnish us with a means of relating certain classes of phenomena with each other. When he takes distance to the subject matter of history, Russell seems to be skeptical about the existence of historical laws. But in his actual historical writing he invokes them constantly, sometimes with fruitful results. I cite a few representative passages in which Russell recognizes the operation of laws in history.

Discussing the Manchester school of economic theory, he writes:

> The principle of free competition, as advocated by the Manchester school, was one which failed to take account of *certain laws of social dynamics*. In the first place, competition *tends* to issue in somebody's victory, with the result that it ceases and is replaced by monopoly. Of this the classic example is afforded by the career of Rockefeller. In the second place, there is a *tendency* for the competition between individuals to be replaced by competition between groups, since a number of individuals can increase their chances of victory by combinations. Of this principle there are two important examples, trade unionism and economic nationalism. Cobden, as we have seen, objected to trade unions, and yet *they were an inevitable result* of competition between employers and employed as to the share of the total product which each should secure. Cobden objected also to economic nationalism, yet this arose among capitalists from motives very similar to those which produced trade unionism among employees. Both in America and Germany, it was obvious to industrialists that they could increase their wealth by combining to extract favors from the State; they thus competed as a national group against national groups in other countries. Although this was contrary to the principle of the Manchester school it was an *economically inevitable development*. In all these ways, Cobden failed to understand *the laws of industrial evolution*, with the result that his doctrines had a merely temporal validity. (*Freedom versus Organization*, 142-143, my italics throughout.)

Of Robert Owen, Russell says: "At last time has proved that he perceived important laws of industrial development which were entirely overlooked by the orthodox economists of his day." (*Ibid.*, 157.)

Of the settlement of the American West we read: "They [the settlers] succeeded in the conquest of the earth; they suc-

ceeded in preserving political freedom; but economic freedom was lost by a process which we can now see to have been inevitable." (*Ibid.*, 254.)

Not only economic laws are invoked by Russell but psychological ones as well. He is not always clear about whether, and how, they are related. Sometimes he treats them as irreducible, as if the same psychological laws operate in all socio-economic systems; sometimes as if economic laws could be derived from psychological ones; and sometimes as if our knowledge of economic laws was sufficient to predict variations in psychological behavior. On the whole he is inclined to regard them as irreducible. Food, shelter, clothing and sex are the basic needs of man; after them, four passions—"acquisitiveness, vanity, rivalry and love of power"—are regarded as "prime movers of almost all that happens in politics."[4] Of these only acquisitiveness can be regarded as an economic force; although Russell often argues that the quest for wealth is only one form of the quest for power.

He makes effective use of these psychological drives in his criticism of the Bolshevik attack upon democracy:

It is possible, having acquired power, to use it for one's own ends, instead of for the people. This is what I believe to be likely to happen in Russia: the establishment of a bureaucratic aristocracy, concentrating authority in its own hands, and creating a regime just as oppressive and cruel as that of capitalism. Marxians never sufficiently recognize that love of power is quite as strong a motive, and quite as great a source of injustice, as love of money; yet this must be obvious to any unbiased student of politics. It is also obvious that the method of violent revolution leading to a minority dictatorship is one peculiarly calculated to create habits of despotism which would survive the crisis by which they were generated. Communist politicians are likely to become just like the politicians of other parties: a few will be honest, but the great majority will merely cultivate the art of telling a plausible tale with a view to tricking the people into intrusting them with power. (*Bolshevism: Practice and Theory*, 140.)

The failure of the Bolshevik theory and practice to take account of psychological factors, according to Russell, explains the betrayal of the professed ideals of the October Revolution:

[4] *Bolshevism: Practice and Theory*, 133.

Over the whole development of Russia and of Bolshevism since the October revolution there broods a tragic fatality. In spite of outward success the inner failure has proceeded by inevitable stages—stages which could, by sufficient acumen, have been foreseen from the first. . . . The ultimate source of the whole train of evils lies in the Bolshevik outlook on life: in its dogmatism of hatred and in its belief that human nature can be completely transformed by force. (*Ibid.*, 180.)

I am not here discussing the validity of these economic and psychological laws. There is much more to be said for the first than for the second. These citations are introduced to show that Russell relies upon them to explain certain aspects of historical events, despite his theoretical discomfort about doing so.

I turn now to a more detailed examination of the causes to which Russell attributes chief historical significance.

## III

*Economics.* Labels for ideas are usually deceptive. But were it not for Russell's disavowals, a good case might be made out for calling him, as far as some aspects of his historical theory are concerned, a critical Marxist. He makes short shrift of *orthodox* Marxism, particularly its metaphysics of dialectical materialism, but admits a larger measure of truth in Marx's historical theories than have some avowed Marxists. Critical Marxists have always rejected historical monism or the belief that all major historical events and cultural changes can be reduced to economic equations of the first degree. In addition to the mode of economic production, they have recognized the influence of tradition, habit, intelligence, and outstanding individuals. When he wrote history, Marx himself was not an orthodox Marxist.

In discussing economic causation in history, Russell tells us: "In the main I agree with Marx, that economic causes are at the bottom of most of the great movements in history, not only political movements, but also those in such departments as religion, art and morals." (*Freedom versus Organization*, 198.)

Despite the qualifications he immediately adds, this makes him out to be much more of an economic determinist than his pronouncements in other places would lead us to expect. And in the body of the book from which this sentence is taken an ex-

traordinary and ingenious use is made of economic factors in explaining events. Practically the entire history of America is presented in economic terms. The issues of slavery and the presence of an open agricultural frontier are portrayed as the central factors in nineteenth century American life. The depression of 1929 is attributed, without much evidence, to the absence of cheap labor and cheap land. The tendency toward "organization" in the entire world is presented as an inescapable consequence of an inescapable economic development. In earlier works, the decline of religious belief among the working classes and its revival among the wealthy, the emancipation of women, changes in sex morality, are attributed in the main to economic factors.

Two questions, however, must be addressed to Russell in conjunction with his theory of economic causation. The first is: precisely what does he mean by an "economic cause?" The second is: what criteria does he employ to determine that it is the most "important" or the most "basic" of all the other causal factors at work?

(1) I have been able to find no clear indication of what Russell means by the term "economic" insofar as it designates an historical cause. Sometimes it means "economic technique," that is, changes in tools and processes which have a revolutionary effect upon production; sometimes it means a desire for wealth, more particularly money; sometimes the presence or absence of land and raw materials; and sometimes what Marxists call social relations of production which are not material things nor psychological motives but a set of institutional rules—e.g., capitalism or feudalism—that govern the production and distribution of wealth.

These distinctions are important because they affect the validity of Russell's acceptance, as well as of his criticism, of the theory of historical materialism. This theory is very widely entertained, not only by historians, but by many others whose dogmatism is inversely proportional to their familiarity with the facts that presumably confirm it. I shall state it in such a way as to bring out the differences between the four senses of the term "economic" in the hope that Russell will define more

closely his own conception as well as its relation to Marx.[5]

According to the theory of historical materialism, by the "economic" factor is meant "the mode of economic production" of which property relations are the legal expression. *Left to itself,* the mode of economic production develops in conformity with certain dynamic laws, comparable to the development of an organism from a seed. It is in terms of the organization and development of the mode of production that major changes in culture are to be explained, including changes in economic techniques and the norms of motivation. Thus Marxists deny that it is economic techniques which produce effects like monopoly and unemployment, but rather the use of such techniques in an economy devoted to the quest for private profit. Man is naturally an inventive animal but whether his inventiveness takes a theological form or a technological form is determined, in the main, by the system of production under which he lives and the struggles, values, and allegiances that result from it. Marxists hold that the industrial techniques and processes which become part of the mode of production are the result of its *selective* needs. In this respect it is like an organism which does not eat everything but usually only what it can use. Discoveries that are "accidentally" made, as well as those that result from pure theory, are used or not used, i.e., have social consequences, only when they fit into the pattern of profitability. Inventions that might lighten human labor in one society are not employed in another. The pace of technological inquiry increases or slackens (not so long ago, industrialists and engineers were demanding a moratorium on inventions!) with the business cycle. "Machinery," wrote Marx in criticizing Proudhon, "is no more an economic category than is the ox which draws the plow. It is only a productive force."

What is true of productive forces is true of productive conditions (raw materials and natural resources). The presence in the ground of coal, gold and oil had no social consequences for the

---

[5] Unfortunately Marx's own writings, literally taken, are not free from ambiguity. Marx was primarily a social revolutionist who wrote to stir people to action as well as to convince them. But his intent, looking aside from verbal inconsistencies, is sufficiently clear. For obvious reasons one cannot make the same allowance for a thinker as methodologically sophisticated as Russell.

primitive societies of the American Indians or for European feudalism. Their absence has important social consequences for any capitalist country.

The same is true for economic motives. The enormous variety of human motives is recognized by Marx, but he holds that the specific form and intensity of their expression is socially determined. Not only was Marx critical of the egoistic Hedonism of Bentham and Stirner, but he was also scornful of the conception of "the economic man" as a perennial human type. The Greeks did not know "the economic man;" Marx hoped that the type would disappear from the Europe of to-morrow. Marx held that human beings are pugnacious *and* pacific, cruel *and* kind, selfish *and* unselfish. But the *prevalence* at any time of one set of motives over another, as expressed in socially approved behavior, is explained by the character, organization and development of productive relations. Thus, the motives of action that prevail in a feudal society will be different from those that operate in a capitalist society, even though the biological impulses are constant. And in a feudal society, the motives of peasant behavior will differ from those of the feudal lords. In a capitalist society, saving and thrift will be considered virtues in one phase of its development; they will be condemned as forms of hoarding in another.

But like every system that is only relatively isolated from other systems and events, the mode of economic production is never left to itself. That is why it cannot be considered the sole cause of any specific cultural phenomenon. Other factors come into play.

This raises the second question: how in fact do we determine that the mode of economic production, or whatever it is we take as "the economic factor," is the most important or basic in history?

(2) In the preface to *Freedom versus Organization*, Russell writes: "While, therefore, economic technique must be regarded as the most important cause of change in the nineteenth century, it cannot be regarded as the sole cause; in particular, it does not account for the division of mankind into nations." (p. vii.) Nor, one is tempted to add, for the division of mankind into black, yellow, and white; male and female; intelligent and dull; in-

habitants of plain, valley, and mountain; all of which have historical effects. How does Bertrand Russell know that economic technique *is* "the most important cause?" This problem has been neglected by most historians, Marxists or not, and one hopes that Russell will treat it further. It seems to me that we are dealing here with a very complicated notion which involves, in part, the concept of "weight of evidence" in particular cases, and a statistical generalization for a class of cases.

## IV

*Ideas and Ideals.* The second of the main causes of political and social change, according to Russell, is ideas, particularly political ideas like democracy and nationalism. This raises the question of his approach to intellectual history. So far as I know he has never systematically discussed the problems connected with the history of ideas, although he may do so in his forthcoming *A History of Philosophy.* His views, however, may be briefly set forth—without too much distortion I hope—on the basis of his discussion of the rôle of specific ideas.

In relation to social conditions, particularly economic needs and interests, a certain scale of autonomy may be set up for ideas. In mathematics, logic, science, and scientific philosophy, the autonomy of ideas is greatest. Here problems arise not by pressures from without but through the natural development of subject matter, and are solved by individuals of unusual calibre. At times Russell suggests that the determination is the other way around, that economic technique, for example, is the product of the march of ideas through the minds of men of genius, and that our modern world is actually the unintended consequence of the free play of ideas.

Ideas in art, religion, metaphysical and moral philosophy, economic theory and political theory—approximately in that order—exhibit a diminishing autonomy in relation to social conditions. The social milieu must be considered even to understand ideas in these fields properly, for their meaning is rarely clear from their syntax. But since man is a *thinking* animal, the ideas he develops are not simply reflections of his condition; they are ways of stabilizing or changing his condition. Insofar

as the social scene permits degrees of freedom in its development, ideas may exercise a relatively independent force in affairs. Since man is a social animal with a *past*, some of his ideas reflect not contemporary conditions but his cultural heritage, and may influence his behavior in meeting or failing to meet present-day problems. ". . . *new* doctrines that have any success must bear some relation to the economic circumstances of their age, but ᴐld doctrines [Christianity] can persist for many centuries without any such relation of any vital kind." (*Freedom versus Organization*, 198.)

To this we may add another generalization implicit in his discussion of ideas. Intellectual movements of the second class of ideas are *effects* of social and political events in countries where they originate, e.g., Locke in England; Marx in Western Europe: but they become *causes* in other countries, e.g., Locke in France; Marx in Russia.

If this does not misrepresent Russell's general position in the history of ideas, several observations are in order. His distinction between types of ideas that are almost completely autonomous in relation to social development and those that are mainly dependent on such development seems to me valid. The currently fashionable view that the history of science is integrally a part of the history of society in the sense that the social conditions of an age determine the scientific ideas which flourish at the time, is more false than true. But it does not follow, as Russell is inclined to believe, that therefore the history of science is the history of its great men in the sense that without the particular scientists who lived when they did, our science and our world would have been substantially different. There is another kind of determination which he overlooks. I shall return to this theme below.

Illuminating, too, is the deftness with which he relates abstractions of the second class of ideas to the concrete interests of the groups which are in possession of power and those which are hungry for it. He would go a very long way with the sociologists of knowledge in respect to these ideas (but not for ideas of the first class), qualifying his agreement by a denial that we are dealing with matters of knowledge. That there is a

time-lag in ideas may also be granted; but when such ideas have influential effects it is questionable whether they are the same ideas as those that were held in the past under the same names. Certainly present-day Christianity, which Russell cites in evidence, is not the Christianity of the Church Fathers nor of the Middle Ages. What explains these changes? And if political and social ideas are effects in countries where they originate, and causes when exported to other countries, how does Russell account for the fact that they are exported to some countries and not to others? Why was Locke the rage in France in the eighteenth century and not in Spain or Poland? In explaining the *acceptance* of ideas that actually influence the present, the distinction between new and old, or native and foreign, ideas is immaterial. The ripeness is all. Social groups are never at a loss for doctrines to sanctify their needs. If new doctrines are not at hand, the old ones will be given a new content. If new doctrines are at hand, and the conditions in which they are introduced differ from those in which they originated, the new doctrines, too, will be altered to fit. Lenin's Marxism is a case in point.

In listing "ideas" as one of the chief causes of political and social change, Russell asserts that, for all their dependence on economic conditions, there are always some important residual elements which cannot be so derived. Insofar as ideas are developed by individuals, this is true. As far as their social acceptance is concerned, the question is more difficult. His historical writing, however, fails to establish his position. The growth of the democratic idea is almost entirely explained in terms of the rise of capitalism and spread of industrialism. The complex of ideas associated with "organization"—whose threat to freedom he regards as the most pressing and pervasive danger of our time—is wholly explained as a result of large scale monopoly capitalism. And although he regards nationalism as the most influential of the ideas that are not social or economic in origin, despite their social and economic effects, he offers no plausible explanation for its rise and diffusion.

Let us look at his treatment of nationalism more closely. Nationalism, in the form we know it, is a comparatively modern ideal. It is something over and above love of country which is

much older than modern nationalism. Geography, language, descent, tradition may enter into it but, according to Russell, the sentiment of aggressive solidarity is its only essential ingredient. How was this sentiment produced? He offers different explanations for different countries. English nationalism arose at the time of the Tudors, Henry VIII and Elizabeth. "It was made holy by Protestantism, glorious by the defeat of the Armada, and profitable by overseas trade and the loot of the Spanish galleons." (*Op. cit.*, 349.) French nationalism arose as a result of the defense and consolidation of the French Revolution. German nationalism is the work of Napoleon, Fichte, and mainly Bismarck; Italian nationalism of Mazzini, Garibaldi and Cavour. Insofar as a common causal element is introduced by Russell it is psychological. But he would be the first to admit that, even if love of home and family have "an instinctive basis," there is no such thing as a nationalistic instinct; that it was almost completely absent during the middle ages, and extremely weak in Italy and Germany up to the nineteenth century. On occasions, nationalism is depicted as an expression of man's unregenerate stupidity. But the question remains: why does human stupidity manifest itself in this form only with the emergence of capitalism and invariably with a quest for more land, more markets and more people to exploit?

It is undoubtedly true that an aggressive nationalistic country will provoke nationalist sentiments in countries it seeks to victimize. To this extent at least psychological causes will account for some types of nationalism. Perhaps the analysis demands a more precise classification of varieties of nationalism before causal inquiries are undertaken. But the type of nationalism which has been the bane of the modern world is inextricably tied to the expansion of capitalism.

Implicit in Russell's treatment of intellectual history is another distinction which I believe to be of great methodological significance. This is a distinction between the *generation* of ideas and their *acceptance*. Ideas always arise in somebody's head; their subsequent career depends upon causes and conditions that may have nothing to do with the factors that determine their individual expression. It is extremely risky to explain in terms of

social and economic conditions, as so many of our social historians do, why a particular individual develops the ideas he does. A man may hit upon an idea as a result of all sorts of experiences—a dream, a book, an experiment, a frustrated passion, a desire to relieve distress or to become rich and powerful. Individual psychological analysis is tremendously complex and so far richer in fables than in reliable facts. The most common error in writing intellectual history is to carry over explanations that hold for the *acceptance* of ideas to the thorny problems of their *generation*. The acceptance or spread of ideas depends largely, but not exclusively, upon institutions of state, school, church and commerce, in which social interests are unequally represented. It is these social interests which forge ideas into weapons, and, independently of their validity in other frames of reference, employ them to bolster or undermine the existing distribution of power, status, prestige and income in society.

With this distinction in mind it is necessary to qualify one of Russell's dicta about the bearing of metaphysical ideas on historical action. "The belief that metaphysics has any bearing upon practical affairs," he writes, "is, to my mind, a proof of logical incapacity." (*Op. cit.*, 196) As evidence he cites the fact that scientists who accept the same body of propositions in physics may be of the most different metaphysical and religious persuasions. This testifies to very little, for, after all, the behavior of scientists in a laboratory is not what is commonly meant by practical affairs in history. What Russell means by his dictum is not what it appears to say but rather 'belief that metaphysics has any *logical* bearing upon practical affairs is proof of logical incapacity'. One can understand this better in the light of a recent observation, that the triumph of logic consists in grasping the truth that almost any two propositions can be shown to be compatible with each other; that good logic is far less fertile than bad logic; and that when it is very good, it is impotent.[6] But since the history of metaphysics, according to Russell, is largely the history of bad logic, a bearing of metaphysical ideas

[6] Bertrand Russell on "Bertrand Russell," Rand School of Social Science, Lecture, May 19, 1943.

on practical affairs—leaving aside for the moment which bears on which—is precisely what we should expect.

It is granted that no metaphysical statement logically entails any belief about practical affairs. Even the metaphysical belief in the existence of an immortal soul, together with the theological doctrine of baptism as a sacrament, does not logically compel acceptance of the belief that the life of the mother *must* be sacrificed to that of the child in the event that only one of them can be saved at childbirth. Metaphysics and theology can easily be reconciled with any practical course the Church chooses to pursue, as its history eloquently proves. But there are at least two other kinds of bearing that metaphysical ideas have on practical affairs—personal or psychological, and social or historical. A man may change his mode of life because of a belief in reincarnation just as he may change his food habits if he becomes convinced that animals have souls. We would be hard put to it sometimes to say whether the belief influenced conduct or whether the conduct sought justification in belief. But that there is some connection between them, no matter which way the causal arrows point, is indisputable.

Far more important in the history of ideas are myths. Metaphysical doctrines are a species of myths, and on Russell's own showing few things have had more bearing on practical affairs. In this case, it is easier to establish the causal dependence of dominant metaphysical ideas upon dominant social interests than in the cases of causation of individual ideas. But although they have had bearing on history, it is doubtful whether they have initiated large historical movements. To assign to them the rank of primary causes goes beyond the evidence.

Nonetheless ideas do count for something in history. Although any adequate theory of history must recognize that history is largely determined by things other than ideas, the knowledge of such determination is often a contributing factor in bringing about certain events or retarding them. As I read Russell, he is inclined to believe that the most influential ideas in history are those for which no scientific evidence can be given. He holds that outside of technical science, rarely, if ever, have

ideas which constitute genuine knowledge, significantly affected events. And he often writes as if the belief that some day the future in this respect will be different from the past is not knowledge but a consoling hope.

An interesting question but one outside the scope of this paper is whether Russell's conception of mind can plausibly account for his theory that ideas have practical, albeit limited, effects in history. A belief in the effectiveness of ideas would seem to require a more consistently behavioral conception of mind than the one to which he subscribes.

## V

*Great Men.* One of the merits of Russell's philosophy of history is its freedom from the dogmas of nineteenth century social determinism which systematically underplayed the significance of outstanding individuals in history. Russell has always been alive to the rôle of personalities in events. *Freedom versus Organization* is full of delightful vignettes of historic characters written with charm and subtlety, spiced with a little malice. Although he has no sympathy with Carlylean extravagance, Russell's conclusions about the historical importance of great men are very bold. They are elevated to the rank of main causes of European and world history. This is not a little startling when considered in the light of what we have called his critical Marxism. Recall his statement of agreement with Marx. Contrast it with the following passage:

I do not believe that, if Bismarck had died in infancy, the history of Europe during the past seventy years would have been at all closely similar to what it has been. And what is true in an eminent degree of Bismarck is true, in a somewhat lesser degree, of many of the prominent men of the nineteenth century. (*Freedom versus Organization*, vii.)

Or compare it with an even extremer claim made in an earlier work:

It is customary amongst a certain school of sociologists to minimize the importance of intelligence, and to attribute all great events to large impersonal causes. I believe this to be an entire delusion. I believe that if a hundred of the men of the seventeenth century had been killed in

infancy, the modern world would not exist. And of these hundred, Galileo is the chief. (*The Scientic Outlook*, 34.)

Here certainly is a challenge. I shall try to show that even allowing for the element of literary exaggeration in these passages and in others throughout his works, Russell wildly overstates the rôle of great men in history. That they exist, that at some points they help redetermine the path of social development, is granted; but in nothing like the frequency and degree he assigns to them.

(1) In order for a great man decisively to affect the course of history, the existence of major *historical* alternatives or possibilities must be recognized. I italicize *historical* alternatives, not logical alternatives, for the latter, of course, are always present but not always historically relevant. The shift from one to the other makes history even more mysterious and difficult to understand than it is.

On Russell's own account, however, there was no major historical alternative to the main path of economic development which a great man might have realized. Given the dynamic laws of capitalism, he tells us, the character of our present world economy, and the phases in its transformation from free competition to national monopoly, could have been, and was, predicted. Bismarck at no point played a decisive rôle in its development, for it took place in countries *other* than Germany, it began *before* him in Germany, and continued *after* him everywhere else. Bismarck himself, insofar as he had any preferences in the way of social systems, was strongly inclined towards a Christian feudal order.

It is a safe generalization to say that as far as economic development is concerned, there are no heroes who redetermine the main course of affairs. It is significant that when Russell speaks of Rockefeller and Bismarck as "two men who have been supreme in creating the modern world," he remarks of Rockefeller: "Technique, *working through him*, produced a social revolution; but it cannot be said that he intended the social consequences of his actions." (*Freedom versus Organization*, 313, my italics.)

It would not be in the least mystical to assert that if Rocke-

feller had not lived, technique would have worked through others. As a matter of fact, it did. It worked through his rivals. He improved upon them, and later others improved upon him. Many things obviously would have been different if Rockefeller had not lived, from Ludlow to the great educational projects of our day, but they would not have been enough to determine a social system.

Yet, if the course of economic development in the nineteenth century left no major alternatives, political history in the broad sense did. Here because of the larger number of historical possibilities present, all of them compatible with what Russell once called "the movement of history in the present age,"[7] objective conditions for the work of outstanding men are at hand. The evidence, if any, for the distinctive significance of Bismarck must be found in the direction he gave to political affairs. Although it is very difficult, I believe it is possible, in principle, to distinguish between those political events which could be inferred from the growth and needs of German economy, and those political events for which the personality of Bismarck is primarily responsible. These questions cannot be answered wholesale but only by an empirical analysis that proceeds from case to case. The cases that involve Bismarck, which Russell cites in support of his thesis, seem to me to be unfortunate because both the unification of Germany and the First World War were primarily consequences of economic causes rather than of Bismarck's statesmanship.

If there was any one event that made it overwhelmingly likely that the World War would take place, it was Germany's decision, *which marked a break with Bismarck's policy*, to build a navy in competition with that of England. The construction of the German navy was not an accident, or the result of the Kaiser's love of the sea, but a step in building up her overseas trade necessitated by her domestic economy. In other words, the pressures

---

[7] "If Bolshevism remains the only vigorous and effective competitor of capitalism, I believe that no form of Socialism will be realized. . . . This belief . . . is one of the grounds upon which I oppose Bolshevism. But to oppose it from the point of view of a supporter of capitalism would be, to my mind, utterly futile and against the movement of history in the present age." (*Bolshevism: Practice and Theory*, 16f.)

that made for the extension of German sea power were the same that carried German industry to its pitch of monopoly. With or without Bismarck, Germany would have been a strong industrial nation in the twentieth century competing with England for commercial hegemony of the Continental and overseas market. With or without Bismarck, the first World War would in all likelihood have occurred although its date might have been different. How else would the conflicts between the great powers, which Russell describes so graphically, have been resolved? One can easily think of a number of *logical* possibilities of composing their differences, but given the limiting conditions of the time, none of them was historically grounded except one, a European socialist revolution, threatened in case of war by the Socialist Basle Congress of 1912. This, however, would have meant another kind of war.

Were everybody to carry arms when travelling in an overcrowded subway system, no one would be surprised at the occurrence of tragic incidents even though they could not be shown to be logically necessary. If nations are heavily armed in a world where their vital economic interests are in conflict, we do not have to find any particular individual responsible for what occurs even though we may trace the occasion of the conflict to one nation rather than another.[8] No reputable historian has ever seriously argued that the assassination of the Austrian Archduke was the primary cause of the World War, or the bombardment of Fort Sumter of the American Civil War. Given human beings as they are, and a social system which can function only by continuously generating conflicts, we can predict what will happen, sooner or later, unless conditions are radically changed. Again the evidence turned up by Russell as a conscientious historian refutes the extreme generalizations of Russell, as a philosopher of history, on the rôle of heroes. It leads him to say in the course of his melancholy conclusions on the First World War:

In those aspects of politics that depended upon modern economic developments, the War was the first large-scale expression of forces which

[8] This is clearly recognized by Russell in his discussion of moral responsibility for the war but not so clearly in his treatment of its causes. (*Freedom versus Organization*, 446.)

had been operative for fifty years and are still growing continually
stronger. The development of nationalistic monopolies, particularly in
iron and steel . . . was, and is, a more important factor in world politics
than most men know or statesmen will admit. The same causes that
produced war in 1914 are still operative, and, unless checked by inter-
national control of investment and of raw material, they will inevitably
produce the same effect, but on a larger scale. (*Freedom versus Organ-
ization*, 451.)

Even more significant than this passage is one in which Rus-
sell himself supplies a key to the necessary distinction between
situations in which it is *historically* impossible for an individual
to change the course of history, and situations in which the pos-
sibility exists.

Every nation allowed its external affairs to be conducted by a small
number of men, and the leading men of every Great Power could, by
greater wisdom, have prevented the War from coming *when* it did.
Perhaps postponement would have given time for a change of system,
and so have prevented the War altogether; but given the system, or
rather the lack of system, a Great War sooner or later could only have
been avoided *by a greater degree of statesmanship everywhere than there
was any reason to expect*. (*Ibid.*, 446, my italics.)

To say that the war "could only have been avoided by a
greater degree of statesmanship everywhere than there was any
reason to expect" is tantamount to saying that there was every
legitimate reason to expect that the war *would* occur. Its occur-
rence was overwhelmingly probable and its non-occurrence very
improbable.

The eventful man in history becomes a causal factor only
when the objective historical probabilities in a given situation
are so evenly balanced that his action touches off a set of conse-
quences appreciably different from what would have occurred if
he had acted otherwise. This does not yet make him a hero or
event-making man, for his action might be the result, not of
special gifts, but of strategic position. Anyone in his place would
be historically important no matter what his personality.

The heroic or event-making man in history is the individual
whose personal traits for good or evil are such that only when
thrown actively into the balance, does the objective alternative,

with an initial lesser probability, actually triumph over the alternative with an initial greater probability. The greater the odds the individual faces, the greater his heroic stature, i.e., the more decisive his causal influence on affairs. But as these odds grow greater and greater, there comes a point when we are justified in saying that it is humanly impossible for anyone to overcome them or deflect the course of the events they determine. The 'great man' whose hypothetical presence would have prevented the World War, would have had to be a very special sort of 'great man'—one of a sort that has never appeared in comparable situations. It is therefore unlikely that Bismarck, Disraeli, Gladstone, or any other statesman of the nineteenth century would have succeeded any better than their inept successors in preventing the World War. They could not prevent the events which made the war historically inevitable.

As a rule I believe that individuals have a greater chance to exercise decisive influence in situations in which new institutions, movements, and systems of ideology are being born than in situations where they are dying. No man can prevent the hour glass of capitalism from running out. But whether it will be replaced by a variant of Hitlerism, or Stalinism or democratic socialism, will depend upon many things, among them perhaps the presence or absence of outstanding personalities.

(2) There remains the question of the heroes of scientific thought and their rôle in history. According to Russell, in some of his moods, scientific ideas are the prime movers in historical and social change. These ideas are the unique discoveries or inventions of a comparative handful of men of genius but for whom we would still be living in a pre-Renaissance world.

As I have already indicated I am sympathetic with Russell's opposition to extreme forms of social determinism in explaining the history of science. The influence of industry and war in suggesting problems and setting the direction of scientific inquiry is obvious, particularly today. But they account at best for the scientist's field of interest, not for the measure of his achievement. Even the scientist's field of interest, in the uncoördinated economy of yesterday, was not always socially determined. Neither *Principia Mathematica*, nor the theory of relativity, nor

quantum physics grew out of military or economic needs. Nor is
the fact that the history of science is largely a history of parallel
inventions and duplicate, independently evolved theories, evi-
dence of social determinism although it does weaken Russell's
position.

Even if we reject social determinism, it seems to me that
there is another alternative to Russell's view. From this alterna-
tive it does *not* follow that if the heroes of science, as we know
them, had not lived, our scientific knowledge and the world
which depends upon it would today be very different. It allows
for the influence of both social conditions and exceptional capaci-
ties, but subordinates them to the influence of the process of sci-
entific inquiry itself, and to the nature and organization of the
scientific community upon the results won. It accounts for the
implicit assumption of many historians of science that in the
absence of a Galileo, a Newton, or a Clerk-Maxwell, their dis-
coveries would, sooner or later, have been made by others.

The general reasons which justify this expectation are, in part,
the following:

(i) The international character of scientific knowledge.
Duhem somewhere remarks that it is by its deficiencies, and only
by its deficiencies, that we can recognize science as the science
of this nation or that. I believe this holds true if we substitute
class or race for nation.

(ii) The continuity of scientific tradition and the similarity
of scientific education. These enable the scientist to unfetter him-
self from parochial prejudices. The reading of common books,
the study of common subjects and related activities gradually
build up a common mind set.

(iii) The use of common instruments.

(iv) The co-operative character of scientific research, the re-
sults of which are as a rule shared except when they conflict with
the interests of business and national defense. Scientists may
scorn other scientists but never their findings.

(v) The convergence of inquiry on certain central problems
at any time. Often there are social reasons for this convergence
but often it is the result of 'open problems', the challenge pro-

voked by previous inquiry, of simplifying assumptions, eliminating inconsistencies, generalizing from 'special cases'.

(vi) The common acceptance of a public method and test to which all scientific claims must conform. Perhaps this is the most important reason of all, for it insures a common theory of meaning and a common criterion of truth. And, finally:

(vii) A normal distribution of talent among those professionally interested in science. There is no reason to assume that fewer men of extraordinary ability follow scientific careers than other pursuits.

If these characterizations of the way in which the scientific community functions are valid, there is a reasonable *presumption* that no single scientist is indispensable for the results that ensue from his activity. Indeed, this is a far safer generalization in the history of science than in the history of politics. Nonetheless the degrees of presumption vary; the question must be decided piecemeal in the light of the specific evidence in each case. When this is done, we get a sliding table of likelihood for different discoveries. There are some discoveries, like the telescope or of the elements that fill the gaps in Mendeleef's chart, which in all likelihood would have been made by others even if their original discoverers had not lived. There are others like the calculus and the law of gravitation in which the likelihood is not so great as in the preceding illustration but great enough to warrant confidence that they would have been discovered in the absence of Leibniz and Newton. There are others in which the likelihood tapers off until we reach cases like Cantor's theory of transfinite numbers or Einstein's theory of relativity in which it is anybody's guess as to whether they would have been developed if their authors had died in infancy.

No one has explicitly stated the criteria for evaluating evidence in these situations. But in practice we recognize the validity of different judgments for different types of scientific discovery. Here again one wishes that Russell had explored matters further. It seems clear that few, if any, scientific ideas could reasonably have been expected to appear at *any* time; and it is also clear that social needs and pressures are not sufficient

to explain some of the greatest discoveries in the history of science. As an alternative to both of these inadequate views, I suggest the following which seems to me to be less inadequate. Where society tolerates the free development of scientific inquiry, it is the organization and method of scientific inquiry itself, the needs of production, war and health, and the spontaneous variation of ideas by men of genius—in order of decreasing weight—which accounts for the history of scientific discovery.

## VI

*Chance.* If great men are not the automatic result of social forces, then their *existence*, as distinct from their *selection*, must be considered as relatively chance events, i.e., relative to social and economic history. This brings us to the last of the main causes of history enumerated by Russell. Although his specific historical account calls attention to the play of chance events, nowhere does he offer an extended analysis of the category of which he makes such fascinating, and sometimes arbitrary, use. His most explicit statement of what he means by chance events is "trivial occurrences which happened to have great effects." (*Op. cit.*, vii.) The terms "trivial" and "great" in this connection are rather unsatisfactory and the phenomena which Russell has in mind can be better described without using them.

A spark is, in one sense, a "trivial occurrence" in comparison with the "great" devastation it causes when it ignites a powder magazine. But it is doubtful that Russell would call the explosion a chance event, irrespective of whether the explosion was planned or whether it was an accident. A star hurtling into the solar system would hardly be called a "trivial occurrence;" yet I believe Russell would be prepared to call it a chance event, irrespective of the gravity of its consequences. When a small force, $a$, of any kind, tips the balance in a situation where two large forces, $b$ and $c$, are in equilibrium, I believe that we are usually prepared to say, not that the cause is $a$, but $a$ plus $b$, or $a$ plus $c$, irrespective of whether $a$ is called a chance event or not. If $a$ is in the same system as $b$ and $c$, it is not a chance event; if it is outside the system, it is.

This suggests what Russell means a little more accurately

than he has expressed it. "Chance" events are events whose causes lie outside the system in which they have effects, independently of whether the causes and effects are "trivial" or "great." Since we can never know that any system is *absolutely* isolated from other systems and events, every prediction concerning the future behavior of a system is conditional upon its freedom from interference. All of the examples Russell gives of chance events, even when he is factually mistaken in so characterizing them, conform to this second notion of chance.

To show this I shall discuss two of his illustrations. In the first he asserts, it could plausibly be maintained

that if Henry VIII had not fallen in love with Anne Boleyn, the United States would not now exist. For it was owing to this event that England broke with the Papacy, and therefore did not acknowledge the Pope's gift of the Americas to Spain and Portugal. If England had remained Catholic, it is probable that what is now the United States would have been part of Spanish America. (*Op. cit.*, 198-199.)

Henry VIII's fancy for Ann Boleyn is an historical chance event because it could not be inferred from the constellation of the social and economic forces of the age. It might have been inferred from the biological and psychological system of traits which constituted Henry's personality. The existence of this second, or personal system, could not be inferred from the social system; but its effects upon the latter were momentous. In fact, however, this illustration is not only fantastic, as Russell recognizes, but false. The break with the Pope would probably have come anyhow, for what Henry and the class that supported him wanted, was church land and property, and the complete domination of the religious establishments that were necessary to sanction the expropriation. Differences on all other issues, as the history of the Church shows, could have been composed. And even if England had remained Catholic, she would no more have recognized the Pope's grant to Spain and Portugal than did Catholic France. The political influence of papal policy during this period was not impressive except when it became the instrument of one or another set of national interests.

The second illustration of chance events is drawn from the class of what Russell calls "medical causes," e.g., the Black

Death. Here, certainly, we are dealing with matters that are anything but "trivial." Yet the plague is an historically chance event because its causes could not be inferred from any amount of social and economic data, although its effects were socially significant.

This interpretation of chance events entails certain views which accord closely with other beliefs in Russell's philosophy of history. It entails a denial that there is any one all-inclusive system of events in terms of which every other system can be explained—an assumption made by all varieties of historical monism. It involves a conception of history narrower in scope than 'the study of everything that happens'. Nor does it breach the postulate of determinism. Chance events are not uncaused events but events relative to some determining strand or strands which they twist or snarl in ways that cannot be foretold by a consideration of the laws alone that describe earlier patterns of the strands.

It follows that the more classes of events the historian considers as part of his province, the fewer chance happenings he will recognize, provided he is able to predict the time of the intersection of the different strands.

## VII

*Moral Reflections on History.* An exposition of Bertrand Russell's philosophy of history would be incomplete without reference to its moral spirit, that is, to the character of the moral evaluations he passes upon events.

Russell is never the mere historian. He is always the reflective moralist. Underneath his intellectual detachment, he is vibrant with a passion for justice, generous and imaginative toward those whom history has broken, and fiercely indignant with cruelty, especially when it is compounded with hypocrisy. He is sensitive, as few historians are, to the lost possibilities and chances of history, to what might very well have been different. Although he does not distinguish carefully enough between abstract logical possibilities and grounded historical ones, he has a fresh eye for the likely "Ifs" of history. Even when he recognizes historic necessity, he never excuses the crimes which

have been justified in its name, whether it is the industrial revolution, the Bolshevik revolution, or the Fascist counter-revolution. From the very outset he has had no patience with fatalistic beliefs in *the* wave of the future,[9] all the more so when he notes the historical consequences of such faith. He saves his most pointed barbs for fanatics, particularly when they fancy they are doing the work of the Lord, whereas he is indulgent to rascals with a talent for compromise. Self-interest does not appear as a vice to him; it is decried only when it doesn't go far enough. His quarrel with utilitarianism is not that its doctrines are ignoble but that they are false. The world would be a better place if only Bentham were right! Recognizing that stupidity is an historical force, he nonetheless believes that intelligence may some day become one. His life-long espousal of a democratic, socialist world order reveals with what tenacity he has clung to this faith.

It is a faith that is more tenacious than robust. As the history of man unrolls from his pen one detects a note of despair at its colossal blunders and inhumanities. There creep back into his writings the lament and resignation of the "Free Man's Worship," that classic expression of a Platonic spirit alien to nature and history. It is particularly in evidence at those moments in his life when he has been tempted to give up history and politics as a bad job, saddened by a spectacle in which the strong and ruthless seem always able to exploit the weak and kind. But the mood passes with the realization that withdrawal from active participation in affairs strengthens whatever forces of oppression prevail at the time. Limited as are the possibilities, the effect of organized, intelligent action often makes the difference between tolerable and intolerable evil. As a consequence, in recent years the attitude of the "Free Man's Worship" has been replaced, not by cynicism, as some critics maintain, but by a desire "to get on with the problems in hand."[10] Hope need not gird itself with a false optimism. And if intelligence fails, let it not be for lack of trying.

[9] Cf. his comments on the fatalism of orthodox Social Democracy, just before the rise of the revisionist movement. *Essays in German Social Democracy*, 6-7.

[10] Bertrand Russell at the Conference on Methods in Science and Philosophy, New School for Social Research, Nov. 29, 1942.

This assumes not only a belief that, within limits, men *can* reconstruct society and make their own history intelligently, but a belief in the validity of the moral ideals which are to guide the process. These ideas may be rooted in wishes but it is not their character as wishes which makes them reasonable. Now Russell certainly writes with the conviction that his moral judgments are more reasonable than those of present day totalitarians, secular and clerical. But so far as I can see he has no theory of value according to which he can legitimately maintain that his moral judgments *are* more reasonable. Without such a theory he runs the risk of appearing as a person of weak nerves for whom the world is too much or as a professed atheist with religious dogmas.

In one of his discussions of religion, he writes: "By a religion I mean a set of beliefs held as dogmas, dominating the conduct of life, going beyond or contrary to evidence, and inculcated by methods which are emotional or authoritarian, not intellectual." (*Bolshevism: Practice and Theory*, 177.)

Presumably beliefs reached by intellectual methods would not be "beyond or contrary to evidence," and therefore would not have the character of religious dogmas. What we should like to know from Russell is whether his moral beliefs are "beyond or contrary to evidence." This is really a rhetorical question because *in practice* Russell is always prepared to present evidence for his moral beliefs. He has never recommended his moral beliefs as more reasonable than others merely because it is Bertrand Russell who holds them. But on his *theory* of value, which removes all moral judgments from the scope of scientific method, all that he can say about his moral beliefs is that they are his own. In terms of his definition they are every whit as much religious dogmas as the beliefs he condemns.

When Russell abandoned his Platonic theory of value for extreme subjectivism, he overlooked an alternative theory not the least of whose merits is that it makes it possible to show that most of his own moral judgments *are* reasonable. According to this alternative theory, ethical values are plans or hypotheses of action in relation to specific *problems* of evaluation. In principle, therefore, it is possible to establish by scientific

methods or intelligence, that one course of conduct is objectively more valid than another. The theory is not question-begging nor does it involve an infinite regress if we take our problems of evaluation one at a time—which is the only way we can intelligently take them. This is not the place to develop the theory or argue in its behalf. But I believe that one of the reasons Russell overlooks it is to be found in his 'mentalistic' theory of mind. His "wishes," in which he roots moral judgments, are pure mental events, not behavioral responses of socially conditioned organisms to the conflicts they face.

Whether or not this alternative theory is defensible, I believe it is plain that Russell's own theory of value does not square with his practical ethical judgments, particularly in history and politics. His theory leads either to complete skepticism of all values or to animal faith (religious faith as he defines it), in allegedly "ultimate" values. His practice, i.e., his judgments of evaluation, shows neither.

As distinct from Hume, with whom he has so much in common, Russell is not complacent before a theory which makes the inescapable practical judgments of science and human affairs unintelligible. This is one of the reasons why he has shifted his theoretical positions so often. I trust it is not presumptuous to suggest that there are other alternatives to his views in moral and historical theory which he has not yet adequately considered.

## VIII

I summarize briefly, in the form of questions, the chief points which require clarification, it seems to me, in Bertrand Russell's philosophy of history. (1) What conditions of validity would historical knowledge have to satisfy in order to be adjudged scientific? (2) What exactly does he understand by "economic" causes in history? (3) What does he mean by the statement that they are "the chief," or "most important," causes in history; and how could such a statement be established? (4) What is the source of ideas, like nationalism, which are influential in history, but which he believes are independent of the "most important" cause? (5) What does he mean by a chance event, and by an historical chance event? (6) Under what conditions, if

any, would he be prepared to say that had a particular hero of history or science *not* lived, events would have turned out substantially the *same?* (7) Why does he believe that his moral judgments on historical events are more reasonable, or less arbitrary, than those of the totalitarians whom he criticizes; and how does he relate his answer to his theory of moral values?

SIDNEY HOOK

DEPARTMENT OF PHILOSOPHY
NEW YORK UNIVERSITY
WASHINGTON SQUARE COLLEGE

*Bertrand Russell*

REPLY TO CRITICISMS

# Reply to Criticisms.

In the following pages I propose to pass over in silence most of the many agreeable & complimentary passages in the preceding essays, & to ignore, with few exceptions, expressions of agreement with my opinions. Where disagreement is expressed, I sometimes find myself on the side of the critic against my former self; in such cases, I shall merely indicate how my change of opinion has come about. There remain, however, a substantial number of issues as to which I am prepared to offer arguments on my side. Taking the material in the order in which Mr. Schilpp has arranged it, I shall pass gradually from the abstract towards the concrete. This will take us first to logic, then to scientific method, then to theory of knowledge & psychology, & thence to metaphysics. Passing over to matters involving judgments of value, we come first to ethics & religion, then to political & social philosophy, & finally to the philosophy of history.

FACSIMILE OF PAGE ONE OF BERTRAND RUSSELL'S
"REPLY TO CRITICISMS"

# REPLY TO CRITICISMS

I N the following pages I propose to pass over in silence
most of the many agreeable and complimentary passages
in the preceding essays, and to ignore, with few exceptions, ex-
pressions of agreement with my opinions. Where disagreement
is expressed, I sometimes find myself on the side of the critic
against my former self; in such cases, I shall merely indicate
how my change of opinion has come about. There remain, how-
ever, a substantial number of issues as to which I am prepared
to offer arguments on my side. Taking the material in the order
in which Mr. Schilpp has arranged it, I shall pass gradually
from the abstract towards the concrete. This will take us first
to logic, then to scientific method, then to theory of knowledge
and psychology, and thence to metaphysics. Passing over to
matters involving judgments of value, we come first to ethics
and religion, then to political and social philosophy, and finally
to the philosophy of history.

Mr. Reichenbach's account of my logic is such as to be almost
wholly pleasurable to me, and it would not call for much in
the way of reply, but for the fact that it raises certain questions
of great importance. The first of these is the law of excluded
middle and the relation of truth to verifiability. Mr. Reichen-
bach and I are agreed that, if the definition of "truth" in any
way involves "verifiability," the law of excluded middle is at
best a convention, and for some purposes an inconvenient one.
But he holds that the law should be abandoned, while I, though
with misgivings, have argued in a contrary sense. This is one
of a number of questions as to which I am prevented from
accepting a certain view by difficulties in carrying it out, but
am prepared to alter my opinion if technical skill supplies an
answer to my difficulties. Mr. Reichenbach's paper contains
allusions to quantum theory and three-valued logic which

arouse my passionate curiosity, but for the moment it must remain unsatisfied. I agree, of course, that a three-valued logic is possible; that is not the question at issue. It is not easy to state the question in a form in which it is not verbal or conventional, but that is what I must attempt to do.

Take, first, the following question. Let us assume that you have assigned proper names to everything that you are capable of naming; let the objects named be $a, b, c, \ldots z$. Suppose every one of these is found by you to possess a certain property P; does this justify you in asserting: "Everything has the property P?" Every logician would reply in the negative. The things that can be named may be taken to be the things that form part of your experience, including memory; therefore, in rejecting the above inference you are holding that there may be things which you have not experienced. "Of course," you will reply, "there are all the things I shall experience in the future." But if you have any confidence in future experience, you pass beyond what can be inferred from past experiences.

This principle of assigning names may be used to define various possible philosophies. Let our list of names consist of all those that I can assign throughout the course of my life. If, then, from the fact that "$P(a)$," "$P(b)$," $\ldots$ "$P(z)$" are all true, I do not allow myself to infer that "$P(x)$" is true for all values of $x$, that is a denial of solipsism. If my list of names consists of all those that sentient beings can assign, the denial of the inference is an assertion that there are, or may be, things that are not experienced at all.

My argument for the law of excluded middle and against the definition of "truth" in terms of "verifiability" is not that it is impossible to construct a system on this basis, but rather that it is possible to construct a system on the opposite basis, and that this wider system, which embraces unverifiable truths, is necessary for the interpretation of beliefs which none of us, if we are sincere, are prepared to abandon. In the *Inquiry* I instanced our belief in the spatio-temporal continuity of causal processes, with the consequent physical system of light-waves, sound-waves, etc. I criticize those who use the concept of "verifi-

ability" on the ground that they use it loosely, in a manner involving wish-fulfilment: they want to believe in science, but not in anything unverifiable, and they shut their eyes to the inconsistency of these two wishes. If they are in fact inconsistent, as I believe them to be, the question as to which to gratify is one of temperament, but the proof of inconsistency is one for the logician. If my arguments in favour of the inconsistency can be refuted, I shall be glad; in the meantime, I do not find that my arguments have yet been met.

This brings me to the question of induction, as to which Mr. Reichenbach asked me to say something. I have, however, nothing to say that he has not already said. It is clear that induction is needed to establish almost all our empirical beliefs, and that it is not deducible from any or all of the principles of deductive logic. Mr. Reichenbach says we must "overcome Hume's tacit presupposition that what is claimed as knowledge must be proven as true," and says that knowledge must be conceived "as a system of posits used as tools for predicting the future." I do not understand this. Of course not all our knowledge can be "proven;" nobody demands a proof of the principles of *deductive* logic. But I do not see what difference is made by regarding knowledge as a "tool;" if it is to be a good "tool for predicting the future," the future must be such as it predicts. If not, it is no better than astrology. I do not see any way out of a dogmatic assertion that we know the inductive principle, or some equivalent; the only alternative is to throw over almost everything that is regarded as knowledge by science and common sense.

At this point, as at many others, I am brought up against a distinction, not always clear-cut, between argumentation as a game and philosophy as a serious attempt to decide what to think. Hume, as a professional, affected to doubt many things which, in fact, he did not doubt; I have done the same thing myself. What is objective in such scepticism is the discovery that from A it is impossible to deduce B, although, hitherto, it has been thought possible, and although it has been held that this was the only good ground for believing B. But if, in fact, a man is going to go on believing B just as firmly as before,

his scepticism is insincere. As a general rule, the effect of logical analysis is to show the mutual independence of propositions which had been thought to be logically connected. Hegel, who deduced from pure logic the whole nature of the world, including the non-existence of the asteroids, was only enabled to do so by his logical incompetence. As logic improves, less and less can be proved. The result, if we regard logical analysis as a game, is an insincere scepticism. But if we are unwilling to profess disbeliefs that we are in fact incapable of entertaining, the result of logical analysis is to increase the number of independent premisses that we accept in our analysis of knowledge. Among such premisses I should put some principle by means of which induction can be justified. What exactly this principle should be is a difficult question, which I hope to deal with at some not distant date, if circumstances permit.

Mr. Morris Weitz's essay on "Analysis and the Unity of Russell's Philosophy" is a remarkably thorough study, such as one expects to see made of Plato or Aristotle or Kant, but hardly of oneself. In the main, his interpretations seem to me completely just, even in some cases where I was myself unconscious of my underlying beliefs and methods. I will note, however, a few misunderstandings.

First: as to relations having no instances. It is a mistake to think that I abandoned this view in "Knowledge by Acquaintance and Knowledge by Description;" I have held it continuously since 1902. Nor is there any difference in this respect between relations and qualities. When I say "A is human" and "B is human," there is absolute identity as regards "human."[1] One may say that A and B are instances of humanity, and, in like manner, if A differs from B and C differs from D, one may say that the two pairs (A, B) and (C, D) are instances of difference. But there are not two humanities or two differences. This doctrine represents an essential disagreement with the Hegelians, and is necessary to the legitimacy of analysis.

---

[1] This illustration is not wholly accurate, since "human" is a complex concept. The argument is only strictly applicable to concepts that are not defined, and therefore count as simple.

Mr. Weitz speaks of "events in the form of 'electrons' and 'protons'." Electrons and protons are not events, according to my theory; they are series of groups of events.

Like most other people, Mr. Weitz has failed to understand the tentative theory, set forth in the *Inquiry*, according to which a given shade of colour is a particular, not a universal. He says, for instance, that this theory "denies implicitly the relation of predication." This is a mistake. If C is a certain shade of colour, the statement "C is a colour" is a subject-predicate proposition. My theory has been misunderstood because readers have persisted in regarding a given shade of colour as a universal. We are accustomed to the idea that a particular may persist through a finite continuous portion of space-time; what I maintain is that it may occupy a *dis*continuous portion of space-time. The chief difficulty of the theory is as regards the construction of space-time, but the difficulty is met as follows: Taking visual space as the most important kind, position in visual space is absolute, and is determined by two coördinates expressing up-and-down, right-and-left with respect to the centre of the field of vision. Each of these coördinates is a quality, or definable in terms of qualities. Thus if I see simultaneously two red dots, one having the positional qualities $\theta$, $\phi$, the other $\theta'$, $\phi'$, if I call red "R," I am seeing two complexes (R, $\theta$, $\phi$) and (R, $\theta'$, $\phi'$). It is essential to the theory to realize that $\theta$ and $\phi$, which are the raw material in our construction of space, are qualities, just as much as redness is, and with the same capacity for repetition.

Mr. Weitz objects that coördinates are not experienceable separate qualities. In saying this, he must be thinking of coördinates in the constructed space of physics. In the raw material, namely perceptual space, coördinates *are* qualities. If a fly tickles me, I know, without looking, whereabouts I am being tickled, because, in tactual space, a touch on one part of the body causes a sensation differing in quality from a touch on another part.

The theory that he is examining does not reject the dualism of universals and particulars; all that it does is to place qualities among particulars. If C is a shade of colour, C is a particular;

but "visual," "auditory," etc., are predicates. The affinities of the theory are not with Plato, but with those who aim at getting rid of "substance." All the well-known difficulties of substance remain so long as we retain a "this" which is not a bundle of qualities, as appears at once when we try to explain how we distinguish between "this" and "that" otherwise than by difference of qualities.

The theory is justified as an application of Occam's razor. It renders superfluous all proper names except those for qualities, but can express whatever could be expressed by the larger vocabulary. Its only important consequence is that such propositions as "if A precedes B and B precedes C, then A precedes C" become empirical generalizations instead of being synthetic *a priori* truths.

With everything else in Mr. Weitz's essay I am in agreement.

[*Editor's Note:* For Mr. Russell's "Note" on Mr. Gödel's essay, please turn to the last paragraph of this "Reply" (on p. 741).]

I come now to Mr. Feibleman's paper, which undertakes to defend the first edition of *The Principles of Mathematics* against my present views. My self of forty years is grateful for the doughty blows he strikes in defence of the poor ghost, but my self of the present day is compelled to undertake the parrying of these blows. As the question of universals comes up repeatedly in this volume, it may be well first to state my present view, and only then to examine Mr. Feibleman's arguments.

To begin with, I deprecate slogans. I will not describe myself as either a nominalist or a realist; in regard to any suggested universal, I will examine its claims, and shall expect sometimes to admit them, sometimes to reject them. The question of *prima facie* admission is technical, but when the technical question has been decided it is necessary to consider what is the metaphysical import, if any, of the technical decision. The technique involved is one wholly subsequent to 1903, and is the chief reason for the difference between my present views and those of that time.

The technical question is that of minimum vocabularies. A minimum vocabulary for a given system of propositions is a set of terms having the two properties, (a) that no one of them can be defined in terms of the others, (b) that by means of all the terms, but not of any sub-class of them, all the propositions of the given system can be expressed. In general, perhaps always, there will be many minimum vocabularies for any given system of propositions. For instance, in the logic of truth-functions we may start with "not-$p$ or not-$q$" or with "not-$p$ and not-$q$." The same sort of choice is possible with regard to the axioms of a deductive system; for instance, in Euclidean geometry the axiom of parallels may be replaced by the axiom: "There is no maximum to the possible area of an equilateral triangle." It is possible, however, to introduce a distinction, not always precise, between different vocabularies or systems of axioms: some may be "simpler" than others. Euclid might have substituted the theorem of Pythagoras for the axiom of parallels, but his proofs would then have been much longer and more difficult. Similarly Newtonian planetary theory can be stated taking the earth as origin, but it is simpler to take the sun, and still simpler to take the centre of gravity of the solar system.

Applying these considerations to the logical analysis of language, our problem is to construct a minimum vocabulary for (say) all the propositions of physics, both those that contain general laws and those that may be described as geographical. Obviously this minimum vocabulary must contain, as a sub-class, a minimum vocabulary for logic. The theory of incomplete symbols shows that it is possible to construct a minimum vocabulary for logic which does not contain the word "class" or the word "the." I incline to think—though as to this I have some hesitation—that the contradictions prove, further, the impossibility of constructing a minimum vocabulary containing the word "class" or the word "the," unless highly complicated and artificial rules of syntax are imposed upon our language. For similar reasons, no acceptable minimum vocabulary will contain words for numbers, i.e., every acceptable minimum vocabulary will be such that numbers are defined by means of it.

The argument in favour of the admission of certain kinds of

universals is derived partly from pure logic, partly from the logical analysis of empirical material. Pure logic is difficult to develop without variable functions; that is to say, we seem to need the concept "any proposition[2] containing the word '*a*'." We seem to need this, for example, in defining identity: *a* is identical with *b* if every proposition containing "*a*" implies the proposition which results from substituting "*b*." Wittgenstein, it is true, tried to develop logic without the concept of identity, but I do not think the attempt was successful. And this is only one of the purposes for which variable functions are needed. To give a meaning to statements containing function-variables is difficult unless universals, in some sense, are admitted.

The less purely logical argument is derived from analysis of ordinary propositions, such as "A precedes B." Here "precedes" functions as a universal. We can, by somewhat elaborate devices, define all universals in terms of particulars and "similarity," or rather "similar," but "similar" remains a universal. The technical conclusion seems to be that every adequate minimum vocabulary must contain at least one universal word, but this word need only occur as an adjective or verb; its use as a substantive is unnecessary.

If it is true, as it seems to be, that the world cannot be described without the use of the word "similar" or some equivalent, that seems to imply something about the world, though I do not know exactly what. This is the sense in which I still believe in universals.

I come now to Mr. Feibleman's arguments. He says, apropos of the word "or," that alternativity is "an unchanging relationship which actual things *may* have." This I should entirely deny. The world can be completely described without the use of the word "or." If you are travelling and somebody says, "that is Mount Etna," he gives you information. You may have been thinking, "that must be Etna or Vesuvius," but you were certainly not thinking that, in addition to Etna and Vesuvius, there is a third mountain, Etna-or-Vesuvius. Only the limitations of our knowledge make the word "or" necessary; omniscience would not need it.

[2] Or at least "any proposition of some one given type."

Mr. Feibleman uses the word "relation" rather loosely. Thus he says that, for me, numbers are "invariant relations between variables." I should not say this, if only because "variables" are nothing; they are like the mountain Etna-or-Vesuvius. And what is invariant in the definition of a number is not a relation, but a form. Take, e.g., the definition of 1:

"$\phi$ is a unit property" means "there is an $a$ such that $\phi\ x$ is true when and only when $x$ is $a$."

Here there is no relation, invariant or otherwise.

The same argument applies to Mr. Feibleman's assertion that logical constants have been proved to be relations.

There is one accusation in Mr. Feibleman's essay which I most emphatically repudiate: he says that I confuse logical possibility and actual exemplification. Every undefined symbol must have an actual exemplification, or else it is meaningless. But how about "or," the reader may ask: logic needs this symbol, and yet we have just declared that it has no exemplification. Here I must make a distinction: there are states of mind which cannot be expressed without the use of the word "or" or some equivalent, but there is no corresponding constituent of the objects to which the states of mind refer.[3] The argument as regards undefined symbols is simple: the process of getting to know what they mean must be ostensive, and if they had no exemplification they could not be "ostended" (if such a word is permissible). Words or phrases that have a definition, such as "golden mountain," are in a different case. But all words that have definitions disappear when a minimum vocabulary is employed.

Some of Mr. Feibleman's remarks seem to show a lack of understanding of mathematical logic. For instance, he thinks that Burali-Forti's paradox can be disposed of by saying that there is no ordinal number 0. But there is the class whose only member is the null relation, and it does not matter two pins whether we choose to call this the ordinal number 0 or not. There is again what seems to me a sheer mistake in saying that I am committed to realism by distinguishing between a thing and the class of which it is the sole member. A class is a property; for instance, "satellite of the earth" is a property. It happens that

[3] See *Inquiry*, chap. V.

there is only one object, the moon, which has this property; the moon gives light, but "satellite of the earth" does not; the property "satellite of the earth" is a unit property, but to say that the moon is one is merely bad grammar. If Mr. Feibleman means that whoever admits that things have properties is committed to realism, he may be right, but that was the very thing he had to prove.

One more criticism, and I have done. He says that I profess to have disproved the statement "time is composed of instants." This is a mistake; I have only *interpreted* the statement. I have shown that the statement follows from a plausible assumption, but I do not think it possible to find out whether this assumption is true.

Mr. Moore's paper on my theory of descriptions raises hardly any questions as to which I have anything to controvert. I admire, as always, his patience in tracking down ambiguities and differences of possible interpretation, and I am led to deplore my own carelessness in the use of ordinary language. As to this, however, I should say that the whole of my theory of descriptions is contained in the definitions at the beginning of *14 of *Principia Mathematica*, and that the reason for using an artificial symbolic language was the inevitable vagueness and ambiguity of any language used for every-day purposes. Mr. Moore points out, quite correctly, that the theory of descriptions does not apply to such sentences as "the whale is a mammal." For this the blame lies on the English language, in which the word "the" is capable of various different meanings. On the whole, I am relieved to have come so well out of such a careful and thorough examination. It seems my worst mistake was to suppose that, if Scott was the author of *Waverley*, he must have *written* *Waverley*, whereas Homer (or whoever was the author of the *Iliad*) probably never wrote the *Iliad* down. I acknowledge this error with equanimity.

The only point that seems to me to call for some explanation is my use of the phrase "may be taken as defining." I used this phrase because the definition of sentences containing descriptive phrases, like various other definitions (e.g., that of cardinal

numbers), is psychologically different from a definition of a term that is new to the reader. If you say to a boy who has never heard the word "pentagon" before: "A pentagon is a plane figure having five sides," he is able to attach a meaning to a word which until then was meaningless. But if his father, being interested in magic, has put a pentagram over the front door, the boy may know the word "pentagram" as an object-word, and if you then give him the geometrical definition he thereby acquires new knowledge. In like manner the two definitions which embody the theory of descriptions (*14.01.02), though formally they are merely nominal definitions, in fact embody new knowledge; but for this, they would not be worth writing about. The new knowledge is as to the structure of phrases which had been familiar but had not been adequately analysed. Consequently the state of mind of a person using these definitions is different from that of a person using descriptive phrases without knowing the definitions.

Mr. Black's essay on my philosophy of language seems to me both interesting and important: it presents precise difficulties which I must answer or confess myself in error. On some points I am prepared to admit the justice of his criticisms, but not, I think, on the points that are most important. But even the criticisms that I think I can rebut seem to me such as are likely to advance our understanding of the matters with which they are concerned.

Mr. Black begins with a paradox resulting inevitably from a definition of "types" that he quotes from me. My definition was wrong, because I distinguished different types of *entities*, not of *symbols*. As to this, I accept what he says. I do not, however, acknowledge a difficulty which he raises, namely that he can think about Russell and he can think about continuity, and therefore "Russell" and "continuity" must be of the same type. I do not believe that "think" has the same sense in these two sentences. Thinking about continuity is thinking about continuous series. I shall say that the word "continuity" cannot be employed significantly except when there is some equivalent phrase using the word "continuous." But this is a long story, and would

lead on to Mr. Black's *bête noire,* the ideal language, which I shall consider shortly.

Mr. Black argues that the theory of types, if true, cannot be stated without contradiction. This is a point which formerly troubled me a good deal; the very word "type" sinned against the letter of the theory. But the trouble can be avoided by re-wording. Words, in themselves, are all of the same type; they are classes of similar series of shapes or noises. They acquire their type-status through the syntactical rules to which they are subject. When I say that "Socrates" and "mankind" are of different types, I mean neither the words as physical occurrences, nor what they mean—for I should say that "mankind" means nothing, though it can occur in significant sentences. Difference of type means difference of syntactical function. Two words of different types can occur in inverted commas in such a way that either can replace the other, but cannot replace each other when the inverted commas are absent.

I have never been satisfied that the theory of types, as I have presented it, is final. I am convinced that some sort of hierarchy is necessary, and I am not sure that a purely extensional hierarchy suffices. But I hope that, in time, some theory will be developed which will be simple and adequate, and at the same time be satisfactory from the point of view of what might be called logical common sense.

I come now to the question of logical constructions. Mr. Black connects this much more closely than I should do with my doctrine that sentences we can understand must be composed of words with whose meaning we are acquainted. My first applications of the method of logical construction were in pure mathematics: the definitions of cardinals, ordinals, and real numbers, and the construction of points in a projective space as pencils in a descriptive space.[4] All these antedated the theory of descriptions, and were dictated by dislike of postulation where it can be avoided. This motive remains, quite independently of my later introduction of acquaintance.

There are some misunderstandings in what Mr. Black says on this head. He thinks that in my ideal language there would

[4] This last was suggested by Pasch.

be only proper names. Ever since my chapter, forty years ago, on "Proper Names, Adjectives, and Verbs," I have emphasised the impossibility of a language consisting only of proper names, and I have repeated the old arguments in the last chapter of the *Inquiry*. Mr. Black must suppose me to hold that we cannot be acquainted with relations—a view which I have repeatedly repudiated with all possible emphasis.

Some of Mr. Black's misunderstandings surprise me. He mentions, as though it were a difficulty for me, that I can know propositions about Attila although I never met him. This is a matter with which I have often dealt, pointing out that "Attila" is really a description. I find no answer to my arguments on this head in Mr. Black's essay.

Another surprising mistake is that he attributes to me the view that *truths* must be known by acquaintance. This is a doctrine that I have never even remotely suggested, and that I should always have stated to be untenable if I had supposed that anybody would ascribe it to me.

Of all Mr. Black's statements, the one that has surprised me most is the assertion that the proposition "you are hot" may be certain. I am constantly being reproached for pursuing comparative certainty, and am informed that everything is so doubtful that we must not believe it unless it follows from something even more doubtful. I have exclaimed, in terror at the fury of the assault, that I do not claim *complete* certainty for anything. Now I suddenly find myself assailed from the opposite side. It seems that, although it is wicked to feel sure of the proposition "I am hot," it is equally wicked to feel any doubt about "you are hot." This puzzles me completely. Mr. Black says that if I am next to a philosopher in a Turkish bath, I can be sure of his being hot. But how am I to know that he is not a robot, wound up to say, "Your philosophy is altogether too egocentric; you forget that man is a social animal, and truth a social concept"? This is perhaps not very probable, but it is surely at least as probable as that I am mistaken in thinking I am hot, which I am constantly assured is possible.

Mr. Black objects strenuously to my suggestion of a philosophical language. I have never intended to urge seriously that

such a language should be created, except in certain fields and for certain problems. The language of mathematical logic is the logical part of such a language, and I am persuaded that it is a help towards correct thinking in logic. The language of theoretical physics is a *slightly* less abstract part of what I should regard as a philosophical language, and is, I am convinced, a great help towards a sound philosophy of the physical world. No doubt my suggestions as to how a philosophical language should be constructed embody my opinions to a considerable extent. But that does not prove that we ought, in our attempts at serious thinking, to be content with ordinary language, with its ambiguities and its abominable syntax. I remain convinced that obstinate addiction to ordinary language in our private thoughts is one of the main obstacles to progress in philosophy. Many current theories would not bear translation into *any* exact language. I suspect that this is one reason for the unpopularity of such languages.

Mr. Black says: "Whatever else Russell is prepared to regard as 'accidental' in language, he is unwilling to abandon the notion that language must 'correspond' to the 'facts', through one-one correlation of elements and identity of logical structure." This is an amazingly crude travesty. It is true that the correspondence theory is the basis from which I *begin* the building up of the concept of "truth," but I hold that even such everyday propositions as "you are hot" involve apparent variables, and I do not hold that there are any "facts" corresponding to propositions that contain apparent variables, or even to such as contain the word "or." And with regard to universals, my language is purposely cautious. I hold that such a sentence as "*a* is similar to *b*" may assert a fact, and that this fact cannot be asserted without the use of the word "similar" or some equivalent. But I do not commit myself as to the analysis of this fact, or as to why the word "similar" is necessary but the word "similarity" is not.

So far, I have not tackled the most important question raised by Mr. Black. He objects to my principle that a proposition which we can understand must be composed of constituents with which we are acquainted. I think his objections rest on misunder-

standings. (For instance, he says that, according to me, a universal word can only be uttered when an instance of it is present. I cannot imagine why he should suppose this.) The use of words which are not learnt through a verbal definition has to be acquired as a habit; that is to say, the child has to experience a series of similar circumstances accompanied by similar noises. To say that we can understand without acquaintance seems to me equivalent to saying that we can acquire a habit without ever being in situations such as would give rise to it. This might be true if language were instinctive, like the cries of animals, but as this is not the case I do not see how we are to understand words if we never have the relevant experience. I should be glad if Mr. Black would explain how he thinks this possible.

Mr. Philip Wiener's essay about my book on Leibniz is very interesting, and sets forth a theory, with which I entirely agree, as to how history of philosophy should be written. In fact, I have been engaged for several years in writing a history of philosophy (now finished) from Thales to the present day, and I have made its distinctive feature a close correlation between philosophic movements and social and political circumstances. I must confess, however, that I have found less occasion to mention such circumstances in connection with Leibniz than with most other philosophers. Some parts of his philosophy—those which he shared with Dr. Pangloss—were typical of his age, but they were not, in my judgment, the important parts. His intellect was highly abstract and logical; his greatest claim to fame is as an inventor of the infinitesimal calculus. One may read Spinoza in order to learn how to live, but not Leibniz. Locke is at least as important as the founder of philosophical liberalism as he is as the founder of the empiricist theory of knowledge. But Leibniz, though he wrote on practically everything, is (so at least I think) only worth reading when he is wholly abstract. Perhaps the same is true of myself; at least, this is Mr. Santayana's opinion.

I find only one observation in Mr. Wiener's essay which I consider definitely mistaken. He says that, since Leibniz's premisses were false, they could have proved anything. He is

relying, I presume, upon the fact that a false proposition implies every other proposition. But it does not follow that it can *prove* any other proposition. The point is this: "*p* implies *q*" is only useful in deduction if it can be known independently of any knowledge as to the truth or falsehood of *p* and *q*. If it is only known because we know *p* to be false, or because we know *q* to be true, it is a useless proposition. This, of course, is true of disjunctions generally; they serve no purpose if they are inferred from knowledge of the truth-values of the component propositions, but only when they are known independently.

Mr. Wiener remarks that Leibniz would not have turned atheist if he had read my refutation of his proofs of God's existence. Of course he would not have *avowed* himself an atheist; one cannot imagine him doing such a thing except in Soviet Russia. But some of his private reflections—particularly the one in which he defines "existence" as "membership of the largest group of compossibles"—suggest that, at times, he himself saw through his own theology. I think he had moments of insight which he felt to be inconvenient, and therefore did not encourage. He was insincere towards himself as well as towards the public. I think Cassirer's Leibniz is the insincere Leibniz, whereas Couturat's and mine is the sincere thinker. But naturally this view would not be taken by a man who thought the doctrines which I consider insincere more profound and nearer to the truth than those which I consider sincere. A similar problem arises, in some degree, as regards most philosophers, but in the case of Leibniz it is peculiarly acute.

I come now to a group of essays concerned with my views on theory of knowledge, scientific method, and psychology. The first of these to be considered is that of Einstein.

I feel it an honour that Einstein should have been willing to contribute this essay, and his praise is very delightful to me. But as to the substance of his essay I am in a difficulty: it says so many important things so briefly that I do not know whether to reply by a sentence or a volume, nor even how far I agree or disagree. When he says that fear of metaphysics is the contemporary malady I am inclined to agree; I find a frequent

unwillingness to probe questions to the bottom from a determination to believe that nothing is really difficult. I find also that many issues are decided by many people on a basis of party spirit, not of detailed examination of the problems involved. In particular, whatever presents itself as empiricism is sure of wide-spread acceptance, not on its merits, but because empiricism is the fashion. For my part, my bias is towards empiricism, but I am convinced that the truth, whatever it may be, does not lie wholly on the side of any one party.

I hope Einstein will, on some future occasion, expand some of the opinions expressed in this essay. For example: "The concepts which arise in our thought and in our linguistic expressions are all—when viewed logically—the free creations of thought which can not inductively be gained from sense-experiences." Number is given as an instance. I feel that this may be true or may be false according to the interpretation put upon it. We are certainly stimulated by our experience to the creation of the concept of number—the connection of the decimal system with our ten fingers is enough to prove this. If one could imagine intelligent beings living on the sun, where everything is gaseous, they would presumably have no concept of number, any more than of "things." They might have mathematics, but the most elementary branch would be topology. Some solar Einstein might invent arithmetic, and imagine a world to which it would be applicable, but the subject would be considered too difficult for schoolboys. Perhaps, conversely, Heraclitus would not have invented his philosophy if he had lived in a northern country where rivers are frozen in winter. The influence of temperature on metaphysics would be a pleasant subject for some new Gulliver. I think the general tendency of such reflections is to throw doubt on the view that concepts arise independently of sensible experience.

Einstein, like many others, objects to my reducing "things" to bundles of qualities. As to this, I shall have more to say later; for the present, I will only remark that it is an application of Occam's razor. Retaining "things" does not enable us to dispense with qualities, whereas bundles of qualities fulfill all the functions for which "things" are supposed to be needed. There

seems to me to be a close analogy to the substitution of classes of similar classes for special hypothetical entities called "numbers."

The questions raised by Einstein's essay are too vast to be adequately discussed in this reply; I have therefore perforce contented myself with a general indication of the sort of thing I should say if space and time (or rather space-time) permitted.

Mr. Laird's discussion of my *Analysis of Mind* is careful and thorough. He disagrees with my theories of desire and pleasure-pain as set forth in that book, and I am inclined to believe that they are inadequate, but I do not believe that an adequate theory would require the re-instatement of the Ego. This is one of two questions that I propose to discuss in Mr. Laird's essay; the other is the question: what do I mean by "stuff"?

I took the word "stuff" from William James, but perhaps it would have been better to use a word with a more technical sound, since what I meant was what I have elsewhere called "particulars." The definition of "particulars" is as follows: among sentences containing no apparent variables or logical words (which we may call "atomic" sentences) there are words of two kinds. Some can only occur in atomic sentences of one certain form, others can occur in atomic sentences of any form. (The "form" of a sentence is the class of significant sentences derived from it by changing some or all of its component words.) The latter are called "proper names," and the objects they designate are called "particulars." A particular is part of the "stuff" of a mind if its name can occur in a sentence giving a datum for psychology. In the above I assume a syntactically correct language. At various points what has just been said needs amplification, but it may serve to indicate what I mean by "stuff." I think there could be a less linguistic definition of "particulars," but it would be difficult to make it precise.

Now if there is such a thing as the Ego, it must be a particular or a system of particulars. If the latter, it can be defined, and becomes identical with what I have called a "biography." If the former, we must know of it (if we know of it at all) either by inference or by observation. I agree with Hume that I do

not know of it by bservation. If it is arrived at by inference, the inference is of just that kind that I seek to invalidate by the principle of substituting constructions for inferences. The basis of this principle is that, where a suitable construction is possible, this very fact invalidates the inference, since it shows that the supposed inferred entity is not necessary for the interpretation of the propositions of the science in question. It was on these grounds that I rejected the Ego as a particular in *The Analysis of Mind*. I cannot see that anything said by Mr. Laird invalidates these grounds. He seems to think that, whereas cognition could perhaps dispense with the Ego, feeling and desire cannot. I should have thought that cognition was much the harder problem for an opponent of the Ego, since it seems more urgently to demand the subject-object relation. But as Mr. Laird thinks otherwise, let us examine desire and pleasure-pain.

For our purposes it is unnecessary—so I should contend—to advance any theory as to what constitutes desire or pleasure-pain; it is only necessary (a) to deny that they involve an observable subject, (b) to provide an explanation of the difference between *you* and *me*. Here (a) is a matter as to which opinions differ, and as to which it is very difficult to advance any arguments; I do not see what I can do except dogmatically to assert my own negative view, and to ask those who take a positive view to make sure that they have not allowed theory to falsify their observation. As regards (b), there is, so far as I can see, no difficulty. There are a number of causal connections between the mental occurrences which we regard as belonging to one person, which do not exist between those belonging to different people; of these memory is the most obvious and the most important. To these must be added compresence, a relation which holds between any two simultaneous contents of a given mind, as well as between any two events which overlap in physical space-time. Let N be the relation "remembering or remembered by." Then "I" means "anything compresent with any member of the ancestry of *this* with respect to N." For the meaning of "ancestry" see *Principia Mathematica*, *90; and for "this" see *Inquiry*, Chapter VII. In defining "you," I must substitute for *this* some inferred entity; cf. *Inquiry*, Chapter XV, especially

pp. 280-281. The inferred entity must not be a member of I (or should I say "me"?).

As regards "mnemic" causation, I agree with Mr. Laird that the hypothesis of causes acting at a distance is too violent, and I should therefore now explain habits by means of modifications of brain structure. (See *Inquiry*, pp. 372-373, Chapter XXI.) I find myself in ontology increasingly materialistic, and in theory of knowledge increasingly subjectivistic. The reconciliation of these two apparently opposed trends is a matter to which I shall return later.

I come now to Mr. Nagel's essay on my philosophy of science, which raises many important issues, and calls for a somewhat full reply. Parts of what I have to say about Mr. Nagel are also relevant to Mr. Stace. I shall omit from my reply all consideration of what Mr. Nagel says on the subject of pure mathematics, because of the great importance of the questions that he raises in regard to physics. I think that, before attempting to answer criticisms, it will be well to state my own present views, which I have found in some respects subject to misunderstanding.

In the first place, I wish to distinguish sharply between ontology and epistemology. In ontology I start by accepting the truth of physics; in epistemology I ask myself: Given the truth of physics, what can be meant by an organism having "knowledge," and what knowledge can it have? I shall begin with ontology.

Philosophers may say: What justification have you for accepting the truth of physics. I reply: Merely a common-sense basis. If you ask any one who is neither a philosopher nor a physicist, he will say that physics has a much better chance of being true than has the system of this or that philosopher. To set up a philosophy against physics is rash; philosophers who have done so have always ended in disaster.

But what is meant by "accepting the truth of physics?" No one supposes the physics of the moment to be incapable of improvement; no prudent person attaches much weight to its more hazardous speculations, e.g., as to the circumference of the uni-

verse. But there remains a vast body of propositions as to whose approximate correctness no reasonable man entertains serious doubts. And even as regards the most dubious parts of physics, they are the best that the human intellect can achieve at present, and have more claim to our assent than any adverse hypotheses advanced by non-physicists. As a methodological assumption, therefore, we do well to assume whatever the consensus of physicists advises us to assume.

There are, however, certain provisoes. We need not listen to physicists outside physics, and it is for the philosopher rather than the physicist to ascertain just what physics asserts. Now there are here two different matters: on the one hand, physics makes prophecies which can be verified; on the other hand, it enunciates general laws from which it deduces consequences of which many cannot be verified. Thus two questions arise: first, what is "verification?" Second, what does physics say, in outline, as to unobservable facts? If the truth of physics is assumed, the second is the prior question.

There are some who would deny that physics need say anything about what cannot be observed; at times I have been one of them. But I have become persuaded that such an interpretation of physics is at best an intellectual game, and that an honest acceptance of physics demands recognition of unobserved occurrences.

Since Einstein, and still more since Heisenberg and Schrödinger, the physical world is no longer regarded as consisting of persistent pieces of matter moving in a three-dimensional space, but as a four-dimensional manifold of events in space-time. The old view resulted from an attempt to make the common-sense concept of "things" available for science; the new view means that "things" are no longer part of the fundamental apparatus of physics.

The essential business of physics is the discovery of "causal laws," by which I mean any principles which, if true, enable us to infer something about a certain region of space-time from something about some other region or regions. It is commonly assumed that these laws, except where certain quantum phenomena are concerned, must embody spatio-temporal continuity:

there is to be no action at a distance. The exceptions as regards minute occurrences in atoms do not affect macroscopic phenomena, as to which, for all practical purposes, continuity may be assumed.

There is some division of opinion as to whether causal laws are the same for living as for dead matter, but the view that they are different is losing ground, and I shall assume it false. The question is not, in an immediate sense, so important as it seems, because in any case ultimate physical laws, as developed in quantum theory, cannot be used where the material is complex, so that other laws, not *known* to be logically connected with the ultimate laws, have to be used in practice. These laws are sufficient to establish macroscopic determinism for living matter, not as a certainty, but as the most probable hypothesis.

The question now arises: Can there, in such a world as the physicists offer for our belief, be any such occurrence as perception is usually supposed to be? And, if not, what is the nearest analogue that is possible, and in what sense can an organism possess "knowledge" of its environment?

There are certain occurrences which are commonly called "perceptions," such as seeing the sun, hearing a clap of thunder, or smelling a rotten egg. What sort of relation can these occurrences have to the sun, the thunder, and the rotten egg respectively?

I have been surprised to find the causal theory of perception treated as something that could be questioned. I can well understand Hume's questioning of causality in general, but if causality in general is admitted, I do not see on what grounds perception should be excepted from its scope. Take the question of time: a gun is fired, let us say, and people are ranged at various points 100 metres, 200 metres, 300 metres, and so on, distant from it. They hear the noise successively. This evidence would be considered amply sufficient, but for philosophic prejudice, for the establishment of a causal law making the hearing of the noise an effect of a disturbance travelling outward from the gun. Or take seeing the sun: if I take suitable measures, I see it at certain times and not at others, and the times when the suitable measures will succeed do not depend on me. The event which I call

"seeing the sun" occurs only—if science is right—when electromagnetic waves of suitable frequency have spent about eight minutes travelling across the intervening space, and have then produced various physiological effects. The waves can be stopped by a screen, the physiological effects by destroying the optic nerve or excising the visual centres in the brain. If this is not to be accepted as evidence of the causal ancestry of "seeing the sun," all scientific reasoning will have to be remodelled.

We can now state the epistemological problem: Accepting the truth of physics, and knowing, otherwise than through the study of physics, certain experiences which are commonly called "seeing the sun," what is the relation between these experiences and the sun? There is in the first place a causal connection: as a rule, the sun is part of a causal chain leading to "seeing the sun," and this causal chain is such that the light-waves which start from the sun are not much impeded in their course until they reach the eye. (Otherwise seeing a plant which has grown by the help of sunlight would be a case of seeing the sun; so, in fact, would seeing anything by daylight.) It is obviously possible to produce, by artificial means, an occurrence which will seem to the percipient to be a case of "seeing the sun" though in fact it is not so. Unless a special kind of causal connection with the sun exists, we are not "seeing the sun," even though our experience may be indistinguishable from one in which we *are* "seeing the sun." All this may be awkward, but it cannot be denied except by those who deny physics.

This brings me at last to Mr. Nagel's essay. He seems to be engaged in a vehement defence of common sense, and he points out, quite truly, that all science starts from common sense. How, then, does science differ from common sense? It differs mainly by the fact that its percentage of mistakes is smaller. By "mistakes" I mean, to begin with, beliefs which are proved wrong by leading to surprise, as, for instance, that the things one sees in a mirror are "real." If I do not know about radio, I shall think there is a strange man in the house when it is only the news. If you give a savage a box containing a gyrostat, he will think it is bewitched because he cannot turn it round. *Most* of our common-sense beliefs must be right from a practical point of

view, or else science could never get started; but some turn out wrong. Science diminishes their number; in this sense it corrects common sense in spite of starting from it. The procedure is exactly like that of correcting testimony by other testimony, where it is assumed throughout that testimony is *usually* trustworthy.

Mr. Nagel asserts with passion that he has seen tables, but he adds that he means this in the sense in which we ordinarily use the words "see" and "table." I might agree if he would take the phrase "see a table" as a whole. Like Mr. Nagel, I have often had the experience called "seeing a table." My objection is that the phrase, as commonly understood, involves false metaphysics. I see, let us say, something continuous, rectangular, shiny, and brown. My seeing is certainly an event in me, though Mr. Nagel is deeply shocked when I say that what I see is in me. American realists induced me to abandon the distinction between a sensation and sense-datum, but the very men who repudiate this distinction object to the inference that the sense-datum is in me. (I shall return to this point shortly.) But in any case what I see when I "see a table" is simultaneous with my seeing, whereas the table as the physical object connected with my seeing is slightly earlier. (The sun is eight minutes earlier, some nebulae hundreds of thousands of years earlier.) What I see has secondary properties recognized, since Locke, as not belonging to the physical object, and primary qualities concerning which the same has been recognized since Berkeley—or since Kant, by those who dislike Berkeley. In what sense, then, can we be said to see the physical object which *is* the table according to physics?

When once the causal process leading from the table to my percept is recognized in all its complexity, it becomes obvious that only by a miracle could my percept resemble the table at all closely. What is more, if this miracle does take place, only a divine revelation can assure us that it does. No such revelation has been vouchsafed to me, and I am therefore left in doubt as to whether the table resembles my visual percept in any respects except those in which physics says it does.

Mr. Nagel is indignant with me because I use the word "see" in an unusual sense. I admit this. The usual sense implies naïve

realism, and whoever is not a naïve realist must either eschew the word "see" or use it in a new sense. Common sense says: "I see a brown table." It will agree to both the statements: "I see a table" and "I see something brown." Since, according to physics, tables have no colour, we must either (a) deny physics, or (b) deny that I see a table, or (c) deny that I see something brown. It is a painful choice; I have chosen (b), but (a) or (c) would lead to at least equal paradoxes.

I come finally to a statement of mine which profoundly shocks Mr. Nagel, as it has shocked various other philosophers; I mean the statement that, when a physiologist looks at another man's brain, what he sees is in his own brain and not in the other man's. I have not so far found any philosopher who knew what I meant by this statement. My defence of it must consist of explaining it, since the arguments brought against it are against some view totally different from mine.

Mr. Nagel says: "I know that I have never seen any portion of my own brain, and that I have seen many physical objects." He goes on to explain that he is using "see" in its customary sense.

It may be that my theory of matter is quite absurd, but at any rate it is not the theory that Mr. Nagel is refuting. I do not think that my visual percepts are a "portion" of my brain; "portion" is a material concept. Briefly, omitting niceties and qualifications, my view is this: A piece of matter is a system of events; if the piece of matter is to be as small as possible, these events must all overlap, or be "compresent." Every event occupies a finite amount of space-time, i.e., overlaps with events which do not overlap with each other. Certain collections of events are "points" or perhaps minimum volumes, since the existence of collections generating points is uncertain. Causal laws enable us to arrange points (or minimum volumes) in a four-dimensional order. Therefore when the causal relations of an event are known, its position in space-time follows tautologically. The causal and temporal connections of percepts with events in afferent and efferent nerves gives percepts a position in the brain of the perceiver. Observe that a "portion" of a brain is a set of points (or minimum volumes); an event may be a member of

certain points (or minimum volumes) that are members of the brain, and is then said to be "in" the brain, but it is not "part" of the brain. It is a member of a member of the brain.

The inferences by which physicists pass from percepts to physical objects (which we are assuming valid) only enable us to know certain facts about the structure of the physical world as ordered by means of causal relations, compresence, and contiguity. Beyond certain very abstract mathematical properties, physics can tell us nothing about the character of the physical world. But there is one part of the physical world which we know otherwise than through physics, namely that part in which our thoughts and feelings are situated. These thoughts and feelings, therefore, are members of the atoms (or minimum material constituents) of our brains. This theory may seem fantastic, but in any case it is not the theory that Mr. Nagel refutes.

I have only one more point to make against Mr. Nagel. He says that if, as I maintain, "things" are those series that obey the laws of physics, then these laws are definitions. Not so; it is "things" that are being defined, and it is an empirical fact (if it is a fact) that there are series obeying the laws of physics and having some of the properties we expect of "things." Quantum theory has made it impossible to use the notion of "thing" (or "matter") in dealing with microscopic phenomena, but in dealing with macroscopic phenomena the notion still has an approximate validity.

Before leaving Mr. Nagel's essay I should like to say that, although I do not agree with him, I am grateful to his criticism for compelling me to clarify the expression of my opinions on various important points. I think it is reasonable to hope that our controversy may be helpful to readers, and that towards this end each of us will have done his part.

Mr. Stace's essay on my neutral monism is a little difficult for me to deal with, because it is concerned with the view I advocated in *Knowledge of the External World* and *Analysis of Mind*, with which I no longer wholly agree, partly for reasons analogous to those which he puts forward against them. I am rather sorry that he excluded *The Analysis of Matter* from the

scope of his discussion, because, although there is some change of view in this book, in the main there is a fuller and more careful statement of theories not very different from those of *The Analysis of Mind*. I cannot understand why Mr. Stace holds that neutral monism must not regard physical objects as causes of sense data.

I will begin with two general remarks. Mr. Stace says that my writings are "extremely obscure," and this is a matter as to which the author is the worst of all possible judges. I must therefore accept his opinion. As I have a very intense desire to make my meaning plain, I regret this. Throughout these pages, I am endeavouring even more to explain what my opinions have been than to defend them; for I consider that some of them have value as hypotheses even if they are not ultimately defensible.

My other general remark has to do with my attempt "to construct matter out of verifiables only," which, Mr. Stace says, "turns out to be nothing but a fraud." The question arises: What is meant by "verifiables?" If it means "things that I experience," or "things that human beings experience," then, I will admit, I do not see how to construct out of such materials alone a world that we can soberly believe to be complete. I will also admit that, at times, I have hoped to find such materials sufficient. I still hold that they are sufficient for everything that is empirically verifiable. But I have found that no one, not even the most emphatic empiricist, is content with what can be empirically verified. It has gradually become clear to me that empiricists (including, at times, my former self) allow a great many shaky inferences, and shrink from much valid analysis, in order to reconcile their faith in empiricism with every-day beliefs which they are not prepared to abandon. We all believe in other people, cats and dogs, chairs and tables, and even the other side of the moon. My real problem is: What are the minimum assumptions which will justify such beliefs?

But the word "verifiables" is capable of meaning something wider than "things that human beings experience," and does mean something wider in the ordinary usage of science. Science, when it believes itself to have established a causal law, allows itself to believe in things which cannot be observed, and so does

common sense. We conclude without hesitation that so-and-so is angry when he behaves in a certain way, although we cannot observe his anger. In a sense, an entity may be said to be "verifiable" when it has been inferred in accordance with the recognized canons of scientific method. In this sense, I do wish to dispense with "unverifiable" entities. This is my reason for doing without matter, points, instants, etc. It is my reason for the use of Occam's razor, since, wherever that implement can shave away an entity, the inference to the entity in question thereby loses its force. All my somewhat elaborate constructions are designed to reduce inferred entities to a minimum. But if entities are validly inferred, I do not think they can be rightly called "unverifiables," in the sense in which this word is commonly used in science.

The theory which Mr. Stace examines, and which I now only partially hold, is perhaps most easily understood when considered as a modification of Leibniz, dropping the dogma that monads are "windowless" and the belief that all of them are in some sense "souls." Each monad mirrors the universe from a certain "point of view." For purposes of explanation, one might simplify the mirroring, and regard each monad as what would be shown in a photograph taken from that point of view. There are, in such a universe, two kinds of space: (1) the assemblage of "points of view," ordered according to the differences of perspective; this constitutes the space of physics; (2) the space in each monad's picture of the universe, which is subjective, and orders a manifold that is wholly within the monad. In Leibniz's system, in which each monad mirrors the whole universe, there is necessarily a one-one correlation between objective space and any subjective space; the geometries of the two will be identical. To take a simplified analogue, consider all numbers of the form $m + 1/n$, where $m$ and $n$ are integers. All numbers having the same $m$ form one monad, the $m$th; this mirrors the universe (consisting of all the monads) because $m + 1/n$ may be considered to represent the $n$th monad. There is no reason why a monad should be a "soul;" it consists merely of all the occurrences exhibiting a certain perspective point of view.

Various modifications are necessary before such a schema becomes even *prima facie* possible. In the first place, it is not the whole universe that is mirrored in any one monad. In the second place, the image of monad A at monad B depends not only on A and its distance from B, but also on the intervening medium. In the third place, B does not mirror the *present* state of A, but its state at a somewhat earlier time, calculated according to the velocity of light or sound or etc. In the fourth place, the image of A and the image of B may so interfere with each other that the resultant event at C cannot be regarded as representing either or both, for instance when stones at the bottom of a stream are seen through rippling water. Nevertheless—so I thought—the Leibnizian schema may be accepted as a ground-plan to be amended. I still think so, although I am more conscious than formerly of the extent of emendation required.

Mr. Stace is puzzled by my hypothesis of unperceived aspects. Yet the hypothesis of such aspects is inevitable if we admit—as we all do in fact—that (a) causation does not act at a distance, (b) we can perceive (in some sense) things from which we are separated by an interval which is not a plenum of souls. For practical purposes, these unperceived aspects may be identified with light-waves or sound-waves or their analogues for other senses, but in strict theory I should say that light-waves and sound-waves are logical structures, built out of events more or less as points are built. Unperceived aspects, therefore, will be constituents of light-waves or sound-waves, but will not be the waves themselves.

Mr. Stace supposes that I follow Locke in regarding secondary, but not primary, qualities as subjective. This is not the case. I regard both as subjective in the sense that neither can exist except in a region where there is an organism with sense-organs and a brain. But both are causally connected with what exists elsewhere; it is through this causal connection that our percepts are linked to the physical events which we are thought by common sense to perceive. As regards space, there is, as already explained, the private space in each monad's image of the world, and the physical space of points of view, which is constructed by means of causal laws.

There is much that I agree with in Mr. Stace's essay. I agree entirely that there is no rational objection to dualism; also that introspective data are observable. I think I agree when he says that generality is peculiar to thought, but generality is a very difficult subject, as to which I have said what I could in Chapter XVIII of the *Inquiry*.

I hope that what I have been saying has not been "extremely obscure." I think the Leibnizian analogy, if not taken too seriously, should help to clarify my meaning.

Mr. Ushenko's essay on my critique of empiricism has been pleasant reading to me, because I find in it an unusually large measure of understanding and agreement. For this very reason, there is little for me to say about it. There are some points where I have difficulty in following Mr. Ushenko: he uses "material implication" in a sense different from mine, and he says that, in my explanation of "you are hot," I use *two* variables, whereas in fact I only use one. I do not understand what he says about "concepts;" I had supposed that I was making free use of them, and in the last chapter of the *Inquiry* I decide for something like a realist theory of universals. Some of the things he says about "concepts" suggest something analogous to Kantian categories, but in one passage this interpretation is repudiated. I much regret that I do not know exactly what theory Mr. Ushenko is advocating, and therefore cannot tell whether I agree with it or not. For everything that I can understand in his essay I am grateful, and I hope that it may serve to clear away misunderstandings.

Mr. Chisholm's paper on epistemological order as I conceive it is an able and careful analysis. I propose to deal with the problem of epistemological order somewhat generally, and shall consider some aspects not touched on by Mr. Chisholm as well as those with which he is primarily concerned.

The first question to be considered is: Is there such a thing as epistemological order? Dr. Dewey, if I have not misunderstood him, would deny it altogether, and so, I think, would many others. If I were making out a case against the concept of epistemological order, I should argue as follows:

"Knowledge (or what passes as such) is, at each moment, an organic whole of interdependent parts; to distinguish some of these as premisses and others as inferences is artificial, since every part is equally premiss and conclusion. The growth of knowledge may be compared to what happens when we gradually approach an object seen dimly through a fog: at first, it is only a vague patch of greater darkness; gradually it assumes a more or less rectangular shape; at last the pattern becomes distinct and we see that it is a house. You may say 'Since it is a house it has doors and windows', or 'since it has doors and windows it is a house', but in fact the knowledge that it is a house and the knowledge that it has doors and windows are parts of one whole of knowledge, in which logical dependence is mutual, not unilateral.

"The notion of epistemological order (I should continue) is derived illegitimately from that of logical order as exemplified in mathematics, and this, itself, is a historical product of Greek philosophy. Euclid starts with axioms which he considers self-evident, and arrives at propositions which, except to a possible mathematical genius, are not self-evident; it is the concept of self-evidence that determines Euclid's procedure. But the modern mathematician does not like this concept; when he uses it, he does so covertly and tries to hide what he considers his guilt. Euclid's axiom or postulate of parallels was never considered adequately self-evident. What is worse, the axiom that two straight lines cannot enclose a space, though most unsophisticated people would still judge it to be self-evident, is now generally considered to be false by astronomers and theoretical physicists. The concept of self-evidence, even in mathematics, would seem to be both inadequate and deceptive. The practice of deducing mathematical systems from axioms, which persists, must be regarded as merely a convenient manner of exposition. And outside mathematics there is even less to be said for starting with what professes to be self-evident."

My own views can best be stated as an answer to the above two paragraphs. I shall make a threefold reply, from the point of view of (1) common sense, (2) logic, (3) physics.

(1) *Common sense.* We all believe that Columbus crossed the Atlantic in 1492. But if we are asked "Why do you believe

this?" we have an answer referring to other parts of our knowledge. We believe it because we were taught it in youth, because the Encyclopedia says so, or because we have read it in some book of history. That we were taught it, or that some book asserts it, is logically prior, in the organization of our knowledge, to our belief about Columbus. Here *causa cognoscendi* and *causa essendi* are sharply opposed: I was taught that Columbus sailed in 1492 because he did sail then, but I know he sailed then because I was taught it. If somebody maintains that the date was 1493, I produce the Encyclopedia and say "look." It is an empirical fact that when people look at a printed page they usually agree as to what it says; therefore at this point my opponent will be reduced to saying that it is a bad Encyclopedia. Ultimately he is convinced by finding that all authorities say the same thing. The conclusive evidence is what common sense calls "the evidence of the senses," i.e., what is seen on a printed page.

Or take a scientific generalization. If Kepler had been asked why he believed in his laws, he would have said that they were inferred from observations of the positions of the planets. It is, of course, equally true that the positions can be inferred from the laws (together with initial positions), but no one would pretend that this is the order of knowledge. The laws are not to be believed unless there is a reason for believing them, whereas the observations of the apparent positions of the planets are accepted without any further ground.

It may be objected that, when once the laws have been established, a single observation which conflicts with them may be rejected as erroneous. But the basis for this rejection is still *mainly* observation; a great many observations lead to Kepler's laws, and it is only because we regard each observation as *prima facie* nearly certain that we are able to reject such as are aberrant.

This of course raises the question of the inference from the observations to the laws. Common sense must recognize not only the "evidence of the senses," but also logical evidence. The question what constitutes logical evidence, however, is one which lies outside the competence of common sense.

(2) *Logic.* The logical part of our problem depends upon the somewhat difficult notion of logical simplicity. In some cases this notion seems not difficult. For instance, if I believe that Robert Boyle was the father of chemistry and the son of the Earl of Cork (as I was taught in youth), my belief can be replaced by two equivalent beliefs, namely, (a) that he was the father of chemistry and (b) that he was the son of the Earl of Cork. In setting out premisses for our knowledge of Robert Boyle, we should prefer (a) and (b) separately to the combination of them into one proposition. Our reason is that (a) and (b) are logically independent of each other, that either can be known without the other being known, and that we cannot imagine any way of knowing the proposition composed of both together except by first knowing (a) and (b) separately. Thus, speaking generally, complex knowledge may be expected to depend upon knowledge that is comparatively simple. I know the exponential theorem because I have followed the proof from the first principles of logic; but I am not so constituted that I could have first known the exponential theorem and thence inferred the principles of logic. The principle of logical simplicity, however, is by no means simple, and cannot be used without great caution.

(3) *Physics.* I come now to a less abstract question: Why should percepts be treated as epistemologically prior to "things?" I have already dealt with this question in connection with Mr. Nagel. Here I will only say that it is not only *logically* possible for me to have an experience which I shall call "seeing the sun" when this experience does not have the usual connection with the sun; it is also *physically* possible. My experience depends upon occurrences at the eye, and it would be quite possible for an ingenious person to produce artificially just such occurrences as are usually produced by the sun. One may put the matter in purely physical terms. Imagine a number of concentric spheres, all of which contain my body. Let one of these spheres be called S. Then in two worlds in which events inside S are the same, all the events in my body will be the same. Therefore, there can only be a valid inference from events inside my body to events outside S, if and in so far as events inside S uniquely determine events outside S. Since events in my body

determine my percepts, this limits the extent to which my percepts can give me information as to what happens outside S, and makes such information dependent upon the laws of physics. I am here assuming physics true; if this assumption is not made, obviously a more sceptical conclusion follows.

I come now to the detail of Mr. Chisholm's essay.

With regard to such a statement as "I see a dog," my objection to taking it as basic is *partly* logical complexity. A dog has a past and a future; it exists when I am not seeing it; it is generally believed to have feelings. It is obviously *possible* that I should have the experience called "seeing a dog" without all this. If I met Robert Boyle and said "I see the father of chemistry and the son of the Earl of Cork," I should be drawing inferences from what I should be seeing; the same is true when I say "I see a dog." My point is not that the inference is invalid; I am convinced that it seldom is. My point is that it *is* an inference, and that it *can* be invalid. But when I say that it is an "inference," I must be understood to be using the word "inference" in a sense in which animals infer. This, I think, I have sufficiently emphasised.

I shall pass by the greater part of Mr. Chisholm's essay, since I am in agreement with it. Especially I agree with him whenever he criticizes the views of others. There are, however, some points as to which he seems to have misunderstood me.

According to my theory in the *Inquiry*, he says, "We are confronted, in a perceptual situation, by the universal itself and not a mere instance of it." My view is that a particular shade of colour (or any other precisely defined quality) is not a universal, but a particular. (I have given my definition of these terms in my reply to Mr. Laird.) The imaginative difficulty of my theory is that it requires us to regard space and time as much less fundamental than we naturally suppose; neither is, on this view, a *principium individuationis*.

My interpretation of "this is red" is *not* "there is something which is redness and is here;" it is an essential part of my theory that "this is red" contains no variable. I interpret "this is red" as "redness is here," where "here" is the proper name of a bundle of compresent qualities. The suggestion that I have

found a meaning of "existence" other than that given in *Principia Mathematica* \*14 has no foundation. The inference from "*fa*" to "There is an *x* such that *fx*" uses "there is" in the usual logical sense.

The theory that every judgment of perception is a partial analysis of a given whole $\overline{W}$ is one which I have put forward tentatively, and I am prepared to find that there are fatal objections to it. At the same time, it is attractive to me, and I should like to find it defensible. It gets rid of the difficulty inherent in the notion of substance, namely that a substance can only be *recognized* by its qualities, from which it seems to follow that what we know can be expressed in terms of qualities, without the use of the notion of substance. It has the further merit of giving a meaning to the process of analysing, which is clearly something different from the logical operation of observing that a rational animal is an animal. And finally it gives an empirical interpretation to such propositions as "if A is before B and B is before C, then A is before C," which otherwise appear as synthetic *a priori* truths.

Mr. Chisholm advances some criticisms of this theory which do not seem to me valid. He supposes us to maintain that what we experience can have parts that we do not experience. The word "experience" is vague and dangerous. I should say that the parts can always be discerned by attention. Take, e.g., a complex taste, such as that of green chartreuse. There is a total taste, which would be noticeably different if any ingredient were omitted; and there is the connoisseur's analytic taste, which distinguishes the separate ingredients without losing the whole. I should not say, as Mr. Chisholm thinks I should, that "the datum is not identical with, but is more than, what we actually experience." My point is that it is possible to experience a whole, and to distinguish it from a whole differently composed, without making all possible true judgments of analysis "this whole $\overline{W}$ contains the quality $q_1$, $q_2$, $q_3$ . . . ." I do maintain, however, that these judgments *can* be made by anybody who attends to $\overline{W}$ and has an adequate vocabulary.

As to the question of recurrence, I consider it a merit in my theory that it makes recurrence *possible*. It does not, however,

make it at all probable. Mr. Chisholm takes the case of my experiences during a blackout, but he omits my thoughts and memories, which are all part of $\overline{W}$, for $\overline{W}$, as I define it, consists of a bundle having the following two properties: (1) any two members of the bundle are compresent; (2) nothing not a member of the bundle is compresent with every member of the bundle. It is very unlikely that all my thoughts will recur exactly at two different periods, even during a blackout.

The theory of "time-qualia" does not seem to me plausible. In the first place, I cannot find such things in my experience. In the second place, the theory requires an absolute instead of a relational theory of time. There is nothing logically impossible about the theory, but I do not like inventing entities, especially when, as in the present instance, I feel that the problem involved is one which requires for its solution only skill in analysis. In such cases, sledge-hammer solutions are only an excuse for laziness. Mr. Chisholm merely offers me the theory as an escape from my supposed difficulties; what his theory would be I do not know. I wish I did, as I am sure it would be worthy of serious consideration.

I do not quite know how to deal with Mr. Brown's essay, "A Logician in the Field of Psychology." My difficulty arises from the fact that I do not recognize my own doctrines in Mr. Brown's caricatures. His arguments against me ignore long discussions dealing with the very points he is making. For instance: he says that physics proves that a sensation cannot be like its cause. In *Analysis of Matter* I argued, rightly or wrongly, that there can be similarity as to *structure*, and that our knowledge of the physical world is only a knowledge of structure. This argument, if mistaken, should have been refuted.

Again he sees an inconsistency in my view that verification is called for when I think I see a cat, but that for judgments of perception there is no method of verification. I thought I had made it abundantly clear that the judgment of perception alone cannot be "there is a cat," but "there is a feline patch of colour."

Again, he says that all propositions can be tested by experi-

ment, ignoring the argument that the result of an experiment must be embodied in a proposition different from the one which is being tested.

He says that, for me, a whole is merely an additive sum. If he had re-read Chapter XXIV of the *Inquiry*, he would have seen how far this is from the truth.

He says that I do not begin the study of language from living language. As to this, I will only say that I doubt whether any other living philosopher has spent as much time as I have observing children learning to speak. No doubt the results of my observations were coloured by my theories, but so are other people's.

In conclusion Mr. Brown says that my awful example has cured him of symbolic logic, to which he was at one time addicted. My difficulties, he contends, spring from my early preoccupation with symbolic logic. I should reply (a) that symbolic logic is merely logic conducted with a modern technique, (b) that it is a merit in logic to reveal difficulties, (c) that Mr. Brown's failure to see the difficulties of his own views springs from his resolute and valiant refusal to be browbeaten by logic.

Mr. Boodin's essay on my metaphysics is very kindly in its tone, considering how profoundly he disagrees with me. My trouble is that the problems which he raises are too vast to be dealt with in any reply which falls short of being a large volume. The chief of these is "atomism." I think that almost everybody in the philosophic world disagrees with me on this subject, but I am quite impenitent, because I never find arguments brought against my logical atomism. I find only a fashion and a dogma. Mr. Boodin says: "Nature does not consist in separate and distinct entities." I fancy almost every reader of this volume will agree with him. But I must ask how he knows this? He gives, so far as I can see, only two reasons: first, that physics uses the conception of a "field;" second, that babies have no clear ideas. I admit both, though the second is an inference involving considerable theory; but I fail to see that either is relevant. As to the first, a "field" is essentially a transmitter of causal influences; technically, it is dealt with by differential equations, which as-

sume some form of atomism. As to the second, it rests on the common fallacy that the analysis of what happens in the minds of muddle-headed people is what they think it is, not what psychologists believe it to be. This is as absurd as it would be to appeal to a crystal for its opinions on crystallography.

I notice in Mr. Boodin a certain dogmatism which is common in opponents of atomism. He says, for instance, that the mathematical continuum has nothing to do with the physical or metaphysical continuum; in the former, there are terms between any two, but in the latter not. I wish he had told us how he knows this. I will not discuss the metaphysical continuum, since that depends upon the metaphysician. But as for the physical continuum, if Mr. Boodin means the continuum assumed in physics, that is precisely the mathematical continuum, since it is assumed that the real numbers are necessary and sufficient for the assignment of coördinates. I should be the first to admit—indeed I have argued emphatically—that there is no conclusive reason to suppose the physical world to have this sort of continuity, but the alternative is discontinuity, not continuity of some other sort.

Mr. Boodin quotes a passage from me according to which it appears that at a certain time I thought only percepts real. This was a technical hypothesis which I was trying to make logically adequate. I should now approach the question in a somewhat different way, which I have tried to explain in connection with Mr. Nagel's essay.

I will, however, add a few words on the matter of solipsism, to which, according to Mr. Boodin, my philosophy condemns me. Let us first cut out the word "solipsism," and thereby get nearer to the logical bare bones of the question. There are, in science, certain statements which are held to embody the results of observation, and certain others which are accepted as inferences from these results. The canons of scientific inference have never yet been formulated; if I have leisure, I hope to try to formulate them myself. In analyzing scientific inference, we methodologically accept as valid whatever scientifically trained common sense regards as valid. We may hope to arrive at certain general principles, of which induction will be one, but by no means the only one. Rejection of action at a distance,

for example, will, I think, be another. Just as certain parts of Euclidean geometry are independent of the axiom of parallels and certain other parts are not, so we may find that this or that principle of scientific inference is not necessary for the whole of science, but only for part of it. This work of analysis should be capable of becoming precise, and not open to controversy except as regards mistakes in detail.

There will have to be a discussion as to the character of the data of observation. I hold, what science seems to make undeniable if its general truth is admitted, that the data of observation have always a certain causal relation to the body of the observer, since they depend upon our sense-organs. It follows that if (a) science is in fact true, and (b) all the principles of inference by which we arrive at it are invalid, then, though the rest of the world exists, we cannot know that it does. If science is not in fact true, this partially agnostic conclusion follows even more obviously. Therefore if we are to hold that we know anything of the external world, we must accept the canons of scientific inference. Whether, when this conclusion has been reached, an individual decides to accept or reject these canons, is a purely personal affair, not susceptible to argument when once the issue has been made clear. I, as a human being, of course accept these canons, though as a professional logician I can play with the idea of rejecting one or the other of them to see what the consequences would be.

I come now to what is, for me, an essentially different department of philosophy—I mean the part that depends upon ethical considerations. I should like to exclude all value judgments from philosophy, except that this would be too violent a breach with usage. The only matter concerned with ethics that I can regard as properly belonging to philosophy is the argument that ethical propositions should be expressed in the optative mood, not in the indicative. Where ethics is concerned, I hold that, so far as fundamentals are concerned, it is impossible to produce conclusive intellectual arguments. When two people differ about (say) the nature of matter, it should be possible to prove either that one is right and the other wrong, or that

both are wrong, or that there are insufficient grounds to warrant any opinion. In a fundamental question of ethics I do not think a theoretical argument is possible. I do not therefore offer the same *kind* of defence for what I have said about values as I do for what I have said on logical or scientific questions.

Both Mr. Brightman's essay on my philosophy of religion and Mr. Buchler's on my ethics raise certain questions as to which I must first attempt to make clear what my own views are.

I am accused of inconsistency, perhaps justly, because, although I hold ultimate ethical valuations to be subjective, I nevertheless allow myself emphatic opinions on ethical questions. If there is an inconsistency, it is one that I cannot get rid of without insincerity; moreover, an inconsistent system may well contain less falsehood than a consistent one. For my own sake, as well as for that of the reader, I propose to examine this question somewhat fully.

In the first place, I am not prepared to forego my right to feel and express ethical passions; no amount of logic, even though it be my own, will persuade me that I ought to do so. There are some men whom I admire, and others whom I think vile; some political systems seem to me tolerable, others an abomination. Pleasure in the spectacle of cruelty horrifies me, and I am not ashamed of the fact that it does. I am no more prepared to give up all this than I am to give up the multiplication table.

The trouble arises through the subjectivity of ethical valuations. Let us see what this amounts to.

In practice, when two people disagree as to whether a certain kind of conduct is right, the difference of opinion can usually, though not always, be reduced to a difference as to means. This is a question in the realm of science. Suppose, for example, one person advocates capital punishment whereas another condemns it: they will probably argue as to its efficacy as a deterrent, which is a matter at least theoretically capable of being decided by statistics. Such cases raise no theoretical difficulty. But there are cases that are more difficult. Christianity, Kant, and Bentham maintain that all human beings are to count alike; Nietzsche

says that most of them should be merely means to an aristocracy. He would not assent to the modern development of this doctrine, that good consists of pleasure to a German or pain to a Jew, and evil consists of pleasure to a Jew or pain to a German, but from the standpoint of ethical theory his doctrine raises the same problems as does that of the Nazis.

Let us consider two theories as to the good. One says, like Christianity, Kant, and democracy: whatever the good may be, any one man's enjoyment of it has the same value as any other man's. The other says: there is a certain sub-class of mankind —white men, Germans, gentiles, or what not—whose good or evil alone counts in an estimation of ends; other men are only to be considered as means. I shall suppose that A takes the first view, and B the second. What can either say to convict the other of error? I can only imagine arguments that would be strictly irrelevant. A might say: If you ignore the interests of a large part of mankind, they will rebel and murder you. B might say: The portion of mankind that I favour is so much superior to the rest in skill and courage that it is sure to rule in any case, so why not frankly acknowledge the true state of affairs? Each of these is an argument as to means, not as to ends. When such arguments are swept away, there remains, so far as I can see, nothing to be said except for each party to express moral disapproval of the other. Those who reject this conclusion advance no argument against it except that it is unpleasant.

The question arises: What am I to mean when I say that this or that is good as an end? To make the argument definite, let us take pleasure as the thing to be discussed. If one man affirms and another denies that pleasure is good *per se*, what is the difference between them? My contention is that the two men differ as to what they desire, but not as to what they assert, since they assert nothing. I maintain that neither asserts anything except derivatively, in the sense in which everything we say may be taken as affirming something about ourselves. If I say, "it will rain tomorrow," I mean to make a meteorological assertion, but to a sceptical listener I only convey that I believe something about tomorrow's weather. There is a similar differ-

ence between expressing a desire and stating that I feel the desire. An ethical judgment, according to me, expresses a desire, but only inferentially implies that I feel this desire, just as a statement in the indicative expresses a belief, but inferentially implies that I have this belief.

I do not think that an ethical judgment *merely* expresses a desire; I agree with Kant that it must have an element of universality. I should interpret, "A is good" as "Would that all men desired A." This *expresses* a wish, but does not *assert* one except by implication.

Mr. Buchler asks what I mean by saying that the good is *primarily* the desired; what I mean is that it is to be defined in terms of desire, and that to define it as the desired is a first step towards a correct definition.

Mr. Buchler maintains that when I say the good life is inspired by love and guided by knowledge, I cannot mean that I wish everybody desired men to live such a life. But let us take the question psychologically. What does the reader learn from reading this sentence? He certainly learns that I wish men lived so, and he may gather that I mean to express something more than this wish. But what is this more? I cannot see that it is anything more than the wish that others should share my wish.

I am quite at a loss to understand why any one should be surprised at my expressing vehement ethical judgments. By my own theory, I am, in doing so, expressing vehement desires as to the desires of mankind; I feel such desires, so why not express them?

What, I imagine, is mainly felt to be lacking in my ethical theory is the element of command, in fact the "categorical imperative." Ethics is a social force which helps a society to cohere, and every one who utters an ethical judgment feels himself in some sense a legislator or a judge, according to the degree of generality of the judgment in question. It would be easy to develop a political theory of ethics, starting from the definition: "The good is the satisfaction of the desires of the holders of power." In a genuine democracy, if such a thing were possible,

the consequences of this definition would not be shocking to democrats. Inductively, it would cover the historical facts admirably; it would explain, for instance, why it was wicked for women to smoke until they got the vote, and then ceased to be so. It is the theory advanced by Thrasymachus in the *Republic*, and "refuted" by the Platonic Socrates with a dose of dishonest sophistry which is large even for him. It is the theory held, though not avowed, by most schoolmasters and almost all education authorities. It may be inferred from the moral code of any community except in times of revolution. I do not, however, adopt this ethic, because I dislike the white man's burden, the inequalities of economic power, and other manifestations of the ethics of governing cliques.

All this, however, may seem beside the point. The point is that an ethical judgment ought—so it is felt—to have the same kind of objectivity as a judgment of fact. A judgment of fact—so I hold—is capable of a property called "truth," which it has or does not have quite independently of what any one may think about it. Very many American philosophers, perhaps most, disagree with me about this, and hold that there is no such property as "truth." For them the problem that I am considering does not exist. But for me it is necessary to acknowledge that I see no property, analogous to "truth," that belongs or does not belong to an ethical judgment. This, it must be admitted, puts ethics in a different category from science.

I cannot see, however, that this difference is as important as it is sometimes thought to be. Take, for example, the question of persuasion. In science there is a technique of persuasion which is so effective that controversies seldom last very long. This technique consists of an appeal to evidence, not to the emotions. But as soon as a question becomes in any way entangled in politics, theoretical methods become inadequate. Are coloured people congenitally less intelligent than white people? Are there national characteristics distinguishing individuals of the various nations? Is there any anatomical evidence that women's brains are inferior to men's? Such questions are normally decided by rhetoric, brass bands, and broken heads. Nevertheless, the detached scientist, if he exists, may, neglected and alone,

persist in applying scientific methods even to questions that rouse passion.

In the matter of persuasion it is often overlooked that the advocate of scientific methods must—since persuading is a practical activity—base himself on the ethical principle that it is better to believe truth than falsehood. In my interpretation, this means that the advocate of scientific methods wishes that men believed truly, and wishes that others shared this wish. Clearly he will not, in fact, advocate scientific methods unless he has this wish. Propaganda agencies are different: they wish people to have certain beliefs, which they may themselves entertain, but which they seldom wish to see subjected to a scientific scrutiny.

Persuasion in ethical questions is necessarily different from persuasion in scientific matters. According to me, the person who judges that A is good is wishing others to feel certain desires. He will therefore, if not hindered by other activities, try to rouse these desires in other people if he thinks he knows how to do so. This is the purpose of preaching, and it was my purpose in the various books in which I have expressed ethical opinions. The art of presenting one's desires persuasively is totally different from that of logical demonstration, but it is equally legitimate.

All of this may be true, I shall be told, *provided your desires are good;* if they are evil, rhetoric in their defence is an art of the devil. But what are "good" desires? Are they anything more than desires that you share? Certainly there *seems* to be something more. Suppose, for example, that some one were to advocate the introduction of bull-fighting in this country. In opposing the proposal, I should *feel,* not only that I was expressing my desires, but that my desires in the matter are *right,* whatever that may mean. As a matter of argument, I can, I think, show that I am not guilty of any logical inconsistency in holding to the above interpretation of ethics and at the same time expressing strong ethical preferences. But in feeling I am not satisfied. I can only say that, while my own opinions as to ethics do not satisfy me, other people's satisfy me still less.

A few matters of detail remain to be noted in Mr. Buchler's

essay. He seems to think that he makes a point against me by pointing out that people often do not know what they desire. From my account of desire in *Analysis of Mind* he will see that I regard it as exceptional when people know what they desire. But their desires influence their behaviour (or, better, are exemplified in their behaviour) just as much when unconscious as when conscious.

He says that I am not concerned to make all human beings' desires coherent. I cannot understand what gave him this impression. The last chapter of *Social Reconstruction* is entirely, or almost entirely, occupied with the integration of desires, first in the individual, then in the world. The wish to harmonize desires is the chief motive of my political and social beliefs, from the nursery to the international state.

Finally, he says that I am courageous, but not judicious, and that I am lacking in *sophrosyne*. This, I think, is just. I will only add that *sophrosyne* is not a quality I wish to possess; I associate it with limited sympathies and a secure income. At one time I lived in Malaga; a few months after I ceased to do so, a large part of the civilian population were exterminated from the air while trying to escape along a narrow coastal road. Things just as bad are happening constantly. During the last war, the War Office sent for me and exhorted me to preserve a sense of humour. With great difficulty I refrained from saying that the casualty lists made me split my sides with laughter. No, I will not be serene and above the battle; what is horrible I will see as horrible, and not as part of some blandly beneficent whole.

Mr. Brightman's essay on my philosophy of religion is a model of truly Christian forbearance; I do not believe that I should have been as kind to some one who had attacked my beliefs in the manner in which I have attacked beliefs which he holds. I will try to follow his example, and to deal with the questions involved as inoffensively as I am able. And first I will re-state in outline my general attitude towards religion, which is somewhat complex.

Religion has three main aspects. In the first place, there are a

man's serious personal beliefs, in so far as they have to do with the nature of the world and the conduct of life. In the second place, there is theology. In the third place there is institutionalized religion, i.e., the churches. The first of these aspects is somewhat vague, but the word "religion" is coming more and more to be used in this sense. Theology is the part of religion with which the philosopher as such is most concerned. The historian and sociologist are chiefly occupied with religion as embodied in institutions. What makes my attitude towards religion complex is that, although I consider some form of personal religion highly desirable, and feel many people unsatisfactory through the lack of it, I cannot accept the theology of any well known religion, and I incline to think that most churches at most times have done more harm than good.

As regards my own personal religion, Mr. Brightman has done full justice to it, and I need say no more about it, except that the expression of it which seems to me least unsatisfactory is the one in *Social Reconstruction* (Chapter VII).

As regards theology, Mr. Brightman maintains that, in some sense, I believe in God; he says also that I ought to use any religious experiences as clues to the nature of the real. "The appreciation of the religious sense of mystery and of the life of the Spirit, and the need for something more than human, are experiences of the divine." I cannot agree. The fact that I feel a *need* for something more than human is no evidence that the need can be satisfied, any more than hunger is evidence that I shall get food. I do not see how any emotion of mine can be evidence of something outside me. If it is said that certain parts of human minds are divine, that may be allowed as a *façon de parler*, but it does not mean that there is a God in the sense in which Christians hitherto have believed in Him. In arguments to God from religious experience there seems to be an unexpressed premiss to the effect that what seem to us our deepest experiences cannot be deceptive, but must have all the significance they appear to have. For such a premiss there seems to me to be no good ground, if "significance" means "proving the existence of this or that." In the realm of value, I admit the significance of religious experience.

The scholastic proofs of the existence of God are now out of fashion among Protestants. Mr. Brightman mentions my discussion of Leibniz's proofs, but does not, perhaps, quite sufficiently recognize that I was discussing Leibniz, and had no occasion to notice any arguments which he does not use. For my part, although I think the old proofs fallacious, I prefer them to the modern ones, because they fail only through definite errors, whereas the modern ones, so far as they are known to me, do not even profess to be proofs in any strict sense. I do not know of any conclusive argument *against* the existence of God, not even the existence of evil. I think Leibniz, in his Théodicée, proved that the evil in the world *may* have been necessary in order to produce a greater good. He did not notice that the same argument proves that the good *may* have been necessary in order to produce a greater evil. If a world which is partly bad may have been created by a wholly benevolent God, a world which is partly good may have been created by a wholly malevolent Devil. Neither seems to me likely, but the one is as likely as the other. The fact that the unpleasant possibility is never noticed shows the optimistic bias which seems to me to infect most writing on the philosophy of religion.

As for the churches, they belong to history, not to philosophy, and I shall therefore say nothing about them.

Mr. Lindeman's essay does not raise many points calling for discussion. I note with pleasure that he sees no necessary connection between my views on social questions and my views on logic and epistemology. I have always maintained that there was no logical connection,[5] pointing to the example of Hume, with whom I agree so largely in abstract matters and disagree so totally in politics. But other people, for the most part, have assured me that there was a connection, though I was not aware of it.

In some things Mr. Lindeman puzzles me. He cannot see how I can think science important, although it "contains no basis for the belief in progress." Surely the answer is simple. Science is a tool which is needed for any deliberate social change, but

---

[5] There is, I think, a psychological connection, but that is a different matter.

whether the social change is for the better or the worse depends upon its purposes, which science alone cannot determine. If I wish to travel to a certain place, a railway time-table is useful; whether my purpose is to visit an aged aunt or to murder a man from whom I have expectations, the time-table will help me equally.

My view that science is ethically neutral becomes, in his mind, a view that science is ethically bad; he thinks he is interpreting my views in speaking of science as "brutalizing," and of scientists as having nothing to do with the ends of life. All this is a complete mistake. "Brutalizing" is not an ethically neutral word. And as for the scientist, he should be also a citizen, and as a citizen he should use his science to make himself more useful. I think Mr. Lindeman was misled by my "scientific society," setting forth possibilities which Mr. Aldous Huxley afterwards popularized as the *Brave New World*. I did not mean to suggest—and I thought I had made this abundantly clear—that this nightmare was the only sort of society deserving to be called "scientific." What I did mean to suggest, and what I still think very important, is that a society is not necessarily good because it is planned. If it is planned by a minority who hold all the power, it will sacrifice the majority. If it is planned by men without kindliness, it will be cruel. If it is planned by men incapable of instinctive happiness, it will be dusty. Science has shown the Germans and English how to destroy each other's cathedrals, but science alone will not show how to build up something equally good to take their place. On the other hand, science is making a world-state technically possible, but non-scientific motives stand in the way of its realization. Science creates possibilities, both good and bad, but it is not science that decides which of them will be realized.

Mr. Lindeman says that my philosophy does not lead to action, and mentions education as my "only genuine activist interest." Throughout my life I have been concerned, so far as my other work permitted, and often even at the expense of my other work, in a number of practical movements, some successful, some unsuccessful. Of those to whom my name is familiar, a small minority (which includes Mr. Lindeman)

know me as a theoretical philosopher. If I can judge by my mail over a long period of years, most of the people who have read my writings or heard me speak think of me as a practical reformer. In America, where I am an alien, my practical activities have been externally restricted. In my own country, did Mr. Lindeman but know it, I have throughout my life taken part in English social and political life. I was an early member of the Fabian Society. I stood for Parliament during the writing of *Principia Mathematica*. It is not my fault that I was not in Parliament during the first World War. I can hardly be properly described as inactive during this period, since the government found it necessary to restrict me to philosophical activities by sending me to prison, where, having nothing better to do, I wrote *Introduction to Mathematical Philosophy*. Mr. Lindeman thinks that I regard a scientist who is interested in politics as an anomaly. This is the exact opposite of the truth. What is true is that, after the Russian Revolution, my dislike of the Russian régime made it difficult for me to coöperate with those Western Radicals who were, as I thought, being misled into support of totalitarianism. This difficulty has now become much less, since Russia no longer casts so strong a spell upon reformers.

Mr. McGill's essay on my political and economic "philosophy" deals mainly with matters which I should regard as lying wholly outside philosophy. He is amazed with me for disagreeing with Marx's economics and failing to admire the Soviet régime. I shall not enter upon an argument on either of these matters, not only because I am convinced that it would be futile, but because they do not seem to me to come within the scope of even a very liberal interpretation of the word "philosophy." I will, however, protest against one remark made by Mr. McGill as regards my criticism of the Bolsheviks. He says that I could not forgive them their rationalism. This is quite the contrary of the truth. They seemed to me to be men in the grip of an unfounded system of theological dogmas; they were "rationalist" only in the sense in which scholastic disputants who relied on syllogisms might be called rationalists.

Faith in Dialectical Materialism seems to me impossible for any one who adheres to scientific method.

Coming to more general matters, Mr. McGill makes much of the usefulness of the state and the necessity of planning, and the unwary reader would get the impression that I disagreed with him on these points. On the contrary, I agree emphatically, provided the state is democratic.

He accuses me of believing in an "ineradicable" impulse to war. I cannot imagine what led him to make such a mistake. What I have said is that people whose lives are unhappy or thwarted are apt to develop hatreds and impulses towards violence, and that, under our present social system, there are very many such people. He misses altogether my views as to the ways in which circumstances affect character.

He makes much of my use of the word "instinct." In *Social Reconstruction*, which was not intended as a contribution to learning, but had an entirely practical purpose, I used the word "instinct" in its popular sense; elsewhere, I have used vaguer words, to make it clear that I was not speaking of instinct in its technical sense. Mr. McGill gives the impression that I use the word "instinct" much more often than I do, and affects to suppose that, when I use the word "impulse," I mean "instinct" as it is used in scientific accounts of animal behaviour. By this means he, no doubt unintentionally, distorts my meaning, and has an easy time in showing that I talk nonsense.

I am somewhat puzzled as to what I should have to say in order to win favour. I am constantly accused of being insufficiently "dynamic," but when, as in *Social Reconstruction* and *Power*, I advocate a dynamic psychology, I am equally taken to task, and am told (by a Marxist!) to remember that human nature is unchangeable.

With regard to *Social Reconstruction*, and to some extent with my other popular books, philosophic readers, knowing that I am classified as a "philosopher," are apt to be led astray. I did not write *Social Reconstruction* in my capacity as a "philosopher;" I wrote it as a human being who suffered from the state of the world, wished to find some way of improving it, and was anxious to speak in plain terms to others who had

similar feelings. If I had never written technical books, this would be obvious to everybody; and if the book is to be understood, my technical activities must be forgotten. If I were a mountaineer and wrote a book on the subject, I might mention the sunrise, and I should not expect to be reminded that, according to the Copernican theory, the sun does not rise. Some criticisms of my books on social and political questions seem to me something like such a reminder.

Mr. Bode, who writes on my educational philosophy, is the only one of the contributors to this volume whom I recognize as (in an impersonal sense) an enemy. I feel that he and I desire very different kinds of society, and that therefore all agreement between us, except on minor points, is impossible.

His attack would have been more effective if he had read my chief book on the subject, the one which, in England, is called *Education*, but in America, to please a conjectured moralistic public, was re-christened by the publisher *Education and the Good Life*. He has also not read, so far as can be discovered, the chapter on education in *Social Reconstruction*. He dislikes me for being English, for being an aristocrat, for not being a pragmatist, and for agreeing with Christianity (which he does not mention) in attaching importance to the individual.[6] As for the first two, they are not matters of choice; there is something Hitlerite in objecting to people on account of accidents of birth. As for the third, he says that I caricature pragmatism by saying that, according to it, truth is what pays; but this is a verbal quotation from William James. As to the fourth, this is the real crux, and the matter that calls for serious discussion.

His method of controversy is the familiar one of first misrepresenting his opponent's position, and then citing contrary statements as proof of inconsistency. I state, in the book which he has read, that as things are at present there is often a conflict between the educational demands of individual culture and the claims of citizenship. I say that, given a better political and

---

[6] Mr. Brightman finds fault with me for attaching too *little* importance to the individual.

social system, this conflict would not exist; I then state the case
for the two sides. The conclusion at which I arrive, and which
he quotes, is: "Considered *sub specie aeternitatis*, the education
of the individual is to my mind a finer thing than the education
of the citizen; but considered politically, in relation to the needs
of the time, the education of the citizen must, I fear, take first
place." By representing my statement of one side of the case as if
it were my balanced judgment, he makes this conclusion appear
like an inconsistency. I get the impression—though in this *I*
may be guilty of misrepresentation—that Mr. Bode sees no con-
flict because he cares only for citizenship, and sees no point in
individual culture except in so far as it produces better citizens.

"Mr. Russell's educational philosophy," says Mr. Bode, "is
becoming increasingly remote from the requirements of asso-
ciated living in our modern society." But what are "require-
ments?" They are the things that must be done in order to
secure certain ends; they do not exist except in relation to those
ends. If different ends are sought, the "requirements" become
different. Education will be very different according to the ends
sought by educators.

There is a danger in speaking of "*the* community" analogous
to that which results from Hegelian talk about "*the* state." If,
wherever Hegel speaks of *the* state, we substitute *a* state, as
logic demands, the plausibility of his arguments is much dimin-
ished. Similarly when people inculcate loyalty to *the* community
we ought to substitute *a* community. We want our own citizens
to be loyal to their own community, but do we want the Japa-
nese to be loyal to theirs? Should we not rejoice, and think it
a gain to the world, if disaffection became common in Japan?
If so, loyalty to one's own community is a virtue or a vice
according to the character of one's own community and of its
international activities. And, if this is granted, it must be re-
grettable if education destroys a citizen's capacity for justly
estimating his own community in comparison with others.

We are thus compelled to ask: should education fit or unfit
a man for world citizenship? The "requirements of associated
living in our modern society," as interpreted by Mr. Bode,
compel us to say that it should *un*fit a man. That is to say, if

you are fit for world citizenship your freedom from the prejudices of your neighbours will cause you to be thought wicked and anti-social, important persons will fight shy of you, and you will have difficulty in making a living. At any rate this will be true in Germany and Japan, which have adopted Mr. Bode's emphasis on citizenship more whole-heartedly than it has yet been adopted in America or England.

It is an old story. The Germans hated Napoleon and decided to imitate him (Hitler has a picture of him in his study). The Japanese hated the white men, and decided to acquire their vices. We hate the Nazis, but some of us think that we can only defeat them by becoming almost equally fanatical. In saying all this I am not wandering from the point. It is just such considerations which show the danger of a narrow conception of citizenship.

Let us consider for a moment the world that would result from an exclusive emphasis on citizenship in every country of the globe. There would be communities of people totally incapable of understanding the point of view of any community but their own, and therefore unable to view international issues with justice. In negotiations between two Powers, no consideration would be held relevant except the prospect of military victory, and education would have so fostered national vanity that each side would greatly exaggerate its chances of overcoming the other. In such circumstances wars would be frequent, bloody, and fruitless. Apart from war, the citizens would only be interested in collective enterprises; there would therefore be no art, no genuinely original science, and no religion except church-going. All this is already being brought about, in a greater or less degree, by the educational administrators who agree with Mr. Bode.

What is there to set against this powerful trend towards the enslavement of the human spirit? I can see nothing except the old religious emphasis upon the individual, which is an essential part of both Christianity and Buddhism. Perhaps something could be done to make people aware what Christ's teaching was. I suggest that clergymen who have occasion to read in church the parable of the Good Samaritan should substitute for "Sa-

maritan" either "German" or "Japanese." They would thus restore to the parable its original flavour, which it has entirely lost through the fact that we expect a Samaritan to be good. I do not think Mr. Bode would like Christ if He were a younger member of the Faculty of Ohio State University; I fear he would find Him subversive, anarchistic, and unpatriotic. Moreover He would criticize the existing religious institutions.

I come finally to Mr. Hook's essay on my philosophy of history. If it is possible to distinguish between a *philosophy* and a *science* of history, I should say that, while certain departments of history can already be made more or less scientific, and one may hope that many more will be, the attempt to create a *philosophy* of history is a mistake. I should regard men like Hegel, Marx, and Spengler as having a philosophy of history, in the sense that they believe in sweeping laws of historical development, either progressive or cyclic. For such vast laws, I should say, there is not, and never can be, any adequate evidence; they are reflections of our own moods upon the cosmos.

But when I said that history is not a *science*, I ought to have been more careful to limit the statement. There are certain social phenomena, more especially those that are economic or statistical, where to a limited extent scientific laws can be discovered. But the limitations are always important. I remember, as a very young man, reading Goshen's *Foreign Exchanges*. The book delighted my scientific tastes by the precision of its reasoning, and by the fact that the theory which it set forth appeared to be fully confirmed by the facts. As a set of hypothetical propositions it remains true; it has the truth of pure mathematics. But in the real world there is no longer a science of foreign exchanges, which have been swept into the vortex of power politics.

Perhaps an illustration will make my position clearer. The exemplar of scientific success is the Newtonian planetary theory, to which we must now add the very slight emendations made by Einstein. (Slight as concerns observed facts, not as concerns theory.) But suppose meteors were much larger and commoner than they are; in that case the Newtonian theory might still

be true, but planets would be frequently dragged or knocked from their courses by unpredictable encounters, and astronomical prediction would be unreliable. The meteors, in this case, would come under the head of what I call "chance." I do not wish to press the analogy, but merely to illustrate how complexity may defeat science even in a rigidly deterministic universe.

Mr. Hook has kindly summed up his queries at the end of his essay, and I will deal with his points *seriatim*.

(1) "What conditions of validity would historical knowledge have to satisfy, to be adjudged scientific?" The obvious test is prediction. To some slight extent prediction is possible; the present war could be predicted, at any rate after 1933. But prediction is not always scientific. A good horseman can predict the behaviour of his horse, but he does so by sympathetic imagination rather than by science. A skilled negotiator uses the same kind of faculty in foreseeing the response to a proposal that he thinks of making. Successful politicians similarly divine mass-responses. All this is prediction, but it is not science.

In order that a prediction may count as scientific, it must be made explicitly by means of a more or less general law obtained inductively from observed facts. The predictions upon which insurance companies base their scale of premiums satisfy this criterion, and so long as the companies remain solvent I shall admit that science has successfully mastered a certain province of social phenomena. But the field of valid prediction is very limited. What will be the population of the present territory of the United States fifty years hence? It is easy to extrapolate from vital statistics, but it would be rash to feel any certainty as to the validity of the extrapolation. The changes in the birth-rate during the last seventy years in Western Europe and America were foreseen by no one; very likely we are equally blind to future changes in the same or in the opposite sense.

It is easy to practise prediction *ex post facto*, and to show that people ought to have expected what occurred. But in this process there is usually something lacking in intellectual sincerity, unless prediction to what is still the future can be practised with equal success. We can now see the causes of the rise

of totalitarian states, but no one (or at most a few lucky guessers) predicted it before 1917. Until then whatever was revolutionary was expected to be democratic; a revolution such as Hitler's was no part of the forecast of those who professed to be scientific.

(2) Mr. Hook next asks what I mean by economic causes in history. I cannot see that there is much difficulty about this. There is first and foremost the technique of production; then there are the laws and customs regulating distribution; then there are raw materials such as the existing technique can utilize. Among causes of change one cannot include economic motives which are constant, but must include exceptional economic discontent, which is a psychological factor. Whether discontent will be an effective cause of change depends upon many factors, some of them not economic. From Spartacus to the Russian Revolution of 1905, history is full of revolts that failed. Sometimes the difference between success or failure may turn on generalship; it may be doubted whether Parliament would have been victorious in the English Civil War but for Cromwell's military skill. In such cases, economic issues may be decided by causes which are in part not economic.

(3) In the history of the last hundred and fifty years, the technique of machine production overshadows everything else as a cause of change; so at least I think. And I think that its potency in this respect is likely to be at least as great during the next hundred and fifty years. I am of course including its effect upon the art of war.

It may be worth while to mention a few of the effects of industrialism. First: a much smaller proportion of the total labour-power of the human race is needed for the production of necessaries; consequently much more is spent on luxuries. The luxury on which most is spent is war; perhaps the next largest item is education. The changes due to the creation of a literate population are very great: they appear especially in the growth of journalism and propaganda. Second: an industrial population is more urban than an agricultural one. The change of habits weakens the force of traditional religion and morals, and has led among other things to the revolutionary

change in the status of women. Third: a portion of the labour liberated from the production of necessaries is spent on new inventions and discoveries; the result is that change is much more rapid than at any former time, and that people who are no longer young live in a world to which their habits are not adapted. This means that the gulf between generations is greater than it used to be. Obviously one could go on through a long volume tracing such effects, but I have said enough to show how much I agree with Marx in this matter.

(4) What is the source of ideas, such as nationalism, which, in my opinion, do not primarily have economic causes?

Here one must distinguish: given the division of the world into nations, economic interests quickly become associated with each nation, and subsequent rivalry may have mainly economic causes. But it is not economic causes that determine the division of mankind into nations. A nation is a unit defined by sentiment, of which the foundation is love of the soil and of what is familiar. But this may or may not develop into nationalism. The stock example is Ireland, as contrasted with the Highlands of Scotland. Their economic circumstances were closely similar, yet after 1745 the Highlanders became part and parcel of the British nation, as much in feeling as in politics, while the Irish never did. The massacre of Glencoe was an atrocity comparable to those of Cromwell in Ireland, but did not leave the same bitterness. I think the main cause of this difference was that the Highlanders became Protestants while the Irish did not. This difference, of course, had its causes, but I do not think they were economic.

The usual genesis of nationalism is as follows: first there is a common peril or a common misfortune; usually geographical propinquity is what causes it to be common. Out of this grows a sympathy for those who share our own peril or misfortune, and probably a common effort to avert it. Thus a community is cemented by coöperation and a common hatred of the enemy. If resistance is successful, or even if it is gloriously unsuccessful, a heroic myth grows up, and is taught to children as soon as they can understand it. In pursuit of the triumph of right, the newly victorious nation inflicts well-merited punishment on its

former oppressors, or at least hopes to do so. If it succeeds, not only is justice vindicated, but wealth accrues to the champions of righteousness, showing that God is on their side. Since education became common, the schools have been found very useful in inculcating these moral sentiments. Aggressive nationalism is quite as full of lofty morality as the defensive sort. Subjectively, the sentiments involved are not those of pecuniary gain, except on the part of a comparatively small minority; indeed, the men who risk death in aggressive war are seldom the men who profit by it.

Nationalism seems to me analogous to the solidarity of members of a creed or party. This kind of solidarity, also, has been a frequent cause of wars; here also the economic motive is secondary. The Albigensians, for instance, would have been much richer if they had allowed themselves to become Catholic, and their motives for not doing so cannot be held to have been economic.

The causes of group-solidarities lie deep in human nature, and are not to be explained by the self-interest psychology of the early nineteenth century. I do not profess to be able to explain them at all fully myself, and most suggested explanations seem to me to introduce questionable mythology.

(5) What do I mean by a "chance" event? I mean one of which the causation is unknown. "Chance" decides whether an expected child turns out to be a boy or a girl, and "chance" decides which of the hereditary possibilities that Mendelian principles allow will be realized. But when we deal with large groups, "chance" no longer decides: there will be about twenty-one boys to twenty girls, if I remember aright. In this sense I should regard the birth of Napoleon as a "chance" event. We do not know why a man of supreme military genius was born in Corsica at that time. And if France had had to rely upon generals no better than the average, the history of the period from 1794 to 1815 might have been very different from what it was.

The best example I know of a "chance" event which had large consequences is one which has been admirably used by Mr. Hook; I mean, the German decision in 1917 to allow

Lenin to go to Russia. I call this a "chance" event because, obviously, the German government must have thought of strong reasons on each side, and might just as easily, so far as we can see, have come to a contrary decision.

(6) Mr. Hook finds fault with me for saying that if a hundred men of the seventeenth century had died in infancy the modern world would not exist. I am prepared to concede that a hundred is too small a number, but the principle would remain if we substituted a hundred thousand. Let us argue the matter on the assumption that this substitution is made.

Consider one simple fact: that the wheel was unknown in America until white men introduced it. No doubt the wheel was the product of an evolution which took a considerable time, but each step required brains, and among the Indians the necessary brains did not happen to occur. To take a more extreme instance: monkeys in a given environment do not develop the same productive technique as men do, and the difference is obviously due to the greater intelligence of men. Intelligence is therefore a *vera causa*. In history, it is remarkable how localized great advances have been. Mathematics, though the early Babylonians reached a certain point, is almost entirely a Greek invention; if the Greeks had not existed, there is no reason to suppose that anything analogous to Euclid's *Elements* would have been written in antiquity, still less during the middle ages. And the Greeks who made mathematical discoveries were a very small number of men. Modern science also owes its inception to a very small number of men, of whom Copernicus, Kepler, and Galileo are the chief. There was no good reason, except the accidental absence of exceptional genius, for the failure of the Arabs during the middle ages to make the discoveries of the sixteenth and seventeenth centuries. It is such facts that make me attach importance to intelligence as a cause of technique—and, moreover, to intelligence which (as in later antiquity) may not be forthcoming when the opportunity for its exercise exists in the environment.

(7) I come at last to the question of moral judgments. As a fundamental problem of ethics I have considered this question in an earlier part of this reply; at the moment, I propose

to offer a more political answer, which raises no fundamental issues. The political systems that I most dislike have the quality of being, in practice, self-refuting; that is to say, those who try to establish them are almost certain to fail. (I have set forth this point of view briefly in *Power*, Chapter XVI.) An aristocracy cannot long retain power except by consent, and consent will not be obtained without certain virtues. In the modern world, the beliefs that led men to submit to aristocracies have lost their force, and a new aristocracy, such as that of the Nazis, rouses so much opposition that it has little chance of permanent success. If you desire a political career which is not to end on the scaffold or in St. Helena, you must be a little careful not to offend the mass of mankind too deeply. I do not say that I should imitate Hitler even if I were sure of success, but that is because my desires are different from his. What I hold practically is something like Leibniz's maximum of compossibles. I regard the satisfaction of desire as *per se* good, no matter what or whose the desire; sometimes desires are compatible, sometimes not. If A and B desire to marry each other, both can be satisfied; if each desires to murder the other without being murdered, at least one must be disappointed. Therefore marriage is better than murder, and love is better than hate.

This, of course, does not go to the root of the matter. Why should I think all satisfaction of desire good? Only owing to an emotion of benevolence. It is therefore circular to deduce the excellence of benevolence from the principle that satisfaction of desire is good. It is, however, not circular, but sound sense, to say to a group of people, or to the whole human race: you are more likely to be happy, and to get what you desire, if you desire things which you can obtain without injuring other people, and if other people's desires also have this character. It might, on this ground, be held that a Nietzschean ethic is foolish, since, if it is held by every one, no one will get any good out of it. Perhaps in this way one might evade fundamental issues. I have, however, no wish to do so, and will therefore refer Mr. Hook to what I said in reply to Mr. Buchler and Mr. Brightman.

There is one thing more that I have to say about history,

although it does not arise out of Mr. Hook's essay. Historical facts often have intrinsic interest, quite independently of their causal connections. Whether history is a science or not, it certainly can be an art, and I, for my part, value it quite as much for its intrinsic interest as for what it can establish in the way of causal laws. I value it also for the knowledge it gives of human beings in circumstances very different from our own—not mainly analytic scientific knowledge, but the sort of knowledge that a dog-lover has of his dog. History has perhaps its greatest value in enlarging the world of our imagination, making us, in thought and feeling, citizens of a larger universe than that of our daily preoccupations. In this way it contributes not only to knowledge, but to wisdom.

NOTE: Dr. Gödel's most interesting paper on my mathematical logic came into my hands after my replies had been completed, and at a time when I had no leisure to work on it. As it is now about eighteen years since I last worked on mathematical logic, it would have taken me a long time to form a critical estimate of Dr. Gödel's opinions. His great ability, as shown in his previous work, makes me think it highly probable that many of his criticisms of me are justified. The writing of *Principia Mathematica* was completed thirty-three years ago, and obviously, in view of subsequent advances in the subject, it needs amending in various ways. If I had the leisure, I should be glad to attempt a revision of its introductory portions, but external circumstances make this impossible. I must therefore ask the reader to give Dr. Gödel's work the attention that it deserves, and to form his own critical judgment on it.

*Bertrand Russell*

BRYN MAWR, PENNSYLVANIA
JULY, 1943

# BIBLIOGRAPHY OF THE WRITINGS OF BERTRAND RUSSELL

## To 1951

*Compiled by*
LESTER E. DENONN

# PREFACE TO THE BIBLIOGRAPHY

EXCUSE for this bibliography by an amateur requires passing personal reference. It is primarily and literally a home-made affair except for most of the periodical data. A statement read about ten years ago in an article by the late Dean Bouton of New York University, in which he suggested that one should pick some author, some topic, or some period to centralize book hunting, led to my choice of the works of Bertrand Russell as the foundation for my growing philosophy library. I then had five or six of his works. I now own sixty-five volumes written by him or to which he contributed, most of which were picked up at random wherever business or pleasure brought me and each contributed the thrill of "another Russell." Hence when Professor Schilpp kindly consented to my preparing the bibliography for this volume, I had much of the material at my elbow. The folly of the choice of a bibliographer who had nothing more than these books and his enthusiasm to offer is his; the mistakes of commission and omission are entirely mine.

Among the known omissions, of which brief mention can be made, are a series of weekly syndicated articles submitted for a period of two years to the *New York American* and an unknown number of articles written for causes and campaigns, like women's suffrage, distributed in pamphlet form by now defunct organizations. I had hoped to find it possible to enlist the aid of some undergraduate in the philosophy department of Trinity College, Cambridge, to try to dig out some of these items together with additional contributions to the Cambridge Magazine, but I found none who could spare the time from war pursuits.

I know of three prior bibliographies of the works of Bertrand Russell. The first appeared in 1929-1930 by Gertrude Jacob of Oberlin College, printed in the *Bulletin of Bibliography and Dramatic Index* under the title, "An Essay Toward a Bibliography." My thanks are due to The F. W. Faxon Company, the publishers thereof, for their kindness in sending me the issues,

when I found the New York Public Library copies mutilated, peculiarly enough solely at the Russell pages. Prior to my receipt thereof, I had gathered most of the material therein. I found it necessary to correct a few items. I verified all and have added considerably to the items listed. Professor Edgar S. Brightman, Chairman of the Boston University Graduate School, kindly loaned me his typescript of a bibliography prepared by associates in the Department of Philosophy. I deeply appreciate his thoughtfulness in sending me this work and acknowledge its aid in supplying some valuable leads. The third bibliography appeared in *Who's Who in Philosophy,* published in 1942 by Philosophical Library, Inc. That was prepared by me and contains such of the material gathered for the present work as came within the compass of the *Who's Who.*

My chief thanks are due to Mr. Russell himself, to whom I owe gratitude for the unforgettable pleasure of a charming afternoon in which he reminiscingly reviewed the material I then had and gave me many valuable hints for additional items.

My wife genially shared the labors of proof-reading.

It is hoped that the chronological list of principal works will add to the value of the bibliography and serve as a further reminder of the versatility and genius of the subject.

LESTER E. DENONN

NEW YORK CITY
*September 1943*

## PREFACE TO THE THIRD EDITION

IN the elapse of almost six years since the Second Edition, Earl Russell has continued to be amazingly prolific to the extent that a bibliographer can not be certain that he has all the entries for even so short a span of a tremendously productive life. These years have justly, though belatedly, crowned his achievements with the Order of Merit and the Nobel Prize for Literature, the latter a singularly notable award for a philosopher.

Reference to a great many of the translations of Russell's works has been added and a number of items have been recovered for prior years through further research at the Library of Congress and elsewhere, as opportunity presented, but the most gratifying results have come from the hints and clues furnished by alert friends.

Lester E. Denonn

NEW YORK CITY
*June 1951*

# WRITINGS OF BERTRAND RUSSELL

*Asterisk preceding entry—see Addenda to Bibliography.

## 1895

*1.* REVIEW of G. Heymans' *Die Gesetze und Elemente des Wissenschaftlichen Denkens. Mind,* New Series, v. IV, 1895, pp. 245-249.

## 1896

*1.* GERMAN SOCIAL DEMOCRACY. (v. 7 of *Studies in Economics and Political Science.*) London, New York, Bombay: Longmans, Green & Company, 1896. 204 pp.

> Lectures given at London School of Economics and Political Science, 1896. Contents: I. Marx and the Theoretic Basis of Social Democracy—II. Lassalle—III. History of German Socialism from the Death of Lassalle to the Passing of the Exceptional Law, 1878—IV. Social Democracy under the Exceptional Law, 1878-1890—V. Organization, Agitation, Tactics, and Programme of Social Democracy since the Fall of the Socialist Law—VI. The Present Position of Social Democracy. Appendix: Social Democracy and the Woman Question in Germany by Alys Russell.

*2.* THE A PRIORI IN GEOMETRY. *Proceedings Aristotelian Society.* London, Williams & Norgate, v. III, 1896, pp. 97-112.

> Captions: I. The Axiom of Free Mobility—II. The Axiom of Dimensions.

*3.* THE LOGIC OF GEOMETRY. *Mind,* New Series, v. V, 1896, pp. 1-23.

> Captions: I. The Axiom of Consequence—A. Philosophical Argument—B. Geometrical Argument—II. The Axiom of Dimensions—III. The Straight Line.

*4.* REVIEW of A. Hannequin's *Essai critique sur l'hypothese des atoms dans la Science contemporaine. Mind,* New Series, v. V, 1896, pp. 410-417.

*5.* ON THE RELATIONS OF NUMBER AND QUANTITY. *Mind,* New Series, v. VI, 1896, pp. 326-341.

## 1897

*1.* AN ESSAY ON THE FOUNDATIONS OF GEOMETRY. Cambridge, at the University Press, 1897. 201 pp.

Contents: Introduction—Our Problem Defined by its Relation to Logic, Psychology and Mathematics—I. A Short History of Metageometry—II. Critical Account of Some Previous Philosophical Theories of Geometry—III. Sec. A. The Axioms of Projective Geometry. Sec. B. The Axioms of Metrical Geometry—IV. Philosophical Consequences.

Translated by M. Cadenat, *Essai sur les fondements de la Geometrie.* Gautier-Villars, 1901. pp. 274.

*2.* REVIEW of L. Couturat's *De l'infini mathematique. Mind,* New Series, v. VI, 1897, pp. 112-119.

## 1898

*1.* LES AXIOMES PROPRES A EUCLIDE SONT-ILS EMPIRIQUES? *Revue de Metaphysique et de Morale,* v. 6, pp. 759-776.

*2.* REVIEW of A. E. H. Love's *Theoretical Mechanics: an Introductory Treatise on the Theory of Mechanics. Mind,* New Series, v. VII, 1898, pp. 404-411.

## 1899

*1.* SUR LES AXIOMES DE LA GEOMETRIE. *Revue de Metaphysique et de Morale,* 1899, pp. 684-707.

*2.* REVIEW of A. Meinong's *Ueber die Bedeutung des Weberschen Gesetzes. Mind,* New Series, v. VIII, 1899, pp. 251-256.

## 1900

*1.* A CRITICAL EXPOSITION OF THE PHILOSOPHY OF LEIBNIZ: WITH AN APPENDIX OF LEADING PASSAGES. Cambridge, at the University Press, 1900. xvi, 311 pp.

Second Edition (with a new preface): London, George Allen & Unwin, Ltd., 1937, xv, 311 pp.

Contents: Preface—I. Leibniz's Premisses—II. Necessary Propositions and the Law of Contradiction—III. Contingent Propositions and the Law of Sufficient Reason—IV. The Conception of Substance—V. The Identity of Indiscernibles and the Law of Continuity, Possibility and Compossibility—VI. Why Did Leibniz Believe in an External World?—VII. The Philosophy of Matter: (a) As the Outcome of the Principles of Dynamics—VIII. The Philosophy of Matter: (b) As Explaining Continuity and Extension—IX. The Labyrinth of the Continuum—X. The Theory of Space and Time and Its Relation to Monadism—XI. The Nature of Monads in General—XII. Soul and Body—XIII. Confused and Unconscious Perception—XIV. Leib-

niz's Theory of Knowledge—XV. Proofs of the Existence of God—XVI. Leibniz's Ethics. Appendix.

Translated into French, 1908.

## 1901

*1.* L'Idee d'Ordre et la Position Absolute dans L'Espace et le Temps. Paris. *Congrès international de philosophie, logique et historie des sciences,* 1901, pp. 241-277.

2. Recent Works on the Principles of Mathematics. *The International Monthly,* v. 4, July 1901, pp. 83-101.

Reprinted under the title, "Mathematics and the Metaphysicians," (with six footnotes added in 1917) in *Mysticism and Logic,* Chp. V (1918).

*3.* On the Notion of Order. *Mind,* New Series, v. X, 1901, pp. 30-51.

*4.* Is Position in Time and Space Absolute or Relative? *Mind,* New Series, v. X, 1901, pp. 293-317.

*5.* Review of W. Hastie's translation of Kant's *Cosmogony. Mind,* New Series, v. X, 1901, pp. 405-407.

## 1902

*1.* Review of P. Boutroux's *L'Imagination et les mathematiques selon Descartes. Mind,* New Series, v. XI, 1902, pp. 108-109.

2. Sur la logique des relations avec des applications à la théorie des séries. *Revue de Mathem.* (Turin), v. 8, 1902. pp. 12-43.

## 1903

\* *1.* The Principles of Mathematics. Cambridge, at the University Press, 1903. ix, 534 pp.

Second Edition (with a new Introduction pp. v-xiv), 1938: New York, W. W. Norton & Company, Inc.; London, George Allen & Unwin, Ltd.; London, McLeod, xxxix, 534 pp.

Contents: *Part I. The Indefinables of Mathematics*—I. Definition of Pure Mathematics—II. Symbolic Logic—III. Implication and Formal Implications—IV. Proper Names, Adjectives and Verbs—V. Denoting—VI. Classes—VII. Propositional Functions—VIII. The Variable—IX. Relations—X. The Contradiction—*Part II. Number*—XI. Definition of Cardinal Numbers—XII. Addition and Multiplication—XIII. Finite and Infinite—XIV. Theory of Finite Numbers—XV. Addition of Terms and Addition of Classes—XVI. Whole and Part—XVII. Infinite Wholes—XVIII. Ratios and Fractions—

\* 2. THE FREE MAN'S WORSHIP. *The Independent Review*, v. I, Dec. 1903, pp. 415-424.

Published also: with a special preface by Bertrand Russell, Portland, Maine, Thomas Bird Mosher, 1923, xvii, 28 pp. Second Edition, 1927.

Reprinted: in *Philosophical Essays*, London, New York, Bombay, and Calcutta, Longmans, Green & Co., 1910, Chp. III. *Mysticism and Logic*, New York, Bombay, Calcutta, Madras, Longmans, Green & Co. 1918, Chp. III. *Selected Papers of Bertrand Russell*, New York, The Modern Library, Inc., 1927, Chp. I. *Little Blue Books*, as "What Can A Free Man Worship?", Haldeman-Julius Publications, Girard, Kansas, #677, 1927, 32 pp.

Other Reprints: in *Ideals of Science and Faith*, as "An Ethical Approach," edited by Rev. J. E. Hand, New York, Longmans, Green & Co.; London, George Allen, 1924, pp. 157-169. *Further Adventures in Essay Reading*, as "A Free Man's Worship," New York, Harcourt, 1928, pp. 517-528. *Essays from Five Centuries*, Boston, Houghton, Mifflin, 1929, pp. 404-412. *Essays toward Truth*, New York, New York, Henry Holt & Co., 1929, pp. 175-185. *Familiar Essays*, New York, Prentice-Hall, 1930, pp. 498-508. *Modern Writers at Work*, New York, Macmillan, 1930, pp. 9-22. *Pageant of Prose*, New York, Harper, 1935, pp. 257-263. *Fifty Essays*, New York, Little Brown & Co., 1936, pp. 320-331. *Modern Reader*, New York, Heath, 1936, pp. 417-424.

Excerpts: in *Golden Book Magazine*, v. 19, Feb. 1934, p. 156.

3. RECENT WORKS ON THE PHILOSOPHY OF LEIBNIZ. *Mind,* New Series, v. XII, 1903, pp. 177-201.

Critical notice of L. Coutourat's *La Logique de Leibniz d'apres des documents inedits,* and E. Cassirer's *Leibniz' System in seinen wissenschaftlichen Grundlagen.*

### 1904

1. LITERATURE OF THE FISCAL CONTROVERSY. *Independent Review,* v. 1, Jan. 1904, pp. 684-688.

Review of Ashley's *The Tariff Problem* and Pigou's *The Riddle of the Tariff.*

2. MR. CHARLES BOOTH'S PROPOSALS FOR FISCAL REFORM. *Contemporary Review,* v. 85, Feb. 1904, pp. 198-206.

3. MEINONG'S THEORY OF COMPLEXES AND ASSUMPTIONS. *Mind,* New Series, v. XIII, 1904; I. pp. 204-219; II. pp. 336-354; III. pp. 509-524.

4. NON-EUCLIDIAN GEOMETRY. *Athenaeum,* v. 124, 1904, pp. 592-593.

Reply to criticism of his *Essay on the Foundations of Geometry.*

5. REVIEW of G. E. Moore's *Principia Ethica. Independent Review,* v. 11, March 1904, pp. 328-333.

6. ON HISTORY. *The Independent Review,* v. III, July 1904, pp. 207-215.

### 1905

1. THE ESSENTIAL IMPORT OF PROPOSITIONS. *Mind,* New Series, v XIV, 1905, pp. 398-401.

Discussion of Paper of Hugh MacColl.

2. REVIEW of H. Poincaré's *Science and Hypothesis. Mind,* New Series, v. XIV, 1905, pp. 412-418.

* 3. ON DENOTING. *Mind,* New Series, v. XIV, 1905, pp. 479-493.

4. REVIEW of A. Meinong's *Untersuchungen zur Gegenstandstheorie und Psychologie. Mind,* New Series, v. XIV, 1905, pp. 530-538.

5. SUR LA RELATION DES MATHÉMATIQUES A LA LOGISTIQUE (avec note de M. A. N. Whitehead). *Revue de Metaphysique et de Morale,* v. 13, 1905. pp. 906-917.

# 1906

*1.* ON SOME DIFFICULTIES IN THE THEORY OF TRANSFINITE NUM-
BERS AND ORDER TYPES. *Proceedings London Mathematical So-
ciety*, Series 2, v. 4, March 7, 1907, pp. 29-53.

*2.* THE THEORY OF IMPLICATION. *American Journal of Mathe-
matics*, v. 28, 1906, pp. 159-202.

> Captions: 1. Primitive Ideas—2. Primitive Propositions—3. Elementary
> Properties—4. Multiplication and Addition—5. Formal Rules—6. Miscel-
> laneous Propositions—7. Propositions Concerning all Values of the Vari-
> ables.

*3.* REPLY TO POINCARÉ'S LETTER, NOTE. *Mind*, New Series, v. XV,
1906, p. 143.

> Reply to Poincaré's comment on Russell's Review, cf. 1905, 2.

*4.* REVIEW of H. MacColl's *Symbolic Logic and Its Applications*.
*Mind*, New Series, v. XV, 1906, pp. 255-260.

*5.* THE NATURE OF TRUTH. *Mind*, New Series, v. XV, 1906, pp.
528-533.

> Reprinted: in *Philosophical Essays*, 1910, first two sections as "The Monistic
> Theory of Truth," and third section rewritten as "On the Nature of Truth
> and Falsehood."

*6.* LES PARADOXES DE LA LOGIQUE. *Revue de Metaphysique et de
Morale*, v. 14, 1906. pp. 627-650.

# 1907

*1.* ON THE NATURE OF TRUTH. *Proceedings Aristotelian Society*,
New Series, London, Williams & Norgate, v. VII, 1906-1907, pp.
28-49.

*2.* THE STUDY OF MATHEMATICS. *New Quarterly*, Nov. 1907.

> Reprinted: in *Philosophical Essays*, 1910, Chp. III. *Mysticism and Logic*,
> 1918, Chp. IV.

*3.* REVIEW of A. Meinong's *Über die Stellung der Gegenstandsthe-
orie im System der Wissenschaften*. *Mind*, New Series, v. XVI,
1907, pp. 436-439.

# 1908

*1.* TRANSATLANTIC 'TRUTH'. *Albany Review*, v. II, No. 10, Jan.
1908, pp. 393-410.

> Reprinted: in *Philosophical Essays*, as "William James's Conception of Truth,"
> 1910, Chp. V.

2. LIBERALISM AND WOMEN'S SUFFRAGE. *Contemporary Review*, v. 94, July 1908, pp. 11-16.

3. DETERMINISM AND MORALS. *Hibbert Journal*, v. 7, Oct. 1908, pp. 113-121.

Reprinted: in *Philosophical Essays*, as "The Elements of Ethics," 1910, Chp. I.

4. MATHEMATICAL LOGIC AS BASED ON THE THEORY OF TYPE. *American Journal of Mathematics*, v. 30, 1908, pp. 222-262.

Captions: I. The Contradictions—II. All and Any—III. The Meaning and Range of Generalized Propositions—IV. The Hierarchy of Types—V. The Axiom of Reducibility—VI. Positive Ideas and Propositions of Symbolic Logic—VII. Elementary Theorie of Classes and Relations—VII. Descriptive Functions—IX. Cardinal Numbers—X. Ordinal Numbers.

5. MR. HALDANE ON INFINITY. *Mind*, New Series, v. XVII, 1908, pp. 238-242.

On Haldane's Presidential Address to Aristotelian Society on "The Methods of Modern Logic and the Conception of Infinity," 1907.

6. "IF" AND "IMPLY." *Mind*, New Series, v. XVII, 1908, p. 300.

A reply to Mr. MacColl.

### 1909

1. PRAGMATISM. *Edinburgh Review*, v. CCIX, No. CCCCXXVIII, Apr. 1909, pp. 363-388.

Review of James' *The Will to Believe* and *Pragmatism*; of Schiller's *Philosophical Essays* and *Studies in Humanism*; of Dewey's *Studies in Logical Theory*; and *Columbia University Essays, Philosophical, and Psychological in Honor of William James*, 1908.

Reprinted: in *Philosophical Essays*, 1910, Chp. IV.

### 1910

1. PRINCIPIA MATHEMATICA. v. I, with Alfred North Whitehead. Cambridge, at the University Press, 1910. xlvi, 674 pp. Second Edition, 1935.

Contents: Preface. Alphabetical List of Propositions Referred to by Names— I. Preliminary Explanation of Ideas and Notations—II. Theory of Logical Types—III. Incomplete Symbols—Part I. Mathematical Logic—Summary of Part I—Sec. A. The Theory of Deduction—B. Theory of Apparent Variables—C. Classes and Relations—D. Logic of Relations—E. Products and Sums of Classes—Part II. Cardinal Arithmetic—Summary of Part II. Sec. A. Unit Classes and Couples—B. Sub-Classes, Sub-Relations and Relative Types—C. One-Many, Many-One, and One-One Relations—D. Selections—

E. Inductive Relations—Appendix A. The Theory of Deduction for Propositions Containing Apparent Variables—B. Mathematical Induction—C. Truth-Functions and Others. List of Definitions.

2. PHILOSOPHICAL ESSAYS. London, New York, Bombay and Calcutta, Longmans, Green & Co., 1910. vi, 185 pp. See also *Mysticism and Logic*, 1918.

Contents: I. The Elements of Ethics (1908)—II. The Free Man's Worship (1903)—III. The Study of Mathematics (1907)—IV. Pragmatism (1909)—V. William James's Conception of Truth (1908)—VI. The Monistic Theory of Truth (1906)—VII. On the Nature of Truth and Falsehood (1906).

3. ANTI-SUFFRAGIST ANXIETIES. *People's Suffrage Federation*, June 1910.

4. THE PHILOSOPHY OF WILLIAM JAMES. *Living Age*, v. 267, Oct. 1, 1910, pp. 52-55.

Written after the death of James.

5. SOME EXPLANATIONS IN REPLY TO MR. BRADLEY. *Mind*, New Series, v. XIX, 1910, pp. 373-378.

Reply to a review of *The Principles of Mathematics*.

6. ETHICS. *New Quarterly*, v. 3, Feb. 1910, pp. 21-34; May, pp. 131-143.

Captions: I. The Subject Matter of Ethics—II. The Meaning of Good and Bad—III. Right and Wrong—IV. Egoism.

Reprinted: in *Philosophical Essays*, as "The Elements of Ethics," 1910, Chp. I.

7. LA THÉORIE DES TYPES LOGIQUES. *Revue de Metaphysique et de Morale*, v. 18, 1910. pp. 263-301.

I. La nature des fonctions propositionnelles. II. Définition et systématique ambiguité des notions de verite et d'erreur. III. Pourquoi une fonction donnée requiert des arguments d'un certain type. IV. La hiérarchie des fonctions et propositions. V. L'axiome de réductibilité. VI. La théorie des classes. VII. Raisons pour accepter l'axiome de réductibilité.

## 1911

1. THE BASIS OF REALISM. *Journal of Philosophy, Psychology, and Scientific Method*, v. VIII, No. 6, March 16, 1911, pp. 158-161.

2. L'IMPORTANCE PHILOSOPHIQUE DE LA LOGISTIQUE. *Revue de Metaphysique et de Morale*, v. 19, 1911. pp. 281-294.

Address: a l'École des Hautes Études sociales, Mar. 22, 1911. See Item #5, 1913 for reference to English translation of this address.

3. KNOWLEDGE BY ACQUAINTANCE AND KNOWLEDGE BY DESCRIPTION. *Proceedings Aristotelian Society*, New Series, v. XI, 1910-1911, pp. 108-128.

Reprinted: in *The Problems of Philosophy*, 1912, Chp. V. *Mysticism and Logic*, 1918, Chp. X.

### 1912

1. PRINCIPIA MATHEMATICA. v. II. With Alfred North Whitehead. Cambridge, at the University Press, 1912. xxxi, 742 pp. Second Edition, 1927.

Contents: Prefatory Statement of Symbolic Conception—Part III. Cardinal Arithmetic—Summary of Part III. Sec. A. Definition and Logical Properties of Cardinal Numbers—B. Addition, Multiplication and Exponentiation—C. Finite and Infinite—Part IV. Relation Arithmetic—Summary of Part IV. Sec. A. Ordinal Similarity and Relation Numbers—B. Additions of Relations, and the Product of Two Relations—C. The Principle of First Differences and the Multiplication and Exponentiation of Relation—D. Arithmetic of Relation Numbers—Part V. Series—Summary of Part V. Sec. A. General Theory of Series—B. On Sections, Segments, Stretches, and Derivatives—C. On Convergence, and the Limits of Function.

2. THE PROBLEMS OF PHILOSOPHY. London, William & Norgate, 1912; New York, Henry Holt & Co., 1912. Home University Library. viii, 255 pp.

Contents: Preface—I. Appearance and Reality—II. The Existence of Matter —III. The Nature of Matter—IV. Idealism—V. Knowledge by Acquaintance and Knowledge by Description (1911)—VI. On Induction—VII. On Our Knowledge of General Principles—VIII. How *a priori* Knowledge Is Possible—IX. The World of Universals—X. On Our Knowledge of Universals—XI. On Intuitive Knowledge—XII. Truth and Falsehood—XIII. Knowledge, Error and Probable Opinion—XIV. The Limits of Philosophical Knowledge—XV. The Value of Philosophy. Index.

Translations: in Spanish, *Los Problems de la Filosofia*, translated by Joaquin Xirau, Barcelona, Buenos Aires, Editorial Labor, S.A., *Biblioteca de Iniciacion Cultural*, 1928, reprinted in 1937, 191 pp.; in Polish, *Zagadnienia Filozofii*, translated by Ludwig Silberstein, Oryginaln Angielskiego, Warsaw, H. Altenberg, 1913, 145 pp. Biblioteka naukona Wendego.

3. ON THE RELATION OF UNIVERSALS AND PARTICULARS. *Proceedings Aristotelian Society*, New Series, v. XII, 1912, pp. 1-24.

4. THE ESSENCE OF RELIGION. *Hibbert Journal*, v. 11, Oct. 1912, pp. 46-62.

Captions: 1. Worship—2. Acquiescence—3. Love.

5. THE PHILOSOPHY OF BERGSON. *Monist*, v. 22, July 1912, pp. 321-347.

Discusses *Creative Evolution, Matter and Memory,* and *Time and Free Will.*

Reprinted: in *The Philosophy of Bergson,* 1914.

6. WHEN SHOULD MARRIAGE BE DISSOLVED? *The English Review,* v. XII, August 1912, pp. 133-141.

7. RESPONSE A M. KOYRE. *Revue de Metaphysique et de Morale,* v. 20, 1912. pp. 725-726.

In response to M. Koyre's "Sur les nombres de M. Russell," appearing in the immediately preceding pages, 722-724.

## 1913

*1.* PRINCIPIA MATHEMATICA. v. III. With Alfred North Whitehead. Cambridge, at the University Press, 1913. viii, 491 pp. Second Edition, 1927.

Contents: Preface—Part V. Series (Cont'd.)—Sec. D. Well Ordered Series —E. Finite and Infinite Series and Ordinals—F. Compact Series, Rational Series, and Continuous Series—Part VI. Quantity—Summary of Part VI. Sec. A. Generalization of Number—B. Vector-Families—C. Measurement— D. Cyclic Families.

*2.* ON THE NOTION OF CAUSE. *Proceedings Aristotelian Society,* v. XIII, 1912-1913, pp. 1-26.

Reprinted: in *Mysticism and Logic,* 1918, Chp. IX.

*3.* MR. WILDON CARR'S DEFENCE OF BERGSON. *The Cambridge Magazine,* Apr. 26, 1913.

Reply to Carr's Article in *The Cambridge Magazine,* Apr. 12, 1913.

Reprinted: in *The Philosophy of Bergson,* 1914.

*4.* THE PLACE OF SCIENCE IN A LIBERAL EDUCATION. (Original title: "Science As An Element in Culture") *The New Statesman and Nation,* v. I, May 24 and 31, 1913, pp. 202-204, 234-236.

Reprinted: in *Mysticism and Logic,* 1918 (*1*), Chp. II; *Contemporary Essays* (ed. by O. Shepard, New York, Scribner, 1929), pp. 250-262; *Essays for Our Day* (ed. by Shackelford and Gass, New York, W. W. Norton, 1931), pp. 249-258.

*5.* THE PHILOSOPHICAL IMPORTANCE OF MATHEMATICAL LOGIC. *Monist,* v. 23, Oct. 1913, pp. 481-493.

Lecture delivered in French at Ecole des Hautes Etudes Sociales, Mar. 22, 1911.

Translated from *Revue de Metaphysique et de Morale*, 1911, by P. E. B. Jourdain and revised by Russell.

See Item #2, 1911.

6. THE NATURE OF SENSE-DATA—A REPLY TO DR. DAWES HICKS. *Mind*, New Series, v. XXII, 1913, pp. 76-81.

## 1914

*1.* OUR KNOWLEDGE OF THE EXTERNAL WORLD AS A FIELD FOR SCIENTIFIC METHOD IN PHILOSOPHY. London, George Allen & Unwin, Ltd., 1914; Chicago and London, The Open Court Publishing Co., 1914. ix, 245 pp. Revised Edition, 1929, George Allen & Unwin, Ltd. and W. W. Norton & Co., Inc. ix, 268 pp.

The Lowell Lectures given in Boston in March and April, 1914.

Contents: Preface—I. Current Tendencies (cf. 1927, *4*)—II. Logic as the Essence of Philosophy—III. On Our Knowledge of the External World—IV. The World of Physics and the World of Sense—V. The Theory of Continuity—VI. The Problem of Infinity Considered Historically—VII. The Positive Theory of Infinity—VIII. On the Notion of Cause, with Application to the Free-Will Problem. Index.

Translated into German.

* *2.* THE PHILOSOPHY OF BERGSON. London, Macmillan & Co., Ltd., 1914; Glasgow, Jas. MacLehose and Sons, 1914. Published for *The Heretics* by Bowes & Bowes, Cambridge, 1914.

Read before the Heretics in Trinity College, March 11, 1913.

*3.* PREFACE to Henri Poincaré's *Science and Method*. London, Edinburgh, Dublin, and New York, T. Nelson & Sons, 1914, pp. 5-8.

Translated by Francis Maitland.

*4.* SCIENTIFIC METHOD IN PHILOSOPHY. Oxford, The Clarendon Press, 1914, 25 pp.

Oxford Lectures in Philosophy. The Herbert Spencer Lecture, delivered at the Museum, Nov. 18, 1914.

Reprinted: in *Decennial Volume*, Oxford, at the Clarendon Press, 1916. 30 pp. Also in *Mysticism and Logic*, 1918, I, as Chapter VI.

Translated: in French, "Methode Scientifique en Philosophie." Traduit de l'Anglais par M. Devaux, Preface de M. Bargin; Paris, J. Vrin, Librarie Philosophique, 1929.

*5.* ON THE NATURE OF ACQUAINTANCE. *Monist*, v. 24, Jan.-July 1914, pp. 1-16; 161-187; 435-453.

Captions: I. Preliminary Description of Experience—II. Neutral Monism—III. Analysis of Experience.

6. DEMOCRACY AND DIRECT ACTION. *English Review,* v. 28, May 1914, pp. 396-403.

Reprinted: in *Dial,* v. 66, May 13, 1919, pp. 445-448.

7. MYSTICISM AND LOGIC. *Hibbert Journal,* v. 12, July 1914, pp. 780-803.

Captions: I. Reason and Intuition—II. Unity and Plurality—III. Time—IV. Good and Evil.

Reprinted: in *Mysticism and Logic,* 1918, Chp. I. *Selections,* 1927, Chp. II.

Excerpts: in part in Lowell Lectures on *Our Knowledge of the External World,* 1914.

Translated by Yusuf Serif: *Mistiklik ve mantik* (yazen), Istanbul, Devlet matbaasi, 1935. viii, 55 pp.

8. DEFINITIONS AND METHODOLOGICAL PRINCIPLES IN THEORY OF KNOWLEDGE. *Monist,* v. 24, Oct. 1914, pp. 582-593.

9. THE RELATION OF SENSE-DATA TO PHYSICS. *Scientia,* No. 4, 1914.

Reprinted: in *Mysticism and Logic,* 1918, Chp. VIII.

10. WHY NATIONS LOVE WAR. In *War and Peace,* Nov. 1914.

Reprinted: in *Justice in War-Time,* 1916, Chp. 4.

## 1915

1. WAR, THE OFFSPRING OF FEAR. London: *Union of Democratic Control,* 1915, 13 pp.

2. ON JUSTICE IN WAR-TIME. AN APPEAL TO THE INTELLECTUALS OF EUROPE. *International Review,* v. 1, No. 4 & 5, pp. 145-151; 223-230.

Reprinted: with additions in *Justice in War-Time,* 1916.

3. SENSATION AND IMAGINATION. *Monist,* v. 25, Jan. 1915, pp. 28-44.

4. THE ETHICS OF WAR. *International Journal of Ethics,* v. 25, Jan. 1915, pp. 127-142.

Reprinted: in *Justice in War-Time,* 1916.

5. IS A PERMANENT PEACE POSSIBLE? *Atlantic Monthly,* v. 115, Mar. 1915, pp. 367-376.

Reprinted: in *Justice in War-Time,* 1916.

6. ON THE EXPERIENCE OF TIME. *Monist,* v. 25, Apr. 1915, pp. 212-233.

7. THE ULTIMATE CONSTITUENTS OF MATTER. *Monist*, v. 25, July 1915, pp. 399-417.

An address delivered before the Philosophical Society of Manchester, Feb. 1915.

Reprinted: in *Mysticism and Logic*, 1918, Chp. VII.

8. THE FUTURE OF ANGLO-GERMAN RIVALRY. *Atlantic Monthly*, v. 116, July 1915, pp. 127-133.

Reprinted: in *Justice in War-Time*, 1916.

9. WAR AND NON-RESISTANCE. *Atlantic Monthly*, v. 116, Aug. 1915, pp. 266-274.

Reprinted: in *International Journal of Ethics*, as "The War and Non-Resistance," v. 26, Oct. 1915, pp. 23-30. In *Justice in War-Time*, 1916.

### 1916

*1 PRINCIPLES OF SOCIAL RECONSTRUCTION. London, George Allen & Unwin, Ltd., 1916. 252 pp. Second Edition, 1920, 250 pp.

Published in America as WHY MEN FIGHT: A METHOD OF ABOLISHING THE INTERNATIONAL DUEL. New York, The Century Co., 1916. 272 pp. Second Edition, New York, Albert & Charles Boni, Bonibooks, 1930. 272 pp.

Contents: I. The Principles of Growth—II. The State—III. War as an Institution—IV. Property—V. Education (1916)—VI. Marriage and the Population Question—VII. Religion and the Churches—VIII. What We Can Do.

2. POLICY OF THE ENTENTE, 1904-1914; A REPLY TO PROFESSOR GILBERT MURRAY, Manchester and London, The National Labour Press, Ltd., 1916. 86 pp.

Contents: Preface—I. Introduction—II. Morocco—III. The Anglo-Russian Entente—IV. Persia—V. What Our Policy Ought to Have Been—Appendix A. Press Interpretations of our Guarantee to Belgium in 1887—Appendix B. What Support Did We Offer to France in 1905?

Reprinted: in *Justice in War-Time*, 1916.

3. JUSTICE IN WAR-TIME. Chicago, London, The Open Court Publishing Co., 1916. ix, 243 pp. London, George Allen & Unwin, Ltd., 1916 with Second Edition in 1924.

Contents: Preface—1. An Appeal to the Intellectuals of Europe (1915)—2. The Ethics of War (1915)—3. War and Non-Resistance (1915)—4. Why Nations Love War (1914)—5. Future of Anglo-German Rivalry (1915)—6. Is a Permanent Peace Possible? (1915)—7. The Danger to Civilization (See 1916, item No. 7)—8. The Entente Policy of 1904-1915—A Reply to Professor Gilbert Murray (1916).

4. THE CASE OF ERNEST F. EVERETT. Pamphlet: *No Conscription Fellowship*, 1916.

The discussion of the case of a conscientious objector which led to the prosecution of Bertrand Russell.

5. LETTER TO THE TIMES OF LONDON, May 17, 1916. Letter referring to the Everett case pamphlet.

Reprinted: in *Bertrand Russell: A College Controversy of the Last War*, by G. H. Hardy, Cambridge, at the University Press, 1942, p. 33.

6. REX VS. BERTRAND RUSSELL. Pamphlet: *No Conscription Fellowship*, 1916, 23 pp. Speech in own defense. A suppressed pamphlet.

Reprinted: in *Living Age*, v. 300, Feb. 15, 1919, pp. 385-394.

7. DANGER TO CIVILIZATION. *Open Court*, v. 30, Mar. 1916, pp. 170-180.

8. RELIGION AND THE CHURCHES. *Unpopular Review*, v. 5, Apr. 1916, pp. 392-409.

Reprinted: in *Principles of Social Reconstruction*, 1916, Chp. VII.

9. WAR AS AN INSTITUTION. *Atlantic Monthly*, v. 117, May 1916, pp. 603-613.

10. EDUCATION AS A POLITICAL INSTITUTION. *Atlantic Monthly*, v. 117, June 1916, pp. 750-757.

Reprinted: in *Principles of Social Reconstruction*, 1916, Chp. V.

*Challenging Essays in Modern Thought*, 1933, pp. 182-199. *Essays of Our Times*, 1928, pp. 359-374.

*11. MARRIAGE AND THE POPULATION QUESTION. *International Journal of Ethics*, v. 26, July 1916, pp. 443-461.

12. FREEDOM OF SPEECH IN ENGLAND. *School & Society*, v. 4, Oct. 21, 1916, pp. 637-638.

13. OPEN LETTER TO PRESIDENT WILSON. *Survey*, v. 37, Dec. 30, 1916, pp. 372-373.

14. PERSONAL STATEMENT. *Open Court*, v. 30, Dec. 1916, pp. 766-767.

15. BERTRAND RUSSELL'S PLEA FOR THE CHILD AS THE VITAL FACTOR IN MODERN EDUCATION. *Current Opinion*, v. 61, 1916, p. 46.

Quoting from *Atlantic Monthly*, 1916.

*16*. MAKING MARTYRS OF 'CONSCIENTIOUS OBJECTORS' IN ENG-
LAND. *Current Opinion*, v. 61, p. 257.
Quoting from Bertrand Russell's *Defense*, 1916.

## 1917

\* *1*. POLITICAL IDEALS. New York, The Century Co., 1917. 172 pp.
Contents: I. Political Ideals (1917)—II. Capitalism and the Wage System—
III. Pitfalls in Socialism—IV. Individual Liberty and Public Control (1917)
V—. National Independence and Internationalism (1917).

*2*. FOR CONSCIENCE SAKE. *Independent*, v. 89, Jan. 15, 1917, pp.
101-103.

*3*. POLITICAL IDEALS. *North American Review*, v. 205, Feb. 1917,
pp. 248-259.
Reprinted: in *Political Ideals*, 1917, Chp. I. *Essays in Contemporary Civiliza-
tion*, 1931, pp. 464-477. *Modern Essays*. 1933, pp. 141-155.

*4*. NATIONAL INDEPENDENCE AND INTERNATIONALISM. *Atlantic
Monthly*, v. 119, May 1917, pp. 622-628.
Reprinted: in *Political Ideals*, 1917, Chp. V.

*5*. INDIVIDUAL LIBERTY AND PUBLIC CONTROL. *Atlantic Monthly*,
v. 120, July 1917, pp. 112-120.
Reprinted: in *Political Ideals*, 1917, Chp. IV.

## 1918

\* *1*. MYSTICISM AND LOGIC AND OTHER ESSAYS. New York, Bombay,
Calcutta, Madras, Longmans, Green & Co., 1918. vi, 234 pp.
Also published: New York, W. W. Norton & Co., 1929. London, George
Allen & Unwin, Ltd., 1929. vi, 234 pp.

Contents: I. Mysticism and Logic (1914)—II. The Place of Science in a
Liberal Education (1913)—III. A Free Man's Worship (1903)—IV. The
Study of Mathematics (1907)—V. Mathematics and the Metaphysician
(1901)—VI. On Scientific Methods in Philosophy (1914)—VII. The
Ultimate Constituents of Matter (1915)—VIII. The Relation of Sense-Data
to Physics (1914)—IX. On the Notion of Cause (1913)—X. Knowledge
by Acquaintance and Knowledge by Description (1911).

\* *2*. ROADS TO FREEDOM: SOCIALISM, ANARCHISM AND SYNDICALISM.
London, George Allen & Unwin, Ltd., 1918. xviii, 215 pp.
Also published: as PROPOSED ROADS TO FREEDOM: SOCIALISM, ANARCHISM
AND SYNDICALISM, New York, Henry Holt & Co., 1919. xviii, 218 pp. Allen
further editions, 1919-1920. Blue Ribbon Book, 1931.

Contents: Preface—Introduction—*Part I. Historical*—I. Marx and Socialist
Doctrine—II. Bakunin and Anarchism—III. The Syndicalist Revolt—*Part*

*II. Problems of the Future*—IV. Work and Pay—V. Government and Law—
VI. International Relations—VII. Science and Art Under Socialism—VIII.
The World as It Could Be Made—Index.

*3. The Philosophy of Mr. B\*rtr\*nd R\*ss\*ll by P.E.B. Jour-
dain. Chicago, The Open Court Publishing Co., 1918. London,
George Allen & Unwin, Ltd., 1918. 96 pp.

Contains an Appendix of Leading Passages from Certain Other Works. Con-
tains quotations from conversations with Bertrand Russell, from *Principia
Mathematica*, from *Philosophical Essays*, from *Philosophy of Leibniz*, and
from *Principles of Mathematics*. (This book is intended as a joke.)

*4. The German Peace Offer. *Tribunal,* 1918.

The basis for the second prosecution of Bertrand Russell as a result of which
he was imprisoned for six months, during which time he wrote his *Intro-
duction to Mathematical Philosophy*.

*5. Pure Reason at Königsberg. Review of Norman Kemp Smith's
*A Commentary to Kant's "Critique of Pure Reason."* The Nation
(London), v. XXIII, No. 16, July 20, 1918, pp. 426 and 428.

*6. Philosophy of Logical Atomism. *Monist,* v. 28, Oct. 1918,
pp. 495-527. Lectures delivered in London in 1918.

Captions: I. Facts and Propositions—II. Particulars, Predicates and Rela-
tions.

*7. Review of C. D. Broad's *Perception, Physics, and Reality*. *Mind,*
New Series, v. XXVII, 1918, pp. 492-498.

*8. Man's War with the Universe in the Religion of Ber-
trand Russell. *Current Opinion,* v. 65, 1918, pp. 45-46.

Contains quotations from A Free Man's Worship.

### 1919

*1. Introduction to Mathematical Philosophy. London,
George Allen & Unwin, Ltd.; New York, The Macmillan Co.,
1919. *Library of Philosophy,* Edited by J. H. Muirhead. viii, 208
pp.

Contents: Preface—Editor's Note—1. The Series of Numeral Numbers—2.
Definition of Number (cf. 1927, 4)—3. Finitude and Mathematical Induction
—4. The Definition of Order—5. Kinds of Relations—6. Similarity of Rela-
tions—7. Rational, Real and Complex Numbers—8. Infinite Cardinal Num-
bers—9. Infinite Series and Ordinals—10. Limits and Continuity—11. Limits
and Continuity of Functions—12. Selections and the Multiplicative Axiom—
13. The Axiom of Infinity and Logical Types—14. Incompatibility and the

Theory of Deduction—15. Proposition Functions—16. Description—17. Classes—18. Mathematics and Logic—Index.

Translated into German and French.

2. ON PROPOSITIONS: WHAT THEY ARE AND HOW THEY MEAN. *Proceedings Aristotelian Society*, Sup. v. II, 1919, pp. 1-43.

Captions: I. Structure—II. Meanings of Images and Words—III. Propositions and Belief—IV. Truth and Falsehood.

3. REVIEW of Dewey's *Essays in Experimental Logic*. *The Journal of Philosophy*, v. XVI, No. 1, January 2, 1919. pp. 5-26.

4. NOTE on C. D. Broad's *A General Notation for the Relation of Numbers*. *Mind*, New Series, v. XXVIII, 1919, p. 124.

5. ECONOMIC UNITY AND POLITICAL DIVISION. *Dial*, v. 66, June 28, 1919, pp. 629-631.

6. PHILOSOPHY OF LOGICAL ATOMISM TO JULY, 1919. *Monist*, v. 29, pp. 32-63; 190-222; 345-380. Cont'd from *Monist*, 1918, 5.

Captions III. Atomic and Molecular Propositions—IV. Proposition and Facts with More than One Verb, Belief, etc.—V. General Propositions and Existence—VI. Descriptions and Incomplete Symbols—VII. The Theory of Types and Symbolism—VIII. Excursus into Metaphysics: What There Is.

### 1920

\* 1. THE PRACTICE AND THEORY OF BOLSHEVISM. London, George Allen & Unwin, Ltd., 1920.

Also published: as BOLSHEVISM: PRACTICE AND THEORY, New York, Harcourt, Brace & Co., 1920, 192 pp.

Contents: Preface—*Part I. The Present Condition of Russia*—I. What is Hoped for from Bolshevism—II. General Characteristics—III. Lenin, Trotsky, and Gorky—IV. Art and Education—V. Communism and the Soviet Constitution—VI. The Failure of Russian Industry—VII. Daily Life in Moscow—VIII. Town and Country—IX. International Policy—*Part II. Bolshevik Theory*—I. The Materialistic Theory of History—II. Deciding Forces in Politics (cf. 1927, 4)—III. Bolshevik Criticism of Democracy—IV. Revolution and Dictatorship—V. Mechanism and the Individual—VI. Why Russian Communism Failed—VII. Conditions for the Success of Communism.

2. RELATIVITY THEORY OF GRAVITATION. *English Review*, v. 30, Jan. 1920, pp. 11-18.

3. BERTRAND RUSSELL PROPHESIES THE SPEEDY TRIUMPH OF SOCIALISM. *Current Opinion*, v. 68, 1920, pp. 813-815.

Quoting from article in the *Liberator*.

*4.* DREAMS AND FACTS. *Dial,* v. 68, Feb. 1920, pp. 214-220.
Reprinted: in *Prose Patterns,* 1933.

*5.* THE WHY AND WHEREFORE OF WISHING FOR THINGS. *Living Age,* v. 304, Feb. 28, 1920, pp. 528-533.

*6.* SOCIALISM AND LIBERAL IDEALS. *Living Age,* v. 306, July 10, 1920. Lecture delivered for the National Guilds League at Kingsway Hall, London, Feb. 26, 1920.
Also published: in *English Review,* v. 30, May-June 1920, pp. 449-455; 499-508.

*7.* IMPRESSIONS OF BOLSHEVIK RUSSIA. *Nation* (London), v. 27, July 10-Aug. 7, 1920, pp. 460-462; 493-494; 520-521; 547-548; 576-577.
Captions: The Rule of the Proletariat—The Puritan Parallel—Plato's Guardians—An Aristocracy—As Internationalists—Evil of the Revolutionary Theory—Lenin as Internationalist—The Evolution of Bolshevism—Lenin, Trotsky, and Gorky—Communism and the Soviet Constitution—Town and Country—Bolshevism and the International Situation.

Reprinted: in *Living Age,* v. 306, 1920, pp. 387-391.

*8.* SOVIET RUSSIA—1920. *Nation* (New York), v. 111, July 31-Aug. 7, 1920, pp. 121-126; 152-154.
Captions: I. The Problem—II. Bolshevist Theory—III. Communism and the Soviet Constitution—IV. Lenin and Trotsky and Gorky—V. The International Situation—VI. Town and Country.

*9.* BOLSHEVIK THEORY. *New Republic,* v. 24, Sept. 15, Nov. 3, 17, 1920, pp. 67-69; 239-241; 296-298.
Captions: I. The Materialistic Concept of History—II. Revolution and Dictatorship—III. Mechanism and the Individual.

*10.* MEANING OF MEANING (Symposium): F. C. S. Schiller, Bertrand Russell, H. H. Joachim. *Mind,* New Series, No. 116, October, 1920, Russell's contribution, pp. 398-404.

## 1921

*\* 1.* THE ANALYSIS OF MIND. London, George Allen & Unwin, Ltd., 1921. 310 pp. New York, The Macmillan Co., 1924. *Library of Philosophy,* ed. by J. H. Muirhead. Lectures given in London and Peking.
Contents: Preface—I. Recent Criticisms of "Consciousness"—II. Instinct and Habit—III. Desire and Feeling—IV. Influence of Past History on Present Occurrences in Living Organisms—V. Psychological and Physical Causal Laws—VI. Introspection—VII. The Definition of Perception—VIII. Sensa-

tion and Images—IX. Memory—X. Words and Meaning (cf. 1927, *4*)—XI.
General Ideas and Thought—XII. Belief—XIII. Truth and Falsehood—
XIV. Emotions and Will—XV. Characteristics of Mental Phenomena—
Index.

2. THE HAPPINESS OF CHINA. *Nation* (London), v. 28, Jan. 8,
1921, pp. 505-506.

3. INDUSTRY IN UNDEVELOPED COUNTRIES. *Atlantic Monthly*, v.
127, June 1921, pp. 787-795.

4. SKETCHES OF MODERN CHINA. *Nation and Athenaeum*, v. 30,
Dec. 3-17, 1921, pp. 375-376; 429-430; 461-463.
   Captions: I. The Feast and the Eclipse—II. Chinese Ethics—III. Chinese
   Amusements.

   Reprinted: in *The Nation*, as "Modern China," v. 113, Dec. 14-28, 1921,
   pp. 701-702; 726-727; 756-757. In *The Problems of China*, 1922.

5. HIGHER EDUCATION IN CHINA. *Dial*, v. 71, Dec. 1921, pp.
693-698.
   Reprinted: in *The Problems of China*, 1922. Chp. XII.

6. SOME TRAITS IN THE CHINESE CHARACTER. *Atlantic Monthly*,
v. 128, Dec. 1921, pp. 771-777.

### 1922

*1.* THE PROBLEM OF CHINA. London, George Allen & Unwin, Ltd.,
1922. 260 pp. New York, The Century Co., 1922. 276 pp.
   Contents: I. Questions (cf. 1927, *4*)—II. China Before the 19th Century—III.
   China and the Western Powers—IV. Modern China—V. Japan Before the
   Restoration—VI. Modern Japan—VII. Japan and China Before 1914—
   VIII. Japan and China During the War—IX. The Washington Conference—
   X. Present Forces and Tendencies in the Far East—XI. Chinese and Western
   Civilization Contrasted (cf. 1927, *4*)—XII. The Chinese Character (cf. 1927,
   *4*)—XIII. Higher Education in China (1921, *5*)—XIV. Industrialism in
   China—XV. The Outlook for China—Appendix—Index.

2. FREE THOUGHT AND OFFICIAL PROPAGANDA. New York, B. W.
Huebsch, Inc., London, George Allen & Unwin, Ltd., 1922, Lon-
don, Watts & Co., 1922. 56 pp. The Moncure D. Conway Memo-
rial Lecture delivered at South Place Institute, London, Mar. 24,
1922.
   Reprinted: in *Sceptical Essays*, 1928, Chp. XII.

3. INTRODUCTION to Ludwig Wittgenstein's *Tractatus Logico-
Philosophicus*. London, Kegan Paul, Trench, Trubner & Co.,
Ltd., 1922. New York, Harcourt, Brace & Co., 1922, pp. 7-23.

4. How Washington Could Help China. *The New Republic*, v. 29, Jan. 4, 1922, pp. 154-155. Letter.

5. Hopes and Fears as Regards America. *The New Republic*, v. 30, Mar. 15-22, 1922, pp. 70-72; 99-101.
Reprinted: in *New Republic Anthology*, 1936, pp. 160-164.

6. Chinese Civilization and the West. *Dial*, v. 72, Apr. 22, 1922, pp. 356-364.
Reprinted: in *The Problems of China*, 1922.

7. What Makes a Social System Good or Bad? With Dora Russell. *Century*, v. 104, N.S. 82, May 1922, pp. 14-21.
Reprinted: in *The Prospects of Industrial Civilization*, 1923, Chp. VIII.

8. How Can Internationalism Be Brought About? With Dora Russell. *Century*, v. 104, N.S. 82, June 1922, pp. 195-202.
Reprinted: in *The Prospects of Industrial Civilization*, as "The Transition to Internationalism," 1923, Chp. V.

9. Socialism in Undeveloped Countries. *Atlantic Monthly*, v. 129, May 1922, pp. 664-671.
Reprinted: in *The Prospects of Industrial Civilization*, 1923, Chp. VI.

10. Toward an Understanding of China. *Century*, v. 104, N.S. 82, Oct. 1922, pp. 912-916.

11. The Outlook for China. *Century*, v. 105, N.S. 83, Nov. 1922, pp. 141-146.
Reprinted: in *The Problems of China*, 1922, Chp. XV.

12. Physics and Perception. *Mind*, New Series, v. XXXI, 1922, pp. 478-485.
A reply to C. A. Strong.

13. Dr. Schiller's Analysis of *The Analysis of Mind*. *Journal of Philosophy*, v. XIX, 1922, pp. 645-651.

## 1923

\* 1. The Prospects of Industrial Civilization. In collaboration with Dora Russell. New York and London, The Century Co., 1923; London, George Allen & Unwin, Ltd., 1923. v, 287 pp.
Contents: Preface—Part One. I. Causes of Present Chaos (1927, *4*)—II. Inherent Tendencies of Industrialism—III. Industrialism and Private Property —IV. Interactions of Industrialism and Nationalism—V. The Transition to Internationalism (1922, *8*)—VI. Socialism in Undeveloped Countries (1922,

9)—VII. Socialism in Advanced Countries—Part Two. VIII. What Makes a Social System Good or Bad? (1922, 7)—IX. Moral Standards and Social Well-Being (cf. 1927, 4)—X. The Sources of Power—XI. The Distribution of Power—XII. Education—XIII. Economic Organization and Mental Freedom.

2. THE ABC OF ATOMS. New York, E. P. Dutton & Co., 1923. 162 pp. London, Kegan Paul, 1923, 175 pp.

Contents: I. Introduction—II. The Periodic Law—III. Electrons and Nuclei—IV. The Hydrogen Spectrum—V. Possible States of the Hydrogen Atom—VI. The Theory of Quanta—VII. Refinements of the Hydrogen Spectrum—VIII. Rings of Electrons—IX. Rays—X. Radio-Activity—XI. The Structure of Nuclei—XII. The New Physics and the Wave Theory of Light—XIII. The New Physics and Relativity—Appendix; Bohr's Theory of the Hydrogen Spectrum.

3. LORD BALFOUR ON METHODOLOGICAL DOUBT. *Nation and Athenaeum*, v. 32, Jan. 6, 1923, pp. 542-544.

4. TOLSTOY'S DOMESTIC PROBLEMS. *The Freeman*, v. 6, Jan. 31, 1923, pp. 501-502.

5. THE CASE OF MARGARET SANGER. *Nation and Athenaeum*, v. 32, Jan. 27, Feb. 10, 1923, pp. 645, 719. Letters to the editor.

6. CHINA AND CHINESE INFLUENCE. *The Freeman*, v. 6, Feb. 28, 1923, pp. 585-587.

7. ON VAGUENESS. *The Australasian Journal of Psychology and Philosophy*, v. 1, 1923, pp. 84-92. Read before the Jowett Society, Oxford.

8. FREEDOM IN EDUCATION: A PROTEST AGAINST MECHANISM. *Dial*, v. 74, Feb. 1923, pp. 153-164.

9. REVIEW of George Santayana's *Life of Reason*. *Outlook*, v. 51, May 5, 1923, pp. 365-368.

10. SOURCES OF POWER. *The Freeman*, v. 7, May 2-16, 1923, pp. 176-179; 200-202; 224-226.

11. WHAT CONSTITUTES INTELLIGENCE. *Nation and Athenaeum*, v. 33, June 9, 1923, pp. 330-331.

12. SLAVERY OR SELF-EXTERMINATION: A FORECAST OF EUROPE'S FUTURE. *The Nation*, v. 117, July 11, 1923, pp. 32-34.

13. PHILOSOPHY IN INDIA AND CHINA. Reviews of S. Radhakrishnan's *Indian Philosophy* and J. Percy Bruce's *Chu Hsi and His Masters*. *Nation and Athenaeum*, v. 34, Sept. 15, 1923, pp. 748-9.

*14.* LEISURE AND MECHANISM. *Dial,* v. 75, Aug. 1923, pp. 105-122.

Captions: Instinctive Happiness—Friendly Feeling—Enjoyment of Beauty—Knowledge.

Reprinted: in *Types of Prose Writing,* 1933, pp. 210-228.

*15.* THE REVIVAL OF PURITANISM. *The Freeman,* v. 8, Oct. 17, 1923, pp. 128-130.

*16.* THE RECRUDESCENCE OF PURITANISM. *Outlook,* v. 52, Oct. 20, 1923, pp. 300-302.

Reprinted: in *Sceptical Essays,* 1928, Chp. X.

*17.* WHERE IS INDUSTRIALISM GOING? *Century Magazine,* v. 107, N.S. 85, Nov. 1923, pp. 141-149.

Reprinted: in *College Readings on Current Problems,* 1925, pp. 327-341. In *Modern Life and Thought,* 1928.

## 1924

*1.* STYLES IN ETHICS. *Our Changing Morality: A Symposium.* Ed. by Freda Kirchway. New York, Albert & Charles Boni, 1924. pp. 1-24.

Reprinted: in *The Nation,* as "New Morals for Old: Styles in Ethics," v. 118, Apr. 30, 1924, pp. 497-499.

*2.* ICARUS OR THE FUTURE OF SCIENCE. New York, E. P. Dutton & Co.; London, Kegan Paul, 1924. 64 pp.

Contents: I. Introduction—II. Effects of the Physical Sciences—III. The Increase of Organization—IV. The Anthropological Sciences—V. Conclusion.

*3.* HOW TO BE FREE AND HAPPY. New York, The Rand School of Social Science, 1924. 46 pp. Lecture delivered under auspices of Free Youth at Cooper Union, New York, on May 28, 1924.

Summarized in *Playground,* v. 18, Nov. 1924, p. 486.

*4.* LOGICAL ATOMISM. In *Contemporary British Philosophy: Personal Statements.* First Series. London, George Allen & Unwin, Ltd.; New York, The Macmillan Co., 1924. pp. 356-383.

*5.* BOLSHEVISM AND THE WEST. Introduction by Samuel Untermeyer—Foreword by Benjamin A. Javits. London, George Allen & Unwin, Ltd., 1924. 78 pp.

A debate on the Resolution: "That the Soviet Form of Government Is Applicable to Western Civilization." Scott Nearing, Affirmative; Bertrand Russell, Negative. Given under the auspices of the League for Public Discussion.

6. PREFACE to Jean Nicod's *La Geometrie dans le Monde Sensible.* Paris, Alcan, 1924. *Bibliotheque de philosophie contemporaire.*

7. DOGMATIC AND SCIENTIFIC ETHICS. *Outlook,* v. 53, Jan. 5, 1924, pp. 9-10.

8. NEED FOR POLITICAL SCEPTICISM. *The Freeman,* v. 8, Feb. 23, 1924, pp. 124-126.
   Reprinted: in *Sceptical Essays,* 1928, Chp. XI.

9. PSYCHOLOGY AND, POLITICS. *Outlook,* v. 53, Mar. 22, 1924, pp. 200-202.
   Reprinted: in *Dial,* v. 80, Mar. 1926, pp. 179-188. In Übers. von K. Wolfs-kehl, *Die Neue Rundschau,* as "Psychologie und Politik," Part 1, pp. 600-610, 1930.

10. MACHINES AND THE EMOTIONS. *Outlook,* v. 53, Mar. 22, 1924, pp. 200-202.
    Reprinted: in *Sceptical Essays,* 1928, Chp. VI.

11. A MOTLEY PANTHEON. *Dial,* v. 76, Mar. 1924, pp. 243-245.

12. THE EFFECT OF SCIENCE ON SOCIAL INSTITUTIONS. *Survey,* v. 52, Apr. 1, 1924, pp. 5-11.

13. IF WE ARE TO PREVENT THE NEXT WAR. *The Century,* v. 108, May 1924, pp. 3-12.
    Reprinted: in *War—Cause and Cure,* 1926, pp. 161-177.

14. DEMOCRACY AND IMPERIALISM. *World Tomorrow,* v. 7, June 1924, pp. 173-174.
    Interview by Anna Rochester.

15. THE AMERICAN INTELLIGENTSIA. *Nation and Athenaeum,* v. 36, Oct. 11, 1924, pp. 50-51.

16. PHILOSOPHY IN THE TWENTIETH CENTURY. *Dial,* v. 77, Oct. 1924, pp. 271-290.
    Reprinted: in *Sceptical Essays,* 1928, Chp. V. In *Twentieth Century Philosophy,* 1943, pp. 225-249.

17. BRITISH LABOR AND CHINESE BRIGANDS. *The Nation,* v. 119, Nov. 5, 1924, pp. 503-506.

18. FREEDOM OR AUTHORITY IN EDUCATION. *Century,* v. 109, N.S. 87, Dec. 1924, pp. 138-139.

19. BRITISH LABOR'S LESSON. *The New Republic,* v. 41, Dec. 31, 1924, pp. 138-139.

## 1925

*1. THE ABC OF RELATIVITY. New York and London, Harper & Bros., 1925. 231 pp. London, Kegan Paul, 1925. 237 pp.

Contents: I. Touch and Sight: The Earth and the Heavens—II. What Happens and What is Observed—III. The Velocity of Light—IV. Clocks and Foot Rules—V. Space-Time—VI. The Special Theory of Relativity—VII. Intervals in Space-Time—VIII. Einstein's Law of Gravitation—IX. Proofs of Einstein's Law of Gravitation—X. Mass, Momentum, Energy and Action —XI. Is the Universe Finite?—XII. Conventions and Natural Laws— XIII. The Abolition of "Force"—XIV. What is Matter?—XV. Philosophical Consequences.

Reprinted: excerpts in *Nation and Athenaeum*, v. 37, July 18, 1925, pp. 619-620; 651-652; 685-686; 712-713.

2. WHAT I BELIEVE. New York, E. P. Dutton & Co., 1925—*Today and Tomorrow Series*, 87 pp. London, Kegan Paul, 1925. 95 pp.

3. INTRODUCTION: MATERIALISM: PAST AND PRESENT. In Frederick A. Lange's *The History of Materialism*. Third (English) Edition, Three Volumes in One, New York, Harcourt, Brace & Co.; London, Kegan Paul, Trench, Trubner & Co., Ltd., 1925, pp. v-xiv.

4. INTRODUCTION to Mrs. Stan Harding's *The Underworld of State*. London, George Allen & Unwin, Ltd., 1925, pp. 11-28.

5. REVIEW: LIFE IN THE MIDDLE AGES. Review of Eileen Power's *Medieval People* and Johan Huizinga's *The Waning of the Middle Ages*. *Dial*, v. 78, Apr. 1925, pp. 295-298.

6. BRITISH POLICY IN CHINA. *Nation and Athenaeum*, v. 37, July 18, 1925, pp. 480-482.

7. SOCIALISM AND EDUCATION. *Harper's Monthly Magazine*, v. 151, Sept. 1925, pp. 413-417.

## 1926

*1. ON EDUCATION ESPECIALLY IN EARLY CHILDHOOD. London, George Allen & Unwin, Ltd., 1926. 254 pp. New York, Boni and Liveright, Inc., 1926. 319 pp., as EDUCATION AND THE GOOD LIFE.

Contents: Introduction—*Part One: Education and the Good Life.*—I. Postulates of Modern Educational Theory—II. The Aims of Education (1927, 4) —*Part Two: Education of Character*—III. The First Year—IV. Fear—V. Play and Fancy—VI. Constructiveness (1931, 1)—VII. Selfishness and Property—VIII. Truthfulness—IX. Punishment—X. Importance of Other Children—XI. Affection and Sympathy—XII. Sex Education—XIII. The Nursery School—*Part Three: Intellectual Education*—XIV. General Principles—

XV. The School Curriculum Before Fourteen—XVI. Late School Years—XVII. Day Schools and Boarding Schools—XVIII. The University—XIX. Conclusion.

2  ENCYCLOPAEDIA BRITANNICA: THIRTEENTH EDITION. New York, The Encyclopaedia Britannica, Inc.; London, The Encyclopaedia Britannica Co., Ltd., 1926.

Article: "Geometry: Part VI. On Non-Euclidean Geometries." With Alfred North Whitehead. v. 11, pp. 724-730.

Captions: Theory of Parallels Before Gauss—Saccheri—Three Periods of Non-Euclidean Geometry—Gauss—Lobatchewsky—Blyyai—Definition of a Manifold—Measure of Curvature—Helmholz—Beltrami—Transition to the Projective Method—The Two Kinds of Elliptic Space.

Articles in Three Supplemental Volumes: 1910-1926.

Article: "Theory of Knowledge." v.30, pp. 642-645.

Captions: Definition of Knowledge—II. The Data—III. Methods of Inference.

Article: Philosophical Consequences of Theory of Relativity. v. 31, pp. 331-332.

Captions: Space-time—Time Not a Single Cosmic Order—Physical Laws—Force and Gravitation—Realism in Relativity—Relativity Physics.

3.  REVIEW: THE MIND AND ITS PLACE IN NATURE. Review of C. D. Broad's book of same title. *Mind,* n.s., v. XXXV, 1926, pp. 72-80.

4.  FREEDOM IN SOCIETY. *Harper's Monthly Magazine,* v. 152, Mar. 1926, pp. 438-444.

5.  WHAT SHALL WE EDUCATE FOR? AN INQUIRY INTO FUNDAMENTALS. *Harper's Monthly Magazine,* v. 152, Apr. 1926, pp. 586-597.
    Reprinted: in *Modern Reader,* 1936, pp. 473-489.

6.  CAPITALISM—OR WHAT? *Banker's Magazine,* v. 112, May 1926, pp. 679-680; 725; 727.
    Captions: Placating the Trade Unions—The Control of Credit—Capitalism and Modern War—Attitude in America Toward Opposition to Financial Power.

7.  REVIEW: RELATIVITY AND RELIGION. Review of Whitehead's *Science and the Modern World. Nation and Athenaeum,* v. 39, May 29, 1926, pp. 206-207.

8.  REVIEW: MEANING OF MEANING. Review of Ogden and Richards' *The Meaning of Meaning. Dial,* v. 81, Aug. 1926, pp. 114-121.

9. Is Science Superstitious? *Dial*, v. 81, Sept. 1926, pp. 179-186.

A review of Burtt's *The Metaphysical Foundation of Modern Physics*, and Whitehead's *Science and the Modern World*.
Reprinted: in *Sceptical Essays*, 1928, Chp. III. In *Little Blue Book*, No. 543. The Haldeman-Julius Company, Girard, Kansas, 1947. 32 pp.

10. The Harm That Good Men Do. *Harper's Monthly Magazine*, v. 153, Oct. 1926, pp. 529-534.
Reprinted: in *Sceptical Essays*, 1928, Chp. IX. In *College Readings in Contemporary Thought*, 1929, pp. 398-406.

11. Behaviourism: Its Effect on Ordinary Mortals Should It Become a Craze. *Century*, v. 113, N.S. 91, Dec. 1926, pp. 148-153.

## 1927

*1. Why I Am Not a Christian. London, Watts & Co., 1927. 31 pp. Lecture delivered on March 6, 1927 at Battersea Town Hall under the auspices of South London Branch of the National Secular Society.

Captions: What is a Christian—The Existence of God—The First Cause Argument—The Natural Law Argument—The Argument from Design—The Moral Argument for Deity—The Argument for the Remedying of Injustice—The Character of Christ—Defects in Christ's Teaching—The Moral Problem—The Emotional Factor—How the Churches Have Retarded Progress—Fear the Foundation of Religion—What We Must Do.
Reprinted: in *Truth Seeker*, 1927, pp. 7-13. In pamphlet form by American Association for the Advancement of Atheism, Inc., 1927. 4 pp. *Little Blue Books*, Haldeman-Julius Publications, Girard, Kansas, #1372, 1927. 32 pp.

2. The Analysis of Matter. New York, Harcourt Brace & Co., Inc., 1927; London, Kegan Paul, Trench, Trubner & Co., Ltd., 1927. viii, 408 pp.

Contents: Preface—I. The Nature of the Problem—*Part One. The Logical Analysis of Physics*—II. Pre-Relativity Physics—III. Electrons and Protons—IV. The Theory of Quanta—V. The Special Theory of Relativity—VI. The General Theory of Relativity—VII. The Method of Tensors—VIII. Geodesics—IX. Invariants and their Physical Interpretation—X. Weyl's Theory—XI. The Principle of Differential Law—XII. Measurement—XIII. Matter and Space—XIV. The Abstractness of Physics—*Part Two. Physics and Perception*—XV. From Primitive Perception to Common Sense—XVI. From Common Sense to Physics—XVII. What is an Empirical Science? —XVIII. Our Knowledge of Particular Matters of Fact—XIX. Data, Inferences, Hypotheses, and Theories—XX. The Causal Theory of Perception—XXI. Perception and Objectivity—XXII. The Belief in General Laws—XXIII. Substance—XXIV. Importance of Structure in Scientific Inference—XXV. Perception from the Standpoint of Physics—XXVI. Non-

Mental Analogues to Perception—*Part Three. The Structure of the Physical World*—XXVII. Particulars and Events—XXVIII. The Construction of Points—XXIX. Space-Time Orders—XXX. Causal Lines—XXXI. Extrinsic Causal Laws—XXXII. Physical and Perceptual Space-Time—XXXIII. Periodicity and Qualitative Series—XXXIV. Types of Physical Occurrences—XXXV. Causality and Interval—XXXVI. The Genesis of Space-Time—XXXVII. Physics and Neutral Monism—XXXVIII. Summary and Conclusion—Index.

Translated by Kurt Grelling, *Philosophie der Materie.* B. G. Teubner, 1929. xi, 433 pp.

*3. AN OUTLINE OF PHILOSOPHY. London, George Allen & Unwin, Ltd., 1927. vi, 317 pp. New York, W. W. Norton & Co., Inc., under the title of: PHILOSOPHY, 1927. 307 pp.

Contents: I. Philosophic Doubts—*Part One. Man From Without*—II. Man and his Environment—III. The Process of Learning in Animals and Infants—IV. Language—V. Perception Objectively Regarded—VI. Memory Objectively Regarded—VII. Inference as a Habit—VIII. Knowledge Behaviouristically Considered—*Part Two. The Physical World*—IX. The Structure of the Atom—X. Relativity—XI. Causal Laws in Physics—XII. Physics and Perception—XIII. Physical and Perceptual Space—XIV. Perception and Physical Causal Laws—XV. The Nature of Our Knowledge of Physics—*Part Three. Man From Within*—XVI. Self-Observation—XVII. Images—XVIII. Imagination and Memory—XIX. The Introspective Analysis of Perception—XX. Consciousness?—XXI. Emotion, Desire, and Will—XXII. Ethics—*Part Four. The Universe*—XXIII. Some Great Philosophies of the Past—XXIV. Truth and Falsehood—XXV. The Validity of Inference—XXVI. Events, Matter, and Mind—XXVII. Man's Place in the Universe—Index.

4. SELECTED PAPERS OF BERTRAND RUSSELL. Selected by and with a Special Introduction by Bertrand Russell. New York, The Modern Library, Inc., 1927. 390 pp.

Contents: Introduction—A Free Man's Worship (1903)—Mysticism and Logic (1918)—The State (1918)—Education (1916)—Science and Art under Socialism (1919)—The World as It Could Be Made (1919)—The Aims of Education (1926)—Questions (1922)—Chinese and Western Civilization Contrasted (1922)—The Chinese Character (1922)—Causes of the Present Chaos (1923)—Moral Standards and Social Well-Being (1923)—Deciding Forces in Politics (1920)—Touch and Sight: The Earth and the Heavens (1925)—Current Tendencies (1914)—Words and Meaning (1921)—Definition of Number (1919).

5. BRITISH FOLLY IN CHINA. *The Nation,* v. 124, Mar. 2, 1927, pp. 227-228.

6. THE TRAINING OF YOUNG CHILDREN. *Harper's Monthly Magazine,* v. 155, Aug. 1927, pp. 313-319.

7. THINGS THAT HAVE MOULDED ME. *Dial*, v. 83, Sept. 1927, pp. 181-186.

8. EDUCATION WITHOUT SEX-TABOOS. *The New Republic*, v. 52, Nov. 16, 1927, pp. 346-348.

## 1928

*1.* SCIENCE. *Whither Mankind: A Panorama of Modern Civilization.* Ed. by Charles A. Beard. New York, London, Toronto, Longmans, Green & Co., 1928, pp. 63-82.

\* *2.* SCEPTICAL ESSAYS. New York, W. W. Norton & Co., Inc., 1928. 256 pp. London, George Allen & Unwin, Ltd., 1928.

Contents: I. Introduction: On The Value of Scepticism (1928)—II. Dreams and Fact—III. Is Science Superstitious? (1926)—IV. Can Man Be Rational?—V. Philosophy in the Twentieth Century (1924)—VII. Behaviourism and Values—VIII. Eastern and Western Ideals of Happiness—IX. The Harm that Good Men Do (1926)—X. The Recrudescence of Puritanism (1923)—XI. The Need for a Political Scepticism (1923)—XII. Free Thought and Official Propaganda (1922)—XIII. Freedom and Society (1926)—XIV. Freedom versus Authority in Education—XV. Psychology and Politics (1924)—XVI. The Danger of Creed Wars—XVII. Some Prospects: Cheerful and Otherwise.

*3.* EFFECTIVE INTOLERANCE: NOTHING MORE ENCOURAGING THAN THE EMINENCE OF MR. BERNARD SHAW. *The Century*, v. 115, N.S. 93, Jan. 1928, pp. 316-325.

*4.* TORTOISE. *Forum*, v. 79, Feb. 1928, pp. 262-263.

*5.* BOLD EXPERIMENT IN EDUCATION. *World Review*, v. 6, Feb. 27, 1928, p. 53.

*6.* MY OWN VIEW OF MARRIAGE. *The Outlook*, v. 148, Mar. 7, 1928, pp. 376-377.

*7.* HOW WILL SCIENCE CHANGE MORALS? *Menorah Journal*, v. 14, Apr. 1928, pp. 321-329.

*8.* THE NEW PHILOSOPHY OF AMERICA. *Fortnightly Review*, v. 129, N.S. 123, May 1928, pp. 618-623.

*9.* PHYSICS AND METAPHYSICS. *Saturday Review of Literature*, v. 4, May 26, 1928, pp. 910-911.

*10.* OSTRICH CODE OF MORALS. *Forum*, v. 80, July 1928, pp. 7-10.

Part of a debate: "Is Companionate Marriage Moral?"

*11.* SCHOOL AND THE VERY YOUNG CHILD. *The Outlook,* v. 149, July 11, 1928, pp. 418-420.

*12.* THE VALUE OF SCEPTICISM. *Plain Talk,* v. 3, Oct. 1928, pp. 423-430.

> Reprinted: in *Sceptical Essays,* 1928, Introduction. In *Little Blue Book* No. 542. Haldeman-Julius Company, Girard, Kansas, 1947. 32 pp.

> Translated by Karl Wolfskehl, "Der Wert des Skeptizismus." *Die Neue Rundschau,* Jahrg. 40, Bd. 2, pp. 1-13.

*13.* SCIENCE AND EDUCATION. *St.-Louis-Dispatch,* 50th Anniversary Number, Dec. 9, 1928.

> Reprinted: in *The Drift of Civilization* (Simon and Schuster, 1930), pp. 85-95.

## 1929

*\*1.* MARRIAGE AND MORALS. New York, Horace Liveright, 1929. London, George Allen & Unwin, Ltd., 1929. 320 pp. Sun Dial Center Books, 1938.

> Contents: I. Why a Sexual Ethic is Necessary—II. Where Fatherhood is Unknown—III. The Dominion of the Father—IV. Phallic Worship, Asceticism and Sin—V. Christian Ethics (1930, 3)—VI. Romantic Love—VII. The Liberation of Women—VIII. The Taboo on Sex Knowledge—IX. The Place of Love in Human Life—X. Marriage—XI. Prostitution—XII. Trial Marriage—XIII. The Family at the Present Day—XIV. The Family in Individual Psychology—XV. The Family and The State—XVI. Divorce—XVII. Population—XVIII. Eugenics—XIX. Sex and Individual Well-Being—XX. The Place of Sex Among Human Values—XXI. Conclusion.

> Reprinted: by Garden City Publishing Co., 1938. Sun Dial Center Books, 1942.

*2.* THREE WAYS TO THE WORLD. *The World Man Lives In*—In v. 12 of the Series: *Man and His World.* Ed. by Baker Brownell. New York, D. Van Nostrand Co., Inc., 1929, pp. 9-21.

> An informal talk before the Contemporary Thought Class at Northwestern University, Chicago, Illinois, 1924.

*3.* ON THE EVILS DUE TO FEAR. *If I Could Preach Just Once.* New York and London, Harpers & Brothers, 1929, pp. 217-230. Under title of *If I Had Only One Sermon to Preach,* England, Laymen Sermons, 1929.

> Reprinted: under title of *If I Had Only One Sermon to Preach,* Harpers, 1932.

*4.* ARE INSECTS INTELLIGENT? Introduction to Major R. W. G. Hingston's *Instinct and Intelligence,* New York, The Macmillan Co., *The Book League of America,* 1929, pp. vii-xiii.

5. On Catholic and Protestant Sceptics. *Dial,* v. 86, Jan. 1929, pp. 43-49.

6. Review of J. H. Denison's *Emotion as the Basis of Civilization. Nation* (London), v. 128, Jan. 23, 1929. p. 108.

7. Review of A. S. Eddington's *The Nature of the Physical World. Nation* (London), v. 128, Feb. 20, 1929. p. 232.

8. Review of Joseph Wood Krutch's *The Modern Temper. Nation* (London), v. 128, Apr. 10, 1929. p. 428.

9. The Twilight of Science: Is the Universe Running Down? *Century,* v. 1´18, N.S. 96, July 1929, pp. 311-315.

10. What Is Western Civilization? *Scientia,* v. 46, July 1929, pp. 35-41.

   Translated: in French by H. deVarigny, in *Scientia,* Suppl., v. 46, July 1929, pp. 21-26.

11. What I Believe. *Forum,* v. 82, Sept. 1929, pp. 129-134.

   Captions: Searching for Certainties—The World War—Golden Rules not Enough—The Dominance of Fear—International Anarchy.

   Reprinted: in *Living Philosophies* (Simon and Schuster, 1931), pp. 9-19. Tower Books, World Publishing Co., 1941.

12. Bertrand Russell on Religion. (Anonymous) *The World Tomorrow,* v. 12, Oct. 1929, p. 391.

13. Idealism for Children. *Saturday Review of Literature,* v. 6, Dec. 14, 1929, p. 575.

14. Letter in reply to Miss Dudderidge, appearing on same page. *Nation* (London), v. 129, Dec. 11, 1929. p. 720.

15. A Liberal View of Divorce. *Little Blue Books,* #1582, Haldeman-Julius Publications, Girard, Kansas, 1929, 32 pp.

### 1930

*1. The Conquest of Happiness. New York, Horace Liveright, Inc., 1930. 249 pp. London, George Allen & Unwin, Ltd., 1930. 252 pp.

   Contents: Preface—*Part One. Causes of Unhappiness*—I. What Makes People Unhappy—II. Byronic Unhappiness—III. Competition—IV. Boredom and Excitement—V. Fatigue—VI. Envy—VII. The Sense of Sin—VIII. Persecution Mania—IX. Fear of Public Opinion—*Part Two. Causes of Happiness* —X. Is Happiness Still Possible?—XI. Zest—XII. Affection—XIII. The

Family—XIV. Work—XV. Impersonal Interests—XVI. Effort and Resignation—XVII. The Happy Man.

Reprinted: in Star Edition, Garden City Publishing Co., Inc., Garden City, New York, 1930. Mentor Book, The New York American Library, 1951.

2. INTRODUCTION to *The New Generation: The Intimate Problems of Modern Parents and Children*, ed. by V. F. Calverton and Samuel D. Schmalhausen. New York, The Macaulay Co., 1930. pp. 17-24.

3. CHRISTIAN ETHICS. *Twenty-Four Views of Marriage;* from the Presbyterian General Assembly's Commission of Marriage, Diorce and Remarriage. Ed. by C. A. Spaulding. New York, The Macmillan Co., 1930. Pp. 54-67.

Reprinted: from *Marriage and Morals*, 1929, Chp. V.

4. HAS RELIGION MADE USEFUL CONTRIBUTIONS TO CIVILIZATION? AN EXAMINATION AND A CRITICISM. London, Watts & Co., 1930. 30 pp.

Contents: Christianity and Sex—The Objections to Religion—The Soul and Immortality—Sources of Intolerance—The Doctrine of Free-Will—The Idea of Righteousness.

Reprinted: in *Little Blue Books*, Haldeman-Julius Publications, Girard, Kansas, No. 1463, 32 pp. *Rationalist Annual*, 1930.

5. DIVORCE BY MUTUAL CONSENT. *Divorce*, New York, The John Day Co., 1930, pp. 11-18. In England Called *Divorce as I See It*, London, Douglas, 1930.

6. IS MODERN MARRIAGE A FAILURE? Resolved: That the present relaxation of family ties is in the interest of the good life. Bertrand Russell, affirmative; John Cowper Powys, negative; Heywood Broun, introduction.

The Discussion Guild, New York City, 1930. 60 pp.

7. MENTAL HEALTH AND THE SCHOOL—A TEACHER'S VIEW. *The Healthy-Minded Child*, ed. by N. A. Crawford and K. A. Menninger. New York, Coward-McCann, Inc., 1930. pp. 77-88.

8. CHINA'S PHILOSOPHY OF HAPPINESS. *The Thinker*, Feb. 1930, pp. 16-23.

9. HOMOGENEOUS AMERICA. *The Outlook and Independent*, v. 154, Feb. 19, 1930, pp. 285-287; 318.

10. WHY IS MODERN YOUTH CYNICAL. *Harper's Monthly Magazine*, v. 160, May 1930, pp. 720-724.

*11.* Are Parents Bad for Children? *Parents' Magazine,* v. 5, May 1930, pp. 18-19.

Reprinted: excerpts in *Review of Reviews,* v. 81, June 1930, pp. 62-63.

*12.* Heads or Tails. *The Atlantic Monthly,* v. 146, Aug. 1930, pp. 163-170.

*13.* Do Men Want Children? *Parents' Magazine,* v. 5, Oct. 1930, pp. 14-15.

*14.* Thirty Years from Now. *Virginia Quarterly Review,* v. 6, Oct. 1930, pp. 575-585.

*15.* Religion and Happiness. *Spectator,* v. 145, Nov. 15, 1930, pp. 714-715.

*16.* 1930 Preface to Jean Nicod's *Foundations of Geometry and Induction,* New York, Harcourt Brace & Co. (International Library of Psychology, Philosophy, and Scientific Method, London, Kegan Paul), 1930.

### 1931

*1.* Constructiveness. *Book of Essays,* ed. by Blanche Colton Williams. New York, Heath, 1931, pp. 318-325.

Reprinted: from *Education Especially in Early Childhood,* 1926, Chp. VI.

\* *2.* The Scientific Outlook. New York, W. W. Norton & Co., Inc., 1931. x, 277 pp.

Contents: Introduction—*Part One. Scientific Knowledge*—I. Examples of Scientific Method—II. Characteristics of Scientific Method—III. Limitations of Scientific Method—IV. Scientific Metaphysics—V. Science and Religion—*Part Two. Scientific Technique*—VI. Beginnings of Scientific Technique—VII. Technique in Inanimate Matter—VIII. Technique in Biology—IX. Technique in Physiology—X. Technique in Psychology—XI. Technique in Society—*Part Three. The Scientific Society*—XII. Artificially Created Societies—XIII. The Individual and the Whole—XIV. Scientific Government—XV. Education in a Scientific Society—XVI. Scientific Reproduction—XVII. Science and Values (1935, *3*)—Index.

*3.* What I Believe. *Nation,* v. 132, Apr. 29, 1931, pp. 469-471.

Reprinted: in *Nation* (with Russell's portrait), v. 150, March 30, 1940, pp. 412-414.

*4.* Free Speech in Childhood. *New Statesman and Nation,* v. 1, May 30, June 13, 27, 1931, pp. 486-488; 575; 643. The last two are in the forms of letters.

*5.* Modern Tendencies in Education. *Spectator,* v. 146, June 13, 1931, pp. 926-927.

6. FREE SPEECH IN CHILDHOOD. *The Nation*, v. 133, July 1, 1931, pp. 12-13.

7. NICE PEOPLE. *Harper's Monthly Magazine*, v. 163, July 1931, pp. 226-230.

8. IN OUR SCHOOL. *The New Republic*, v. 68, Sept. 9, 1931, pp. 92-94.

9. FAMILIE UND EHE. Übersetzt von M. Kahn. *Die Neue Rundschau*, v. 42, Part 2, Oct. 1931, pp. 512-525.

10. REVIEW of *Foundations of Mathematics and other Logical Essays* by E. P. Ramsey. *Mind*, New Series, v. XLVI, Oct. 1931, pp. 476-482.

11. SHALL THE HOME BE ABOLISHED? Bertrand Russell-Sherwood Anderson Debate. *Literary Digest* (with Portrait), v. 111, Nov. 28, 1931, pp. 25-26.

### 1932

1. ON THE MEANING OF LIFE. *On the Meaning of Life*, ed. by Will Durant, New York, Ray Long & Richard R. Smith, Inc., 1932. p. 106.
Letter of June 20, 1931 in response to inquiry on the subject.

*2. EDUCATION AND THE SOCIAL ORDER. London, George Allen & Unwin, Ltd., 1932. 254 pp. New York, called *Education and the Modern World*, W. W. Norton & Co., Inc., 1932. 245 pp.
Contents: I. The Individual Versus the Citizen—II. The Negative Theory of Education—III. Education and Heredity—IV. Emotion and Discipline—V. Aristocrats, Democrats, and Bureaucrats—VI. The Herd in Education—VII. Religion in Education—VIII. Sex in Education—IX. Patriotism in Education—X. Class-Feeling in Education—XI. Competition in Education—XII. Education under Communism—XIII. Education and Economics—XIV. Propaganda in Education—XV. The Reconciliation of Individuality and Citizenship—Index.

3. REFORMULATION OF THE NATURE OF MIND. Contributed to Charles W. Morris' *Six Theories of Mind*. University of Chicago Press, 1932. pp. 135-8.

4. REVIEW of R. Weiss's *Principles of Mathematics*. *Monist*, v. 42, Jan. 1932, pp. 112-154.

5. IN PRAISE OF IDLENESS. *Review of Reviews*, v. 82, Oct. 1932, pp. 48-54.

Reprinted: in *In Praise of Idleness,* 1935, Chp. I.

Reprinted: in *Harper's Monthly Magazine,* v. 165, Oct. 1932, pp. 552-559. In *Contemporary Opinion,* 1933, pp. 519-530. In *Essays of Today,* 1935, pp. 499-512.

6. REVIEW of Ramsey's *The Foundations of Mathematics and Other Logical Essays. Philosophy,* v. 7, 1932. pp. 84-6.

## 1933

*1.* SCIENTIFIC SOCIETY. In *Science in the Changing World,* ed. by M. Adams. New York, Appleton-Century, 1933, pp. 201-208.

2. THE MODERN MIDAS. *Harper's Monthly Magazine,* v. 166, Feb. 1933, pp. 327-334.

## 1934

*\*1.* FREEDOM AND ORGANIZATION 1814-1914. London, George Allen & Unwin, 1934. 528 pp. New York, called *Freedom versus Organization 1812-1914,* W. W. Norton & Co., Inc., 1934. viii, 477 pp.

Contents: Preface—*Part One. The Principles of Legitimacy*—I. Napoleon's Successors—II. The Congress of Vienna—III. The Holy Alliance—IV. The Twilight of Metternich—*Part Two. The March of Mind.*—Section A. The Social Background—V. The Aristocracy—VI. Country Life—VII. Industrialism.—Section B. The Philosophical Radicals—VIII. Malthus—IX. Bentham—X. James Mill—XI. Ricardo—XII. The Benthamite Doctrine—XIII. Democracy in England—XIV. Free Trade—Section C. Socialism—XV. Owen and Early Socialism—XVI. Early Trade Unionism—XVII. Marx and Engels—XVIII. Dialectic Materialism—XIX. The Theory of Surplus Value—XX. The Politics of Marxism—*Part Three. Democracy and Plutocracy in America*—Section A. Democracy in America—XXI. Jeffersonian Democracy—XXII. The Settlement of the West—XXIII. Jacksonian Democracy—XXIV. Slavery and Disunion—XXV. Lincoln and National Unity—Section B. Competition and Monopoly in America—XXVI. Competitive Capitalism—XXVII. The Approach to Capitalism—XXVIII. Nationalism and Imperialism—XXIX. The Principle of Nationality—XXX. Bismarck and German Unity—XXXI. The Economic Development of the German Empire—XXXII. Imperialism—XXXIII. The Arbiters of Europe—Bibliography—Index.

2. WHY I AM NOT A COMMUNIST. In *The Meaning of Marx: A Symposium.* New York, Farrar & Rinehart, Inc., 1934. pp. 83-85. Reprinted: in *Modern Monthly,* v. VIII, Apr., 1934, pp. 133-134.

3. THOMAS PAINE. In *Great Democrats,* ed. by A. B. Brown. London, Nicholson, 1934. pp. 527-538.

4. MARRIAGE AND CHILDREN. In *Modern English Readings,* ed. by

R. S. Loomis and D. L. Clark. New York, Farrar, 1934. pp. 241-248.

5. THE TECHNIQUE FOR POLITICIANS. *Esquire*, v. I., Mar. 1934. pp. 26, 133.

6. EDUCATION AND CIVILIZATION. *New Statesman and Nation*, v. 7, May 5, 1934, pp. 666-668.

   Reprinted: in *In Praise of Idleness*, 1935, Chp. XII (under title: "Education and Discipline").

7. THE SPHERE OF LIBERTY. *Esquire*, v. II., July 1934. p. 29.

8. THE LIMITATIONS OF SELF-HELP. *Esquire*, v. II., Oct. 1934. p. 27.

9. MEN VERSUS INSECTS. *Scribner's Magazine*, v. 96, Dec. 1934, p. 380.

   Reprinted: in *In Praise of Idleness*, 1935, Chp. XI.

## 1935

\* *1*. IN PRAISE OF IDLENESS AND OTHER ESSAYS. New York, W. W. Norton & Co., Inc., 1935. viii, 270 pp.

   Contents: I. In Praise of Idleness (1932, *4*)—II. "Useless" Knowledge—III. Architecture and Social Questions—IV. The Modern Midas (1933, *2*)—V. The Ancestry of Fascism (1935, *4*)—VI. Scylla and Charybdis, or Communism and Fascism (1934, *2*)—VII. The Case for Socialism—VIII. Western Civilization—IX. On Youthful Cynicism—X. Modern Homogeneity—XI. Men Versus Insects (1934, *6*)—XII. Education and Discipline—XIII. Stoicism and Mental Health (written in 1928)—XIV. On Comets—XV. What is the Soul? (written in 1928).

\* *2*. RELIGION AND SCIENCE. New York, Henry Holt and Co., Inc., 1935. 271 pp. Home University of Modern Knowledge. London, T. Butterworth-Nelson, 1935.

   Contents: I. Grounds of Conflict—II. The Copernican Revolution—III. Revolution—IV. Demonology and Medicine—V. Soul and Body—VI. Determinism—VII. Mysticism—VIII. Cosmic Purpose—IX. Science and Ethics—X. Conclusion—Index.

*3*. SCIENCE AND VALUES. In *Leadership in a Changing World*, ed. by M. D. Hoffman and R. Wanger. New York, Harper, 1935. pp. 278-284.

   Reprinted: from *The Scientific Outlook*, 1931, Chp. XVII.

*4*. THE REVOLT AGAINST REASON. *Political Quarterly*, v. 6, Jan. 1935, pp. 1-19.

Reprinted: in *In Praise of Idleness* as "The Ancestry of Fascism," 1935, Chp. V.

Reprinted: in *The Atlantic Monthly*, v. 155, Feb. 1935, pp. 222-232.

5. ENGLAND'S DUTY TO INDIA. *Asia*, v. 35, Feb. 1935, pp. 68-70.

6. A WEEKLY DIARY. *New Statesman and Nation*, v. 9, May 25-June 22, 1935, pp. 742-743; 798-799; 854-855; 886-887; 918-919.

### 1936

*1. WHICH WAY TO PEACE? London, Michael Joseph, Ltd.; Canada, S. J. R. Sauners, 1936. 224 pp.

Contents: I. The Imminent Danger of War—II. The Nature of the Next War—III. Isolationism—IV. Collective Security—V. Alliances—VI. The Policy of Expedients—VII. Wars of Principle—VIII. Pacifism as a National Policy—IX. Some Warlike Fallacies—X. Conditions for Permanent Peace—XI. Peace and Current Politics—XII. Individual Pacifism.

2. THE LIMITS OF EMPIRICISM. *Proceedings of the Aristotelian Society*, v. XXXVI, 1935-1936, pp. 131-150.

*3. DETERMINISM AND PHYSICS. The 18th Earl Grey Memorial Lecture delivered at King's Hall, Armstrong College, Newcastle-upon-Tyne, Jan. 14, 1936. The Librarian, Armstrong College, 1936, 18 pp.

4. WHY RADICALS ARE UNPOPULAR. *Common Sense*, v. V, Mar. 1936, pp. 13-15.

Captions: An Uncomfortable Realism—The Appeal to Personal Hatred—The Problem a Radical Faces.

5. OUR SEXUAL ETHICS. *The American Mercury*, v. XXXVIII, May 1936, pp. 36-41.

6. BRITISH FOREIGN POLICY. *New Statesman anl Nation*, v. 12, July 18, 1936, p. 82.

Letter to the editor.

7. SPANISH CONSPIRACY. *New Statesman and Nation*, v. 12, Aug 15, 1936, p. 218.

Letter to the editor.

8. FAR EASTERN IMPERIALISM. *New Statesman and Nation*, v. 12, Nov. 7, 1936, p. 736.

A review of Freda Utley's *Japan's Feet of Clay*.

*9.* WHICH WAY TO PEACE. *New Statesman and Nation*, v. 12, Nov. 28, 1936, p. 847.
Letter to the editor.

*10.* AUTO-OBITUARY—THE LAST SURVIVOR OF A DEAD EPOCH. *The Listener*, v. XVI, Aug. 12, 1936, p. 289. Publication of the British Broadcasting Corporation.
Reprinted: in *Coronet*, v. 10, 1941, pp. 36-38. In *Unpopular Essays*, Simon and Schuster, 1950. pp. 173-175.

*11.* ON ORDER IN TIME. *Proceedings* Cambridge Philosophical Society, v. 32, 1936. pp. 216-228.

*12.* THE CONGRESS OF SCIENTIFIC PHILOSOPHY. *Actes du congres international de philosophie scientifique.* v. I, Paris, Herman & Cie, 1936. pp. 10-11.

### 1937

*1.* THE AMBERLEY PAPERS. With Patricia Russell. The Letters and Diaries of Bertrand Russell's Parents. New York, W. W. Norton & Co., Inc.; two volumes. 552 pp. and 581 pp. England, Hogarth, 1937; Toronto, Canada, Longmans, 1937; London, Hogarth, 1940.
Contents (v. I): Genealogical Tables—Preface—I. The Stanleys of Alderley —II. The Russells—III. Kate Stanley's Childhood and Youth—IV. Amberley's Early Boyhood—V. Harrow—VI. Edinburgh, Cambridge, and Travels —VII. Courtship—VIII. Marriage to End of 1865—IX. 1866—Index. Contents (v. II): X. Parliament and America, 1867 and 1868—XI. The South Devon Election—XII. 1869—XIII. 1870—XIV. 1871—XV. Can War Be Abolished?—XVI. Family Controversies—XVII. 1872—XVIII. 1873-1874—XIX. The Death of Kate, Rachel, and Amberley—Index.

*2.* ON BEING MODERN-MINDED. *The Nation*, v. 144, Jan. 9, 1937, pp. 47-48.

* *3.* PHILOSOPHY'S ULTERIOR MOTIVE. *The Atlantic Monthly*, v. 159. Feb. 1937, pp. 149-155.

*4.* POWER—ANCIENT AND MODERN. *Political Quarterly*, v. 8, Apr. 1937, pp. 155-164.

*5.* THE FUTURE OF DEMOCRACY. *The New Republic*, v. LXXX. May 5, 1937, pp. 381-382.

*6.* MAN'S DIARY IN STICKS AND STONES. *Rotarian*, v. 50, June 1937, pp. 15-16.

7. THE SUPERIOR VIRTUE OF THE OPPRESSED. *The Nation,* v. 144, June 26, 1937, pp. 731-732.

8. TWO PROPHETS. A Review of R. Osborn's *Freud and Marx. New Statesman and Nation,* v. 13 (N.S.), p. 416.

9. ON VERIFICATION. Presidential Address, Nov. 8, 1937. *Proceedings Aristotelian Society,* n.s., 38, 1937/38. pp. 1-20.

## 1938

*1.* SCIENCE AND SOCIAL INSTITUTIONS. In *Dare We Look Ahead?* New York, The Macmillan Co., 1938, pp. 9-29. London, George Allen & Unwin, Ltd., 1938.
Based on the Fabian Lectures, 1937.

2. AIMS OF EDUCATION. In *Toward Today: A Collection of English and American Essays,* ed. by E. A. Walter. New York, Scott, 1938, pp. 189-202.

*3.* CHINESE CHARACTER. In *Opinions and Attitudes in the Twentieth Century,* ed. by S. S. Morgan and W. H. Thomas. New York, Nelson, 1938, pp. 306-316.
Reprinted: from *The Problems of China,* 1922, Chp. XII.

*4.* POWER: A NEW SOCIAL ANALYSIS. New York, W. W. Norton & Co., Inc., 1938. 315 pp.
Contents: I. The Impulse to Power—II. Leaders and Followers—III. The Forms of Power—IV. Priestly Power—V. Kingly Power—VI. Naked Power —VII. Revolutionary Power—VIII. Economic Power—IX. Power over Opinion (1938, *8*)—X. Sources of Power—XI. The Biology of Organizations—XII. Powers and Forms of Governments—XIII. Organizations and the Individual—XIV. Competition—XV. Power and Moral Codes—XVI. Power Philosophies—XVII. The Ethics of Power—XVIII. The Taming of Power (1938, *9*)—Index.

5. THE RELEVANCE OF PSYCHOLOGY TO LOGIC. *Proceedings Aristotelian Society,* v. XVII, 1938, pp. 42-53.

6. MY RELIGIOUS REMINISCENCES. *The Rationalist Annual,* 55th Year of Publication, 1938, pp. 3-8.

7. ARISTOCRATIC REBELS: BYRON AND THE MODERN WORLD. *Saturday Review of Literature,* v. 17, Feb. 12, 1938, pp. 3-4.

8. POWER OVER OPINION. *Saturday Review of Literature*, v. 18, Aug. 13, 1938, pp. 13-14 (with portrait).
   Reprinted: from *Power: A New Social Analysis*, 1938, 4, Chp. IX.

9. THE TAMING OF POWER. *The Atlantic Monthly*, v. 162, Oct. 1938, pp. 439-449.
   Reprinted: from *Power: A New Social Analysis*, 1938, 4, Chp. XVIII.

*10.* TAMING ECONOMIC POWER. Radio Discussion with T. V. Smith and Paul Douglas. The University of Chicago Round Table, Nov. 15, 1938, Red Network of the National Broadcasting Company. Printed in pamphlet, The University of Chicago Round Table, University of Chicago, Chicago, Illinois, 1938.

*11.* ON THE IMPORTANCE OF LOGICAL FORM. *Encyclopaedia and Unified Science;* International Encyclopaedia of Unified Science. v. I, University of Chicago, 1938. pp. 39-41.

## 1939

*1.* WHAT IS HAPPINESS? In *What Is Happiness*, New York, H. C. Kinsey & Co., Inc., 1939, pp. 55-65.

2. MORAL STANDARDS AND SOCIAL WELL-BEING. In *Century Readings in the English Essay*, Revised Edition, ed. by L. Wann. New York, Appleton-Century, 1939, pp. 531-541.
   Reprinted: from *The Prospects of Industrial Civilization*, 1923, Chp. IX.

3. LIVING PHILOSOPHY, REVISED. In *I Believe: The Personal Philosophies of Certain Eminent Men and Women of Our Time,* ed. by and with Introduction and Biographical Notes by Clifton Fadiman. New York, Simon and Schuster, Inc., 1939, pp. 409-412.

4. DEWEY'S NEW LOGIC. In: Schilpp, Paul Arthur, ed., *The Philosophy of John Dewey*, Evanston and Chicago, Northwestern University, 1939. (*The Library of Living Philosophers*, v. 1), pp. 135-156.

5. DEMOCRACY AND ECONOMICS. In *Calling America: The Challenge to Democracy Reaches Over Here*. New York and London, Harper & Brothers, 1939, pp. 76-78.
   Contents: The Abuse of Economic Power—The Coalescence with Political Power—The Democratic Alternative—The Problem of Transition—A Distinctive American Democracy.

Reprinted: In *Survey Graphic*, v. 28, Feb. 1939, pp. 130-132.

6. IS SECURITY INCREASING? Radio Discussion with A. Hart and
M. H. C. Laves. The University of Chicago Round Table, Jan.
15, 1939. Red Network of the National Broadcasting Company.
Printed in Pamphlet, The University of Chicago Round Table,
University of Chicago, Chicago, Illinois, 1939.

7. ROLE OF THE INTELLECTUAL IN THE MODERN WORLD. An
address delivered to the Sociology Club of the University of Chi-
cago. *American Journal of Sociology*, v. 44, Jan. 1939, pp. 491-
498.

8. MUNICH RATHER THAN WAR. *The Nation*, v. 148, Feb. 11,
1939, pp. 173-175.

9. THE CASE FOR UNITED STATES NEUTRALITY—IF WAR COMES,
SHALL WE PARTICIPATE OR BE NEUTRAL? A Symposium. *Com-
mon Sense*, v. VIII, March 1939, pp. 8-9.

10. EDUCATION FOR DEMOCRACY. Abridged. *Elementary School Jour-
nal*, v. 39, Apr. 1939, pp. 564-567.

   Reprinted: in *National Education Association*, v. 28, Apr. 1939, pp. 97-98.

11. CAN POWER BE HUMANIZED? *Forum*, v. 102, Oct. 1939, pp. 184-
185.

## 1940

1. FREEDOM AND GOVERNMENT. In *Freedom: Its Meaning*, ed. by
Ruth Nanda Anshen. New York, Harcourt, Brace & Co., 1940,
pp. 249-264.

2. AN INQUIRY INTO MEANING AND TRUTH. New York, W. W.
Norton & Co., Inc., 1940. 445 pp. London, George Allen &
Unwin, Ltd., 1940. The William James Lectures at Harvard Uni-
versity.

   Contents: Preface—Introduction—I. What Is a Word?—II. Sentences, Syn-
   tax, and Parts of Speech—III. Sentences Describing Experiences—IV. The
   Object-Language—V. Logical Words—VI. Proper Names—VII. Egocentric
   Particulars—VIII. Perception and Knowledge—IX. Epistemological Premisses
   —X. Basic Propositions—XI. Factual Premisses—XII. An Analysis of
   Problems Concerning Propositions—XIII. The Significance of Sentences: A.
   General—B. Psychological Analysis of Significance—C. Syntax and Sig-
   nificance—XIV. Language as Expression—XV. What Sentences "Indicate"—
   XVI. Truth and Falsehood: Preliminary Discussion—XVII. Truth and Ex-

perience—XVIII. General Beliefs—XIX. Extensionality and Atomicity—
XX. The Law of Excluded Middle—XXI. Truth and Verification—XXII.
Significance and Verifiability—XXIII. Warranted Assertibility—XXIV.
Analysis—XXV. Language and Metaphysics—Index.

3. THE PHILOSOPHY OF SANTAYANA. In: Schilpp, Paul Arthur, ed.,
   *The Philosophy of George Santayana*, Evanston and Chicago,
   Northwestern University, 1940. (*The Library of Living Philoso-
   phers*, v. 2) pp. 451-474.

4. LETTER to the *New York Times* on "The Bertrand Russell Case,"
   April 26, 1940.

   Reprinted: in part in *The Bertrand Russell Case*, ed. by John Dewey and
   Horace M. Kallen. New York, The Viking Press, 1941. In *Behind the
   Bertrand Russell Case*, by Horace M. Kallen, p. 29.

5. TOWARD WORLD FEDERATION—TOO OPTIMISTIC. *Asia*, v. 40,
   March 1940, pp. 126-127.

   Comment on article by Hans Kohn.

6. FREEDOM AND THE COLLEGES. *The American Mercury*, v. 50,
   May 1940, pp. 24-33.

*7. THE FUNCTIONS OF A TEACHER. *Harper's Magazine*, v. 181, June
   1940, pp. 11-16.

8. BYRON AND THE MODERN WORLD. *Journal of the History of
   Ideas* v. 1, Jan. 1940, pp. 24-37.

### 1941

1. HEGEL'S PHILOSOPHY OF HISTORY. Dialogue with Huntington
   Cairns, Allen Tate and Mark Van Doren. Columbia Broadcasting
   System, Inc. Printed in *Invitation to Learning*. New York, Random
   House, 1941, pp. 410-422. Canada, The Macmillan Company of
   Canada, Ltd., 1941.

   Also published: Home Library, 1942.

2. LET THE PEOPLE THINK. A Selection of Essays. London, Watts
   & Co., 1941. The Thinker's Library, No. 84. 116 pp.

   Contents: On the Value of Scepticism—Can Man Be Rational?—Free
   Thought and Official Propaganda—Is Science Superstitious?—Stoicism and
   Mental Health—The Ancestry of Fascism—"Useless" Knowledge—On
   Youthful Cynicism—Modern Homogeneity—Men Versus Insects—What Is
   the Soul?—On Comets.

3. DR. RUSSELL DENIES PACIFISM. Letter in *New York Times*, Jan.
   27, 1941.

4. LONG TIME ADVOCATE OF PEACE APPROVES PRESENT WAR. Letter in *New York Times,* Feb. 16, 1941.

5. BLUEPRINT FOR AN ENDURING PEACE. *American Mercury,* v. 52, June 1941, pp. 666-676.

6. BERTRAND RUSSELL URGES CREATION OF WORLD FEDERATION CONTROLLING ALL ARMAMENTS. *The New Leader,* v. XXIV., Sept. 27, 1941. p. 4.

7. A PHILOSOPHY FOR YOU IN THESE TIMES. *The Reader's Digest,* v. 93, Oct. 1941, pp. 5-7.

8. SPEAKING OF LIBERTY. Dialogue with Rex Stout, broadcast WEAF and Red Network, July 24, 1941. Mimeographed copy, prepared by Council for Democracy, New York, 1941, No. 15.

## 1942

1. DESCARTES' "DISCOURSE ON METHOD." Dialogue with Jacques Barzun and Mark Van Doren. In *New Invitation to Learning,* New York, Random House, 1942, pp. 93-104. (CBS program, "Invitation to Learning.")

2. SPINOZA'S ETHICS. Dialogue with Scott Buchanan and Mark Van Doren. In *Invitation to Learning,* New York, Random House, 1942, pp. 107-118 (CBS program, "Invitation to Learning.")

3. CARROLL'S "ALICE IN WONDERLAND." Dialogue with Katherine Ann Porter and Mark Van Doren. In *Invitation to Learning,* New York, Random House, 1942, pp. 208-220. (CBS program, "Invitation to Learning.")

4. TO END THE DEADLOCK IN INDIA. *Asia,* v. 42, June 1942, pp. 338-340.

5. PROPOSALS FOR AN INTERNATIONAL UNIVERSITY. *Fortnightly,* v. 158 (v. 152, N.S.), July 1942, pp. 8-16.

6. FREEDOM IN A TIME OF STRESS. *Rotarian,* v. 61, Sept. 1942, pp. 23-24.

7. INDIAN SITUATION. *Nation,* v. 155, Sept. 5, 1942, p. 200.

8. WHAT ABOUT INDIA? Address and discussion with others. The American Forum of the Air, Oct. 11, 1942. Printed, Washington, D.C., Ransdell, Inc., 1942, pp. 7-13.

9. How to Become a Philosopher: The Art of Rational Conjecture. Haldeman-Julius Publications, The *How-To* Series, v. 7, 1942, pp. 5-16.

10. How to Become a Logician: The Art of Drawing Inferences. Haldeman-Julius Publications, The *How-To* Series, v. 8, 1942, pp. 16-27.

11. How to Become a Mathematician: The Art of Reckoning. Haldeman-Julius Publications, The *How-To* Series, 1942, pp. 28-40.

### 1943

1. The International Significance of the Indian Problem. With Patricia Russell. *Free World*, v. V, Jan. 1943, pp. 63-69.

   Reprinted as "India Looms Up" in *Treasury for the Free World*, edited by Ben Raeburn, Arco Publishing Company, 1945. pp. 74-77.

2. Some Problems of the Post-War World. *Free World*, v. V, Mar. 1943, pp. 297-301.

   Reprinted as "Problems We Will Face" in *Treasury for the Free World*, edited by Ben Raeburn, Arco Publishing Company, 1945. pp. 31-34.

*3. An Outline of Intellectual Rubbish: A Hilarious Catalogue of Organized and Individual Stupidity. Haldeman-Julius Publications, Girard, Kansas, 1943, 26 pp.

4. What Shall We Do With Germany? *Saturday Review of Literature*, v. 26, May 29, 1943. p. 8.

5. Zionism and the Peace Settlement. *New Palestine*, v. 33, June 11, 1943, pp. 5-7.

   Reprinted in: *Palestine—Jewish Commonwealth in Our Times*. Zionist Organization of America, Washington, D.C., July, 1943.

6. Education After the War. *American Mercury*, v. 78, Aug. 1943, pp. 194-203.

7. How to Read and Understand History: The Past as the Key to the Future. Haldeman-Julius Publications, Girard, Kansas, Fall, 1943, 32 pp.

8. Our World after the War: A Plan for International Action. *The New Leader*, v. XXVI, Nov. 27, 1943, pp. 5, 7.

   I. The International Authority. II. Territorial Questions. III. The Treatment of Germany. IV. Self-Government in Weaker Countries. V. Relations of the Great Powers.

9. BRITAIN'S SHRUNKEN ECONOMY MAKES HER DEPENDENT ON U.S. *The New Leader*, v. XXVI, Dec. 4, 1943, p. 5.
Part II. of Article "Our World after the War," *The New Leader*, Nov. 27, 1943, item 8 above.

10. CITIZENSHIP IN A GREAT STATE. *Fortune*, v. XXVIII, Dec. 1943, pp. 167, 168, 170, 172, 175, 176, 178, 180, 182 and 185.

## 1944

1. MY MENTAL DEVELOPMENT. In: Schilpp, Paul Arthur, ed., *The Philosophy of Bertrand Russell*, Evanston and Chicago, Northwestern University, 1944. (*The Library of Living Philosophers*, v. 5).
Written for the present volume.

2. REPLY TO CRITICISM. Bertrand Russell's Rejoinder to his expositors and critics, in: Schilpp, Paul Arthur, ed., *The Philosophy of Bertrand Russell*, Evanston and Chicago, Northwestern University, 1944. (*The Library of Living Philosophers*, v. 5).
Written for the present volume.

3. THE VALUE OF FREE THOUGHT: How to Become a Truth-Seeker and Break the Chains of Mental Slavery. *The American Freeman*, Haldeman-Julius Publications, Girard, Kansas, No. 2063, Aug. 1944. pp. 1-4.
Reprinted: Haldeman-Julius Company, Girard, Kansas, *Big Blue Book*, 1944. 24 pp.

4. FUTURE OF PACIFISM. *American Scholar*, v. 13, Jan. 1944. pp. 7-13.

5. COOPERATE WITH SOVIET RUSSIA. *The New Leader*, v. XVII, Feb. 5, 1944, p. 8.
Based on broadcast over WEVD under auspices of The Rand School.

6. WESTERN HEGEMONY IN POST-WAR ASIA. *The New Leader*, v. XXVII., Feb. 26, 1944. p. 7.

7. VICTORS AND VANQUISHED. *The New Leader*, v. XXVII, Mar. 18, 1944, 21st Anniversary Number, p. 9.

8. PROGRESSIVE EDUCATION. *New Statesman and Nation*, v. 27, Apr. 22, 1944. p. 274.

9. CAN AMERICANS AND BRITAINS BE FRIENDS? *The Saturday Evening Post*, v. 216, June 3, 1944, pp. 14-15; 57-59.

*10.* EDUCATION IN INTERNATIONAL UNDERSTANDING. *Tomorrow,*
v. III, June 1944, pp. 19-21.

*11.* FOUR POWER ALLIANCE: STEP TO PEACE. *The New Leader,* v.
XXVII, Aug. 12, 1944, p. 9.

## 1945

*1.* A HISTORY OF WESTERN PHILOSOPHY: Its connection with Politi-
cal and Social Circumstances from the Earliest Times to the Present
Day. London, George Allen & Unwin, Ltd., 1945. New York,
Simon and Schuster, 1945, 928 pp.

Contents: Book One. Ancient Philosophy. Part I. The Pre-Socratics Chap. I.
The Rise of Greek Civilization. Chap. II. The Milesian School. Chap. III.
Pythagoras. Chap. IV. Heraclitus. Chap. V. Parmenides. Chap. VI. Empedocles.
Chap. VII. Athens in Relation to Culture. Chap. VIII. Anaxogoras. Chap. IX.
The Atomists. Chap. X. Protagoras Part II. Socrates, Plato, and Aristotle.
Chap. XI. Socrates. Chap. XII. The Influence of Sparta. Chap. XIII. The
Source of Plato's Opinions. Chap. XIV. Plato's Utopia. Chap. XV. The Theory
of Ideas. Chap. XVI. Plato's Theory of Immortality. Chap. XVII. Plato's
Cosmogony. Chap. XVIII. Knowledge and Perception in Plato. Chap. XIX.
Aristotle's Metaphysics. Chap. XX. Aristotle's Ethics. Chap. XXI. Aristotle's
Politics. Chap. XXI. Aristotle's Politics. Chap. XXII. Aristotle's Logic. Chap.
XXIII. Aristotle's Physics. Chap. XXIV. Early Greek Mathematics and Astron-
omy. Part III. Ancient Philosophy after Aristotle. Chap XXV. The Hellenistic
World. Chap. XXVI. Cynics and Sceptics. Chap. XXVII. The Epicureans. Chap.
XXVIII. Stoicism. Chapt. XXIX. The Roman Empire in Relation to Culture.
Chap. XXX. Plotinus. Book Two. Catholic Philosophy. Introduction. Part I.
The Fathers. Chap. I. The Religious Development of the Jews. Chap. II. Chris-
tianity during the First Four Centuries. Chap. III. Three Doctors of the Church.
Chap. IV. Saint Augustine's Philosophy and Theology. Chap. V. The Fifth and
Sixth Centuries. Chap. VI. Saint Benedict and Gregory the Great. Part II. The
Schoolmen. Chap. VII. The Papacy in the Dark Ages. Chap. VIII. John the
Scot. Chap. IX. Ecclesiastical Reform in the Eleventh Century. Chap. X. Mo-
hammedan Culture and Philosophy. Chap. XI. The Twelfth Century. Chap.
XII. The Thirteenth Century. Chap. XIII. Saint Thomas Aquinas. Chap. XIV.
Franciscan Schoolmen. Chap. XV. The Eclipse of the Papacy. Book Three. Mod-
ern Philosophy. Part I. From the Renaissance to Hume, Chap. I. General Char-
acteristics. Chap. II. The Italian Renaissance. Chap. III. Machiavelli. Chap. IV.
Erasmus and More. Chap. V. The Reformation and Counter-Reformation.
Chap. VI. The Rise of Science. Chap. VII. Francis Bacon. Chap. VIII. Hobbes's
Leviathan. Chap. IX. Descartes. Chap. X. Spinoza. Chap. XI. Leibniz. Chap.
XII. Philosophical Liberalism. Chap. XIII. Locke's Theory of Knowledge.
Chap. XIV. Locke's Political Philosophy. Chap. XV. Locke's Influence. Chap.
XVI. Berkeley. Chap. XVII. Hume. Part II. From Rousseau to the Present Day.
Chap. XVIII. The Romantic Movement. Chap. XIX. Rousseau. Chap. XX.
Kant. Chap. XXI. Currents of Thought in the Nineteenth Century. Chap. XXII.

Hegel. Chap. XXIII. Byron. Chap. XXIV. Schopenhauer. Chap. XXV. Nietzs-che. Chap. XXVI. The Utilitarians. Chap. XXVII. Karl Marx. Chap. XXVIII. Bergson, Chap. XXIX. William James. Chap. XXX. John Dewey. Chap. XXXI. The Philosophy of Logical Analysis.

Translated: By J. A. Hollo. "*Länsimaisen Filosofian Historia Politisten Ja Sosialisten Olosuhteiden Yhteydessi Varhaisimmista Ajoista Nykyaikaan Asti.* Helsinki, Werner, Söderström, 1948. 525,950 pp. by L. Pavolini. *Storia della Filosofia Ouidentale.* Milano, Longanesi, 1948. 406,248,508 pp. By Rob Limburg. *Geschiednis der Westerse Filosofie, Iverband met politieke en sociale omstandigheden van de oudstetijden tot heden.* Gravenhage, Servire, 1948. 774 pp.

2. AMERICAN AND BRITISH NATIONALISM. *Horizon* (British). Jan. 1945.

3. HOW TO AVOID THE ATOMIC WAR. *Common Sense,* October 1945, v. XIV, pp. 3-5.

4. FOOD PARCELS STILL NEEDED. Letter on editorial page, *New York Times,* Nov. 3, 1945, signed also by the Bishop of Chichester and Victor Gollancz.

5. CONVERSATIONS WITH BERTRAND RUSSELL. In *Among the Great.* Conversations with Romain Rolland, Mahatma Gandhi, Bertrand Russell, Rabindranath Tagore, Sri Aurobindo by Dilip Kumar Roy. Introduction by S. Radhakrishnan. Bombay, N. M. Tripathi, 1945. xx, 330 pp.

## 1946

1. IDEAS THAT HAVE HARMED MANKIND. Big Blue Book, Haldeman-Julius Company, Girard, Kansas, 1946. 33 pp. Reprinted: in *Unpopular Essays.* Simon & Schuster, 1950. pp. 146-165.

2. IDEAS THAT HAVE HELPED MANKIND. Big Blue Book, Haldeman-Julius Company, Girard, Kansas, 1946. 32 pp. Reprinted: in *Unpopular Essays,* Simon & Schuster, 1950. pp. 124-145.

3. IS MATERIALISM BANKRUPT? MIND AND MATTER IN MODERN SCIENCE. *Rationalist Annual,* 1946. Reprinted: Big Bue Book, Haldeman-Julius Company, Girard, Kansas, 1946. 32 pp.

4. PHYSICS AND EXPERIENCE. Cambridge at the University Press, 1946. 26 pp. The Henry Sidgwick Lecture at Newnham College, Cambridge, Nov. 19, 1945.

Reprinted: With a few alterations as a chapter in *Human Knowledge: Its Scope and Limits,* 1948. pp. 195-210.

Translated: By Dr. Ludwig Paneth. *Physik und Erfahrung.* Zürich, Rascher, 1948. 52 pp.

5. FOREWORD to James Feibleman's *An Introduction to Pierce's Philosophy*. Harper & Brothers, New York and London, 1946. pp. xv.-xvi.

6. SHOULD RUSSIA SHARE IN THE CONTROL OF THE RUHR? With Dr. Joad, Lord Vansittart and Prof. Cole. *Free World*, Jan. 1946, v. 11. pp. 55-56.

1947

1. PHILOSOPHY AND POLITICS. National Book League by the Cambridge University Press, 1947. 29 pp. Fourth Annual Lecture of the National Book League at Friends House, London, Oct. 23, 1946.

Reprinted: in *Unpopular Essays*, Simon & Schuster, 1950. pp. 1-20.

2. STILL TIME FOR GOOD SENSE. '47 *The Magazine of the Year*, v. 1, Nov. 1947. pp. 56-63.

3. THE FAITH OF A RATIONALIST: NO SUPERNATURAL REASONS NEEDED TO MAKE MEN KIND. *The Listener*, London, 1946. 6 pp. Radio Address, B.B.C.

Reprinted: Big Blue Book, Haldeman-Julius Company, Girard,, Kansas, 1947. 32 pp.

1948

1. HUMAN KNOWLEDGE: ITS SCOPE AND LIMITS. George Allen & Unwin, Ltd., 1948. 538 pp. Simon and Schuster, New York, 1948. 524 pp.

Contents: Part One: The World of Science. I. Individual and Social Knowledge. II. The Universe of Astronomy. III. The World of Physics. IV. Biological Evolution. V. The Physiology of Sensation and Volition. VI. The Science of Mind. Part Two: Language. I. The Uses of Language. II. Ostensive Definition. III. Proper Names. IV. Egocentric Particulars. V. Suspended Reactions: Knowledge and Belief. VI. Sentences. VII. External Reference of Ideas and Beliefs. VIII. Truth: Elementary Forms. IX. Logical Words and Falsehood. X. General Knowledge. XI. Fact, Belief, Truth, and Knowledge. Part Three: Science and Perception. I. Knowledge of Facts and Knowledge of Laws. II. Solipsism. III. Common-sense Inference. IV. Physics and Experience. (1946). V. Time in Experience. VI. Space in Psychology. VII. Mind and Matter. Part Four: Scientific Concepts. I. Interpretation. II. Minimum Vocabularies. III. Structure. IV. Structure and Minimum Vocabularies. V. Time, Public and Private. VI. Space in Classical Physics. VII. Space-Time. VIII. The Principle of Individuation. IX. Causal Laws. X. Space-Time and Causality. Part Five: Probability. I. Kinds of Probability. II. The Calculus of Probability. III. The Finite-Frequency Interpretation. IV. The Mises-Reichenbach Frequency Theory. V. Keynes's Theory of Probability. VI. Degrees of Credibility. VII. Probability and Induction. Part Six: Postulates of Scientific Inference. I. Kinds of Knowledge. II. The Role of Induction. III. The Postulate of Natural Kinds or of Limited Variety. IV. Knowledge Transcending Experience. V. Causal Lines. VI. Structure and Causal Laws. VII. Interaction. VIII. Analogy. IX. Summary of Postulates. X. The Limits of Empiricism.

2. How to Achieve World Government. *The New Leader*, Mar. 6, 1948, v. xxxi, pp. 8.

3. Whitehead and Principia Mathematica. *Mind*, Apr. 1948, v. 57, pp. 137-138.

4. Boredom or Doom in a Scientific World. *United Nations World*, v. 2, Aug. 1948, pp. 14-16.

5. World Government — By Force or Consent? *The New Leader*, Sept. 4, 1948. v. xxxi, p. 8.

### 1949

1. Authority and the Individual. London, George Allen & Unwin, Ltd. New York, Simon and Schuster, 1949. 125 pp. The Reith Lectures over B.B.C. for 1948-1949. Reprinted in *The Listener*.

   Contents: I. Social Cohesion and Human Nature. II. Social Cohesion and Government. III. The Role of Individuality. IV. The Conflict of Technique and Human Nature. V. Control and Initiative: Their Respective Spheres. VI. Individual and Social Ethics.

2. Values in the Atomic Age. The Sir Halley Stewart Lectures for 1948. London, George Allen & Unwin, Ltd., 1949. pp. 81-104.

3. Atomic Energy and the Problems of Europe. *19th Cent.*, Jan. 1949, v. 145. pp. 39-43. Address given at the Westminster School, Nov. 20, 1948. Includes questions and answers.

4. The Atom Bomb and the Problems of Europe. *The New Leader*, Feb. 12, 1949, v. xxxii. p. 6.

5. Reply to Inquiry: Should U. N. Meetings Open With Prayer or Meditation? *U. N. World*, Aug. 1949, v. 3, p. 13.

6. Ten Years Since the War Began. *The New Leader*, Sept. 3, 1949, v. xxxii. p. 6.

7. On Russian Science. *The Evening Standard*, (England), Sept. 7, 1949.

8. A Guide For Living in the Atomic Age. *U. N. World*, Nov. 1949, v. 3. pp. 33-36.

9. Exceptional Man. *Atlantic Monthly*. Nov. 1949, v. 184. pp. 52-56.

10. The High Cost of Survival. *This Week* (New York Herald Tribune), Dec. 18, 1949. pp. 5, 12.

1950

1. UNPOPULAR ESSAYS. London, George Allen & Unwin, Ltd. New York, Simon and Schuster, 1950. 228 pp.

Contents: I. Philosophy and Politics (1947) II. Philosophy for Laymen. III. The Future of Mankind. IV. Philosophy's Ulterior Motives (1937) V. The Superior Virtue of the Oppressed (1937) VI. On Being Modern-Minded. VII. An Outline of Intellectual Rubbish (1943) VIII. The Function of a Teacher (1940) IX. Ideas That Have Helped Mankind. (1946) X. Ideas That Have Harmed Mankind. (1946) XI. Eminent Men I have Known. XII. Obituary. (1936)

2. AMERICANS ARE . . . "THE IMPACT OF AMERICA UPON EUROPEAN CULTURE." *Vogue,* Feb. 1950. pp. 164, 210, 211.

3. IS A THIRD WORLD WAR INEVITABLE? *U. N. Word,* Mar. 1950, v. IV, pp. 11-13.

4. THE SCIENCE TO SAVE US FROM SCIENCE. *New York Times Magazine,* Mar. 19, 1950. pp. 9, 31-33.

5. CAME THE REVOLUTION. *Saturday Review of Literature,* Mar. 25, 1950, v. xxxiii. pp. 9, 10, 36, 37.

6. WHY FANATICISM BRINGS DEFEAT. *Sci. Digest,* Apr. 1950, v. 27. pp. 34-5.

7. CAN WE AFFORD TO KEEP OPEN MINDS? *The New York Times Magazine,* June 11, 1950. pp. 9, 37, 39.

8. IF WE ARE TO SURVIVE THIS TIME. *The New York Times Magazine,* Sept. 3, 1950. pp. 5, 17, 18.

9. LETTER TO WHIT BURNETT on choosing chapter from WHY MEN FIGHT (1916, item No. 1) for *The World's Best,* edited by Whit Burnett, Dial Press, 1950, pp. 447-456.

10. THE KIND OF FEAR WE SORELY NEED. *The New York Times Magazine,* Oct. 29, 1950, pp. 9, 52-55.

11. TO REPLACE OUR FEARS WITH HOPE. *The New York Times Magazine,* Dec. 31, 1950. pp. 5, 23, 25.

1951

1. THE IMPACT OF SCIENCE ON SOCIETY. Matchette Foundation Lectures at Columbia University. Columbia University Press, 1951. 64 pp.

Contents: I. Science and Tradition. II. Effects of Scientific Technique. III. Science and Values.

*2.* THE POLITICAL AND CULTURAL INFLUENCE. In *The Impact of America On European Culture,* adapted from the "Third Programme" of the B.B.C. Boston, The Beacon Press, 1951. pp. 3-19.

*3.* NATURE AND ORIGIN OF SCIENTIFIC METHOD. In *The Western Tradition.* London, Vox Mundi Books; Boston, The Beacon Press, 1951. pp. 23-28. British Broadcasting Talks.

*4.* SCEPTICISM AND TOLERANCE. In *The Western Tradition.* London, Vox Mundi Books; Boston, The Beacon Press, 1951. pp. 100-104. British Broadcasting Talks.

*5.* GEORGE BERNARD SHAW. *Virginia Quarterly,* Jan. 1951, v. 27. pp. 1-7.

*6.* TO FACE DANGER WITHOUT HYSTERIA. *The New York Times Magazine,* Jan. 21, 1951. pp. 7, 42, 44, 45. Reprinted in *Worth Reading.* The New York Times Company, 1951. pp. 21-24.

*7.* GLADSTONE AND LENIN. Excerpt from *Unpopular Essays. Atlantic Monthly,* Feb. 1951, v. 187. pp. 66-68.

*8.* FUTURE OF MAN. Excerpt from *Unpopular Essays. Atlantic Monthly,* Mar. 1951, v. 187. pp. 48-51.

*9.* WHAT'S WRONG WITH AMERICANS. *Look,* April 24, 1951, v. 15. pp. 34-35.

*10.* NO FUNK, NO FRIVOLITY, NO FANATICISM. *The New York Times Magazine,* May 6, 1951. pp. 7, 22, 23.

*11.* CHINA AND HISTORY. In *Saturday Review.* August 4, 1951. xxxiv., p. 39. Reprinted in *Saturday Review Reader #2.* Bantam Books, New York, 1953. pp. 119-121.

*12.* WHAT CAN I DO? In *Mademoiselle.* March 1951, v. xvi, pp. 107, 160-162.

*13.* AUTOBIOGRAPHICAL NOTE. In *The New York Herald Tribune Book Review.* October 7, 1951, p. 5.

*14.* NEW HOPES FOR A CHANGING WORLD. Address at the Twentieth Annual Herald Tribune Forum. Printed in the *New York Herald Tribune,* Sunday, October 28, 1951, Section 9, pp. 16, 18. Reprinted by the *New York Herald Tribune* in Forum Volume, pp. 49-54. Theme: "Balancing Moral Responsibility and Scientific Progress".

*15.* THE BEST ANSWER TO FANATICISM-LIBERALISM. *The New York Times Magazine,* Dec. 16, 1951, pp. 9, 40-42.

*16.* THE NARROW LINE. In *This Week, New York Herald Tribune,* Dec. 16, 1951, pp. 7, 22, 35.

*17.* DISCUSSION with Robert M. MacIver and Lyman Bryson on JOHN STUART MILL's *On Liberty.* In *Invitation to Learning,* v. 1, Winter Issue, 1951-1952, pp. 356-363.

*18.* THE CORSICAN ORDEAL OF MISS X. Published anonymously in Go, Dec. 1951. Reprinted in *Satan in the Suburbs and Other Short Stories,* 1953, pp. 60-86.

*19.* PREFACE TO GUSTAV HERLING's *A World Apart.* New York, Roy Publishers, pp. ix-x.

*20.* MEMORIAL TO LUDWIG WITTGENSTEIN. In *Mind* n.s., LX, 1951.

### 1952

*1.* NEW HOPES FOR A CHANGING WORLD. London, George Allen & Unwin, Ltd.; New York, Simon and Schuster, 1952, pp. 213.

Part One: Man and Nature. I. Current Perplexities. II. Three Kinds of Conflict. III. Mastery over Physical Nature. IV. The Limits of Human Power. V. Population.

Part Two: Man and Man. VI. Social Units. VII. The Size of Social Units. VIII. The Rule of Force. IX. Law. X. Conflicts of Manners of Life. XI. World Government. XII. Racial Antagonism. XIII. Creeds and Ideologies. XIV. Economic Cooperation and Competition. XV. The Next Half-Century.

Part Three: Man and Himself. XVI. Ideas Which Have Become Obsolete. XVII. Fear. XVIII. Fortitude. XIX. Life Without Fear. XX. The Happy Man. XXI. The Happy World.

*2.* LETTER. In *The Manchester Guardian,* Jan. 12, 1952, p. 4. In reply to William Henry Chamberlin's letter appearing on Jan. 8, 1952 criticizing an earlier article of Lord Russell.

*3.* THE SPRINGS OF HUMAN ACTION. *The Atlantic Monthly,* Mar. 1952, v. 189, pp. 27-31. A development of the speech made in Stockholm in Dec. 1950 on receipt of the Nobel Prize for Literature.

*4.* PREFACE TO BERTRAND RUSSELL's DICTIONARY OF MIND, MATTER AND MORALS, p. v. New York, Philosophical Library, 1952. Edited by Lester E. Denonn.

*5.* THE DANGEROUS DAYS. *Glamour,* May 1952, v. 27, pp. 118, 119, 135.

*6.* ADVICE TO THOSE WHO WANT TO ATTAIN 80. *The New York Times Magazine,* May 18, 1952, p. 13.

*7.* THE NEXT EIGHTY YEARS. *The Observer,* London, May 18, 1952, p. 4. *Saturday Review,* Aug. 9, 1952, pp. 8, 9, 48, 49. Reprinted in *Saturday Review Reader, #2,* pp. 22-31.

*8.* MY FIRST EIGHTY YEARS. Interview by Romney Wheeler on NBC-TV, May 18, 1952. Printed in the *New York Post,* Sunday, May 25, 1952, pp. 10M-11M and in *The Atlantic Monthly* for August 1952.

*9.* THE CHANCES OF WAR. *Look,* June 17, 1952, pp. 48, 50, 51.

*10.* REFLECTIONS ON MY EIGHTIETH BIRTHDAY. *The Listener,* May 22, 1952, pp. 8, 23, 24. Reprinted in *Portraits from Memory.*

*11.* THE AMERICAN WAY (A BRITON SAYS) IS DOUR. *The New York Times Magazine,* Sunday, June 15, 1952, pp. 12, 30.

*12.* THE ESSENTIALS FOR A STABLE WORLD. *The New York Times Magazine,* Sunday, August 3, 1952, pp. 11, 53. Reprinted in *Fact and Fiction* under the title *Three Essentials for a Stable World.*

*13.* "THE FAULTLESS MAX" AT 80. *The New York Times Magazine,* Sunday, Aug. 24, 1952, pp. 18, 19, 41.

*14.* AS SCHOOL OPENS—THE EDUCATORS EXAMINED. *The New York Times Magazine,* Sunday, Sept. 7, 1952, pp. 9, 44, 45.

*15.* WHAT I WON'T LIVE TO SEE. *Look,* v. 16, Nov. 4, 1952, pp. 72, 74, 75.

*16.* PORTRAITS FROM MEMORY: ALFRED NORTH WHITEHEAD. *Harper's Magazine,* Dec. 1952, v. 205, pp. 50-52. Reprinted in *Portraits from Memory.*

*17.* MAHATMA GANDHI. (Third in a series dealing with the turning point in the lives of famous men.) *The Atlantic Monthly,* Dec. 1952, v. 190, pp. 35-39. Reprinted in *High Moment: Stories of Supreme Crises in the Lives of Great Men as Told by Bertrand Russell and Others.* Edited by Wallace Brockway. New York, Simon and Schuster, 1955, pp. 205-216.

*18.* HOW FANATICS ARE MADE. A review of *The Origins of Totalitarian Democracy* by J. L. Talmon and *The True Believer* by Eric Hoffer. *The Observer,* London, Mar. 23, 1952, p. 4.

*19.* IS AMERICA IN THE GRIP OF HYSTERIA? A discussion with the Editors. *The New Leader,* Mar. 3, 1952, v. xxxv., p. 2.

*20.* PORTRAITS FROM MEMORY: MAYNARD KEYNES AND LYTTON STRACHEY. *The Listener,* v. xlviii, July 17, 1952, pp. 97-98. Reprinted in *Portraits from Memory.*

*21.* PORTRAITS FROM MEMORY: D. H. LAWRENCE. *The Listener,* v. xlviii, July 24, 1952, pp. 135-136. Reprinted in *Portraits from Memory.*

*22.* PORTRAITS FROM MEMORY: COMPLETELY MARRIED—SIDNEY AND BEATRICE WEBB. *The Listener,* v. xlviii, July 31, 1952, pp. 177-178. Reprinted in *Portraits from Memory.* Reprinted in *The Spoken Word: A Selection from Twenty-five Years of The Listener.* Edited by Richard Church. London, Collins, 1955, pp. 167-170.

*23.* REASON AND PASSION. *The Listener,* v. xlviii, Sept. 25, 1952, pp. 495-496.

*24.* WHAT IS FREEDOM ? London, Background Book, Batchworth Press, 1952, pp. 24. Revised 1960. Reprinted in *Fact and Fiction. Fiction.*

### 1953

*1.* THE IMPACT OF SCIENCE ON SOCIETY. New York, Simon and Schuster, 1953, pp. 115.

I. Science and Tradition. II. General Effects of Scientific Technique. III. Scientific Technique in an Oligarchy. IV. Democracy and Scientific Technique. V. Science and War. VI. Science and Values. VII. Can a Scientific Society be Stable?

Lectures originally given at Ruskin College, Oxford. I., II. and VI. were repeated at Columbia University as the Machette Foundation lectures and printed by Columbia University Press (See Item 1, 1951). VII. was the Lloyd Roberts lecture given at the Royal Society of Medicine, London.

*2.* SATAN IN THE SUBURBS AND OTHER STORIES. New York, Simon and Schuster, 1953; London, George Allen & Unwin Limited, 1953, pp. 148.

Satan in the Suburbs or Horrors Manufactured Here. The Corsican Ordeal of Miss X. The Infra-radioscope. The Guardian of Parnassus. Benefit of Clergy. The last appeared in *Harper's Bazaar,* June 1953, 86th year vol., pp. 86-87.

*3.* THE GOOD CITIZEN'S ALPHABET. London, Gaberbocchus Press Limited, 1953. Drawings by Franciszka Themeros. New York, The Wisdom Library, Philosophical Library, Inc., 1958.

*4.* WHAT IS DEMOCRACY? London, Background Books, Batchworth Press, 1953, pp. 39. Revised 1960. Reprinted in *Fact and Fiction*.

*5.* HOW TO BE HAPPY IN 1953. *United Nations World,* Jan. 1953, v. 7, pp. 12-15, 63.

*6.* PORTRAITS FROM MEMORY: MAYNARD KEYNES AND LYTTON STRACHEY. *Harper's Magazine,* Jan. 1953, v. 206, pp. 70-72. See item 20, 1952. Reprinted in *Portraits from Memory*.

*7.* PORTRAITS FROM MEMORY: D. H. LAWRENCE. *Harper's Magazine*, Feb. 1953, v. 206, pp. 93-95. See item 21, 1952. Reprinted in *Portraits from Memory*.

*8.* PORTRAITS FROM MEMORY: SIDNEY AND BEATRICE WEBB. *Harper's Magazine*, Mar. 1953, v. 206, pp. 92-94. See item 22, 1952. Reprinted in *Portraits from Memory*.

*9.* "G" IS FOR GOBBLEDEGOOK. *This Week, New York Herald Tribune,* Sunday, April 12, 1953, pp. 23, 64.

*10.* LOOKING BACKWARD TO THE 1950's. *The New York Times Magazine*, Sunday, Apr. 26, 1953, pp. 12, 58, 59.

*11.* WHAT WOULD HELP MANKIND MOST? *The New York Times Magazine*, Sunday, Sept. 27, 1953, pp. 10, 47, 48, 49. Condensed under title To TURN US FROM MADNESS in *The Reader's Digest*, Dec. 1953, v. 63, pp. 1-3.

*12.* WHAT IS AN AGNOSTIC? *Look,* Nov. 3, 1953, v. 17, pp. 96, 98, 99, 100, 101. Reprinted in *A Guide to the Religions of America*. Edited by Leo Rosten. New York, Simon and Schuster, 1955, pp. 149-157.

*13.* PREFACE TO PROFESSOR MMAA's LECTURE by Stefan Themeros. London, Gaberbocchus Press Limited, 1953, pp. 9-11.

*14.* TECHNICS AND TOTALITARIANISM. Review of Leonard Woolf's *Principia Politica: A Study of Communal Psychology. Encounter,* Nov. 1953, v. 1, pp. 75-77.

*15.* PORTRAITS FROM MEMORY: CAMBRIDGE IN THE EIGHTEEN-NINETIES. *The Listener*, Aug. 20, 1953, v. 1, pp. 307-308. Reprinted in *Portraits from Memory*.

*16.* PORTRAITS FROM MEMORY: CAMBRIDGE FRIENDSHIPS. *The Listener*, Aug. 27, 1953, v. 1, pp. 337-338. Reprinted in *Portraits from Memory*.

*17.* PORTRAITS FROM MEMORY: H. G. WELLS: LIBERATOR OF THOUGHT. *The Listener,* Sept. 10, 1953, v. 1, pp. 417-418. Reprinted in *Portraits from Memory.*

*18.* BENEFIT OF CLERGY. *Harper's Bazaar,* June 1953, pp. 86, 87, 124, 130. Reprinted in *Satan in the Suburbs.*

### 1954

*1.* NIGHTMARES OF EMINENT PERSONS AND OTHER STORIES. London, George Allen & Unwin, Limited, 1954; New York, Simon and Schuster, 1955, pp. 177.

Preface. Introduction. Nightmares of Eminent Persons. The Queen of Sheba's Nightmare: Put Not Thy Trust in Princes. Mr. Bowdler's Nightmare: Family Bliss. The Psychoanalyst's Nightmare: Adjustment—A Fugue. The Metaphysician's Nightmare: Retro Me Satanas. The Existentialist's Nightmare: The Achievement of Existence. The Mathematician's Nightmare: The Vision of Professor Squarepunt. Stalin's Nightmare: Amor Vincit Omnia. Eisenhower's Nightmare: The McCarthy-Malenkov Pact. Dean Acheson's Nightmare: The Swan Song of Menelaus S. Bloggs. Dr. Southport Vulpes's Nightmare: The Victory of Mind over Matter. Zahatopolk. Faith and Mountains.

*2.* HUMAN SOCIETY IN ETHICS AND POLITICS. London, George Allen & Unwin, Limited, 1954; New York, Simon and Schuster, 1955, pp. 227.

Part One: Ethics. I. Sources of Ethical Beliefs and Feelings. II. Moral Codes. III. Morality as a Means. IV. Good and Bad. V. Partial and General Goods. VI. Moral Obligation. VII. Sin. VIII. Ethical Controversy. IX. Is There Ethical Knowledge? X. Authority in Ethics. XI. Production and Distribution. XII. Superstitious Ethics. XIII. Ethical Sanctions.

Part Two: The Conflict of Passions. I. From Ethics to Politics. II. Politically Important Desires. III. Forethought and Skill. IV. Myth and Magic. V. Cohesion and Rivalry. VI. Scientific Technique and the Future. VII. Will Religious Faith Cure Our Troubles? VIII. Conquest. IX. Steps Toward a Stable Peace. X. Prologue or Epilogue?

*3.* HISTORY AS AN ART. Herman Ould Memorial Lecture at Aldington, Kent, 1954. London, Hand & Flower Press, 1954, pp. 23.

*4.* THE CORRODING EFFECTS OF SUSPICION. *The York Times Magazine,* Feb. 14, 1954, pp. 7, 55-56.

*5.* A PRESCRIPTION FOR THE WORLD. *Saturday Review,* Aug. 28, 1954, pp. 9-11, 38-40.

*6.* THE HYDROGEN BOMB AND WORLD GOVERNMENT. *The Listener,* v. lii, July 22, 1954, pp. 133-134.

*7.* 1948 RUSSELL VS. 1954 RUSSELL. 1948 Letter to Dr. Marseille.

1954 Letter explaining change of views on relations with Russia. *Saturday Review,* Oct. 16, 1954, pp. 25, 26.

*8.* VIRTUE AND THE CENSOR. *Encounter,* July 1954, v. 1, pp. 8-10.

*9.* REVIEW OF SAINT OF RATIONALISM: THE LIFE OF JOHN STUART MILL by Michael St. John Packe. *The Observer,* London, Apr. 4, 1954, p. 9.

*10.* COMMISSION FOR PEACE. *The Nation,* Dec. 18, 1954, v. 179, pp. 531-533.

*11.* LIGHT VERSUS HEAT: REVIEW OF PHILOSOPHICAL ESSAYS BY A. J. AYER. *The Observer,* Aug. 8, 1954, p. 7.

*12.* KNOWLEDGE AND WISDOM. *The Listener,* Sept. 9, 1954, v. lii, p. 390.

*13.* MAN'S PERIL FROM THE HYDROGEN BOMB. *The Listener,* Dec. 30, 1954, v. lii, pp. 1135-1136. Reprinted by the Friends Peace Committee, London.

*14.* WHAT NEUTRALS CAN DO TO SAVE THE WORLD. *Britain Today,* September 1954. Reprinted in *Fact and Fiction.*

## 1955

*1.* MAN'S DUEL WITH THE HYDROGEN BOMB. *Saturday Review,* Apr. 2, 1955, pp. 11, 12, 41.

*2.* CAN THE LIBERAL SURVIVE? Guest editorial in the *Saturday Review,* Mar. 19, 1955, pp. 22, 35.

*3.* LETTER to President Dwight D. Eisenhower, Premier Nickolai A. Bulganin, Prime Minister Anthony Eden, President Rene Coty, Chinese Communist Leader Mao Tse-tung and Prime Minister Louis S. St. Laurent forwarding letter about hydrogen bomb warfare as signed by Prof. Percy W. Bridgman, Albert Einstein, Prof. Leopold Infeld, Prof. Hermann J. Muller, Prof. Cecil F. Powell, Prof. Joseph Rotblat, Bertrand Russell and Prof. Hideki Yukana, together with Bertrand Russell's prefatory statement read to newspaper correspondents at conference in London on July 9, 1955 as printed in the newspapers of July 10, 1955.

*4.* SCIENCE AND HUMAN LIFE. In *What is Science,* edited by James R. Newman. New York, Simon and Schuster, 1955, pp. 6-17.

*5.* THE GREATNESS OF ALBERT EINSTEIN. *The New Leader,* May

30, 1955, v. xxxviii., pp. 8-10. *The Listener*, Apr. 28, 1955, v. liii , pp. 745-746. Reprinted in *Great Essays in Science*. Edited by Martin Gardner. Pocket Library, Inc., New York, 1957, pp. 398-402.

6. PHILOSOPHERS AND IDIOTS. *The Listener*, Feb. 10, 1955, v. liii , pp. 247, 249.

7. THE ROAD TO PEACE. In *The Bomb: Challenge and Answer*. With A. Haldow, Low Beveridge, H. Osborne. Edited by G. McAllister. London: Batsford, 1955.

8. JOHN STUART MILL. Lecture on a Master Mind, read, Jan. 19, 1955. British Academy Proceedings, 1955, v. 41, 1956, pp. 43-59.

### 1956

1. PORTRAITS FROM MEMORY AND OTHER ESSAYS. London, George Allen & Unwin, Limited; New York, Simon and Schuster, 1956, pp. 246.

Adaptation: An Autobiographical Epitome. Six Autobiographical Essays: Why I Took to Philosophy, Some Philosophical Contacts, Experiences of a Pacifist in the First World War, From Logic to Politics, Beliefs: Discarded and Retained, Hopes: Realized and Disappointed. How to Grow Old. Reflections on My Eightieth Birthday. Portraits from Memory: Some College Dons of the Nineties, Some of My Contemporaries at Cambridge, George Bernard Shaw, H. G. Wells, Joseph Conrad, George Santayana, Alfred North Whitehead, Sidney and Beatrice Webb, D. H. Lawrence. Lord John Russell. John Stuart Mill. Mind and Matter. The Cult of 'Common Usage.' Knowledge and Wisdom. A Philosophy for Our Time. A Plea for Clear Thinking. History as an Art. How I Write. The Road to Happiness. Symptoms of Orwell's 1984. Why I am not a Communist. Man's Peril. Steps Toward Peace.

Knowledge and Wisdom was reprinted under the title The World's Need for Wisdom in Wisdom, Feb. 1957, v. 2, p. 29-31 together with photographs and selections from other works as well as Lester E. Denonn's Introduction to The Wit and Wisdom of Bertrand Russell (Boston, The Beacon Press, 1951) from which the selections were taken. Knowledge and Wisdom was also reprinted in Essays in Philosophy Edited by Houston Peterson and James Bayley. Pocket Library, 1959, pp. 498-502.

2. LOGIC AND KNOWLEDGE: ESSAYS 1901-1950. Edited by Robert Charles Marsh. London, George Allen & Unwin, Limited; New York, The Macmillan Company, 1956, pp. 382.

Prefatory Note. 1901—The Logic of Relations. 1905—On Denoting. 1908—Mathematical Logic as Based on the Theory of Types. 1911—On the Relations of Universals and Particulars. 1914—On the Nature of Acquaintance. 1918—The Philosophy of Logical Atomism. 1919—On Propositions: What They Are and How They Mean. 1924—Logical Atomism. 1936—On Order in Time. 1950—Logical Positivism.

*3.* LETTER Regarding the Rosenberg Spy Case. *The Manchester Guardian*, Mar. 26, 1956.

*4.* IN THE COMPANY OF CRANKS. *Saturday Review*, Aug. 11, 1956, pp. 7-8.

*5.* INTRODUCTION to British edition of Corliss Lamont's *Freedom is as Freedom Does*.

*6.* LETTER. *The Manchester Guardian*, Dec. 4, 1956.

*7.* REVIEW of Urmson's *Philosophical Analysis: Its Development between the Two World Wars*. *The Hibbert Journal*, July, 1956.

*8.* THE STORY OF CIVILIZATION. Talk on B.B.C. European Service, 1956. Printed in *Fact and Fiction*.

## 1957

*1.* WHY I AM NOT A CHRISTIAN AND OTHER ESSAYS ON RELIGION AND RELATED SUBJECTS. Edited, with an Appendix on the "Bertrand Russell Case" by Paul Edwards. London, George Allen & Unwin, Limited; New York, Simon and Schuster, 1957, pp. 225.

Preface by Bertrand Russell. 1927—Why I am not a Christian. 1930—Has Religion Made Useful Contributions to Civilization. 1925—What I Believe. 1936—Do We Survive Death? (Answer to Bishop Barnes, in The Mysteries of Life and Death. London, Hutchinson and Company.) 1899—Seems, Madam? Nay, It Is. (Never before published.) 1903—A Free Man's Worship. 1928—On Catholic and Protestant Skeptics. 1925—Life in the Middle Ages. 1934—The Fate of Thomas Paine. 1931—Nice People. 1930—The New Generation. 1936—Our Sexual Ethics. 1940—Freedom and the Colleges. 1954—Can Religion Cure Our Troubles? Stockholm newspaper, Dagens Nyketer, Nov. 9 and 11, 1954. 1952—Religion and Morals. 1948—The Existence of God (In the English edition only), a debate between Bertrand Russell and Father F. C. Copleston, S.J. over B.B.C. Third Programme. Published in *Humanitas*.

*2.* UNDERSTANDING HISTORY AND OTHER ESSAYS. New York, Philosophical Library, Inc., 1957, pp. 122. Also printed in paperback by The Wisdom Library, a Division of Philosophical Library.

1943—How to Read and Understand History (The Past as the Key to the Future). 1944—The Value of Free Thought (How to Become a Truth-Seeker and Break the Chains of Mental Slavery). 1946—Mentalism and Materialism (Is Materialism Bankrupt? Mind and Matter in Modern Science).

*3.* NOV. 23, 1957—OPEN LETTER TO DWIGHT D. EISENHOWER AND NIKITA S. KHRUSHCHEV. London, *The New Statesman*. Reprinted

in *Look*, Jan. 21, 1958, v. 22, pp. 18-19. Reprinted as *The Vital Letters of Russell, Khrushchev, Dulles*. Introduction by Kingsley Martin. London, Macgibbon & Kee, 1958. Russell Open Letter, pp. 15-19. Russell reply, pp. 70-77. Italian edition—*Lettera ai potenti della terra. Con le reposte di Nikita Kruscev e Foster Dulles.* Edited by Giulio Einaudi. Torino, presso la Tipografia Toso, 1958.

*4.* FOREWORD. In *Fall Out*. Contributions by nine English scientists. London, Macgibbon & Kee, 1957.

*5.* THE STATE OF U. S. LIBERTIES. Reply to an article by Norman Thomas. *The New Leader*, Feb. 18, 1957, v. xl , pp. 16-18.

*6.* HEAVEN AND HOPE. *Newsweek*, Jan. 28, 1957. Question from *London Sunday Times: Do Men Survive Death?*

*7.* THE IMPORTANCE OF SHELLEY. First in series on *Books that Influenced My Youth. London Calling—The Overseas Journal of the* B.B.C., Mar. 7, 1957, p. 4. Reprinted in *Fact and Fiction*.

*8.* THE ROMANCE OF REVOLT: TURGENEV. Second of the series on *Books that Influenced My Youth. London Calling*, Mar. 14, 1957, p. 10. Reprinted in *Fact and Fiction*.

*9.* REVOLT IN THE ABSTRACT: IBSEN. Third of the series on *Books that Influenced My Youth. London Calling*, Mar. 21, 1957, p. 12. Reprinted in *Fact and Fiction*.

*10.* DISGUST AND ITS ANTIDOTE: CARLYLE, SWIFT, MILTON. Fourth of the series on *Books that Influenced My Youth. London Calling*, Mar. 28, 1957, p. 10. Reprinted in *Fact and Fiction*.

*11.* AN EDUCATION IN HISTORY: DRAPER, GIBBON. Fifth of the series on *Books that Influenced My Youth. London Calling*, Apr. 4, 1957, p. 6. Reprinted in *Fact and Fiction*.

*12.* THE PURSUIT OF TRUTH: CLIFFORD. Sixth and final talk of the series on *Books that Influenced My Youth. London Calling*, Apr. 11, 1957, p. 14. Reprinted in *Fact and Fiction*.

*13.* THREE REASONS WHY THEY DISLIKE US. *The New York Times Magazine*, Sept. 8, 1957, pp. 20, 115.

*14.* VOICE OF THE SAGES: INTERVIEW BY IRWIN ROSS. *New York Post,* Nov. 6, 1957, v. 156, Daily Magazine Section II , p. 2.

15. CAN SCIENTIFIC MAN SURVIVE? Guest editorial in the *Saturday Review*, Dec. 21, 1957, pp. 24, 25. *The Sunday Times,* London. Reprinted in *The Challenge of the Sputnik.* Edited by Richard Witkin. Doubleday Headline Publications, 1958, pp. 93-96.

16. THE REASONING OF EUROPEANS. A Talk on the B.B.C. Overseas Service, 1957. Reprinted in *Fact and Fiction.*

17. POPULATION PRESSURE AND WAR. In *The Human Sum,* ed. by C. H. Rolph, London, Heinemann, 1957. Reprinted in *Fact and Fiction.*

### 1958

1. THE WILL TO DOUBT. New York, Philosophical Library, Inc., 1958, pp. 126. Reprint of essays (with alterations) from SCEPTICAL ESSAYS: Can Man Be Rational? Free Thought and Official Propaganda. On the Value of Scepticism. Is Science Superstitious? And from IN PRAISE OF IDLENESS AND OTHER ESSAYS: On Youthful Cynicism. 'Useless' Knowledge. What is the Soul? The Ancestry of Fascism. Aoticism and Mental Health. Modern Homogeneity. Men versus Insects. On Comets.

2. INTERVIEW WITH JOSEPH ALSOP. In column, *Matter of Fact. New York Herald Tribune,* Feb. 18, 1958, pp. 1, 12.

3. INTERVIEW WITH MIKE WALLACE. In column, *Mike Wallace Asks. New York Post,* Feb. 28, 1958, p. 24.

4. LETTER: CAMPAIGN AGAINST NUCLEAR WEAPONS. Response to Dulles and Khrushchev. *The New Statesman,* Apr. 2, 1958.

5. WHY I CHANGED MY MIND. Guest editorial in the *Saturday Review,* May 31, 1958, p. 18.

6. COMMENT ON WALTER KAUFMANN'S CRITIQUE OF RELIGION AND PHILOSOPHY. Harper advertisement in *The New York Times Book Review,* Sunday, June 8, 1958.

7. INTERVIEW WITH NORMAN COUSINS. Editorial. *Saturday Review,* July 20, 1958, p. 34. Entitled: *In the Direction of Sanity—On Atomic Weapons.*

8. A VISIT WITH BERTRAND RUSSELL: MANKIND DOES NOT HAVE TO DIE BY RADIATION. Picture interview by Edward M. Korry, Look European Editor. *Look,* Aug. 5, 1958, v. 22, pp. 20-25.

*9.* LORD RUSSELL HAS PLAN FOR PEACE: INTERVIEW BY KINGSBURY SMITH OF UNITED PRESS INTERNATIONAL. *World-Telegram and Sun*, second section, Aug. 8, 1958, p. 2.

*10.* RESPECT FOR LAW. *San Francisco Review*, v. i, pp. 62-65.

*11.* OPEN LETTER TO THE MEN AT GENEVA. Letter signed by Albert Schweitzer, Bertrand Russell and 170 others. *Saturday Review*, Nov. 22, 1958, p. 22.

*12.* SMALL WORLD: INTERCONTINENTAL TELEPHONE CONVERSA- TION. 6 P.M., New York time, Oct. 19, 1958. Edward R. Murrow with Bertrand Russell, Willard F. Libby and Homi J. Bhabha. John Crosby in the *New York Herald Tribune*, Oct. 20, 1958, quotes what Russell said about atomic energy.

*13.* WISDOM: INTERVIEW BY ROMNEY WHEELER. In volume by that name. Edited by James Nelson. New York, W. W. Norton & Com- pany, Inc., 1958, pp. 101-111.

*14.* WORLD COMMUNISM AND NUCLEAR WAR: A DEBATE ON THE ULTIMATE THREAT. In answer to article by Sidney Hook entitled *A Foreign Policy for Survival* (*The New Leader*, April 7, 1958). *The New Leader*, May 26, 1958, v. xli, pp. 9-10. Followed by an article by Sidney Hook entitled *A Free Man's Choice*.

*15.* FREEDOM TO SURVIVE: ROUND TWO OF A VITAL DEBATE. *The New Leader*, v. xli., July 7 and 14, 1958, pp. 23-25. Followed by an article by Sidney Hook entitled *Bertrand Russell Retreats*.

*16.* DEBATE WITH CRITIC ON ABOLITION OF WAR. *Bulletin of The Atomic Scientists*, Apr. 1958.

*17.* FORMAL ADDRESS TO THE CONGRESS OF THE PUGWASH MOVE- MENT AT VIENNA, September 20, 1958. Printed in *Fact and Fiction*.

### 1959

*1.* COMMON SENSE AND NUCLEAR WARFARE. London, George Allen & Unwin, Limited; New York, Simon and Schuster, 1959, pp. 92. I. If Brinkmanship Continues. II. If Nuclear War Comes. III. Methods of Settling Disputes in the Nuclear Age. IV. Programme of Steps Towards Peace. V. New Outlook Needed before Negotiations. VI. Disarmament. VII. Steps Toward Conciliation. VIII. Territorial Adjustments. IX. Approach to an International Authority. X. Some Necessary Changes in Outlook. Appendix I. Unilateral Disarmament. Appendix II. Inconsistency?

*2.* MY PHILOSOPHICAL DEVELOPMENT. London, George Allen & Unwin, Limited; New York, Simon and Schuster, 1959, pp. 279.
1. Introductory Outline. 2. My Present View of the World. 3. First Efforts. 4. Excursion into Idealism. 5. Revolt into Pluralism. 6. Logical Technique in Mathematics. 7. Principia Mathematica: Philosophical Aspects. 8. Principia Mathematica: Mathematical Aspects. 9. The External World. 10. The Impact of Wittgenstein. 11. Theory of Knowledge. 12. Consciousness and Experience. 13. Language. 14. Universals and Particulars and Names. 15. The Definition of 'Truth.' 16. Non-Demonstrative Inference. 17. The Retreat from Pythagoras. 18. Some Replies to Criticism constituting reviews of Urmson's Philosophical Analysis: Its Development between the Two World Wars; Warnock's Metaphysics in Logic, published in Essays in Conceptual Analysis; Strawson's On Referring, in the same volume; and Ryle's The Concept of Mind. Appendix: Russell's Philosophy—A Study of Its Development by Alan Wood.

Chapter 16 was reprinted in the *Centennial Review of Arts and Sciences,* Summer 1959, v. III., pp. 237-257. Chapter 2 and part of 10 appeared in *Encounter,* Jan. 1959. Chapters 3, 4, 5, 6, 7, 8, 9, 11, 13 and 18 appeared in *Encounter,* Feb. 1959.

*3.* WISDOM OF THE WEST: A HISTORICAL SURVEY OF WESTERN PHILOSOPHY IN ITS SOCIAL AND POLITICAL SETTING. Edited by Paul Foulkes. London, Macdonald; New York, Doubleday & Company, Inc., 1959, pp. 320.

Prologue: Before Socrates; Athens; Hellenism; Early Christianity; Scholasticism; Rise of Modern Philosophy; British Empiricism; Enlightenment and Romanticism; Utilitarianism and since; Contemporary; Epilogue.

*4.* SELF-PORTRAIT OF A REBEL-PHILOSOPHER-SKEPTIC. B.B.C. interview with John Freeman. *The Listener,* May 3, 1959. Excerpts in *The New York Times Magazine,* May 3, 1959, pp. 32, 34, 37, 39. Reprinted in Wisdom Library volume entitled *The Future of Science,* 1959.

*5.* THE EXPANDING MENTAL UNIVERSE. No. 31 in series, *Adventures of the Mind.* *The Saturday Evening Post,* July 18, 1959, v. 232, pp. 24, 91-93 with photograph. Reprinted in volume entitled *Adventures of the Mind.* Edited by Richard Thruelsen and John Kobber. New York, Alfred A. Knopf, 1959, pp. 275-285.

*6.* INTRODUCTION to Ernest Gellner's *Words and Things:* A Critical Account of Linguistic Philosophy and a Study of Ideology. London, Victor Gollancz, Ltd., 1959; Boston, Beacon Press, 1960, pp. 13-15.

*7.* LETTER. Regarding the refusal of *Mind* to review the Gellner book. *The London Times,* Nov. 5, 1959.

*8.* MY PRESENT VIEW OF THE WORLD. *Encounter,* Jan. 1959, v. xii, pp. 3-10.

*9.* MY PHILOSOPHICAL DEVELOPMENT. *Encounter,* v. xii, Feb. 1959, pp. 18-29.

*10.* LETTER TO C. P. SNOW. In discussion of C. P. Snow's *Two Cultures. Encounter,* Aug. 1959, v. xiii, p. 71.

*11.* LETTER. In reply to Nov. 21 letter of Alec Kassman, Editor, *The Aristotelian Society,* on the refusal of Professor Ryle to review the Gellner book in *Mind.*

*12.* THE FUTURE OF MAN. Symposium sponsored by Joseph E. Seagram & Sons, Inc., on the dedication of its headquarters building in New York at 375 Park Avenue on Sept. 29, 1959, pp. 37-39, 41, 42, 43, 48, 49, 52, 55, 57, 58.

*13.* THE FUTURE OF SCIENCE. New York, The Wisdom Library, 1959, pp. 86. I. The Future of Science (Icarus). II. Self Portrait of the Author. Interview with John Freeman over B.B.C.

*14.* PARABLES. *The New Statesman,* 1959. Reprinted in *Fact and Fiction.*

*15.* WAR AND PEACE IN MY LIFETIME. Talk on B.B.C. Asian Service, 1959. Printed in *Fact and Fiction.*

*16.* ADDRESS TO THE C.N.D. MEETING AT MANCHESTER. May 1, 1959. Printed in *Fact and Fiction.*

### 1960

*1.* BERTRAND RUSSELL SPEAKS HIS MIND. Cleveland and New York, The World Publishing Company, 1960; Canada, Nelson, Foster & Scott, Ltd., 1960, pp. 173.

Interviews by Woodrow Wyatt. What is Philosophy? Religion, War and Pacifism. Communism and Capitalism. Taboo Morality. Power. What is Happiness? Nationalism. Great Britain. The Role of the Individual. Fanaticism and Tolerance. The H-Bomb. The Possible Future of Mankind.
Reprinted serially in the *New York Post,* 1961. Reprinted—New York, Avon Book Division, The Hearst Corporation, 1960, pp. 144.

*2.* PREFACE AND LETTERS IN EINSTEIN ON PEACE. Edited by Otto Nathan and Heinz Norden. New York, Simon and Schuster, 1960.

Preface, pp. xv., xvi. Manifesto for World Disarmament issued on May 30, 1930 by the Women's International League for Peace and Freedom—signed by Bertrand Russell, Albert Einstein, Stefan Zweig, Thomas Mann, Jane Addams and Ivan Pavlov, pp. 105, 106. Manifesto against Conscription and the Military Training of Youth, issued on Oct. 12, 1930 by the Joint Peace Council, embracing the Quakers, the Fellowship of Reconciliation, The War

Resisters' International, The Women's International League for Peace and Freedom and other pacifist groups, signed, among others, by Bertrand Russell and Albert Einstein, pp. 113-114. Letter to the *New York Times*, June 26, 1953, in support of Einstein's view urging intellectuals to refuse to testify before Congressional investigating committees, p. 550. Letter to Einstein, Feb. 11, 1955, concerning the abolition of war, pp. 624-626. Letter to Einstein, Feb. 25, 1955, with further reference to the abolition of war, pp. 627-628. Memorandum regarding the statement for abolition of war, dated Feb. 15, 1955, p. 629. Letter to Einstein, Apr. 5, 1955, concerning the abolition of war, pp. 631-632. Preface to the declaration regarding the abolition of war, pp. 632-633. Declaration, B.B.C., Dec. 23, 1954, regarding the abolition of war, signed by Bertrand Russell and Albert Einstein with eight other scientists, pp. 633-636, printed in the *New York Times*, July 10, 1955 and reprinted by War Resisters' League.

*3.* BERTRAND RUSSELL LOOKS AT HIGHER EDUCATION TODAY. *The New York University Alumni News*, v. 5, Jan. 1960, p. 3; *Syracuse University Alumni News*, v. xli, Spring 1960, pp. 31-34 under title, *University Education and Modern Conditions*, and in *Arkansas University Alumnus*, 1959. Reprinted in *Fact and Fiction*.

*4.* THE POSSIBLE FUTURE OF MANKIND. *Harper's Bazaar*, Jan. 1960, v. 93, pp. 122-123. Reprinted in *Bertrand Russell Speaks His Mind*.

*5.* THE CASE FOR NEUTRALISM. In opposition to article by Hugh Gaitskell. *The New York Times Magazine*, July 24, 1960, pp. 10, 35, 36. Letter in rebuttal to Hugh Gaitskell in *The New York Times Magazine*, Aug. 14, 1960, pp. 90-91. Reprinted in *Background and Foreground: An Anthology of Articles from The New York Times Magazine*. Edited by Lester Markel. Great Neck, New York, Channel Press, 1960, pp. 87-98. (This does not include the rebuttal letter.)

*6.* FOREWORD to OUT OF THIS WORLD: AN ANTHOLOGY OF SCIENCE FICTION. Vol. I. Chosen by Anabel Williams, Ellis and Mably Owen. London and Glasgow, Blackie, 1960, pp. 9-10.

*7.* OLD AND YOUNG CULTURES. Sonning Prize Address, 1960. Printed in *Fact and Fiction*.

*8.* THE SOCIAL RESPONSIBILITIES OF SCIENTISTS. Science, Feb. 12, 1960. Reprinted in *Fact and Fiction*.

*9.* CAN WAR BE ABOLISHED? Russian journal, *Science and Religion*, 1960. Reprinted in *Fact and Fiction*.

*1.* PREFACE TO THE BASIC WRITINGS OF BERTRAND RUSSELL: 1903-
1959. London, George Allen & Unwin, Limited; New York, Simon
and Schuster, 1961, pp. 736. Edited by Robert E. Egner and Lester
E. Denonn.

> This work contains eighty-one Russell selections grouped under seventeen
> headings: 1. Autobiographical Asides. 2. The Nobel Prize Winning Man of
> Letters. 3. The Philosopher of Language. 4. The Logician and Philosopher
> of Mathematics. 5. The Epistemologist. 6. The Metaphysician. 7. Historian
> of Philosophy. 8. The Psychologist. 9. The Moral Philosopher. 10. The Phi-
> losopher of Education. 11. The Philosopher of Politics. 12. The Philosopher
> in the Field of Economics. 13. The Philosopher of History. 14. The Philos-
> opher of Culture: East and West. 15. The Philosopher of Religion. 16. The
> Philosopher and Expositor of Science. 17. The Analyst of International
> Affairs.

*2.* LETTER CONCERNING DISARMAMENT: BERTRAND RUSSELL RE-
PLIES TO MR. CHRISTOPHER MAYHEW (M.P.). *Encounter,* June
1961, v. xvi , pp. 94-95.

*3.* HAS MAN A FUTURE? London, George Allen & Unwin, Ltd.,
1961, pp. 128. (Published in 1962 by Simon and Schuster, New
York.)

> I. Prologue or Epilogue? II. The Atom Bomb. III. The H-Bomb. IV. Lib-
> erty or Death? V. Scientists and the H-Bomb. VI. Long-Term Conditions
> of Human Survival. VII. Why World Government is Disliked. VIII. First
> Steps Toward Secure Peace. IX. Disarmament. X. Territorial Problems.
> XI. A Stable World.

*4.* FACT AND FICTION. London, George Allen & Unwin, Ltd., 1961,
pp. 282. (Published in 1962 by Simon and Schuster, New York.)

> *Part One:* Books that Influenced Me in Youth. I. The Importance of Shelley.
> II. The Romance of Revolt. III. Revolt in the Abstract. IV. Disgust and Its
> Antidote. V. An Education in History. VI. The Pursuit of Truth.    *Part*
> *Two:* Politics and Education. I. What is Freedom? II. What is Democ-
> racy? III. A Scientist's Plea for Democracy. IV. The Story of Colonization.
> V. Pros and Cons of Nationalism. VI. The Reasoning of Europeans. VII.
> The World I Should Like to Live In. VIII. Old and Young Cultures.
> IX. Education for a Difficult World. X. University Education.    *Part*
> *Three:* Divertissements. I. Cranks. II. The Right Will Prevail or the
> Road to Lhasa. III. Newly Discovered Maxims of La Rochefoucauld. IV.
> Nightmares. 1. The Fisherman's Nightmare or Magna est Veritas. 2. The
> Theologian's Nightmare. V. Dreams. 1. Jowett, 2. God. 3. Henry the
> Navigator. 4. Prince Napoleon. 5. The Catalogue. VI. Parables. 1. Plan-
> etary Effulgence. 2. The Misfortune of Being Out-of-Date. 3. Murderer's
> Fatherland.    *Part Four:* Peace and War. I. Psychology and East-West
> Tensions. II. War and Peace in My Lifetime. III. The Social Responsibil-
> ities of Scientists. IV. Three Essentials for a Stable World. V. Population

Pressure and World War III. VI. Vienna Address. VII. Manchester Address. VIII. What Neutrals Can Do to Save the World. IX. The Case for British Neutralism. X. Can War Be Abolished? XI. Human Life is in Danger.

## 1962

1. FOREWORD TO FRED J. COOK: *The Warfare State*. New York, The Macmillan Company; London, Macmillan New York, 1962, pp. vii-xiii.

2. HISTORY OF THE WORLD: IN EPITOME. Four page, illustrated satirical booklet. London, Gaberbocchus Press, Ltd., May 18, 1962.

3. INTERVIEW WITH ELDON GRIFFITHS ON *War, Peace, the Bomb*. *Newsweek*, vol. lx, no. 8, August 20, 1962, pp. 56-57.

4. LETTER TO NEW YORK TIMES, September 1, 1962, on reducing the sentence of Don Martin.

5. THE MISFORTUNE OF BEING OUT-OF-DATE: A PARABLE. *Harper's Bazaar,* January, 1962, no. 3002, pp. 126, 148, 150. Reprinted in *Fact and Fiction.*

6. LETTER RE ETZIONI REVIEW OF KAHN'S *On Thermonuclear War* (Fall, 1961), Columbia University Forum, Winter 1962, Volume v, no. 1, p. 3.

7. TO AVOID NUCLEAR WAR. *The Atlantic Monthly,* vol. 210, no. 5, November 1962, pp. 65-67.

# ADDENDA AND REVISIONS

### 1897

*1.* AN ESSAY ON THE FOUNDATIONS OF GEOMETRY. Cambridge, at the University Press, 1897. 201 pp.

This expansion of Bertrand Russell's Cambridge thesis has been reprinted. New York, Dover Publications, Inc., 1956, 201 pp. Foreword by Morris Kline.

### 1901

*6.* THE LOGIC OF RELATIONS: WITH SOME APPLICATIONS TO THE THEORY OF SERIES. *Rivista di Matematica*, v. vii, pp. 115-148, Turin, 1900-1901.

Translated by Robert C. Marsh. In *Logic and Knowledge*, 1956. General Theory of Relations. Cardinal Numbers. Progressions. Finite and Infinite. Compact Series. Fundamental Series in a Compact Series.

### 1903

*1.* THE PRINCIPLES OF MATHEMATICS. Cambridge, at the University Press, 1903; London, George Allen & Unwin Ltd., 1937, Second Edition. ix, 534 pp.

Translated by Juan Carlos Grimberg. *Los Principios De La Matematica.* Buenos Aires, 1948.

*2.* THE FREE MAN's WORSHIP. *The Independent Review*, v. I, Dec. 1903, pp. 415-424.

Reprinted: in *Little Blue Books,* with a new introduction and under title of "What Can a Free Man Worship?" Haldeman-Julius Publications, Girard, Kansas, #677, 1927, 32 pp. *Fifty Modern English Writers,* edited by W. Somerset Maugham, Doubleday Doran, 1933, pp. 1294-1302. *Toward Liberal Education,* edited by Locke, Gibson and Arnus, Rinehart & Co., New York, 1948, pp. 625-631.

### 1904

*7.* AXIOM OF INFINITY. *The Hibbert Journal*, v. 2, July 1904, pp. 809-812.

*8.* TARIFF CONTROVERSY: Bibliog. *Edinburgh Review,* v. 199, 1904 pp. 169-196. Published anonymously.

*9.* AN ETHICAL APPROACH. In *Ideals of Science and Faith.* Edited by J. E. Hand. New York, Longmans, 1904.

## 1905

*3.* ON DENOTING. *Mind,* New Series, v. xiv, 1905, pp. 479-493.

Reprinted in *Readings in Philosophical Analysis,* edited by Feigl and Sellars. New York, Appleton-Century-Crofts, Inc., 1949, pp. 103-115. Also reprinted in *Logic and Knowledge,* 1956. Edited by Robert C. Marsh.

## 1908

4. MATHEMATICAL LOGIC AS BASED ON THE THEORY OF TYPE. *American Journal of Mathematics,* v. 30, 1908, pp. 222-262. Reprinted in *Logic and Knowledge,* 1956. Edited by Robert C. Marsh.

## 1912

2. THE PROBLEMS OF PHILOSOPHY. London, William & Norgate, 1912; New York, Henry Holt & Co., 1912. Home University Library. pp. viii, 255.

Reprinted—New York, Oxford University Press, Galaxy Book, 1959, pp. 167. Translated into Russian by S. I. Stein. Problemy filosofii. St. Petersburg, 1914. The last chapter on The Value of Philosophy in *Basic Problems of Philosophy.* Edited by D. J. Bronstein, Y. H. Krikorian and P. P. Wiener. Second edition—Englewood Cliffs, Prentice Hall, Inc., 1955, pp. 560-564.

*3.* ON THE RELATION OF UNIVERSALS AND PARTICULARS. *Proceedings Aristotelian Society,* New Series, v. xii, 1912, pp. 1-24.

This lecture at which Henri Bergson was in attendance was reprinted in *Logic and Knowledge,* 1956, with a note added in 1955. Edited by Charles C. Marsh.

## 1912

8. THE PROFESSOR'S GUIDE TO LAUGHTER. Review of Bergson on Laughter. *The Cambridge Review,* v. xxxii, 1912, pp. 193-194.

## 1914

*1.* OUR KNOWLEDGE OF THE EXTERNAL WORLD AS A FIELD FOR SCIENTIFIC METHOD IN PHILOSOPHY.

Reprinted—New York, Mentor Book, New American Library, 1960, pp. 191. Pp. 247-256 reprinted in *Readings in the Philosophy of Science.* Edited by Herbert Feigl and May Brodbeck. New York, Appleton-Century-Crofts, Inc., 1953, pp. 402-407, under title of *On the Notion of Cause, with Application to the Free-Will Problem.*

2. THE PHILOSOPHY OF BERGSON. London, Macmillan & Co., Ltd., 1914; Glasgow, Jas. MacLehose and Sons, 1914. Published for *The Heretics* by Bowes & Bowes, Cambridge, 1914. 36 pp. Contains reply by H. W. Carr and rejoinder by Russell.

*5.* ON THE NATURE OF ACQUAINTANCE.
Reprinted in *Logic and Knowledge,* 1956. Edited by Robert C. Marsh.

### 1915

*10.* LETTER ON SENSE-DATA. *Journal of Philosophy,* v. xii, 1915, pp. 391-392.

### 1916

*1.* PRINCIPLES OF SOCIAL RECONSTRUCTION. London, George Allen & Unwin, Ltd., 1916. 252 pp. Second Edition, 1920, 250 pp.
Chapter II reprinted as "The State as Organized Power" in *Leviathan in Crisis,* edited by Waldo R. Browne, The Viking Press, New York, 1946. pp. 44-55. Chapter V reprinted in *The World's Best,* edited by Whit Burnett, The Dial Press, New York, 1950. pp. 447-456. Contains a short note from Russell stating why he recommends this selection.
Translated by Dr. Antoni Panski. *Przebudowa Spozeczna,* Warszawa, Roj, 1932. 220 pp.

*11.* MARRIAGE AND THE POPULATION QUESTION. *International Journal of Ethics,* v. 26, July 1916, pp. 443-461.
Reprinted in part as MARRIAGE in *Selected Articles on Marriage and Divorce,* the Handbook Series, compiled by Julia E. Johnsen, The H. W. Wilson Company, New York, 1925. pp. 51-54.

*17.* MR. RUSSELL'S REPLY (to T. E. Hulme writing under the pseudonym of North Staffs). *Cambridge Magazine,* Vol. v, No. 13.
Reprinted in *T. E. Hulme: Further Speculations.* Edited by Sam Hynes. University of Nebraska Press, Lincoln, Nebraska, 1962. Pages 209-211.

*18.* NORTH STAFFS' PRAISE OF WAR, *Cambridge Magazine,* Vol. v, No. 17.
Reprinted in *T. E. Hulme: Further Speculations.* Edited by Sam Hynes. University of Nebraska Press, Lincoln, Nebraska, 1962. Pages 211-213.

### 1917

*1.* POLITICAL IDEALS. New York, The Century Co., 1917. 172 pp.
Chapter I reprinted in *Essays in Contemporary Civilization,* edited by C. W. Thomas, New York, The Macmillan Co., 1931.

*6.* USE OF FORCE AS A SANCTION FOR INTERNATIONAL GOVERNMENTS. In Magazine, War and Peace. A symposium.

### 1918

*1.* MYSTICISM AND LOGIC AND OTHER ESSAYS. New York, Bombay, Calcutta, Madras, Longmans, Green & Co., 1918, vi, 234 pp.
Translated by Yusuf Serif, *Mistiklik ve mantik,* Istanbul, Devlet, matbaasi, 1935. vii, 55 pp. Chaps. II and III translated by Stein Rokkan with other essays of Russell in volume entiled *Frihet og fornuft,* Oslo, E. G. Mortensen, 1947. Reprinted, Pelican Books, 1953 and Garden City, New York, Dou-

bleday Anchor Books, Doubleday and Company, Inc., 1957, 226 pp. Chapter
on Definition of Number in *The World of Mathematics*. Edited by James R.
Newman. New York, Simon and Schuster, v. I., 1956, pp. 537-543. Mathe-
matics and the Metaphysicians in the same work, pp. 1576-1592. Pp. 180-205
reprinted in *Readings in the Philosophy of Science*. Edited by Herbert Feigl
and May Brodbeck. New York, Appleton-Century-Crofts, Inc., 1953, pp. 387-
402, *On the Notion of Cause, with Applications to the Free-Will Problem*.

2. ROADS TO FREEDOM: SOCIALISM, ANARCHISM AND SYNDICALISM.
London, George Allen & Unwin, Ltd., 1918. xviii, 215 pp.

Translated: By Garcia Paladini, *Los Caminos de la libertad; el socialismo, el
anarquismo y el sindicalismo*. Madrid, M. Aguilar, 1932. 244 pp. Biblioteca
de ideas y estudios contemporaneos. By Amelja Kurlandzka, *Drogi Do Wol-
nosci. Socializm, Anarchizm I. Syndykalizm*, Warszawa, Roj. 1935. 239 pp.

3. THE PHILOSOPHY OF MR. B\*RTR\*ND R\*SS\*LL by P. E. B. Jour-
dain. Chicago, The Open Court Publishing Co., 1918; London,
George Allen & Unwin, Ltd., 1918. 96 pp. Printed in *Monist*,
Chicago, Illinois, 1911, v. 21. pp. 481-508.

Contains an Appendix of Leading Passages from Certain Other Works. Con-
tains quotations from conversations with Bertrand Russell and from *Prin-
cipia Mathematica, Philosophical Essays, Philosophy of Leibniz* and *Prin-
ciples of Mathematics*. When contemplating the inclusion of this work here,
the bibliographer queried Russell about it and he said (See "Recollections
of Three Hours with Bertrand Russell," *Correct English*, v. 43, pp. 14-19 at
p. 16): "That was a curious work containing many direct statements of
mine. Jourdain, poor fellow, suffered from paralysis. I would go to see him
frequently and bring him all sorts of odd mental gymnastics, such as, 'First
the idea slipped my mind and then it went clean out of my head. Where was
the idea between the two events?' It seems that Jourdain took them all down
and got them out in book form, adding some others that he picked up else-
where."

6. PHILOSOPHY OF LOGICAL ATOMISM.

Reprinted in *Logic and Knowledge*, 1956. Edited by Charles C. Marsh. Rus-
sell in *My Philosophical Development* refers to some mimeographed mate-
rial here quoted which consisted of a series of questions by Carr and others
and answers by Russell.

## 1919

2. ON PROPOSITIONS: WHAT THEY ARE AND HOW THEY MEAN.

Reprinted in *Logic and Knowledge*, 1956. Edited by Robert C. Marsh.

6. PHILOSOPHY OF LOGICAL ATOMISM TO JULY 1919.

Reprinted in *Logic and Knowledge*, 1956. Edited by Robert C. Marsh.

7. DEMOCRACY AND DIRECT ACTION. *English Review*, May 1919,
v. 28, pp. 396-403.

### 1920

*1.* The Practice and Theory of Bolshevism. London, George Allen & Unwin, Ltd., 1920. Second Edition, 1949. 130 pp. Eliminates Chap. IV of Part I, written by Miss D. W. Black.

*11.* What I Eat. A symposium compiled by Felix Grendon, *McCall's Magazine*, April 1920, v. xvii. pp. 24.

*12.* On Communism. In *The Liberator,* 1920. Edited by Max Eastman.

### 1921

*1.* The Analysis of Mind. London, George Allen & Unwin, Ltd., 1921; New York, The Macmillan Co., 1924. 310 pp. *Library of Philosophy,* ed. J. H. Muirhead. Lectures given in London and Peking.
Contents: Chap. III reprinted from article in *Athenaeum.*

*7.* On Religion. Lecture given in China. Shao-nien Chung-kuo (*The Journal of the Young China Society*), v. ii, Feb. 1921, pp. 36-43.

### 1922

*5.* Hopes and Fears as Regards America.
Also reprinted in part in *The New Republic,* 40th Anniversary Issue, Nov. 22, 1954, p. 94.

*14.* Bring Us Peace—On Nationalism. *The New Student*, v. ii, Oct. 7, 1922, National Student-Forum, pp. 1-2.

*15.* The Difficulties of Bishops. *Rationalist Annual,* 1922.

### 1923

*1.* The Prospects of Industrial Civilization. In collaboration with Dora Russell, New York and London, The Century Co., 1923; London, George Allen & Unwin, Ltd., 1923. v, 287 pp.
Chap. IX reprinted as a chapter in *Selected Papers* (1927, item 4) and in *Essays in Contemporary Civilization,* edited by C. W. Thomas, New York, The Macmillan Co., 1931.
Translated by Amelja Kurlandzka, *Perspektyny Przemyslowej Cyvilizacji.* (Przywspolpracy Dory Russell) Warsawa, Roj, 1933. 310 pp.

*18.* Can Men Be Rational? *Rationalist Annual,* 1923.
Reprinted: in *Little Blue Book,* No. 544. Haldeman-Julius Company, Girard, Kansas, 1947. 32 pp.

### 1924

*2.* Icarus or the Future of Science.
Reprinted as *The Future of Science.* New York, Wisdom Library, 1959.

*4.* LOGICAL ATOMISM
Reprinted in *Logic and Knowledge,* 1956. Edited by Robert C. Marsh.

*6.* PREFACE TO JEAN NICOD'S *La Geometrie Dans Le Monde Sensible.*
Translated by Philip Paul Wiener. New York, The Humanities Press, 1950, Library of Psychology, Philosophy and Scientific Method, pp. 5-9.

*20.* GOVERNMENT BY PROPAGANDA. In v. I., *These Eventful Years: The Twentieth Century in the Making.* London, The Encyclopedia Britannica, Ltd., 1924. pp. 380-385.

*21.* INTRODUCTION TO *Space, Time, Motion: An Historical Introduction to the General Theory of Relativity.* By Alex. Ves. Vesiliev. London, 1924.

### 1925

*1.* THE ABC OF RELATIVITY. New York and London, Harper & Bros., 1925. 231 pp.; London, Kegan Paul, 1925. 237 pp.
Translated by Ernesto Sabato. *El ABC de la relatividad.* Buenos Aires, Ediciones Imam, 1943. 194 pp.

Revised edition. Edited by Felix Pirani. London, George Allen & Unwin, Limited, 1958, 139 pp.; New York, Mentor Books, New American Library, 1959, 144 pp. Chapter on Space-Time reprinted in *New Worlds of Modern Science,* edited by Leonard Engel. New York, Dell Publishing Company, Inc., 1956, pp. 52-59.

*3.* INTRODUCTION: MATERIALISM: PAST AND PRESENT. In Frederick A. Lange's *The History of Materialism.*
Reprinted in the *International Library of Psychology, Philosophy and Scientific Method,* New York, The Humanities Press, 1950.

### 1926

*1.* ON EDUCATION ESPECIALLY IN EARLY CHILDHOOD. London, George Allen & Unwin, Ltd., 1926. 254 pp.; New York, Boni and Liveright, Inc., 1926, 319 pp. as EDUCATION AND THE GOOD LIFE.
Translated: By Janina Hosiassonowna. *O wychowaniu, ze specjalnem unuzglednieniem wczesnego dziecinstwa.* Warsawa, Nasza Ksiegarna, 1932, 258 pp. Bibljoteka Dziel Pedagogicznyck Nr. 29. *Uppfostran för Livet.* Stockholm, Natur O. Kultur, 1933. 233 pp. by Tommaso Fiori. *L'Educazione Dei Nostri Figli.* Bari, G. Laterza, 1934. xv, 240 pp. By Georg Govert. *Erziehung vornehmlich in Frühester Kindheit.* Düsseldorf & Frankfort, Meridian-Verl., 1948, 199 pp.

*12.* PERCEPTION. Lecture to British Institute of Philosophy, in *Journal of Philosophical Studies* (Philosophy), 1926.

### 1927

*1.* WHY I AM NOT A CHRISTIAN. London, Watts & Co., 1927. 31 pp.

Lecture delivered on March 6, 1927 at Battersea Town Hall under the auspices of South London Branch of the National Secular Society. Translated: By Amelja Kurlandzka. *Dlaczego nie Jestem Chrescijaninem?* Warszawa, Wolnomysliciel Polski. Druk, 1948. 32 pp. By Annie Farchy. *Warum ich kein Christ Bin.* Vorwort. *Wer ist Bertrand Russell?* by Kurt Grelling. Dresden, Kreis d. Freunde monist, 1932. 32 pp.

2. THE ANALYSIS OF MATTER.
Reprinted with a new introduction by Lester E. Denonn. New York, Dover Publications, Inc., 1954, pp. 408.

3. AN OUTLINE OF PHILOSOPHY. London, George Allen & Unwin, Ltd., 1927, vi, 317 pp.; New York, W. W. Norton & Co., Inc., under the title of: PHILOSOPHY, 1927, 307 pp.
Translated: by Alf Ahlberg. *Den Nya Filosofien.* Stockholm, Bokförlegst Natur Ochkultur. By Crespo y Crespo. *Fundamentos de Filosofia.* Barcelona, Apolo, 1935. 360 pp. By Dr. Janina Hosiasson. *Zarys Filozofii.* Warszawa, J. Przeworski, 1939. 362 pp. Reprinted—New York, Meridian Books, Inc., 1960, 317 pp.

9. IS SCIENCE SUPERSTITIOUS? *Rationalist Annual,* 1927.
Reprinted in *Little Blue Books,* No. 543, Haldeman-Julius Company, Girard, Kansas, 1947. 32 pp. Also in *Sceptical Essays,* (1928, item No. 2). See, also, 1926, item No. 9.

## 1928

2. SCEPTICAL ESSAYS. New York, W. W. Norton & Co., Inc., 1928, 256 pp.; London, George Allen & Unwin, Ltd., 1928.
Chap. I reprinted in *Little Blue Books,* No. 542, Haldeman-Julius Company, Girard, Kansas, 1947. 32 pp. Chap. V. reprinted in *Twentieth Century Philosophy,* edited by Dagobert D. Runes, Philosophical Library, 1943. pp. 227-249. The *Introduction* at pp. 1276-1286 and Chap. VIII at pp. 1286-1293 are reprinted in *Fifty Modern English Writers,* edited by W. Somerset Maugham, Doubleday Doran, 1933.

Translated: By Andre Bernard. *Essais Sceptiques,* Paris, Rieder, 1933. 356 pp. By Amelia Kurlandzka. *Szkice Sceptyczne.* Warszawa, Roj, 1937. 347 pp. Chap. I translated by Karl Wolfskehl as *Der Wert des Skeptizismus,* Berlin, Neue Rundschau, 1929, Jahrg. 40. pp. 1-13.

Chap. XV translated by Karl Wolfskehl as *Psychologic und Politik,* Berlin, Neue Rundschau, 1930, Jahrg. 41. pp. 600-610. Chaps. I, X, XII, and XVI translated by Stein Rokkan with other essays of Russell under title of *Frihet og fornuft.* Oslo, E. G. Mortensen, 1947.

Reprinted—Unwin Books; New York, Barnes & Noble, 1961, 172 pp. Translated—Essais sceptiques; traduit de l'anglais par Andre Bernard. Paris, Les Editions Rieder, 1933, 354 pp. Extracts from the Introduction, *The Harm that Good Men Do* and *Can Men be Rational,* in Cohen and Cohen, *Readings in Jurisprudence and Legal Philosophy.* New York, Prentice Hall, Inc., 1951, pp. 610-614.

*14.* EXTRACT FROM ADDRESS AT ANNUAL DINNER OF THE RATIONAL-
IST PRESS ASSOCIATION, LIMITED, MAY 14, 1928. In F. J. Gould's
*The Pioneers of Johnson's Court.* London, Watts & Co., 1929,
1935, pp. 146-7.

*15.* ADDRESS DELIVERED AT DINNER AT HOTEL ASTOR, NEW YORK,
IN HONOR OF MORRIS RAPHAEL COHEN, OCTOBER 15, 1927. In a
tribute to Professor Morris Raphael Cohen, Teacher and Philos-
opher. Published in *The Youth Who Sat at His Feet,* New York,
1928, pp. 46-49.

1929

*1.* MARRIAGE AND MORALS. New York, Horace Liveright, 1929;
London, George Allen & Unwin, Ltd., 1929. 320 pp. Sun Dial
Center Books, 1938.
Translated: By Helena Bolz. *Malzen stne i moralnosc z uponaznienia autora
przelozyla.* Antonieqiczona, Warszawa, Roj, 1931. 247 pp. By G. Torna-
buoni. *Matrimonio E Morale.* Milano, 1949. 288 pp.

*16.* OPINION ABOUT THE SACCO-VANZETTI CASE. *Lantern,* v. ii,
1929. pp. 11.

1930

*1.* THE CONQUEST OF HAPPINESS. New York, Horace Liveright,
Inc., 1930, 249 pp.; London, George Allen & Unwin, Ltd., 1930,
252 pp. Mentor Books, The New American Library, 1951.
Translated: By Julio Huici. *La Conquista de la Felicidad.* Madrid, Espasa-
Calpe, S. A., 1931, 257 pp. By Magda Kahn, *Schlüssel zum Glück.* München,
Drei Masken Verl., 1932. 215 pp. By Antonio Panski. *Podboj Szczescia.*
Warszawa, Roj, 1933. 248 pp. By Lotte Holmboe. *Menneskelykke.* Oslo,
Tanum, 1948. 187 pp.
Selection entitled "Unhappiness," in *Problems in Prose,* edited by Paul
Haines. New York, Harper & Bros., 1950, pp. 124-129.

*17.* REPORT TO THE COUNCIL OF TRINITY COLLEGE RECOMMENDING
THE AWARD OF A GRANT TO WITTGENSTEIN WITH BIOGRAPHICAL
SKETCH IN A FOOTNOTE. In Georg Von Wright's *Ludwig Witt-
genstein: a Memoir.* Oxford University Press, at the University,
1958, p. 13.

1931

*2.* THE SCIENTIFIC OUTLOOK. New York, W. W. Norton & Co.,
Inc., 1931. x, 277 pp.
Translated: By Jan Krassowski. *Poglady i Widoki Nauki Wspolcznej.*
Warszawa, J. Przenorski, 1934, 1936, 1938. 299 pp. By Emilio A. G. Loliva.
*Panorama Scientifico.* Bari, G. Laterza, 1934. vii, 254 pp.
Selection in *Basic Problems of Philosophy: Selected Readings.* Edited by
D. J. Bronstein, Y. H. Krikorian and P. P. Wiener. Englewood Cliffs, New
Jersey, Prentice-Hall, Inc., 1955, Second Edition, pp. 255-270.

### 1932

2. EDUCATION AND THE SOCIAL ORDER. London, George Allen &
Unwin, Ltd., 1932, 254 pp.; New York, as *Education and the
Modern World*, W. W. Norton & Co., Inc., 1932, 245 pp.

Chapters II and III and chapters IV and V of the English edition run to-
gether in the American edition.

Translated: By W. Phielix. *Opvoeding en de Moderne Samenleving.* Den
Dolder, de Driehoek, 1938. 273 pp.

7. ANSWER TO QUESTIONNAIRE ON THE RELIGION OF SCIENTISTS:
BEING RECENT OPINIONS EXPRESSED BY TWO HUNDRED FEL-
LOWS OF THE ROYAL SOCIETY ON THE SUBJECT OF RELIGION
AND THEOLOGY. Edited by C. L. Drawbridge on behalf of the
Christian Evidence Society. New York, The Macmillan Company,
1932, pp. 32, 46, 61, 83, 101, 115, 155.

### 1933

3. MODERN MARRIAGE: A REVIEW OF "YOURS UNFAITHFULLY,"
A COMEDY IN THREE ACTS by Miles Malleson. *The Observer,*
London, Apr. 23, 1933, p. 5.

### 1934

1. FREEDOM AND ORGANIZATION 1814-1914. London, George Allen
& Unwin, Ltd., 1934, 528 pp.; New York, as *Freedom versus
Organization 1814-1914,* W. W. Norton & Co., Inc., 1934, viii,
471 pp.

Translated: By Leon Felipe. *Libertad Y Organizacion, 1814-1914.* Madrid,
Espasa-Calpe, 1936. 480 pp. By Anna Feiler Wertheimsteinne. *Egye Vszazad
Elettörtenete, 1814-1914.* Budapest, Revai, 1936. v. I. 291 pp.; v. II. 306 pp.
By Dr. Antoni Panski. *Wiek Dziewietnasty.* Warszawa, Roj., 1936. 313,
333 pp. By A. M. Petitjean. *Histoire des Idées En XIX Siècle. Liberté et
Organisation.* Paris, Gallimard, 1938. 397 pp. By Alfred Faber. *Freiheit und
Organisation 1814-1914.* Berlin, Cornelsen, 1948. 548 pp. By Jaroslav Kriz.
*Svoboda a Organisage* 1814-1914. Praha, Denické nakaladatelstoi, 1948.
536 pp.

2. WHY I AM NOT A COMMUNIST.

Reprinted in *Portraits from Memory.* Reprinted in *Background Book,*
Phoenix House, Ltd., under title "Why I Opposed Communism."

5. THE TECHNIQUE FOR POLITICIANS.

Reprinted in *Ideas & Models.* Edited by Louise Pound, Robert Law, Theo-
dore Sternberg, Lowry Wimberly, James Callahan and Norman Eliason.
New York, Henry Holt and Company, 1935, pp. 55-58.

## 1935

*1.* IN PRAISE OF IDLENESS AND OTHER ESSAYS. New York, W. W. Norton & Co., Inc., 1935. viii, 270 pp.

Chapters XIII and XV reprinted as *Little Blue Books,* Haldeman-Julius Company, Girard, Kansas.

Translated: By Antoni Panski. *Puchwala Prozniactwa.* Warszawa, Roj, 1937. 270 pp. By Alf Ahlberg. *Till Lättjans Lov.* Stockholm, Natur o. kultur, 1937. 188 pp. Chapters I, VI and XIII translated by Stein Rokkan with other essays of Russell in volume entitled *Frihet og fornuft.* Oslo, E. G. Mortensen, 1947.

*2.* RELIGION AND SCIENCE. New York, Henry Holt and Co., Inc., 1935, 271 pp., Home University of Modern Knowledge; London, T. Butterworth-Nelson, 1935.

Translated: By Ake Malmström. *Religion och Vetenspap.* Stockholm, Natur o Kultur, 1937. 168 pp. by J. Aalbers. *Godsdienst en Wetenschap.* Rotterdam, Av. Douker, 1948, 169 pp.

Reprinted—New York, Oxford University Press, Galaxy Book, 255 pp. Translated—*Science et religion.* Trad. par Philippe Mantoux. Paris, Gallinaud, 1957, pp. 249.

## 1936

*1.* WHICH WAY TO PEACE? London, Michael Joseph, Ltd.; Canada, S. J. R. Sauners, 1936, 244 pp.

Last chapter reprinted by Fellowship of Reconciliation, New York, 12 pp. Translated: By Antoni Panski. *Droga do Pokoju.* Warszawa, Roj, 1937. 264 pp. By Carl-Fredrik Palmstierna. *Vägen till Freden.* Stockholm, Bonwier, 1938. 179 pp.

*3.* DETERMINISM AND PHYSICS. The 18th Earl Grey Memorial Lecture delivered at King's Hall, Armstrong College, Newcastle-upon-Tyne, Jan. 14, 1936. The Librarian, Armstrong College, 1936. 18 pp. Reprinted from Proceedings of the University of Durham Philosophical Society.

*11.* ON ORDER IN TIME.

Reprinted in *Logic and Knowledge,* 1936. Edited by Robert C. Marsh.

## 1937

*3.* PHILOSOPHY'S ULTERIOR MOTIVE. *The Atlantic Monthly,* v. 159. Feb. 1937, pp. 149-155.

Reprinted: In *Unpopular Essays,* New York, Simon and Schuster, 1950. pp. 45-57.

## 1938

*4.* POWER: A NEW SOCIAL ANALYSIS. London, George Allen & Un-

win, Ltd., 1938, 328 pp.; New York, W. W. Norton & Co., Inc., 1938, 315 pp.

Chapter XVIII reprinted in *Opinions and Attitudes in the Twentieth Century*, Fourth Edition, edited by Stewart Morgan, New York, The Ronald Press, 1948. pp. 447-464.

Translated: By Luis Echavarri. *El poder en los hombres y en los pueblos*. Buenos Aires, Editorial Losada, 1939. 248 pp. By Rubens Gomes de Sonza. *O poder (uma nova analise social)*. S. Paulo, Livraria, Martins, 1941. 234 pp. By Paul Gerner. *Makt*. Stockholm, Natur. o. kultur, 1939. 285 pp. *Macht, Eine Sozialkritische Studie*. Zurich, Europe verlag, 1947, pp. 267.

7. ARISTOCRATIC REBELS: BYRON AND THE MODERN WORLD.

Reprinted in *The Saturday Review Treasury*. New York, Simon and Schuster, 1957, pp. 172-181.

*12.* WHAT IS HAPPINESS? In *What is Happiness?* London, John Lowe, 1938; New York, H. C. Kinsey & Co., Inc., 1939, pp. 55-65.

1939

6. IS SECURITY INCREASING?

Reprinted in *Effective Reading: Methods and Models*. Edited by M. L. Rosenthal, W. C. Hummel and V. E. Leichty. Boston, Houghton, Mifflin Company, 1944, pp. 135-140.

1940

*2.* AN INQUIRY INTO MEANING AND TRUTH.

Translation—*Signification et verité*. Trad. de l'anglais par Philippe Devaux. Paris, Fammarion, pp. 408.

7. THE FUNCTIONS OF A TEACHER. *Harper's Magazine*, v. 181, June 1940, pp. 11-16.

Reprinted in *Unpopular Essays*, New York, Simon and Schuster, 1950. pp. 112-123.

Reprinted in *Gentlemen, Scholars and Scoundrels: A Treasury of the Best of Harper's Magazine From 1850 to the Present*. Edited by Horace Knowles. New York, Harper & Brothers, pp. 522-531.

*9.* ON FREEDOM IN TIME OF STRESS. New York Regional Progressive Conference, 1940. See 1942, item #6.

*10.* LETTERS TO ALBERT C. BARNES, dated June 18, July 20, August 17, and August 24, 1940 with reference to Lord Russell's appointment to teach at the Barnes Foundation. Printed in *Art and Argyrol: The Life and Career of Dr. Albert C. Barnes* by William Schack. New York, Thomas Yoseloff, 1960, pp. 324-327.

1941

9. God Is Not a Mathematician. In *New Worlds in Science,* edited by H. Ward, McBride, 1941, Popular Edition, 1944.

1943

3. An Outline of Intellectual Rubbish: A Hilarious Catalogue of Organized and Individual Stupidity. Haldeman-Julius Publications, Girard, Kansas, 1943. 26 pp.

Reprinted in *Unpopular Essays,* New York, Simon and Schuster, 1950. pp. 71-111.

7. How to Read and Understand History: The Past as the Key to the Future.

Reprinted in *Understanding History and Other Essays.* New York, Philosophical Library, Inc., 1957, pp. 9-56.

1944

1. My Mental Development

Reprinted in *The World of Mathematics.* New York, Simon and Schuster, v. I., 1956, pp. 381-394. Edited by James R. Newman.

3. The Value of Free Thought: How to Become a Truth-Seeker and Break the Chains of Mental Slavery.

Reprinted in *Understanding History and Other Essays.* New York, Philosophical Library, Inc., 1957, pp. 57-103.

1945

1. A History of Western Philosophy. New York, Simon and Schuster, 1959, 843 pp.

Chapter XXXI reprinted in *The Age of Analysis.* Edited by Morton White. Boston, Houghton Mifflin Co., 1955 and New York, Mentor Book, The New American Library, 1955, pp. 194-203.

6. Free Schools in a State System. *The Observer,* London, June 10, 1945, p. 4.

7. The Outlook for Mankind. 1945 Horizon article reprinted in *The Golden Horizon.* Edited by Cyril Connolly. London, Weidenfeld & Nicolson, Ltd., 1954, pp. 145-153.

8. Speech to the House of Lords on Atomic Weapons and Atomic Warfare. Hansard, *Official Report, House of Lords,* Vol. 138, No. 30, November 28, 1945.

### 1946

3. Is Materialism Bankrupt? Mind and Matter in Modern Science.

   Reprinted as *Mentalism and Materialism* in *Understanding History and Other Essays*. New York, Philosophical Library, Inc., 1957, pp. 105-122.

7. Preface to W. K. Clifford's *The Common Sense of the Exact Sciences*. New York, Alfred Knopf, 1946 and New York, Dover Publications, Inc., 1955, pp. v-x.

8. A Fable Relative to Universals and Particulars. *Polemic*, No. 2, 1946, pp. 24-5.

### 1947

1. Philosophy and Politics.

   Reprinted in *Modern Political Thought: The Great Issues*. Edited by William Ebenstein. New York, Rinehart & Company, Inc., 1954, pp. 8-21. Also reprinted in the Beacon Press, 1960, edition of *Authority and the Individual*.

4. Towards World Government. Based on lectures given for The New Commonwealth in Holland and Belgium in the autumn of 1947. London, The New Commonwealth, Thorney House, 1947, pp. 3-12.

5. Comment on Technological Change and Cultural Integration by Chapple and Coon. In *Conflicts of Power in Modern Culture*. Conference on Science, Philosophy and Religion in their Relation to the Democratic Way of Life. Edited by Lyman Bryson, Louis Finkelstein and R. M. MacIver. New York and London, Harper & Bros., 1947, pp. 265-266.

6. Letter Signed by 11 Englishmen Declaring Control of Atomic Energy Frustrated by Intransigence of the Soviet Union. Signed by Bertrand Russell and others. *New York Herald Tribune,* Dec. 21, 1947; *The Times of London,* Dec. 22, 1947. Einstein claimed in a letter to Henry Usborne of The Crusade for World Government that Russell's signature was not authorized by him. *Einstein on Peace.* New York, Simon and Schuster, 1960, p. 463.

7. A Scientist's Plea for Democracy. Talk on b.b.c. Third Programme, 1947. Printed in *Fact and Fiction*.

### 1948

6. Answers to Questions. In *Last Chance: Eleven Questions That Will Decide Our Destiny*. With others. Edited by Clara Urquhart. Beacon Press, Boston, Massachusetts, 1948. pp. 73, 82-3, 92, 103, 112, 123, 133, 142, 151, 160, 168.

7. On World Government. *Der Monat,* Oct. 1948.

8. The Existence of God: A Debate Between Bertrand Russell and Father F. C. Copleston, S.J. *Humanitas.* Reprinted in the English edition of *Why I am not a Christian,* 1957.

### 1949

*11.* Introduction to Freda Utley's Lost Illusion. London, 1949.

### 1950

*1.* Unpopular Essays.
Chapter III on *The Future of Mankind* appeared in the *Atlantic Monthly* of March 1957.

*4.* The Science to Save Us from Science.
Reprinted in *Great Essays in Science.* Edited by Martin Gardner. New York, The Pocket Library, Pocket Books, Inc., 1957, pp. 389-397.

*5.* Came the Revolution.
Reprinted in *The Saturday Review Reader.* New York, Bantam Books, Inc., 1951, pp. 125-133.

*7.* Can We Afford to Keep Open Minds?
Reprinted in *Current Thinking and Writing.* Edited by Joseph M. Bachelor, Ralph L. Henry and Rachel Salisbury. New York, Appleton-Century-Crofts, Inc., 1951, pp. 247-250. Reprinted in *Readings for Comprehension.* Edited by Benfield Pressey and Robert M. Bear. New York, Charles Scribner's Sons, 1951, pp. 167-174.

*12.* Logical Positivism: Wittgenstein Memorial.
Revue International de Philosophie, v. iv, 1950, p. 19. Reprinted in *Logic and Knowledge,* 1956. Edited by Robert C. Marsh. Portions taken from *Human Knowledge: Its Scope and Limits,* 1948.

*13.* What Went Wrong: Review of the God that Failed: Six Studies in Communism by Arthur Koestler, Ignazio Silone, Andre Gide, Richard Wright, Louis Fischer and Stephen Spender. *The Observer,* London, Jan. 29, 1950, p. 4.

*14.* Happy Australia. *The Observer,* London, Oct. 22, 1950, p. 4.

*15.* Loquacious Man and His Mind: Review of the Reith Lectures on Doubt and Certainty in Science by J. Z. Young. *The Observer,* London, Dec. 24, 1950, p. 4.

# CHRONOLOGICAL LIST OF PRINCIPAL WORKS

1896—German Social Democracy.

1897—An Essay on the Foundations of Geometry.

1900—A Critical Exposition of the Philosophy of Leibniz.

1903—The Principles of Mathematics.

1910—Principia Mathematica—Vol. I. (With A. N. Whitehead.)

1910—Philosophical Essays.

1912—Principia Mathematica—Vol. II. (With A. N. Whitehead.)

1912—The Problems of Philosophy.

1913—Principia Mathematica—Vol. III. (With A. N. Whitehead.)

1914—Our Knowledge of the External World as a Field for Scientific Method in Philosophy.

1914—Scientific Method in Philosophy.

1914—The Philosophy of Bergson. (Controversy with H. W. Carr.)

1915—War, the Offspring of Fear.

1916—Principles of Social Reconstruction. (Why Men Fight: A Method of Abolishing the International Duel.)

1916—Policy of the Entente, 1904-1914. (Part of: Justice in War-Time.)

1916—Justice in War-Time.

1917—Political Ideals.

1918—Mysticism and Logic and Other Essays.

1918—Roads to Freedom: Socialism, Anarchism and Syndicalism. (Proposed Roads to Freedom: Socialism, Anarchism and Syndicalism.)

1919—Introduction to Mathematical Philosophy.

1920—The Practice and Theory of Bolshevism. (Bolshevism in Theory and Practice.)

1921—The Analysis of Mind.

1922—The Problem of China.

1922—Free Thought and Official Propaganda.

1923—The Prospects of Industrial Civilization. (With Dora Russell.)

1923—The ABC of Atoms.

1924—Bolshevism and the West. (Debate with Scott Nearing.)

1924—Icarus or the Future of Science.

1924—How to be Free and Happy.

1924—Logical Atomism.

1925—The ABC of Relativity.

1925—What I Believe.

1926—On Education Especially in Early Childhood. (Education and the Good Life.)

1927—Why I am not a Christian.

1927—The Analysis of Matter.

1927—An Outline of Philosophy. (Philosophy.)

1928—Sceptical Essays.

1929—Marriage and Morals.

1930—The Conquest of Happiness.

1930—Has Religion Made Useful Contributions to Civilization?

1931—The Scientific Outlook.

1932—Education and the Social Order. (Education and the Modern World.)

1934—Freedom and Organization 1814-1914. (Freedom versus Organization 1814-1914.)

1935—In Praise of Idleness and Other Essays.

1935—Religion and Science.

1936—Which Way to Peace?

1936—Determinism and Physics.

1937—The Amberley Papers. The Letters and Diaries of Bertrand Russell's Parents. (With Patricia Russell.)

1938—Power: A New Social Analysis.

1940—An Inquiry into Meaning and Truth.

1945—A History of Western Philosophy.

1948—Human Knowledge: Its Scope and Limits.

1949—Authority and the Individual.

1950—Unpopular Essays.

1951—The Impact of Science on Society.

1952— New Hopes for a Changing World.

1953— Satan in the Suburbs and Other Stories.

1954— Nightmares of Eminent Persons and Other Stories.

1954— Human Society in Ethics and Politics.

1954— History as an Art.

1956— Portraits from Memory and Other Essays.

1956— Logic and Knowledge: Essays 1901-1950. (Edited by Robert C. March.)

1957— Why I am not a Christian and Other Essays on Religion and Related Subjects. (Edited by Paul Edwards.)

1957— Understanding History and Other Essays. (Reprint of Earlier Essays.)

1958— The Will to Doubt. (Reprint of Earlier Essays.)
1959—Common Sense and Nuclear Warfare.
1959—My Philosophical Development.
1959—Wisdom of the West.
1960—Bertrand Russell Speaks His Mind.
1961—Has Man a Future?
1961—Fact and Fiction.
1961—The Basic Writings of Bertrand Russell. (Edited by Robert E. Egner and Lester E. Denonn.)

# INDEX

(Arranged by ROBERT S. HARTMAN)

of God, 553; traditional and institutional, 550

Chrono-geography, 485

Church, Alonzo, 150n, 232n

Churches, 542, 726f; influence on education, 622f, 636

Churchill, Winston, 547

Chwistek, L., 138, 139n

Circularity, 133ff

Citizens, cannot have God-like will, 625; defined by Russell, 622; education must train, 632f

Citizenship, education for, 624, 626, 632f; and the God-like will, 628; and individual, 731ff; sense of, interpreted, 631; necessary, 630f; and State obligation, 631

Clarke, Samuel, 540

Class, logical, 131f, 136, 141, 151, 189ff, 348, 687; and number, 29ff, 113, 321f; and properties of individuals, 323, 689; and realism, 161ff; and relation, 25; and things, 167f, 689; contradiction about classes that are not members of themselves, 13, 37; existence of, 325f, 329; logical constructions, 141, 143, 323ff; no-class theory, 133, 136n, 141f, 148; null-class, 141, 689; physical objects, 342, 348; plurality of things, 137, 140; similarity of classes, 29; substitution of classes of similar classes, 698; symbols, treated like descriptions, 14, 94, 98ff; unit class, 141; well-ordered, 344n

Class (social), conflict, 564n; hatred, 574; war, 574; warfare, Marxist policy of, 562

Classical moralists, 519

Classics, 572

Classification, of propositions, 42; of situations, 434

Clericalism, 531

Closed societies, 732ff

Cobden, Richard, 652

Cognition(s), 297ff, 301, 451, 454, 457, 460, 699

Cohen, Hermann, 273

Coherence, theory of truth, linguistic, 388, 460

Cole, G. D. H., 596f, 615

Color blindness, 456

Columbus, 711f

Common sense, 67, 330, 412, 700, 703, 705, 711ff; knowledge, 330ff, 336, 425; logical, 692; view, right of, 506f

Communicability of propositions, 390

Communication, of conation, 502

Communism, 268, 562f, 567n, 597n, 598; Russell's objection to, 563

*Communist Manifesto*, 610

Communists, 569

Community, and the individual, 624-635, 637, 639-642; the conflicts in, 634, 637; tradition, the unifying element in, 637

Community Chest, 544

Comparison, predication as, 434f

Completely general, propositions, 85, 87f; facts, 85

Complex, 111, 235, 238, 392, 441; constituents of—propositions, 97, 162, 253, 694f; knowledge, 713; symbols, 94

Complexity, 169, 172, 341

Compresence, 343, 699, 705f

Compulsion, 523; approved by Russell, 629; as viewed by the "lunatic fringe" of education, 630; physical and psychological, 519

Conation, the basic psychological facts, 497f; as directed movement of an organism, 502; awareness of conation basis to conception of causality, 502

Concept, 131f, 137ff, 141, 151; empiricism, 414ff; existence-propositions, 406ff; free creation of thought, 287, 695; symbol, 407

Conception, 108n

Conceptualism, 388, 417

Condillac, E. B., 582

Conditional definitions, 348

Conditioned reflex, 464f, 470; responses, 458

Conditioning, 460

Conscious states, 522

Consciousness, 7, 61, 63, 67, 72, 107n, 108n, 299f, 304, 306, 311, 314, 357, 359, 374, 379f, 447; misleading term of, 498f

Conservation of mass and momentum, 347n

Conservatism, majority on side of, 635

Consistency, of Russell's philosophy, 58, 106n; of language, 37ff, 44; of science, 44

Constatations, M. Schlick's, 432, 439

Constants, logical, 158ff, 164ff

Constructionism, 57, 65, 92-110, 240-251, 338-349, 364ff

Constructions, descriptions, 246; logical, 108, 167, 244ff, 309, 320-330, 338ff, 348f, 355n, 692f; of public space out of